Houses from Books

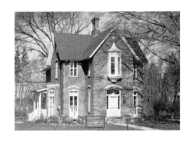 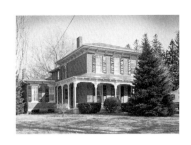 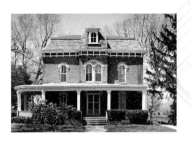

Houses from Books

Treatises, Pattern Books, and Catalogs in American Architecture, 1738–1950: A History and Guide

Daniel D. Reiff

THE PENNSYLVANIA STATE UNIVERSITY PRESS
UNIVERSITY PARK, PENNSYLVANIA

This book has been aided by a grant from Furthermore, the publication program of
The J. M. Kaplan Fund.
Library of Congress Cataloging-in-Publication Data

Reiff, Daniel D. (Daniel Drake)
 Houses from books: treatises, pattern books, and catalogs in American architecture, 1738–1950,
a history and guide / Daniel D. Reiff.
 p. cm.
 Includes bibliographical references and index.
 ISBN 0-271-01943-3 (cloth : alk. paper)
 1. Architecture, Domestic—United States—Designs and plans. 2. Architecture—United States—
Bibliography. 3. Architecture—Bibliography. 4. Architecture, Domestic—United States—History—
Sources—Bibliography. I. Title

NA7205 .R435 2001
728'.0973—dc21
 99-046642

It is the policy of The Pennsylvania State University Press to use acid-free paper for the first printing of all
clothbound books. Publications on uncoated stock satisfy the minimum requirements of American National Standard for Information Sciences—Permanence of Paper for Printed Library Materials, ANSI
Z39.48–1992.

To my wife, Janet, and to my sons, Nicholas and Michael,
who survived an entire decade of
houses from books—and even the ubiquitous AABN.

Contents

Preface

While conducting research in 1969 on Federal-style houses in Georgetown and Washington, D.C., for the U.S. Commission of Fine Arts, I was struck by the fact that among the considerable number of traditional "vernacular" row houses and individual dwellings, a few stood out because of architectural details (arches framing the ground-floor windows) much more sophisticated than the rest. On further investigation, I found that almost identical treatment appeared in contemporary builders' manuals. Thus began my interest in the role of printed books in architectural design, which has been a persistent aspect of my research ever since.

At certain times, this influence on American architecture has seemed large; at other times, it has seemed small or nonexistent. As one of many factors in the process that produces a house executed in a particular style, the influence of designs in books has long appeared to me to be a most significant, and often overlooked, aspect. The original purpose of architectural treatises, carpenters' manuals, and the pattern books that succeeded them was to distribute design ideas invented (or at least gathered together) by the author. Because the author was usually a practicing architect or carpenter, such a book might well reflect both his own artistic genius and others' ideas already developed in the author's particular region. Such books then diffused motifs, codified architectural styles, and even set out new principles of planning and siting. They were collected and used by architects and craftsmen of the day. Although travel to see new work and to find new commissions was undoubtedly an abiding method for the development and diffusion of new ideas in the nineteenth century as it had been in earlier centuries, the dramatic increase in the numbers of such architectural books published during the nineteenth century and into the twentieth is evidence of their importance for design of buildings then and for our understanding of such buildings today.

The impact of published designs and details on actual buildings has been a thread I have followed with growing interest for many years. My book on Washington, D.C., and Georgetown architecture of 1971 included some of these early nineteenth-century pattern-book designs.[1] My subsequent study of the western New York village of Fredonia (published in 1972) included sections on how pattern books had affected even remote areas[2] and briefly explored the "mail-order plan" phenomenon of the late nineteenth and early twentieth centuries. In my study of Georgian houses in England and Virginia before 1750, I found that architectural treatises and builders' manuals had played a rich and important role in the seventeenth and eighteenth centuries as well.[3]

From my own architectural research locally and from heading countywide architectural surveys in 1973 through 1976, I realized that the role of the printed book in influencing the domestic architecture that we see all around us was considerable, and subsequent study of Greek Revival dwellings in Chautauqua County amply bore this out.[4] Thus in 1984, on a sabbatical leave, I began my research on the influence of designs in books on houses in America.

The purposes of this study are several. Fundamentally, this book is a detailed investigation of the whole phenomenon of "houses from books," from the earliest case (apparently 1738) of an entire facade adapted from a design on the printed page, through 1950. This investigation also explores other related factors besides possible

specific design sources for houses: who the people and firms who produced these books were, and how they went about their business; the ways such designs were used by the builders and architects of these houses; the architectural training and education during this period; the ways that the books diffused ideas, motifs, and designs; and the origins and meanings of the house styles and types discussed.

This study is also intended to be of interest—and of real use—to many others beyond students and scholars of American architectural history. It should significantly assist those conducting architectural surveys at the local or state level, as well as homeowners and architects anxious to explore and identify the styles, sources, and meanings of individual dwellings. In fact, the last portion of this study is arranged as a sort of "catalog" that can also function as a research guide for those attempting to locate a possible original model and date for a particular house design (throughout the book, I have provided, where possible, references to alternative sources or examples of a particular design).

Although facade designs were imitated occasionally (and details frequently) from the eighteenth century into the early nineteenth, the heyday of American copying of house designs in books begins in the early 1840s. This study is based on a thorough review of books from 1600 onward, but most examples come with the publications of A. J. Downing and his followers and successors. Of books published between 1842 and 1952, I examined 4,153 designs in fifty-four different books and catalogs; this survey thus provides a useful distillation of a fair number of representative sources.[5] Only when the majority of carpenters' and builders' manuals, pattern books, mail-order catalogs, and other such books are systematically entered on a computerized database by some foresighted eleemosynary organization will it be possible for researchers to make an exhaustive search for possible published models of any given dwelling.

My debts of gratitude to the people who helped with, facilitated, or encouraged this study are many: to Donald A. MacPhee, former president of the State University of New York College at Fredonia, my thanks for his consistent encouragement and support of research among his faculty and his recognition of its vital role even at an institution devoted to undergraduate instruction. Without sabbatical leaves during 1984–85 and 1991–92, this work could never have been undertaken and completed. I am also grateful to the National Endowment for the Humanities for a Fel-

lowship for College Teachers and to the Graham Foundation for Advanced Studies in the Fine Arts for a research grant. These greatly facilitated my work during my sabbaticals.

I also want to thank the College at Fredonia for a number of smaller grants over the years, which have materially assisted my work. A Fredonia Mini-Grant for Research in 1986 paid for having sixteen house plans drawn up by the architect Richard L. Peebles Jr.; fourteen of them found their way into this study, and three additional plans I drew up myself. A Professional Development Grant in 1986 permitted me to purchase useful research materials, as did a second Mini-Grant in 1987. A Release Time Award for the spring term of 1990 enabled me to devote additional time to my research. To the college faculty and administration involved in these programs, I am especially grateful. My thanks also to former Dean Sanford J. Zeman who provided funds in 1989 for travel related to my research.

The college's Sponsored Programs/Research Office has also been of inestimable assistance in many ways. Maggie Bryan-Peterson and Marlene Chizmadia made my application for grants a nearly painless task. My greatest debt to this office, however, is to Joanne Foeller, who, since 1991, has word-processed the manuscript, and its endless revisions and emendations, with intelligence, great care, and good humor.

During the research and fieldwork for this project, I have been assisted by a great many people. Foremost among them are the owners of the ninety-three houses that I selected for thorough inspection, which included measured floor plans and occasionally interior photography. Their cooperation, personal insights, and information are much appreciated. Those people whose houses I have used in this study are gratefully acknowledged at the appropriate place in the notes. I also appreciate the interest of many others who assisted me in my work in various ways, especially those who lent or gave me plan or house catalogs or related booklets: These include Bernice Billings, Richard Cheek, Charles J. Czech, Mrs. Byron Danforth, Kathryn M. Downing, Herbert J. Graves, Jean B. Harper, Sara Kazalunas, Nelson Kofoed, Walter Langsam, Gary J. Pierce, Homer Sackett, and Douglas H. Shepard.

My debt in this area to numerous antiquarian book dealers is also considerable. Not only did they supply a good number of rare books that I purchased for this study, but their sales catalogs of such volumes became valuable research tools. Most of the citations in my Appendix listings of such books and catalogs come from the offerings, between 1981 and 1992, of these firms: Acanthus Books, B. R. Artcraft Company,

F. A. Bernett, Incorporated, Book Mark, Nancy Sheiry Glaister, Thomas Karapantso, Riverow Bookshop, Craig Ross Bookseller, and Geoffrey Steele, Incorporated.

For other volumes that I consulted, my thanks go to several libraries. Most of the original seventeenth- and eighteenth-century treatises I studied are in the Library or in the Research Department of the Colonial Williamsburg Foundation, except for Scamozzi, in the Buffalo and Erie County Public Library Rare Book Room. A few of the nineteenth- and twentieth-century volumes studied are in the collection of the Library of Congress: Atwood (1876), Radford (1912 and 1919), Standard Homes Company (1930), and Aladdin (1931); the Bibliography provides full citations for all these volumes.

Other libraries were of great help in other ways. I owe a special debt to the Daniel Reed Library at the State University College, Fredonia, especially Margaret E. Pabst and her Interlibrary Loan staff, as well as Gary D. Barber (Reference) and Jack T. Ericson (Archives), over many years. I am equally indebted to the curators at the Historical Museum of the Darwin R. Barker Library, Fredonia, New York, notably Ann M. Fahnestock and Donna N. Carlson, for their assistance and interest over many years, and to the staff at the Buffalo and Erie County Public Library, especially Donald Cloudsley and Mary Jane Smith, for facilitating my work during 1991–93 with *The American Architect and Building News*. My thanks also to the West Point Academy Library for lending its microfilm copy of this journal.

A number of organizations or individuals have provided me with original photographs or have lent me material to copy-photo; they are gratefully acknowledged in the appropriate illustration captions and in footnotes. The remaining photographs and copy-photos are my own.

Some of the reproductions I have used are from catalogs published after 1925, which thus might still be under seventy-five-year copyright protection. I have made concerted efforts to track down all the firms involved or their successors. In this regard, I wish to give special thanks to Will J. Sovereign, grandson of a founder of the Aladdin Company, and also to Vicki Cwiok of the Sears, Roebuck and Company Archives, for their permissions to reproduce material.

During my research on particular houses as well as on individuals involved in the building trades, I was provided helpful data by many people; points of information used in this study are gratefully acknowledged at the appropriate place in the notes. I also owe a considerable debt of gratitude to the eighteen car-penters, builders, architects, homeowners, and others who consented to give me extensive interviews. The information they provided, sometimes recorded on tape, was essential to this study; a listing of all the interviews is provided in the Bibliography. In this regard, my special thanks to Ann Carter who prepared typed transcripts of five of the taped interviews.

I am also most grateful to Douglas H. Shepard, who supplied me with dates for a great many houses in Fredonia and also in Dunkirk, New York, drawn from his ongoing research on dating each house in Fredonia from contemporary historical records. His assistance and discussions on knotty issues of dating were of great help and interest.

My thanks also to former students Michele B. Furdell, Karen Karalus, and Joanne Goetz, whose term papers on architecture cited in local newspapers provided many helpful leads.

In a book of this sort, the visual material is as important as the other research and historical data; thus my sincere thanks go to several people who assisted me with the photographs and the graphics. The Creative Support Services of the College at Fredonia not only processed all the black and white film that I shot over a dozen-year period, but also generously made available to me its black and white photography lab for my printing of the necessary photographs. In this regard, I am especially grateful to Deborah A. Lanni for her advice, for black and white copy negatives from color slides, and for providing (with the assistance of Derek Tackitt and Mary Smilie) about 120 prints of copy work, much of which I have used here. (In the captions and notes, RCHME stands for the Royal Commission on the Historical Monuments of England, and HABS for the Historic American Buildings Survey.)

Charlotte R. Morse, also of the College's Creative Support Services, was responsible for most of the splendid graphs and for the Sears map, which add an invaluable component to the study. For the house-type graphs based on selected twentieth-century catalogs, I am indebted to Marc V. Stress, both for designing the twelve house "logos" and also for preparing the graphs.

Finally, I am most appreciative of the encouragement and interest in this project provided by Frederick D. Cawley, the late William H. Jordy, Francis R. Kowsky, and David Williams McKee—as well as the editors and designers at Penn State Press, who were models of collegial cooperation and efficiency. And to many other friends, colleagues, and my family, who have expressed their interest in this project over the years, my sincere thanks.

1

Architectural Books in England, c. 1550–1750

THE USE OF ILLUSTRATED architectural treatises and manuals as an aid in architectural design dates back 450 years to the sixteenth century, when such volumes were the vehicle for introducing the new Renaissance style north of the Alps. Especially in countries with little monumental Roman architecture to look to for possible ideas (as was the case in England), illustrated books were essential.

The first illustrated architectural treatise ever written was probably that of Marcus Vitruvius Pollio, the Roman engineer and architect who lived from about 90 to 20 B.C.[1] His treatise *De architectura*, in ten "books" or chapters, dealt with the theory, history, and practice of architecture and originally had ten or twelve illustrations; these were lost, however, in transcriptions of the manuscript in later centuries. The treatise was rediscovered by Italian humanists in 1414, and in

spite of its by now somewhat corrupted text, it was studied with great care. Vitruvius was an important key in understanding classical architecture, just then being revived and reinterpreted by architects, painters, and scholars.

Leon Battista Alberti's impressive treatise *De re aedificatoria* (which circulated first in manuscript form by the 1450s and was finally published in Florence in 1485), also composed in ten books, was inspired by Vitruvius. Like his model, Alberti wrote in Latin and had no illustrations in the treatise.[2]

In part to help explain the classical architecture discussed by Vitruvius, an illustrated edition of his book at last appeared; it was edited by Fra Giovanni Giocondo, published in Venice in 1511, and contained 136 illustrations. An Italian translation, also illustrated, was issued in 1521. It was not long before practicing architects, from their own experience and study and in light of the growing knowledge of classical architecture, published their own works aimed at making the classical orders and design accessible to designers and craftsmen.

Sebastiano Serlio's treatise is the earliest of such books to be widely used. The first portion issued (Venice, 1537) was entitled *Regole generali di architetura sopra le cinque maniere de gli edifici . . .* and later became Book IV of his full treatise. As the title promises, it discusses the five orders (in great detail), but he also includes gateways, arcades, doors and windows, fireplaces, ceiling designs, the treatment of masonry surfaces, and even some whole facade designs in about 112 plates, many of them full page. Although Vitruvius is his prime source and its frequent mention gives special sanction to Serlio's work, his own fertile imagination (and what he had seen during his working career as an architect) supplied many ideas as well.

The need for such books was in large part due to the revival in the fifteenth century of a style of architecture with an entirely different theoretical basis and system of detail and composition from that of the preceding Middle Ages. We should not, however, overlook the fact that books had indeed played a part in the Middle Ages as well. Great cathedrals were obviously carefully designed, a joint effort of the clergy, the architect in charge of the project, and the master craftsmen heading the various divisions of the work (masonry, carpentry, sculpture, architectural detailing, stained glass, metalwork, and so on).[3] The master craftsmen, as is clear in studying the history of cathedral building in Europe, looked closely at what was being built elsewhere, and there was a continual "dialogue" between completed (and near-completed) work

and buildings that aimed to improve on these previous efforts.

Individual craftsmen and guilds had drawings, notebooks, and templates, as well as their own experience and observations, to draw on. One of the most complete craftsman's compilations of drawings made during travels from site to site is the famous "notebook" by the early thirteenth-century designer Villard de Honnecourt.[4] Of his surviving sixty-four plates, at least fourteen relate specifically to buildings. They include plans, sections, elevations (both inside and out), details, and other drawings that would be referred to on future occasions. In fact, it is thought that Villard's plan and elevation drawing of Laon Cathedral's north facade tower was the source for designing the west towers of Bamburg Cathedral in this style; for Villard apparently passed through that city on his way to Hungary.[5] His six drawings of Rheims Cathedral (inside and outside elevations, plans and moldings of piers, cross-section of the buttress system above the side aisles, and a detail of a window) are clear and detailed, revealing very careful observation.[6]

For medieval designers of cathedrals or of a wealthy merchant's or abbott's house in stone, such books of designs were undoubtedly welcome supplements to what could be observed of building and design in the immediate region. Not until the development of printing with movable type in the mid-fifteenth century, however, did the reproduction and dissemination of such manuals become possible.

Although the influence of the printed architectural book was felt in many countries of Europe at the end of the Middle Ages, as people sought information on the new "antique style" being developed in Italy, I focus on England alone, because that country had the strongest influence on the architecture in America during the seventeenth and eighteenth centuries.

Classicism in Sixteenth-Century England

The introduction of Renaissance design was slow and fitful in late medieval England. Travel on the continent by diplomats, members of the court, and others introduced England to the new mode of design; but classicism was decidedly a foreign language and at first was seen as a new form of embellishment or decoration to an essentially late-medieval fabric. As we might expect, it was craftsmen who first brought classical

details to England.[7] Henry VIII is known to have brought Italian artisans to England in the 1530s; and it is thought that they were the expert workmen responsible for the splendid classical choir screen that spans, somewhat incongruously, the late Gothic nave of King's College Chapel, Cambridge. French carvers, much closer to hand and familiar with the classical style already adapted to northern tastes from the extensive royal works at Fontainbleau and in the Loire valley, were more common, however. As early as the 1520s, carved capitals French in style are known,[8] and some early classicizing funeral monuments may have been carved in France and simply imported.

English stone carvers and woodworkers soon picked up the new style, and royal work with classical detailing is recorded at Hampton Court and Whitehall in the 1530s. Foreign craftsmen were also still employed, as at Nonsuch Palace, begun in 1538. A drawing for an elaborate arcaded screen thought to be for Nonsuch and dating from the 1540s is preserved.[9] Such workmen would have relied on their own drawings and experience, but within a few decades, printed books vastly augmented their resources.

During the second half of the sixteenth century, influenced by the new interest in the "antique style," architectural treatises and editions of them adapted to the use of craftsmen began to appear and made their influence felt in England.[10] The concept of turning to books for assistance did not begin with architectural volumes, however; it is significant that among the earliest technical books needed to supplement or update traditional apprenticeship or guild information were volumes on highly practical matters—surveying, for example. Sir Anthony Fitzherbert's *Book of Surveying* appeared in 1523 and Sir Richard Benese's *The Manner of Measuring*, in 1537.

Often the owners of country seats being built or rebuilt in the sixteenth century were the motivating forces for adapting the new classical motifs to the late-medieval traditions. Sir William Sharington in his work at Lacock Abbey, Wiltshire, between 1540 and 1549, revealed his own personal predilection for the ancient mode;[11] the Duke of Northumberland even sent the painter John Shute to Italy in 1550 to investigate the new style on his behalf.[12] It is well known that Lord Burghley wrote to Paris for an unnamed book on architecture in 1568;[13] and cases of owners lending architectural tomes to their workmen are also documented. Sir Edward Pytts began a new country house, Kyre Park, Worcestershire, in 1588; to assist his chief mason John Chaunce in the classical details, he lent him some book (not specified), which as he recorded

in his will was only on loan and was to be returned to him.[14] Because architectural treatises were, especially in the early years, very expensive and beyond the means of most workmen, patrons—whose intellectual curiosity and desire to build in the latest mode predisposed them to purchase such volumes—lent them to the craftsmen after discussing how they were to be used.

A good number of architectural books can be cited as having had an influence in England during this transitional period of classicism in the mid- to late sixteenth century. Most are books that we can document as being used by designers and craftsmen in particular buildings. A review of some of these indicates both the type of book selected and also the uses to which the books were actually put.

Naturally, the classical orders, the new element of design that was both the distinctive decorative feature of classical buildings and also its structural and visual armature, were in immediate demand. One of the very first illustrated books on these was by Sebastiano Serlio, who issued his treatise in parts.[15] The first to appear (Venice, 1537) was Book IV, dealing mainly with the five classical orders. Book III, on ancient Roman buildings and their details, was also published in Venice, in 1540. The next two parts, Book I (dealing with geometry) and Book II (on perspective and its uses in architectural design), were published in Paris in 1545. Book V, discussing the design of temples (and churches), also appeared in Paris, in 1547. A collected edition of all five was finally published in Venice in 1584, and two other books appeared later.

Serlio's thoroughly illustrated books, partly because they were published so early, soon made their impact felt in England. As I sketch out below, the details of quite a number of buildings can be traced to Serlio. His impact on England is also signaled by the first book written in English of this type, John Shute's *First and Chief Groundes of Architecture*, published in 1563. In spite of the fact that Shute had been to Italy, the book seems based mainly on his reading of Serlio's Book IV, and also of Vitruvius. Its main topic was the five classical orders.

The influence of Shute's book is difficult to assess. It seems to have been quite popular, because further editions of it appeared in 1579, 1584, and 1587. The fact that copies of it are very rare today may simply mean that craftsmen "used up" the book by their frequent reference to it. However that may be, only one building with a detail based on a design by Shute is certain—two buttressing pilasters at Kirby Hall, Northamptonshire (1570–75), with ornaments taken from his title page.[16]

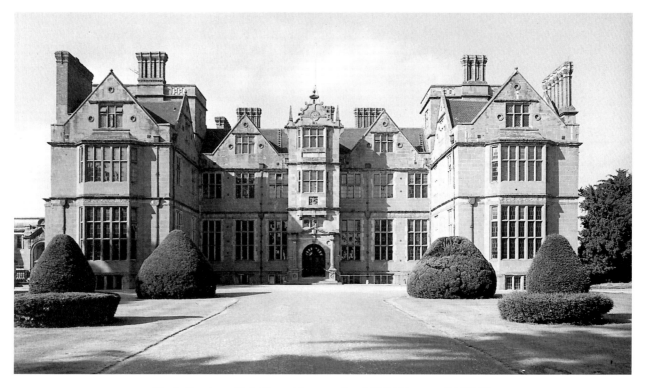

Fig. 2. Condover Hall, Shropshire, completed 1598 (Courtesy RCHME).

Other architectural books, suggesting the avid interest in the subject, also appeared at this time. Hans Blum's *Quinque Columnarum* (like Serlio's Book IV and Shute, focusing on the classical orders) was published in Zurich in 1550 and according to Summerson "was in use in England certainly by 1570."[17] That it went through six additional German-language editions before the end of the sixteenth century certainly suggests its popularity. There was also a French edition in 1562 and Dutch editions in 1572 and 1598 (and seven English editions in the seventeenth century!). Vignola's *Regola delli cinque ordini d'architettura* (Rome, 1562), inspired by Serlio's Book IV, also seems to have been used in England.

Serlio's books, especially after the 1566 collected edition, were consulted the most, however.[18] By outlining some of the documented instances of craftsmen adapting or copying his designs, we can get an idea of how his books were actually used. About the earliest instance are details on the inner courtyard at Kirby Hall, Northamptonshire (1570–75), which are based on Serlio's designs.[19] At Longleat House, Wiltshire (1572), the designer Sir John Thynne prominently used a motif from Serlio: Doric pilasters with rosettes in the necking band, from Book IV, fol. 17 verso. Furthermore, in one of his drawings for the house, he includes globes with flames shooting from the circumference

in three places, a distinctive motif found several times in Serlio's Book IV.[20]

Robert Smythson, who designed Wollaton Hall, Nottinghamshire (1580–88), drew, it seems, on Serlio, Book III, for the plan of the house, as well as for the design of a chimneypiece, traceable to Serlio's Books III and VII.[21] Holdenby, Northamptonshire, begun by Sir Christopher Hatton in 1574, has two arches (dated 1583), which appear to be based on Serlio's designs from his Book VI.[22] In the 1590s, Robert Smythson again turned to Serlio for chimneypieces at Hardwick Hall, Derbyshire (1590–97).[23]

If we look more closely at two Elizabethan houses from the late sixteenth century, we can get a clearer idea of what types of classical details were used and also of how these were integrated with the late-medieval house type of the day.

Condover Hall, Shropshire, built by the mason Walter Hancock for Judge Thomas Owen, was completed in 1598. Its clarity of design, uniformity of window treatment, and consistency of late medieval detailing make it a particularly harmonious house. The prominent steep gables and the grouped chimneys at once link it to its medieval ancestors, but two of its features are part of the new taste: the cresting of "strapwork" flanked by obelisks on top of the central entrance porch and the classical door casing below. Hancock was ob-

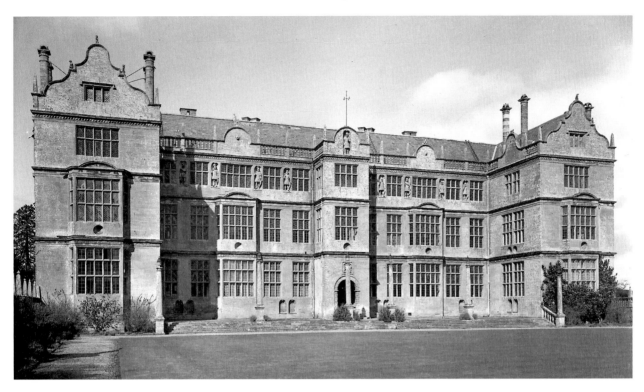

Fig. 3. Montacute House, Somerset, 1598–1601 (Courtesy RCHME).

viously cautious in using the new motifs: The Dutch strapwork and obelisks (ultimately from designs in books) are familiar from other country houses, such as the courtyard tower of Burghley House of 1577–85, but the classical doorway is apparently unique.[24]

The arched doorway is flanked on each side by a Roman Doric column on a pedestal, each supporting an impost block with full entablature. *Between* these upper cornices is a pediment, visually supported only by the frieze below. Thus it appears to be "incorrect," or misunderstood,[25] because the standard usage, shown in Serlio many times, is for the pediment to extend beyond the supporting columns.[26] Oddly enough, this is not incorrect at all! Although the source (probably a drawing or print) has yet to be located, this peculiar arrangement, which in the early years of adapting the ancient motifs would not be recognized as unusual, comes from the arch of Augustus at Rimini (27 B.C.), even to the roundels placed in the spandrels above the arch.[27] Perhaps the learned judge himself suggested this motif, rich in symbolic meaning, for the portal to his mansion.

The new features at Condover Hall enliven the central bay and reveal the two main new stylistic currents: Artisan Mannerism detailing based on Dutch work; and Roman motifs revived during the Italian Renaissance. Yet the building is still very much late medieval in overall silhouette, design, and plan.

A second country house of about the same date is an especially revealing comparison. Montacute House, Somerset, was begun in 1588 and completed in 1601 by the master mason William Arnold for the lawyer Sir Edward Phelipps.[28] Like Condover Hall, it is a traditional H-plan house with projecting facade wings enriched with two-story bay windows and a central full-height entrance porch with arched doorway. Montacute House too has some stylish Dutch features, the most prominent being the curvilinear gables on the leading wings.[29] Arnold has made a real attempt, however, to employ classical features in place of late medieval ones wherever possible. A careful study of the east front reveals a surprisingly large number of such "antique" details and also the fact that they almost all come from one source: Serlio's Book IV.

Although this book focused on the five classical orders and their attendant parts (entablatures and pedestals), it also included a great deal of other useful material—designs for chimneypieces, doorways, doors, ceilings, arcades, niches, classical detailing (for friezes), moldings, masonry treatment, and also whole facade designs. It was a rich cornucopia for anyone learning the vocabulary of ancient architecture and modern adaptations of it.

Elements of Montacute House drawn from Serlio include the Tuscan columns standing on the terrace;

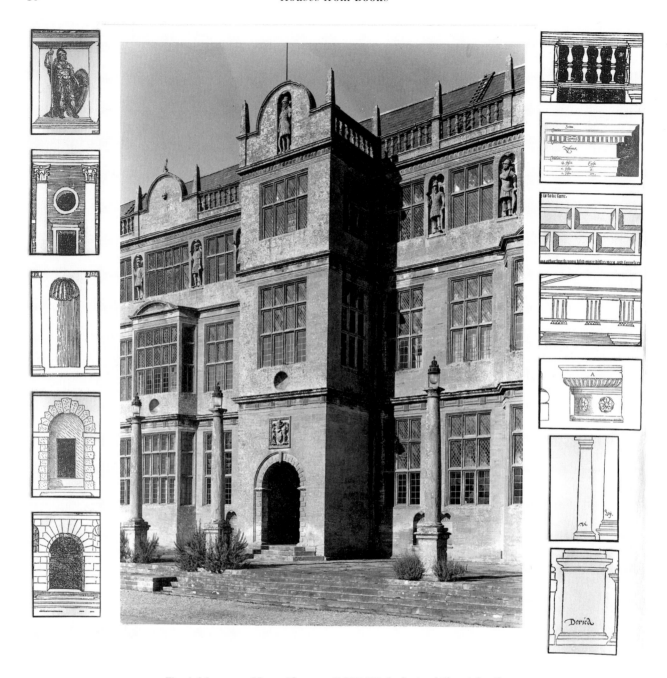

Fig. 4. Montacute House (Courtesy RCHME): Serlio (and Shute) details.

their Doric pedestals; the Doric capitals with rosettes in the necking band; the round-arched doorway above the steps; the rusticated border of the doorway; the shell-topped niches; the Doric cornice and frieze at the first-floor level; the Ionic entablature at the second; the beveled panels between the Doric triglyphs; the segmental pediments (over the bay windows); and the classical balustrade at the eaves. All these can be traced to specific plates in Serlio.[30] It is possible that the recessed concave circles at the second-floor level were inspired by Serlio as well;[31] although they are of different proportions than those at Montacute, Serlio does illustrate obelisks on parapets in some of his buildings.[32]

One feature not in Serlio, the "Roman" soldiers in the niches (the figures actually represent the Nine Worthies), might have come from Shute, who depicts similarly clad figures on the pedestal of his Doric caryatid.[33]

All these classical details do not make Montacute a classical building; but before the development in England of the principles of Renaissance design and

the understanding that classical buildings needed to be composed as a consistent and inter-related statement of both classical principles and motifs, such substitution of "antique" style detailing for late medieval was a logical approach.

Even if Serlio was the most adaptable source of new designs and ideas, other volumes were consulted as well in the sixteenth century. The books by J. Vredeman de Vries, specifically his *Architectura* (Antwerp, 1563) and *Compertimenta* (Antwerp, 1566), contained a good deal of fanciful northern "strapwork" detailing, adaptations of Mannerist motifs ultimately from Fontainbleau. One country house (Wollaton Hall, 1580–88) can be pointed to as containing many features "derived directly from plates" by de Vries,[34] and the general influence of his books seems to have been considerable.[35]

Andrea Palladio's *I quattro libri dell'architettura* (Venice, 1570) also seems to have made its influence felt in England in the sixteenth century—and, as is well known, went on to become, in the seventeenth century, and especially the eighteenth, a book of immense importance to architects. In the sixteenth century, however, it was just one of many volumes consulted by owners and craftsmen alike to learn the new "antique mode." Palladio's Book II, which contained plans and elevations of his own buildings, was apparently the source for the plan of Hardwick Hall, Derbyshire (1590–97). The use of colonnades between projecting facade wings at both front and back "suggests most strongly," according to Summerson, the Palladian source.[36]

Another book, which contained elaborate and fanciful architectural details and designs based on Mannerist traditions, was Wendel Dietterlin's *Architectura* (issued in parts between 1593 and 1594, with a revised and enlarged edition published in Nuremberg in 1598). Specific cases of borrowing are very rare—only one, from 1607, has so far been found[37]—but the general influence of the book's elaborate plates, as adapted for the enrichment of entrance porches of the later sixteenth and early seventeenth centuries, was considerable.[38]

It is clear from this analysis of the use of architectural books in the sixteenth century that published designs were of great importance. Some were copied directly as replacements for (or as supplements to) late medieval detailing on buildings that remained firmly in the indigenous traditional mode in all other respects. At other times, classical motifs in books were freely adapted and were often given an oddly unclassical feel by their thinness or distortion—or by using only *part* of the classical feature. In a few cases, ideas for portions of plans were used. In no cases were whole facades used or were details employed in a consistent or "classical" way. This treatment came only in the next century, when Renaissance principles of design were introduced to form the armature for classical details, now so familiar.

Some of the quotations and paraphrases from classical treatises were probably at secondhand; a builder seeing a feature in the antique style on a newly erected structure would undoubtedly study it with care and perhaps would make a drawing of it. In this way, constructed examples were as important for spreading the new style as were the ultimate source, the printed plate in a book.

Classicism in Seventeenth-Century England

During the sixteenth century, the overall design of a building was often arrived at in steps: The plan might come from one source, the elevations from another; divisions and their detailing from the experience and inventiveness of craftsmen—and at any stage, inspiration from printed books was possible. Even when a "total design" in the new classical mode was attempted, the result was still additive.[39] It took an underpinning of classical theory and a thorough understanding of the classical architectural vocabulary to truly design *in* the classical style. This synthesis was finally achieved in the early seventeenth century by one person: Inigo Jones. Working in the context of a vivid interest at the English court in the new Renaissance style and the classical monuments it drew on, Jones in his early maturity, beginning about 1620, single-handedly transformed architectural design of the era. Yet he too learned from and drew on designs in books.

Jones was not alone in his interest in the new architecture. A courtier of the day who is representative of the educated fascination with the revival of classical architecture was Henry Wotton. He had traveled widely in Europe from the 1590s onward and under James I was the English ambassador to Venice beginning in 1604, retiring from diplomatic service in 1623.[40] His famous treatise *The Elements of Architecture* appeared the following year. Although he frequently cites architectural books by Vitruvius, Alberti, Palladio, Vignola, and Philibert de l'Orme, Wotton's wide reading in other literature (including Dürer, Vasari, Protagoras, and Plato) and his own clarity of analysis and presentation make the book especially

revealing. Written for other courtiers (and unillustrated),[41] it nevertheless reflects the interest of the day in educated circles in understanding and reviving the classical vocabulary.

Inigo Jones, trained as a painter and employed early on by the court as a designer of masques and pageants, was the vehicle for introducing mature classicism into England.[42] His early efforts in architectural design, however, were not too different from the manner of adapting classical features to traditional forms of the previous century. Jones had traveled on the continent between 1598 and 1601, apparently to study Italian stage design and art. Although not yet focusing specifically on architectural design, Jones did provide drawings for a few projects in the early years of the seventeenth century. They reveal his dependence on books, but also show his transition to thinking in terms of larger compositional units, not just bits and pieces.

One early work of about 1608 was a design for the New Exchange in London. The overall form followed the models for arcaded market buildings as set out in Serlio. Jones's design included rather fanciful towers, which also seem to be inspired by Serlio, whose arcaded buildings have projecting upper sections (see Book VII, pages 37 and 47). Some of the details also seem to be from Serlio's gateways (such as Book VI, plates 14 and 16), but some of the details may be inspired by Palladio.

Another early work of about this same time was Jones's study for capping off the damaged central spire of the old Gothic Saint Paul's Cathedral. His design incorporated an arcade drawn directly from Palladio's Basilica in Vicenza, depicted in Palladio's Book III, plates 19–20.[43]

Jones was not the only designer still relying on Serlio. When the master carpenter Robert Lyming completed the impressive classical gallery on the south front of Hatfield House, Hertfordshire (in 1611), he too seems to have been inspired by Serlio's Book VII, where a design on page 47 illustrates a similarly composed arcade with pilasters against piers.[44] When John Smythson (the son of Robert Smythson) designed the decoration for chimneypieces at Bolsover Castle (begun 1612), he used motifs also drawn from Serlio's Books IV and VI.[45]

It was Jones's second trip to Italy, in the suite of Thomas Howard (second earl of Arundel), during 1613–14, that transformed him into a true architect in the classical Renaissance style. Jones studied most closely the buildings by Palladio (using the *Quattro Libri*, Book II, as his guide and annotating it as he went). He also carefully studied ancient Roman work, with Palladio's Book IV as his reference. Seeing the architecture in context and in three dimensions must have been a revelation to him. Jones also visited Henry Wotton in Venice (noting that he had original drawings by Palladio in his collection).

His fourteen months in Italy helped transform Jones's architectural vision. He was now far more able to see in terms of overall design and composition in the classical mode, not in bits and pieces more or less happily joined together. This new vision, and his mature drawing style, conceived in terms of overall controlled design, not additive pieces, transformed English architecture on his return.[46]

Soon after completing his trip, he became Surveyor of the King's Works in 1615.[47] Subsequent works in architecture reveal a new method of composition in the classical Renaissance vocabulary, but still drawing inspiration, and occasionally even details, from architectural books.

If we examine a few of his projects, we can see that even an architectural genius found book illustrations of use. One of his earliest projects as surveyor was the Star Chamber, for James I, designed about 1617. Although in no way a copy of a Palladio design, it is similar in mass, use of colossal columns, and general composition to Palladio's work, specifically the villa shown in Book II, plate 40.[48]

His early design for the Banqueting House, c. 1619, is especially revealing. His drawing shows a solid understanding of classical composition, in which the overall design and the parts that give it clarity work together consistently and harmoniously. He must have cast his eye on printed designs, too—even if he surpassed them: Palladio's Book II, plate 54, illustrates an elevation that, in overall composition, use of windows with alternating segmental and gabled pediments, and two-story central-pedimented feature, is very close. Even the wings at the sides may be a treatment inspired by the plate in Scamozzi's *L'idea della architettura universale* (1615), Book II, page 287.[49] Yet although such illustrations may have helped in his initial compositions, Jones's subsequent drawings and the completed building reveal his own design process working out the solution with clarity and authority.[50]

A similar approach can be seen in his first design of 1619 for the Prince's Lodging at Newmarket, Suffolk, for Prince Charles. This drawing has a distinct similarity to a villa by Palladio and a plate by Scamozzi,[51] but in subsequent drawings, Jones moves away from these to a more personal and more consistent and restrained classical design solution. Even at this date, however, he was not above borrowing a specific feature from a published plate: The arched entrance (with iron balcony above) that Jones composed

for Edward Cecil's house in The Strand, London, about 1618, was modeled on a plate from Jacques Francart's *Livre d'architecture* of 1616.[52] On the other hand, sometimes plates in architectural treatises were the catalyst for an analysis of classical composition or proportion and were not directly used as sources of a design feature.[53]

The fact that Jones made ample use of designs in architectural treatises is not really surprising, especially when we realize that he owned a considerable library. Many of the books were architectural or related material. A good portion of his library survives, and among the forty-nine documented books are works by Vitruvius, Alberti, Serlio, Palladio, Cataneo, Rusconi, Vignola, Scamozzi, and de l'Orme. Among the "nonarchitectural" volumes are Plato, Aristotle, Plutarch, Strabo, Polybius, Herodotus, and Vasari. All the books in this sampling (except Cataneo's *L'architettura* of 1567) had Jones's annotations.[54]

Designers without Jones's experience and vision not only relied more closely on published plates for special details, but also observed and copied the new work they saw around them. John Smythson is a perfect example. We saw earlier that he used plates from Serlio for chimneypiece designs at Bolsover Castle; when he visited London and environs in 1618–19, he studied new construction and made drawings of what he found useful. Many reappeared at Bolsover: wall paneling from Theobalds; Jones's balcony and doorway at Sir Edward Cecil's house; and the Italian-style gateway by Jones at Arundel House.[55] As was common in the medieval and vernacular tradition, *built* examples provided models for future emulation.

By 1620, Jones designed with mature originality in the new classical mode, even if in the early stages of composition he referred to plates by Palladio, Serlio, or Scamozzi. When he was called on to prepare a design for a "minor" building, Jones still seems to have found adapting illustrations in books helpful. Two good examples of this can be cited.

The first is his design (although drawn by his assistant John Webb) for a house in Blackfriars, London, (Fig. 8) for Sir Peter Killigrew.[56] Dating it seems from the late 1620s, it is a small city house in Renaissance style with classical features, which would have made it stand out in a London full of Tudor and Elizabethan dwellings. The rusticated doorway and heavy window voussoirs on the first floor, the cornice caps above the second-floor windows, the classical cornice-like belt course between the second and third floors, and the corner quoins all remind us of features in Serlio. In fact, the design *is* a close adaptation of a small house design in Serlio's Book VII, page 131 (a similar house with corner

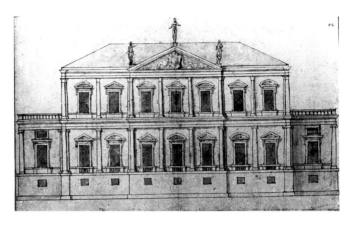

Fig. 5. Jones, Banqueting House, Design 1 (Courtesy Devonshire Collection, Chatsworth).

Fig. 6. Palladio, Quattro Libri, Book II, plate 54.

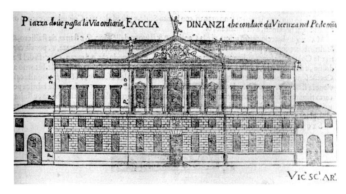

Fig. 7. Scamozzi, Della Architettura, III, 287.

quoins is in Book VII, page 191).[57] Jones has not just copied the design, however; he has integrated a third story, given each floor a certain hierarchy (heavier at the bottom, lighter at the top), and made the proportions of the floors—and the whole composition—more harmonious. Some details, such as the coved cornice, are not to be found in Serlio at all.

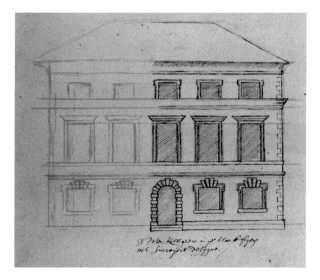

*Fig. 8. Jones, Killigrew House, late 1620s (Courtesy the
Provost and Fellows of Worcester College, Oxford).*

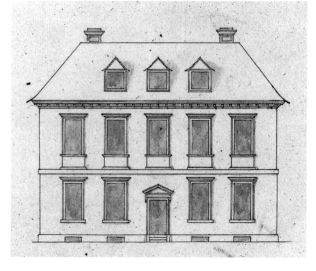

*Fig. 10. Jones, house design, Lothbury, 1638 (Courtesy the
Provost and Fellows of Worcester College, Oxford).*

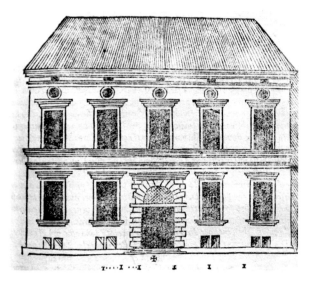

Fig. 9. Serlio Book VII, 131.

Fig. 11. Serlio, Book VII, 155.

A second example, which shows him following a plate even more closely, dates from 1638. This is his design for a house to be erected at Lothbury, London, a development by Lord Maltravers where farthing tokens were to be minted.[58] His model here, which he followed very closely indeed, is also Serlio: Book VII, page 155. Despite the Lothbury house being a near copy of Serlio, Jones has made some significant alterations and did not just slavishly copy his model. Relative to the continental model,[59] Jones has increased the size of the windows and decreased the size of the door, possibly in response to the less brilliant light at England's latitude. He has also provided a more deli-

cate and better proportioned cornice and has located the cellar windows in the foundation course, not above the water table, which makes more sense. Although designed in a most restrained classical style (the hipped roof is another feature often found in the Renaissance models of Palladio and Serlio), this house in its day would have been an astonishing apparition from a very different artistic realm. A typical substantial two-and-a-half-story house of brick of about this size, for comparison, would be Ash Manor, at Ash Green, Kent, built in 1637 (see Fig. 23). It is a vernacular type (ultimately based on country houses with entrance porches such as Condover Hall or Montacute of the sixteenth

century), which was pretty standard in the seventeenth century.[60]

Some interesting points are raised by these two house designs by Jones. First, why did he turn to Serlio and copy him as closely as he did? It is probably because there was no tradition in England at this early date for classical houses of such small size. Serlio's Book VII, which was full of house designs, was a logical starting place. Only later, and certainly influenced by these and other early "small house designs" of Jones, did an indigenous formula for small but classically inspired dwellings develop.[61]

A second significant point is that Jones respected architectural hierarchy or propriety; he did not make these small dwellings miniature palaces or villas. There are no pilasters or columns or porticoes or grand flights of steps as in Palladio's villas. Nor are there high-style features (such as balustrades or facade pediments), which he used in the Prince's Lodging or the Queen's House, Greenwich (completed in 1635). He recognized that a small house, even if the residence for a person of distinction (such as Sir Peter Killigrew or Lord Maltravers), should not have inappropriately grandiose design or detailing for its size or purpose.

Finally even an architectural genius like Jones found the illustrations in architectural books of use. For lesser lights, such volumes, when the Renaissance style finally met wider acceptance, were essential in many ways.

Jones was the first professional architect of his day: Although trained as a painter, he was not from the building trades, and following the admonitions of Vitruvius, he had a wide range of interests and abilities.[62] He might supervise construction and needed a knowledge of the crafts, but his main functions were artistic and intellectual. As Wotton happily expressed it, the architect's "glory doth . . . consist, in the Designement and Idea of the Whole Worke, and his truest ambition should be to make the Forme, which is the nobler Part, . . . triumph over Matter."[63]

A second architect of this era, who worked into the latter half of the seventeenth century and was of immense importance for subsequent domestic architecture, was Roger Pratt. An examination of two of his key buildings, their relation to the printed book, and their influence reveals much about the maturing profession of architect at this crucial period.[64]

The Pratt family was long established in Norfolk as landed gentry. Roger Pratt (born in 1620) attended Magdalen College, Oxford, and entered the Inner Temple, London, in 1639 to study law. His father's death the following year provided him funds to settle debts

and to continue his legal studies in comfort. In with the Civil War looming, he left for travel on the continent where he visited France, Italy, Flanders, and Holland during the next six years. He spent a good deal of time looking closely at architecture. Returning to England in 1649, he established himself at his lodgings at Inner Temple, a man of learning and leisure, but taking more and more interest in architecture. Pratt's concept of an architect's requirements for developing artistic taste included three key factors: the study of older and also contemporary buildings of Italy and France; the best things to be found in England (the work of Jones); and a "diligent study" of authors such as Palladio, Scamozzi, and Fréart.[65]

His first "commission" was helping his cousin, Sir George Pratt, with the country seat he was building. He first persuaded Sir George to demolish the work he had just begun and to build a house on classical principles consistent with the work of Inigo Jones. Pratt, as his famous notebooks make clear, had, however, looked at European buildings carefully, read widely, and thought at length about architecture; the design for his cousin's house, Coleshill, was distinctly his own.[66]

Several elements went into the creation of this clear and logical classical design. The first factor was Pratt's own ideas on what the country house of a gentleman should be (simpler in design than those for nobility or royalty).[67] His notebooks set out the criteria at great length, but a few quotes give an idea of his thinking: "To make all things here look handsome, and strong, the least ornaments will be a water table to divide each storey, an architrave moulding round about the windows, and at the top wall next the roof; and lastly the coining. The roof may be with straight and plain modillions only [i.e., not a full entablature]."[68] The plan should be simple and compact: "[T]he best forms . . . for a private man I conceive to be that which is an oblong square exactly," by which he probably means a rectangle of two to one proportions.

A second source of Pratt's architectural ideas was constructed examples he had seen. Coleshill was to be a clearly designed, simply detailed, but elegant classical dwelling. "There is no doubt that the most beautiful buildings of these times are chiefly to be seen in Italy and France," he observed.[69] The palaces of Genoa specially drew his attention; although he thought them overly decorated, a few he admired for their simplicity and clarity of design;[70] many were illustrated in Peter Paul Rubens's book on the palaces of Genoa, which Pratt had in his collection.[71]

It also seems likely, in light of his interest in the best of English classicism, that he had visited Chevening, Kent, built between about 1630 and 1655,

Fig. 12. Coleshill, from Campbell, Vitruvius Britannicus
(1771), 5: plate 87.

Fig. 13. Serlio, Book VII, 33 (top).
Fig. 14. Serlio, Book VII, 33 (bottom).

a country house influenced in its design by Jones.[72] A hipped-roof building of three floors with corner quoins and restrained classical detailing (such as window caps, roof balustrade, and eaves cornice), Chevening was a most distinctive country house in its day. In addition, Pratt needed to look no further than the river front of Jones's Queen's House, Greenwich, for a model of restrained classicism without the use of columns or pilasters.

A final resource was certainly architectural books. Pratt had a considerable library, and a good number of the books were architectural. Many can be documented from his notebooks, including Vitruvius and Alberti (both in French editions); Serlio's Books I–V; Pietro Cataneo, *I Quattro Primi Libri di Architettura* (Venice, 1559); Jacques Androuet du Cerceau, *Livre d'architecture* (Paris, 1611); Pierre Le Muet, *Traicté des cinque ordres d'architecture . . . traduit du Palladio* (Paris, 1647); Rubens's *Palazzi di Genova* (1622), as well as Scamozzi, Fréart, and de Chambray.[73]

Pratt designed Coleshill (beginning in 1649, it was finally completed in 1662) with the buildings he had seen and studied in England and the continent in mind and his own principles guiding his decisions. He also seems to have used his books. The overall similarity to two plates from Serlio's Book VII, page 33, has long been recognized.[74] As models of astylar classical designs—facades without columns or pilasters—they would certainly have been a useful starting point. Of course there are many other parallels: the low basement level; the long rectangular format; the windows provided with flat cornice caps and the door with a pediment; and the chimneys prominent in the roof slope.

His use of designs in books, at least for detailing, is confirmed by two features that can be traced to plates. The first are the paneled chimneys and their classical caps, which seem to come from Le Muet's *Manière de bien bastir* (1623).[75] The second is the main door on the west facade. As is at once obvious, this is an extremely close copy of the illustration on folio 38 in Serlio's Book IV. Although the pediment is made taller and the scroll brackets with pendant leaf a bit longer, this plate is clearly the model. One slight variation, the eared architrave or head of the doorway (not found in this plate), is depicted in this same form in fol. 49.

Equally apparent, Coleshill is not a "bookish" building. Pratt may have derived some details, and perhaps the general form, from Serlio, but the overall design has an artistic consistency, and the details fit harmoniously within it; the composition is not "additive." Like Jones, Pratt conceived of the building as an organic totality within classical principles—as we would expect from a mature architect.

Coleshill was a most distinctive building for its day, an early thoroughgoing Renaissance country house, but it had surprisingly little immediate influence as a model of a new type. Only two houses closely emulated its style—although neither with quite the suave mastery of Pratt: Thorpe Hall, Peterborough (1653–56), and Wisbech Castle, Cambridgeshire (c.

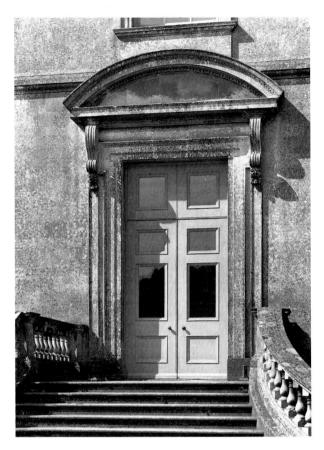

Fig. 15. Pratt, Coleshill, detail (Courtesy Country Life
Picture Library).

Fig. 16. Serlio, Book IV, fol. 38.

1658).[76] In the 1650s, this style may still have appeared too modern. As Lord Clarendon wrote soon after 1660 (in reference to Thorpe Hall), "[T]he manner and style of its architecture" have been "little used in England before."[77]

During the 1660s, Pratt designed a country house that did have an immense influence and helped transform domestic architecture. Kingston Lacey (Fig. 17), near Wimborne, Dorset, was designed in 1662 for Sir Ralph Bankes.[78] The contract for construction was signed in April 1663, and the house was completed in 1665. Because it was refaced and remodeled in the nineteenth century, it is fortunate that Pratt's original drawing for the facade survives.

The sources of this design are varied. A fundamental change from Coleshill is that Kingston Lacey (which is almost the same length as Coleshill, but a bit thicker) employs a slightly projecting three-bay central-pedimented pavilion (or frontispiece). This feature in Pratt's architectural hierarchy was appropriate for houses of noblemen. Such houses were to be bigger and more elaborately detailed than those of gentle-

men and could have such pedimented frontispieces;[79] even pilasters between the windows were allowed. (With a prince or king, such pilasters were essential, and the use of a projecting portico in this category was also permitted.)

The main style of Kingston Lacey followed closely that of Coleshill. The two-story height with hipped roof and cupola, roof dormers and balustrade, and windows arranged in three groups of three, with corner quoins and classical detailing enriching the composition—all parallel Coleshill. Many of these features, such as the prominent corner quoins, had specific Italian Renaissance associations.[80]

The central-pedimented feature also seems to have a specific source, probably Inigo Jones's Prince's Lodging, Newmarket. Not only did Pratt know and admire Jones and his work, but the Lodging was an appropriate model: Although indeed for a prince, it was a less elaborate building (for his occupancy during the horse-racing season) than other royal dwellings. Furthermore, Pratt had seen the pedimented central feature used frequently in France. On some of "the

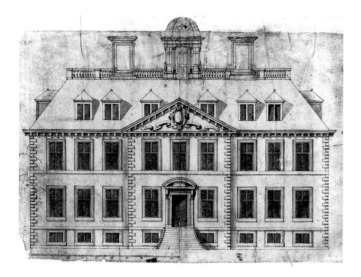

*Fig. 17. Pratt, Kingston Lacey, drawing, 1662
(Courtesy* Country Life *Picture Library).*

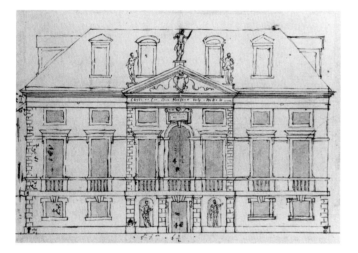

*Fig. 18. Jones, Prince's Lodging, Newmarket (Courtesy British
Architectural Library, RIBA, London).*

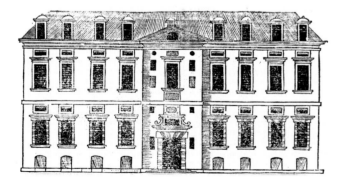

Fig. 19. Serlio, Book VII, *167.*

most noble houses," he observed, "the three windows in the middle of the front do generally project one foot or more before the rest of the building and have a common frontispiece [pediment] to them."[81] As an enrichment to make the building more classical,[82] this feature was clearly appropriate for homes of the nobility.

Finally, it may be that he looked as well to architectural treatises for the use of such a feature. Serlio's design in Book VII, page 67, is reasonably close to this formulation, and pedimented frontispieces can even be found in Palladio.[83]

A final distinctive feature is the construction of Kingston Lacey in red brick, with light stone for the trim. This treatment is given aesthetic approval by Jones's having used it for the Prince's Lodging, as well as by the long history of employing brick for substantial, and even royal, building in England for centuries.[84]

Kingston Lacey had an immense influence on country-house design.[85] It provided a model for a new type of Renaissance-style country house, which seemed to have met the needs of the day, for houses of the Kingston Lacey type soon were being built in significant numbers all over England. The first seems to have been Melton Constable, Norfolk, of about 1664–70; and important examples recur in every decade for one hundred years: More than fifty country houses of this type can readily be documented through the 1760s.[86] Naturally, although Kingston Lacey itself—and perhaps Pratt's drawings for it—provided a model or archetype of a classical country house, it was also the vehicle for spreading the knowledge and use of the classical detailing that enriched it. Once additional houses were erected following these lines, they in their turn became models of emulation.

One good example that shows how close these later versions might come to the archetype is Uppark, in Sussex, built about 1690.[87] Although it never had a central cupola or roof balustrade (many omitted them, and others have lost them over the years), in other ways it is extremely close indeed. Originally there were even dormers (later removed) flanking the pediment, as at Kingston Lacey.

It is important to note that constructed examples (and perhaps also the experience of the workmen who had built the houses) were the method of diffusion of this popular type. No engravings of Kingston Lacey or other dwellings of this type appeared in any architectural book until well into the eighteenth century. The first such illustration seems to be a plate in Colen Campbell's *Vitruvius Britannicus* (vol. II, plate 51, published in 1717).[88] Soon a trickle of such published

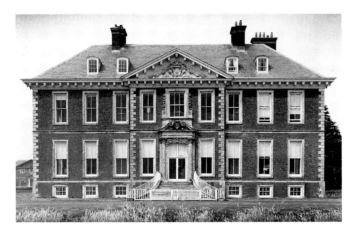

Fig. 20. Uppark, Sussex, c. 1690.

designs began to appear: In Campbell's volume III, plate 91, Horseheath itself was illustrated, and by 1728 James Gibbs included several of this type in his *A Book of Architecture* (plates 63, 64, etc.). Although they may have assisted in the propagation of the Pratt model, it is clear that with dozens of such houses already standing before Campbell's book even appeared, the constructed examples and the experience of builders—who probably made drawings of the buildings as had John Thorpe or Villard de Honnecourt before them—spread the type and its detailing, not the illustrations in books. The architectural plate had been essential in the early years of Renaissance design in England; but once the classical idiom had been acclimatized in models suited to English taste, designers needed to refer to the traditional architectural books mainly for detailing and interior features.

A documented example of this practice can be found in the country houses built by the mason-architect Francis Smith (1672–1738), the "leading master builder" in the midlands during the early eighteenth century. Smith owned a few treatises on architecture from which he adapted architectural details for the exteriors and interiors of his houses.[89] According to Andor Gomme, Smith derived most of his classical orders from Fréart's *Parallel of the Ancient Architecture and the Modern* (1650; translated into English by John Evelyn in 1664), although later in life he replaced it with the more up-to-date volume by Gibbs, *Rules for Drawing the Several Parts of Architecture* (1732). For more "exotic" classical details inspired by Italian Baroque models, Smith referred to plates in Domenico de Rossi's *Studio d'architettura civile*—for door and window frames and caps and Borrominiesque capitals. Some details were copied literally;

others were varied with considerable originality. For specialized or distinctive detailing, such books were obviously useful.

As might be expected, even professional architects of the day—especially self-taught ones—also found books of value in their work. William Adam, the best-known architect in Scotland for most of the first half of the eighteenth century, owned "an important architectural library."[90]

During the eighteenth century, the architectural profession in Britain matured to the point where countless architects, of greater or lesser talents, were now able to prepare house designs in the acclimatized English Renaissance style with ease. When one surveys the 117 buildings or proposed designs in the three volumes of *Vitruvius Britannicus* (1715–25), it is remarkable how varied and original (within a neo-Palladian bent) the buildings are. By this date, only one country house (Campbell's Mereworth Castle of 1722–25, in vol. III, plate 37) is obviously a copy from a plate in an older architectural treatise—in this case, Palladio. By now, it was more important, in the work of the professional architects, to keep an eye on what others were designing and building. A case in point is the influence of Campbell's Wanstead House, Essex, built in 1715–20. As a model for very large country seats, it was soon emulated in several other palatial houses begun in the 1730s.[91]

This "vernacular Renaissance" style, propagated through these country houses and ones similar to them, soon influenced smaller dwellings as well. Small houses in brick with hipped roofs and some classical detailing were appearing in the 1680s and were reasonably common in the south counties by the 1690s; by the early eighteenth century they had reached a level of artistic

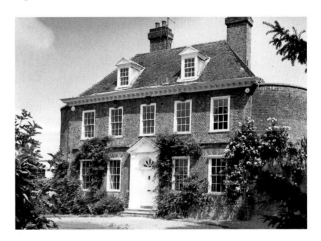

Fig. 21. Delbridge House, Wingham, Kent, c. 1720.

excellence that revealed that the builders had well assimilated the new style and were able to compose in it on their own.[92] A good example, probably dating from about 1720, is Delbridge House, Wingham, Kent.

The overall balanced hipped-roof form at once calls to mind the domestic Renaissance mode begun by Jones and Pratt. A careful examination of the house reveals a consistent use of classical detailing for all its features: The top of the water table is molded brick of classical profile; the belt course between floors imitates an Ionic architrave; the windows have molded classical keystones; the cornice is enriched with Ionic dentils; and the dormers are capped with correctly angled pediments. The door casing, a work of art in its own right, is skillfully composed.[93]

At first one is tempted to assume that the builder derived all these classical features from books. It is possible that he did go back to old volumes such as Serlio or popular editions of Palladio, but it seems more likely that he drew on his own experience (which would have begun with a long apprenticeship) in building such houses. What is pretty clear is that he did not turn to the sorts of builders' manuals that grew to be so popular in the eighteenth century. The earliest of these books appears only at this very time, in the 1720s, when classical detailing of this sort had been in use for at least twenty-five or thirty years. With a dramatic upturn in building activity in the early eighteenth century, in London and elsewhere, these time-tested details needed to be supplemented (especially in more ambitious dwellings) by additional classical designs available to the craftsman. Soon this was achieved.

Eighteenth-Century Architectural Books

Up to this point, I have been discussing architectural treatises and their illustrations with a focus on their impact on design in the sixteenth and seventeenth centuries. In the early eighteenth century, a change in aesthetic focus (affecting primarily high-style designs) and a great upswing in building activity (mainly domestic) altered the demands for architectural books. Thus we should here sketch out more systematically the various types of books available during this period to put this development in the early eighteenth century in context.[94]

Among the earliest books on architecture I mentioned were surveyor's books, such as Benese's *Manner of Measuring* (1537). As we have seen, surveyors also often had a hand in designing houses, so that this training in measure, calculation, materials, and thinking in terms of plans was very useful for anyone involved in building. Vincent Wing's *Art of Surveying* (1664) was specifically designed for "Surveyors, Architects, Engineers, Masons, Carpenters, Joyners, Bricklayers," and other craftsmen. Such books continued in print well into the eighteenth century; Henry Coggeshall's *The Art of Practical Measuring* was issued in 1729 (the fourth edition of a work first published in 1677).

At the end of the seventeenth century, books related to this genre, in their focus on practical matters of measure, geometry, and techniques of the crafts, were published specifically for the building trades. The first was Joseph Moxon's *Mechanick Exercises*, appearing as a series of pamphlets beginning in 1678; the "Arts of Smithing, Joinery, Carpentry, Turning, Bricklayery," and other crafts were explained in detail. The third (probably the first collected) edition appeared in 1703, the same year that Richard Neve's *The City and Country Purchaser's and Builder's Dictionary* was published. Neither had many illustrations.

The main category of architectural book, as we have seen, was the architectural treatise, so prominent from the sixteenth century onward. Beginning with Shute's book of 1563, the importance of the treatises by Serlio, Palladio, Vignola, Scamozzi, and others during the sixteenth and seventeenth centuries is well documented. The fundamental concern of these volumes was the classical orders and their attendant features (such as entablatures and pedestals) and details; often ancillary material such as door and window treatments or decorative embellishments was also included. Palladio and Serlio added surveys of classical buildings and plans and also their own designs for dwellings and other buildings.

Many of these were expensive tomes only the wealthy could afford; but there were also "pocket-size" editions of the orders that were cheap enough for workmen themselves to own. One of the earliest popular editions was Hans Blum's book on the five orders *Quinque Columnarum* (1550), which saw twenty-four editions and translations in Europe through 1672 and seven English editions between 1601 and 1678. Clearly it met the needs of craftsmen learning and adapting the new classical style. Books for craftsmen based on the Italian treatises also appeared in English: Vignola in 1655, Palladio's Book I in 1663, and Scamozzi's Book VI in 1669. Even if craftsmen did not own copies of larger treatises (such as Serlio, whose Books I–V were translated into English in 1611), they clearly had reference to them—or possibly to drawings based on favorite plates.

Although they were closely related to architectural treatises, Wittkower considers books such as

Wotton's *The Elements of Architecture* (1624) a separate category with its own audience. Such books (including John Dee's preface to a 1570 edition of Euclid, which discussed architecture) were written by knowledgeable amateurs for members of the court and learned men of the day. Even without any illustrations, Wotton's treatise, with sound information on architectural theory and practice, went through many reprintings and was still available as late as 1750.

In the early eighteenth century, architectural treatises continued to be published. Giacomo Leoni's English version of Palladio's *Four Books* appeared between 1715 and 1719; the more accurate edition by Isaac Ware was published in 1738. Reflecting the maturity of British architectural practice at the time (and the competing aesthetic camps of the Neo-Palladians and the architects favoring a restrained Baroque mode), expensive treatises were now issued by architects themselves. These were published largely to display their own works as models for emulation (and to drum up business) and secondarily to persuade people to adopt one or the other stylistic preference. Colen Campbell's *Vitruvius Britannicus* was the first of these expensive folios, the three volumes appearing in 1715, 1717, and 1725. James Gibbs's *A Book of Architecture* (1728) also presented his own designs in sumptuous plates.

The early eighteenth century also saw the development and proliferation of an essentially new type of volume, the architectural pattern book, oriented to craftsmen. Naturally, it had its roots in earlier books. As we have seen, craftsmen often more or less directly copied classical orders and details from the treatises they referred to. (Serlio's Book VII, which included designs of entire house facades for more modest dwellings—less grand than Palladio's or Scamozzi's or Rubens's villas and palaces—was essentially unique). The earliest volume oriented specifically for craftsmen, and including designs for them to adapt, seems to have been Robert Pricke's *The Architect's Store-House* of 1674. The title page reveals its contents and audience: "Being A Collection of Several Designes of Frontispieces, Doors, and Window-Cases, Cieling-Pieces, Alcoves, Chimney-Pieces, and Fountains, with divers other sorts useful in Eminent Buildings. Likewise a Representation of the Five Columns of Architecture. Useful for Painters Carvers Masons Carpenters Bricklayers Joyners Cabinet-Makers Plaisterers, &c."

Another volume that might be considered an early pattern book is Moxon's *Mechanick Exercises* of 1703: One of its plates depicts an entire house facade (a modest three-bay, three-floor structure), and another is a scale drawing of the profile for a brick cornice and a molded brick belt course.[95]

The first of these popular builders' pattern books of the eighteenth century, a type of book that proliferated vigorously in the following decades, was William Halfpenny's *Practical Architecture . . . Representing the Five Orders, with Their Several Doors & Windows . . .* (1724), which, as the title explains, would be "Very usefull to all true Lovers of Architecture, but particularly so to those who are engag'd in ye Noble Art of Building." The next year, Halfpenny issued another manual aimed at the craftsman, *The Art of Sound Building, Demonstrated in Geometrical Problems* (1725), which as the title enumerates included "Geometrical Lines For all Kinds of Arches, Niches, Groins, and Twisted Rails." Halfpenny made it clear that the volume was for artisans themselves; it contained "easy Practical Methods for Carpenters, Joiners, Masons, or Bricklayers, to work by," and "was suited to every Capacity." That this volume had to be reprinted that very year suggests that it fulfilled a growing need for classical detailing and features adapted to actual working practices. It should also be remembered that Gibbs's tome, despite its size and cost, was adapted to builders' use; as the subtitle indicated, it contained "Designs of Buildings and Ornaments," just the sort of thing craftsmen could emulate. Gibbs made clear in his preface that these designs were to be copied: His book provided "gentlemen in the remote parts of the country where little or no assistance can be procured . . . with Draughts of useful and convenient Buildings and proper Ornaments; which may be executed by any Workman who understands Lines." That his designs were just what builders of the day wanted is signaled by how many of them were pirated by other pattern-book makers, such as Batty Langley, William Salmon, and Edward Hoppus.[96]

From the 1720s through the rest of the eighteenth century, the pattern book as well as expensive tomes such as Gibbs and Campbell appeared in increasing numbers. Wittkower summarizes it well: "From the early years of the eighteenth century onwards the production of architectural books in England increased by leaps and bounds. Soon not a year passed without the appearance of a noteworthy architectural publication. The beginning of the Georgian era saw an enormous building boom (in the wake of the economic boom) and general interest in architecture became passionate. The architectural books appeared in response to this passion and at the same time stimulated it."[97]

Thanks to Eileen Harris's massive and meticulous study of British architectural books between 1556 and 1799, we can examine this phenomenon in context. The second half of the seventeenth century saw 42 new editions of architectural books in English (and 65 later editions); the first half of the eighteenth cen-

British Architectural Books 1556–1799

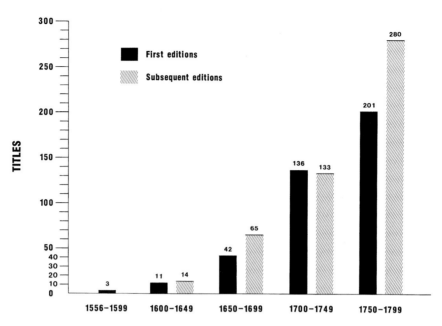

Fig. 22. British architectural books, 1556–1799.

tury witnessed three times that number of new editions—136 to be exact—and twice the number of later editions. What is even more remarkable is that this popularity of the illustrated book continued to mushroom: The second half of the century saw more than 480 architectural titles issued, both new and subsequent editions.[98] The actual use of these builders' manuals is indeed documented in features found on constructed London buildings from the 1720s onward, traceable to specific plates.[99] Of course, the books themselves prove the case: Such a vast flood of books would not have been published had there not been a ready market for them.

At the same time, there was a good deal of pirating of plates among the books, so that designs were not always "up-to-date." For example, Batty Langley's *The City and Country Builder's and Workman's Treasury of Design* (1740), plate 31, illustrates two doorways meticulously copied from Gibbs's *Book of Architecture* (1728), plates 102, number 2, and 105, number 2.[100] Such copying was common practice: John Aheron's *A General Treatise of Architecture* (1754), Book 4, plate 2, copies two door cases from William Salmon's *Palladio Londinensis* (1734), plates 25 and 26—which Salmon in turn had based on Serlio. Some manual writers were egregious copiers; most of the numerous plates in Batty Langley's *Ancient Masonry* (1736) were based on other books.[101]

Some of the plates in such manuals were decidedly out of date when published. For example, when William Pain illustrated a design for a Doric door casing as plate 38 in his *Practical House Carpenter* (1789), he was basing it on a type that was erected in London nearly forty years before![102] Because London was the center for so much architectural innovation (because of the amount of building continually being undertaken) as well as publishing, this is not surprising; a design that was popular in London presently made its way into builder's manuals, to be emulated in the provinces. As Cruickshank and Wyld have observed, pattern books "consolidated and spread ideas already current in architecture, rather than assuming an innovatory role,"[103] and in fact such books were sometimes "simply graveyards for old architectural plates. It is common for example to see in a pattern book published in the 1730s, designs that were fashionable 20 or 30 years before."[104]

Yet the continued popularity of the builders' manuals with their wealth of illustrations proves their usefulness. They represent the popularization of the sort of illustrated treatise that was of such assistance in the sixteenth and seventeenth centuries. As the graph demonstrates, the increase in the number of architectural volumes of all types—treatises, pattern books, builders' manuals, and other works—over a 250-year period was truly phenomenal, confirming the value and vitality of architectural books.

2

Architectural Books in Eighteenth- and Early Nineteenth-Century America

DURING THE seventeenth century in England, as we saw, the introduction of classical motifs and principles matured dramatically and spread widely during that one hundred-year span. From the classical bits and pieces more or less happily enriching the traditional form of Montacute House (completed in 1601), to the introduction of mature classical design by Jones in the 1620s and 1630s, to the acclimatizing of the classical idiom—and dwelling types adapted to country houses—by Roger Pratt, we observed the growing knowledge of classical design in the high-style dwellings of the century. However, for smaller houses during most of that century, even prosperous yeoman farmers' dwellings, the later medieval vernacular was still the standard type. By the 1650s, a classical pediment might embellish a medium-sized brick farmhouse,[1] but not until the 1680s were small substantial

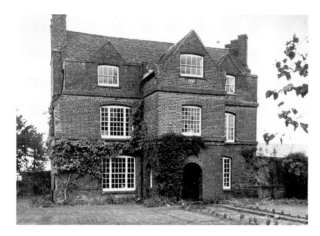

Fig. 23. Ash Manor, Ash Green, Kent, 1673.

houses in town or country designed with the clarity of the new Renaissance style (the symmetrical hipped-roof mode, of the type Jones created in the 1620s), with simple classical embellishments—a molded water table, a classical cornice, perhaps a belt course inspired by classical moldings. During the early eighteenth century, as we saw in Delbridge House, this new vernacular Renaissance mode was fairly widespread for substantial small houses in brick or stone.[2]

The same process of gradual introduction of classical motifs and principles into the vernacular architecture of America occurred during the eighteenth century. As is well known, American architecture during the seventeenth century, in both the north (as in New England) and the south (as in Virginia), saw a proliferation of dwellings of essentially late medieval vernacular character.[3] In New England, houses were designed largely in the lobby plan (with central chimney and two main flanking rooms), which had a long and well-documented history as a popular vernacular type in England. Among the most famous examples of that mode in the north are the Whipple House (c. 1639) in Ipswich, Massachusetts, or the Parson Capen House (1683), Topsfield, Massachusetts. In the south, where conditions of both climate and society were different, other vernacular forms were adapted to use. In Virginia, the form was usually that of a rectangular dwelling of one and a half stories with a fireplace at one end; or if the house had two rooms, the kitchen was at one end and the parlor at the other. Early examples were of wood; about the earliest survivor of the brick versions was the Adam Thoroughgood House (c. 1680) at Virginia Beach.

The dwellings of America were at an entirely different social and architectural level from those discussed previously in England; mansions the size and grandeur of Montacute House (1598–1601) were not erected in America until the nineteenth century. Just as for modest dwellings in England, however, the classical details that presaged the introduction of more systematically Renaissance-style dwellings also began to appear at the end of the seventeenth century in the colonies in both north and south.

In Massachusetts, artisans coming from England (usually London) were largely responsible for a new classical standard, first seen in the brick Foster-Hutchinson House (1690–92), Boston.[4] Three stories tall, like London townhouses of the same date, it was enriched with facade pilasters, a second-floor central pedimented doorway with balcony, a classical cornice, and a roof balustrade. It must have seemed as astonishing in the midst of the largely medieval-style gabled wood houses of Boston as had Jones's Banqueting House in the medieval London of his day. Especially noteworthy is the fact that the four Ionic pilaster capitals were of cut Portland stone, imported from London for the purpose. From then onward, mainly in the early years of the eighteenth century, the classical idiom rapidly gained ground in New England.

A somewhat similar process took place in Virginia. The earliest classical features introduced into a vernacular environment appeared on the Main Building (1695–1700) for the College of William and Mary at Williamsburg. A large three-and-a-half-story brick structure, its classical features were limited, it seems—the building burned in 1705—to a classical cornice, a hipped roof, and possibly pedimented roof dormers.[5] Just as in Boston, however, this new Renaissance ideal, here hipped-roof buildings with classical cornices, quickly spread. It was soon found in other public buildings (such as the new Statehouse or Capitol of 1701–5) and in private houses (Fairfield, notably the wing of c. 1709–10).[6] Again, the introduction of such classical features was probably due to craftsmen from England who would naturally know, both from their own apprenticeships and also from what was being built around them, how to execute these classical features.

On the basis of this new classical ideal and its key details and with a strong background in bricklaying going back thirty or forty years, it is not surprising that by about 1715 Virginia had developed its own form of small, classical, brick hipped-roof house parallel to those in England (such as Delbridge House). The first appears to have been the Jaquelin-Ambler House in Jamestown;[7] but soon the type was well established, and numerous variations of it can be found. About the earliest firmly dated is the Brafferton, Williamsburg, of 1723.[8] At this early date, its classical

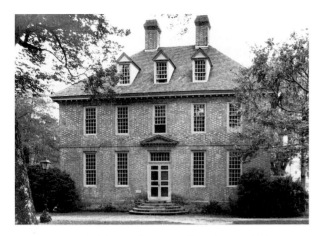

Fig. 24. The Brafferton, Williamsburg, 1723.

detailing (cornice and doorway pediment) must be due to the craftsmen's own knowledge of these features, because the use of the popular eighteenth-century builders' manuals was still a thing of the future for America.

When we survey the development of American architecture during the eighteenth century, we can observe, not surprisingly, that architectural books play a growing role in the increasingly sophisticated architectural design in the colonies. A survey of instances where books have had an impact on, or have been the source of design for, houses (and other buildings) demonstrates how important the printed page was for colonial builders, just as it had been in England.

How do we know that designs derived from architectural books had an impact on colonial and early American architecture? There is evidence in both the buildings themselves and in documents of the era. Before surveying actual cases and analyzing what they tell us about how such books were used, we can summarize the "proofs" we will encounter.

The most direct evidence that houses were sometimes designed based on plates in books is that in a good number of instances from the eighteenth century the dwelling and the plate are so close as to effectively prove the case, especially when they stand out dramatically from the "standard types" being built at that time around them. Naturally, the designs are often somewhat modified, but the congruences are still convincing.

Related to this is the fact that a large number of cases can be documented in which exterior and interior details (door casings, elaborate windows, fireplaces, and other such features) very closely match plates in books—and, as is the case with facades, the books were published before the date of the constructed work.

One can also find features that, although not quite congruent with a plate, are very close indeed. Such correspondences suggest that either the craftsman was developing a design based on the printed model but using his own creative ingenuity, or that he had perhaps seen work of this type, based on engraved sources, which he was then emulating. In either case, the printed page is not too far distant.

Occasionally there is even more direct proof: A designer may specifically state that he drew on books for his work; or a British carpenters' manual survives with the name of a known American carpenter written in it.

Furthermore, there is clear evidence of the importance of books in American design; British books were imported in growing numbers into the colonies; and on the eve of the Revolution, books began to be printed in America, sure proof of a demand for such volumes. Finally, there is the parallel with English practice: The importance of books both during the introductory period of assimilating the new style and later (especially for details) even when designers could work within the new mode. Book importing began on a small scale and grew dramatically, which would not have happened if there was no market for the books.

The Use of Architectural Books Before Mid-Century

When we turn to a study of what was actually built, we find that in the first half of the century the use of books was extremely limited. Clearly, the standard house types, and the limited classical detailing (cornices, pedimented dormers, and the like) easily mastered by craftsmen, satisfied most people.[9] There is, it seems, only one example of a dwelling erected following a design in a book in the first half of the eighteenth century: Drayton Hall (Fig. 25), near Charleston, South Carolina. Built between 1738 and 1742, it is closely based on Palladio's plate 56 in Book II (or possibly Leoni's variation of this type in his Book II, plate 61).[10] The owner, John Drayton (more likely than a craftsman to own such a book), probably specifically chose the design, related to the simpler hipped-roof houses of the day, but infinitely more grand and classical. Drayton Hall is unique, however. The next building erected following a plate was not until 1749, with Peter Harrison's Redwood Library in Newport, and the next *dwelling*, Mount Airy, in Virginia, was built in 1758–62.

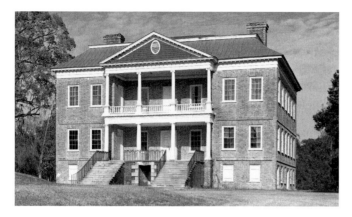

*Fig. 25. Drayton Hall, South Carolina, 1738–42
(HABS, Library of Congress).*

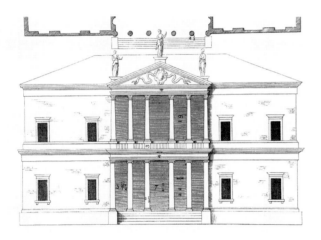

Fig. 26. Palladio, Book II, plate 56.

Although patrons were content with the locally developed house types (usually with hipped roof, sometimes gabled), they could enrich their houses with classical details to elevate them in artistic (and social) standing; but only in the 1750s is a new house type adopted. A concerted effort to find facade models for the impressive mansions in Virginia has been conducted since the 1940s; no prototypes before Mount Airy have been found.[11]

What we do find is that builders before mid-century occasionally imported already carved, sophisticated features to incorporate in their houses. Drayton Hall is a case in point: The eight columns of the west portico are English Portland stone, as are the sophisticated door casings on the east facade, as well as the three window enframements, complete with side pilasters and pediments, above.[12] This practice is by no means rare in this period: Ready-made details appear on quite a number of houses. For example, the carved stone keystones used at Rosewell, Virginia (1726–37),

are identical to ones found on London buildings of the day. Westover, also in Virginia, built about 1730–35, is full of imported carved work that ennobled the dwelling. The two splendid door cases, sometimes thought to be based on pattern-book designs, are in fact more richly and accurately carved than the plates they are often compared with—and also predate published examples. The door cases are of Portland stone and were probably purchased in London. Inside Westover, two of the stone fireplaces and three of those made of wood, well beyond the technical and artistic abilities of colonial carvers of the day, are also certainly imported.[13]

This practice of importing finished work is probably the answer to questions about the Ionic door casing on the west facade of the Isaac Royall House in Medford, Massachusetts, of 1732–37. Although often compared to a design in William Salmon's *Palladio Londinensis* (1734),[14] a careful examination shows that the Royall House doorway is in fact a much more elaborate Ionic style, with details not found at all in the Salmon plate: The volutes are turned outward, not flush with the wall; there is a band of egg-and-dart, with bead-and-reel below it, between the volutes, where the plate is plain; the volutes are given a foliate enrichment on the upper molding (and perforations in the scroll), both omitted by Salmon; and the rosette at the center of the upper molding is not present in the engraving. Either the door casing was ordered from England, or a craftsman capable of this work was imported.

Just as the use of pattern books or treatises to provide models for facade designs was extremely rare in the first half of the century, such use was equally rare for interior details. In fact, the only well-known example from the first half of the eighteenth century is also at Drayton Hall: the carved wood fireplace in the great hall, based closely on plate 64 in William Kent's *Designs of Inigo Jones* (1727).[15] The lower portion has been somewhat simplified by employing Doric pilasters to support the mantel shelf rather than the sculpted female herms with side scrolls as depicted by Kent; but the upper portion is remarkably close, in both overall form and details, to the plate.

Certainly one strong reason for the absence of work based on architectural book designs is that such books were as yet quite rare in America. There are two studies on the availability of such volumes in America, the first by Helen Park (1961 and 1973), the second by Janice Schimmelman (1986).[16] It must be borne in mind that each study used slightly different criteria for the numbers they arrive at. Park's list drew

Architectural Books Available in America: 1700–1799

First Citations

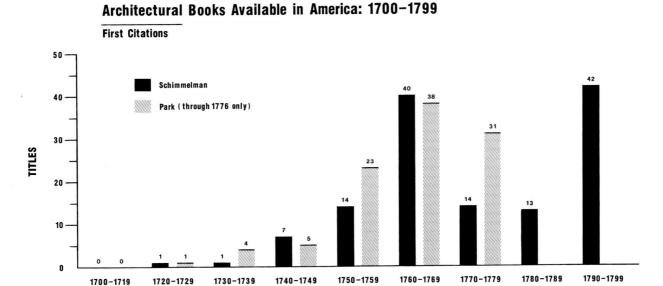

Fig. 27. Architectural books available in America, 1700–1799: First citations.

on citations in booksellers' catalogs, holdings of semi-public libraries, and private collections or libraries; she also included works focusing on geometry (closely related to building and design, of course). Schimmelman's list included most of the same sources as Park, as well as a few new ones, but excluded private holdings and also works on geometry. If we keep these distinctions in mind as accounting for apparent "discrepancies," their results are very revealing.

The most striking fact is that between 1700 and 1719 *no* architectural books are documented in America; and between 1720 and 1729, only *one!* The next decade is not much better: Park found only four books, Schimmelman, one. It is in the 1740s, however, that an upturn begins: The authors found five and seven books, respectively. With the 1750s, architectural books are finally available in some quantities: Park found twenty-three listings (Schimmelman 14). If their results are tabulated, we can recognize at once that the 1760s was nearly the high point of book importation. Naturally the numbers dipped in the 1770s and 1780s with the Revolutionary War but rebounded to the old levels, and more, in the 1790s. The 1750s onward are clearly the "decades of the books."

At the same time, we must be careful to recognize that a book might have found its way across the Atlantic in the possession of an emigrating craftsman or it might have been imported as a purchase of a planter or prosperous merchant for whom architecture was one of many gentlemanly interests. Such books might never appear in published lists—but

could influence design nonetheless. We can find instances where a book is clearly the source for a design well before its first documented appearance in America. The Drayton Hall fireplace is one instance: Kent's book (of 1727) is used for a fireplace of 1738–42—but the first reference to the volume comes only from 1775! The facade of Mount Airy (to be discussed below) is another good example; the book design of 1728 is clearly the model for a building begun in 1758—although the volume is first documented in America only in 1760. In each case, the evidence of the plate's use is obvious and incontrovertible. Yet, with these caveats, the Park and Schimmelman listings are valuable indications of the popularity, and use, of such architectural books.

The known examples of building facades and exterior and interior details clearly based on plates from books testify to this popularity and use. These examples occur in large numbers from mid-century onward. A review of a selection from 1748 into the early years of the nineteenth century, for which illustrated citations can usually be provided, helps us understand the uses of such books and their importance to domestic design.

The works of the Newport seaman and merchant Peter Harrison, who was also active in the design of significant buildings in his day, show a direct reliance on architectural books that allowed him to introduce a more advanced classicism (of the more austere neo-Palladian type) into the colonies. His Redwood Library, Newport (1748–50), as is well known, is based on two

books. For the impressive temple-front elevation, he drew on a design in Edward Hoppus's *Andrea Palladio's Architecture* (1735–36), a headpiece vignette—not one of Palladio's plates—in Book IV.[17] For the large arched windows originally at the rear of the building, he drew on motifs shown on a plate of Chiswick House in William Kent's *Designs of Inigo Jones* (1727), I, plate 73.[18]

In King's Chapel, Boston (1749–58), Harrison again drew on a plate in one of his architectural books, James Gibbs's *A Book of Architecture* (1728), plate 24, for the side elevation of the church.[19] Harrison used the plate as the starting point for an overall design, which has a good compositional consistency, rather than just parts assembled together. It is interesting to note that Harrison had at his death (in 1775) a remarkable library, which included twenty-nine architectural books.[20]

Designs from Books in the 1750s, 1760s, and 1770s

Architectural details based on book designs become quite common beginning in the 1750s. One of the earliest are the two plaster ceilings in Kenmore, near Fredericksburg, Virginia, of 1752. The library ceiling is based in part on a plate from Batty Langley's *The City and Country Builder's, and Workman's Treasury of Designs* (1740), plate 170; the ceiling in the drawing room is based on the central portion of plate 175 from Langley's same book.[21] In each case, the craftsman executing the plaster work added a great many of his own motifs, or motifs from as yet unidentified books, but the basic reliance on the Langley plates is clear.

Sometimes motifs are taken from a published plate and are "translated" into a craftsman's personal style. William Buckland, a professionally trained woodcarver, drew on a design in Batty Langley's *Gothic Architecture, Improved by Rules and Proportions* (1747), for his rear porch at Gunston Hall, Virginia (1755–59), but modified the design so as to place the Gothic arches in a *Doric* enframement—a unique treatment in colonial America of the day.[22]

Langley's *Treasury of Designs* of 1740 appeared in several editions (in 1745, 1750, 1756, and 1770), signaling its popularity. It was certainly widely used in America. The front door on Mount Vernon, Virginia, during the remodeling of 1758–59, was based on plate 33 (right doorway).[23] (Langley's *Treasury of Designs*

was popular in the north, too; it was the source for the front door of the Vassall-Longfellow House in Cambridge, Massachusetts, of 1749.)[24]

Interior details at Mount Vernon were also based, in many cases, on sophisticated designs in English books. The mantel in the dining room (of 1759) is close to plate 50 in Abraham Swan's *The British Architect: Or, The Builder's Treasury* (1745),[25] which, as the title-page proclaimed, included "A great Variety of New and Curious Chimney-Pieces, in the most elegant and modern Taste." The mantel in the west parlor has portions closely based on Swan's *British Architect*, plate 51;[26] and the classical door casing in the west parlor is based on plate 349 in Batty Langley's *Ancient Masonry* (1734, 1736).[27]

During this period of 1758–62, the impressive rear facade for Mount Airy, Virginia, was built, closely following plate 58 in Gibbs's *Book of Architecture* (1728).[28] Mount Airy was probably designed by its owner, John Tayloe II,[29] who, as a cultured and wealthy gentleman, would be expected to have some interest in and knowledge of architecture—and could have afforded a book like Gibbs. Although Tayloe drew much from the Gibbs plate, it is clear that he modified the model to meet local needs and practices: Mount Airy is not as large as the prototype (only seven bays rather than nine), and he has eliminated the roof parapet, which was a British feature inspired by building practices in the City of London after 1707. We at once recognize that the Gibbs plate is a form of the Kingston Lacey–type house with central pedimented pavilion, which by 1758 enjoyed nearly a century of diffusion in England. It is interesting to note that the earliest instance of this house type in America seems to date only from this decade of architectural flowering: Montpelier, Maryland, of about 1751. Mount Airy appears to be the second example of this type. Clearly such architectural books permitted advanced design to be used in America earlier than were motifs brought only by workmen familiar with the latest achievements in England.

Despite prominent examples of owners of mansions providing their craftsmen with plates in books to follow— such as Drayton Hall and Mount Airy— it seems that craftsmen themselves were the most avid purchasers of architectural books imported from England. The many examples of features on houses drawn from plates are an indication of this; but there is explicit proof, too. Three of the books owned by the Philadelphia carpenter Robert Smith have survived, and each was inscribed by Smith with the date of purchase: Langley's *Treasury of Designs* (1750 ed.) bought

in 1751, Palladio's *The Four Books* (an edition of 1737) bought in 1754, and Campbell's *Vitruvius Britannicus* (1715–25) acquired—or at least volume III is so inscribed—in 1756.[30] This instance is hardly unique. When the North Carolina carpenter Benjamin Soane died in 1753, he possessed "a large collection of architectural books" as well as the tools of his trade.[31]

From the end of the 1750s, we find another good example of features drawn from books in Peter Harrison's Touro Synagogue (1759–63) in Newport. The impressive classical front porch could certainly be based on plate 39, figure 3, in Gibbs's *Rules for Drawing the Several Parts of Architecture* (1732, with later editions in 1736, 1738, and 1753). Some of the interior detailing appears to be drawn from plates in Isaac Ware's *Designs of Inigo Jones and Others* (1731), William Kent's *Designs of Inigo Jones* (1727), and Langley's *Treasury of Designs* (1740).[32]

Harrison was responsible for quite a number of sophisticated building designs (most of them for public structures) during this era, and all were based on book plates. One of his best known is his Brick Market in Newport, Rhode Island (1761–72), for which he selected plate 16 in volume I of Campbell's *Vitruvius Britannicus* (1715), eminently adapted to the purpose of a market building (the ground floor being open).[33] In its original context, with frame vernacular gambrel and gabled houses around it, Harrison's Market must have been an aesthetic revelation to anyone visiting Newport.

During the 1760s, Harrison continued to put his library of architectural tomes to good use on other buildings. For the interior of his Christ Church, Cambridge, Massachusetts (1760–61), he seems to have had recourse to Gibbs's *Rules for Drawing . . . Architecture* (1732). For the screen and balustrade inside the front door, he used plate 36; for the large Ionic columns of the nave, plate 2.[34] Gibbs was certainly a fruitful source for Harrison; when he designed the summer house for the Abraham Redwood estate in Newport in 1766, he found a model, which he copied very closely, in Gibbs's *Book of Architecture* (1728), plate 80.[35]

In the 1760s, a number of impressive mansions base their overall facade design on plates from books. Brandon, Virginia, of c. 1765, is a highly unusual composition; although the elements are not too different from the brick vernacular Renaissance designs of the fifty years preceding it, the composition in terms of wings and pavilions certainly appears to have been inspired by a plate in Robert Morris's *Select Architecture: Being Regular Designs Of Plans and Elevations Well Suited to Both Town and Country* (1755; 2d ed.,

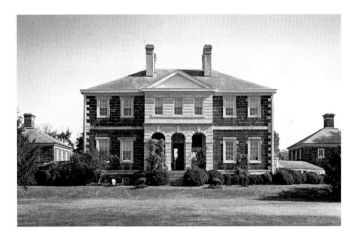

Fig. 28. *Mount Airy, Virginia, 1748–58.*

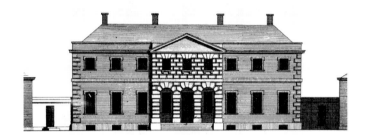

Fig. 29. *Gibbs*, Book of Architecture *(1728), plate 58.*

1757).[36] About the same time is the Miles Brewton House in Charleston, South Carolina (1765–69), which has the two-story portico we first saw nearly twenty years before at Drayton Hall.[37] Although one might say that the Brewton House also went back to Palladio's plate—or Leoni's version of it—it is actually more likely that Drayton Hall itself was the source. In fact, the influence of built prototypes or models at the vernacular level and also high-style types (such as Kingston Lacey) is a source of design that one should not lose sight of while focusing on houses and details based on plates in books. After all, Drayton Hall is only twelve miles outside Charleston.

Because of the uniqueness of this sort of two-story portico in Virginia, it is probable that for Shirley Plantation (c. 1769)[38] the source again was the Palladio or Leoni plate—unless the inspiration came from the two-level portico added to the Capitol building in Williamsburg when it was rebuilt in 1751–53 after the original was destroyed by fire.

Much has been made of the splendid drawing of 1767 by John Hawks for Governor Tryon's palace at New Bern, North Carolina.[39] The fact that a preliminary study exists, as well as the professional level of

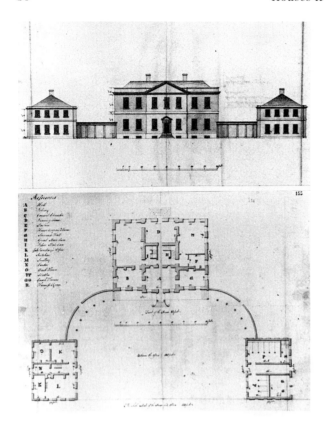

Fig. 30. Hawks, Tryon's Palace design, 1767. (Courtesy North Carolina Division of Archives and History, from British Public Records Office.)

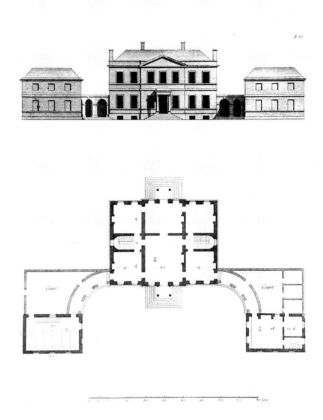

Fig. 31. Gibbs (1728), plate 63.

execution of the final draft, has led most scholars to consider the palace design an original composition by Hawks. Although it certainly was created to meet the specific needs of Governor Tryon, Hawks also seems to have relied heavily on books. The first drawing,[40] depicting a three-story dwelling connected to flanking wings by an open colonnade, is virtually identical to the design by Robert Morris depicted in plate 11 of his *Select Architecture: Being Regular Designs of Plans and Elevations Well Suited to Both Town and Country* (2d ed., 1757). The second, more finished drawing surely owes a great deal to James Gibbs, specifically plate 63 of his *Book on Architecture*, for its design and layout.

Hawks was an experienced surveyor and architect, and he supervised the construction of the building (between 1767 and 1770) with professional efficiency. This does not mean, however, that he did not resort to plates in books to assist him with his designs. In fact, at his death, his estate included, as we would expect, "a set of architectural books."[41]

The same plate 63 from Gibbs (with possible influence from plate 64 as well) seems to have been the

model for Blandfield, Essex County, Virginia, built about 1769–74. A sophisticated Kingston Lacy–type dwelling, both the central block (with the same fenestration pattern as plate 63) and the connected wings replicate the Gibbs illustration in American-style brickwork and detailing (i.e., without the British eaves parapet).[42]

From the 1760s also date two of the closest copies of architectural plates for interior details from the eighteenth century. The first is the fireplace, carved between 1759 and 1764, in the Wentworth House (c. 1750), Portsmouth, New Hampshire; it copies with great fidelity the sumptuous composition in plate 64 of Kent's *Designs of Inigo Jones* (1727), which we saw previously used as the model for the main fireplace at Drayton Hall. Here we even have the carved female herms and the flanking scrolls at each side.[43] Actually, the talented wood carver may have copied not Kent (a folio rare in the colonies) but, as Abbott Lowell Cummings discovered, the same plate as pirated by Edward Hoppus in his *Gentleman's and Builder's Repository: or, Architecture Display'd* (London, c. 1737, with later editions).[44] The Hoppus volume was found by Park to have been listed at least nineteen

Fig. 32. Wentworth House, near Portsmouth, New Hampshire, fireplace (from Kimball, Domestic Architecture *[1922], fig. 94).*

Fig. 33. Kent, Designs of Inigo Jones *(1727), 64.*

times by owners or booksellers. It is revealing to see how the wood carver has altered the proportions of the design (and eliminated the broken pediment above) to fit the height of the room it was intended for.

This practice was hardly unique in Portsmouth; numerous other cases of details taken from books of designs have been identified. In the John Wentworth House (1763), for example, a distinctive frieze decoration of opposed fishes on a parlor mantelpiece is "clearly derived from plates in Kent's *Designs of Inigo Jones*, perhaps as plagiarized by Hoppus."[45]

Better known, and widely illustrated, is the fireplace in the main room at the Jeremiah Lee House in Marblehead, Massachusetts (1768), which is copied from plate 51 in Swan's *British Architect* (1745).[46] Again the carver has changed the proportions to fit the setting better and has even added hanging swags at each side in a consistent style—all of it a tour de force of craftsmanship.

In the 1770s, one can find a good number of additional buildings with some—occasionally extensive—borrowing from design-book plates. Certainly

the first facade drawing of Thomas Jefferson's Monticello in 1771[47] owes a great deal to the two-story portico feature from Palladio we have seen several times before; but this is what we might expect from a student of architecture who was just learning about design and composition at this time.

From this period dates the work of one of the most gifted of architectural designers in the colonies at the time, William Buckland. Trained as a joiner and cabinetmaker in London, he came to America in 1755 after a seven-year apprenticeship and thus was up-to-date on current practice and taste. I mentioned his porch at Gunston Hall above. His major domestic work, however, in which he designed the building itself as well as the exterior and interior detailing, was at the Hammond-Harwood House in Annapolis, Maryland (1773–74).

In light of his training as a joiner and cabinetmaker rather than as a carpenter or mason, it is not surprising to find that for this dwelling, the first for which he supplied the overall design, he selected a high-style composition consisting of a central block with

Fig. 34. Hammond-Harwood House, Annapolis, Maryland (Photo by M. E. Warren), and pattern-book details.

side wings connected by low passages—a type well known in England, tracing its ancestry directly to Palladio. Had he wanted to show Mathias Hammond a model of what he planned, he could well have used plate 63 in Gibbs's *Book of Architecture* (1728), very much in the same spirit as the completed dwelling, even to the arches in the links between house and wings. For the house itself, plate 66 would have been a good model (slightly smaller in size than the dwelling of plate 63), although the stone quoins depicted in plate 66 were by this date inappropriate both for an elegant townhouse and for a region with a strong bricklayers' aesthetic, where edging details were skillfully done in brick, without need of stone embellishments. The end wings with their polygonal facades could well have been inspired by those depicted in plate 25 of Robert Morris's *Select Architecture* (2d ed., 1757). Both the Gibbs and the Morris are known to have been in Buckland's library.[48]

Buckland's design for the rear elevation of the house included a central pedimented pavilion with *pilasters* supporting the entablature, thus elevating the

house in its social and artistic hierarchy, according to Pratt's dicta.[49]

When Buckland turned to the details of the mansion, as we might expect, he relied heavily on books, although the designs were executed with the exquisite clarity and robustness of his own style of carving.

The composition of the central pavilion, featuring a curved flight of steps, a pedimented Ionic door casing with arched doorway within, and a second-floor window with classical surround (in contrast to the plain brick detailing around all the other windows),[50] appears to have been derived from Abraham Swan's *A Collection of Designs in Architecture* (1757), II, plate 11 (detail). The famous Ionic door casing itself is essentially identical to one on plate 23 in Swan's *British Architect* (1745),[51] although the splendid relief swags in the spandrels are Buckland's own.

A second prominent feature of the facade, the bull's-eye window in the pediment with its elaborate carved surround, is a feature Buckland derived from Gibbs. Originally designed for the east-end pediment of Saint Martin-in-the-Fields, London (1720–26),

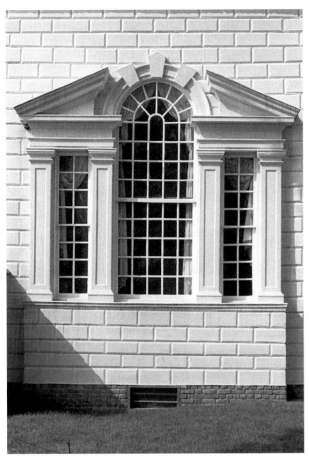

Fig. 35. Mount Vernon, Virginia, window of 1774–79.

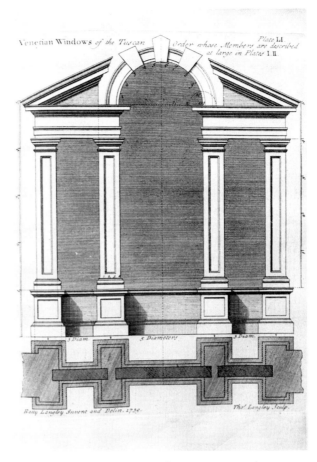

Fig. 36. Langley, Treasury of Designs *(1740), plate 51.*

Gibbs subsequently published it (and an alternative design similar to it) as plate 110 (bottom) in his *Book of Architecture* of 1728.[52] Also from Saint Martin's is the heavily rusticated window treatment used on the south side of the house on the second floor.[53] Buckland had recourse to plates in Swan's book for his interior fireplace designs as well.[54] It should come as no surprise that on Buckland's death in 1774, his estate inventory listed a library of thirty-eight volumes, of which fifteen titles were books of architecture and design.[55]

Other carpenters, whose names have not come down to us, also consulted such books for exterior and interior designs. The fine door casing of the Read House, in Cambridge, Massachusetts (c. 1772), was based on a plate from Langley's *Treasury of Designs* (1740),[56] and the drawing-room mantel in Elmwood, Virginia (c. 1774), is quite close to plate 75 in Langley's *Treasury*.[57]

The use of book designs for public buildings continued as well. A fine example from the 1770s is the First Baptist Meeting House in Providence, Rhode Island (1774–75), whose designer, Joseph Brown (a college professor by occupation), turned to Gibbs's

Book of Architecture (1728) for two prominent features. The impressive steeple of the meetinghouse is closely based on the middle design of plate 30, one of six proposed for Saint Martin-in-the-Fields. The ground-level entrance porch Brown copied from "the porch on Marybone Chapel" [*sic*], London, shown on plate 25 in Gibbs's book.[58]

The further enlargement of Mount Vernon in 1774–79 included additional features drawn from architectural books. One of the most impressive, and especially interesting for the accuracy with which it follows its model, is the large Palladian window in the east end, lighting the new banquet room.[59] All the moldings and details are meticulously copied from Langley's *Treasury of Designs* (1740), plate 51. The accuracy was undoubtedly assisted by Langley's providing plate 52, where the "Members are described at large." While carpenters of talent such as Buckland could master and surpass designs in books, others took a more literal approach to the models selected. (The mantel in the library at Mount Vernon may also date from this period; parts of it are based on plate 81 in Langley's *Treasury*.[60])

Architectural Books After the Revolution

As one would expect, there was a sharp diminution of building during the war years, but at the end of the 1780s a design of special interest appears. This is the facade for the Library Company of Philadelphia, designed by William Thornton and built in 1789–90. Born on Tortola, British West Indies, on his father's plantation, Thornton was raised in England and studied medicine at the University of Edinburgh, receiving his degree (through the University of Aberdeen) in 1784. He then returned to Tortola but in 1786 moved to Philadelphia. It is at that time that this well-traveled doctor, of wide-ranging interests and with artistic abilities, designed the Library Company building, his first work of architecture. A quotation from a letter he wrote eleven years later puts his achievement in context as the work of a talented amateur with recourse to architectural books of the day: "It will perhaps be deemed presumptuous that I began to study Architecture, and to work for Prizes at the same time. . . . A Plan for a Public Library in Philadelphia was proposed, and the Prize for the best plan, &c., was a Share in the Company. I studied Architecture, set to work, and drew one of the *ancient* Ionic Order: This Order I admire much.—The Prize was adjudged to me."[61]

From Thornton's description, one might be led to believe that he created a building facade independent of any models; but in fact it was based closely on plate 9 in volume II of Abraham Swan's *A Collection of Designs in Architecture, Containing New Plans and Elevations of Houses, For General Use* (1757), two copies of which were owned by the Library Company.[62] His design followed the plate very closely in most ways, even to the balustrade with urns at the eaves, but he eliminated the cut-stone rustication around the windows and doors as inappropriate for local traditions of brickwork, increased the second story's height, and added the niche above the main doorway to hold a statue of Benjamin Franklin, the founder of the Company. With its central pedimented pavilion with pilasters, it was a very formal statement in the Philadelphia of its day.

All facades with advanced stylistic treatment did not come from books, however. Woodlands, the estate of William Hamilton outside Philadelphia, was constructed in 1787–89 (the complete rebuilding of an existing dwelling) in a thoroughly Adamesque style.[63] It is usually credited with introducing oval rooms and other such refined features from the work of the Adam brothers into America and thus inaugurating the Fed-

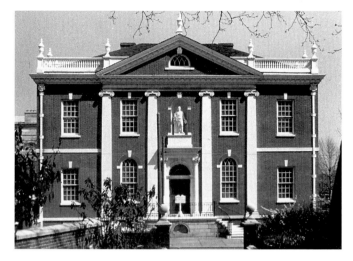

Fig. 37. Thornton, Library Company, Philadelphia, 1789–90 (as rebuilt 1954).

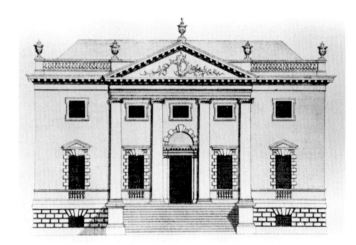

Fig. 38. Swan, Collection of Designs (1757), 2: plate 9.

eral style. The elevation design has been compared to a building by Robert Adam.[64] In fact, the Woodlands facade (and its distinctive plan) appears to have been composed by a London architect familiar with the Adam style, with the information on the old dwelling and its setting provided by Hamilton.[65]

Even American designers of ability, such as Charles Bulfinch, turned to books for assistance. After graduating from Harvard College, he embarked on a grand tour in Europe during 1785–87. He was impressed with many of the buildings by contemporary architects and certainly would have studied Robert Adam's Royal Society of Arts building (1772–74) during his stay in London. When, on his return, he began designing architecture, he used this Adam facade as the main feature of

his Joseph Coolidge Sr. House, Boston (1791–92).[66] Although he might have referred to drawings of the existing Adam building (executed with somewhat plainer surface detailing than planned), he certainly also consulted the plate of it reproduced in *The Works in Architecture of Robert and James Adam* (1773), volume I, plate 4; the panel above the Palladian window on the Coolidge house contains swags similar in lightness to those in the engraved plate, but not included on the building when erected.

Thomas Jefferson's design for the President's House in Washington, D.C., a near copy of Palladio's Villa Rotonda, comes from this same period. Generally thought to be one of the submissions during the 1792 competition for that dwelling, it may in fact date from a year earlier, when the site for the President's House was a very different one.[67] Be that as it may, the Jefferson drawing is usually compared to the plate in Leoni's version of Palladio,[68] which in this instance is no different from Palladio's original (Book II, plate 13), except for the insertion of oval windows in the dome. Jefferson's proposed President's House, however, is different from either of these plates in having the four porticoes open at the sides, not closed by walls perforated by a large arched window. Although this change could have been due to Jefferson's own understanding of consistency in the use of the classical orders (no other arches appear in the composition), it is also possible that he referred to another plate to give him ideas—Mereworth Castle, near Maidstone, Kent, the version of the Villa Rotonda built in 1722–25 by Colen Campbell. It is reproduced in Campbell's *Vitruvius Britannicus*, III (1725), plate 37.[69] Not only would this plate have given him a visual record of the open portico, but it confirmed the Villa Rotonda's adaptability to modern domestic use.[70]

The President's House design that was ultimately built was by James Hoban, a carpenter from Charleston, South Carolina, who had training in architectural drawing in Dublin before emigrating to America in 1785. The design of the President's House has a complicated history, fortunately now unraveled by recent scholarship.[71]

The competition was advertised in the spring of 1792, and Hoban's design was adjudged the best by the Commissioners and George Washington in July. This first design (the elevation drawing of which has been lost) was a three-story house eleven bays long with pedimented frontispiece containing engaged columns above a rusticated first story.[72] Even in the early nineteenth century, it was well known that this was based on Leinster House, Dublin (1745–47), a mansion of the same composition. This building was known

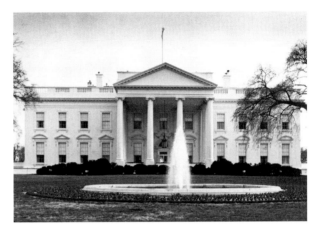

Fig. 39. Hoban, President's House, Washington, D.C., 1793.

personally to Hoban; but in preparing his competition design he seems to have had recourse to an engraving of 1779 of Leinster House, for the grouping of the windows shown in that print (which differs from the mansion as constructed) is the same as that in the design for the President's House.[73] One can also find models of palatial houses of this same type—three stories tall with rusticated first stories and pilasters in the pedimented frontispiece—in Gibbs.[74]

George Washington thought however, that the winning design was too small and instructed Hoban to increase it by one-fifth. When the cost of the enlarged structure was calculated, it was decided, after some correspondence between Washington and the Commissioners during 1793, to build this expanded dimension, but to reduce the house from three full floors to two. Hoban redesigned the elevation, and it is this facade that is well known from the elegant drawing that survives, and from the existing building.

It has long been recognized that this second design looked a great deal like facades depicted in Gibbs's *Book of Architecture*, especially plate 53 or even plate 47 (bottom). It is possible, however, that it was plate 41 that was now studied (Fig. 40). The original advertisement for the President's House had stated that it would be "a recommendation of any Plan if the Central Part of it may be detached and erected for the present with the appearance of a complete whole and be capable of admitting the additional parts in future, if they shall be wanting."[75] This was also a point of view held by Washington himself.[76] It may well be that the Gibbs plate, with end blocks that could be added later to enlarge the President's House, seemed like the perfect solution to Hoban.[77] Be that as it may, it is clear that the first design for the President's House was al-

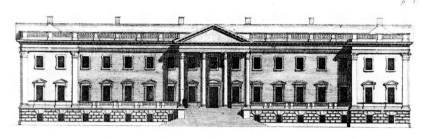

Front towards the Garden

Fig. 40. Gibbs (1728), plate 41.

most certainly based on an engraving of Leinster House and that the current facade probably owes a great deal to the published models of James Gibbs.

Plates in books also played an important part in Thornton's first design for the Capitol. Having been sent, in Tortola, a copy of the newspaper announcement about the 1792 competition, Thornton set to work designing: as he wrote in July to the Commissioners, "I have been constantly engaged since [learning of the competition] in endeavoring to accomplish your purpose.—I have made my drawings with the greatest accuracy."[78] It is clear from an account he wrote ten years later that he was learning about architecture as well as preparing his design: "I lamented not having studied architecture, and resolved to attempt the grand undertaking and study at the same time. I studied some months and worked almost night and day."[79]

His preliminary design was apparently never submitted because on arrival in Philadelphia in November 1792 he learned that none of the original submissions (due by July 15) had been satisfactory. (He then improved his chances for subsequent submissions by consulting with Jefferson and apparently also with competitors.) This preliminary design survives and is clearly based mainly on Campbell's elevations for Wanstead House, Essex, the first two plans for which were published in *Vitruvius Britannicus*, I (1715), plates 22 and 24–25.[80] Thornton's original proposal for the Capitol is very close to these in many ways, but his reliance on plates in books is evident not just from this similarity; we recall that he had consulted books for his Library design six years before. Furthermore, in a letter he wrote a few years later, he refers specifically to both *Vitruvius Britannicus* and William Chambers's *A Treatise on Civil Architecture* (1759) and cites the illustrations of seven country houses in them to justify his use of a high basement for the Capitol building design then being considered.[81]

I have mentioned Jefferson's Monticello in regard to his selection, about 1771, of the two-level portico from Palladio for the original entrance facade. We can return to Monticello again here, for Jefferson took a long time building, and rebuilding, his country house, and throughout the process books were essential.

The early plans for Monticello (and perhaps the very earliest ideas for its elevation design, too) were based on plate 37 in Robert Morris's *Select Architecture* (1755). After four variations carefully evolved from the Morris plan, Jefferson arrived at the fifth design, which was begun in 1768 (and completed in 1782) for his country house.[82] The two-level portico (which may never have been fully erected) was for this "first" Monticello. Palladio was not used only for the facade, however; Jefferson planned to employ the various orders from this treatise in the interior as well : "Parlour—Corinthian—Palladio Book I, Plates 23, 24; Dining Room—Doric: Chamber—Ionic Dentils Palladio temple of Fortuna Virilis—Book 3, Plates 34, 35, 36, and 37."[83] It is worth pointing out that Book I is Palladio's own form of the classical orders, while Book III includes orders carefully copied from ancient monuments.

On his return from Europe, after having spent the years 1784–89 in Paris as minister to France, Jefferson's ideas on architecture had matured from seeing impressive Roman remains *in situ* as well as contemporary French architecture. His enthusiasm for the Hôtel de Salm in Paris (1782–86) is well known; it provided the impetus for redesigning Monticello as a building that would appear to be essentially one story tall and may also have given him the idea of capping one facade with a dome.

When Jefferson returned to construction at Monticello in the campaign of 1796–1809, books were still vital to his work. Morris, Palladio, and ancient Roman examples had been sources for the first Monticello; now he turned to additional treatises on Roman architecture and also to James Gibbs.

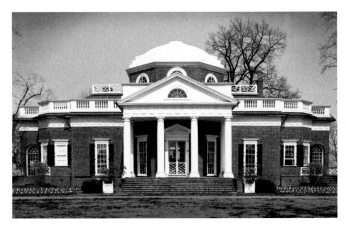

Fig. 41. Jefferson, Monticello, Virginia.

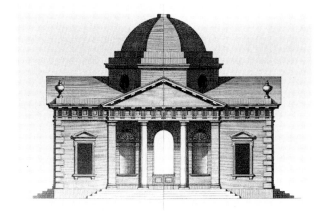

Fig. 42. Gibbs (1728), plate 67.

On the interior of his expanded dwelling, he carried out a consistently classical decoration of rooms with entablatures and fireplaces embellished with authentic Roman detailing. For example, he turned to Roland Fréart de Chambray's *Parallèle de l'architecture antique avec la moderne* (in the revised edition by C. A. Jombert of 1766), a book first published in 1650 and containing the ancient Roman orders as well as versions of them by ten subsequent architects, including Palladio, Scamozzi, Serlio, Vignola, Cataneo, Bullant, and de l'Orme. From this cornucopia, he selected—as we know from his annotated copy, which survives—entablatures for various rooms: for his own bedroom that from the temple of Fortuna Virilis, Rome; for the hall, the frieze from the temple of Antonius and Faustina, Rome; for the north piazza, the entablature from the baths of Diocletian; and so on.[84]

This use of Roman classicism for interior detailing extended to fireplaces as well, whose friezes were carved based on plates in another of his books, Antoine Desgodets's *Les Edifices antiques de Rome* (first published in 1682), which Jefferson owned in the 1779 edition. The frieze in Jefferson's bedroom mantel, and that in the parlor (and the frieze in the entablature of the hall), all come from specific plates in Desgodets.[85]

Somewhat surprisingly, Jefferson turned back to Gibbs for the garden facade of Monticello, basing it on plate 67 from *A Book of Architecture*.[86] Its simple clarity of design certainly is parallel with Roman work and in Jefferson's composition forms the center of his new "one-story" country house.

Thus despite Jefferson's real gifts in architectural design, plates in books still formed an essential component of his work. This may not, in fact, be at all surprising in light of Jefferson's passion for books, especially those relating to architecture. (His first book

on architecture was, it seems, purchased from an old cabinetmaker in Williamsburg while Jefferson was a student at the college.)[87] By 1815 when Jefferson sold his personal library to the federal government (to help rebuild the Congressional Library burned by the British in the War of 1812), it totaled 2,700 volumes; 49 were books on architecture.[88]

The use of plates in books as models for buildings or as aids in the formulation of designs should not obscure the fact that constructed buildings themselves were sometimes the archetypes. Naturally these models had to be studied and drawn, but the fact that they were not in books did not limit them as objects of emulation. James Hoban was apparently the source for the facade design of the First Bank of the United States in Philadelphia (built 1795–97), even though the businessman Samuel Blodgett Jr., a friend of Hoban's, is usually considered the designer, because he supplied the drawings. The model that was copied most closely was Thomas Cooley's Royal Exchange, Dublin (built 1769–79), a building Hoban had worked on before emigrating to America.[89] The facades of the two buildings, even to the unequal spacing of the colossal Corinthian columns, are essentially the same. Either Hoban had drawings of the Dublin building with him when he emigrated, or his familiarity with the building enabled him to draw it up when needed.

Better-known reliance on a built—and unpublished—model is Bulfinch's use of the central-domed motif of William Chambers's Somerset House, London (begun 1776), for the State House in Boston.[90] Bulfinch expressed his admiration for this building, and the central feature on the river facade is indeed composed in the same way as Bulfinch's design (built 1795–97). In fact, built models were not rare for Bulfinch, despite his genuine ability as a designer; for

his first townhouse for Harrison Gray Otis in Boston (built 1795–96) he copied the facade of the William Bingham House of Philadelphia, of which he made a careful drawing on one of his visits.[91] Again, when he designed and helped to supervise construction of Harvard College's new Stoughton Hall (1804–5), it was essentially a duplicate, with more delicate Federal-style detailing, of the adjacent Hollis Hall (1762–63).[92] Naturally, the advantages of this sort of constructed archetype were immense: The calculations for the amount of brickwork, timber, and roofing material were made much easier, and changes in plan or detailing from the model could be most easily visualized and carried out.

Books as Models in the Early Nineteenth Century

Plates in books continued to have a profound effect on architectural design, at least of high-style buildings, in the early years of the nineteenth century. Bulfinch's facade for the Ezekiel Hersey Derby House of Salem, Massachusetts (c. 1800), is a good example: It is closely based on Robert Adam's house for Sir Watkin Williams-Wynn, London (1772–73).[93] The changes Bulfinch made in adapting the original design are due to its being constructed in wood rather than masonry, its wider proportions (four bays rather than three), and the greater delicacy of detailing that, by now, was in vogue. He may have studied the house in London during his European trip (1785–87) or consulted the plate in volume II of *The Works in Architecture of Robert and James Adam* (1779). Although this is not a volume ascertained to have been in Bulfinch's library (whose contents are incompletely known), both volumes were for sale in Boston about 1787, and the books were undoubtedly available to him.[94]

Sometimes one finds a dwelling that, because of some unusual feature, suggests that a pattern book was the source of its design. Such appears to be the case with the Samuel Tenney House (c. 1800) in Exeter, New Hampshire. The normal five-bay facade is surmounted by a unique three-bay "monitor"-type roof with facade pediment, which reveals "a clear debt" to plates 39–40 and plate 65 in James Paine's *Plans, Elevations, and Sections, of Noblemen and Gentlemen's Houses*, I (1767). The book was known to have been in the possession of one of the local carpenters who is thought to have erected the dwelling.[95]

Samuel McIntire of Salem, Massachusetts, who like Bulfinch worked in an elegant Federal style, also had recourse to plates in books. Trained as a carpenter and carver, McIntire developed his artistic skills during his career (largely through the study of books) and became an architect of considerable note. As we might expect, one of his earliest and grandest Salem dwellings, the Peirce-Nichols House (1782), has decorations and details "quite directly inspired" from a book—plates in Batty Langley's *Treasury of Designs* (1740).[96]

He seems to have continued this practice even in his maturity. On a sheet of drawings for interior details of the fourth Elias Hasket Derby House (1795–99), he penned at the bottom: "Frieze in middle figure plate 61 in Pain's small book," probably referring to *The Builder's Pocket-Treasury* (Boston, 1794).[97] Even as late as 1804 for the John Gardner House, one of his most suave achievements in the Federal style, McIntire seems to have based the facade closely on plates in two books published in nearby Boston in the 1790s: William Pain's *The Practical House Carpenter* (1796)[98] and Asher Benjamin's *The Country Builder's Assistant* (1798).[99] Both designs feature hipped-roof five-bay houses three stories tall with a central entrance. Whereas McIntire may have derived his use of prominent facade belt courses and chimneys on the exterior walls from Pain, other features are closer to Benjamin: the square third-floor windows, the balustraded eaves (in place of the impractical English-style eaves parapet), and a doorway framed by classical orders, not just molded jambs. The keystone lintels used by McIntire and his elegant entrance porch are his own contributions.

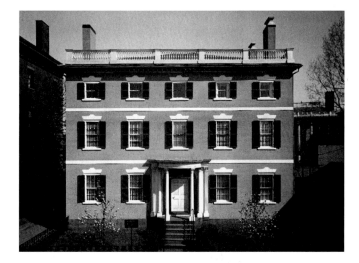

Fig. 43. McIntire, Gardner House, Salem, Massachusetts (Courtesy Peabody Essex Museum, Salem, Massachusetts).

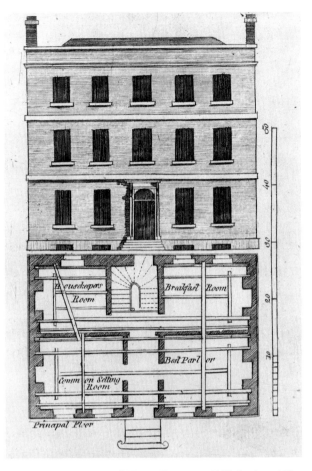

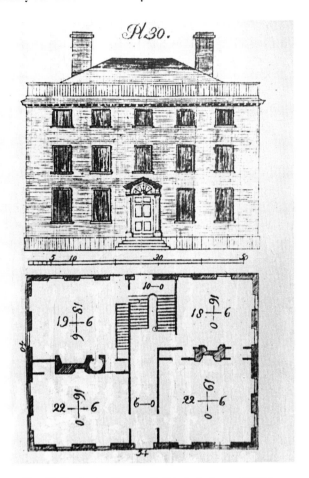

Fig. 44. Pain, Practical House Carpenter *(1796), plate 100 (Courtesy Peabody Essex Museum, Salem, Massachusetts).*

Fig. 45. Benjamin, Country Builder's Assistant *(1798), plate 30.*

However, an intriguing possibility is that McIntire did not directly use these plates, but rather was inspired by a *built* dwelling of this style, the Salem merchant William Gray's house of 1801 (Fig. 46). Perhaps it was *this* builder who had recourse to the Pain and Benjamin designs first, and McIntire's elegant facade simply improved on an existing expression of the pattern-book plates!

Most of the copying from builders' manuals of the day seems to have been of details (as it had been in the later Georgian period), however, not of house facades. One of the most popular Federal-style books was Asher Benjamin's *American Builder's Companion* (Boston, 1806), whose usefulness is signaled by its frequent reprinting (in 1811, 1816, 1820, 1826, and 1827), usually with corrections and additions each time. In one case, a builder as far away as Ohio borrowed from one of its plates.[100] Such wide-ranging influence of these books does not appear to have been uncommon. A stair-stringer decoration from Owen

Biddle's *The Young Carpenter's Assistant* (Philadelphia, 1805), plate 31, is copied quite closely in a house in North Carolina.[101]

Such copying by craftsmen of published plates was commented on in the press of the day, too. A critic writing about high-style architecture in the Philadelphia *Analectic Magazine* in 1815 observed: "Our domestic architecture is for the most part copied, and often very badly copied too, from the common English books, with but little variety, and no adaptation to our own climate or habits of life."[102]

Yet such comparisons, especially between house facades and plates in books, must be approached with care. The Thomas Law House, in Washington, D.C., is a case in point. As the comparison shows, it is extremely close to a plate in Asher Benjamin's *The American Builder's Companion* (Boston, 1806) and appears to reveal the wide influence of Benjamin's popular books, but the Law House dates from 1796, a full decade before the plate was published![103]

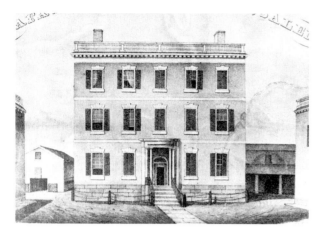

*Fig. 46. William Gray House, Salem, Massachusetts, 1801
(Courtesy Peabody Essex Museum, Salem, Massachusetts).*

The solution to this apparent conundrum is actually not hard to divine. We saw previously that in both England (c. 1680–1730s) and Virginia (c. 1715–1750s) the local builders' vernacular developed house types that evolved quite happily and were enriched and embellished without the aid of facade designs in books. The fact that the hipped-roof types common in England and Virginia appeared in pattern books only in the 1740s and 1750s,[104] after their popularity was finally being challenged by more advanced types, reminds us that such builders' manuals often codified motifs and ideas that had already found general acceptance in advanced circles.

The Law House illustrates this. The use of arches framing windows on the ground-floor level[105] of dwellings is a feature pioneered by the Adam brothers (as in the Williams-Wynn House of 1772–73 mentioned above). Such arches can be found as early as the 1760s in their work, and by the 1770s they were common; another well-known dwelling that uses them is 20 Portman Square, London, of 1775–77.[106] Bulfinch seems to have introduced the motif to America, for it appears in his work as early as 1792 and was used with great effect on his row of brick dwellings at 17–24 Franklin Place, Boston, in 1794–95.[107] Other architects (well before 1806) also used it, such as John McComb in New York City about 1799 and Benjamin Henry Latrobe in Philadelphia in 1800–1801.[108] Thus the builder of the Law House was probably inspired by constructed examples in other metropolitan centers, not by a plate in a book; and it was the success of the motif that encouraged Benjamin to include it in his manual. In fact, a second parallel can be found in nearby Georgetown, D.C.: The Laird-Dunlop House, built in 1799, is a three-bay design, again nearly duplicating a plate (number 33) in Benjamin's 1806 volume.[109]

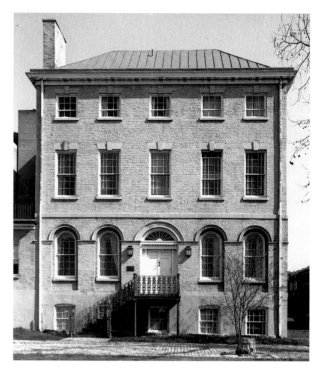

Fig. 47. Law House, Washington, D.C.

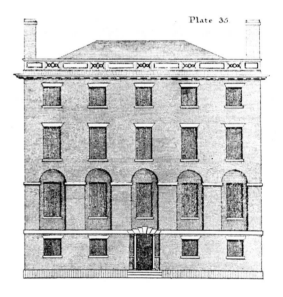

Fig. 48. Benjamin, American Builders Companion
(1806), plate 35.

Despite these caveats, we can see that plates in books did continue to play an important role in architectural design in the early years of the nineteenth century. An especially revealing case is Tudor Place, an estate in Georgetown, D.C., designed by William Thornton.

We have seen that Thornton owed most of his architectural knowledge to the study of books, but he

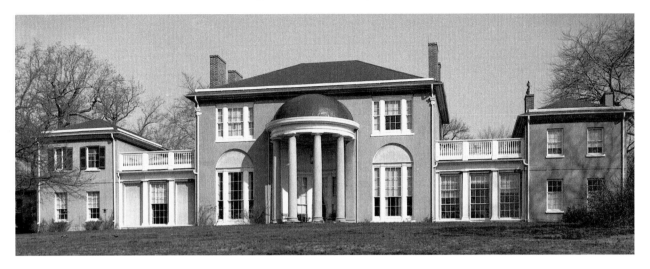

Fig. 49. Thornton, Tudor Place, Georgetown, Washington, D.C., completed 1816.

undoubtedly also learned a great deal in his many con-ferences about the design of the Capitol with the Com-missioners and Stephen Hallet, a professional archi-tect trained in France, who was hired in 1793 to pro-vide workable plans for the building and to supervise construction (although this arrangement lasted only until late 1794). We witness Thornton's growing ma-turity in handling complex shapes in ground plans, and in meeting distinctive site requirements, in his work on Colonel John Tayloe's Washington house (The Octagon) built in 1798–1800. Two of his preliminary drawings for the plan reveal his interest in ovals, circles, and clear overall geometry, which was at the forefront of architectural design of the day, even if the brick exterior of the Tayloe house was executed in the cur-rent Federal style.[110]

Tudor Place reveals Thornton's sophisticated ar-chitectural designs especially well. In 1805, Thomas Peter bought a spacious, commanding site above Georgetown for a country house. Two dwellings, each about twenty by thirty-eight feet in size, had been erected there already, around 1797, with a space of about ninety-two feet left between, for a subsequent great house with wings to link them. Thornton set about, some time after 1805, designing the mansion to fit into this space and to incorporate the existing structures.

Thornton reveals his up-to-date design skills in many distinctive features in the plans, the facade stud-ies, and the completed building.[111] His studies for the plan, of which at least five preliminary designs sur-vive, show a complex refining of the use of circular and oval rooms within the essentially rectangular form of the mansion, very much the spatial variety devel-oped by the Adam brothers in England, brought to

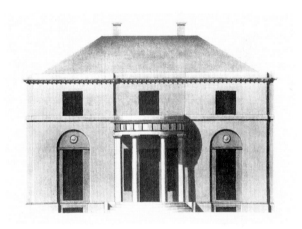

Fig. 50. Richardson, New Vitruvius Brittanicus
(1802), plate 10.

America in The Woodlands, and used in the 1790s by a growing number of architects, including Hoban, Bulfinch, and McIntire. Thornton also includes a cir-cular porch, half of which projects beyond the line of the facade, half of which is subsumed into the body of the building. From the outside, this appears as a two-story "tholos" temple, complete with dome—a bold and commanding feature. And the exterior is also treated, in contrast to virtually all other buildings in America in its day, as a monolithic block of solid ge-ometry, its mass emphasized by the "tholos" scooping out a semicylinder from it. The brickwork is covered in stucco, obliterating the additive sense that walls of bricks usually have. Thornton also used triple-light windows in an arched opening on the facade, again an advanced feature at the time. Finally, the overall composition of a substantial central block connected by low wings to end buildings was not a common fea-

ture in America. Tudor Place, completed in 1816, was undeniably one of America's most up-to-date dwellings, in large part because Thornton had consulted an up-to-date book on British architecture: George Richardson's *The New Vitruvius Britannicus.*[112] Volume I appeared in 1802, and volume II in 1808. Thornton probably achieved his final designs for Tudor Place closer to 1810 than 1805 and thus could have used both volumes in his work.

When we compare the floor plans, the facade studies, and the completed building itself to plates in Richardson's volumes, we find that essentially all the distinctive features that Thornton used can be found in these tomes. For example, the idea of a circular porch or room, half inside and half outside the line of the facade, is found in six plates in these books;[113] the use of oval rooms occurs in at least ten plates;[114] the exterior facade feature of a domed, semicircular projection appears on at least four houses;[115] the clear simple overall geometry is seen in many dwellings;[116] the composition of a central block with low wings connected to end pavilions occurs on seven or eight houses;[117] triple windows under arches are quite common;[118] and even the idea of stucco finishes over brick can be found in Richardson's books.[119]

Although some of the Richardson plates are closer to Thornton's preliminary facade studies than to the completed building, we can still see that the composition, details, and even the form of the completed central block owe a great deal to *The New Vitruvius Britannicus.* Sydney Lodge, Hampshire, designed by John Soane and built in 1789, is especially close to Thornton's final design, even in the use of a simple Doric order for the projecting porch.

It is not only because Thornton was a self-trained architectural designer that he employed illustrations in books to assist in his compositions. Even Benjamin Henry Latrobe, a British architect professionally trained in both design and engineering, who had come to America in 1796, appears to have had recourse to prints of buildings on occasion. His design for Saint Paul's Church, in Alexandria, Virginia (1817), duplicates the distinctive lofty triple-arch facade, with circular rose windows above each archway, of Peterborough Cathedral.[120]

This review of examples of houses (and a few public buildings), which in one way or another employed designs in books, raises some interesting points. One is the relative lack of influence from books in the first half of the eighteenth century. This is undoubtedly due, as suggested, to the skilled and knowledgeable craftsmen themselves (most having mastered the

field through apprenticeship) and to the dominance of "standard" house types, which could be readily modified and adapted as individual cases required.[121] Carpenters and masons simply did not need to refer to books for either plans or elevations or for the modest detailing required. Any fancy interior woodwork would have been the province of a specialist (a joiner and cabinetmaker), who would likely have had a fuller knowledge of classical detailing.

This lack of need for printed models—when built models were all about—is in a way confirmed by the scarcity of architectural drawings from the first half of the century. Kimball illustrated only two,[122] and later studies have also found such drawings extremely rare. Jeffrey Cohen puts it succinctly: "In the hands of builders [vernacular types] . . . must have constituted a norm so well established that only minor variations needed to be specified to an experienced builder, and these could be communicated through means other than original drawings. It therefore seems possible that preparatory drawings were never made for even such considerable building efforts as the hundreds of center-hall, double-pile houses of eighteenth-century America."[123]

Illustrated architectural books, when they became available, however, were certainly of interest to builders and carpenters. We know that carpenters' manuals were obtainable in Philadelphia as early as 1734, and even *Vitruvius Britannicus* was available by 1736.[124] Among the first order for books by the Library Company of Philadelphia (founded in 1731) were two on architecture: a volume of Palladio and John Evelyn's *A Parallel of the Antient Architecture with the Modern* (London, 1664), a translation of Fréart.[125] By 1749, the first catalog of the Library Company mentioned six books on architecture, including significant volumes such as *Vitruvius Britannicus,* Ware's translation of Palladio, and Francis Price's *The British Carpenter* (2d ed., 1735).[126] Carpenters were also early stockholders in the Company, and its accessibility to them was assisted by the Library's occupying rooms on the second floor of the Carpenters' Hall until 1789, when it moved into its own building.[127]

After about 1750, as we have seen, recourse to books for elaborate houses was more common; and this is certainly reflected in the accessibility of books on architecture. The Park and Schimmelman lists document this new demand for books, and two cases that help confirm the interest that craftsmen had in such volumes can be cited. When Swan's *British Architect* was reissued in Philadelphia in 1774, it had "nearly two hundred subscribers, most of whom were carpenters."[128] The 1789–90 list of shareholders for the new

Library Company building included fourteen carpenters and eight bricklayers.[129] Clearly, architectural books and their illustrations were now quite important in the design of buildings.

Finally, examining the persons who, from our review of known examples, used these books is also revealing. One group, both before and after 1750, can be called "gentlemen architects." This category included John Drayton (of Drayton Hall) and John Tayloe II (at Mount Airy), both wealthy planters. Certainly Peter Harrison can be included in this group, for although he began life as a seaman and merchant, he married into a prominent and wealthy family and by providing all but one of his plans gratis, clearly qualifies as a gentleman architect. Thomas Jefferson, trained as a lawyer, and William Thornton, a doctor, saw architecture as one of the polite achievements, not an extension of a craft. Charles Bulfinch, owing to financial reverses, had to make architectural design his vocation, but started out, the son of a doctor and a Harvard graduate, as a gentleman architect. Such men had the cultural interest and wealth to afford the books that played such an important part in their architectural designs. Although Bulfinch (and even Jefferson) certainly learned a great deal about materials and structure in their architectural careers, they were by no means trained craftsmen, with the understanding of the building process that comes only from long apprenticeship and years of on-the-job experience.

Probably the largest group to use these books was the craftsmen themselves. In most of the cases I reviewed, the name of the person who introduced the academic feature or detail based on a design in a book was unknown, but it was undoubtedly the carpenter (or mason or plasterer) who executed the work. Only a relatively few of them, through diligent study, added

the ability to create overall designs to their technical skills and rose to the level of "craftsman architect." Some became well known. Both Samuel McIntire and Asher Benjamin were carpenters by training; William Buckland, a joiner and cabinetmaker, and James Hoban, an unspecified "artisan." Professionally trained architects—who understood overall composition and design and were also familiar with structure and engineering—were very rare: Stephen Hallet and Benjamin H. Latrobe were about the only two at the end of the eighteenth century.[130]

Most of the design books and manuals used in America were also *by* craftsmen who had higher aspirations for their talents. William Salmon was trained as a carpenter; Abraham Swan and William Pain were carpenters and joiners; Batty Langley began as a gardener; Edward Hoppus as a surveyor; and George Richardson and Isaac Ware were draftsmen (Ware also being an engraver).

Somewhat surprisingly, of the architects whose books were used in America, only two were thoroughly trained professionals: James Gibbs had studied in Rome under Carlo Fontana; and Robert Adam had studied under his father and then had visited Italy. Campbell was trained as a lawyer first, and his architectural background is uncertain; and William Kent began as a painter, gradually moving into interior decoration, and finally into architecture.

With the aid of books, an intelligent craftsman, as we saw, could also produce designs for buildings. It was a phenomenon common in England, too. Robert Mylne, who had been apprenticed as a carpenter but then had spent five years studying architecture in Italy and France, observed in 1760 that "a carpenter could convert himself by the help of a *Palladio Londinensis*, lying on his bench, into an architect."[131]

3

Builders' Manuals and Pattern Books, 1820s–1850s

BETWEEN THE 1820s and the 1850s, a major transformation in how builders used books on architecture took place. This innovation was in large part due to changes in the purpose and content of the books; nevertheless in both Greek Revival and then Gothic Revival dwellings, the importance of books to builders continued to be very great.

The introduction of Greek architectural motifs and details by Latrobe in his Bank of Pennsylvania (built 1799–1801) in Philadelphia cannot be considered the beginning of the mature Greek Revival, for his composition employed a prominent exterior dome inconsistent with classical Greek style. The design competition held in 1817 for the Second Bank of the United States, Philadelphia, however, does mark the beginning of that maturity. The competition program encouraged the designers to follow the simplest lines of Greek

architecture, and William Strickland's winning entry was just that—a rectangular building with end porticoes composed as virtual copies of the pedimented ends of the Parthenon. Accurate and detailed archaeological reconstructions of these elevations had been available to scholars and architects since James Stuart and Nicholas Revett had published volume II of *The Antiquities of Athens* in 1787.[1] The reconstruction of the Parthenon (chapter I, plate III), as well as the Erechtheion, and careful measured drawings of their columns, capitals, and details, made these beautiful buildings readily accessible to architects.

The year 1817 also saw the completion of the first major dwelling in America to employ a monumental Greek portico as the dominating feature of its design: George Hadfield used the massive Doric order of Paestum (or possibly Corinth) for the Custis-Lee Mansion in Arlington, Virginia.[2]

Strickland's bank, built between 1818 and 1824, originated a long line of temple-fronted public buildings (usually Doric or Ionic) during the next forty years. For domestic building, however, the key structure seems to have been the Bowers House of Northampton, Massachusetts. Commissioned in 1825 by the Boston merchant Henry Bowers from the New York architect Ithiel Town, the stone mansion, intended as Bowers's retirement home, was built by two local craftsmen in 1826–27.[3] This house seems to have been the archetype for numerous impressive dwellings with central porticoes and side wings built thereafter[4] and probably helped create or inspire the many other Greek Revival house types that quickly developed in New England at this time.

The Greek Revival, which rapidly supplanted the late Federal style still built in the 1820s and even 1830s, was extremely popular. Several factors may help to explain this.[5]

Early American travelers to Greece, notably the influential "traveler, ambassador, dilettante, and banker" Nicholas Biddle (who had visited as early as 1806), were impressed by the beauty of Greek architecture; George Tucker's paper "On Architecture," published in *The Port Folio* in 1814, held that Greek forms were "the most suitable inspiration for an American architecture."[6] After the War of 1812 had seen the destruction by the British of both the Capitol and the White House in 1814, a change to a national style of building without the direct links to Georgian- and Adam-style antecedents must have seemed imperative to many.

To architects, the Greek models were full of possibilities. Especially in the wake of the increased interest in large, simple volumetric units with restrained surface decoration, as explored by John Soane (and Boullée

and Ledoux) in the late eighteenth century—an emphasis that Latrobe brought to America—the clarity of Greek design must have seemed a logical next step.

There was also a vivid popular interest in the Greek style because of its associations with ancient Greece, the first (albeit imperfect) democracy, as well as with the contemporary Greeks and their struggles to free themselves from Turkish rule. This conflict was widely seen as a parallel with the American Revolution. The outpouring of support for the Greek revolution was signaled by two nationwide fund-raising campaigns, the first in 1824, which raised $80,000, and the second in 1827–28, which was equally successful.[7] That this was a popular grass-roots appeal is evident from contemporary documents. For example, the First Presbyterian Church of Newburyport, Massachusetts, noted in its church records for May 4, 1828: "[H]ad a contribution for the Greeks, who are now supposed to be in a state of distress & poverty struggling for their liberty, and collected $79.40 for their relief."[8]

The popularity of things Greek is evidenced by two interesting facts: The Greek Revival style can be found throughout America, from the Atlantic to the Pacific, in succeeding decades; and nearly four hundred villages and towns in virtually every state were given Greek (or Roman) names.[9]

Greek Revival Builders' Manuals

It has long been recognized that architectural books had a strong impact on the design of Greek Revival houses. Both I. T. Frary in 1936, and Talbot Hamlin in 1944,[10] provided innumerable examples of dwellings and public buildings with details drawn from builders' manuals, and many more cases have come to light since then.

The first book with the new Greek orders available to ordinary builders and carpenters was John Haviland's *The Builders' Assistant*, in three volumes, (Philadelphia, 1818–21). The volumes with the most impact, and those that can be clearly documented, however, were the books by Asher Benjamin and Minard Lafever.

The earliest of these manuals was Benjamin's *The American Builder's Companion*, which in its sixth edition in 1827 included seven additional plates on the Greek Doric and Ionic orders, probably based on Stuart and Revett. The rest of the book still included late Federal-style details and facade designs; there were no facade designs in the Greek style.

Benjamin's next book focused almost entirely on the Greek mode: *The Practical House Carpenter: Being a Complete Development of the Grecian Orders of Architecture* (Boston, 1830). As he observed in his introduction, "[S]ince my last publication, the Roman school of architecture [i.e., the Federal style] has been entirely changed for the Grecian." He included two different Greek Doric models (as well as Roman and Renaissance Doric); Greek Ionic (as well as the Ionic of Chambers and Palladio); and details in the Greek mode for doorways, lintels, dormers, fireplaces, frieze detailing, and so on. There were no house designs or elevations. It was a most popular book; a second edition had to be published that same year, a third in 1832, and a fourth in 1835. It continued to be reprinted through 1856.

A successful rival came out about the same time: Minard Lafever's *The Modern Builder's Guide* (New York, 1833). Like Benjamin, he was a house carpenter turned architect, but from central New York state rather than Massachusetts. Lafever illustrated two forms of Greek Doric, two Ionic, and also the Corinthian, along with designs for fireplaces, doors and doorways, cornices, frieze detailing, interior wall and window treatments, a ceiling design, and several front doorway designs. There were also, at last, two house designs. The first was a small porticoed dwelling with simplified square Doric piers; the second, a much grander effort, again had a central pedimented section, but now in the Ionic order, with flanking wings containing Doric columns.[11] The general influence from the Bowers House of eight years before is evident. *The Modern Builder's Guide* was also very popular for there were subsequent editions in 1841, 1846, 1849, 1850, 1853, and 1855.

Lafever's second Greek Revival carpenter's manual was *The Beauties of Modern Architecture* (New York, 1835). It had a range of material similar to his earlier work, but also included an elevation view of the Parthenon (copied from Stuart and Revett), three other views of the reconstructed Parthenon, and five ancient temple plans. It is important to note that he completely omitted any overall facade designs for houses as models of emulation.

All these volumes were specifically intended for practical use by craftsmen. Although the titles usually make this evident, the authors explain their purposes further in their introductions. Minard Lafever noted in his *Modern Builder's Guide* (1833) that the book was intended for "carpenters and builders in general, but especially . . . the wants of such as are commencing the study and practice of the building art"; it was not aimed at "the experienced architect." In his *Beauties of Modern Architecture* (1835), he wrote that the book was "intended exclusively for the operative workman," so as to "enable him to become a complete master of his business." Asher Benjamin was also explicit about the audience for his designs. In the preface to the fourth edition (1835) of his *Practical House Carpenter,* he explains that his aim was "to make this work useful to the practical builder," and he provided "the most difficult parts on a large scale" so that "a workman of ordinary capacity can make himself perfect master of the orders, without the aid of an instructor."

These books were of immense importance for the development and spread of the Greek Revival. We know this from two factors: the large number of editions[12] and copies sold and the many constructed designs based on the plates.

As mentioned above, these manuals were reprinted frequently. Benjamin's *Practical House Carpenter* (1830) had eighteen editions through 1857; his *Practice of Architecture* (1833) was published in seven editions by 1851; Lafever's *Modern Builder's Guide* (1833) had seven editions through 1855; and his *Beauties of Modern Architecture* (1835) saw five editions through 1855. Just how many copies this output represents is difficult to determine, but we can get a general idea from the comment by Benjamin in the introduction to the 1835 edition of his *Practical House Carpenter:* "Three editions of this work, each containing one thousand copies, having been sold, the author is encouraged to publish a fourth." If we presume that all thirty-seven editions of these four representative books (all known to have been used by carpenters) were actually issued[13] and assign to half of them runs of one thousand copies and the other half, say, five hundred copies, the total would be about twenty-eight thousand books—an impressive number. Furthermore, based on past practices, we can assume that the influence from these volumes was far greater than this number, for when a carpenter copied a plate, that example would then be a model for untold subsequent versions. Furthermore, if the books were passed around, others could make drawings of favorite plates.

The most impressive proof of the great impact of these volumes on American domestic (and also public) building is how many—and how wide-ranging—are the examples we can find that are based on specific plates.[14] The manner in which the plates were copied or adapted also suggests the flexibility and even creativity in this process.

Plate 28 in Benjamin's *Practical House Carpenter* (1830) depicts a doorway with side pilasters en-

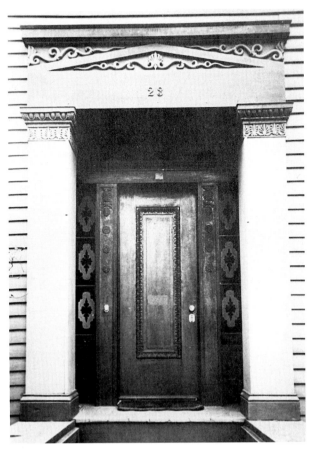

Fig. 60. Forbes-Cushing House, Fredonia, New York, 1842, detail.

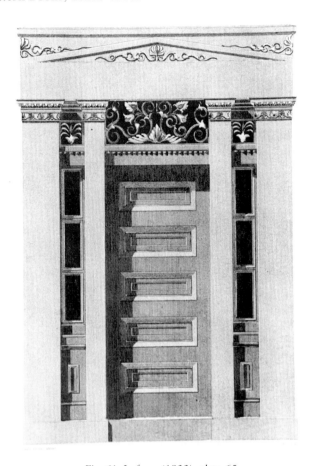

Fig. 61. Lafever (1833), plate 65.

and specific: "The drawing room to be finished with sliding and folding doors (as per plate No. 7 in Lafevers Modern Architecture 1835).... All the doors and windows in the hall and dining room & Library to be finished as per plate 19 in Lafever.... All the doors on the second story to be finished as per plate no 14 with no 19 cornice.... Front entrance to be as p/ plate no 13 with double doors.... All the above plates referred to are from Lafever's Modern Architecture of 1835."[41]

The contract also mentions that the "Collonade [is] to be composed of six Corinthian columns, the style to be used is that from the monument of Lysicratus," which, although the specifications do not cite it, is shown on plate 43 in Lafever's book.

Another southern instance of drawing on Lafever, this time for an interior doorway, is at Bocage Plantation, Louisiana (c. 1840), where two plates (numbers 13 and 26) are adapted. Another Lafever interior detail is found in a house in Kentucky, where a plaster ceiling medallion is based on plate 21 of *The Beauties of Modern Architecture*.[42]

Using designs from both of Lafever's books in the same dwelling was not uncommon either. The exterior portico columns of the Leavenworth House (c. 1840) of Syracuse, New York, copied Lafever's own Ionic order from *The Beauties of Modern Architecture* (plate 31), and the main entrance used the door enframement from plate 13 (with columns of plate 31 style within it). Inside the house, the dining-room windows were framed with pilasters that contained the Lafever palmette of plates 80 and 87 in *The Modern Builder's Guide*.[43]

An especially revealing example of how a craftsman could embellish an interior with motifs drawn from more than one of the builders' guides is provided by the Campbell-Whittlesey House (1835) in Rochester. The doorways into the double front parlors are enframed with casings shaped like those illustrated in *The Modern Builder's Guide*, plate 82. Their lintel design is also taken from this plate; but the jamb palmettes just below this are drawn from plate 19 of *The Beauties of Modern Architecture*. The

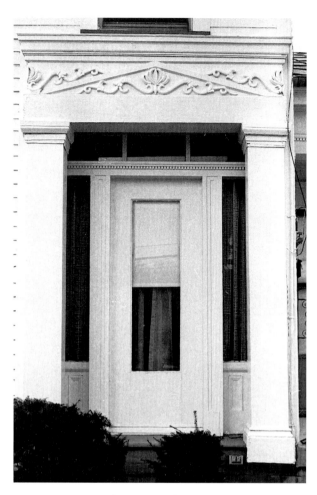

Fig. 62. 100 Eagle Street, Fredonia, New York, detail.

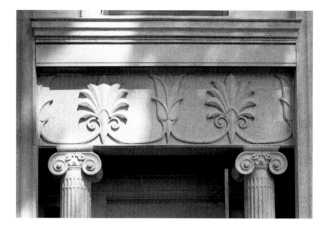

Fig. 63. Smith-Bly House, Ashville, New York, 1835, detail.

Fig. 64. Lafever (1833), plate 48, detail.

enframement of the double doors connecting the two parlors is based on that shown in plate 19 of *Modern Architecture*, with the lintel decoration a free version of the palmettes (omitting the anthemia) of the frieze in plate 26, and the jamb palmettes elongated versions of the comparable feature in this same plate. The end of the lintel frieze is terminated with motifs similar to those in the *Builder's Guide*, plate 82. The panels at each side of the double doors duplicate those shown in plate 13 of *Modern Architecture*, the source also for the band of rosettes that runs above the door casing. The windows in the parlors have jamb details based on the palmettes of plate 19 of *Modern Architecture*, but the lintel above copies the "key" motif—here placed horizontally—of Asher Benjamin as seen in his *Practical House Carpenter* (1830), plate 21. Yet despite the use of these three manuals as sources, the craftsman has given the designs a lightness and delicacy that is consistent throughout.[44]

The Smith-Bly House (1835) in Ashville, New York, is another good example of builders' using more

than one source and also adapting the plates to their own personal styles.[45] The capitals of the pilasters across the facade are all based on Lafever's Ionic order of *The Beauties of Modern Architecture*, plate 31; this is also the source for the columns used in the front doorway. The doubled termination of the fluting (also seen, in a different form, in the pilasters) is certainly an original touch. Rather astonishing, however, is the gigantic palmette and anthemion relief over the doorway, occupying the entire frieze under a wide cornice (and completely crowding out the architrave).[46] This detail seems to trace its origin to the equally angular reliefs in the raking frieze depicted in plate 48 of *The Modern Builder's Guide*. Windows in the side wing are each capped with a large single plant form, of indeterminate origin, confirming how personally the Greek motifs depicted in these books could at times be interpreted and adapted.

Such personal adaptation of the plates in carpenters' manuals is not rare, in spite of the many instances we have cited where published designs were

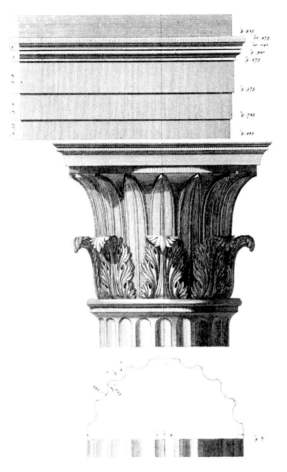

Fig. 65. Stuart and Revett, Antiquities of Athens (1762),
1: chap. 3, plate 7.

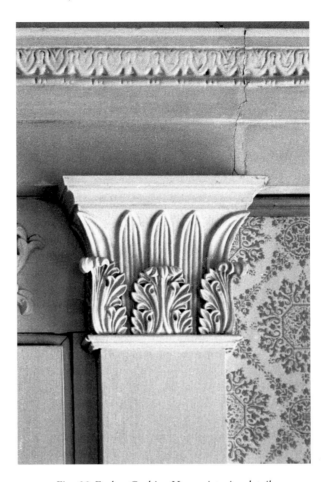

Fig. 66. Forbes-Cushing House, interior detail.

copied with great fidelity. The career and work of the carpenter and contractor Jacob W. Holt, of Virginia and North Carolina, have been carefully reconstructed by Catherine Bishir; in Holt's reliance on designs in Greek Revival manuals, he often adapted them with "robust simplification," although many details can nonetheless be traced to specific plates.[47]

Although I have surveyed selected books by Benjamin and Lafever, naturally others were also employed. For example, the capital from the "Tower of the Winds" in Athens, shown in Stuart and Revett, I, chapter III, plate 7, appears in three of the dwellings I have included: the Leavenworth House of c. 1840 in Syracuse (framing the dining-room windows); the Forbes-Cushing House in Fredonia of 1842 (front and back parlors); and the Avery House in Granville, Ohio, of 1842 (in the entrance doorway). It is an order omitted by Lafever and Benjamin in the three manuals focused on here. Although Benjamin had included a very sketchy version in his American Builder's Companion, plate 22, number 5, it is obvious that the plaster

worker in the Fredonia house followed (or used molds based on) an engraving as detailed as that in Stuart and Revett.

This review of specific cases where designs from Greek Revival carpenters' manuals were used as sources for constructed details reveals several interesting facts. The first is how widely spread was the influence of these books: Vermont, Massachusetts, Pennsylvania, New York, Ohio, Kentucky, North Carolina, South Carolina, Mississippi, Alabama, Louisiana, and even Oregon—and this is obviously only a small sampling of such cases. As noted before, the Greek Revival style can be found in at least thirty-seven states, and it certainly appears that books were important to many of the builders of houses both large and small.

Second, it is significant to note that these carpenters' manuals were used in the full range of house types being erected, from grand mansions like Rose Hill or Milford, where elaborately carved capitals and a complete range of detailing and trim could all be drawn from plates in books, to a humble farmhouse

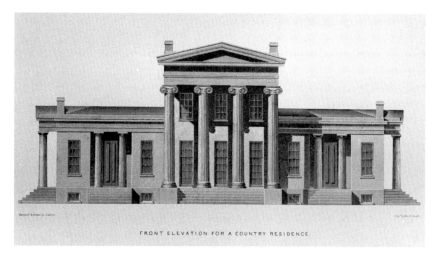

Fig. 67. Lafever (1833), plate 75.

(like the one near Stockton, New York), which was enriched only by a simple doorway and perhaps by a cornice, based on plates in books.

A third point is that the nature of design features borrowed was extremely varied: doorways, columns and capitals, cornices, porches, frieze details, interior door and window treatments, ceiling rosettes, and so on. Yet what may come as a surprise is that I have not illustrated any entire house facades based on plates in these books. As observed earlier, only two are in fact shown in these volumes, both in Lafever's *The Modern Builder's Guide* of 1833. The famous plate 75 depicting "a country residence" is often thought to be the model for the many temple-type houses with flanking wings that can be found throughout the northeast and beyond. The Austin Smith House in Westfield, New York, is a good example of the type. Hamlin, for example, stated that "the large number of houses with four-column two-story Ionic porches, flanked by lower wings, . . . are all reduced modifications of [this] influential design."[48]

Yet the differences between these houses and the Lafever plate are usually great: The central portion is almost never as narrow as Lafever's model, and it usually contains the main door; the side wings are not as long and do not generally have recessed columns (pilasters against the wall, or a colonnade across the front of each wing, is far more common). They rarely have the projecting columned porches at each end, either.

Furthermore, the date of the Smith House, inscribed clearly on its cornerstone, is 1830: Thus the Lafever plate as purported influence is eliminated. In fact, this house type must have been commonly known by that time, for a Doric version in Haydenville, Massachusetts, is ascribed a date of "c. 1830" as well.[49]

The model for all these houses was undoubtedly Ithiel Town's Bowers House of Northampton, Massachusetts, completed in 1827. It must have engendered a type that spread very rapidly, for Elias S. Barger, the carpenter who proudly inscribed his name, and the title "architect," on the Smith House cornerstone, was only seventeen years old in 1830, as documented by census records.[50] Thus it did not need years of experience to compose such a house—only two or three years of apprenticeship, and the skill and vision to adapt a house type then gaining popularity. In less than twenty-five years, the type had spread six hundred miles farther west, as the Kuehneman House in Racine, Wisconsin, illustrates.

The architectural richness of the Austin Smith house raises another point it is important to emphasize. The pattern books served a purpose beyond pro-

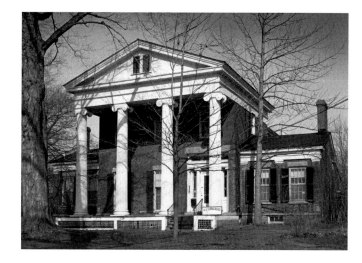

Fig. 68. Smith House, Westfield, New York, 1830.

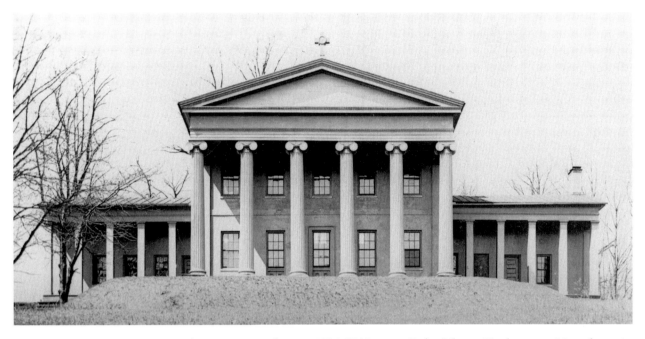

Fig. 69. Town, Bowers House, Northampton, Massachusetts, 1826–27 (Courtesy Forbes Library, Northampton, Massachusetts).

viding builders with accurate details of columns, doorways, and interior features to follow. Such book plates undoubtedly were also valuable for informing the *owners* of the sorts of design features, or level of richness, the house was to have. We have already noted that such books were sometimes referred to specifically, and by plate, in the contract itself. For a house such as this, Barger probably needed only a sketch plan to establish the size and disposition of the rooms, with the dimensions (if not the plan itself) as part of the contract. For the exterior, however, existing models could be referred to, and for details, Barger could have discussed the options with Smith by reference to such books as Benjamin's. The mode of construction, and standard detailing, was all within the craftsman's own knowledge acquired by means of apprenticeship and experience. Clearly carpenters and builders were, in fact, "architects" too: planning, designing, calculating, working out alternative forms within financial constraints— but then (unlike an architect in the modern sense) going ahead and building the house as well. For a mason or carpenter, the builders' guides were supplements to their own considerable knowledge and skill.

Most Greek Revival houses are very different from Lafever's two plates. In fact, one of the most popular vernacular types for farmhouses and small urban dwellings has very little in common with either Lafever design: no freestanding columns, one rather than two wings, and an abbreviated pediment with the horizontal member interrupted to allow the inser-

tion of windows in the half-story above. It is a type that can be found in widely dispersed areas. Our three samples here come from Earlville, New York, in the central part of the state; Ellington, in the far western corner; and Sacketts Harbor, in the northernmost reaches. And houses of this same type appear farther south and west too: One is documented in Union City, Pennsylvania; another (built in 1854) is located near Medina, Ohio; a third (of c. 1840) was erected in Milwaukee, Wisconsin.[51] Clearly the type was spread by builders, not pattern books. It is a type that was built most frequently in many villages (in Fredonia, New

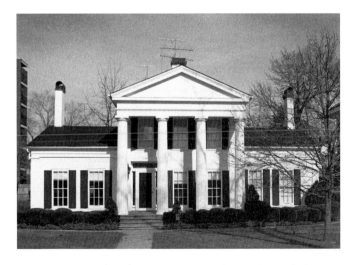

Fig. 70. Keuhneman House, Racine, Wisconsin, c. 1853.

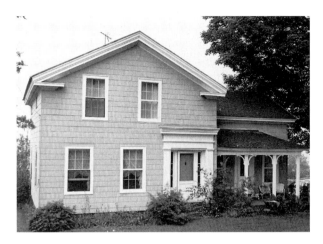

Fig. 71. House in Earlville, New York.

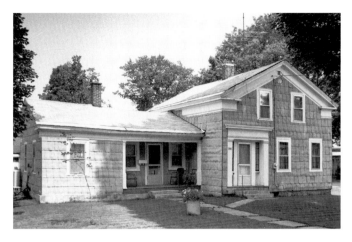

Fig. 72. House in Ellington, New York.

York, accounting for almost half of the 257 Greek Revival houses extant[52]) and in the country as well.[53] To be sure, the doorways on all three samples might be based on a simplification of examples shown in Lafever's *The Modern Builder's Guide* (1833), plates 63, 64, 80 (right), or 81 (left); or possibly these are versions of Benjamin's doorway shown in plate 28 of *The Practical House Carpenter* (1830). It is equally possible that, like the house type, the doorway was developed by the carpenters themselves, based on early constructed examples. A. J. Davis, for example, had designed (and presumably built then or soon after) a doorway of this simplified type in New York City as early as 1829.[54]

These illustrations also bring up the interesting point of architectural hierarchy. Both the Austin Smith House and the Sacketts Harbor dwelling are fully Greek Revival: the low-pitched gable emulating a classical temple; the simple, clear, blocky units; the classical orders employed, together with the appropriate detailing (cornices, frieze boards, etc.). Yet the builder of the smaller and less ambitious house surely recognized that to attempt to make a small dwelling simply a tiny version of a mansion would render it ridiculous—and very expensive, too. Freestanding columns and elaborate detail are dispensed with, and in its place is a workable, successful shorthand version of the full classical garb, which was equally readable as "Greek."

In fact, there are several established types (in decreasing levels of elaboration) between these two houses, and some are even more modest than the last.[55] This is the same concept of architectural propriety that Roger Pratt had set down and followed two hundred years before.

Despite the dominance of vernacular house types and the use of doorways and other such details from

Fig. 73. House near Sacketts Harbor, New York.

books, we should remember that carpenters themselves did, on occasion, draw up plans and profiles of details. Like the few survivors from the eighteenth century, these were probably ephemeral drawings intended to work out a problem or to show the owner the work to be done. Apparently, the drawings were often not even made on paper. In his reminiscence of his early training in Massachusetts, William W. Boyington observed: "The majority of buildings at that period [c. 1827] were planned and built by master builders, who usually made their plans on the face of the trestle-board, and shaded them with white, red, and blue chalk to designate wood, brick, and stone. Details were made, full size, in the same way. My father was a master builder, and used to make his own plans largely in the way mentioned."[56]

Despite the vitality of popular house types, to which details from carpenters' manuals might be adapted or added, were any entire dwellings ever built following either of Lafever's designs? If so, they were

certainly uncommon, and the only one that I was able to find, which is as faithful to a Lafever plate as are the many cases of doorways and details copied by carpenters, is a farmhouse near Alabama, New York, closely based on Lafever's frontispiece—but with added end porches of four Doric columns, a motif from plate 75.[57]

Even though copying an entire house design appears to have been extremely rare, this frontispiece might have provided a good visual record for emulation of a popular vernacular Greek Revival feature: the square pier used in place of round columns on many a porch and facade.

Pattern Books in the 1840s and 1850s

Carpenters' manuals and various other illustrated treatises and volumes on architectural design were used as models or patterns for architectural details and facade designs for generations. In the 1830s and 1840s, however, even while the Greek Revival and the books of Benjamin and Lafever flourished, a significant revolution in the character of such books began with the ascendance of volumes very different in content and intent from builders' manuals.

These manuals were, after all, primarily for craftsmen themselves. They provided additional technical information and stylish designs, which craftsmen could readily use. In most cases, these features were to be adapted to existing vernacular types, with only rare cases of designs for entire facades being traceable to books—particularly in the Greek Revival period.

An examination of the books themselves makes this clear. Benjamin's *American Builder's Companion* (6th ed., 1827) contained an initial ten plates devoted to practical geometry, especially as related to the design and execution of moldings, capitals, and the like. Then the classical orders and their details were highlighted because, as Benjamin explains (30), they are "the basis upon which the whole decorative part of the art is chiefly built." Then he included enriched friezes, a ceiling design, fireplace details, and also technical drawings for roof framing and staircase construction. Five house designs are included, as well as five churches. The text mainly describes and explains the plates.

His *Practical House Carpenter* (1830) was very much the same, with a few more fireplace and doorway designs, but with house designs now eliminated. This book went through sixteen more editions through 1857, signaling its real value to builders.

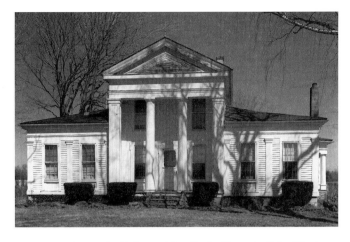

Fig. 74. House in Alabama, New York (Photo by John King).

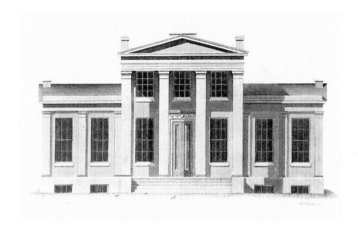

Fig. 75. Lafever (1833), frontispiece.

Lafever's *Modern Builder's Guide* (1833) was similar. It too began with a long section on practical geometry, especially as related to complex carpentry and framing. Roof trusses, partitions, and staircases followed, accounting for nearly one-half the book. Then come the classical orders and details, and the designs for doors, interior and exterior door casings, window frames, wall treatments, and appropriate details in the Greek style. Two house designs are included. This volume was also very popular as we have seen, and six later editions were published through 1855.

Lafever's *Beauties of Modern Architecture* (1835), a more slender book, dispensed with geometrical plates and included a good number of designs for doors and doorways, windows, classical orders, and even three plates on ancient Greek temples. Apparently at this point Lafever wished to make his book of more literary interest as well, for he appended a sixty-four-page "Architectural History," extracted word for word "from Elme's [*sic*] Dictionary." An eleven-page

glossary of architectural terms he reprinted from the *Encyclopedia Britannica.* There were no plates of house facade designs. This volume too went through four later editions, through 1855.

No greater contrast could be imagined, then, between these books and two new volumes, heralding the Romantic age and architecture firmly within the Picturesque movement, which appeared at this time. The first was Alexander Jackson Davis's *Rural Residences, Etc. Consisting of Designs . . . for Cottages, Farm-Houses, Villas, and Village Churches.*[58] Dated 1837, it actually appeared in 1838 and contained eight colored lithographic designs, plans, and a page of descriptive text for each. Nothing could have been further from the current Greek Revival mode. Illustrated were a Gothic Revival mansion in stone and a small Gothic cottage; a frame board-and-batten farmhouse related to the Picturesque movement; a square Italian villa; an "Oriental-style" villa; and a whimsical "American House"—a miniature Greek temple with all the columns rendered as vertical logs with the bark left on. There was also a Gothic church and a village schoolhouse clad in vertical board-and-batten.

Such a book consisting of plans and elevations alone was as diametrically opposed to the contents of the carpenters' manuals as could be imagined. It was really an "idea book," introducing the reader (probably the house owner, not the carpenter) to new styles of architecture. In each case, Davis gives some indications of materials and costs, but these were only guidelines; if the designs were to be built "accurate detailed patterns should be furnished by an architect, as guides to the workmen," as he observed when describing the "Farmer's House."

Davis's book seems to have been published in a small and expensive edition; only twenty-six copies are known today. Four years later, Davis's friend Andrew Jackson Downing,[59] a horticulturist and landscape designer, published his *Cottage Residences; or, A Series of Designs for Rural Cottages and Cottage Villas, and Their Gardens and Grounds* (1842). In its first edition, it contained eleven designs; in the third edition of 1847 there were sixteen, the same as the fourth of 1852. This edition was reprinted seven times, through 1868, attesting to the book's popularity.[60]

This was Downing's first volume devoted exclusively to architecture. It began with an introductory chapter, written in his distinctive mellifluous prose, on architectural principles and theory, emphasizing the fitness of design for its purpose, the truthfulness of architectural expression, and the associative qualities of architecture. Downing had included a chapter

"Rural Architecture" in his 1841 book, *A Treatise on the Theory and Practice of Landscape Gardening*, where he directly acknowledged his debt to British books.[61] Here too we can see that many of his ideas are drawn from English writers on Picturesque design; but Downing has adapted everything to the social and financial needs of America, with full attention paid to American materials and climate.

Downing was also an active proponent of the latest conveniences in domestic architecture: "No dwelling can be considered complete which has not a water-closet under its roof, though the expense may yet for some time prevent their general introduction into small cottages." He also advocated "proper drains to the kitchen and basement, the introduction of water-pipes, cisterns, etc."; observed that "a bathing-room requires little space"; and stated that "the rotary [water] pump," dumbwaiters, speaking tubes, and closets were highly recommended as well.[62] With careful planning, fully considering the proper orientation of the house as to the weather, and taking advantage of the best views from its rooms, the house would be more comfortable and healthful as well as agreeable to live in.

The plans, however, should be adapted to the specific needs and character of the occupants, whatever the size of dwelling: "[W]hat may be entirely fit and convenient for one, would be considered quite unsuitable for another." For that reason, the plans in his book were only suggestions: "[T]here are doubtless many desiring to build a cottage, who will find no one of the plans hereafter submitted precisely what they want."[63]

The first edition of *Cottage Residences* contained eleven designs for houses, with their plans: five in Gothic or Tudor revival styles (including a large stone mansion designed by A. J. Davis);[64] three simplified versions of the Gothic cottage mode; and three Italian villa–style houses. In each, the character and advantages of the style and plan and a discussion of its details (and layout of the grounds) were included. In addition to the perspective view and plan, Downing also often provides in the text vignettes of architectural details such as porches, window treatments, chimneys, brackets; molding profiles; and suggestions as to preferred materials and colors to be used. These vignettes were intended to be flexible guidelines: Regarding a Gothic bargeboard, he observed that it was to be "cut out of thick plank" but that "if thought too elaborate, may be simplified by omitting the minor details."[65] Estimates of construction costs are also included. Although not directly stated, it is implied that skillful carpenters and builders would be able to

copy, or adapt, the designs without too much difficulty. We indeed know from contemporary accounts about the 1840s and 1850s that builders and contractors generally were adept at drawing up their own plans.[66]

A few of Downing's key ideas about architecture should be mentioned, for they helped formulate a new aesthetic awareness and introduced new styles for the rest of the nineteenth century. These ideas are also important to keep in mind when we study examples of dwellings constructed following Downing's designs.

Inherent architectural beauty and cultural (and political) associations were important factors in the popularity of the Greek Revival. Both factors, in different forms, were important to Downing as well. As he observed, "[A]ll the delight which the imagination receives from architecture as an art of taste is derived from *beauty of form*, and from the *sentiment* associated with certain modes of building long prevalent in any age or country."[67] Downing also understood that architectural propriety required that a house not be a "miniature cathedral," but should be of appropriate design for its size and use: "[A]ll domestic architecture, in a given style, should be a subdued expression or manifestation of that style adjusted to the humbler requirements of the building and the . . . purposes of domestic life."[68]

The two styles Downing proposed as fit models for domestic use in his *Cottage Residences* were domestic Gothic Revival and Italianate. "The Rural Gothic style, characterized mainly by pointed gables, and the Italian, by projecting roofs, balconies, and terraces, are much the most beautiful modes for our country residences. Their outlines are highly picturesque and harmonious with nature. Their forms are convenient, their accessories elegant, and they are highly

expressive of the refined and unostentatious enjoyments of the country."[69]

Downing's concept of architecture and its details as being "expressive of purpose" is one factor making dwellings pleasing to the viewer. A house should, clearly, "look like a house:" Some dwellings "are so meagre and comfortless in their exteriors, that one might . . . [suppose] them barns."[70] For Downing, the most "prominent features conveying expression of purpose in dwelling-houses, are the chimneys, the windows, and the porch, verandah, or piazza,"[71] — the chimneys denoting that it is a dwelling (not a barn) and also the idea of cozy hospitality; the windows, the healthful light and airy interiors; and the verandas (which in warm weather become "the lounging apartment of the family"), the idea of comfort.

The aesthetic aspect of design was also important. The "picturesqueness" of a building (the term originating with the aesthetic movement, which began in late eighteenth-century England) emphasized the beauty of variety and irregularity in form, silhouette, texture, and even color.[72] Often fitness of purpose and the picturesque were combined, as when a bay window both animated the three-dimensional mass of a house and also suggested, according to Downing, "those elegant enjoyments which belong to the habitation of man in a cultivated and refined state of society."[73] Chimneys could also combine both factors: "The chimney-tops generally occupy the highest portions of the roof, breaking against the sky boldly, and, if enriched, will not only increase the expression of purpose, but add also to the picturesque beauty of the composition."[74]

It is also worth mentioning here that the picturesque was a guiding aesthetic principle throughout the

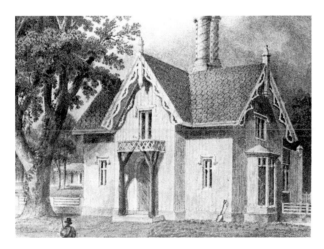

Fig. 76. Davis, Rural Residences *(1838), "Gate-House."*

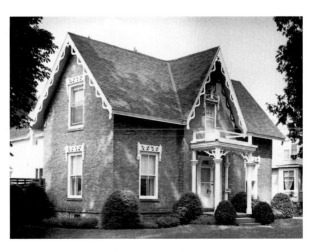

Fig. 77. 68 Elm Street, Potsdam, New York.

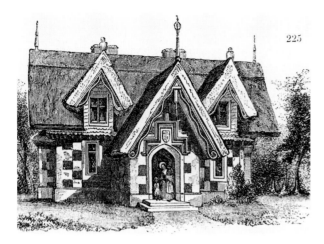

Fig. 78. "Entrance Lodge" from J. C. Loudon,
The Villa Gardener *(1850 ed.)*, fig. 225.

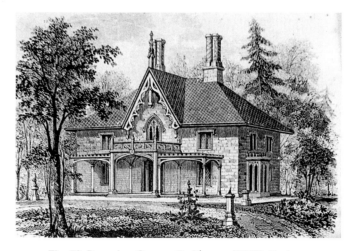

Fig. 79. Downing, Cottage Residences *(1842)*, Design II.

century, gradually growing in animation until its apotheosis in the Victorian Gothic and Queen Anne at the end of the century.[75]

Although Downing greatly popularized the Gothic Cottage, it was, after all, A. J. Davis who had first published a design for one in his *Rural Residences* of 1838. In partnership with Ithiel Town between 1829 and 1835, Davis had access to Town's splendid architectural library and would have been familiar with English designs in this style, such as one published in P. F. Robinson's *Rural Architecture* (London, 1823)[76] or even built examples in the Gothic Cottage style such as Robert Lugar's Betshanger Lodge, Kent, by 1828. Although Downing's designs are best known, it does appear that Davis's plate for a "Gate-Lodge" in rustic Gothic style was also a source for constructed dwellings; in both overall design and in the particular form of the bargeboards, a house in Potsdam, New York, certainly seems to owe much to the Davis plate.[77]

Downing too looked to English sources for ideas, not just to Davis's archetype, as we know from citations of British books in his writing. J. C. Loudon's *The Suburban Gardener* (1st ed., 1838) illustrated a Gothic Revival "Entrance Lodge" built by E. B. Lamb in Buckinghamshire about 1837–40, which is a typical English example. Naturally the thatch roofing was inappropriate for America, but other aspects of the design clearly appealed to Downing, and some of his designs are quite close to this model.[78]

The designs Downing published in *Cottage Residences* had an enormous influence, helping to transform architecture in America at the dawn of the Romantic era. Types that he adumbrated here, the Gothic cottage (in several forms) and the Italian villa, can be

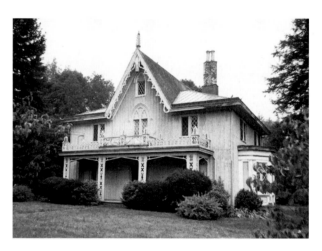

Fig. 80. Davis, Delamater House, Rhinebeck,
New York, 1843–44.

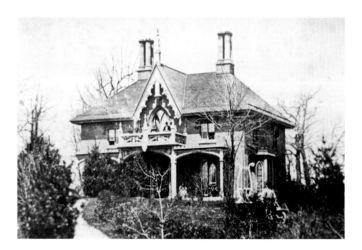

Fig. 81. Upham-Wright House, Newark, Ohio, c. 1848
(Courtesy Mary Sherwood Wright Jones).

found throughout much of the United States in literal copies and in free—sometimes very free—adaptations. By examining a few cases of how these designs were interpreted, we can get an idea of how builders approached these book illustrations and can confirm their widespread use.

One of the most influential of Downing's illustrations in *Cottage Residences* was the "Cottage in the English or Rural Gothic Style," his Design II. What is surprising is how rapidly copies of this were built throughout the northeast and how many Gothic cottages generally in this style are quite common even today.[79]

Apparently the earliest copy of this plate is the Henry Delamater House in Rhinebeck, New York,[80] which was built by Downing's colleague A. J. Davis—to whom he had sent the original drawing to be professionally rendered on the block for the wood engraver of the *Cottage Residences* illustrations. The house was designed in 1843 (and built the following year) with a few minor changes: The facade gable is a bit taller; the side roofs are much lower; and the veranda cornice is straight across—even though Downing had noted that because "the spirit of Gothic architecture lies in vertical lines" a veranda with "a long unbroken horizontal line" would "mar the architectural character of the cottage."[81] Downing had solved this problem by composing it in three sections of two different levels.

In essentially all other details, however, Davis's house duplicated Downing's design. The use of vertical board-and-batten is also Downing's approved and preferred treatment for wood construction.

Another very early copy of this plate is the Charles B. Sedgwick House, formerly in Syracuse, New York, designed by A. J. Davis in 1845 for an attorney.[82] Here Davis followed the engraving more closely, although there are two small changes: The roof is gabled, not hipped, at the sides; and the second-floor windows on the facade wings are replaced by decorative shields and moldings. It seems to have been of brick covered with stucco, a mode of construction also recommended by Downing. All other details carefully follow the engraving.

Houses erected without the aid of famous architects are also found in the 1840s. One of the closest copies of the Downing plate is the Upham-Wright House in Newark, Ohio, built in 1848–49.[83] Downing preferred masonry construction, especially for high-style houses with historically appropriate detail; this house is built with tan-colored bricks, and the window caps are in ocher-colored stone (see Color Plate I).

Fig. 82. Downing (1842), 45, fig. 14.

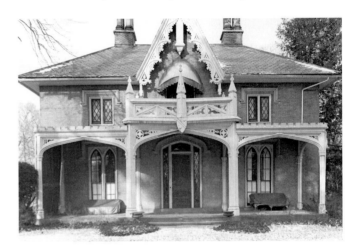

Fig. 83. Upham-Wright House, facade.

The house was built by George Upham, who had come with his family from Claremont, New Hampshire, about 1847. He purchased forty acres of land and built the house with bricks made on the site. Both Upham sons were killed in the Civil War, and the family sold the house in October 1868 to Virgil Hillyer Wright, who had moved to Newark in 1851 or 1852 from nearby Granville; Wright founded the First National Bank of Newark in 1865.[84]

A careful examination of the house shows that it is an exact copy of both the general composition and the details of Downing's Design II. Downing had provided vignettes of the veranda and porch with window above it, the veranda cornice, and a detail (and section) of the supporting posts. All these, even to the shield at the center of the middle arch, are copied with care. The proportions and form (if not the rich sur-

Fig. 84. Downing (1842), 46, fig. 15.
Fig. 85. Upham-Wright House, detail.
Fig. 86. Downing (1842), 45, fig. 13.

face detailing) of the chimney pots recommended by Downing were also carefully duplicated (see Color Plate I). Even the gable bargeboards, which Downing had observed could be simplified if desired, are replicated almost exactly. The original windows, however, were sash; the diamond casements now in place were inserted in 1905, when some interior remodeling and redecorating were undertaken.

When it came to the plan, George Upham had the house enlarged somewhat. The front rooms are virtually identical in size to the dimensions on the plan,[85] although their arrangement is somewhat different; but the kitchen wing is considerably larger and follows a more complex plan—as well as Downing's admonition that the designs in his book were only guidelines, to be adapted to fit the family's particular needs.

The high level of craftsmanship and the accuracy of translating Downing's design bring up two important points. The first is that Downing obviously understood that a competent carpenter or builder was capable of adapting the design and its details to meet specific needs with no more than a small perspective view, plan, and vignettes of details. Such craftsmen were already adept at designing, planning, and detailing buildings—and then constructing them. The very paucity of Downing's illustrations confirms his confidence in the abilities of accomplished craftsmen.

The second point is how easily carpenters seem to have been able to recreate the overall form as well as the detail of Downing's design with clarity, accuracy, and even verve. The house shows a level of expertise really no different from a dwelling designed by a contemporaneous "professional architect" such as A. J. Davis.

What is also remarkable about this instance of an owner's electing to follow a design in *Cottage Residences* is that the grounds too were very much in the Downing style. The old photograph shows that the landscape was full of evergreens, the type of tree Downing preferred for a picturesque house such as this, and to this day majestic spruces tower over Downing's Gothic cottage.

A second Gothic cottage of almost identical design was erected nearby.[86] The detailing was somewhat simpler: It lacked a bay window on the right side, there was no gable finial, and the windows did not have stone label moldings.

Another outstanding example of a builder carefully following Downing's plate is the Timothy Brooks House in Salem, Massachusetts.[87] Built in 1851 for a grocer, the only significant difference between the house and the design is that the carpenter, who in most ways "made a supreme effort to copy the plate to the last detail," has introduced prominent corner quoins. This non-Gothic feature may reveal the strength of the local classical tradition or the fact that the new Gothic Revival style was as yet not fully assimilated and understood. The walling of the house is constructed of flush siding, again a classical treatment.

A Gothic cottage in stone, the material Downing preferred for its durability and natural hues, was erected for Oakes Ames, in North Easton, Massachusetts, in 1853–54. It now has later additions to the rear, but the front portion is a close copy of Design II, despite having a gabled rather than hipped roof for the side wings. Although now the slightly projecting central bay of the veranda lacks its capping Gothic

Fig. 87. Upham-Wright House, plan.

Fig. 88. Downing (1842), Design II, plan.

railing, an old photograph of the house shows that it originally had one and that it duplicated the Downing model. The photo also shows that the house originally had chimneys treated like Design II.[88]

The great popularity of this design is manifested by the complete rebuilding in 1856 by the Townsend family of their 1804 house outside New Haven, Connecticut, to copy the Downing design.[89] Considering that a Federal-style house is at the core of the current Gothic Revival dwelling, the transformation is remarkable and is a persuasive statement of the popularity and stylishness of Downing's design.

Also from the 1850s (specific date not ascertained) is the Nathaniel Mudge House in Rome, New York. Now somewhat remodeled, the old photograph (Fig. 90) shows that it too was copied from Downing's Design II. The local builder enriched the original design, however: The veranda has Gothic railings; the second story (which is somewhat taller than Downing's model) has full-size, and quite elaborate, tracery windows; the bargeboards in the central gable continue along the edge of the facade and side eaves; and the paired chimneys are constructed as rectangular stacks,

Fig. 89. Townsend House, Raynham, near New Haven, Connecticut, rebuilt 1856.

not the chimney pots favored by Downing. There is also an additional bay at the left side, not included in the original design. Constructed of stone (or so it appears in the photograph; it is now stuccoed), it must have been one of the most faithful of the "Downing cottages" of its day.[90]

*Fig. 90. Mudge House, Rome, New York, 1850s
(Photo courtesy Chester Williams).*

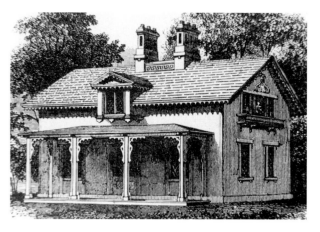

Fig. 91. Downing (1842), Design I.

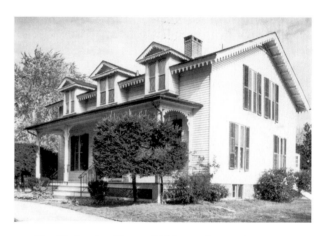

*Fig. 92. Bartlett House, Old Lyme, Connecticut, 1844
(Photo by George B. Tatum).*

A final example from the late 1850s can be cited: the Edward W. Nichols Cottage erected by A. J. Davis in 1859 at Llewellyn Park, Orange, New Jersey. Although his original watercolor drawing for this dwelling shows it without flanking facade windows at the second story, when the structure was erected, circular ones were inserted thus making it quite close to the Downing model. Constructed of board-and-batten, painted in tan and brown, and with prominent decorative chimney pots, it is one of the best known of these Downing-style cottages.[91]

Variants on the Downing model, combining it with features from other designs in *Cottage Residences*, reveal how creative a local carpenter could be in adapting the model to the needs of his clients. The Butler-Hoffman House, New Hartford, New York,[92] of 1850, is apparently a combination of this model with Design IV, which is a taller version with a gabled roof. The builder has used the lancet facade window of Design II for the attic window and the porch of Design II as well within the framework of Design IV. A dwelling in Hillsdale, New York, of 1845–50,[93] which at first glance appears to be a copy of this Design IV (it is two full stories with an attic window in the facade gable and has the veranda straight across, as in Design IV) also combines the two, for the roof form has hipped side wings, as depicted in Design II.

The John J. Brown House, Portland, Maine, of 1845,[94] also looks like Design II, but without the side wings of the veranda—only the central portion. Because the central gabled portion projects a foot or two—and none of the examples above (nor Designs II

and IV) has this feature—it may draw on another model. Although Downing's Design III (a Tudor house) and Design VII (Gothic, but with a considerable projection so that the small chamber above is carried on an open first-floor porch) might have suggested this feature, actually it is closest in spirit to A. J. Davis's Gothic cottage in *Rural Residences* of 1838.

Even Downing's simplest model for a cottage with artistic qualities, his Design I ("A Suburban Cottage for a Small Family"), was deemed significant enough to be followed closely in a constructed dwelling—and by none other than A. J. Davis. His Bartlett House, in Old Lyme, Connecticut, from 1844, is extremely close (despite the additional dormers) to the published prototype.[95]

As George B. Tatum has observed, "*Cottage Residences* was an immediate success, and gradually houses based, directly or indirectly, on the designs it offered could be found in almost every state of the Union."[96] Clearly the Gothic cottage style from the

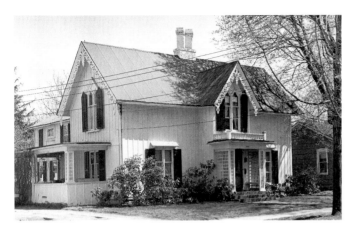

Fig. 93. *York-Skinner House, Westfield, New York, c. 1863.*

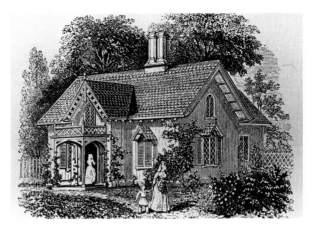

Fig. 94. Downing, Architecture of Country Houses
(1850), Design VI.

models of Downing (and Davis) found many avid converts in the 1840s and 1850s.

The books by Downing, Davis, and others were not the only sources of designs to be copied by local builders. The periodical *Godey's Lady's Book and Lady's Magazine* began publishing house designs in 1846, and in only three years the editor proclaimed that "hundreds of cottages have been built from plans that we have published."[97]

Downing continued his success with his next, larger, book, *The Architecture of Country Houses; Including Designs for Cottages, Farm Houses, and Villas . . .* (1850), which included thirty-four designs, with plans, for houses. Several were extremely small board-and-batten cottages, showing that careful planning and modest exterior embellishment could render even the humblest dwelling comfortable as well as artistic. Among the cottages[98] were six clearly Gothic in design (and three Italianate); among the larger villas, five were Gothic (and five Italianate). This volume too had a great success, as its publishing history shows; it was reprinted eight times through 1866.

We can also find examples, both published and not well known, of builders copying exactly, or adapting creatively, plates from *The Architecture of Country Houses.* One case that illustrates how widely spread was its influence is the Surgeon's Quarters, Fort Dalles, Oregon, of 1857.[99] It copies quite faithfully (with the front door replicating the window above) the distinctive Gothic cottage in Design III. An especially good example of how designs from Downing's *Country Houses* could be adapted is the York-Skinner House in Westfield, New York, of about 1863, which copies Design VI.

The York-Skinner House as seen today is the result of two major building campaigns. The rear por-

tion was constructed about 1810–15 (a rear addition to this was made in 1922); the front Gothic Revival portion was added about 1863.[100] It copies Design VI closely, with the only major change being the raising of the second story somewhat, giving it a taller elevation—and more comfortable headroom on the second floor. The paired brick chimneys, the decorative bargeboards, the board-and-batten siding all enrich this Downing design. When the carpenter planned the windows, he selected a treatment illustrated twenty-eight pages earlier and followed it carefully.

What may come as a surprise, given this subtle modification and adaptation of Downing's design, is that the ground plan of this portion of the house is essentially a duplicate of the published plan: two chambers separated by a central hallway with stairs and a small projecting entrance porch. In Downing's plan, the flanking rooms are 16 by 18 feet; in the Westfield

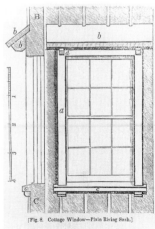

Fig. 95. *York-Skinner House, Westfield, New York, detail.*
Fig. 96. *Downing (1850), 77, fig. 8.*

Fig. 97. Highwic, Auckland, New Zealand, 1862 (Courtesy David Reynolds).

Fig. 98. "Cottage-Villa" design by Gervase Wheeler in Downing (1850), fig. 130.

cottage, the left chamber measures 15 feet, 8 inches, by 18 feet, 1 inch, with the right chamber ¹/₂ inch smaller in both directions. The hallway in Downing's design is 8 feet across; in the Westfield dwelling, it measures 8 feet, 1 inch. Somewhat surprisingly, another dwelling following this Downing plate and copied even more closely was built by a merchant in Auckland, New Zealand, in 1862! Downing's fame was indeed world-wide.[101]

One of the designs published in *Country Houses*, a Gothic Revival board-and-batten dwelling with twin facade gables, seems to have been especially popular. The design, by Gervase Wheeler of Philadelphia, had been first built in Brunswick, Maine.[102] Versions of it were widely distributed, however. Two particularly interesting houses based on it were built in Canandaigua, in central New York, in the 1850s, only one block apart.[103] Both are smaller than the Wheeler original and have special features of their own (the porch projecting beyond the side wings, a dormer window in the transverse roof slope). It is revealing to note that the builder, probably the same for both houses, has varied the composition to give each "individuality": One is sided with the more canonical board-and-batten, while the other has traditional horizontal clapboards. Even the carved moldings above the attic windows are different in both, although the label moldings capping the main windows are the same. The one at 48 Howell Street has bargeboards very close to those in the Downing illustration; 40 Gibson Street may never have had any, given the prominence of its gable finial and the positioning of the attic windows farther up in the gable peak.[104]

Examples of this Wheeler-designed Gothic cottage can be found elsewhere in the state, too: In northern New York a larger variation, built in 1852, with the porch kept between the wings as in the Downing illustration, can be found in Potsdam; and another one,

Fig. 99. 48 Howell Street, Canandaigua, New York, 1850s.

extremely close to Design XXIV, is documented in western New York. Yet another version of this distinctive design appears in Utah.[105]

Wheeler published two books of designs himself; the first, *Rural Homes: or, Sketches of Houses Suited to American Country Life* (New York, 1851), was reprinted at least eight times through 1868. One of his designs in this volume, for a rather idiosyncratic Gothic Revival dwelling, was copied faithfully by Joseph Warren Revere when he built his country house near Morristown, New Jersey, in 1854, and is today well known.[106]

A final example of a copied plate in Downing's *Country Houses* can be cited to emphasize the widespread influence of his books. Design XXV, a Gothic cottage with entrance porch and flanking verandas, was duplicated almost exactly in the William R. Elly House in Lexington, Kentucky (early 1850s).[107] The builder sensibly elevated the second story somewhat and provided the front windows with gables to make them more usable, as well as to echo the tall facade gable. The bargeboards of the Elly House were copied accurately from Downing's figure 137, illustrated in the essay accompanying his design.

Fig. 100. *40 Gibson Street, Canandaigua, New York, 1850s.*

Fig. 101. *Edward W. Foster House, Potsdam, New York, 1852.*

The profound and wide-ranging influence of Downing's designs is suggested not only by these examples of builders copying and adapting his plates, but by contemporary accounts as well. When the Swedish novelist Fredrika Bremer (who became a friend of Downing's) visited the United States in 1849–51, she was informed that "nobody, whether he be rich or poor, builds a house or lays out a garden without consulting Downing's works; every young couple who sets up housekeeping buys them."[108]

Additional proof of the immediate popularity of the designs in *Cottage Residences* is the speed with which they were copied in other publications. The winning entry for a farmhouse in the 1847 competition sponsored by the New York State Agricultural Society was won by an Albany woman whose design followed very closely Downing's Design v, although her plan (and the positioning of the wing) was different.[109] Its publication in *The Cultivator* in 1848 certainly spread the "Downing cottage" style even wider.

Downing's Gothic cottages were also copied by other pattern-book writers; an early and especially revealing example of this is in the work of Oliver P. Smith, who published *The Domestic Architect: Comprising a Series of Original Designs for Rural and Ornamental Cottages,* in Buffalo in 1854. Smith styled himself "architect" on the title page; little is known about him except that he had earlier practiced in the southern part of Chautauqua County.[110]

The book itself illustrates this period of transition in architectural publications, for it is both carpenters' manual *and* pattern book. Many of the plates were of the old style, depicting the classical orders, geometrical problems, details of door casings, and balustrades, but there are also veranda columns and Gothic revival bargeboards—all clearly oriented to the carpenter. Smith included ten house designs (occasionally in perspective views) with their plans, which clearly

Fig. 102. *Smith,* Domestic Architect *(1854), plate 41.*

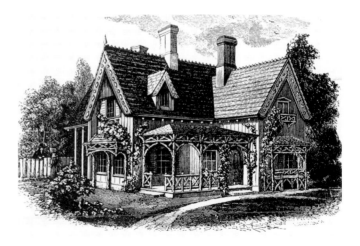

Fig. 103. *Downing,* Cottage Residences *(4th ed., 1852), Design XI.*

show an influence of the new Gothic and Italianate styles, and method of presentation, of Downing's books. The artlessness of his illustrations suggests that these were copied directly from his own drawings; and the book was in fact oriented "to the country builder" who is in need of "the plainest and easiest rules in the

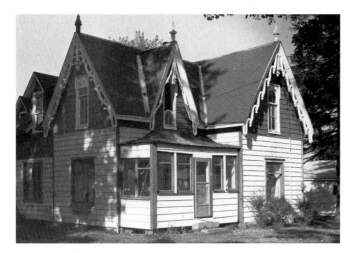

Fig. 104. House in Stockton, New York.

rudiments" of architecture. His aim, as he explained in his preface, was to make the work practical and useful: to "instruct and assist the practical builder in the important business of his profession, and, through him, to aid in elevating the standard of Rural Architecture in this country." This latter sentiment certainly echoes Downing.

One of Smith's designs, plate 41, illustrates an L-shaped asymmetrical (and thus more picturesque) Gothic cottage most likely inspired by Downing's Design XI, published in the fourth edition (1852) of *Cottage Residences*, after first appearing in the July 1851 issue of the *Horticulturist* as a "simple rural cottage suitable for a clergyman."[111] (An earlier version of this type of L-shaped Gothic cottage had appeared in

Downing's *Country Houses* in 1850 as Design IV; the house was to be of stuccoed brick.) At least two houses clearly based on Smith's plate can be found in Chautauqua County, where he is thought to have begun his career. The first is in Cassadaga.[112] Not only is the general outline just like Smith's plate, but the details too are drawn from his book: The bargeboards of the front gable copy those of plate 10; the front finial copies that in plate 32, figure 4; and the bay windows, with panels below the sash, are quite close to plate 32, figure 1. Other features, such as the distinctive porch window caps or the bargeboards of the other two gables, are not found in Smith's volume.

Another example from the same county, which shows how Smith's book was used, is in Stockton. Like the engraved model in plate 41, all three gables are enriched with bargeboards of different designs. Those of the main facade gable are copied from plate 10, figure 1; those in the end gable are based closely on those in plate 27, figure 4; and while there is no plate for the bargeboards in the dormer, they are generally like the serpentine ones visible in both plate 41 and in a dormer on a more complex gothic cottage depicted in Smith's plate 31.

Even smaller details can be traced to plates in this volume. The finial in the facade gable copies that in plate 32, figure 4; the apex of the finial in the dormer duplicates the design of plate 24, figure 4, while the boxed rosette at the base of this finial is taken from plate 10, figure 2. The use of arched windows, with a leaf pattern in the spandrel above, comes from plate. 31 (and the leaf detail shown enlarged in plate

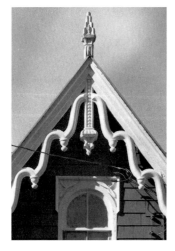

Fig. 105. House in Stockton, New York, detail.
Fig. 106. Smith (1854), plate 10, fig. 1.
Fig. 107. Smith (1854), plate 32, fig. 4.

24, fig. 4). Because Smith's book was prepared (and copyrighted) in 1852 and published in 1854, the immediate influence of Downing's L-shaped Gothic cottage, even if enriched in Smith's adaptation of it, signals the authority and popularity of Downing's models.[113]

Smith's picturesque asymmetrical design, and this sort of L-shaped Gothic cottage in general, is a clear parallel to the many Greek Revival farmhouses with side wing (often with the entrance in the wing, rather than in the "main block"). This may have assisted in the spread of the new Gothic cottage vernacular; and conversely, the "translation" of the popular Greek Revival type into Gothic may have been an aim of Smith—and even of Downing.

Oliver P. Smith was not the only pattern-book author to avail himself of plates, or ideas, in Downing. The Downing 1842 Gothic cottage, despite its identification with that author, was copied closely (except for giving it a gabled roof to provide more attic accommodation) as figure 144 in *Woodward's Country Homes* of 1865 by George E. Woodward;[114] and the L-shaped dwelling that Smith adapted from the 1852 edition of *Cottage Residences* was also copied and slightly modified by Henry W. Cleaveland, William Backus, and Samuel D. Backus in their *Village and Farm Cottages* of 1856, as Design XII. In *Woodward's Architecture and Rural Art* (No. 1, 1867), George Woodward may even have drawn on Smith's version of this house type, for the relation of roofs and form of the dormer are closer to his rather than Downing's design. Even very modest houses were copied. A "Working Man's Model Cottage," Design V in Downing's *Country Houses,* was copied exactly, even to the thrifty working man returning home with shovel on his shoulder, as figure 53, page 153, in Z. Baker's *Modern House Builder, From the Log Cabin and Cottage to the Mansion* (Boston, 1857).[115]

This sampling of houses constructed as copies or variants of plates in Downing's two books and the manual by Smith confirms that designs and details in these sorts of volumes were indeed used exactly as they were intended: as patterns for houses. That they influenced other authors and helped establish a Gothic Revival vernacular confirms the power of the printed image. One final example of a Gothic house based on a book design shows how such images could be adapted.

Samuel Sloan, a noted Philadelphia carpenter turned architect, published *The Model Architect* in two lavish volumes in 1852–53. It went through three later editions (1860, 1868, and 1873) and was twice pirated, proof of its popularity.[116] More than half of the forty-eight dwellings illustrated were Italianate,

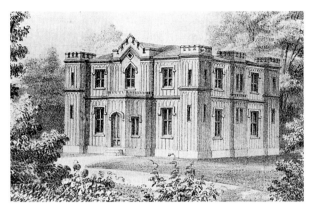

Fig. 108. Sloan, Model Architect *(1853), 2: Design 47.*

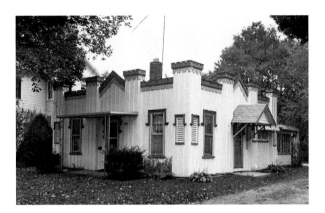

Fig. 109. 323 Summit Street, Granville, Ohio, c. 1855.

but a good number were Gothic, including the remarkable house in the "castellated style" he illustrated in volume II. Downing had, as we would expect, condemned building such a design in wood ("There cannot well be a greater violation of correct taste than to build a Gothic castellated villa with thin wood boards"), and in fact Sloan recognized how inappropriate for such a design wood—even board-and-batten—was.[117] Yet it is undeniable that for a person looking for a "novel style . . . differing in general effect from the magority [*sic*] of buildings"[118] this would certainly fill the bill. The fact that a miniature version of the Sloan design, cleverly adapted by a local carpenter, was actually constructed in Granville, Ohio, about 1855[119] confirms the persuasive appeal of these pattern-book plates.

The Gothic Revival house, which Downing helped inaugurate and popularize in America, was attractive for many reasons. Certainly its inherent beauty and its picturesqueness in both massing and detail were aesthetic aspects that appealed to many. Equally valid were undoubtedly its associations, espe-

cially with the delights of "home life": the veranda reflecting relaxed family lounging during the summer; the chimneys; the cozy hearth for family gathering in the winter; the steep roofs, "highly suitable for a cold country liable to heavy snows,"[120] suggesting protection and coziness. Furthermore, the blending of Gothic houses into the landscape, by means of their irregular silhouettes (like evergreens about them), the natural materials (stone, or vertical board-and-batten preferred), and "natural" colors of tan, ocher, or gray, was part of a renewed interest in nature and its drama and beauty seen as well in contemporary trends in landscape painting.

Historical associations were always strong with Downing, however. The Gothic or Tudor style suggested the "romance and chivalry" and "hearty hospitality" of "Merry England" to him;[121] and surely the Gothic cottage also had a somewhat "churchy" or scholarly quality, from its associations with old parsonages and the colleges of Oxford and Cambridge. It is likely, in view of its more modest success compared, say, with Greek Revival or Italianate, that the Gothic Revival was a style often favored by individualists for their dwellings—the very person Downing typified in an 1850 essay about the privacy of small- or medium-sized lots: "While you preserve the beauty of the view, shut out, by boundary belts and thickets, all eyes but those that are fairly within your own grounds. This will enable you to feel at home all over your place, and to indulge your individual taste in walking, riding, reciting your next speech or sermon, or wearing any peculiarly rustic costume, without being suspected of being a 'queer fellow' by any of your neighbors."[122]

The second major new style, which Downing's books helped introduce to America, was the Italianate. It was favored, like the Gothic Revival, for its picturesque beauty, expression of comfortable home life, and cultural associations. Downing found the Italian style as well adapted "for domestic purposes" as the Greek, he thought, was not; furthermore, "the Italian style, by its verandas and balconies, its projecting roofs, and the capacity and variety of its form, is especially suited to a warm climate."[123] For the well-to-do, "an Italian villa may recall, to one familiar with Italy and art . . . the classic beauty of that fair and smiling land, where pictures, sculptured figures, vases, and urns, in all exquisite forms, make part of the decorations and 'surroundings' of domestic and public edifices."[124] Such a villa "in the Roman style" would also "recall to the classic mind the famed Tusculum retreat of Pliny."[125]

The Italianate style traces its origins to the evocative rural buildings depicted in the paintings of the popular seventeenth-century masters Claude Lorrain and Nicolas Poussin, although other painters of the day (such as Domenichino) also depicted blocky buildings with low-pitched roofs, often with lofty towers attached.[126] (The style also owed a good deal, especially in the use of round-arch loggias and prominent eaves with brackets, to villas built during the Italian Renaissance.) The style was developed in England by the versatile John Nash, whose Cronkhill in Shropshire, of c. 1802, is considered the first Italian villa.[127] The style was popularized in books soon thereafter. Robert Lugar's *Architectural Sketches for Cottages* (1805) illustrated a "fully asymmetrical design" labeled "Italian Villa" rather like Nash's Cronkhill;[128] by 1833, about one-third of the designs in Francis Goodwin's *Domestic Architecture* were Italian villas.[129] J. C. Loudon's *Encyclopedia of Cottage, Farm, and Villa Architecture* (1833) depicted many also—in fact, in England his book "may be considered the bible of the villa style."[130] Downing acknowledged consulting works of all three of these authors.

The first Italianate house to be erected in the United States was Riverside, the Bishop Doane House in Burlington, New Jersey, built in 1838–39 by John Notman, a Scottish carpenter-architect who had come to the United States in 1831. Riverside, a well-designed asymmetrical villa (although lacking a lofty tower), soon became well known when an illustration of it was published by Downing in his *Treatise on the Theory and Practice of Landscape Gardening* (1841), followed by a long description and analysis of it supplied by Notman.[131]

As we have seen, three Italianate designs were published by Downing in his *Cottage Residences* of 1842. One of them, his Design VI ("An Irregular Villa in the Italian Style, Bracketed"), was a highly picturesque and evocative composition.[132] Of these three models, this was the most popular, and we can find many examples that follow its design quite closely.

A very early version of this model is the Jones-Butler House in Utica, New York, built about 1852;[133] it follows the Downing design in being clad in board-and-batten and in having the square bay window and lunette attic window featured in Design VI. Another early version in wood (but with traditional clapboarding) is the John C. Hopewell Villa in Flemington, New Jersey, erected about 1854.[134] Although somewhat enlarged from Design VI (the lateral wing is three stories rather than two), it has the same slender proportions as Downing's mode and repeats the circular window in the tower shown in *Cottage Residences*. An impressive version in stone, said to date

projecting decorative canopy for one major window came from the Francis Dodge House. Both dwellings had other features he emulated: the arcaded veranda, bay windows, and balustrades.

Finally, one cannot fail to mention one of the most distinctive modes of architectural design of this period, a form widely propagated by an architectural treatise—the octagon house. Although octagonal, polygonal, and even round buildings were occasionally built in America in the eighteenth and early nineteenth centuries, the "fad" for octagonal houses was essentially created by the publications of one man, Orson Squire Fowler.[153] In his first book, *A Home for All or a New, Cheap, Convenient, and Superior Mode of Building* (1848), Fowler argued for the efficiency and economy of the octagonal shape and plan and the method of building he called "board-wall" construction (boards laid flat on top of one another and pinned together). His second edition, increased from 96 to 192 pages, entitled *A Home for All or The Gravel Wall and Octagon Mode of Building . . .* (1853), advocated the use of poured concrete for wall construction. This edition, besides thirty-two plans and diagrams, also included perspective views of two octagon houses: his own at Fishkill, New York, of four stories, and a house at Williamsburg, New York,[154] of more common two-story size. Both were enriched by Italianate detailing, with a cupola surmounting the roof.

Whether of board-wall, concrete, or traditional brick or frame construction, it is clear that the spread of Fowler-style octagons was in large part due to his books, which went through many printings in the 1840s and 1850s. When octagon houses are found to be of board-wall or concrete construction, the influence of Fowler's books is even more obvious. Fowler-inspired octagons were built throughout the United States from the 1850s for several decades; in his two books on the octagon phenomenon, Carl Schmidt documents or cites 417 octagon houses from Maine to California, as well as a large number of other octagonal structures.[155] Clearly, the printed page, and Fowler's illustrations, had a profound impact on a distinctive form of dwelling.

All the books we have reviewed and in which we have found designs copied by local builders presupposed that the local craftsmen could readily adapt the plans to their traditional methods and could copy the details of these new-style buildings. Although technical suggestions were made throughout, clearly Downing, Sloan, and the others had a high regard for the technical abilities of the builders and carpenters who would be copying or adapting their designs.

At the same time, Downing recognized that the larger or more complex buildings or those meeting special needs (or with exterior details or interior finishes more elaborate than those discussed and illustrated in his book) required the abilities of an architect—someone specially trained in design and planning in the latest styles. In fact, in his 1841 *Treatise*, Downing noted at the end of his section "Rural Architecture" that A. J. Davis and John Notman were "the most successful American architects in this branch of the art, with which we are acquainted"—steering business to the two architects who had helped him with designs for his book. In later volumes, Downing also cited the authors of designs he used that were not his own: John Notman and A. J. Davis for Designs IX and X in *Cottage Residences* (1842); and W. Russell West (Design XX), A. J. Davis (Design XXII as well as several others), Gervase Wheeler (Design XXIV), and Richard Upjohn (Design XXVII) in *Country Houses* (1850).

Samuel Sloan's *Model Architect* was designed to be used by, and to help, local builders. As he observed, "[W]hen a pleasing design, with all its concomitants, is found . . . it may be adopted without hesitation"; although he then observed: "but when a building adapted to some peculiar notions is desired, the only

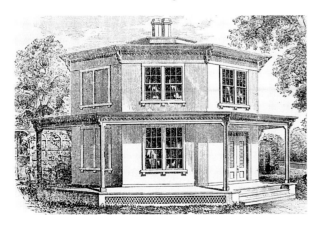

Fig. 128. Fowler, A Home for All *(1853), fig. 20.*

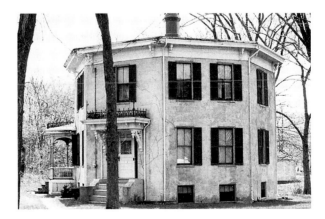

Fig. 129. Concrete octagon house, Hyannis, Massachusetts.

safe course is to communicate these to some experienced Architect, who will elaborate them."[156] Of course, Sloan's volumes were implicitly an advertisement for his own expert services; in the preface his name is followed by the title "architect" and his business address in Philadelphia. As Harold N. Cooledge Jr. has observed, the book "brought Sloan commissions from all over the United States—for residences, schools, churches, and public buildings."[157] Sloan's dual aim for his publication (instruction of the public and a means of his getting more business) was thus the same as had motivated Colen Campbell and James Gibbs more than a century before.

Calvert Vaux left nothing to chance in urging his readers to hire an architect to prepare their designs. In his preface to *Villas and Cottages* (1857), he ingenuously observed that his plates "are not brought before the public as model designs," but as an inspiration in general and as comparative material for those thinking of building; for best design results and to be certain the dwelling costs what the owner expected, the employer and "his architect" should carefully discuss the work. The last page of his book is in fact an advertisement for his own services[158]—and also one of the earliest ads that lists an architect's "usual commission" for his services (to include plans and specifications, detail drawings, and superintendence) as 5 percent of the cost of the building. Anyone impressed with the designs in his book would know just where to turn for customized work.

The firm of Cleaveland and Backus Brothers did more than just list its title ("architects") and Wall Street business address in *Village and Farm Cottages* of 1856. On the page facing the table of contents, under the bold heading "NOTICE," the firm also announced a unique service for readers of the book:

Fig. 130. Vaux (1857), page 319.

For the convenience of such as may wish to build after any of the designs in this work, the Authors have prepared careful, lithographed working drawings and printed specifications for each. These comprise every thing necessary to enable any competent workman fully to understand the plans. They will be forwarded, together with blank forms of contract, by mail, on receipt of a special application, and remittance, at the following rates:—For any one of the first ten designs, $3. For Numbers 11, 12, 13, and 14, $4 each. For the last ten, $5 each.

They will be pleased to answer any inquiries that may arise, and to make such suggestions relative to the execution of the designs in particular localities, as the circumstances of the case, and the information furnished, shall seem to require.

These amounts were one-tenth the price of what an architect would charge for individualized plans, working drawings, and specifications. If the purchaser was generally content with the published design and was confident that his local builder could make minor changes to meet his particular needs, such mail-order plans provided a great saving over hiring an architect. Obviously Cleaveland and Backus Brothers thought that the people who ordered such plans were probably not the ones who would hire an architect in the first place—or perhaps once they saw the plans, some might be led to hire them as architects for truly individualized plans. For Cleaveland and Backus Brothers, such plans, based on designs already produced for this book, represented a reasonable investment of time for the initial drawings; and because all subsequent copies gave them nearly 100 percent profit, if enough copies were sold, this could be a significant contribution to their income. Their Plan Service began a movement in architectural design that has lasted to the present day.[159]

Books, Training, and Design Through the 1850s

As we have seen, in the early nineteenth century and even before, books were important to craftsmen for both new technical information and for designs to supplement, or to update and replace, their traditional features. In our sampling, we have examined books generally thought to have been used by craftsmen and

across the facade, and a doorway in one side bay. One in East Claridon was built in 1828 by the local builder Charles B. Smith as his own house; another was erected soon thereafter in the country nearby. Although mirror images of each other, the cornice dentil molding, the fanlight in the pediment, the wide spacing of the bay containing the entrance, and the doorway itself (with flanking Ionic pilasters) make the two dwellings virtually duplicates.[183]

Another instance can be found in Fredonia, New York. In 1842, a local businessman, Thomas G. Abell, commissioned a Greek Revival house for his daughter Katherine on her marriage. Six years later when Katherine's sister-in-law married, she too was given (probably by *her* father) an essentially identical house in another part of the village. Both were three-bay boxy dwellings with a side hallway plan; both had virtually identical elaborate plasterwork in the connected front parlors.[184]

In a final Greek Revival example in Randolph, New York, the house, which is illustrated in Hamlin, has a central block of one and one-half stories with a colonnade of four Doric columns; the side wings, with Doric recessed porches, are one story tall. Not illustrated, however, is its duplicate nearby, which differs only in small details: Its main block windows do not reach to the floor; it lacks tiny frieze windows in its wings; and the eared window enframements are slightly different. Without very careful scrutiny, however, photographs of the two dwellings appear to be of the same structure.[185]

The reason for making duplicates may be practical or aesthetic. If a craftsman erected a duplicate of a house he has just built, not only was the time and effort needed to draw a new plan and to design the framing and detailing shortened, but he also knew in advance exactly how much material and time were required to construct it. In other cases, an owner may simply have admired and copied an existing house (as in the Orford cases), assuring himself thereby that the results were precisely what he expected. In this instance, the pre-existing house becomes a full-scale, three-dimensional model for the client and his builder to consult.[186]

In duplicates of the Gothic Revival or Italianate period, another factor is introduced because the houses could have been based on the same pattern-book plate. As we have seen, however, even "copies" of the same plate (such as Downing's famous Gothic Cottage) introduce small variations that help set them apart. Thus true duplicates, with only minute differences, suggest that one builder erected both or that the duplicate was a conscious replication of a built model.

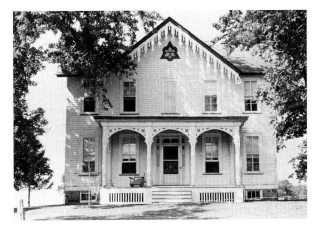

Fig. 136. Farm House, RD 1, Ringoes, New Jersey.

Occasionally, duplicates of architectural details were effected when a builder copied work done for one job at another site. If he had drawings of the details, so much the better. An instance of this is found in Albany, where Joel Rathbone had a Gothic Revival house built following designs prepared in 1842 by A. J. Davis. In March 1845, Rathbone wrote to Davis: "I have never ceased to regret that on my completing my building, I presented the plans, drawings, &c. to the carpenter Mr. Smith. . . . [H]e has copied them into everything he has built since, so that my windows, mullions, doors, jambs, cornice &c. &c. are duplicated all over and about this city." Usually, however, it was built examples that inspired emulation.[187]

An instructive case comes from Flemington, New Jersey. The Gothic Revival house at 187 Main Street, erected about 1870, clearly owes much to Downing's Design IV of 1842—a two-story house with central-facade gable ornamented with bargeboards and an arched veranda across the front. In fact, the form of the veranda columns of 187 Main Street and their Gothic spandrels are very similar to the detail Downing published for Design II (see Fig. 82).

After this house was constructed, a neighbor directly across the street undertook to remodel his Federal-style house in emulation. Because his house was a traditional five-bay facade, his porch has only three arches (to line up with the door and windows behind), but he must have hired the same carpenter, for the bargeboards are identical. This success seems to have inspired yet a third owner, a farmer some miles out of town, to remodel *his* house in the identical manner, with the identical bargeboards. His attic window, however, was given an individualistic shape.[188]

Another duplicate pair of L-shaped late Gothic Revival houses can be found in Genesee County in

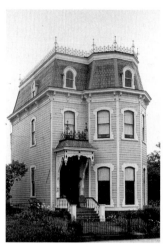

Fig. 137. House in New Hope, New Jersey.
Fig. 138. 269 High Street, Petersburg, Virginia.

central New York state. The two-story bay window on the right wing and the gabled window caps throughout on both make them almost twins; only the differing form of the bargeboards distinguishes them.[189]

Duplicates in Italianate houses are also common. Two majestic square villas in New Jersey, with verandas across the front, square cupolas, and oval attic windows between brackets, have only slight differences

to distinguish them; one (of about 1860) is in Freehold, and the other is in Allentown.[190]

Nevertheless, caution is in order. "Duplicates," especially after pattern books began to appear in such numbers in the 1850s, may arise simply because local builders selected the same plate to modify. The two Second Empire dwellings depicted appear to be at least fraternal twins, but because one is in New Hope, New Jersey, and the other in Petersburg, Virginia, the likelihood is that common plates are the link.

From this review of examples from the Greek Revival, Gothic Revival, and early Italianate periods, we can see that builders' manuals and pattern books had a profound effect on American housing. In some instances, the designs were copied with care, sometimes essentially duplicated; in other cases, a reasonably close variation was produced. Equally important was the very large number of houses (or their details) that were built "in the manner of" the plates illustrated; this is not an area I have here explored, but anyone involved in survey work will recognize at once the truth of the assertion. For every "copy" from a published design, there are a dozen free variations, owing much in overall form, or even detailing, to the published illustration, but permitting the local builder (or the owner) wide range in artistic or financial freedom.[191]

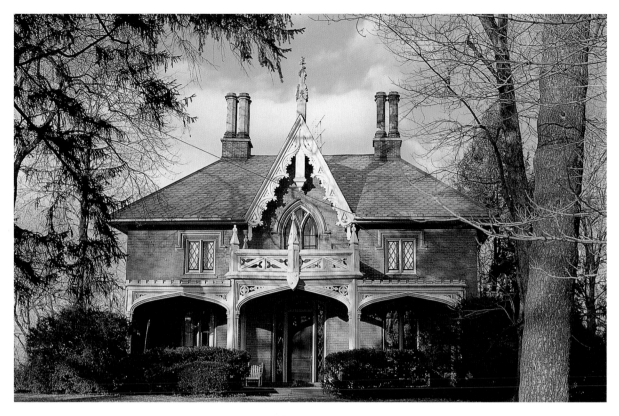

Color Plate I: Upham-Wright House, Newark, Ohio, 1848–49.

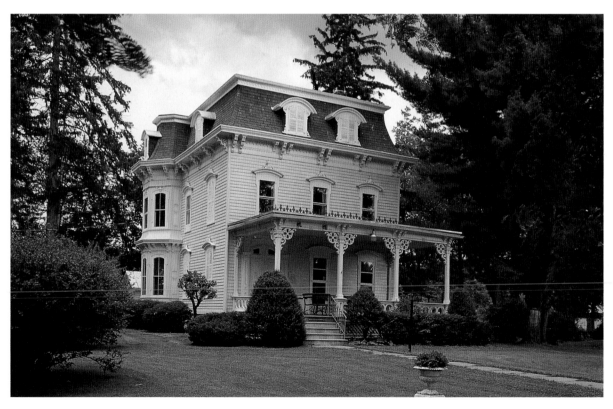

Color Plate II: House in Schoharie, New York, 1870s.

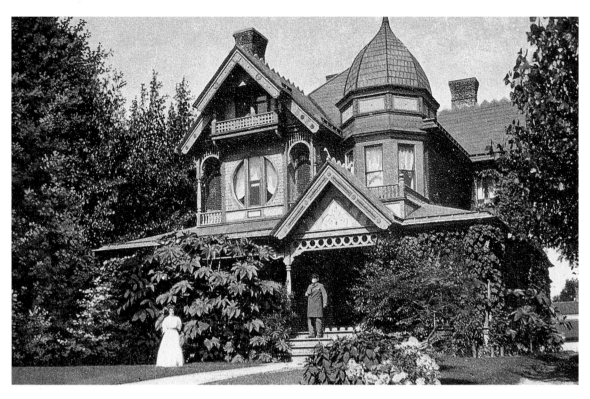

Color Plate III: Captain Storm House, Westfield, New York, 1896 (Postcard c. 1900, Courtesy William S. Edwards).

Color Plate IV: 1081–83 North Main Street, Jamestown, New York.

Color Plate V: 199, 197, and 195 Water Street, Fredonia, New York, 1920s.

Color Plate VI: 1191 Central Avenue, Dunkirk, New York.

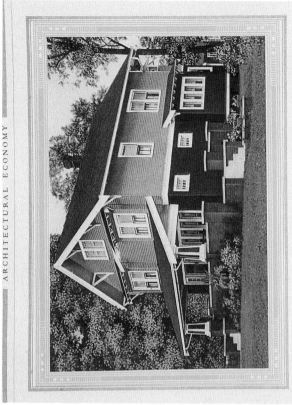

Two Story Residence No. 4002

THE rooms in this house have the generous proportions that the exterior promises. The living, dining room and kitchen downstairs, are all spacious. The same space upstairs is divided between three sleeping rooms and a bath. Two sun porches add to its comfort.

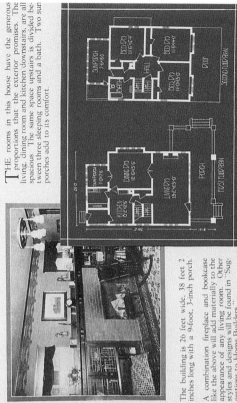

The building is 26 feet wide, 38 feet 2 inches long with a 9-foot, 3-inch porch.

A combination fireplace and bookcase like the above will add materially to the appearance of any living room. Other styles and designs will be found in "Suggestions to Home Builders."

Color Plate VIII: Architectural Economy (1920), 65.

Color Plate VII: Cover of Sears, Roebuck & Co.'s 1918 catalog.

INTERIORS — *The* VERONA

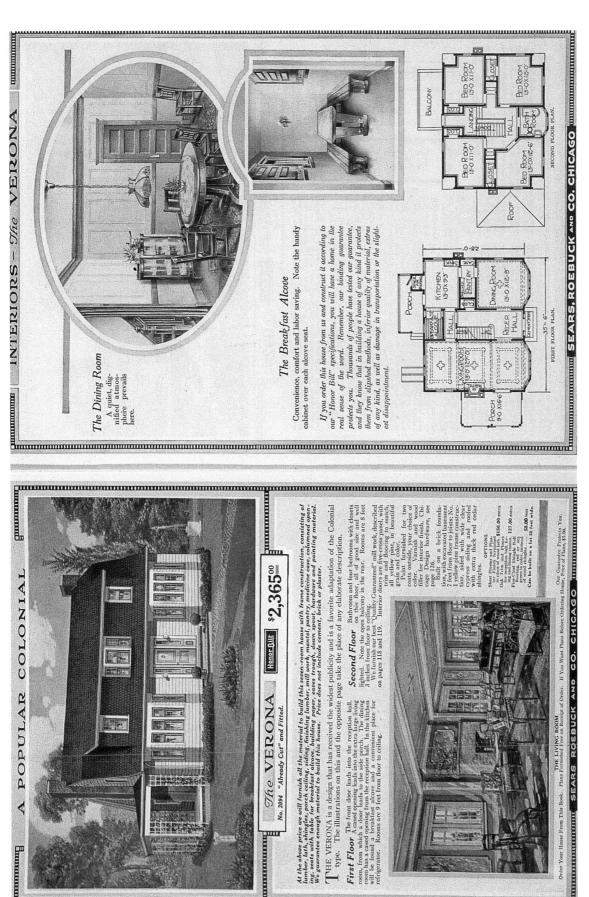

The Dining Room

A quiet, dignified atmosphere prevails here.

The Breakfast Alcove

Convenience, comfort and labor saving. Note the handy cabinet over each alcove seat.

If you order this house from us and construct it according to our "Honor Bilt" specifications, you will have a home in the real sense of the word. Remember, our binding guarantee protects you. Thousands of people have tested our guarantee, and they know that in building a house of any kind it protects them from slipshod methods, inferior quality of material, extras of any kind, as well as damage in transportation or the slightest disappointment.

SECOND FLOOR PLAN.

FIRST FLOOR PLAN.

SEARS, ROEBUCK AND CO. CHICAGO

A POPULAR COLONIAL

The VERONA

Honor Bilt $2,365.00

No. 2094 "Already Cut" and Fitted.

At the above price we will furnish all the material to build this seven-room house with frame construction, consisting of lumber, lath, shingles, porch ceiling, siding, finishing lumber, mill work, mantel, pantry, medicine case, columned opening, seats with table for breakfast alcove, building paper, eaves trough, down spout, hardware and painting material. We guarantee enough material to build this house. Price does not include cement, brick or plaster.

THE VERONA is a design that has received the widest publicity and is a favorite adaptation of the Colonial type. The illustrations on this and the opposite page take the place of any elaborate description.

First Floor The front door leads into the reception hall. A cased opening leads into the extra large living room, from which a door leads to the side porch. The dining room has a cased opening from the reception hall. In the kitchen will be found a breakfast alcove and a convenient place for refrigerator. Rooms are 9 feet from floor to ceiling.

Second Floor Bathroom and four bedrooms with closets on this floor, all of good size and well lighted. Note the open balcony in the rear. Rooms are 8 feet 3 inches from floor to ceiling. Interior doors are five-cross panel, with trim and flooring to match, all yellow pine, in beautiful grain and color.

We furnish our best "Quality Guaranteed" mill work, described on pages 118 and 119.

Paint furnished for two coats outside, your choice of color. Varnish and wood filler for interior finish. Chicago Design hardware, see page 126.

Built on a brick foundation, with excavated basement 7 feet from floor to joists; No. 1 yellow pine frame construction, sided with wide clear cypress siding and roofed with extra thick red cedar shingles.

OPTIONS
Sheet Plaster and Plaster Finely furnished in place of wood lath, $156.00 extra
Oak Trim and Plank Floors for reception hall, living and dining rooms. $127.00 extra
Fire-Chief Shingle Roll Roofing, red or green in color, instead of wood shingles. $8.00 less
Can be built on a lot 50 feet wide.

Our Guarantee Protects You.

Order Your House From This Book. Plans Furnished Free on Receipt of Order. If You Want Plans Before Ordering House, Price of Plans, $5.00.

THE LIVING ROOM

SEARS, ROEBUCK AND CO. CHICAGO

Color Plate IX: Sears, Honor Bilt Modern Homes (1918 catalog), 32–33.

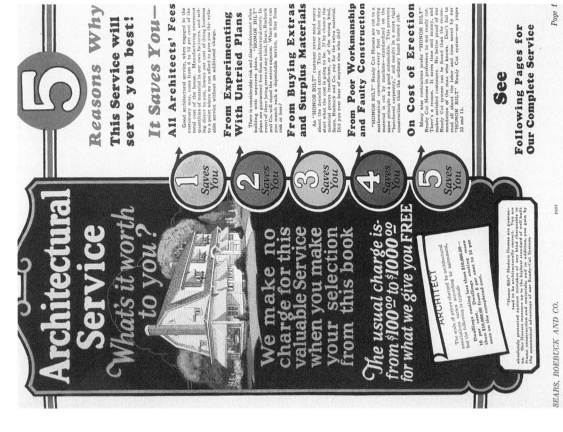

Color Plate XI: Sears, Honor Bilt Modern Homes (1928 catalog), 17 (Courtesy Sears, Roebuck & Co.).

Color Plate X: Sears, Honor Bilt Modern Homes (1928 catalog), 2 (Courtesy Sears, Roebuck & Co.).

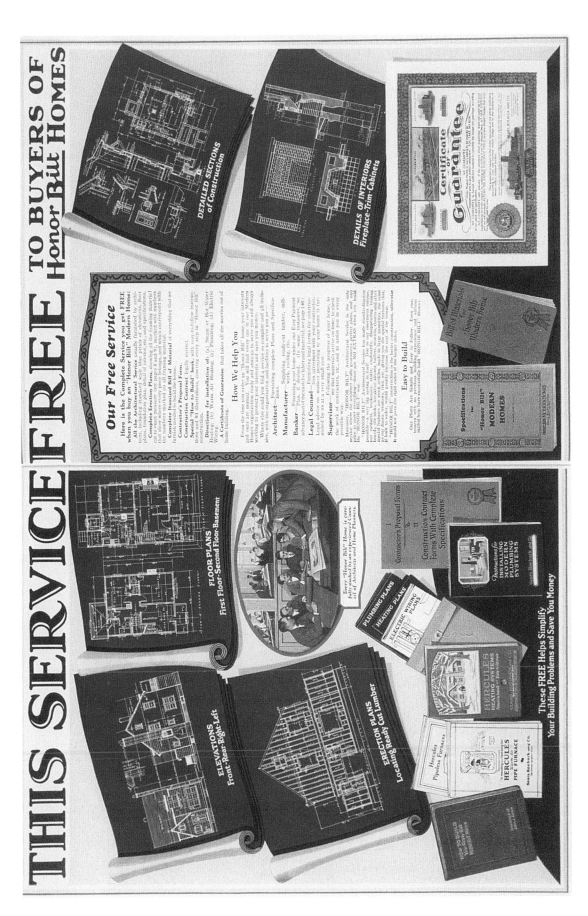

Color Plate XII: Sears, Honor Bilt Modern Home, (1928 catalog), 18–19 (Courtesy Sears, Roebuck & Co.).

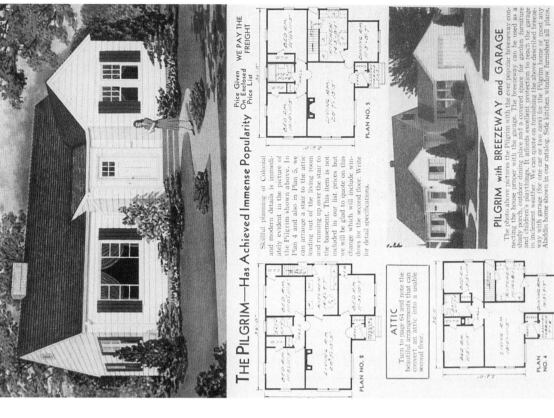

THE PILGRIM—Has Achieved Immense Popularity

Skilful planning of Colonial and modern details is immediately evident in the picture of the Pilgrim shown above. In Plan 4 and also in Plan 5, we can arrange a stair to the attic leading out of the living room and running up over the stair to the basement. This item is not included in our list prices but we will be glad to quote on this change which will include windows for the second floor. Write for detail specifications.

Price Given On Enclosed Price List

WE PAY THE FREIGHT

ATTIC
Turn to page 64 and note the beautiful arrangements that can convert an attic into a usable second floor.

PILGRIM with BREEZEWAY and GARAGE

The photo above pictures the Pilgrim with the ever popular breezeway connecting the house proper with the garage. The breezeway can be used as a shady porch, outdoor dining place and a covered space for garden furniture and children's playthings. It affords excellent protection to reach the garage in inclement weather. We can quote on furnishing the above described breezeway with garage (for one car or two cars) for the Pilgrim home or most any Aladdin home shown in our catalog. Side kitchen window furnished all plans.

Color Plate XIV: Aladdin, Readi-cut Homes (1952), 44.

3 Coats of Paint for Honor Bilt Homes
WE FURNISH

Beautiful Homes
MASTER WHITE and Colors

Town homes should be painted in a color that will harmonize with neighboring residences. Country or suburban homes are more pleasing when decorated in light shades.

Good taste dictates a different harmonizing shade or color for the trimming of a house. This gives the house a neat, well dressed appearance and relieves the monotony of a single color.

"Honor Bilt" Homes are high grade in every way. Building standards of the highest order apply. That's why we furnish three coats of Seroco "Master White." Paint for the exterior. Less than three coats of paint would not insure proper protection and lasting color.

Seroco "Master White." Paint is made in our own large paint factory. Skilled labor, the latest equipment known to the industry, the best raw materials, plus twenty-five years of successful experience, produce the best paint. It is backed by the strongest guarantee ever written for paint, which is reproduced below. This guarantee is our pledge of satisfaction.

The bungalow shown directly above is The Vallonia, described on page 46. The bungalow illustrated at the left is The Rodessa described on page 55.

These Color reproductions are as nearly accurate as can be reproduced with printing ink

143—OUTSIDE WHITE
156—IVORY WHITE
139—BLACK

154—CREAM

146—COLONIAL YELLOW

102—DOVE

118—BUFF

101—FRENCH GRAY

117—PURE BLUE

136—EMERALD GREEN

121—LEATHER BROWN

Guarantee

We guarantee to furnish new paint free of charge, IF IT ON ANY PAINT sold and used under the name of SEROCO "MASTER WHITE" and for PAINT for the PURPOSE FOR WHICH recommended, if applied according to directions and with reasonable care, the paint fails to give the best all around satisfaction. Should any of these conditions arise, apply again with Seroco "Master White," paint to these cold and cracked surfaces. Master White" will protect application of the same Seroco "Master White" it is service fully every to a right and still gives you the service we have a right to expect.

We guarantee because we have such absolute confidence in our product, and still are our true liberal guarantee.

SEARS, ROEBUCK AND CO.

Page 20

P-697

SEARS, ROEBUCK AND CO.

Color Plate XIII: Sears, Honor Bilt Modern Homes (1928 catalog), 20 (Courtesy Sears, Roebuck & Co.).

4

Books and Building, 1863–1897

THE PUBLISHING of books on architecture dipped somewhat during the period of the Civil War, as did much domestic building, as we might expect during a period of social and economic dislocation. As Hitchcock's listing reveals, however, books about the *design* of houses diminished in number only very slightly (see Fig. 131); apparently, the construction of larger dwellings was spurred in some instances by the financial success of businessmen. The New York architect Henry Hudson Holly commented in the preface to his 1863 book *Country Seats:* "This work was fully prepared for the press some two years since, and was about being put into the hands of publishers, when the 'War for the Union' broke out, and seemed for a time to paralyze any new enterprise; the author, therefore, thought proper to postpone the publication, until affairs should be in a more settled

state, which, although not fully realized at the present time, yet as business has so far become based upon a war footing, the ball is kept rolling, and fortunes appear to be made even faster than in times of peace."

The 1860s and 1870s were a period of change for pattern books. A review of several of the more popular volumes shows that both the styles of buildings depicted and the nature of the plates included changed and that these new books were both popular and useful.

The Downing-Type Pattern Book

The architect Henry Hudson Holly, who had studied for two years with Gervase Wheeler and had continued his education for one year in England, opened his New York office in 1857.[1] One of his earliest projects was his pattern book, *Holly's Country Seats: Containing Lithographic Designs for Cottages, Villas, Mansions, Etc.* (1863, reprinted 1866). It followed the format of Downing, Vaux, Cleaveland, Backus, and Backus, and others in presenting perspective designs and small floor plans, with a few pages of descriptive and informative text. Holly included a variety of traditional and new designs. Of twenty-five freestanding houses, fourteen were Gothic or Medieval Revival; three were Italianate; there was one Italian villa with tower; and two, with their clipped-gable roofs emulating thatch and tile treatment, suggested cozy cottages and farmhouses of England. Four were up-to-date mansarded dwellings; and two featured prominent half-timbering and detailing that we now usually call "Stick Style." These latter two styles deserve a few words of comment.

Dwellings and public buildings with high roofs in the French manner were introduced into the United States in the 1850s. Popularized first in England (based on French antecedents going back to Pierre Lescot's wing for the Louvre begun in 1546), the "mansard" roof commemorates the French architect François Mansart who popularized this roof treatment in the early seventeenth century. Calvert Vaux was apparently the first to publish the mansard roof in an American pattern book. His *Villas and Cottages* (1857) illustrated as Design 26 a "suburban house with a [concave] curved roof," built in Newburgh about 1852–53, in partnership with Downing. Two other dwellings (Designs 23 and 29, both designed with his new partner, Frederick C. Withers) with convex mansards were also depicted. Mansard roofs were employed on public buildings of the 1850s; James Renwick's Charity Hospital of New York (begun 1858) and his Corcoran Art Gallery in Washington, D.C. (begun 1859), are about the earliest.[2] The style, with its associations of European, and specifically French, cosmopolitan culture, soon became very popular. Such roofs also permitted the attic space to be used as a full story; and the striking shape, often perforated with dormers and capped with cresting, rendered buildings even more picturesque.

Holly's "Stick Style" designs (such as Numbers 1 and 7) were also early manifestations of this movement. In these buildings, the timber bracing and corner posts, common in European half-timberwork, are emphasized on the exterior as an enriching (and highly picturesque) design feature. The relation to the openwork often found on Gothic Revival dwellings, seen in Downing and later pattern books, the idea of structural honesty, and the use of wood in a consciously woodlike manner, reveal the style's complex origins.[3]

Like most of the pattern books we have previously reviewed, Holly also provided an estimate for the cost of each design. Those who admired the designs, however, would need much more information to build any of them, and Holly inserted his own advertisement on page vii, just before the preface: "Henry Hudson Holly, Architect . . . Charges, on Contracts exceeding $3,000: for Plans and Specifications, $2\frac{1}{2}$ per cent.; for Detail drawings, 1 per cent.; for Superintendence, $1\frac{1}{2}$ per cent. . . . Expenses added." These were the "standard" rates, which Vaux had also published five years before.

Another pattern book, very much in the style inaugurated by Downing more than twenty years before, was *Woodward's Country Homes* (1865). George E. Woodward, "Architect and Civil Engineer" (as well as "Architectural Book Publisher"), with his office in New York City, illustrated eighteen dwellings in rather small perspective views and plans; he included a few elevation drawings, too. Two-thirds of his designs were Gothic and Medieval Revival, with a sampling of English vernacular, Italianate, mansarded, and Stick Style. His designs were largely traditional, for three of them were versions of the L-shaped Gothic cottage featured by Downing in 1852 and Smith in 1854, and one design, Number 34, was a gabled-roof version of Downing's 1842 Gothic Cottage (Design II). If lacking in originality, Woodward made up for it by variety: He included vignette designs for several stables, an icehouse, a summerhouse, a schoolhouse, a church, fences, gates, a headstone, and an example of updating an old house by remodeling. (Holly had also included four designs showing how old-fashioned houses could be made current and stylish by thorough remodeling.)

What is especially interesting in Woodward's book, however, is his long discussion of "Balloon

Frames" on pages 151–66. This mode of construction, in which sawn lumber such as two-by-fours nailed together replaces heavy timbers mortised together, was first used in Chicago in 1832 (and facilitated the city's rapid growth in subsequent decades).[4] As Woodward explains, "[T]he Balloon Frame has for more than twenty years been before the building public. Its success, adaptability, and practicability, have been fully demonstrated." He goes on to observe that "its simple, effective, and economical manner of construction, has very materially aided the rapid settlement of the West" because in areas "which must do without the aid of the mechanic or the knowledge of his skill," house construction could now take place, "to a great extent, within the control of the pioneer."[5] Furthermore, it was a much cheaper way to build: if a carpenter was employed: "[T]he Balloon Frame can be put up for *forty per cent. less money* than the mortice and tenon frame,"[6] although, Woodward asserted, one could do it oneself as well. His discussion of balloon frame construction included twelve detail illustrations.

The development of the balloon frame, and the diminishing use of heavy timber framing and cross-bracing, may be one reason for the popularity of Stick Style designs at this juncture—as reflections of "traditional" construction now being superseded.[7]

Woodward does not provide any estimates for any of his designs or any special ad for his own services—although his name and business address appear frequently: on the title page, as well as in the advertising section at the rear, where some of the books he wrote and/or published are featured.

Woodward's Country Homes was remarkably popular. There were subsequent editions in 1866 ("4th and 5th thousand"), and the eighth edition, "revised and enlarged," appeared in 1866 and was reprinted in 1868, 1869, 1870, and beyond.

His next publishing venture was *Woodward's Architecture and Rural Art, No. I* (1867), which also had a variety of traditional designs. Of twenty-three houses, twelve were Gothic or Medieval Revival; four were Italianate, and six were simple vernacular houses; one was mansarded. Several were familiar old designs: Number 11 owes a good deal to Downing's 1842 Design I; Number 23 is much like Smith's 1854 L-shaped cottage, plate 41; and Woodward's Number 38 is a traditional square Italianate house with hipped roof like Cleaveland, Backus, and Backus's Design 25 of 1856. As before, he provided a cornucopia of additional design vignettes, including icehouses, stables, a fruit-drying house, a chicken coop, barns, well houses, a tool house, a piggery, a smokehouse, a schoolhouse, a birdhouse, and a grape arbor. He also provided many plans for landscaping lots of varying sizes and for constructing ornamental roads and rustic seats.

Again, Woodward gives few estimates for construction. "As prices are constantly changing, it is useless to make statements that are only calculated to mislead," he observed, and added: "The best way is to show the nearest good mechanic the design, tell him, as nearly as possible your wishes, and he can give the most reliable figures."[8] As an alternative means of determining building costs in one's locality, he suggests and illustrates a novel approach: "Let him select such a house already built in that vicinity as shall represent, in style of architecture and character of finish, about what he desires to construct, and of which the cost of building is known; then compute the area or number of square feet covered by the building; divide the number of dollars of cost by the number of square feet thus found, and the price per square foot is ascertained."[9] An even more accurate method, which he demonstrates as well, is to calculate the cubic content of the built model and the proposed house, rather than the square footage.

Although showing the designs in his book to a local carpenter for estimates and construction was probably the way that most people used the book, Woodward inserted his own ad prominently on the last page: "Geo. E. Woodward, Architect, Civil & Landscape Engineer, 191 Broadway, New York," for those wishing professional services.

The second volume, *Woodward's Architecture and Rural Art No. II*, appeared in 1868 and contained designs for sixteen larger and more elaborate houses, of which six were mansarded, six were Gothic or Medieval Revival, four were Italianate, and one English vernacular. As in No. I, he included an example of remodeling to update an old house. This volume had a few supplementary designs (a mansarded and an Italianate barn) but added (51–58) "Specifications for Providing Materials and Labor for the Construction of a Dwelling-House," with each task under "Excavation," "Mason Work," and "Carpenter Work" outlined and described. A diagram of balloon-frame construction was included (as fig. 31) in the section on carpentry. These specifications were intended as only suggestions, however: "The following style of specification we have found, in practice, to answer the best purpose. It is short and comprehensive. . . . In making use of them, or adapting them to other buildings, it will be necessary to supply such other instructions as may be required."[10]

Neither volume had the success of his *Country Homes;* the first part was reissued in 1869, and Hitchcock lists only one other, undated, reprint of that part.

It is interesting to note that in the advertising section at the end of volume II Woodward provided a "Catalogue of Architectural & Agricultural Books, Published and For Sale by Geo. E. Woodward," all of which could be ordered by mail. Under "Architecture," he carried forty-eight titles, from *Allen's Rural Architecture* and *Fowler's Home for All*, to *Ruskin's Seven Lamps of Architecture* and *Vitruvius, Architecture*. Naturally volumes we have reviewed by Downing, Sloan, Cleaveland, and Vaux were included, as well as his own books. "Drawing and Painting" listed twenty-three titles; "Engineering, Surveying, &c.," thirty-five; and "Agricultural and Horticultural Books," eighty-five titles! This reminds us of how vital books were to builders and to fledgling—and even professional—architects, and how many were readily available in the 1860s.

One reason that *Woodward's Architecture and Rural Art* had far less demand than his *Country Homes* may have been that the illustrations were very small, and some (such as that for Design 3, "A Compact Cottage") even lilliputian, the dwelling and its plans measuring only three-quarters of an inch across. This scale would not be very useful for carpenters attempting to adapt these designs to construct dwellings. The illustrations in *Country Homes* of 1865 had been about the same size as those in the books by Downing, Vaux, Holly, or Cleaveland and Backus Brothers, two or three inches across and sometimes larger. Woodward had also omitted architectural details in his books, something that was apparently just as important to builders and carpenters as the designs they enriched.

This problem was solved in a new type of publication that began at this time, pattern books with large-scale drawings of architectural features, sometimes to the exclusion of overall designs and plans—the very details that local builders could use to update and enrich traditional vernacular domestic and commercial structures.

Design Books for Craftsmen

The first of this new type of pattern book seems to have been Marcus F. Cummings and Charles C. Miller's *Architecture: Designs for Street Fronts, Suburban Houses, and Cottages, Including Details for both Exterior and Interior* (Troy, N.Y., 1868). It became an instant success, and eight editions were printed between then and 1872, many in runs of one thousand copies each.[11] In the introduction, the authors explain the new approach they take and their reasons for producing this form of pattern book:

Many architectural works have been published in our country . . . in which are given plans, elevations, and perspective views of buildings of all kinds. . . . The illustrations . . . though they portray many beautiful buildings and well arranged plans, are almost invariably drawn to so small a scale as to render comprehending their details, impossible to any one except experienced architects.

To arrange the rooms and appurtenances of a building in accordance with a given diagram is not a difficult task, even though the scale of the diagram be very small; but to erect a building, and to make all the details of its exterior and interior finish beautiful, and to have each detail such that it will aid in forming a harmonious whole, requires for a guide something more elaborated than an illustration in perspective, such as can be found in nearly all of the architectural works published in this country.

This work differs in its design from any, heretofore issued; it contains designs for all the various features which enter into the composition of buildings . . . given in detail, and drawn to so large a scale that any one familiar with the construction of work cannot fail to comprehend their forms and their construction. In addition to these, there are given a variety of elevations of fronts of buildings in which the details are incorporated, thereby showing their effect when combined, forming a whole. . . .

No plans of houses are given in this work, for the reason, that the wants of persons in regard to the arrangements of their buildings are as different as are their characters; and to present plans within the small compass of a book that would suit even a respectable minority of those who build every year would be an impossibility. . . .

This work will be found particularly valuable in situations where it is not convenient to secure the services of an architect; in such localities owners and their builders are usually thrown upon their own resources of knowledge, as to what is good and in proper taste to introduce into the design of the building they propose to erect; and if they possess a work in which every needed architectural feature, both those of

Fig. 139. *Cummings and Miller,* Architecture Designs . . .
(1868), plate 30.

Fig. 140. *Cummings and Miller (1868), plate 39.*

utility and those of ornament, is given, necessary to the complete construction of the building, it will not be a difficult task to make the structure a good-proportioned and inviting one.

Without such a work, the only alternative is either to engage an architect or to follow in the footsteps of some predecessor, copy his building as far as is practicable.

Although the book would thus be a boon to the "practical builder," the authors also observed that the best approach for "any one who desires to incorporate the features of any particular style in a building they propose to erect" is to "procure complete designs and drawings from an architect of known ability." In the advertising section at the end, there is a full-page ad boldly announcing that "C. C. Miller, Toledo, O. [and] M. F. Cummings, Troy, N.Y., Architects and Superintendents, will furnish Designs, Detail Drawings, and Specifications of Buildings of all kinds, for any part of the country," and perhaps even more signifi-

cantly for readers of the book, "drawings, in detail, of any of the designs in this work [will be] furnished on application," another early instance of architectural plans available by mail.

Architecture presented a full range of details (and some whole facades to demonstrate their arrangement on buildings). These included: front entrances, belt courses, quoins, windows, window caps, cornices, mansard roofs, dormers, bargeboards, porches, verandas, door and window canopies, bay windows, "observatories" (roof cupolas), balcony railings, and chimney caps. Interior details included newels and balusters, doors, and moldings. Of the twenty-one sample house facades shown (although no plans or perspective views were included), eleven were Italianate, six Gothic Revival, and four mansarded. In some ways, the book thus returned to the carpenters' manual format popular before Downing's books. Because both Miller and Cummings had been trained as carpenters in their youth and had gained architectural knowledge in the offices of established architects, their sympathy with the needs of craftsmen on the job is under-

standable.[12] The book was extremely popular throughout the United States.[13]

Cummings and Miller's next book, *Modern American Architecture* (copyrighted 1867), was somewhat changed in approach: The authors included plans and secondary elevations for the sample buildings they showed; they explain in their preface that "there seems to be a great desire to have a work containing not only full detail-drawings, but complete plans and elevations of buildings of various kinds, mainly dwelling houses, such as are required to meet the wants of the American people."[14]

Marcus Cummings (now without the partnership of Miller) used this same format in his third venture, *Cummings' Architectural Details, Containing 387 Designs and 967 Illustrations of the Various Parts Needed in the Construction of Buildings, Public and Private . . . Also Plans and Elevations of Houses, Stores, Cottages, and Other Buildings* (New York, 1873). The plates were similar in variety and type to the 1868 *Architecture*, although there were more interior details, including wainscoting, doors, windows, ceilings, stucco cornices and ribs, mantels, moldings, inside casings, and baseboards. He also included nine house designs, with plans: Four were mansarded, two were Italian villas, two Italianate, and one Gothic Revival. In his preface, Cummings was candid about whom the book was directed to: "It is not supposed by the author that [these] contents will add much to the resources of architects, who are located in the larger cities, but those who have a country practice . . . may find in the illustrations many valuable hints."

As we might expect, architect and bookseller Woodward also issued a book of detail architecture, but in combination with large perspective views as well as elevation drawings and plans. His *Woodward's National Architect* ("by Geo. E. Woodward, Architect, & Edward G. Thompson, Architect") containing "1000 Designs, Plans, & Details" appeared in 1869. Like Cummings and Miller, he explained in his introduction the reason for his selection of material:

> In presenting to the public a new work on Architecture, we have endeavored to occupy a field not hitherto covered in a similar manner, and also to fulfill a demand that has been made on us for some years past for practical working plans adapted to the wants of the great mass of the inhabitants of our country—plans, elevations, working details, estimates, and specifications so clearly made out and so thoroughly and practically prepared, that they may at once be placed in the hands of a builder for execution. . . .

> Front and side elevations, plans and detail drawings to working scale are given for each design, and in many cases perspective views are shown. In addition, we have added a large number of miscellaneous details which will enable any one to select such styles of finish as he may prefer.

> The drawings are so carefully made and figured as to explain thoroughly their meaning without further description than that found necessary in the specifications, and we have, therefore, carefully avoided all theories, essays, or speculations on the subject, believing we can convey more practical and valuable information by carefully-executed drawings than by whole volumes of descriptive matter.

That builders wanted details as well as designs and plans is not surprising, for the period between 1865 and 1870 was one of great building activity: "More new houses were built [then] than in any other five years of the country's history."[15]

Woodward's book contained a great deal of useful material. Of the sixteen freestanding houses depicted, seven were Gothic or board-and-batten; six were mansarded, two were Italianate or bracketed; and one was Stick Style. He also included a schoolhouse, an icehouse, a boat- and bath-house, and a stable. His details were as extensive as Cummings and Miller's: brackets, cornices, chimneys, latticework, French roofs, bay windows and towers, dormer windows, balconies, verandas and porches, bargeboards and cresting, as well as "canopies, hoods, and cupolas." His interior details included staircases, doors and windows, mantels, and plaster moldings and finishes.

Woodward's introduction also mentions that forms of specifications, which "may be adapted to any of the designs, so that full and final estimates can be obtained from local builders," were included. These are very detailed; for example, in the specifications for Design 1, an L-shaped cottage of the type popularized by Downing and Smith in the 1850s, he provides nine pages detailing the carpenter's work, three for the mason, and three for the plumber. Reflecting as well the growing professionalism of the building trades, he includes a three-page outline for an "Approved form of Contract in General Use." As seen previously, a catalog of architectural books he sold is included in the advertising section.

The pattern–book format of house designs with large-scale detail drawings, plans, and even specifica-

*Fig. 145. 47 North Main Street, Earlville, New York
(Photo by Robert H. Kuiper).*

Fig. 146. Hussey, Home Building *(1875), plate 31.*

Italianate, five Swiss/Stick Style, four Italian villa, and three English vernacular (houses with clipped gable roofs). All are depicted in a clear perspective view, with two floor plans. Although builders could certainly base their work on these, Hussey also announced his own professional services: "[A]ny further information in connection with this work will be cheerfully given on application, and any working plans or specifications will be promptly furnished at the most moderate charges." Again, we have a case of an architect popularizing his designs by a pattern book and advertising working plans and specifications available by mail.

How would a local builder use such plans? We can examine one dwelling, which by its closeness to the design published by Hussey, certainly appears to have been built following such mail-order plans, and assess their use.

The George King House in Earlville, New York, was built, it is thought, in the late 1870s by the owner of a general store.[29] We can see at a glance that Hussey's design has been followed closely throughout, from overall composition (although in mirror image) to details such as the form of the tower roof and its dormers, to the gable bargeboards. We see as well that the design has been somewhat altered: The parlor at the right projects farther forward and con-

tains a window by the steps, which the model lacks; and the local builder has employed a fancier gabled window cap than is depicted in the print. Turning to the plan (Fig. 147), we find, to our surprise, that while the general disposition of rooms, at least in the front portion of the house, is much the same, the sizes are different. The parlor is longer and a bit wider; the dining room behind it smaller; and in place of the Hussey kitchen behind the central stairs, we have a living room, with kitchen in a wing beyond.

Would it have been worthwhile for a local builder to purchase the plans and then to change them this much? Certainly the specifications would assist in calculating the cost and in purchasing materials, but one wonders whether the carpenter could not have just as easily looked closely at the published plate, as builders of course did with designs from the 1840s onward, and drawn up his own plans, adapted to the owner's particular needs, thus bypassing the mail-order plans altogether. Whichever approach was used, the result owed a great debt to Hussey's interesting design of an Italian villa updated with a quasi-mansard roof on its tower and made more picturesque by the complex bargeboards, finials, and cast-iron cresting. Although the local builder omitted the stickwork detailing on the tower, equivalent pictur-

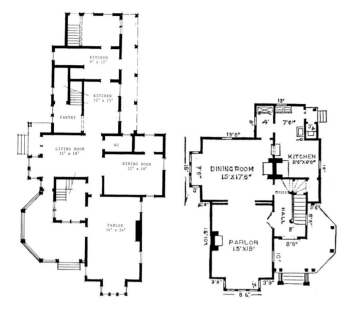

Fig. 147. 47 North Main Street, Earlville, New York, plan.
Fig. 148. Hussey (1875), plate 31, detail.

esque richness of surface is imparted by the paired brackets and more elaborate window caps, not depicted in the Hussey design.

Home Building seems to have been reasonably popular, because a second edition appeared in 1877. Certainly one can find constructed dwellings that are close to its plates. An example similar to the straightforward rectangular Italianate design of plate 3 can be found in Fredonia, New York. The G. W. Lewis House has many features in common with the Hussey plate besides the general form and three-bay facade: It also has the circular window in the gable end, the chimney located in the middle of the dwelling, and a bay window at one side (whether the bay should go in the front parlor or the rear living room or dining room would be a typical local modification to meet an owner's particular needs).[30] The segmental windows are in fact more appropriate to Italianate design than are the flat-headed ones depicted by Hussey.

Pattern books full of designs for houses always seem to have been much in demand. George Woodward brought out volume II of his *Woodward's National Architect* in 1877, which, according to the subtitle, contained "original designs, plans, and details, to working scale, for city and country houses." This was reviewed in *The American Architect and Building News.* One of the main editorial concerns of the journal was assisting and encouraging the professionalization of architects; the journal provided information on schools and training, published educational series on both historical and

technical matters, and illustrated good current work. The journal also tried to appeal to novice architects and builder-architects, especially in its early years. Its review of Woodward's volume II reveals this tension between builders and professionally trained (or aspiring) architects.[31] "Mr. Woodward's architectural publications have, we believe, had a very large circulation, especially in the latitude of New York, and we do not doubt have had no unimportant influence upon builders' work in those regions." Turning to the book itself, the journal observed that "the mechanical execution of the work is excellent, the plans are ingenious, compact, and economical, and the elevations are such as constitute the better sort of builders' work rendered familiar to us by countless repetitions in all parts of the country. . . . Any one who desires to know what the 'American style' is will find it, if anywhere, handsomely set forth in this book."

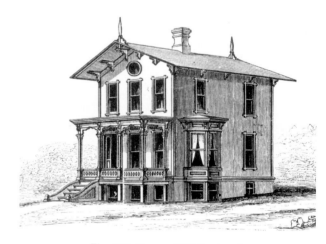

Fig. 149. Hussey (1875), plate 3.

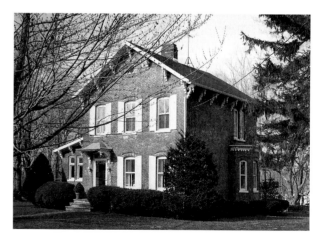

Fig. 150. 211 Chestnut Street, Fredonia, New York.

The journal noted that "Mr. Woodward's publication is one of the best of its kind," and although it was "not instructive for the architect as an artist and man of science," it was undeniably valuable for "the builder who builds without an architect," for which it would be "full of inspiration." The editors were also anxious to put such volumes in perspective, as they relate to the architectural profession.

> In the presence of books of this character it seems necessary to recall why architects exist at all. . . . We do not think . . . [that such a book] competes in any respect with the work of architects. The business of the book apparently is to supply ideas concerning buildings: the function of the architect is to give form to the especial requirements of his client, to adjust the building to the site, to study the aspect and the grades; to give the structure all the grace, character, individuality, of which it is capable within the financial limits imposed; to meet all the conditions of ventilation, drainage, heating, plumbing, according to the best available science; to prepare detail plans and specifications; to obtain competitive estimates; to prepare contracts; to direct the execution; to decorate and complete—in fine, to create a work of art.

Readers of pattern books would, however, be perfectly familiar with the true duties of an architect, from the discussions in the books by Downing, Vaux, Sloan, and many others.

Palliser, Palliser & Co.

Significantly contributing to the boom in architectural publications in the 1870s and 1880s, as depicted on our graph, was George Palliser, and later the firm of Palliser, Palliser & Co. of Bridgeport, Connecticut. George Palliser emigrated from England to Newark, New Jersey, in 1868 and established himself as a master carpenter and then as co-owner of a sash, blind, and door factory.[32] After he moved to Bridgeport in 1873 and became involved in the design of speculative housing being built at a great rate under the aegis of the mayor P. T. Barnum and others, his career dramatically expanded.

As early as 1876, however, George Palliser, "Architect," had achieved great success and had published his first book of plans, *Palliser's Model Homes for the People*. It is most revealing of his working methods and the development of not just "plans by mail," but now "architectural design by mail."

Palliser's Model Homes was an inexpensive forty-six-page booklet that sold for only twenty-five cents, thanks to the limited number of illustrations and to nearly half of its pages being devoted to ads for building materials. It was published in an edition of five thousand, which was nearly exhausted in only two years.[33] Of forty-two house designs, fourteen were depicted by inexpensive woodcuts, with brief descriptions. Two were mansarded, two Italianate, and one designed in a more sumptuous and complex Gothic now called Victorian Gothic. Most of the designs (seven) were in a boxy vernacular of his own, combining Gothic and Italianate details to give the inexpensive dwellings a tincture of sophisticated style. Two others were Italian Villa types, but with Gothic detailing.

Each entry, illustrated or not, listed the price for its "plans and specifications," ranging generally from $5 to $50, with one at $3.50 and one at $85. It is the sort of service we have seen before, beginning with Cleaveland and Backus Brothers in 1856 and Cummings and Miller in the 1860s.

> With a view to help those who contemplate building to decide on what to build, and to give them an idea what can be built for a certain amount of money, on receipt of charges given, I will send to any address a complete set of any of the following plans, drawn by hand, to a scale of one-quarter of an inch to the foot. These plans are the latest made by me, and are nearly all in course of erection. . . . Parties sending for any of the following plans should get the one that comes nearest their wants, giving number required, and a full description will accompany each, giving style of finish and improvements included in the estimate and everything else of importance.[34]

Palliser does not specify what "a complete set" of plans consists of; but two of his designs ("Palliser's Centennial Villa" and his "Model Gothic Cottage") were available in a "full set of lithographed plans" very inexpensively—for only fifty cents each—and each of these had "front, side, and rear elevations, floor and roof plans, to a scale of one-eighth of an inch to the foot."[35] The distinctive thing about Palliser's book-

let is that it also promoted his business of designing buildings for clients through the mail—not just of providing them with plans and specifications for their study or use.

This idea was not, as we have seen, uniquely his. Sometimes, as with Calvert Vaux's ad of 1857, correspondence back and forth with the architect in the process of preparing designs is implicit. H. H. Holly, George Woodward, and Cummings and Miller also provided architectural services through correspondence, as we have noted, but Palliser carried this process further by explicitly stating just how the business would be carried out and what the client could expect. Like many architects of his day, he had clearly been conducting design through the mail for several years:

> In consequence of my increasing business, supplying parties in every section of the United States with designs, plans, specifications, etc., I find it necessary to adopt a system for conducting this class of business, and which I trust will supply a want which has long been felt, especially in the country, where architects have done but little business, and the people have been obliged to plan their own houses or copy from their neighbors.[36]

> Parties who require a full set of plans and other papers necessary in the proper conducting of their building affairs, should write full particulars as per directions given on page 6, and send to my address, with a sum not less than 2 per cent. of the proposed cost of the building, and I will make designs, plans, specifications and all working drawings; also furnish printed forms of contracts and full instructions how to manage building affairs in the best and most economical manner. The designs and plans will be to a scale of a quarter of an inch to the foot, and will be made to meet the circumstances of each particular case, and satisfaction is guaranteed to every one employing me.[37]

The "directions given on page 6" was a list of seventeen items, including the size and shape of the lot, the amount the client proposed spending, the materials to be used, the size of the house and the stories required, the number and use of rooms for each floor, the character of the site and ground, outside details (such as bay windows or towers), the "style of finish on the inside" (such as wainscoting, mantels, etc.), what improvements ("hot and cold water . . . warming, baths, gas, water-closets, etc.") were desired, the direction of winds and storms, and so on. "After receiving particulars, anything mentioned that will interfere with the proper arrangement of the rooms and the carrying out of a suitable design, will at once be brought to your notice, and I shall correspond with you until everything will harmonize, as I do not wish to send out plans when I think they will not give satisfaction."[38]

These individually designed houses were provided with a much fuller selection of drawings than those ordered from his catalog: "The drawings, etc., furnished to parties employing me, will comprise the following: One original set of plans and elevations; copies of the same for the contractors; full size working drawings; one original set of specifications; copies for the contractors; and all necessary forms of contract."[39]

Palliser also provided a similar service for "parties who are about to erect cheap houses and do not think it necessary to get a full set of plans, specifications, etc."[40] He assured his readers of both his professional expertise[41] and of the real advantages in using architect-prepared plans and specifications to avoid errors.[42]

Given the great number of copies of this booklet disseminated, it is likely that a good number of people did order the plans and build from them. An instructive example of this can be found in Fredonia, New York, in a house built in 1886, which appears to have been based on his plans.

Designs 23 and 23½, "plans and specifications for either, $17.50," used the same cross-shaped ground plan, although that for 23½ had "very slight alteration." Design 23, a dwelling with "bold outlines and solid and substantial appearance," was in Palliser's economical vernacular with details predominantly Italianate, but in this case with paired Gothic-like windows in the attic. The elevation for Design 23½ had "an exterior design similar to No. 11" depicted a few pages earlier. "These two . . . show what can be done in making two elevations from one floor plan, and for a nice country home, for the amount expended [about $3,500], cannot be surpassed." In erecting 11 Cleveland Avenue, the local builder seems to have followed Number 23½ quite closely, although he incorporated the windows on both floors of the side projections and also the bay window—here continued for two floors—of Number 23. Perhaps with the plans of Number 23½ in hand, he referred to the vignette of Number 23 for additional ideas in adapting it to the owner's needs.[43]

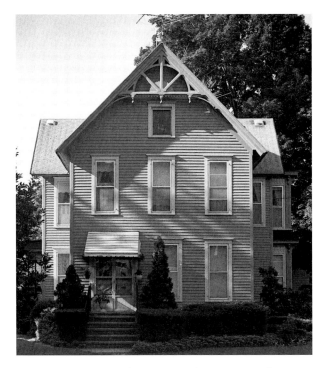

Fig. 151. 11 Cleveland Avenue, Fredonia, New York, 1886.

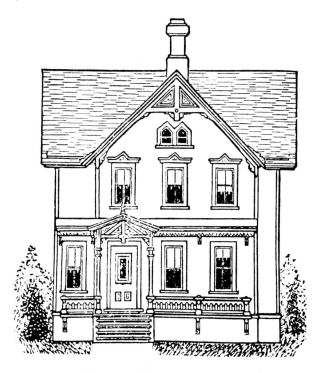

Fig. 152. Palliser's Model Homes . . . *(1876), Design 11.*

Many of the twenty-one pages of ads that Palliser included in *Model Homes for the People* were for building materials and components. Much of the material advertised was made in up-to-date factories and could be shipped "to any part of the United States." His ads included providers or manufacturers of plumbing materials, furnaces, mantels, metal cornices, roofing materials, iron caps and columns, hardware, staircases, "sash, blinds, door[s] and mouldings," stonework, and even wholesale lumber. Many were Connecticut businesses, but others were in New York or Boston, reminding us of the truly national scope of such books, and such businesses. Theoretically, a person building from Palliser's plans could also fit up his house with components ordered from these suppliers.

George Palliser's business thrived; his brother Charles soon joined him, and the firm of Palliser, Palliser & Co. was founded in late 1877. Hitchcock lists eleven separate titles of works by George Palliser or the firm; Michael A. Tomlan has recorded more than twenty publications issued between 1876 and 1908, making the Pallisers "among the foremost disseminators of architectural designs of their time."[44]

The revised 1878 version of *Palliser's Model Homes* was really an entirely new book; none of the old designs was repeated. The new edition contained illustrations (perspective views with two floor plans) for eighteen houses and other buildings (a barn, stable,

and carriage house, a school, a combination bank and library building, a town hall, and three churches). All the houses were based on designs prepared by the Pallisers "in the past few months" and were "with one or two exceptions . . . now in process of erection."[45]

These houses were much more sophisticated and up-to-date in style, almost all being simplified yet artistic versions of the Queen Anne then coming into vogue. Its main origins were the vernacular revival work of the 1860s and 1870s of Richard Norman Shaw in England, whose designs were soon popularized in America.[46] The first example of "Shavian Queen Anne" constructed in the United States was H. H. Richardson's Watts Sherman House in Newport, of 1874. Popularized by the British buildings at the 1876 Centennial Exposition, the Pallisers, perhaps aided by their English background, were obviously among the earliest to produce popular or vernacular versions of this highly picturesque mode for middle-class dwellings. In discussing Plate III, they observed that "the exterior [of the design] is very striking, the front gable is very handsome, and is a free-rendering of what is known as the Queen Anne style of architecture." In discussing Plate XIV, they explained the style a bit further: "The house . . . is a good example of one of the half-timber and tile designs of the Jacobite period, though, unlike its prototype, shingles cut to a pattern are substituted for tiles from the second story

up. The first story shows what has the appearance of a timber construction."

Most of the Palliser designs have the asymmetrical appearance, sloped roofs, decorative cut-shingle work, some "half-timber" effects (continuing Stick Style ideas), gables with openwork bargeboards, and contrasts of surface boarding that are the highly picturesque hallmarks of the Queen Anne style.

The designs depicted were for houses built over a wide geographic range: Many were in Connecticut, of course, but also in Massachusetts, Ohio, Virginia, Indiana, Iowa, and Mississippi, confirming the broad scope of the Pallisers' architectural practice and influence.

This book differed from the first edition. One could, apparently, still order plans and specifications for the designs depicted, as they noted in small print in their business ad at the back of the book,[47] but everywhere else the readers were urged to hire the Pallisers to prepare individualized plans for them. The three introductory essays repeatedly emphasize the importance, for effective and artistic design, of hiring a professional architect: "When any one contemplates building, no matter whether it is a building to cost but $500, if he is wise he will consult an architect with reference to its design, construction, &c."[48] This in part saved the owner money and time:

It is a well known fact that when a builder has complete drawings to work from, that he will save a large amount of time that he would otherwise have to spend in thinking up every detail of the work as it progresses, to say nothing of the time the employer would have to spend with him. The possible alterations in the work caused by advice from his friends . . . is money saved, by having a thoroughly studied and prepared design, from which no deviations are made, and which would enable the builder to go through with the work with the utmost despatch.

They warned as well against the "old fogy of a carpenter" who has "never studied anything outside of the village" in which he lives; "such men . . . are stumbling blocks in the way of architecture in the village and country."[49]

The Pallisers' architectural services by mail were set out very similarly to the 1876 instructions. The list of "particulars" was only fourteen items long here, but it is clear that further details were worked out through correspondence.

It is our constant aim to please our clients, and we usually succeed. Our long practice has convinced us that it is quite as easy to satisfy parties with our designs, when we never see them, as in any other way. When parties correspond with us in regard to procuring designs, we are always prompt in answering their inquiries. . . . We shall be very glad to hear from all persons who intend to build, and wish our services, and we will serve them faithfully. . . .

Our drawings are made on vellum, so that they will stand wear and tear; are thoroughly lettered, figured, and made plain as daylight. Also, any one can understand our full-size working drawings. The specifications are always made complete in every particular, and are furnished in duplicate, for builder and proprietor, as are also our forms of contract; and all instructions are given our clients in the most complete way, to enable them to have the design properly executed, and their building affairs satisfactorily conducted.[50]

The designs in *Palliser's Model Homes* are, however, of adequate size and clarity to be of use to architects and builders in their own right—as pattern-book designs had been for generations. Can we document their use in this manner?

The answer is yes. If we examine one dwelling that seems to have relied heavily on Palliser designs, we can get an insight into how local architects and builders adapted these up-to-date plates in their own work, the very sort of uplifting of artistic taste in remoter regions that was one of the ostensible aims of so many of these pattern books.

A self-trained architect, active in western New York and northwestern Pennsylvania, who is known to have drawn on pattern-book designs—and specifically on Palliser—to assist in his work, is Enoch A. Curtis. Born in Busti, New York, in 1831, he began life as a farmer, but at the age of twenty-one was apprenticed to a carpenter and joiner. He followed this trade until he enlisted in the army in 1862; discharged in late 1864 after being seriously wounded, he ran a hardware business in Fredonia, New York, for several years. He also studied architecture from books, both before and after the war, and in November 1867 opened his office as an architect. He was soon well known throughout the region. More than sixty residences and

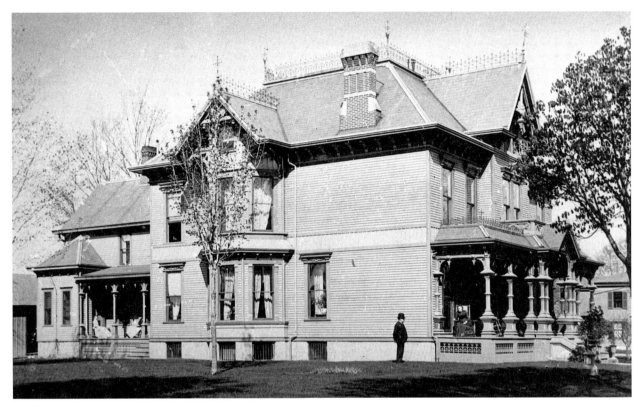

*Fig. 153. Aaron O. Putnam House, Fredonia, New York, photo c. 1885
(Courtesy Historical Museum of the D. R. Barker Library, Fredonia, New York).*

public buildings by him are documented, mainly from the period 1868 through 1900.[51]

From his work in the late 1860s, it is clear that Curtis did avail himself of pattern books of the day to help in his designs. For his brick Putnam Brothers store in Fredonia of 1868–69, he used a design in Cummings and Miller's *Architecture* (1868) for its cornice; and in his Odd Fellows Building of 1869–70, he again turned to this book for at least nine details or features.

Aaron O. Putnam, who with his brother Nathan owned a prosperous local dry goods store, was a man who enjoyed entertaining; his new house commissioned from Curtis was intended to be a local showplace reflecting his taste as well as his wealth.[52] As we might expect, Curtis studied published plates for design ideas, but, interestingly enough, created a dwelling that was not (except for one part) a literal copy of any of them. The house was designed, it seems, in 1878; the cellar hole was dug out by mid-June.[53]

One of the main sources for the A. O. Putnam House appears to have been plate 7 in *Palliser's Model Homes* of 1878. The overall form, the projecting gabled facade bay with paired windows on the second floor,

a veranda with gabled central porch, the stickwork banding are all features found in plate 7. That this particular plate was a key design source seems to be confirmed by the sunburst motif in the stickwork bargeboards in the Putnam House facade gable, which appears to have been inspired by the similar motif in the end gable of the Pallisers' plate. Other features seem to have been inspired by plate 9 from the same book: the veranda carried across the entire facade, with hipped, rather than gabled, ends; and the two-story bay window on the side elevation. The paired facade window with cornice cap enriched by a central gable may have been copied from a house design with windows of this type reproduced in plate 16 of *Cummings' Architectural Details* (1873). Certainly some of the other details on the Putnam House are similar to plates in this and other pattern books of the day, such as Bicknell's *Detail . . . Architecture* of 1876.[54]

As we might expect from an architect learning from published plates, Curtis sometimes copied literally. The porte-cochere is a virtual duplicate of one depicted in *Atwood's Modern American Homesteads* (New York, 1876) by the New York City architect D. T.

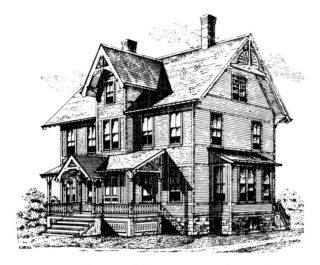

Fig. 154. Palliser's Model Homes *(1878), plate 7, detail.*

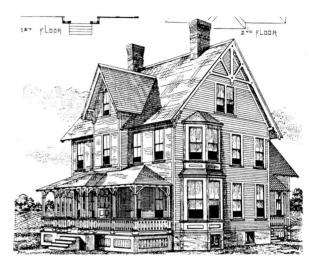

Fig. 155. Palliser's Model Homes *(1878), plate 9, detail.*

Atwood. While some details such as the gablet rosettes and the arch keystones have been omitted, other features are copied carefully, such as the median bosses in the paired support columns. Illustrations in books always seem to have been important to Curtis. When he designed the C. D. Ellis House in Laona, New York, about 1890, he showed Ellis and his wife (according to family tradition) a book of designs to select from and then came back with his own hand-drawn plans for the dwelling based on the illustration—but un-

doubtedly including modifications and "customizing" they had agreed on.[55]

Curtis also turned to the periodical press for ideas. The form of the hipped roof, the band of vertical Stick Style boarding between the two floors, and perhaps even the low balustrade on the roof of the entrance porch all most likely derive from the plate published in the January 3, 1877, issue of *The American Architect and Building News.*[56] This dwelling, designed by the nationally noted firm of Peabody and

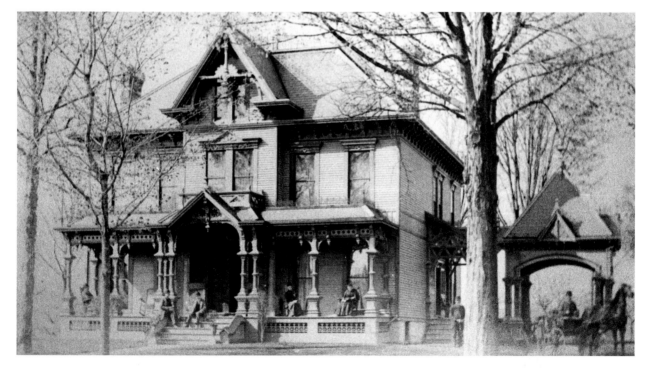

Fig. 156. A. O. Putnam House, Fredonia, New York, photo c. 1885
(Courtesy Historical Museum of the D. R. Barker Library, Fredonia, New York).

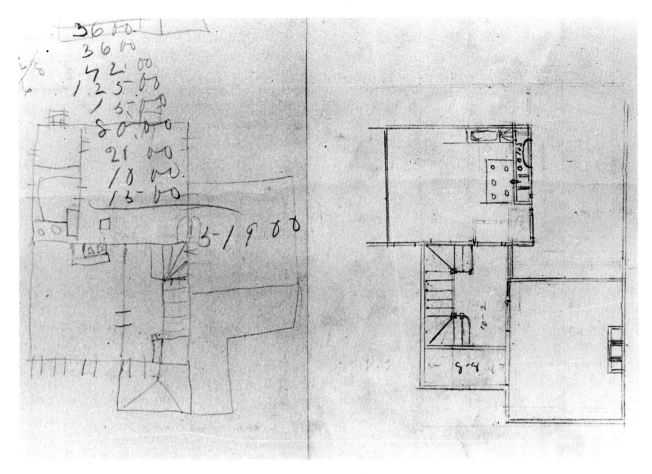

Fig. 166. Carpenter's sketches, c. 1880s.

ticework, shingles, staircases, verge boards and wainscoting.[67]

Comstock issued the book to keep builders' designs up-to-date. As he commented in the preface, since Bicknell's book appeared in 1873 "great change has taken place in the style of Architecture," with "the French [style], then largely in vogue . . . supplanted by our present" styles, as enumerated on his title page. His aim was to make the book "one of practical utility."

And so it seems to have been. The vintage copy consulted for this study was well used. Several plates had details sketched in modified form on the facing blank verso; arithmetic calculations appeared on others; and the verso facing plate 17 was covered with calculations, as well as three sketchy floor plans that apparently were variations of a facing design. The "low priced Queen Anne cottage" in the middle of plate 17 has a few modifications to both the elevation and the plan penciled on the plate. On a loose sheet of paper found elsewhere in the book are two additional penciled plans, one quite detailed, clearly prepared by some practical builder. Such books were meant to be used by craftsmen themselves—

and obviously were. Some of the volumes were even cited favorably in the professional press of the day.[68]

To return to the prolific Pallisers, in 1883, undoubtedly because of the growth of their business, the firm moved to New York City. In 1887, the architects published a new volume, *Palliser's New Cottage Homes and Details,* intended to be "a most practical book for Architects, Builders, Carpenters, and all who . . . contemplate building, or the improvement of Buildings." In the preface, they comment on the great popularity of their previous books and state that *Palliser's Useful Details* (1881) had reached an "immense circulation" of 50,000 copies! Their books, they asserted, had had a widespread impact: "Thousands of houses have been built from Palliser, Palliser, & Co.'s popular books of Cottage plans, details, and specifications. In fact there is not a city, town, or village of consequence in the country but what contains from two to twenty buildings so erected."[69] How they ascertained this ubiquity is not explained.

They thought that their books had had a salutary effect on American architectural design, too: "[A]s

a result of their popular teachings we find in the rural districts among the buildings erected at the present day almost an entire absence of the vulgar, meaningless, square-box like or barnesque style of Architecture." The Pallisers were also proud to observe (echoing Downing's words of thirty years earlier) that "the idea is no longer prevalent that good taste in Architectural design should be exercised only in regard to the erection of the more costly structures built for people of means, but on the contrary, more thought and attention is now paid to the design and erection of the smallest Cottages and Villas than has been given in the past to the more ornate and costly dwellings."

Palliser's New Cottage Homes and Details, they confidently asserted, was a book very much needed: "[T]here are thousands of cities, towns, and villages in all the States of the Union in which the wants of the people continually demand the erection of buildings such as are represented in this book." They were quick to point out that "all the designs given are new and original" and offer a "mass of practical Architectural designs and details, easy of construction, pleasing in form, and generally of an inexpensive though artistic and tasteful character."

Each house design was provided with the "cost of the construction and finishing . . . exactly as it has been built from our plans," although the Pallisers cautioned readers that total cost was a highly variable factor: "[M]any people forget to consider that time, site, fluctuations in prices, various localities, style of finish, and business management will affect the cost very materially." Nevertheless, it was a useful assurance that the design had indeed been built for the price stated. They also added a cautionary note: "We do not publish these designs in any other form, giving costs of constructing each on an increased scale, or separate from the designs for the use of builders only, as we understand has been done in other quarters. [Some firms provide] designs on single sheets for builders to show parties intending to build, giving no costs, that information being reserved for the builder" who could then charge whatever he felt would give him a fair profit—or what he thought he could get away with. The Pallisers were in fact here referring to the *Builders' Portfolio* of just such plates, which Robert W. Shoppell and his Co-operative Building Plan Association began to issue in 1886—an approach that the Pallisers roundly condemned.

The Pallisers also published in *New Cottage Homes and Details* two other aids to prospective builders: "specifications" for buildings and a contract form. The sample specifications, "written to go with work-

ing and detail drawings," were prepared for a small, medium, and large house (each depicted in their plates) as examples of how such documents should be prepared. That for the large house (Design 16, plate 16) was about six thousand words long—twice the length of either of the others.

Such sample specifications were apparently a real help to architects. Woodward had provided examples to be emulated in publications of 1868 and 1869, Hussey had also published them in 1875, and they appeared in Bicknell's *Village Builder* of 1878. The Pallisers, however, seem to have made this one of their specialties; they published a book of forms of *Specifications for Frame House* in 1878, and their *Palliser's Specifications* (1881) met with approval even from the editors of *The American Architect*:[70]

> The idea of using ready-made specifications does not generally commend itself at first to the experienced architect. . . . In Palliser's Specifications we have the first example within our knowledge of a fairly complete set for brick buildings, as well as those of wood, and it is high but deserved praise to say that with the proper amount of additional matter to suit the peculiarities of particular buildings, for which ample blank spaces are left, such specification could easily be made as thorough and full as the most scrupulous architect need desire. . . . [The book] shows throughout the hand of a thoroughly experienced architect—one not only experienced in a certain class of work, but in a great variety of processes and modes of finishing. The plumbing specification is very nearly a model of its kind.

The second item, their copyrighted two-page "Form of Contract," could be ordered directly from the Pallisers: "Be sure and have a right contract before going ahead," they admonished, "and by so doing you may save an endless amount of trouble and it may be some money." "Palliser's Building Contract Form with Bond (revised 1888) are sent post-paid to any address on receipt of price, viz. 5 cents each, or 40 cents per dozen. They are endorsed by leading Architects, Builders, and Lawyers, throughout the United States and Canada." Although, as we have seen, pattern-book writers had been including sample or "blank" contracts in their works for a number of years (Woodward in the 1860s and Bicknell in the 1870s), the

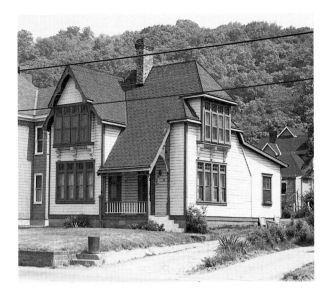

Fig. 167. House in Ambridge, Pennsylvania.

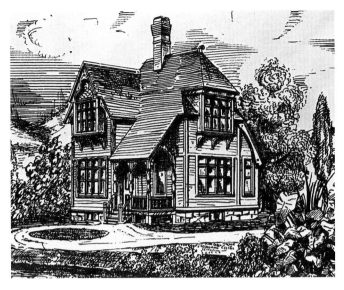

Fig. 168. Palliser's New Cottage Homes . . . *(1887), plate 40, detail.*

Pallisers' contracts were apparently the best. They had published their first (for sale to architects) in 1881 and had received warm approbation from *The American Architect*:[71]

> Every architect has learned the inadequacy of the ordinary building contracts sold by stationers, and a printed form containing all the provisions which are usually necessary will be of value to many. . . . Of the Messrs. Palliser's [*sic*] contract we may say in general that the plan is excellent; and if we call attention to some omissions, with some deviations from the usual forms, it is quite as much for the sake of inviting discussion upon a document which is likely to be widely used in the profession as on account of any injury which they do to its substantial value.

Of course, the firm of Palliser, Palliser & Co. continued to solicit the public's business and to design "every description of buildings" through correspondence. As the full-page ad on the last page of their book explained, "[I]t matters not whether our clients reside in the States of Connecticut, Massachusetts, or New York, near to us or 3,000 miles away—distance is no obstacle—we can serve them equally as well, as upwards of two thousand of our clients residing in every state and territory in the Union, Canada, Nova Scotia, and the Brazils can testify." They proudly quote encomiums from the press in support of their work:

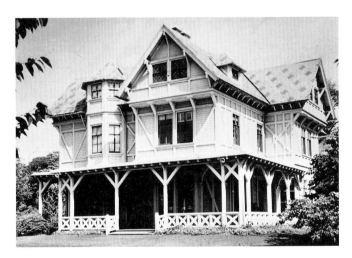

Fig. 169. Hunt, Griswold House, Newport, Rhode Island, 1862.

"Their designs, even for the cheapest dwellings, are tasteful, picturesque, and elegant," said a reviewer in *Scientific American*.

Like their previous books, *Palliser's New Cottage Homes* seems to have been popular, too. Two later editions of the title appeared, in 1888 and in about 1891, although the differing page numbers as given by Hitchcock may indicate that these contained new designs under the same title.

As we might expect, one can find dwellings actually constructed following plates in their *New Cottage Homes* of 1887. An instructive example is in Ambridge, Pennsylvania. It copies Design 126, a "one-and-a-half-story six-room cottage," for which they

provide a perspective view, front and side elevations, two floor plans, and on the facing page detail drawings for the bargeboard, shingle, and window treatment of the facade, the porch, and the chimney. As executed, the builder simplified the porch entrance arch and used a very different sort of bracket to visually support the front and the side bays—brackets of a more Italianate or mansarded type, rather than Queen Anne, probably because they were "in stock" locally. It is not clear whether the rear addition is original or later. Be that as it may, Design 126 has been carried out with remarkable fidelity to the Palliser design. If perhaps not "two to twenty buildings" in every city or town, a careful survey would undoubtedly turn up a very large number of modest Queen Anne houses that trace their design to a book by the Pallisers. Such houses still reflect the picturesque richness of noted touchstones of the movement such as Hunt's Griswold House of two decades before.

Such a modest house was still a creditable reflection of the custom-designed Queen Anne dwellings that by now had been popular for nearly a decade. A comparison of the Palliser design with a "country house near Cleveland" designed by the New York City architect W. A. Bates, as published in *The American Architect* on August 7, 1878, is instructive. Bates's design (which has six rooms on the first floor alone) is wonderfully picturesque in its massing; his use of varied materials and textures, the projecting bays and dormers, and the lofty paneled chimneys translate the country houses of Richard Norman Shaw into an American, and less palatial, idiom. The Pallisers continue this a step further, eschewing costly detail-work, but retaining in the composition, the arrangement of the roof planes, and the form of what detailing and shingle work is incorporated, much of

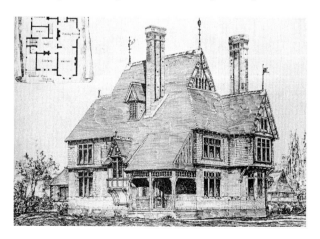

Fig. 170. AABN, August 7, 1878.

the Queen Anne style appropriate for a modest six-room cottage.

The Pallisers' "design by mail" service was distinctive, however. More common were companies or architects who provided a wealth of designs in their catalogs, for which prospective homebuilders could order plans and specifications and which they could have their local carpenters build. One of the most popular and prolific firms was The Co-operative Building Plan Association, founded and headed by Robert W. Shoppell of New York.[72]

R. W. Shoppell's Co-operative Building Plan Association

Probably inspired by George Palliser's mail-order plan service as set out in his *Model Homes for the People* (1876), Shoppell issued low-cost catalogs of a wide range of house designs, from which one could order drawings and specifications at reasonable rates. Unlike the Pallisers, Shoppell's business, from 1881 when he published his first catalog, *Artistic Modern Houses of Low Cost,* until 1907, was devoted entirely to producing plans for sale, with very little "custom designing" involved. From the beginning, the catalogs depicted a perspective illustration, plans, a description, and a cost estimate. From this, the prospective homeowner or builder could order the "working plans with complete directions, details, specifications, and estimates of quantities, at a fractional part of the charges made by architects,"[73] as Shoppell explained in his second book, *How to Build, Furnish, and Decorate* (1883).

The success of his third book, *Building Plans for Modern Low Cost Houses* (1884), encouraged him to inaugurate a quarterly publication to disseminate his plans more rapidly and broadly. *Shoppell's Modern Houses* began in January 1886 and ran for twenty-two years, until it became a monthly magazine (*Shoppell's Homes—Decorations—Gardens*), which did not sell mail-order house plans.[74]

In the first issue of *Modern Houses,* Shoppell explained the history and purpose of his organization:

> The Co-operative Building Plan Association is an Association of Architects. Its history is simply this: Four years ago Mr. Shoppell issued the initial number of a series of pamphlets, giving plans, perspective views, and descriptions of a large number

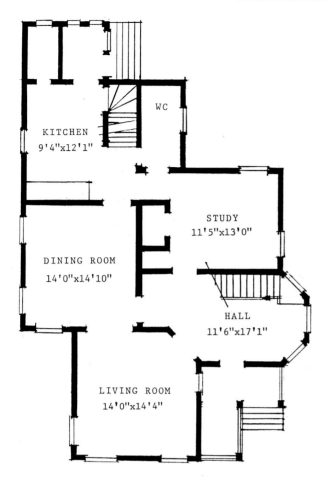

Fig. 178. Butcher House, plan.

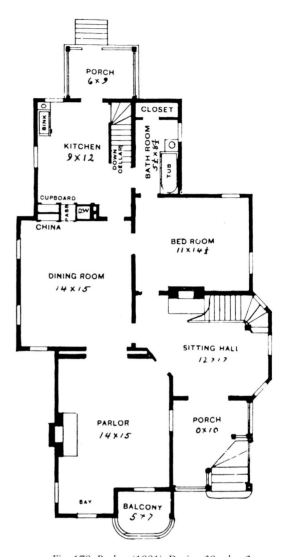

Fig. 179. Barber (1891), Design 39, plan 2.

and a sheet of color samples for outside painting." Barber confidently assured the client that "everything necessary for the builder is supplied."[93]

Naturally, some clients would want changes from the plans depicted in his book. As he noted: "In ordering plans, in which you would like slight changes, it is best to take the plans as they are and effect the change between yourself and builder, without additional cost. But if changes of importance are required it had better be left to us, for which our charges will always be moderate. Write for charges."

As he noted elsewhere in his catalog, "[W]rite us concerning any changes wanted in plans, and keep writing till you get just what you want. Don't be afraid of writing too often. We are not easily offended."[94] Clearly this was also the beginning of a "mail-order design" service, which had been popularized by the Pallisers and which he established along their lines with

a general questionnaire in 1892 and with a much-expanded version in 1898.[95]

Barber's *Cottage Souvenir No. 2* of 1891 also included (besides some stable/carriage house designs, a barn, a church, and a chapel, and some store fronts) a number of verandas, bay windows, gable ornaments, and interior details such as staircases and newel posts, for which plans too could be ordered, to be executed by local mill works or carpenters.

There were probably thousands of houses erected to Barber's mail-order designs; hundreds have been identified and located today.[96] An examination of a few less well known examples reveals just how such plans were actually used.

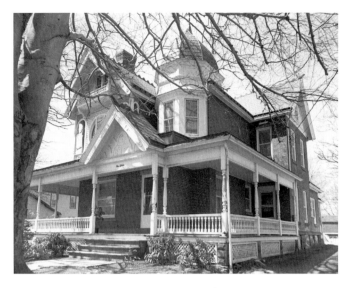

Fig. 180. Captain Storm House, Westfield, New York, 1896.

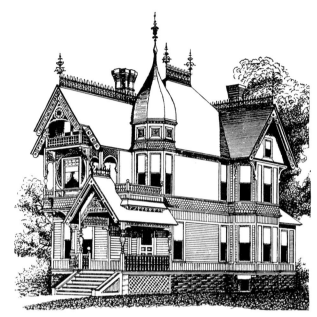

Fig. 181. Barber (1891), 72.

In 1895–96, a prosperous grape grower and farmer, Richard Butcher, erected Barber's Design Number 39 (whose plans cost $25) on his property a mile and a half south of Fredonia, New York.[97] He followed plan Number 2, which was the same as Number 1 except for a kitchen wing placed at the rear so that a ground-floor bedroom could be located beyond the stair hall. Comparing the plan of the Butcher House and Barber's published plan reveals that the local carpenters followed it quite closely, except for some minor interior partition changes, omitting two fireplaces,[98] expanding the kitchen three feet to the left, and eliminating the projecting facade bay. This latter change made the facade somewhat less picturesque in its silhouette and massing, but otherwise, as a comparison of the Barber view and an old photograph of the house reveals, the result was very close to the Barber design. Surely this is how countless Barber houses were erected—with the "slight changes" worked out between the owner and the builder.

The house is a distinctive if somewhat simplified version of the custom-designed Queen Anne dwelling, of about the same size, which had been published in *The American Architect* in 1878 (see Fig. 170). Thus although it is not quite as "up-to-date" as a local architect might have been able to achieve, it is still a well-thought-out design partaking of a significant national movement of the day.

A second Barber Queen Anne house, based on Design 33 in the *Cottage Souvenir* of 1891, can be found in Westfield, New York. It was built in 1896 by a local builder-architect, Harry E. Wratten, for Stephen

V. Storm, a ship captain.[99] It was based on plan Number 2, a slightly expanded version of Number 1; the plans cost thirty-two dollars. Although the Barber illustrations depicted the house as entirely of wood (except for stone foundations), he notes that this "very substantial and handsome" house "has recently been erected with the first story veneered with brick, second story and roof slated" [*sic*] and that prospective owners "can have it in the same treatment, or brick all the way up, either veneered or solid walls." Clearly there was a good deal of flexibility acknowledged for wall finishes.

Captain Storm decided to have this latter treatment—brick veneer all the way up, but there were still plenty of areas for the rich woodwork, paneling, and shingling, which gives the Queen Anne style much of its visual interest. An old photograph of the house (See Color Plate III), taken before the maturity of the magnificent beech tree that now hides much of the facade, shows that the elaborate woodwork of the Barber plans was followed carefully.[100]

What is interesting to note when comparing the plans is that the Storm House was expanded to each side by having the sitting room and dining room each lengthened about three feet; the front parlor, however, was shortened by two feet. The entrance had a small vestibule created, and the entrance porch was replaced by a veranda wrapping around the front portion of the house.

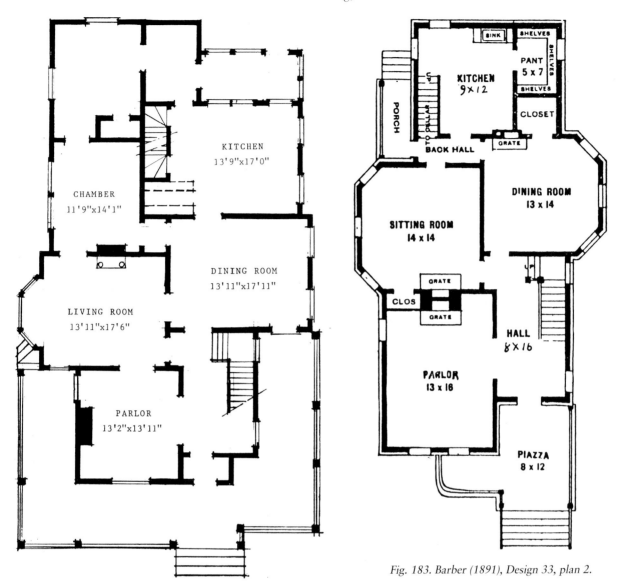

Fig. 182. Storm House, plan.

Fig. 183. Barber (1891), Design 33, plan 2.

Changes to the Barber plan at the rear were more drastic. The kitchen was moved directly behind the dining room, and two additional chambers were created behind the sitting room. Clearly builder Wratten used the Barber plans as a starting point for a house modified to meet Captain Storm's specific requirements; but except for the rear portion, he would not have had to make many changes to the Barber blueprints, and he seems to have followed the full-sized detail drawings for the trim with care.

A final example of a house built from designs in the *Cottage Souvenir* of 1891 can be cited from the far northern reaches of New York state, in

Gouverneur. The slight differences between the built example and Design Number 1 are probably also due to a local builder's "improving" the blueprints to meet the client's needs; there is no alternative plan provided by Barber.

In 1892, Barber published a new edition of his popular book: *The Cottage Souvenir, Revised and Enlarged, Containing over Two Hundred Original Designs and Plans of Artistic Dwellings.* Like the *Cottage Souvenir No. 2*, this was widely advertised, so that it too received national exposure. Design Number 27, depicted in one such ad, was an especially popular Barber house, and examples of it are found in as

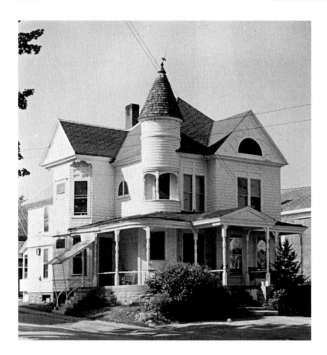

Fig. 184. House in Gouverneur, New York.

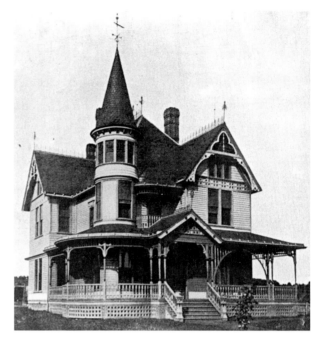

Fig. 185. Barber (1891), 14.

widely separated locations as Ottawa, Illinois, Eau Claire, Wisconsin, and Calvert, Texas.[101] A fourth version is found in Meadville, Pennsylvania.

George M. Roueche, who had a dry goods and hardware store in Meadville, purchased the lot in 1889 and had his Barber house erected in 1892. An old photograph of the house, which shows it from the side and with all its original cresting, reveals that it seems to have followed the Barber plans exactly—although reversed, as it sits on a corner lot with the side street to the right.[102] The richness of surface textures (fish-scale shingles, clapboards, pebble dash, turned and carved woodwork) and the variety of materials (the sculpturesque chimney alone is composed of pressed brick, cut and carved stone, and molded brick) complement the complex interplay of shapes and volumes that make such Queen Anne dwellings so vividly picturesque.

It should be emphasized that none of these houses, based on designs of the early 1890s, despite their having "duplicates" elsewhere in the country, came as precut "kits" shipped from the factory ready to assemble. This idea was probably engendered by the fame of the Jeremiah Nunan Mansion in Jacksonville, Oregon, a Barber house that indeed *was* shipped to Oregon in 1892 from Tennessee in fourteen boxcars, "precut, partially assembled . . . with drapes, carpets, plumbing, lights" and with a foreman from Barber's office who hired local workmen to erect the building.[103] Michael A. Tomlan has examined this

"prefabrication" issue and has discovered that "measurements taken on different buildings of specific details which at first glance appear identical repeatedly reveal considerable differences in craftsmanship," as one would expect of carpenters following the same working drawings. "Only on occasion, with a more elaborate design or in a particularly remote area did [Barber] or a member of his firm supervise construction."[104] Certainly the Nunan Mansion was one of these exceptions.

By at least 1902, however, Barber *was* supplying not only house plans, but also the building material—an approach that was to grow rapidly in popularity in subsequent decades. In Barber's *Modern Architectural Designer* (Knoxville, 1902), he states on page 181 that "we will give price at which all the material will be furnished and delivered for building," and ads by builders in the rear advertising section of his books from this period include notices that they "have built many of the finest homes in various parts of the country using plans and materials of Geo. F. Barber."[105]

It should not be surprising, of course, that by 1902 one could buy all the material to go along with the purchased plans. The idea of prefabricated houses (where the material was not just supplied but was already precisely cut so that it could be easily fitted together) was pretty well known by the end of the nineteenth century. A brief look at this form of housing puts this development in context.

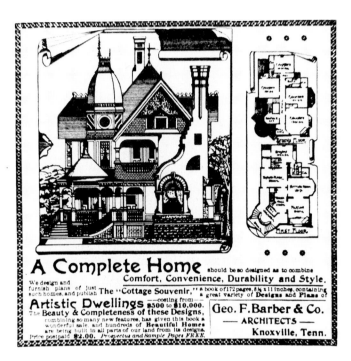

Fig. 186. Advertisement for Barber's Cottage Souvenir
(1892 ed.), from Harper's Weekly.

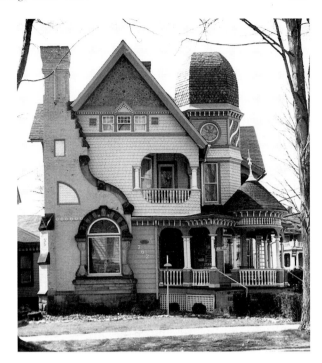

Fig. 187. George M. Roueche House, Meadville,
Pennsylvania, 1892.

During the second half of the nineteenth century, several companies in the United States manufactured "portable" and "sectional" houses, which could be shipped and set up easily—and some of which could be demounted with equal ease, it was claimed, and re-erected elsewhere. Such houses (which tended to be small) were made for shipment to California in 1849–50 during the Gold Rush, for use in the Civil War, and for vacation cottages during the 1870s and 1880s, but they were hardly the size of a Barber house. Those in the 1862 Skillings and Flint catalog of "Portable Sectional Houses" ranged from $125--$650.[106]

Twenty years later, such dwellings were apparently not well known to the architectural profession. For a letter of inquiry about "portable houses" to *The American Architect* in 1882, the editors could provide the names of only two firms (The Portable House and Manufacturing Co. and The Adjustable Building Company), both in New York City. Four months later, the editors addressed the issue of not being able to locate such concerns: "The most frequently repeated of all the many questions which we receive—one which we have become weary of answering—is the inquiry where the sectional or portable buildings . . . are to be procured. Our correspondents alone, for the last four or five years, supposing them to order one house each, would have kept a considerable establishment fully

occupied, and we hope that any persons undertaking such business, for their own benefit as well as ours, will keep us informed of their whereabouts."[107]

Within a year, the Portable House and Manufacturing Co. of New York began publishing illustrated ads in *The American Architect* advertising section; later the E. F. Hodgson Co. was founded in Boston and in 1892 began producing sectional cottages.[108]

Barber's Nunan Mansion and his houses of the early twentieth century were clearly not this type of dwelling, even if the concept of "factory-built houses" played a role. What we see rather is the use of precut materials, from a lumber mill or factory, which would be assembled at the site in the traditional manner. This concept also traces its development to this period; two cases can be cited.

Apparently in the mid-1860s, Col. Lyman Bridges began manufacturing "ready-made houses" in Chicago, exhibiting one of his creations at the Paris Exposition Universelle of 1867. It was standard balloon-frame construction, but came as a "complete package," including "the sills and everything above them," with all "finishing lumber dressed, ready to be fitted together" and all the components ("doors, door frames, glazed sash, steps, stairs, brackets, railings, trimmings, locks, knobs, hinges, screws, nails, [even] chimney and flues") ready for assembly, according to an 1870 catalog.[109]

Fig. 188. AABN, *December 1, 1883, Advertisers*
Trade Supplement, page 3.

This was not an uncommon practice of the day. Carl R. Lounsbury describes the manufacture of "knock-down" buildings in North Carolina, in the context of the mechanization of the building industry, between 1856 and 1885. By 1872, one Raleigh woodworking shop had forty men "who made the frames, doors, windows, and flooring and assembled the buildings," which were sold "to farmers and others at less expense to them than they could be sawed and built by hand work." In 1885, a visitor at Raleigh's North Carolina Car Company observed that "house building is and has been one of the specialities of the company, and this speciality consists in making and framing a building of any dimensions (the larger the better) and placing it aboard cars or wagons, ready for any intelligent carpenter to set it up."[110]

One of the best-known "knock-down" houses of this period is the Miller Cottage at Chautauqua Institution in western New York state. Lewis Miller, the co-founder of Chautauqua in 1874, was an inventor, industrialist, educator, and philanthropist from Akron, Ohio, 135 miles to the southwest. To provide a place for himself and his family to stay at Chautauqua each summer, he had the attractive Stick Style dwelling precut in Akron and shipped north; the walls are

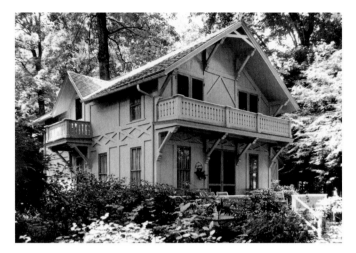

Fig. 189. Miller Cottage, Chautauqua Institution, 1875.

actually one board thick, with the X-bracing on the exterior surfaces part of its structural system. It is said that Miller designed the house himself—which would be perfectly logical, for not only was he a gifted inventor (he made his fortune in farm machinery and had more than 150 patents to his name), but his father had been a part-time housebuilder as well.[111]

His semiprefabricated cottage was a rarity at the time. It would be some years yet before cutting all the lumber for a house in a factory and shipping the package to the site became at all common.

Prefabricated Architectural Components

During these decades, the ubiquity of building *components*, such as doors and door frames, windows, blinds, mantels, brackets, staircases, and other such complex features, which could be best made in a factory by special machinery, is a phenomenon we should briefly explore. Many a Barber house, whose plans had come from Tennessee, had mantels and detailing that had been made in cities far from Knoxville or the building site.

We have already glimpsed in passing the occasional use of previously constructed architectural details, which were then inserted into dwellings. Among the earliest examples were the fireplaces, both wood and stone, as well as the exterior door casings, for Westover, in Virginia, from the early 1730s. An interesting case from the late eighteenth century is the Federal-style fireplace, decorated with the *Triumph of*

Mars panel, in the dining room of Bulfinch's Harrison Gray Otis House, Boston, of 1795–96. Another fireplace with the identical frieze relief is also found in Boston, but in a house not by Bulfinch, and it is now thought that both mantels were imported from England.[112] Because the *Triumph of Mars* can also be found on a mantel in a 1797–1804 house in Delaware as well as in an old house in Canterbury, England, which was renovated in the late eighteenth century, it seems certain that all four were, ultimately, from a central (probably London) source, sold either as "compo" details ready to apply or as made-up mantels, and exported for use in the provinces.[113]

Although the sale of preconstructed architectural elements can be found in the early nineteenth century (such as an elaborate porch in New Bern, North Carolina, which was imported from New York in 1818),[114] it was after the Civil War that factory-made building components became common.

A glance at the entries in Lawrence B. Romaine's *Guide to American Trade Catalogs 1744–1900* for building materials catalogs tells us a good deal about the market for manufactured components in the later nineteenth century. Although some of the 296 trade catalogs he cites are for products such as cement, structural ironwork, bridges, and nondomestic items, a very large number advertise elements that could be introduced into houses: doors, window sash, shutters, and blinds; fireplaces and mantels; moldings (in wood as well as plaster) and wood turning; molded brick; "wood carpets" (veneer parquetry); "fretwork, grilles and screens"; balustrades, staircases, railings; roofing materials; and terra-cotta (chimney tops and tiles). Romaine lists 11 catalogs from the 1850s (the earliest dates); fourteen from the 1860s; and 30 from the 1870s. The next two decades show the great proliferation of manufactured building components: 107 catalogs from the 1880s and 105 from the 1890s! (He cites only 31 after 1900, the cutoff date of his compilation.)

Some of the catalog contents show how varied and rich was the manufacturing cornucopia for a local builder who might want to order professionally designed and constructed features, as a sampling reveals. The c. 1868 catalog of the Wesley M. Cameron Company in Cincinnati advertised "window frames, mantels, pilasters, columns, . . . flooring, [and] . . . prefabricated stairs complete with rail and newel post for shipment to any point." The c. 1875 catalog of Mills & Spelmire Mfg. Co. (also of Cincinnati) sold "mouldings, doors, sash, blinds, frames, etc." and included nearly five hundred items. In 1882, Johnson & Hurd of Minneapolis issued an illustrated price list

for "sash, doors, blinds, mouldings, window frames, stairs, newels, balusters, and railings." From the 1891 catalog of Charles A. Millen & Co. in Boston, one could order "mouldings, builders' trimmings, stair rails, posts, balusters, and mantels."

This review shows the wide range of manufactured materials available to builders and carpenters. Mantels and fireplaces were among the most commonly offered items—Romaine lists twenty-seven catalogs specifically mentioning them, and many other firms certainly carried them as well. If one wished to order iron gates, railings, posts, window caps, cresting, steel roofing, siding, or ceilings, catalogs were available for these too.

I earlier noted in passing this "components by mail" business in my discussions of Hussey's *Home Building* (1875) and *Palliser's Model Homes* (1876), both of which contained ads for building elements. The suppliers advertising in Palliser (24–44) were quite specific about their willingness to ship goods anywhere. A manufacturer of slate and marble mantels noted, "[G]oods shipped to any part of the United States"; a sash, blind, door, and molding factory (which also produced stair rails, banisters, and window frames, and "scroll and fancy sawing, turning, carved work, brackets, verandas, columns, and trimmings") stated, "[O]rders filled in any part of the country"; and even a Bridgeport wholesale and retail lumber dealer (who also did sawing, planing, and matching) proclaimed that "having unsurpassed transportation facilities by water and rail, we can fill orders in any part of the country at short notice and at lowest prices." From Romaine's list, we can see that such companies of the 1870s redoubled their efforts at a national market in the 1880s and 1890s, with the aid of catalogs.[115] The Interior Woodworking Co. of Chicago (not in Romaine) solicited business through the professional press; an ad in *The American Architect and Building News* for April 14, 1894 (xiii), illustrated one of their mantels and stated: "Wood Mantels, 100 Different Designs, Prices from $25 to $400 . . . Send for Catalogue."

Professional architects (in Boston at least) seem to have taken a dim view of the widespread use of factory-made elements. The editors of *The American Architect and Building News*, in a September 1878 review of a pattern book of the day, complained: "The designs in this book are the commonplace results of adapting machine-made double-hung sashes, machine-made doors and blinds, machine-made mouldings and details, to elevations which, for the most part, pretty readily grow out of plans adapted . . . to the needs of

frugal country people . . . whose habits of living are adjusted to a very small scale of expenditure."[116]

Many architects and builders found these catalogs essential to their work, however. One unfortunate firm in Akron, Ohio, whose office and "nearly all its contents . . . drawings, etc., the accumulation of years of study and experience" were "consumed in the great fire here," wrote to *The American Architect* in 1886 for help: "Will you please put a line in your paper, stating that, with our other effects we lost all, or nearly all our collection of catalogues, and would be thankful if manufacturers and dealers in our class of goods would mail us copies of their catalogues."[117] Of course, once *on* a manufacturer's mailing list, such publications often just kept coming. Two-and-a-half years after the death of the Texas architect Henry C. Holland, a friend of his wrote to *The American Architect* (November 6, 1897, 52) to complain that since Mr. Holland's death, "I have been almost daily loaded with letters, circulars, etc. . . . [from] publishers, dealers, etc." and asked the editors to insert a notice of Mr. Holland's demise, to stem the flow of trade literature.

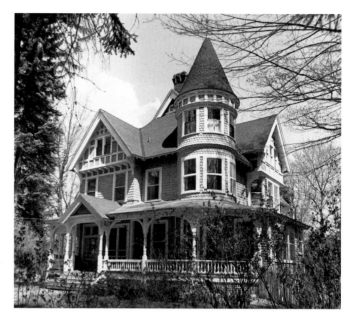

Fig. 190. Sauer House, Cooperstown, New York, 1892–93.

Scientific American House Designs

Attractive designs for Queen Anne houses with corner towers were available from many other sources besides Barber's catalogs. *The American Architect* occasionally depicted them, as for example on September 15, 1883, or on February 8, 1896. Another source, also a journal, which seems to have been especially influential, was *The Scientific American Architects and Builders Edition;* it appeared monthly from 1885 until 1905. Besides articles on all manner of topics of interest to "architects, builders, constructing engineers, and contractors," each issue had two buildings and their plans illustrated in color, with specifications and descriptions also provided. Most were dwellings already erected, so that the location and architect were provided.[118]

These large and handsome plates certainly provided enough information for a local carpenter to make a duplicate on his own. We can look at two or three cases where builders in small towns did just that, suggesting that this journal, which had a very wide circulation, was also a significant aid in introducing up-to-date and stylish dwellings in villages and towns without architects of their own.

William H. Michaels, who had established a meat market in Cooperstown, New York, in 1880, prospered

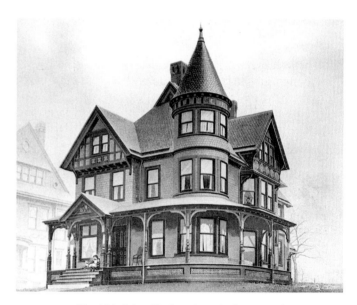

Fig. 191. Scientific American Architects and Builders Edition, May 1891.

sufficiently to build his own commercial building in 1886 and his impressive dwelling six years later. It was begun on April 26, 1892, and completed January 8, 1893, and is said to have cost six thousand dollars.[119] As the comparison shows, it is a duplicate of a house designed by the architect Joseph W. Northrop in Bridgeport, Connecticut, and reproduced in the May 1891 issue of the *Architects and Builders Edition*. Except for minor details, it follows the model with astonishing precision.

features, and these were reprinted in Downing's *Rural Essays* (1853).[5]

Probably the most famous popular publication of the day containing architectural designs was *Godey's Lady's Book and Lady's Magazine*. According to George L. Hersey, between 1846 and 1892 the magazine published about 450 house designs![6] Other popular periodicals also included house plans. In a review of H. Hudson Holly's *Modern Dwellings in Town and Country* (1878), it was observed that "the greater part of this book . . . appeared in *Harper's Magazine* two years ago."[7]

Fortunately, the impact of published plans in popular periodicals can at last be studied. Margaret Culbertson's recent thorough examination and indexing of thirty-four such periodicals (including *Godey's Magazine* in its various forms) published between 1850 and 1915 turned up more than 6,500 house designs, by more than 2,000 architects and designers—confirming again the importance of the printed page for disseminating house designs.[8]

Professional Architecture Journals in the United States

Most designs for houses and other buildings appeared of course in the professional press devoted to building and architecture.[9] Even before the establishment of American journals, foreign periodicals were available and were read by some American architects. England had a wide variety to choose from. J. C. Loudon's *Architectural Magazine* (published in 1834–39) was about the earliest; *The Builder*, published in London beginning in 1842, was popular throughout the century, as was *Building News* (begun in 1854). Later came the *Architectural Association Sketchbook* (started in 1867) and *The Architect* (begun in 1869). Even without a knowledge of foreign languages, Americans could derive much important visual information from journals such as the *Revue générale de l'architecture* (Paris, 1840–90), the *Architektonisches Skitzzenbuch* (Berlin, 1852–86), and *Croquis d'architecture* (Paris, 1866–98).

A brief review of the better known American journals or those with more than just local circulation emphasizes the wide variety of periodicals available to craftsmen and architects who wished to keep abreast of news, designs, technical information, and other data.

Just as in agriculture, craftsmen—"mechanics"—had their own journals in the early nineteenth

century, and on occasion they would include items such as architectural history, as did the *Mechanics' Magazine* (New York, 1833–37), which in 1834 published an account of ancient and medieval architecture.[10] What the editors of *The American Architect and Building News* called "perhaps the earliest of American architectural journals" dates from 1847 and was entitled the *American Architect*. Published monthly in New York, it went through more than twenty issues and contained lithographed views of houses and descriptive text.[11]

A dozen years later, *The Architect's and Mechanic's Journal* (New York, 1859–61) appeared as a full-fledged architectural periodical.[12] Inspired by *The Builder* of London, it included illustrations of buildings and extensive discussions of all aspects of construction. As the masthead proclaimed, it was intended for "the architect, machinist, builder, carpenter, decorative artist, and real estate owner." Publication ended with the onset of the Civil War, and the next periodical to appear was *The Architectural Review and American Builders' Journal* (Philadelphia, 1868–70), a monthly. Edited by Samuel Sloan, it included illustrations of current building of the day and also numerous articles on topics such as architecture, engineering, some architectural history, landscape gardening, and decorative and fine arts.[13] Book reviews and advertising appeared in it as well.

That same year, 1868, the *American Builder and Journal of Art* was founded in Chicago, although it moved to New York in 1873 (becoming simply the *American Builder*; it merged with *Illustrated Wood Worker* in 1880). It was oriented to builders and carpenters as well as architects and included all aspects of building. Another periodical founded in the 1860s was *The Manufacturer and Builder* (New York, 1869–97), subtitled "a practical journal of industrial progress." Thanks to the mailing list of the editor's other journal (on mining), *The Manufacturer and Builder* reached 10,000 subscriptions after only four issues! Illustrations of architecture were included, but construction matters were its main focus.

The American Architect and Builders' Monthly (Philadelphia, 1870–71), "a journal devoted to architecture and art generally," was inspired by Sloan's periodical, but had an even shorter life, lasting less than a year. It contained news on architectural and building activity in major cities, articles on architectural (and some nonarchitectural) matters, illustrations, and advertising. A slightly different format was employed by both *The Architectural Sketch Book* (Boston, 1873–76) and *The New York Sketch Book of Architecture*

(1874–76). Published monthly, each illustrated designs by leading architects in their respective cities. They were "essentially portfolios of contemporary buildings, travel sketches, and historical work,"[14] with little written text.

One of the most influential of such journals, *The American Architect and Building News*, was founded in Boston in 1876; its offices moved to New York in 1904 (and in 1938 it was absorbed by *The Architectural Record*). Its main audience was architects, but there was much, especially in its early years, for the builder and contractor as well. Like many of the previous journals, it included a wide range of contents: illustrations of contemporary (as well as historic) architecture, current "business news," technical articles, architectural history, book reviews, advice on architectural training, and numerous other topics—as well as ample advertising. By about 1890, it had a circulation of 7,500—and most of the 8,070 architects (or their firms) listed in the U.S. census of that year undoubtedly subscribed to *The American Architect and Building News*.

One of the most successful periodicals of these decades, which was oriented to "members of the principal manufacturing and building trades,"[15] was *Carpentry and Building* (New York, 1879–1910). Articles on "practical carpentry" and masonry, roofing, construction in general, and architecture were included; it had a very wide circulation among craftsmen as well as architects. In 1890, its circulation was about 20,000.[16]

The west coast was finally represented by a major periodical with *The California Architect and Building News* (San Francisco, 1879–1900), modeled on *The American Architect and Building News*. Another journal founded beyond the east coast in these years was the *Cincinnati Building Review*, also begun in 1879.

Periodicals that catered to craftsmen, not just architects, seem to have had the greatest popularity. The *Builder and Woodworker* of New York (which had absorbed the *American Builder* in 1880) prospered for many years; in 1890 its circulation reached 8,000, although it ceased publication in the depression of 1893. Another journal founded in the early 1880s was *Building* (New York), begun in 1882. Reflecting the widespread distribution of architects by then, the next major periodical to be established was in Minneapolis—the *Northwestern Architect and Improvement Record* (1882–94). In the same year, yet another New York City journal appeared, *Architecture and Building* (1882–99).

In the following year, one of the most important "regional" journals (it was to have a national impact)

was begun—*The Inland Architect* (Chicago, 1883–1903), and 1883 seemed to be the annus mirabilis for professional journals. *The Builder* (Holyoke, Massachusetts), *The Northwestern Improvement Record*—which in 1885 changed its name to *The Northwest Architect and Improvement Record*—(Saint Paul, Minnesota), *The Journal of Progress* (Philadelphia), and *The Building Trade Journal* (Saint Louis) were all founded in that year, with *The Builder and Manufacturers' Journal* (Pittsburgh) appearing in 1884. All of these, as *The American Architect and Building News* noted, "In one way or another endeavor to educate the building classes."[17]

In the following year, the *National Builder* (city not given) was launched, with great fanfare; its first number even included "a colored plate . . . showing, in plan and elevation, a wooden dwelling-house" and also "a sheet of details on manilla tissue paper."[18] More significant was the inauguration of the *Scientific American Building Monthly* (begun as the "Special Trade Edition" of *Scientific American*), which featured technical articles, numerous illustrations, and color plates as well. It ran from 1885 through 1905.

Other journals begun in the 1880s include *Architect and Builder* (Kansas City, 1886–1907); *Architectural Era* (1887–93), "an architectural journal devoted to architecture, building, decoration, and the kindred arts," founded in Syracuse, then moving to New York and then Philadelphia; and Bicknell and Comstock's *Modern Architectural Designs and Details* (New York, 1887–90), intended to be "useful in the practical work of an Architect or Builder." Its first volume (1887–88) was actually a reissue of Comstock's book of the same name, which had been published in 1881. In Atlanta, the *Southern Architect* began publishing in 1889, and in Denver, the *Western Architect and Building News* (1889–91) appeared. We also recall that *Shoppell's Modern Houses* (New York, 1886–1904), "an illustrated architectural quarterly," also started at this time, published by Shoppell's Co-operative Building Plan Association as a vehicle for selling his mail-order plans, although it did have some articles on other architectural matters, landscaping, and interior decoration.

The great number of journals begun during these years was cause for editorial comment in 1888 by *The American Architect*: "The announcement of the approaching birth of some new architectural or building periodical . . . fills us each time with a mild astonishment"; the editors asked, "How far is it safe to carry the mania for establishing new journals of nearly identical character, and all looking for support to the same

profession and trades, and to the same set of advertisers?"[19] Although not all the publications survived to maturity, by 1890 a large number of trade periodicals were available, as *The American Architect* editors observed: "Looking over the 'directory' just issued by an advertising agent, we counted this week, a list of *fifty-five* journals under the heading 'Architecture, Building, and Real Estate.'"[20] They went on to point out that the *Architectural News*, "a ten-page monthly published in San Francisco," appeared to be the latest of these many periodicals, and they jocularly commented that "[i]f the present birth-rate waxes and does not wane, some future writer on architecture will record that 'In the United States all architects are divided into two classes, those who edit professional journals, and those who do not; the first class greatly outnumbers the second.'"[21]

In contrast to this flood of publications in the 1880s, the 1890s saw far fewer new journals. *The Architectural Record*, founded in New York in 1891 as a quarterly, was intended for both architects and the interested layman and included extensive articles on architectural history, architectural education, and kindred matters. Also from the 1890s dates George F. Barber's monthly *American Homes* (1895–1904), "a journal devoted to planning, building, and beautifying the home." Established in Knoxville, it moved to New York in 1902. Although its real aim was to promote his mail-order plan (and ultimately precut house) business, Barber also included articles on "suburban life in general" and "on furniture, drapery, [and] gardening," as well as "serialized romances."[22]

As if this vast cornucopia of journals for architects, builders, and craftsmen was not enough, specialized foreign journals were readily available, too. In 1888, in response to a student's inquiry about the names of leading non-English journals, *The American Architect* editors observed that the "*Revue Générale d' Architecture; Moniteur des Architectes; Encyclopedie d' Architecture; Bulletin Mensuel de la Société Centrale des Architectes; La Semaine des Constructeurs; La Construction Moderne*, all of Paris; *Deutsche Bauzeitung*, Berlin; *Weiner Bauindustrie Zeitung*, Vienna; *Architectonische Rundschau*, Stuttgart; *Zodtchy*, St. Petersburg; are among the most important."[23] Although many subscribers undoubtedly studied such works only for their illustrations, others read foreign publications with care. In response to an inquiry in *The American Architect* about what the German building material Xylolith was and who manufactured it, a reader in Phoenixville, Pennsylvania, pointed out that "an article descriptive of the material" could be found in the January 4, 1896, issue of the Leipzig *Illustrierte Zeitung*.[24]

Finally, by the 1880s and 1890s, students in American architecture schools were also publishing their best class work. The *Technology Architectural Review* (Boston, 1887–90) showcased the drawings of students at Massachusetts Institute of Technology,[25] and students at Cornell University and the University of Pennsylvania produced yearbooks of their work in the 1890s.[26]

Americans involved in design and building thus not only had access to a large number of American architectural books (nearly three hundred new titles published between 1861 and 1890 and innumerable older volumes reissued) as well as foreign titles, but the periodical press was overflowing with relevant journals. Although some were short lived, I have cited thirty-one periodicals, published after 1860, which contained an enormous amount of material in supplement of available books—to say nothing of the seventeen foreign journals mentioned that could be consulted too.

The American Architect and Building News Between 1876 and 1901

The only way to get a good sense of what these journals included and how they might have influenced design during the last quarter of the nineteenth century is to review the contents of one of them in depth. I have selected *The American Architect and Building News* because it was long lived and contained a wide range of material appealing to builders, aspiring architects, and established professionals. I have already noted its relevance in the previous chapter. Data from a review of its weekly issues between 1876 and the end of 1900 provide a good cross-section of what its—and the profession's—interests were during this period of rapid technological and professional change.[27]

Founded in Boston, *The American Architect* began publication January 1, 1876. Throughout the next twenty-five years, many features of concern to builders and architects are consistently investigated and discussed, from building technology and construction methods, professional training and practices, to book reviews and excerpts, articles, and illustrations on current American building, historical illustrations and studies, and consideration of foreign architecture—to say nothing of building news and events and ample

advertising. Because of its location in Boston and later in New York, architects in these cities naturally received fuller coverage than did those in other areas. Yet the journal attempted to be national (and later in the nineteenth century, international) in scope and was read nationwide. For example, during a two-and-a-half month period in 1884, letters to the editor came from the northeast (New York, Massachusetts, Connecticut), from the south (Maryland, Delaware, Georgia, Missouri), the midwest and southwest (Ohio, Iowa, Illinois, Nebraska, Michigan, Minnesota, Kansas, Texas, Wyoming, and the Dakota Territory), and the west coast (California and Oregon).[28] Although the focus on topics varied over the period from 1876 through 1900, a number of subjects were of consistent interest.

New Technology and Construction Methods

As one might expect, new technology was often featured to introduce subscribers to the latest developments in the building field. Plumbing was a subject repeatedly discussed. The earliest treatment was the series "Modern Plumbing," which began in 1878 and ran for many issues; another series, "Recent Modifications in Sanitary Drainage," commenced the following year; in 1882, there appeared "Notes on House Drainage" and the twenty-one part series (by none other than Glenn Brown), "Water Closets," which included their history as well as modern technology.[29] "Sanitary Plumbing" ran for more than thirty installments in 1883–84; at the end of the decade, the journal published the series "The Water Supply of Buildings" in 1887.[30] The next major article did not appear until 1893 with the "Review of Recent Plumbing Practices," which was capped in 1897 by an impressive "Bibliography of House Drainage, Plumbing Work, and Sewage Disposal for Houses" of six full columns, including citations of books, pamphlets, and papers in scientific journals. Finally, in 1899, a series that reviewed "A Half Century of Sanitation" appeared.

Although not as extensively covered as plumbing and drainage, at least eleven articles or series focused on electricity. The first was "Electrical Progress in America," of 1885; followed by an article reprinted from The Builder, "The Prevention of Fire Risks from Electric Lighting," in 1886 and "The Safe Installation of Electric Wires" in 1889, followed in 1890 by the series "The Dangers of Electric-Lighting." By now, electrical work was more common, as reflected in the 1894 series "Electrical Science for Architects" and another series, the "National Electric Code," in 1897.

Not surprisingly, builders and architects wanted information on traditional aspects of construction and any improvements to them as well. A number of items in 1881–82 debated the merits of the balloon frame, often in the form of letters from subscribers (such as "The Stanchness of Balloon-Frames")[31] although as late as 1886 a letter requested information on both balloon framing and traditional wood framing methods.[32] Wood in general, as a building material, also came in for attention. "Some Practical Notes on Building Woods" of 1882 (reprinted from The Builder), the series "Transverse Strength of Timber" of 1883–84, and the series "Better Wood Construction" of 1892 are representative. Tests on timber by the U.S. government in 1893 were also reported on.[33]

Especially in the early years, articles on masonry were prominent, such as the series "Building Stones" of 1881, "The Cause and Prevention of Decay in Building Stone" of 1885, and the series "Some General Observations on the Strength and Stability of Masonry" begun in 1888. Other articles focused on building materials generally, such as "The Porosity of Building Materials" in 1880 and the series "Building Materials" of 1887; these were augmented by more specialized articles such as "The Theory and History of Cohesive Construction" in 1889 (on Guastavino arches and domes) and "Testing Fireproof Arches" in 1891. Occasionally, other construction topics were touched on, such as "A Few Words on Foundations" in 1883, "Chimney Construction" in 1884, "Principles of Domestic Fire Place Construction" in 1886, and "Brick Veneered Building" and "Fireproof Construction" (by P. B. Wight), in 1893. Except for the latter item, all these had direct relevance to house building, the main source of commissions for most architects reading the journal. Toward the end of the century, when the contents of The American Architect leaned more heavily toward major building—a larger percentage of schools, office buildings, churches, commercial structures, mansions, theaters, apartment buildings, and the like— the articles were of less interest to builders and architects in more traditional domestic work and more relevant to architects and firms undertaking large projects. "The Use of Structural Steel" of 1889, the series "Strains in Compound Frame Structures," begun in 1894, and "Aluminium [sic] as a Material of Construction" in 1899 would have little appeal to the domestic architect.

Many of these aspects of building were also included in numerous articles that provided a more integrated approach. For example, the long series,

"Building Superintendence," of 1881–83, was full of important technical information, as was the series of fifty-two articles titled "Safe Building" of 1886–91.

New materials fascinated readers of *The American Architect*. Plasterboard, first mentioned in a letter of 1888, was discussed during the next several years.[34] By 1893, an advertiser claimed that "plaster boards" could "take the place of lath and plaster," were "cheaper, better, lighter, [and] tougher than plaster," and not only would not crack, but were "perfectly dry [and] everlasting."[35] A new material, which did not survive to our own day, was "straw boards," despite their apparent durability.[36]

Concrete and Cement

As one might expect from the popularization by Orson Squire Fowler of mass concrete construction for houses in the 1850s, this material was given frequent coverage. Several articles or series dealt with it: "Concrete Building" of 1876, "Concrete as a Building Material" in 1885, an English series on concrete reprinted the following year, and "Concrete Construction" of 1891. Articles focusing on specific technical aspects of concrete were also included, such as a discussion of the proper mix for concrete, "of vital interest to architects," in 1896,[37] the article, "The Compressive Strength of Concrete," in 1899, and "Experiments to Determine the Effects of Freezing on Concrete" in 1900. Articles on special uses of concrete were included, too, such as "Constructional and Decorative Concrete" of 1882 and "Concrete in Foundations" and "Concrete Floors and Paving," both in 1884.[38]

Cement was also given ample coverage, beginning with "The Adhesive Strength of Portland Cement" and "Report on 'Cements'. . . to the Commissioners of the District of Columbia 1882," both of 1883, "A New Method of Manufacturing Portland Cement" of 1884, "Cements" in 1885, "Natural and Hydraulic Cements" of 1887, and in 1900, an article on the growth of the use of cement in the United States.[39] Books on cement and concrete were also among those reviewed by the journal for its readers.[40]

Forests and the Timber Supply

The price of lumber in the United States had doubled in 1870 from its pre–Civil War prices; and as readily available supplies slowly diminished, the price crept upward over the years—although only between 1910 and 1920 did a dramatic price surge (increasing by a factor of about 3.5) take place.[41] Concern with the timber supply, vital for domestic construction, was reflected in the close watch that *The American Architect* kept on this matter. White pine was the journal's main concern. "The White Pine Supply" appeared in 1882, "The White Pine . . . Nearly Extinct . . ." in 1897, and "The Waning White Pine Supply" and "The Future of the White Pine Crop," both in 1899. Other articles dealt with timber forests in general, such as "The Forest Supply in the U.S." of 1885, "Forest Growth and Timber Consumption" of 1893, "Wise Action in Pennsylvania, " a report of 1897 in regard to the forests, and in 1899 "Some Provisions of the Minnesota Forest Preserve Act." The editors also reported in that year on the supply of spruce ("still the common wood for framing"); tree owners found it more profitable to sell it for use as paper, which brought in more than four times as much as when it was sold for lumber.[42]

Obviously, reforestation and management were essential, and not only did the editors urge this approach, but they reported on the movement as well. "The Government's Attempts to Preserve the Forests" in the east were discussed in 1897, "The Minnesota Tree-Planting Bounty Law" and "The Need for Reforestation" were included in 1898, and a series "Forest Management in Maine" was begun in 1899. New Hampshire's "Forest Renewal" was highlighted the next year.[43] The lumber industry itself was examined in an article of 1882, the "Census Statistics Concerning Lumber" in 1891, and even "improvements" to lumber were reported, such as methods of fireproofing and preserving wood in 1899.[44] The establishment of "The New Yale School of Forestry" noted in 1900 was clearly a salutary development for protecting the diminishing supply of building timber.

Self-Education in Architecture

Before the establishment of schools of architecture in the United States (beginning in 1865), there were really only two ways for a person to become an architect without going to study in Europe: to apprentice as a craftsman (usually a carpenter) and then study books and journals or to work for an established architect, usually as a draftsman, and learn by doing and observing. As the editors of *The American Architect* commented in 1876, "A few years ago it was difficult to give satisfactory advice to a young man in our country who wished to become an architect. There were no architectural schools in the United States; no common understanding of what an architect's train-

ing was; and few such appliances as books, photographs, and drawings, to aid in it. For those who could not go to Europe to study—of course very few could—there was no resource but to go into some architect's office, and learn what could be got from routine-work there."[45] With several schools of architecture to choose from, however (Massachusetts Institute of Technology's program was begun in 1865, that at Cornell in 1871, and those at the Universities of Syracuse and Illinois in 1873),[46] the editor's advice was invariably to "go first to a professional school, and do not trust what you can learn in an architect's office. The standard of respectable professional attainment is much higher than it was a few years ago, and it requires much more effort to attain it."[47] A few years later, they were willing to admit, however, that apprenticeships in an architect's office had some value, although schools were still paramount for the modern architect: "We think it decidedly best in such cases that a pupil should attend a professional school. There are many things essential to an architect's practice which must be and are learned by study in offices; but there are others which he can learn to much better advantage in a well appointed school."[48]

During the next decades, the editors consistently recommended attending architecture schools as the best mode of training.[49] Many in the United States, however, could not afford this, and the numerous letters over the years from all parts of the country requesting information about what books to study to become an architect attest to the continuing importance of self-education in America.

The editors' replies to these queries provided a wide range of titles in articles such as "Books for Beginners" and "Books for Students"; they also advised "How to Study Architecture" on one's own. Some volumes focused on the history of architecture and on technical treatises, and references to articles in their own journal were also given.[50] As correspondents pointed out, there were a great many architects in the United States who, through intense study on their own, had risen to success in their profession.[51] The numerous lists of books that the editors published "for professional study" as well as the articles in the journal itself clearly assisted a great many in their architectural work.

Books were certainly central to the work of many architects. Even a major, and highly original, professionally trained architect like H. H. Richardson had an extensive library: At his death in 1886, he owned 380 volumes on architecture and art (as well as a collection of about 598 photographs, 200 of which were

Fig. 200. H. H. Richardson's library and study, AABN, December 27, 1884.

in fifty bound volumes).[52] The view of Richardson's "library and study" published in 1884 shows a room crammed full of books—more than 175 are visible in the drawing.[53]

Architectural self-education was also possible by mail. Ads of The Correspondence School of Industrial Sciences (later The International Correspondence Schools) of Scranton, Pennsylvania, regularly appeared in the 1890s and touted "Architecture Taught By Mail." The school offered all manner of subjects, such as "Architectural Drawing, Plumbing, Heating, and Ventilation, Bridge Engineering, Railroad Engineering, Surveying and Mapping, Electrical Engineering, Mechanics, [and] Mechanical Drawing."[54]

Testimonials included by the school in its publications are full of cases of craftsmen who, through their correspondence courses, became practicing architects.[55] One *individual* who taught "architecture by mail" was C. Powell Karr, "a well-known architect of New York" who "for the past four or five years"

had offered courses in "architectural drawing and design, architectural engineering, technical and decorative art and design"; his courses lasted from two to four years.[56]

Professional Training in Architecture

The American Architect editors consistently recommended architectural training either in professional schools in the United States, in France, or other European countries, or (for advanced students and self-trained architects who wished a capstone to their education) by means of extensive travel in Europe. American schools of architecture were their preferred method of training, however. Quite a number were now in business. In addition to Massachusetts Institute of Technology, Cornell, Illinois, and Syracuse, all founded before 1876, other architectural programs soon followed: at Columbia University in 1881, the University of Pennsylvania in 1890, George Washington University in 1893, Armour Institute of Technology and Harvard University in 1895, and University of Notre Dame in 1898.[57] An *American Architect* advertising column, "Architectural Instruction," in 1895 listed these (except for Armour Institute and George Washington) and also included Tulane University, the Chicago Art Institute's School of Architecture, as well as the Pratt Institute, the Cooper Institute, the Metropolitan Museum of Art, and the Institute of Artist-Artisans, all of New York.[58] By 1899, the column also listed Brown University, Purdue University, and the private Atelier Masqueray (founded in 1893) in New York City.[59]

The American Architect regularly published articles about architectural training in general and reports on the various schools of architecture, their curricula, and their approaches to teaching. Among general articles were ones such as "The Qualifications of Architects" series begun in 1877, or "Young Architects: Professional Study" of 1879, or "Architectural Education" of 1900.

Readers could learn a good deal about the methods of instruction and programs at architectural schools from articles (such as the series "Architectural Education in the United States" of 1888) or letters in *The American Architect,* especially in the 1880s and 1890s. Massachusetts Institute of Technology's programs were given the most attention,[60] but Columbia (the editors' own favorite)[61] and Cornell[62] were also frequently mentioned. Other articles or notices appeared on Harvard,[63] and Pratt, Illinois, the University of Pennsylvania, the Chicago Art Institute, the

University of Missouri, and the "Philadelphia School of Architecture" were also included.[64]

Architectural training in Europe was not ignored. English methods were examined,[65] as well as French,[66] German,[67] Italian,[68] and European approaches to architecture in general.[69] There was sometimes lively debate such as Ralph Adams Cram's essay "The Case Against the École des Beaux-Arts" in 1896.[70]

Even students who did not attend formal courses of instruction on the continent could derive much benefit from a tour of Europe with sketchbook in hand. This was the specific advice given in 1886 and 1887 to subscribers who wished to polish their architectural training;[71] and articles on European sketching and study trips were featured in *The American Architect.* For example, the long series "An Editor's Trip Abroad" ran in 1886; "A Sketching Trip Through England," appeared the following year; the ten-installment "An Architectural 'Summer School' Abroad" ran in 1897–98; and despite its title, "Hints to Art Students on Travelling Abroad," a four-part series in 1895, was primarily for students of architecture.[72] Even students and architects who did not venture to Europe could learn about its architectural history and about current building on the continent, through the full coverage of these matters in the journal itself.

European Architecture and Architectural History

From its first year (although mainly in the 1880s and 1890s), *The American Architect* had well-illustrated articles on all aspects of architectural history and contemporary building in Europe, as well as plates illustrating both; the two topics are sometimes difficult to separate, because articles often carried the architectural history of a country up to contemporary times. England was a special favorite, with occasional articles on historical architects (such as Vanbrugh and the Adam brothers) or contemporary figures (such as William Morris).[73] Series were especially common, such as "English Cathedrals" of 1882 and a survey of "English Architecture" (starting with medieval), begun in 1891 and "English Country Churches" of 1895. In 1894, plates of the Vicars' Close at Wells were included.

Italy was prominently represented (and even Greece) by articles such as "Excavations at Olympia" in 1880, although long series were more common; "Italian Cities" in 1889, "Italian Towers" in 1890, followed by "Venetian Wells" in 1891, "Italian Architecture" and "Lombard Architecture" in 1892, and "Medieval Campanile in Rome" in 1898. Many of these were transla-

tions of the illustrated articles in Paul Planat's *Encyclopédie de l'architecture* (1888–92). In fact, quite a number of the articles on the general architectural history of Europe, such as "Military Architecture" and "Religious Architecture" (which ran for twenty-six installments), both of 1890, "Stairways" (begun 1891), "Byzantine Architecture" and "Fireplaces" (both of 1892), "Railway Stations" and "Apses" (both 1893), and "Style" and "Towers and Turrets" (1894) were all translations of Planat. Some other special series were reprinted from foreign periodicals (as was "Staircases" of 1884 and "Spires, Domes, and Towers" of 1890).

In this context, it is interesting to note that the writings of Eugène-Emmanuel Viollet-le-Duc were also frequently featured in the journal, complete with his illustrations. In fact, his "Habitations of Man in All Ages" was one of the first historical series in the journal (beginning in February 1876), and between then and 1895 more than seventy articles, reviews, excerpts, letters, or accounts by or about Viollet-le-Duc were included![74]

Spain was also popular. Over the years, at least three long illustrated series were published: "Spanish Architecture" in 1883–84; "A Run Through Spain" in 1890–91; and "Spanish Architecture" (from Planat) in 1891. A series "Austrian Architecture" was published in 1890; and Germany had articles devoted to its buildings, too, "German Architecture" and "German Castles"; both series were running in 1891. Even Japan was included; the long series "Japanese Homes and Their Surroundings" (extracted from Edward Morse's book) began in 1886, and other articles and illustrations also appeared.[75] Ancient Mexico too received attention.[76] In virtually every case, the historical series were illustrated with in-text vignettes and occasionally with full-page plates in the plates section at the rear of the journal. Readers of *The American Architect* thus had a full and detailed illustrated survey of historic and contemporary architecture in Europe at their fingertips.

Professional Practice

Whether one had attended a professional school or was a self-taught architect in practice, the numerous articles that regularly appeared on all aspects of professional practice for architects would be valuable information. Data on qualifications, responsibilities, and duties; relationships of architect and client (and contractor); nature of contracts and of superintendence; architects' fees; proposed licensing of architects by the states—all were covered. A review of a selection of their titles and dates demonstrates how valuable these appeared to be to the editors of *The American Architect*.

Among the earliest articles on this general topic in the journal was "The Qualifications of Architects," a series begun in 1877. Soon appeared "The Responsibility of Architects" in 1878, a letter, "Responsibilities of Architects," on July 21, 1883, and in the same year "The Duties of the Architect" (reprinted from an English journal), as well as the start of the series "Modern Architectural Practice." In 1887, we find "The Ethics of Architectural Practice" and in 1889 "Responsibility of Architects," a report of the Western Association of Architects. In a profession growing in complexity and in social status, such articles were undoubtedly valuable points of information and discussion.

Client and contractor relations were also explored. "The Personal Relation of Architect and Client" of 1877, the series "Architect and Client," which began in that same year, and "An Architect and his Sub-Contractor" of 1879 are early examples. In 1884, "Architects, Clients, and Contractors" (a reprint of a British article) appeared, and in 1886, "Architects, Clients, and Builders" was published, as well as the start of the series "Architect, Builder, and Owner Before the Law." Even toward the end of the century, when a somewhat larger percentage of the profession had attended professional schools, one could still read articles on the topic, such as "The Relation of Architect and Client" of 1895.

Contracts and superintendence were also important topics. The series "Notes on Contracts" began in 1879; in 1882, the article "Architects' Superintendence" (reprinted from *Building News*) as well as a sample "Contract for Building" appeared. "The Proposed 'Standard Form' for Building Contracts" was published in early 1889, with follow-up items the same year, "The Uniform Building Contract" and "Building Law: Uniform Building Contracts." A sample form for an "Agreement between Architect and Client" appeared in 1890; all of these aimed at making clear and fair the relations between all parties concerned.

As one might expect, the percentage schedules and fees paid to architects came in for a great deal of discussion. "The Computation of Architects' Fees" and "Architects' Charges" (citing the American Institute of Architects [AIA]) appeared in 1880; and the "Schedule of Charges Adopted by the St. Louis Institute of Architects" (about competitions) and "Architects' Charges" (based on English legal cases) were both published in 1881. Letters and editorial comments about "Architects' Fees" appeared twice in 1882; a proposed "Formula for Calculating Architects'

6

Catalog and Mail-Order House Companies and Designs, 1900–1920

FROM THE TURN of the century through 1940, the demand for catalogs from which one could order house plans seems to have been insatiable. During this period, a great number of companies located in every part of the United States met this need with attractive, fully illustrated catalogs. Just how many companies were active in this period is difficult to determine, but as a sort of skeletal continuation of Hitchcock's compilation, I have provided an annotated listing (see Appendixes 1 and 2) of house-plan books and catalogs issued by more than seventy-five companies between 1883 and 1951 (and a second listing of plan catalogs published by more than twenty-five individuals or groups).[1]

Although by no means complete, these samples are nonetheless representative of catalogs available during these

years and give an idea of the enormous range of choices prospective home builders had in selecting plans.

During this period, we also can see the development of an essentially new housing approach, whose roots during the second half of the nineteenth century we have noted in passing: not just mail-order plans, but mail-order *houses*—or at least virtually all the materials necessary for a person to build a house. Although related to "portable" or prefabricated houses in some ways, mail-order houses of the twentieth century are in fact closer to the "knockdown" buildings of the nineteenth century. The "mail-order house" business, however, was actually an outgrowth of two related movements: the building components industry, which had blossomed after the Civil War, and the expansion of the wholesale lumber business at the turn of the century.

To survey this movement during the first half of this period, the decades between 1900 and 1920, we can examine in detail five of the most popular of these companies (two that sold just plans and specifications and three that sold the house materials as well) and explore something of their origins; how their businesses were organized; the nature and often the sources of the designs sold; what new house types or styles were introduced; and how the plans seem to have been put to use in actual practice. In some ways, these companies continued established practices from the nineteenth century, but new approaches were offered as well.

The Radford Architectural Company

Between its founding in 1902 by William A. Radford and 1926 (when he retired from the business), the Radford Architectural Company of Chicago published more than forty catalogs of house plans, technical books, encyclopedias of construction, books of details, instruction books, as well as three monthly trade journals. By 1911, the company called itself the "largest architectural establishment in the world."[2] It grew from the Radford Brothers lumber and mill work business of Oshkosh, Wisconsin, of the 1880s; in 1890, William Radford became the secretary-treasurer of the Radford Sash and Door Company, which shortly thereafter moved to Chicago. In 1902, Radford founded the Radford Architectural Company, with himself as president and treasurer.

The first catalog of house plans, *The Radford Ideal Homes*, was apparently published as early as 1898, under the aegis of the Radford Sash and Door Company: The Library of Congress National Union Catalog's first entry for that title is for a *third* edition of 1900, 72 pages long. The 1902 sixth edition, containing 100 house designs and plans, had 109 pages, the same length as the eighth edition of 1904 and the tenth edition of 1907.[3] The book was still in print in 1919. A second compilation of house designs, *The Radford American Homes*, appeared in 1903, "a continuation of the work which was begun in *The Radford Ideal Homes* and which met with such phenomenal success all over the world," as we are told in the very first sentence of the text.[4]

Both books consisted of perspective views, rendered to look very much like black-and-white photos, with first- and second-floor plans and with the overall size of the house also provided. Virtually all two hundred designs in these two catalogs are signed by either G. W. Ashby or W. H. Schroeder as architect.

As Radford explained, his catalogs contained "original, practical, and attractive house designs, such as seventy-five to ninety per cent. of the people to-day wish to build." The plans were drawn with special attention to "the most economical construction," with "every bit of space utilized to the best advantage." Furthermore, "every plan is designed by a licensed architect who stands at the head of his profession in this particular class of work." It was also claimed that "Radford Houses are now being erected in every country of the world where frame houses are built, which bespeaks for our plans more than anything we can say."

Most of the plans and specifications cost five dollars, although a few for smaller dwellings were only three dollars, and some for more pretentious dwellings were ten or fifteen dollars. For this sum, the purchaser received blueprints, from original drawings, of the foundation and cellar plan; floor plans; "front, right, left, and rear" elevations; roof plan; and "all necessary details of the interior work, such as door and window casings and trim, . . . picture mouldings, . . . newel posts, balusters, rail, etc." in large scale or even full size. "These blue prints are substantially and artistically bound in cloth and heavy waterproof paper."

The specifications consisted of "from about sixteen to twenty pages of closely typewritten matter," also bound "in the same artistic manner as the plans." The company did not supply a lumber bill, because building practices, lumber sizes and grades, and types of wood available differed in various parts of the country, and these decisions were best left to the contractor who, with the plans and specifications, could draw up the proper contract for the work.

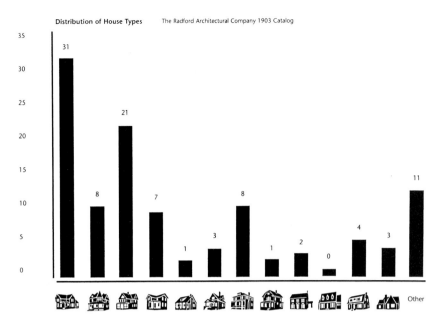

Fig. 213. Distribution of house types, Radford Architectural Company, 1903 catalog.

As we saw repeatedly in nineteenth-century pattern books, the advantages of cost savings, efficiency, and accuracy that plans and specifications assured were explained; "no misunderstandings can arise when a set of our plans and specifications are before the contractor and the home builder."

The Radford Company could provide "architect-prepared" plans so inexpensively because multiple copies of the same drawings were sold; thus their prices were "not more than one-seventh to one-tenth of the price usually charged." "[Because] we divide the expense of these plans among so many, it is possible for us to sell them at these low prices. The margin of profit is very close, but it enables us to sell thousands of sets of plans, which save many times their cost to both the owner and the contractor in erecting even the smallest dwelling."

Estimated costs to construct each dwelling were also provided, but the company cautioned that these were based "on the most favorable conditions in all respects, and does not include plumbing and heating." The only sure way of obtaining an estimate to meet local conditions was to consult "your local responsible material dealers and reliable contractors, for they, and they alone, know your local conditions."

As it would be prohibitively expensive, Radford did not make changes in the plans sold, although they would provide blueprints printed in reverse if desired—but because the lettering would be backward, a right-reading plan should also be used to avoid errors. For clients who might have "special plans" they wanted worked up, Radford did have a "special department under the supervision of a licensed architect," with "very reasonable" prices. In the catalogs, Radford illustrated "only low and medium priced houses"; but in the Special Department "we handle the finest work in addition to that of low and medium price." "[S]end us as full and complete information as possible, accompanied by a rough sketch illustrating as near as you can your ideas and requirements. Immediately upon receipt of this information from you, we will make you a price on these plans and specifications carrying out your own ideas, and if our price proves to be satisfactory, we will submit pencil sketch subject to your corrections and additions before proceeding to complete the plans." This was, then, very much like the designing by mail services provided by the Pallisers. How extensive this Radford special service was, however, is not known; the mail-order plan business and the sale of the many technical books seem to have been the mainstay of the company.

Sometimes a publication combined both plans and technical details: Radford's two-volume *Practical Carpentry* of 1907 ("being a complete, up-to-date explanation of modern carpentry and an encyclopedia on the modern methods used in the erection of buildings, from the laying of the foundation to the delivery of the building to the painter") contained a selection of fifty house plans in each volume, many the same as in *Ideal Homes* but with different design numbers.[5]

Although *Ideal Homes* and *American Homes* were early popular catalogs, the company soon produced others, and these indicate the range and type of the plan books. *Radford's Artistic Homes* (1908) contained 250 designs; *Radford's Artistic Bungalows*, with 208 designs, appeared the same year. *Cement Houses and How to Build Them*, with 87 designs, was published in 1909, as was *Radford's Portfolio of Plans*, a compilation of more than 300 Radford designs. *Radford's Brick Houses and How to Build Them* (1912), with 300 designs and details of construction, and *Stores and Flat Buildings* (1913), with 72 designs, suggest the wide range of the company's plan service; other books provided plans for garages and barns. All these, and many other volumes, could be ordered from Radford's offices in Chicago or New York. Some catalogs were also available from local lumber dealers, who probably purchased them in bulk; the copy of *The Radford American Homes* (1903) used in this study has an embossed heavy paper cover with the title *One Hundred Modern Homes* and with "Proctor Mftg. Co. / Ogdensburg, N.Y." overprinted at the bottom—although the title page is unchanged.[6]

The designs depicted in Radford's first two catalogs owed a great deal to the Queen Anne style; as the graph shows, more than half the houses were variations on this theme, with antecedents often traceable to types made popular by Shoppell, Barber, or even the early work of the Pallisers. Origins of some of the new types depicted are suggested in the discussion of specific examples below.

By 1926, the Radford Architectural Company had produced "complete plans and specifications for more than 1,000 different"[7] buildings, and the houses had been erected "as far north as the Hudson Bay and as far south as the Gulf of Mexico. They are built upon the Atlantic and Pacific coasts, and you can also find them in Australia and South Africa." Radford Homes must have appeared in nearly every community in the United States. An examination of several cases that are either documented Radford dwellings or that convincingly match Radford designs enable us to see just how the plans were used and adapted and to assess the changing architectural styles and types of the early twentieth century.

The John W. Jackson House in Sharpsville, Pennsylvania, built in 1903, is an early and documented Radford house; because the original plans and specifications survive, it is an excellent point at which to begin our discussion of Radford plans and the dwellings based on them.[8]

Design 86, the plans and specifications for which cost five dollars, is a Queen Anne cottage measuring

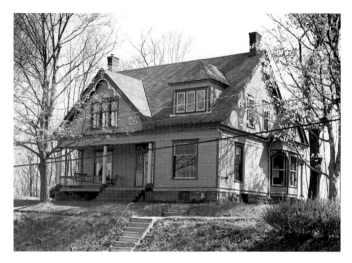

Fig. 214. *John W. Jackson House, Sharpsville, Pennsylvania, 1903.*

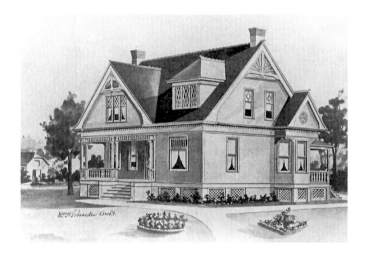

Fig. 215. Radford Ideal Homes *(1904 ed.), 4, Design 86.*

forty feet square. It is depicted in *The Radford Ideal Homes*, and both the 1904 and 1907 editions claimed that it could be built for $1,500. The house was erected by a man who in 1872 had come to Sharpsville, then a prospering industrial center, as a tinsmith. He first worked on roofing projects and then was employed by a hardware firm, where he began making—and seems to have invented—the long-spouted oilcans required by locomotives of the day. In 1891, he established the J. W. Jackson Company to manufacture these "Jackson Oilers," and the firm prospered, often receiving large orders for entire railroad lines. After his death in 1926, the business was carried on for more than twenty years by his son.

As we can see by the photograph, the house was built closely following the Radford design. The blueprints, on thirteen-and-one-half by twenty-inch pa-

Fig. 216. Blueprint, Radford, Design 86 (Courtesy Frank and Constance Robinson).

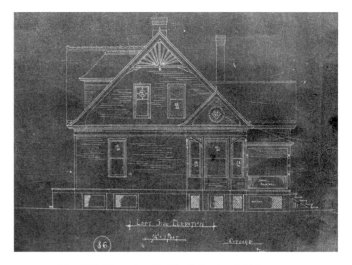

Fig. 217. Blueprint, Radford, Design 86 (Courtesy Frank and Constance Robinson).

per, consisted of eight sheets mostly at one-quarter inch to the foot; front elevation (and section); right, left, and rear elevations; foundation plan; first- and second-floor plans; and a sheet of details (stairs, baseboards, picture moldings, doors, and door frames, etc.). They are identified as by "Radford–Oshkosh–Chicago" with the blind-stamped circular seal of the designer: "State of Illinois / Licensed Archt. / W. H. Schroeder / Chicago."

The blueprints reveal a few changes, made in pencil on them: The fireplace in the dining room is to be omitted; a rear porch (between the flanking stairs) has been added, with a door from there into the kitchen, rather than from the side porch; and locations for the radiators have been added. Furthermore, two portions of the blueprints have been traced over in pencil, as if a carbon copy were being made by one of the craftsmen: the circular window above the side bay and the spindle work for the front gable.

As billed in the Radford catalogs, the specifications are indeed neatly typed, with a heavy paper cover and red cloth binding with brass fasteners; the sheets measure nine and one-half by twelve inches. Origi-

nally, there were fifteen pages, but the first and last sheets were later removed.[9] The typed text is in dark purple (some form of mechanical reproduction), with a few portions typed in using a purple ribbon (which originally probably matched very closely), and other paragraphs were added in purple carbon copy. Clearly, there was a standard set of specifications for Design 86, which was customized for each person. These, for example, have the page and a half dealing with excavation of the foundations and the drainage system (pages E and E1) crossed out in red ink and replaced later following the last page (N) by a new page for "Plumbing Specifications," in purple carbon, because the house was to be connected to the city mains. Pages that are missing must have made special reference to the excavated cellar, form of fireplaces, heating system, and changes in the front porch design, not otherwise mentioned in the specifications. Other omissions, also crossed out in red ink, deal with the wood shingle roof (it seems originally to have had a slate roof instead) and the cistern (not needed, of course, with city water).

A comparison between the blueprints and the house as built shows how closely the contractor carried out the Radford designs. Even the special mullions in the second-floor "left side" elevation were duplicated, as well as the exact form of the brackets for the dining-room bay and the circular window above it. A comparison of the porch and main gable of the house shown in an old photo, with the blueprint of the same area, reveals a few alterations in the Radford plans. The spindles in the bargeboards are about the same, but the framework in which they are set is a little fancier; and as built the porch has fluted Tuscan columns, not the

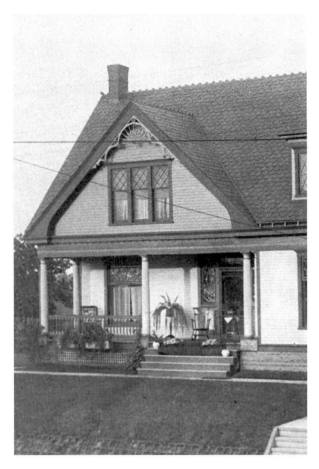

*Fig. 218. Jackson House, detail of c. 1910 photo
(Courtesy Frank and Constance Robinson).*

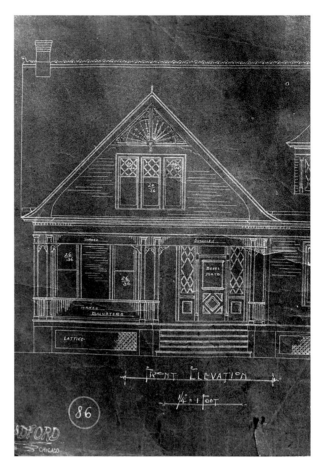

*Fig. 219. Blueprint, Radford, Design 86
(Courtesy Frank and Constance Robinson).*

paired chamfered wood posts of the blueprint. The two windows behind are also replaced by one large single window, with an art glass panel above. The change in columns shows that the local builder recognized the growing popularity of colonial and classical forms in the early years of the twentieth century.

The two interior views reveal that the form of the staircase and its newel posts, the door frames and doors, and even moldings closely follow the Radford detail sheet. Although not clearly visible, the simpler door casing with bull's-eye corner blocks is indeed found on the kitchen door, through the opening at the far left. What is interesting to note is that in the chamber to the left of the entrance hall the elaborate fireplace, not mentioned in the Radford specifications, is of the type that local contractors could order from any number of specialized mantel companies. This particular one is quite similar to model R 2316 depicted in the 1903 *General Catalogue of E. L. Roberts & Co.* of Chicago, "wholesale manufacturers of Doors, Glazed Sash, Blinds, Mouldings, Fine Stairwork, Art and Window Glass, Mantels," and so on, remind-

ing us of how much of the fancy detail work could be ordered through the mail, like furniture.[10]

Although the house carefully follows the blueprints, , it is worth pointing out, especially in light of other comparisons made below between constructed dwellings and their published plans, that despite the dimensions given on the blueprints, as built there are minor variations. For example, the parlor is 13 by 15 feet on the blueprints, but as constructed is 13 feet, 2 inches, by 15 feet, 1 1/2 inches; the hall is 1 1/4 inches wider than shown on the plans; and the first floor chamber is 3/4 inch deeper and 1/4 inch wider than the plans. These points are minor, however; in essentially all other ways, the Jackson House is a splendid realization of the Radford plans, with some interior finishes and exterior details a little more elaborate than specified—just the sort of customizing we would expect to meet the particular tastes of the owner.

Radford's Design 517, published in *American Homes* of 1903, is a larger and more complex Queen Anne design, in which the picturesque massing and projecting bays are compactly arranged and the de-

Fig. 220. Jackson House, interior, entrance hall.

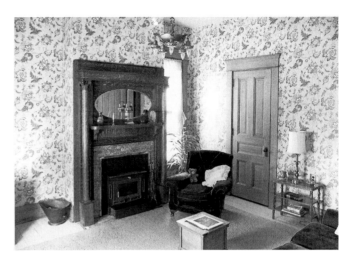

Fig. 222. Jackson House, interior, chamber.

Fig. 221. Blueprint, Radford, Design 86 (Courtesy
Frank and Constance Robinson).

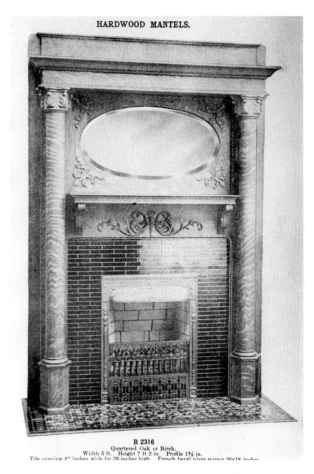

Fig. 223. E. L. Roberts & Co., 1903, catalog, 313.

tailing simplified and made more classical under the impact of Academic and Colonial revivals. The semicircular attic windows and especially the prominent Ionic veranda with pediment marking the entrance are the most prominent of the classical features.

The overall design, however, surely owes a great deal to the Queen Anne houses popular several years before. A dwelling in New Jersey, designed by H. Hudson Holly and quite similar in composition, was published in *The American Architect* on February 21,

1880; and a design extremely close to the Radford model was published as Design 646 in the January–March 1890 issue of *Shoppell's Modern Houses*.[11] Because we know from our review of the *American Architect and Building News* that architects turned

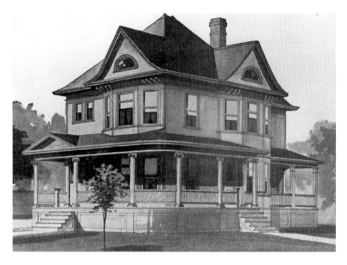

Fig. 224. Radford American Homes *(1903), 157, Design 517.*

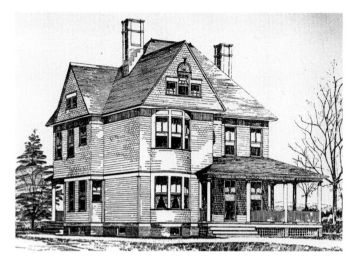

Fig. 225. Shoppell's Modern Houses
(January-March 1890), Design 646.

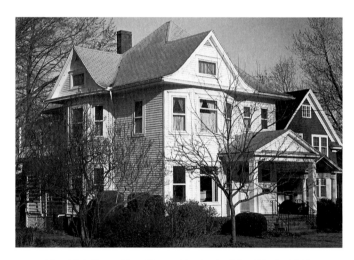

Fig. 226. Festus Day House, Fredonia, New York, 1905.

for design ideas to published images with persistent regularity, Shoppell's model, given slightly more classical detailing, might well have been G. W. Ashby's source for the Radford plate.

The Festus Day House, built in Fredonia, New York, in 1905, is a mirror-image realization of this Radford model.[12] Although now having only a small entrance porch, the house originally did have a wraparound veranda (by 1903, called a porch) with Ionic columns just like the Radford design, as seen in an old photograph of the house. The overall composition and its details follow the Radford design closely, except for the use of rectangular rather than lunette attic windows.

The local builder followed the plans closely although they are reversed. The only obvious change was altering the peculiar angled entry into the sitting room and dining room to a more straightforward approach. The room dimensions are extremely close, as a comparison of the plans shows; the sitting room is wider because the bay window sticks out farther than the one on the Radford plans. Even openings at the side of the parlor and the rear of the sitting room, although now covered over, originally followed the blueprints. The layout of the kitchen was changed somewhat, undoubtedly to meet the client's particular needs. Radford's impressive classicizing Queen Anne dwelling obviously found favor in this village; another copy of the design, as published (not reversed), is found a mile away. Especially revealing is the fact that Radford's design was pirated within a few years by Sears, Roebuck & Co.[13] Its "Modern Home Number 119," which was available between 1911 and 1917, has an almost identical exterior composition and plan—even to the

angled passage into the sitting room from the entrance hall. Certainly there was a good deal of cribbing among companies of appealing designs or perhaps models known to be selling well.

The Radford American Homes also contained several palatial Queen Anne dwellings. One of the most impressive, with its corner tower linking it to a long line of Queen Anne types going back twenty years, is Design 141, the work of W. F. Schroeder. Although one can find similar Queen Anne houses with corner towers in *The American Architect* (September 15, 1883, for example, or, on a grander scale, June 27, 1891 [see Figs. 204 and 207]), the direct source for this one seems to be Shoppell's Design 1990 from the October 1900 issue of his *Modern Houses.* Like the previously discussed Radford model, the composition has been up-

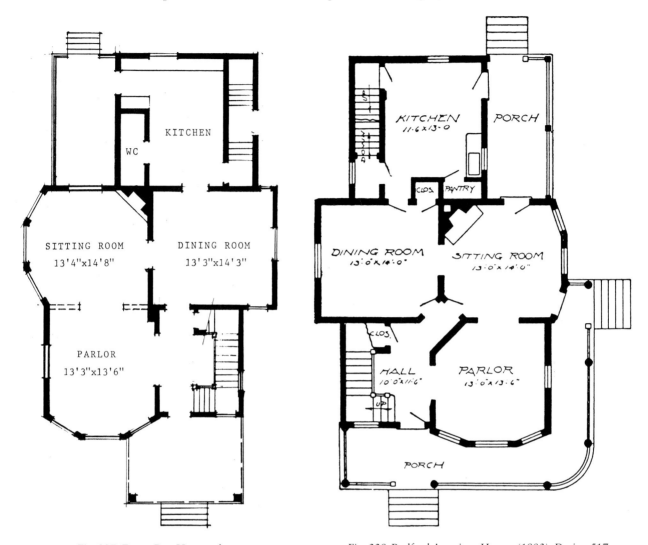

Fig. 227. Festus Day House, plan. *Fig. 228.* Radford American Homes *(1903), Design 517.*

dated with restrained classical details: The Palladian window in the side gable and the classical porch complete with grouped columns and a correctly proportioned pediment are the most notable (Fig. 229).

A version of Design 141 was erected in Dunkirk, New York, about 1905 for Michael P. Toomey, who operated a livery business and earlier had sold flour and feed.[14] At first glance, the house appears to be a mirror image of the Radford design, with some alterations to the form of the side bay. A comparison of the published plan with that of the house as constructed reveals, however, that it is *not* a mirror-image plan as we saw in the Festus Day House, but rather a creatively reworked version of the Schroeder original. The main change to the front portion was moving the tower bay from the hall to the parlor. This made good sense because the right side of the house faces a large

municipal park, and such a bay would have provided a good view; the tower also articulates the composition of the house on its corner lot more effectively. Other changes were concentrated to the left rear, where the house was extended and chambers rearranged. Yet, the original plans were used as the basis for this design; dimensions of rooms, as a comparison of the plans shows, are extremely close, despite the rearrangement of the plan. Apparently, a local builder, or possibly an architect, customized the Radford plan to meet the distinctive site requirements and the particular needs of the clients.

The interior detailing of the Toomey House, at least on the first floor, is quite elaborate. Although without the original blueprints it is impossible to say just how many details parallel the finishes specified in the original design, the impressive "colonnade" (as such

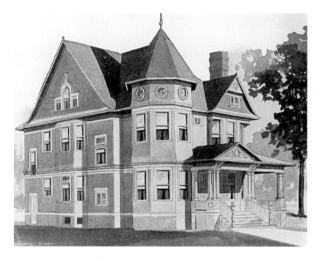

Fig. 229. Radford American Homes *(1903), 55, Design 141.*

Fig. 231. Michael P. Toomey House, Dunkirk, New York, c. 1905.

Fig. 230. Shoppell's Modern Houses
(October 1900), Design 1990.

features were called) between hall and parlor is not on the published plans and was clearly an appropriate classical feature introduced in the reformulation of the interior. Colonnades of this type could be purchased from manufacturers who specialized in such interior detailing. Although the Morgan Sash and Door Company design depicted ("a beautiful Colonial design which would enrich the interior of any home") is from a catalog of a decade later,[15] it is representative of the stock woodwork available to contractors for insertion into houses. The fireplace in the living room is also the sort of feature that could be ordered for local installation. In this case, the published design is a bit closer to the date of the house and comes from the Gordon-Van Tine Co. catalog of 1915.[16] Similar designs can be found in the E. L. Roberts & Co. catalog as early as 1903. The modification of the original

Radford plan and exterior composition and the use of factory-built interior components remind us how readily local builders could adapt and bring together "outside" plans and details to meet local aesthetic and practical requirements.

A far more common Radford design was Number 110 in *American Homes* (1903), a sort of vernacular Queen Anne. In its simple boxy form, this type of house is indeed not too far removed from vernacular buildings with virtually no stylistic trim or references; but this dwelling, with its cross gable, steep roof with shingled-gable ends (a contrast of texture with the clapboards below), and prominent Palladian window with classical keystone in the main gable, does have enough of the "tiniest allusive gestures" (to use Summerson's phrase) to the Queen Anne to raise it from the purely vernacular to very modest high style. W. H. Schroeder, its author, probably had some of Shoppell's boxy Queen Anne designs in mind when composing this, particularly Design 635, published in the January–March 1890 issue of *Shoppell's Modern Houses.*[17] These in turn go back to some of the designs in *Palliser's Model Homes* (1878) such as plates III and IV and even I (bottom). Perhaps we should see Schroeder's design as a practicing architect's simplified version—yet keeping distinctive features such as the Palladian window in a field of shingles, a classical porch across the front, and side gabled projection—of a rectangular high-style Queen Anne, such as the house published in *The American Architect* on November 17, 1894.[18]

This economical, Foursquare version of the Queen Anne was a Radford favorite: A dozen other designs in *American Homes* are of this same type, with projecting side wing (and there are several variants),

Fig. 254. Radford American Homes, *147, Design 500.*

Fig. 255. Henry Endicott House, by Chamberlin & Whidden, Boston, AABN, May 5, 1888.

links with cozy seaside cottages and the vernacular houses of the colonial era were still obvious.

Radford provided a number of gambrel-roofed houses of Shingle Style character in his early catalogs. One of the most appealing is a diminutive version, Design 121, in *American Homes.* The ample gambrel roofs, patterned shingle work filling the gable ends, and the ins-and-outs of the side bay and the recessed porch place this modest house well within the Shingle Style tradition. A realization of this design in a slightly more elaborate form can be found in Jamestown, New York.[30] Although the gambrel at the side has been extended outward a few feet, the overall form and location of the chimneys (and cellar windows!) confirm that the Radford design was most likely the model. The projecting bay windows for the gable ends are a creative touch in augmenting the Radford design.

This form of gambrel-roofed cottage with a cross gable, which Radford introduced into his repertoire with this 1903 design, became reasonably popular during the next twenty years, and similar models were sold by other companies. Sears, for example, offered one between 1911 and 1917; a design of this type was published by Gustav Stickley in *The Craftsman* magazine for February 1915; and Henry Atterbury Smith's *The Books of a Thousand Homes,* volume I (1923, 3d ed. 1927), also featured one.[31]

These small, gambrel Shingle Style houses also often sported prominent colonial detailing, as did the Loring House; they are part of the early Colonial Revival movement being developed during the 1880s as well. A fine cross-gabled Shingle Style house with ample gambrel roof, published in *The American Architect* of January 18, 1890, has a prominent Palladian window in one wall, and Shoppell pub-

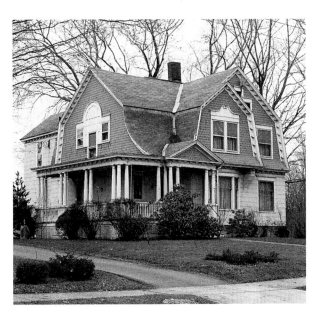

Fig. 256. Jerome Farrar House, Westfield, New York, 1904.

lished a number of similar designs, between 1890 and 1900, with colonial detailing in gambrel-roofed houses: Palladian windows or motifs based on them; colonial-type balustrades; columned porches; and oval windows.[32]

A second Radford design from 1903, Number 500, takes off from this more classical aspect of the Shingle Style, now becoming more of a vernacular Colonial Revival.[33] As we see in the design, the picturesque arrangement of the gambrel roofs, suggesting cozy enclosure as well as historic antecedents, is combined with clapboards, not shingles. Prominent classical detailing includes a Palladian-window-like motif in the left gable complete with paneling and swags;

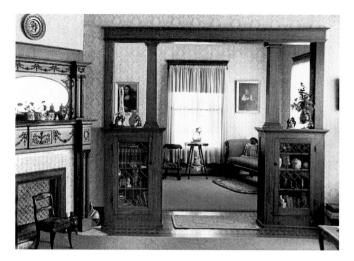

Fig. 257. Farrer House, interior.

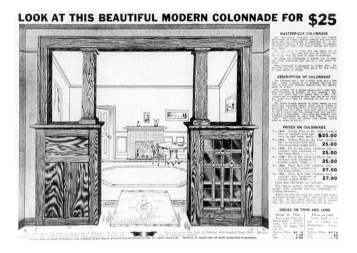

Fig. 258. Gordon-Van Tine Co., Architectural Details (1915), 73.

a porch with Ionic columns; and a facade gable with swan's-neck pediment and relief swags.

By 1903, such picturesque colonial designs featuring intersecting gambrel roofs and prominent Georgian detailing were common among architects; a good example by a Boston firm was published in *The American Architect* of May 5, 1888. Even the colonial-style detailing used by Ashby in Design Number 500 had appeared in the national architectural press and was thus well known. A three-story frame Colonial Revival dwelling with prominent gambrel roofs, by a Detroit firm of architects, was illustrated in *The American Architect* of October 29, 1898 (see Fig. 209). It featured an Ionic porch, modified Palladian windows, graceful swags on fascia boards, and a swan's-neck pediment (on a prominent dormer), reminding us of how swiftly design features in grand houses found their way into middle-class versions.

The Radford design was splendidly carried out and even enriched in the Jerome Farrar House in Westfield, New York, built in 1904.[34] A current view of the house shows us that, as built, the classical features of the porch were considerably expanded; not only were paired rather than single columns used, but the porch was run along the side as well, so that sixteen fluted Tuscan columns ornament the house, rather than just the two Ionic ones depicted in G. W. Ashby's design. As executed, the entrance to the porch is emphasized by a correctly proportioned pediment, stressing the classical heritage of the design.

Just as the exterior was modified and "improved," so was the interior. The Radford plan was followed closely, but an additional two feet were added along the right side, and five feet were added across the back.

As the exterior view shows, the rear kitchen wing was also raised to two full stories. Interior finishes were more elaborate than had probably been specified by Radford. The wall between the sitting room and library was opened up with a colonnade, and a richly detailed classical mantel was also provided in a corner where none is indicated on the plans. As the photo shows, the colonnade is a feature that local builders would have had no difficulty purchasing from manufacturers who specialized in such woodwork, and the fireplace is also probably from some such source. With this expansion and enrichment of the Radford plan, it is not surprising to learn that the cost of the house as built was about two thousand dollars more than the amount indicated in *American Homes*.

Most of the Radford designs were for "low and medium priced houses"; in his *American Homes* of 1903, 86 percent were estimated to cost, at maximum, between $1,000 and $2,750. Six percent were $800 or under, and 8 percent were between $3,000 and $4,200. One of the most sophisticated designs, falling into the latter category at $3,250, was the Colonial Revival design Number 569. Although so many of Radford's houses have only modest architectural detailing to suggest their high-style counterparts, Design 569 is unequivocally Colonial. The hipped-roof form, a Georgian type going back to the early eighteenth century, is provided with pedimented dormers; corner piers support a full classical entablature; and the Ionic porch is enriched with a latticework balustrade (seen also between the facade dormers). All these features evoke any number of colonial antecedents.

This more formal Colonial Revival, contrasting with the informal colonialism of the Shingle Style, grew

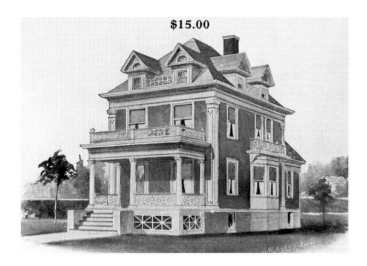

$15.00

Fig. 259. Radford American Homes *(1903), 227, Design 569.*

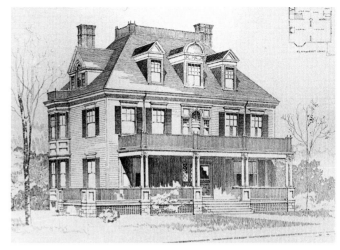

Fig. 260. George P. Howlett House, West Newton, Massachusetts, AABN, *June 27, 1891.*

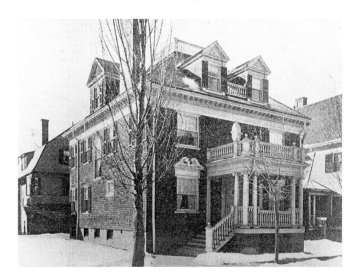

Fig. 261. Dr. Forrest G. Eddy House, Providence, Rhode Island, AABN, *March 16, 1901.*

in the same decades as did the latter mode. The first, somewhat asymmetrical but nonetheless mature, Colonial Revival house is generally considered to be Arthur Little's George D. Howe Residence at Manchester-by-the-Sea, Massachusetts, of 1879. The first Colonial Revival house of this type to appear in *The American Architect* was published on March 20, 1886 (see Fig. 201), and less than a year later, on February 5, 1887, the journal illustrated a formally composed hipped-roof Colonial Revival mansion complete with corner quoins, one-story classical entrance porch, and pedimented roof dormers (see Fig. 205). Several others of similar type were published in the next few years, but *The American Architect* also illustrated this mode as adapted to more modest Colonial Revival homes. One of the best, and the type of house from which G. W. Ashby's design derives, is a home in West Newton, Massachusetts, designed by the Cambridge architect C. Herbert McClare. The house appeared in *The American Architect*'s June 27, 1891, issue. A brick version of this colonial hipped-roof type, with latticework between the roof dormers as seen in the Radford 1903 design, can be found in *The American Architect* for March 16, 1901 (it was designed by the architect James Shaw Jr. of Providence).

This kind of Colonial dwelling became a durable house type. As we would expect, Shoppell picked up this mode of design, too; his hipped-roof colonial-style dwelling (Design 1967) published in the October 1900 issue of *Modern Houses* is a good example, although with more Queen Anne holdovers, such as the turned porch columns and paired roof dormers, than in McClare's design.

As we have seen, *The American Architect* had an enormous number of plates, measured drawings, and even articles about old colonial buildings, especially dwellings; no architect would have had difficulty in studying good illustrations of overall designs as well as details. There were also, beginning even before the centennial, a large number of well-illustrated books on colonial architecture. In the "Sampling of Books on Colonial Houses, 1874–1945," in Appendix 6, I have listed twenty-eight volumes, published between 1874 and 1902, of the sort that architects and draftsmen would have been able to consult. Perhaps it is surprising, in light of the popularity of this style in the professional press and in illustrated histories and tomes, that Radford had only this single Colonial Revival plan in 1903.

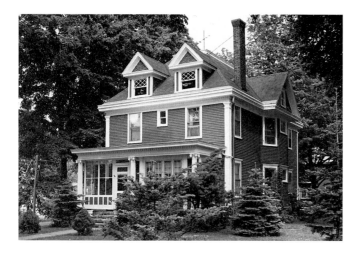

Fig. 262. William S. Sly House, Fredonia, New York, 1907–8.

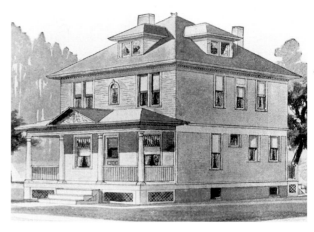

Fig. 263. Radford American Homes *(1903), 103, Design 126.*

Radford Design 569 was beautifully realized in the William S. Sly House of Fredonia, New York, built in 1907–8.[35] A comparison of the design and the constructed dwelling shows that some changes to the Radford plans were made. The most obvious is that the Sly House is wider. This was effected by filling in a "notch" in the plan's left corner, which made the entrance hall and the facade five feet wider. Another obvious change was continuing the dining-room bay at the right side up two full stories and capping it with a pediment. The insertion of a side-wall fireplace necessitated shifting windows on that side, too. In overall form and many details (Ionic columns for the porch, full-height corner piers with V-pattern at the top, prominent dentils in the cornice), however, the Sly dwelling and Ashby's design are remarkably congruent.

The interior was rearranged even more. Whereas the overall layout of the Radford plan is followed (entrance hall and living room at the front, chamber and dining room behind them, and pantries and kitchen across the rear), the expanded entrance hall is given a grand oak staircase, a fine colonnade separates this hall from the living room, and the dining room, which boasts oak wall paneling and a beamed ceiling, has been shortened to give more space to the adjacent chamber. One clever augmentation of the plan was to extend the living room onto the porch, so that eight feet, eight inches were added to its length, while on the exterior it appears only that part of the front porch has been glazed in. These room changes were essentially within the boundaries of the Radford design: The width of the house on the plans, including the bay, is given as 30 feet; the Sly House measures 31 feet; and the total depth is 39 feet, 6 inches, on the plan versus 40 feet, 6 inches, as built.

The final Radford house type we consider is one that is now generally called the Foursquare. The term is indeed appropriate, for the house, of which Design 126 from *American Homes* of 1903 is a good example, is not only usually square or rectangular, but has a compactness and geometric clarity that suggest a foursquare or forthright quality. Because it became an enormously popular house type during the next thirty years, it is important to sketch out its probable antecedents.

Radford's Design 126, another creation of W. H. Schroeder, is distinguished by its cubic form, prominent hipped roof with compact dormers, wide eaves, as well as a one-story front porch, complete in this case with a pediment over the central entrance. Several architectural threads seem to have been brought together here.

One is clearly the hipped-roof house type, which, because of its clarity of organization and straightforward construction, had been popular for nearly two hundred years. We saw previously that the Georgian type was developed in Virginia about 1715, with The Brafferton (1723) in Williamsburg (see Fig. 24) one of the famous early examples. This hipped-roof type continued as a popular mode of building for the rest of the eighteenth century[36] and was continued, although with a lower and less prominent hipped roof, into the Federal period. We recall that Asher Benjamin illustrated one such dwelling as figure 30 in his *Country Builders Assistant* of 1798 (see Fig. 45), and constructed examples of the early nineteenth century are quite common. It continued in vogue during the Greek Revival, too; two dwellings we discussed for their architectural detailing, the Jonathan Goldsmith House (1841) in Painesville, Ohio, and the Forbes-Cushing House (1842) in Fredonia, New York, were both astylar

Fig. 264. Downing (1850), 131, Design XII.

Fig. 265. AABN, *July 3, 1880.*

houses with prominent hipped roofs. Even mansions with Doric porticoes (beneath entablatures without pediments) from the 1830s and 1840s often had hipped roofs. [37]

During the Italianate movement, the hipped-roof cubic house became nearly ubiquitous. A. J. Downing's *Country Houses* (1850) has a good variety of them. Some, such as the "Suburban Cottage" in Design VII, were quite large and impressive, in this case about forty-four feet wide; but he illustrated modest versions, too. Design XI, "A Square Suburban Cottage," despite its name was thirty-three by twenty-eight feet in size, and Design XII, "A Cubical Cottage in the Tuscan style" was even more Foursquare, measuring thirty by thirty feet. All had low hipped roofs, projecting eaves, and a porch or veranda. As we saw, such squarish Italian villas became very popular; both Sloan in 1852 (see Fig. 122) and Cleaveland and Backus Brothers in 1856 (see Fig. 126) published fine examples of the type. Square houses, although with mansard roofs, were popular into the 1880s.

Although these are significant background trends, the Foursquare probably owes more to the rectilinear house designs that one occasionally finds in the 1880s, either in inexpensive dwellings or in the work of architects with individualistic ideas. Two good examples from *The American Architect* illustrate this; and because we know how avidly this journal was read and the plates collected throughout the United States, it may even be that these designs were themselves factors in the origins of the Foursquare.

The first is a "labourers cottage" containing two apartments, at Milton, Massachusetts, published on July 3, 1880. At first it may appear to be an Italianate design (the location of the chimneys, the window trim,

Fig. 266. AABN, *December 11, 1886.*

and the wide eaves with brackets all seem to hark back to Downing's models), but the divisions of the exterior surface by wood strips and the use of cut shingles for the second story with clapboards below reveal the Queen Anne aesthetic, even if in tincture only. The second *American Architect* plate, from December 11, 1886, is of a house near Cincinnati, Ohio, by Buddemeyer, Plympton, and Trowbridge, architects, of Cincinnati. It too owes a good deal to Italianate models, but the Stick Style (or could it be Japanese inspired?) half-timber-like detailing clearly links it to "constructional" decoration. A boxy Queen Anne house with some Colonial Revival detailing, designed by the Boston architect Frank W. Weston and published in the November 9, 1889, issue, can also be cited. Although Weston's dwelling did not have the wide eaves, its overall boxy shape and the simple dormers in the hipped roof confirm the currency of this "utilitarian" form of house during these years.

By the 1890s, the Foursquare as a type seems to coalesce. Thomas W. Hanchett has identified the house designed by Frank E. Kidder, a Denver architect (and graduate of the Massachusetts Institute of Technology), for himself as apparently the first; it was published in the January 1891 issue of *Architecture and Building*. Within a few years, this type was firmly established; the style first appeared in the popular builders' magazines, according to Hanchett, with a design for a brick version by Grodavent Brothers of Denver in the April 1895 issue of *Carpentry and Building*.[38] Soon, Foursquare designs appeared in *The American Architect*, such as the impressive dwelling by the Denver architect William Cowe, which was published on September 12, 1896—and thus became known throughout the land. Schroeder may even have had an eye on this particular model, for the overall proportions, form of roof dormers, paired second-story fa-

cade windows, and classical pediment accenting the front steps and entrance are all quite similar to the Radford design of seven years later. When we realize that the impressive Foursquares of the Grodavent Brothers and of William Cowe date from the very years that George F. Barber was publishing—and people were building—his highly picturesque Queen Anne designs, the radical simplicity of this straightforward design is forcefully brought home.

In light of this "modernism" of the Foursquare, it is not surprising to find that Frank Lloyd Wright employed this mode in 1894 for his Peter Goan Residence in LaGrange, Illinois. In that dwelling, Wright animated the cubic severity of the Foursquare by including a two-story bay at one side and a one-story facade bay. The house originally had both a first-story terrace and a second-story porch, all of which would have masked somewhat the forthright cubic quality of the basic composition.[39] Such one- and two-story bays were to become common features in many versions of the Foursquare.

This simplified, cubic form of dwelling, with only minimal references to historical antecedents, was reflected in the earliest Radford Foursquare designs. Both Number 6 and Number 104 in *Ideal Homes* are extremely plain in exterior detailing, as are two in *American Homes* of 1903, Number 566 and Number 567; all but the last example have the full-width front porch featured in the 1895 design by the Grodavent Brothers. The example of the Foursquare we began this discussion with, Number 126 of 1903, also has several classical features (the Tuscan columns on the porch, the central porch pediment, and the small arched window on the second floor), which reminds us that the classical tradition of hipped-roof houses of the Colo-

Fig. 267. Mrs. A. J. Trott House, Denver, Colorado, by Grodavent Brothers (First published April 1895).

Fig. 268. AABN, *September 12, 1896.*

Fig. 269. Shoppell's Modern Houses *(October 1900), Design 1982.*

Fig. 286. *"Brick Cottage,"* The Craftsman *(March 1911).*

Fig. 287. *"Craftsman House,"* The Craftsman *(May 1909).*

tant.[56] One published in the same issue (March 1911) as the Greene-inspired "Craftsman Cottage" illustrated earlier is the "Brick Cottage" (Design Number 112) shown here. The combination of brick and "the rived shingles and rough slates of the gables and roof" gives it a particularly rustic charm, and the "flat dormer . . . accentuates the low bungalow effect." The front pergola/porch linked it directly with surrounding nature (a more protected "dining porch" is at the rear). In a way, it is a simplified and less picturesque version of Design Number 111.

Two-story houses, which while fully "Craftsman" could not be considered "bungalows," were also frequently published. An early example dating from the May 1909 issue is the "Craftsman House Designed for a Narrow Lot," Design Number 67. With a foundation of split fieldstone, prominent stone chimney, second story clad in hand-split shingles, and shingled roof (the first floor was cement), natural textures and colors abound. Both front porch and back patio have projecting rafter ends to convey the sense of "pergola," even if both are conventionally roofed. Although similar to many of Stickley's other one- and two-story bungalows and cottages, this has its roots in the late nineteenth century, too; a house by the Cincinnati architect S. E. Des Jardins, published in *The American Architect* of November 10, 1888, reminds us of how much Stickley and other architects of the reform and Craftsman movements learned from Shingle Style and picturesque architecture of the 1880s and 1890s.

A final Stickley design that proved influential in subsequent years is his "Craftsman Shingled Bungalow Number 201," published in February 1915. The broad expanse of roof and the low profile emphasize its bungalow character; "the shingled walls and roof have been kept fairly low, both for economy of con-

Fig. 288. AABN, *November 10, 1888.*

struction and to emphasize the homelike air of the exterior. Rough stone is used for the foundation and chimney," just the sort of design that would appeal to A. J. Downing—and it did! In Downing's *Country Houses* (1850), his Design XIX[bis], figure 110, is "A small bracketed Country House" of very similar style. Whether or not Downing's illustration was a source for Stickley's distinctive roof form, it reminds us of the durable appeal of these clipped-gable roofs of English origin: They derive from thatch and tiled roofs, which often have the gable apex clipped and roofed over to prevent rain from entering at that point. The association of this sort of roof with popular images of the cozy English cottage is obvious as well.

Readers of *The Craftsman* during the first few years that plans were published could use the illustrations as general inspiration for their own houses or have a builder adapt them directly, as so commonly done in the nineteenth century. Stickley also offered assistance; in an editorial note following a design pub-

Fig. 289. "Shingled Bungalow," The Craftsman (February 1915).

Fig. 290. Downing (1850), Design XIX [bis], fig. 110.

lished in May 1903, he offered to "help any subscriber who wanted details" on "building, finishing, or decorating" of Craftsman houses.[57] Soon Stickley went even further to assist readers who wanted to build Craftsman dwellings. In November 1903, he announced the creation of a Homebuilders' Club for readers of his magazine. "Any subscriber was eligible to order a free set of house plans for any one of a series of houses to be published in *The Craftsman* each month" beginning in 1904; before the magazine ceased publication in 1916, more than two hundred such plans had been made available.[58] Furthermore, purchasers of Stickley's books of house designs were also alerted to the free plans. Pasted to the flyleaf of *Craftsman Homes* (1909) was the following notice: "To Prospective Home Builders: Architects' drawings of 30 of the houses illustrated and described in this book have been made, and are in stock at the office of *The Craftsman*. To anyone sending us $3.00 for a year's subscription . . . we will send blueprints of plans, elevations, and detail drawings from which any one of these houses may be built."[59] The fact that these were free plans is distinctive; it clearly reveals the public-spirited tone of Stickley's message. And if a person needed help in modifying the plans, he or she could hire the Craftsman architects (who remain nameless) to make changes or even to design entirely original houses. For a brief period (1909), Stickley even had his own construction firm for such work—the Craftsman House Building Company, which carried out custom-designed dwellings in the greater New York City area.[60] It lasted less than a year, however.

How many subscribers ordered his plans and built houses from them and how many others had their local contractors adapt or copy the plans in the maga-

zine more or less freely is not known, but the number must have been significant. In 1915, Stickley claimed that more than twenty million dollars had been spent "in that year alone to build Craftsman houses in all parts of the United States and as far afield as the Fiji Islands."[61] Mary Ann Smith documents ten houses built between 1909 and 1914 (in addition to Stickley's own house in New Jersey) based on published *Craftsman* plans.[62] Another good example of this is the Vaill House in New Jersey, built in 1911 and now restored inside and out.[63] It followed the *Craftsman* blueprints closely, although in mirror image. The material was changed from brick with vertical boarding in the gable ends to hollow terra-cotta block with cement finish. The original roof was to be shingled ("preferably dark red in color"); as built it had red Spanish tile. The plan and interior detailing, however, follow with great care Design Number 104, which had been published in the December 1904 issue of *The Craftsman*. There are undoubtedly a great many more Craftsman houses based on the published illustrations or the free blueprints, which await discovery.

William Radford's profit came from the multiple sets of blueprints from the same original drawings, which were sold through his catalogs; for Gustav Stickley, the plans he provided were not really an end in themselves, but a means of encouraging people to build Craftsman homes and fill them with furniture and accessories purchased from his company. An obvious next step was to provide free plans to sell the materials and interior mill work, plumbing, and fittings, with which to build the houses. The first to take this step seems to have been, despite its incongruous name, the Chicago House Wrecking Co.[64]

The Chicago House Wrecking Co.

The Chicago House Wrecking Co. was founded in 1893 by the four Harris brothers[65]; they planned to demolish the materials from the Columbian Exposition buildings when it closed in 1894 and then to market the materials. Although the name implies that the company also demolished houses, its specialty was dismantling the international expositions of the time. Writing in 1909, the company observed that "every Exposition of modern days . . . since 1893, has been purchased and dismantled by this company." The profits could be most impressive. The 1904 Louisiana Purchase Exposition at Saint Louis had cost seventeen million dollars; "the Wrecking Company paid $450,000 for everything within the grounds, including the fence," except for some foreign and state buildings that were purchased separately. [T]hey paid $3,300 for the Pennsylvania building, which cost $300,000, including all the furniture, carpets, and other equipments." Some of the material (such as nearly a million light bulbs) went to "dealers and contractors in that sort of supplies"; but the company sorted and stored most of the material on its own forty-acre property outside Chicago.[66]

Building materials were naturally varied and abundant, and for certain projects the fact that the material was secondhand made little difference. As one reporter observed, "2,000 carloads of lumber have already been shipped to various parts of the country, and several hundred carloads of doors and windows have been sold to contractors who are building factories, warehouses, and other cheap structures. . . . Forty-five miles of railroad iron have been sold to a suburban trolley railroad company in Illinois." The most important building material salvaged was lumber. "Three million feet of lumber were saved from the Horticultural building, and Mr. Harris, the manager for the wrecking company, tells me that they will save, altogether, about 90,000,000 feet, which will sell for $11 a thousand and upward. Lumber that has been badly used and is full of nails is cut into short lengths for fuel and other purposes. Lumber is the greatest item of salvage, and from that alone the wreckers expect to reimburse themselves for all they paid to the Exposition officials." Naturally, other materials were salvaged and were then cleaned and refinished by the company.

> About 900 carloads of sewer pipe have been taken up from the soil and it is all being cleaned and inspected, ready to be offered for sale. . . .

> Three million pounds of copper wire, which originally cost the Exposition Company $900,000, has also been secured. . . . Every foot of it is carefully inspected, it is reeled upon the original spools, which were preserved, and the large part of it is as good as new.

This sort of salvage was only one aspect of this energetic company's activity. It also purchased vast quantities of goods "forced on the market through unnatural causes," such as bankruptcies, sheriffs' sales, and special manufacturers' sales. It also bought what today are called "seconds" and goods with minor damage. The company was straightforward about these imperfect or reconditioned items: "All the wire [we sell] is new; some of it is not strictly first class, but it is sold for just what it is—no attempt at deception in any part of our business. . . . The 'B' grade [bath] tubs are some that have been very slightly damaged in shipment and on which . . . we are able to make you an exceptionally low price." Purchasing "seconds" and making any minor repairs needed enabled the company to provide goods to people at very low prices. As a House Wrecking Co. manager explained to a reporter:

> "We sell a whole bath-room outfit—tub, lavatory, and closet, with the fittings and piping, for $25.00 up to $150.00."
>
> "Many farmers buying bath room outfits?"
>
> "Thousands of them. They want the most up-to-date homes they can get—and when they come to us we enable them to get everything they want at prices which have completely outfitted many a farm home that wouldn't otherwise be more than half fitted or furnished. This system of ours distributes a vast amount of valuable production that would otherwise remain unsold. We think our name a misnomer. Instead of House Wreckers we are House-Builders, Home-Makers, we preserve instead of destroy."

A good part of the stock, "bought by us at Sheriffs,' Receivers,' and manufacturers' sales," was brand new. Of twenty-four different departments (from Furniture and Rugs, Wire, Hardware, and Plumbing Material, to Structural Iron, Ready Roofing, Heating Apparatus, and Lumber), at least half carried "strictly brand new" goods or both new and refurbished items.

The Lumber department (Number 22) could "furnish anything needed in lumber, every bit of which is absolutely brand new; nothing second-hand or overhauled in this department." Whether the material in the Mill work department (Number 10), containing "doors, windows, and all necessary interior and exterior trim" included used material is not stated. The thoroughly illustrated general catalog for 1909–10 contained 439 tightly packed pages, including 16 pages of color plates of rugs, carpets, linoleum, and portieres.

The catalog also included twenty-eight pages on houses and barns. "We make a specialty of furnishing material for practically complete house and barn designs," they explained. "On the following pages we give you a few sample pages taken from our FREE Plan Book . . . [which] contains nearly 100 pages." The plans, specifications, and material lists were also free (with "full and complete information" on the service in the plan book).

> Our proposition is so clearly outlined in same that you cannot misunderstand it, and to any one intending to build, a careful reading of our Plan Book will be of invaluable benefit. Ordering [building] material . . . by mail is a simple matter through our system. You can do it right in your own home. You can get plans, specifications, and material list containing full information on practically everything going into the construction of the building in one-tenth the time it would require if you had to go out and get all the information yourself in a round-about manner.

It is not stated just when this aspect of the business was begun, but it was possibly as early as 1906, judging from how well it was established by 1909.

Examining a house plan catalog (from 1913) tells us a good deal about the company's approach—and its claim of having inaugurated this method of "mail-order materials":

> We are the originators of the idea of giving a Plan Book absolutely free and of furnishing Blue Print Plans, Specifications, and Material List practically free as outlined in the following pages. Others have attempted to imitate us even going as far as copying our most successful designs, but a careful comparison will show that they are only beginning where we have left off— trailing after us, so to speak.

Fig. 291. Chicago House Wrecking Co., 1913 catalog (cover).

We are the largest establishment in the United States selling building material in this manner, direct to the consumer, and we are the only establishment of our magnitude that carries its tremendous stock at one plant, where it can be seen and inspected either before or during the time it is being loaded, and from where you can generally load all your material for one building in one car.

By 1913, this aspect of the business was dominant: "Contrary to our name . . . we do not wreck houses; we have outgrown this many years ago, and handle little or no second-hand material except in the machinery and kindred lines. In connection with our great general merchandise establishment, we have one of the largest lumberyards right in the heart of Chicago, and immense warehouses where all better stocks are constantly under cover."

As the graph shows, the house-plan catalog included a wide variety of styles, with Foursquares, one-and-a-half-story gabled bungalows, and even

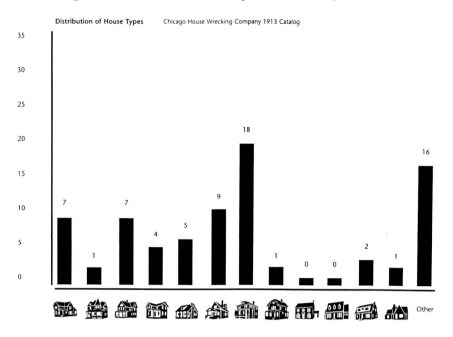

Fig. 292. Distribution of house types: Chicago House Wrecking Co., 1913 catalog.

Stickley Bungalows dominating, along with some older types.

Anyone could order plans and specifications, along with a material list, for the houses depicted, for only $2.00. If on inspecting the blueprints the purchaser did not like them, they could be returned and $1.50 would be refunded. (Of course, one could just keep the plans and other data and consider the $2.00 spent as the purchase price.) If the purchaser subsequently ordered the materials itemized on the list, which would be sufficient to actually build the house (excluding of course masonry materials or plaster), the cost of the plans was deducted from the materials cost so that the plans were then in fact free.

> The advantage of buying all the material necessary for the construction of a building from one source is apparent to all, but in buying from this Company there is a further advantage in the fact that we make a study of furnishing materials that will build the house to the best possible advantage and at the lowest cost, not only considering the cost of material, but the cost of construction as well.
>
> In the first place, we understand the lumber and mill work business in every detail. We know what materials to buy to best advantage. This knowledge in turn is passed over to our Architectural department and our architects, thoroughly practical in every detail combine this knowledge with theirs, and the result is a practical, modern, up-to-date design built without waste of any kind.
>
> Our position in the market enables us to buy at a figure impossible to others, and to sell at prices lower than the material costs many regular dealers. . . .
>
> No firm in the country is as well equipped to make low prices on building material as we are. We are known all over the world as cash buyers for bargains and the bargains of the world are laid at our door for our consideration. We are satisfied with a small fixed profit.
>
> We can furnish you with anything that is necessary for the construction of your house, not only lumber, hardware, sash, doors and mill work, but can furnish you with your plumbing outfits, and with either hot air, hot water, or steam heating plants and also, the innumerable accessories that are necessary to a house, not forgetting our complete line of furniture, rugs and carpets, all in brand new, bright and clean stock.

Just as did Barber or Radford, Chicago House Wrecking recommended that minor changes ("such

as moving a partition back or forward, or a door and window") could be easily made by the carpenter and seldom altered the construction cost. If none of the published plans met one's requirements, one could send in a sketch "showing the size of house over all, rough lay-out of floor plans, showing arrangement and size of rooms, location of windows, doors, etc., also give approximate ceiling heights and rough sketch of style of roof you prefer," and for five dollars (for a dwelling of up to six rooms) the architectural department would work up "architecturally correct pencil plans." These would include floor plans, front elevation, inside trim and outside wall detail sheets, and a porch detail sheet, as well as a "guaranteed material specification estimate and a delivered price." Larger houses cost proportionally more: A nine- or ten-room dwelling was nine dollars for this service. "If after you have received our Special Offer, as outlined above, and you are satisfied to proceed further with your building operations, we will furnish you complete Blue Print Plans, made just as correctly and as complete as any of our regular houses, illustrated in this Plan Book, for $10.00 and up—depending upon how complicated the design may be, all amounts so paid may be deducted from order for material if placed with us." Thus "architectural design by mail," following in the footsteps of the Pallisers decades before, was another of the company's offerings. At least one house from the custom-design service of about this time has been located and documented—a Colonial Revival dwelling with two-story Ionic facade portico, located in Washington, Iowa.[67]

The firm changed its name to Harris Brothers Company by 1915 and continued in business selling materials for its house plans until about 1938.[68]

How widely were the Chicago House Wrecking Co. stock plans employed, and how were they adapted when the houses were built? We can attempt to answer these questions by looking at two dwellings almost certainly built according to its plans in Fredonia, New York. The fact that they are located in a small western New York village, typical of many during the early twentieth century, suggests that the company reached far and wide, certainly farther afield than just the midwest. The letters of encomium for its plans and materials published in the 1913 catalog represent a broad geographical distribution: Ohio, Pennsylvania, New Jersey, Iowa, Missouri, South Dakota, Kansas, and Texas.

House Design Number 156, a Foursquare design (called in the copy "a further development of the two story bungalow pattern"), illustrated in the 1909 se-

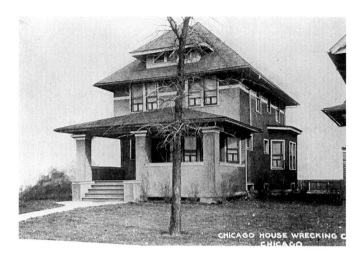

Fig. 293. Chicago House Wrecking Co., house, Design 156 (from 1913 catalog).

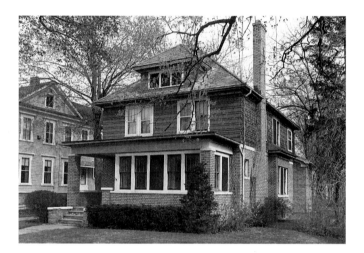

Fig. 294. Charles R. Brown House, Fredonia, New York, 1925.

lection and repeated in the 1913 catalog, was of frame construction with "veneer cement on the outside; a method of construction very popular." The approximate price F.O.B. Chicago (purchasers could write for the current exact price F.O.B. their own station) was $797. For an additional $120, one could get window shades, all the paint needed, and the plumbing equipment (including kitchen and bathroom). The heating plant was also extra and ranged from $83 for hot air to $199 for hot water. Naturally, one would also have to pay separately for constructing the foundations, for materials such as brick, mortar, and plaster, and for the cost of labor in building the house.

The house in Fredonia (built probably in 1925) appears to follow the Chicago House Wrecking Co.

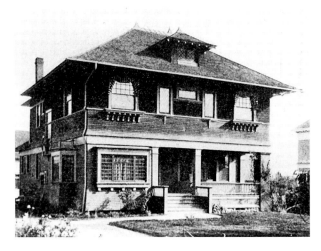

Fig. 295. AABN, *May 13, 1899, advertising section, page iv.*

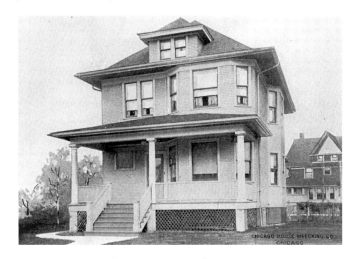

Fig. 296. Chicago House Wrecking Co., *Design 134 (from 1913 catalog).*

plan closely: The location and form of windows, the shape of dormer, and even the "massive porch across the front" follow the model very carefully. The local builder obviously selected a different exterior finish, using brick veneer for the first story and shingles for the second and inserted a fireplace in the living room—always an option in such plans, as we have seen. The dwelling thus has more of a Craftsman appearance than the cement surface would have had, although both display "the very substantial and lasting appearance" of the design promised in the catalog.

This picturesque combination of materials differentiating the first and second floors, and the prominent use of shingles, was not due only to the examples and writings of Stickley. A Foursquare in Pasadena, California (Blick & Moore, architects), with just such a variety of surface finishes, was published in *The American Architect* for May 13, 1899, suggesting the currency of this approach for Foursquares, at least among professional architects, at the end of the nineteenth century.

The second Chicago House Wrecking example from 1909, Design Number 134, a slightly larger dwelling whose materials would cost $810, was also a popular Foursquare, with bay windows at both front and side (in the 1913 catalog the identical design and plan was given the number 134A and a price of $969). "The swell front or bay windows, the handsome dormer, and the massive colonial porch give the exterior an exceedingly pleasing and substantial effect," we are assured. It was built in Fredonia by Henry J. Green, an electrician, in 1910.[69] As a comparison of the plans and room dimensions reveals, the Green House fol-

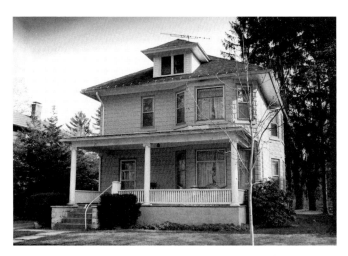

Fig. 297. Henry J. Green House, *Fredonia, New York, 1910.*

lows the Chicago House Wrecking design almost to the inch. Some minor changes were made: The pantry was eliminated to make the kitchen and dining room bigger, and the location of windows and doors was altered slightly.

Did the owner really order the materials from Chicago House Wrecking? The exterior—surely a major part of the package—is not frame as in the advertised model, but was built in concrete block. Although it is possible that all the interior and roof framing was ordered (the company did advertise its willingness to supply materials for modified lists), it seems just as likely that the plans were ordered, and then a local contractor simply used them to construct this dwelling.

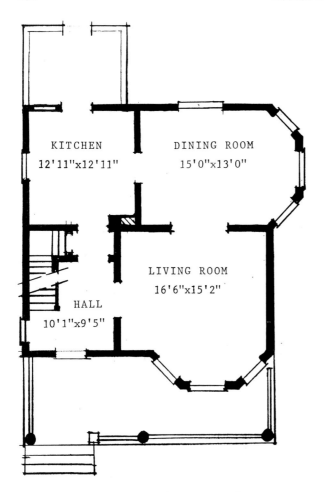

Fig. 298. Henry J. Green House, plan.

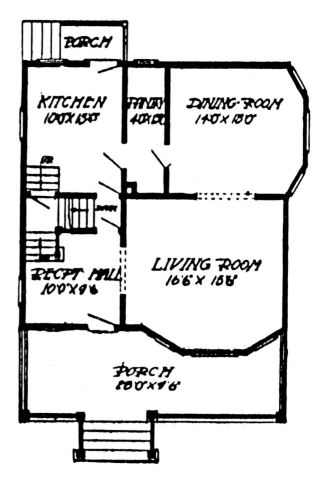

Fig. 299. Chicago House Wrecking Co., Design 134, plan.

The Foursquare was a well-established house type by 1909; but a new type that the Chicago House Wrecking Co. was among the first to popularize is the boxy two-story clipped-gable dwelling, which in its 1913 catalog, was Design Number 57. Despite the assertion that it was a "strictly modern home," its "handsome exterior appearance" owes a good deal to the nineteenth century. Vaux apparently introduced this sort of English-style dwelling to the pattern books; in his *Villas and Cottages* (1857), he included a vignette and plans for a "Farm-House" of this type. In 1863, H. H. Holly included a two-story cottage (Design 4) with this distinctive roof shape, although with a cross-wing as well. It was still in favor in 1903, for William Radford included several dwellings (both one story and two) with clipped-gable roofs. As we saw, Stickley developed a one-story shingled bungalow using this form of roof by 1915.

This rather boxy type, a full two stories tall with a front porch, as depicted by the House Wrecking Co.,

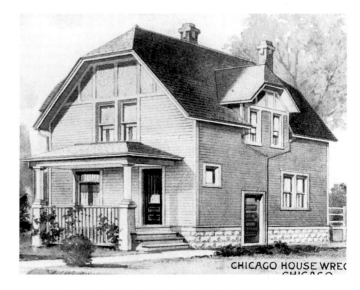

Fig. 300. Chicago House Wrecking Co., house, Design 57 (from 1913 catalog).

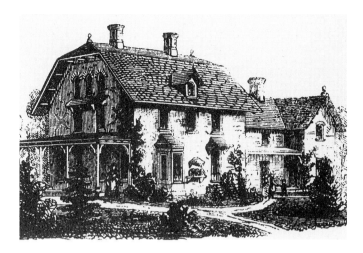

Fig. 301. Vaux (1857), 146, "Design for a Farm-House."

became a popular model in the first decades of the twentieth century; Sears carried several versions of it between 1911 and 1926.

Sears, Roebuck & Co.

Of all the companies that sold plans or houses by mail, Sears, Roebuck & Co. is today the most famous. This is in large part due to its being (until 1993) a giant in the mail-order business and also because the fact that it once also "sold houses," largely forgotten since the demise of this department in 1940, is intriguing to many. The Sears "houses by mail" business, when it began in 1908, differed little from that of the Chicago House Wrecking Co.—and was perhaps not even as complete. This aspect of Sears's retail business has been studied thoroughly in recent years in both books and articles, and "Sears houses" appear in local newspapers as historically interesting curiosities with some frequency.[70]

As is well known, Richard W. Sears began his mail-order retail business in 1886 selling watches and later jewelry; he was joined in this venture by Alvah C. Roebuck (a watch repairman) in 1887, and, after various twists and turns, their business was established as Sears, Roebuck & Co. in Chicago in 1893. Mr. Roebuck retired in a few years, but Mr. Sears, with two new partners and more capital, expanded the business rapidly. By 1905–6, the concern built an extensive new facility for its mail-order company on a forty-acre site on the west side of Chicago.

Among the countless items sold in its general catalogs, which Sears began issuing in 1893, were building materials of all kinds. In the 1897 catalog, eight pages were devoted to all manner of hardware (locks, hinges, catches, pulls, hooks, and so on); four pages described interior and exterior woodwork, trim, and doors (as well as building paper, roofing material, and metal siding); and a few pages offered paint, varnish, and stain. This department did not thrive, and Sears planned to close it down in 1906. The new manager of the area, Frank W. Kushel, thought that it could become profitable, however, and aggressively promoted building materials, especially through the house-plan service, which was inaugurated in 1908. A careful examination of the Sears program can be made from information in the general catalog of that year (a separate catalog, *Book of Modern Homes and Building Plans*, was also issued in 1908).[71]

The services that Sears offered were similar to those of Chicago House Wrecking. Prospective home builders could send for the free catalog of house designs, which included twenty-two models illustrated "with the finest half-tone cuts . . . reproduced from washed drawings made by some of the foremost architects in this country." Then the client could order the plans and specifications desired.[72] These were blueprints of original drawings and also specifications, which consisted of "from fifteen to twenty pages of closely typewritten matter." As the 1908 general catalog explains in detail, the blueprints included all drawings needed to erect the dwelling, the specifications covered all "material and labor required," and a "complete bill of materials and labor" was included. "All this detailed information will [enable you to] . . . estimate almost to a dollar what the building when completed will cost."

> Every free house plan we offer represents the most careful study of the best known licensed architects in this country who were especially engaged by us for this service. Before making these plans our architects carefully canvassed the requirements of people in all parts of the United States, embodying the very latest ideas in these plans and giving us houses suited for the city, the town, and the farm home. These complete building plans which we give free bring out the ideas of the best posted contractors and builders in this country, as well as the very best architects.

Such plans and specifications would cost "from $50.00 to $200.00 depending upon the size and kind of house you propose to build" if they were obtained from architects. The "enormous savings" that home builders could achieve were twofold: First, the plans were essentially free; and second, if people bought building materials from Sears, they would save 25 to 33 percent over local suppliers. By studying the bill of materials carefully, prospective home builders could see how inexpensive Sears's high-grade materials were in comparison to local concerns. As Sears explained, "[B]esides saving you the entire cost of architect fees for plans and specifications, we save you one-third the cost of your mill work, including windows, doors, mouldings, casings, stairwork, [mantels,] grilles, flooring. We also save you from 25 to 50 per cent on the cost of your plumbing materials, furnaces, and hot water systems, water supply outfits, paints and varnishes, building hardware, in fact we can save you on every item which enters the construction of any house, *dimension lumber excepted*" [italics added].

We saw previously that Chicago House Wrecking Co. did not supply any masonry materials ("brick, lime, cement, or plaster"), but it may come as a surprise that in its first offerings Sears not only omitted masonry goods, but excluded lumber, too! "We want to supply you with all the material which will enter into your new home with the single exception of the rough lumber." *Finished* lumber might include items such as hardwood (or tongue-and-groove pine) flooring, clapboards, or shingles. Because of the "extremely low prices" for the Sears materials, however, the company was confident that it would "receive a liberal share of your orders for mill work and other building materials." Naturally, the machined and manufactured items were those on which the highest profit could be made, even though, as Sears reassured readers, because the company made much of this itself, it could sell at "manufacturing cost, with just one small margin of profit added." This was much lower than "the prices asked by local dealers who sell you goods which have passed through manufacturers', jobbers', and retailers' hands and therefore paid a profit to several individuals."

Within a few years, however, the Modern Homes Department was considerably expanded with the purchase of a lumber mill in Louisiana in 1909, a forty-acre lumberyard in Illinois in 1911, and a mill-work plant in Ohio in 1912. Building components were still the main stock-in-trade, however. In 1911, the "sash department had 100,000 sashes in stock and produced 5,000 per day; 75,000 doors were on hand, and 1,500 were manufactured per day;" but now Sears also had

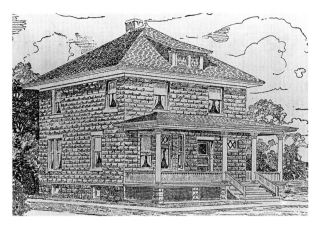

Fig. 302. Sears house, Design 52 (from 1908 general catalog, page 597).

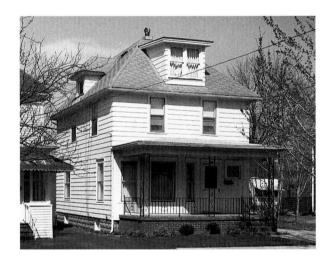

Fig. 303. William J. Shaw House, Fredonia, New York, 1912–13.

plenty of lumber—1,250 carloads in stock in 1911.[73] Probably the success of Sears's neighbor, the Chicago House Wrecking Co., showed Sears that lumber could also be sold at a profit to those using its house plans.[74]

By examining a few Sears houses from these beginning years, we can get a better idea of how people made use of this service. One of Sears's first designs was a "handsome nine-room concrete" Foursquare illustrated in the 1908 general catalog. Sears noted that "concrete houses can be erected at one-third less than any other kind of stone structures" and pointed out that its own "concrete block building machines . . . the most perfect and most rapid . . . machines made" (fully explained and illustrated elsewhere in the catalog) enabled the owner to make the blocks himself.[75]

As we have seen, in these early years Sears supplied only the mill work, mechanical systems (plumbing and heating), and hardware, not any lumber. If

one wanted to erect "this elegant house" in frame construction, the owner was likely to simply turn to his local contractor, undoubtedly with the plans and specifications (which cost only one dollar) in hand. Whether the interior mill work was indeed ordered from Sears or obtained locally, it was really a modest percentage of the entire dwelling's cost.

An interesting version of this 1908 Sears design was built in frame in Fredonia, New York, at 106 Liberty Street in 1912–13. The plan is almost identical to the published design, with only two significant changes: The entrance hall is enlarged toward the rear, and the room behind it (on the plan a bedroom) is reduced in size and made into the kitchen; a rear wing was omitted. Despite the changes in partitions, the central chimney is in the same location as that shown on the Sears plan. As a comparison of the 1908 engraving and Number 106 shows, the exterior disposition, even to the diamond-pane window on the front porch lighting the stairs, matches well.

This house and its neighbor to the left, 102 Liberty Street, were built at the same time and have exactly the same plan. To fit them on the restricted lot, however, the design was made a bit smaller—both are two feet shorter and five feet narrower than the Sears plan. To prevent their being duplicates of each other, Number 102 was given a roof gable rather than a dormer.[76]

One wonders whether a local builder might not have just ordered the Sears plans and, purchasing selected mill work from Sears or not, adapted the blueprints to his own needs. After all, only one dollar for plans and specifications was a real bargain: As we saw, plans for sale by Radford for comparable dwellings cost five times as much.

Within a few years of beginning its Modern Homes Department, Sears found that, thanks to its newly acquired lumberyards and mill works, it could also sell lumber in addition to the finished woodwork and hardware. This same house was depicted in its 1911 catalog; now, Sears explained that it would furnish "all the material to build" the house—except the concrete blocks—for $782. This would include all the "mill work, flooring, ceiling, finishing lumber, roofing, pipe, gutter, sash weights, hardware, painting material, *lumber, and lath*" [italics added]. By allowing "a fair price for labor, cement, brick, and plaster, which we do not furnish," the house could be erected for about $2,200. Heating and plumbing were extra.

Naturally, for a frame house, once all the lumber and mill work inside and out were available from Sears at near-wholesale prices, ordering it all from Sears made good sense. Although a local carpenter would still have to cut all the lumber on the site to fit

according to the blueprints, having all the material selected and shipped as a unit must have been a great convenience. A good example of a Sears house from these early years is Modern Home Number 123; the design owes much to the capacious gambrel-roofed houses of the Shingle Style a few decades before, although updated with prominent classical detailing (the roof and eaves moldings, classical pediment above the entry steps, and Tuscan columns for the porch). The design was offered between 1911 and 1915 and was built in Granville, Ohio, about 1912.[77]

The Minnie Buxton Kerr House follows the Sears plans quite closely, both inside and out, although with some departures. On the exterior, the side bay is changed from a gambrel-roofed treatment, which nicely echoed the front gable, to a more prosaic rectangular bay. Inside, there were some partition changes: The lobby and closet of the front hall were omitted to give that area more space for the stairs; and in the kitchen area, the pantry and entry at the right were thrown together to

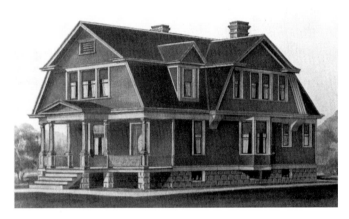

Fig. 304. Sears, Design 123 (1912 catalog).

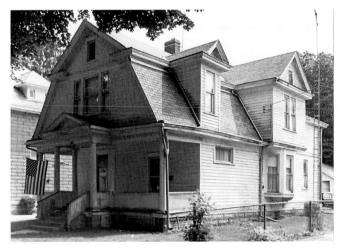

Fig. 305. Minnie Buxton Kerr House, Granville, Ohio, c. 1912.

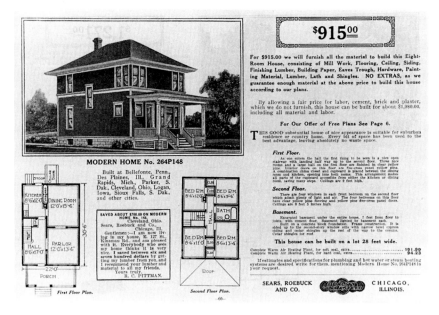

Fig. 306. Sears, Design 264P148 (1915 catalog).

form a bathroom; the secondary stairs at the left were removed (the space used for a recessed back porch) and placed as a straight run on the inner kitchen wall. Yet a comparison of the layout and dimensions of the rooms reveals that the plans were followed closely, occasionally to the inch. Even the foundations of the Kerr House, as specified in the Sears ad, are of concrete block.

The local carpenter would have had considerable leeway in his work. Sears supplied "enough material . . . to build this house according to our plans," but the material was not specially cut or fitted, and changes to meet the needs of the owner or at the discretion of the carpenter were easy to make. In the nearby village of Hebron, Ohio, a duplicate of the Kerr House also has the rectangular rather than the gambrel bay on the south side. Furthermore, elsewhere in Granville, there are other houses similar in style to Modern Home Number 123, but with different proportions or details—as if the carpenter, with plans in hand, did a series of variants or "improvements" in later houses he constructed.[78]

Others, however, built their Sears houses exactly following the blueprints, even though minor changes were easily made. One good example from the early years of this Sears enterprise is Modern Home Number 264P148, a Foursquare with distinctive corner windows, offered (under various numbers) between 1911 and 1921. The example illustrated here is from the 1915 catalog. All the materials, including "lumber, lath, and shingles" guaranteed to be "enough material . . . to build this house according to our plans," but excluding plumbing or heating, sold for $915. The

cost of "labor, cement, brick, and plaster" would bring the total for the dwelling to $1,980.

This "good substantial house of nice appearance" suitable for "suburban residence or country home" was erected on a farm two and a half miles from Westfield, New York. Because so many Sears houses were purchased for farms, a brief examination of this instance is instructive.

Bert and Emma Taylor's farm, of about 175 acres on the Lake Erie shore, included dairy cattle, oats, and from about 1930 on, Concord grapes. They and their five children lived in a capacious boxy Queen Anne dwelling built in 1898; the original farmhouse, a one-and-a-half-story vernacular Greek Revival structure, was just to the southwest and was eventually used as a packing house. About 1914, the Taylors decided to construct a dwelling for a tenant farmer, on the other side of the original house. Why they selected a Sears house is not known, but Bert's brother Bill, although also a farmer, liked carpentry and had moved several buildings himself; he probably interested his brother in building a Sears model. The plans and specifications were purchased, as well as all the materials available, from Sears and brought to the site by wagon from the Westfield railroad depot. Taylor employed a carpenter from Westfield to build the house, although he and his brother may have helped some, too. Old photographs of the house show that it was painted in three colors, as suggested in the Sears catalog vignette.[79] Farmers who already owned the land for a new house could undoubtedly prepare the foundations themselves and help

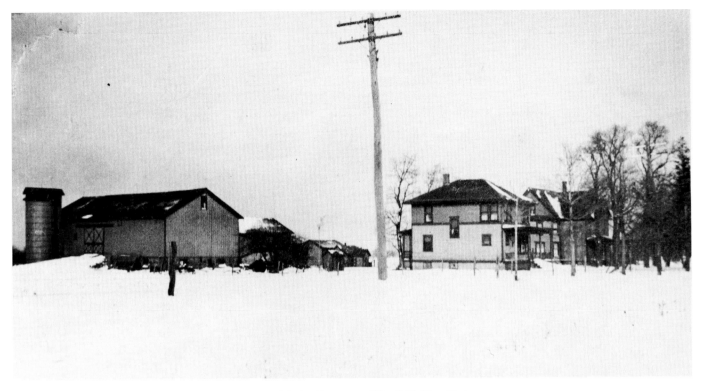

Fig. 307. Taylor Farm, near Westfield, New York.

with—or even carry out—construction; in such cases, the Sears "package" was advantageous and efficient.

As constructed, the Taylor tenant house follows the Sears blueprints virtually to the inch. The only real change as built was the elimination of the pass-through cupboards between kitchen and dining room. Because even the peculiar "one-column colonnade" was used at the entrance to both the parlor and the dining room, it seems clear that all the material was provided by Sears.

As an examination of the 1915 Sears Modern Homes catalog shows (Fig. 310), the Foursquare was a popular model, making up 16 of the 112 dwellings shown. Even more popular were bungalows, both one-and-a-half-story gabled versions (22 models depicted) and Stickley Bungalow types (17 shown). The fact that traditional Queen Anne houses and gambrel-roofed houses of generally colonial character were still carried shows that Sears was conscious of both conservative and more up-to-date tastes. That this wide range of styles to choose from permitted almost every home builder to find a house he liked is confirmed by the company's success: By 1915, only seven years after the Modern Homes division was begun, the plans had been "successfully used by 3,000 builders," and one model (Number 264P136) had been built by "more than 100 people."

In addition to 112 houses, the 1915 catalog offered six barns, two carriage houses, and various other farm structures (different sizes of corncribs, hog houses, chicken houses; a machinery and tool house, and a milk house). The catalog also illustrated three "Ready Made Houses," from three to five rooms: "Simplex houses are portable. They can be taken apart as readily as they are put together. Ideal for lakeside or summer resorts." A free catalog, *Ready Made Buildings* (2d ed.), was available; Ready Made garages as well as a schoolhouse were also included. Like the standard houses, blueprints ("showing floor plan and elevations of any Ready Made Building") could be ordered for one dollar. The catalog ended with illustrated views of lumber mills; an ad for the building material and mill-work catalog ("over 900 kinds and sizes of doors, 960 kinds and sizes of windows and sash"); an ad for the "Modern Heating Systems: Hot Water, Steam, Warm Air" catalog; another for the "Modern Plumbing" catalog—with the last page devoted to extracts from twenty-two letters of encomium from owners of "the thousands of houses built from our plans and with our materials."

By 1918, Sears had added another, novel, feature, first developed, it appears, by the Aladdin Company of Bay City, Michigan, a rival in the "houses by mail"

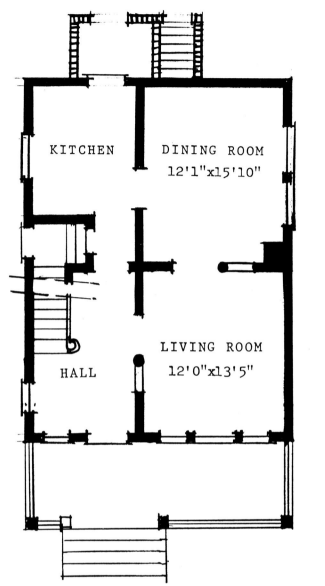

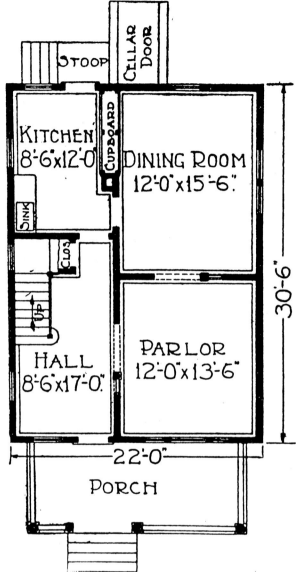

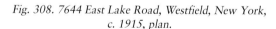

Fig. 308. 7644 East Lake Road, Westfield, New York,
c. 1915, plan.

Fig. 309. Plan, Sears, Design 264P148 (1915 catalog).

business. Of the ninety Sears houses offered, well over half (53) were now available with the lumber cut and fitted at the factory. Some of these had a somewhat cheaper version not cut or fitted, and thirty-eight houses were available only in this form.

In the 1918 catalog of *Honor Bilt Modern Homes* (See Color Plate VII), Sears offered the prospective home builder two grades of construction for its houses: Most were "Honor Bilt," which meant that the dwellings were designed in the most sturdy form of balloon-frame construction. Joists, rafters, and studs were on fourteen-inch centers; there was double studding

at the sides of doors and windows and double plates above and below windows; and subflooring and wood sheathing were employed.[80] Some dwellings were also available in a "Standard Built" version, in which members were more widely spaced (rafters on thirty-four-inch centers and studs and joists on twenty-two-inch centers); there was no double studding (except for the top plate); and there was no subfloor or wall sheathing behind the clapboards. For all the Modern Homes, however, only the best yellow pine (or for shingles, red cedar) was used; "we do not handle hemlock, spruce, or inferior types of lumber." Thus owners could choose

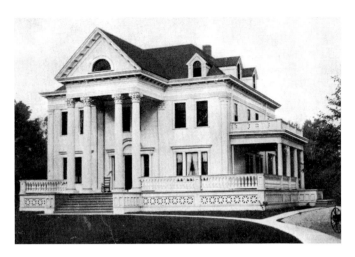

Fig. 319. Langellier House, Watseka, Illinois, 1903
(Courtesy Mrs. Charles Beebe).

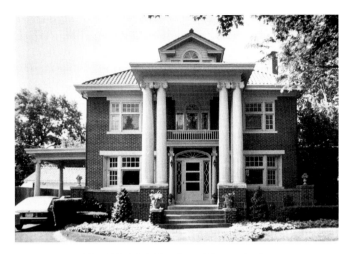

Fig. 320. 2465 East Broad Street, Bexley
(a portion of Columbus), Ohio.

house built in 1903 with many features in common with "The Magnolia," as the comparison shows.[86] Clearly, the Sears architects produced designs that followed, a few years after, popular movements in American architecture.

Although it was offered by Sears for only four years (1918–21), built examples of "The Magnolia" have been located. The best known, which has been frequently reproduced, is found in Canton, Ohio: The exterior follows the published model exactly (a second story on the right wing may be later). A second Magnolia, although with Ionic rather than Corinthian columns, is in South Bend, Indiana.[87] A third example, which raises some interesting questions, is located in Columbus, Ohio. As a comparison of the Columbus dwelling and the Sears design shows, it follows the model with care. The two second-floor windows thrown together as one is not a significant change; but the fact that it is a *brick* dwelling with a tile roof certainly is.

"The Magnolia" was available only in the precut and fitted mode; thus it would be inconceivable for anyone to order it and then not use any of the materials intended for the exterior walls and roof covering! What seems to have happened here is that a local owner or builder ordered the Sears plans—which at ten dollars were still a great bargain—and then erected his own version of it. Of course, it is also possible, given the clarity of the Magnolia elevation view and the ample detail in the published plans of both floors (to say nothing of the seven photographic interior views that Sears also published), that a local builder simply adapted the catalog illustrations himself, because in changing to brick construction, he would have to prepare his own working drawings anyway.

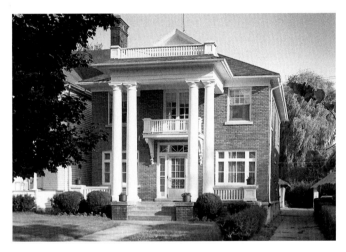

Fig. 321. Joseph Sanesi House, Dunkirk, New York, c. 1921–23.

A second example of a brick Magnolia (built between 1921 and 1923) can be found in Dunkirk, New York.[88] Despite the lack of side wings because of the narrow lot, the similarities to the Sears model are still striking, but the house is much narrower than its model. In fact, although 93 West Fourth Street is the same depth as "The Magnolia" (36' 1" versus 36' 0"), it is a full ten feet narrower (29' 10" versus 40' 0").

Furthermore, the plan of the Dunkirk house is considerably different; instead of the formal central hallway with staircase and rooms on either side, here the plan is far more compact: One enters the living room, which runs across the front of the house, in the middle of its long side; the stairs are at one end. The dining room, kitchen, pantry, W.C., and cellar stairs occupy the rear half of the house. Here we almost cer-

tainly have an instance of a local builder who studied the illustration in the Sears catalog and created his own version of it, without ordering the plans or, in all likelihood, any of the materials from Sears. In this manner, the Sears catalogs, and undoubtedly those of other companies, were a source of architectural inspiration and even of designs in and of themselves.

The Aladdin Company

Although by 1918 precut and fitted lumber for houses from Sears and other concerns was well known, the method appears to have been "invented" and popularized by Aladdin houses as early as 1906. When founded in that year by William J. Sovereign and Otto E. Sovereign, their business was grandly called the North American Construction Company.[89] Although their father had been in the lumber business since 1870, settling in Bay City, Michigan, in 1878, the Sovereign brothers' expertise was in other areas: W. J. (they later went by their initials in the catalogs) was trained as a lawyer, and O. E. had taken courses at a business college, spent two years at Michigan Agricultural College, and learned the advertising business by correspondence from the Chicago School of Advertising; his early career was as a newspaper editor and reporter.

The inspiration for what was to become "Aladdin Readi-Cut Homes" was not the "portable" houses of the day, but rather a boat-building company in Bay City, which sold by mail precut and fitted boats for purchasers to assemble. The brothers began work on precut houses following the same pattern in 1906, the year of their first catalog. Their first advertisement (in *Boating* magazine) in April 1907 offered boathouses and summer cottages. "Anyone who can drive a nail can put together an 'ALADDIN' House."[90] They also offered garages.

Naturally, on their slender initial capital, orders when received were sent to a local lumber mill that then cut all the lumber according to the Sovereigns' drawings. Their first order (July 8, 1907) was for a summer cottage costing $298.

Their business grew rapidly thereafter. By 1910 (when the term "Readi-Cut" was being used), gross sales were $87,000; the 56-page 1911 catalog depicted 47 houses and 2 garages. By 1915, the 128-page catalog included 101 houses, 18 summer cottages, 5 garages, and a variety of extra features: four barns, a poultry house (available in thirty different sizes!), a hog house (fourteen sizes), a milkhouse (eight sizes), as well as interior features such as cabinets, colon-

nades, buffets, and even a furnace, a "bathroom outfit," and a kitchen range. Four pages of "Homecraft" furniture and electric light fixtures were available from Aladdin, too.

The houses depicted by 1915, when their sales reached $1,100,000, ranged from modest vernacular cottages—with a good number available in different sizes and styles—to costly dwellings. "The Delta," a four-room cottage measuring sixteen by twenty-four feet (with no bathroom) cost $310; "The Hereford," a seven-room and bath Foursquare, twenty by twenty-four feet, cost $835; "The Berkshire," a two-story, five-bay Colonial-style house (30 by 48 feet) of nine rooms and bath, cost $2,375. These prices did not include the cost of plumbing or heating, foundations or masonry for chimneys, but did include plasterboard or lath and plaster.

In the initial years, the Sovereign brothers did not own their own lumberyards and in fact had a very small staff; as orders arrived, the detailed lumber list and cutting instructions were sent to one of several local Bay City lumberyards that prepared the lumber for them. By January 1, 1915, the North American Construction Company had its own mill yards, with "a capacity of twice all other mills in Bay City which are producing Readi-Cut houses." The company was quick to defend its primacy in developing these precut houses. As explained in the 1915 catalog: "Aladdin Readi-Cut Houses . . . may be new to *you*, but the system was planned and put in operation ten years ago. . . . W. J. Sovereign, president of the North American Construction Company, conceived this tremendous thought, originated, perfected, and established the system. Imitators have been many the past three or four years, but not one has yet even approached Aladdin efficiency."

Like Sears, Aladdin (the company changed its name to The Aladdin Company about 1917) proudly described the high quality of its lumber, soundness of construction, reliability as a company, the savings that the Readi-Cut system ensured, and the ease of building the houses. Excerpts from the "Short Statements of Fact" in the 1915 catalog present the main selling points succinctly:

> The North American Construction Company originated the Readi-Cut System of house construction, and is alone responsible for its development.
>
> An Aladdin house is exactly like any other well-constructed house when it is erected. It cannot be taken apart except as you would tear apart any other good house.

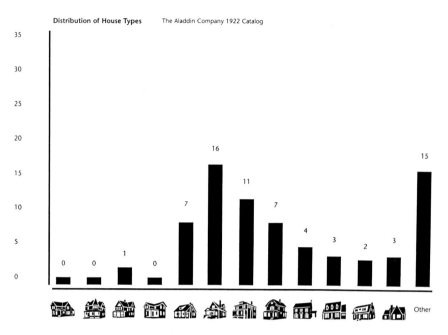

Fig. 322. Distribution of house types: Aladdin Company, 1922 catalog.

A saw is practically unnecessary in the erection of one of our houses. We do the measuring, sawing, and fitting in our mills, by automatic machinery and best skilled labor.

Our mills are situated right in the heart of the great timber lands of Michigan, Florida, Louisiana, and Oregon [as well as Canada]. . . .

You get the finest grade of material throughout the entire house at a less price for the completed house than you can buy through any other source.

Aladdin houses are designed so that mill-run lengths are used almost throughout. Using mill-run lengths makes unnecessary the cutting to waste of good lumber. We reduce waste in everything down to less than 2%.

Skilled labor can be dispensed with in the erection and completion of any but the large Aladdin houses—because we supply the skilled labor in our mills, preparing the entire house for you to fit and nail together in a few days.

You pay but one profit on all the material.

You know what your complete house will cost. Everything [except masonry[91]] is included in the price stated in this catalog and in specifications.

You know exactly what your completed house will look like. We show you photo-graphs of your house, inside and outside, floor plans, furnish complete specifications.

You save several months' time, for we usually ship your house promptly upon receipt of your order. It can be erected in one-third the usual time.

Aladdin homes grew rapidly in popularity; 3,200 were sold in 1917, with a peak of $5,100,000 in sales reached in 1920. A large part of the company's success was due to the attractive and varied house styles offered, not just to the economy or ease of construction. In the 1915 catalog, for example, 101 houses were illustrated (as well as 18 summer cottages). The houses included one- and two-story gabled vernacular dwellings, usually with attractive shingle or clapboarding detailing; Stickley Bungalows; one- and two-story Craftsman and California-type bungalows and houses; Foursquares; clipped-gable houses; Colonial-style houses, both gabled and hipped roofed; an early "Dutch Colonial" gambrel dwelling; English-style dwellings; and gambrel-roofed houses. A graph of the house types in the 1922 catalog shows a similar pattern. There was something for every taste and bank account. By examining several of the Aladdin models in detail, especially as actually constructed, we can get a better idea of the character and sources of the company's designs.

As the graph shows, Aladdin offered a good variety of house types to choose from. Like most mail-order house or house-plan companies of its day,

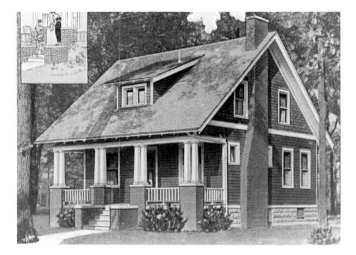

Fig. 323. Aladdin Company, "The Detroit" (1918 catalog).

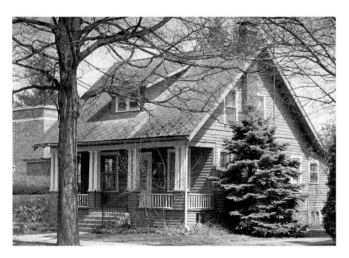

Fig. 324. 232 North Granger Street, Granville, Ohio
(Photo by Ione Drake Reiff).

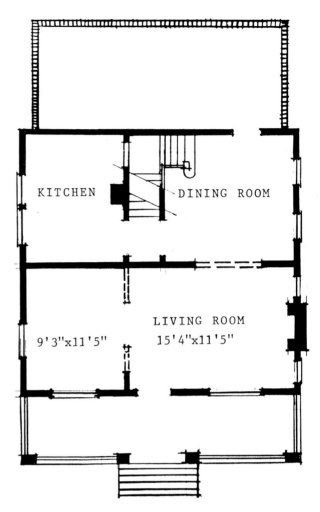

Fig. 325. 232 North Granger Street, plan.

Aladdin featured Stickley Bungalows; one that appears in catalogs from at least 1915 through 1931 is "The Detroit," "a two-story design and yet carrying genuine bungalow lines throughout." This was built, among other places, in Granville, Ohio, and a comparison of the constructed example with the designs in the Aladdin catalogs is quite revealing. It is certain that this is an Aladdin house both because of the congruency of exterior design and interior plan and also because a keychain (with ten keys) with the Aladdin logo is still preserved in the house.[92]

What is interesting to observe is that the Granville Detroit combines features found in models of different years. In 1915, the house had clapboarded porch foundations and piers, as we see it constructed; from 1918 onward, the illustrations show these features in brick. Yet the band separating the side clapboards from the gable shingles on the side in the 1918 model is at the eaves line, whereas in all other years it is several courses above, close to the second-story windows; and this is the form that was built. Perhaps the Granville bungalow model dates from a 1916 or 1917 catalog, when these features were being adjusted. On the inside, there are similar anomalies. The kitchen chimney is on the inner wall in 1915 and 1931 and as built, but it is in the corner in 1918 and 1919. Furthermore, the illustrations of "The Detroit" and the plans do not always exactly coincide: All exterior views show two windows in the dining room, but the *plans* for 1918 and 1919 show only one. Thus we can see that matching a built example to plates and plans, even when we know for certain that it follows the published design, has to take into account that the actual dwelling sold may not have conformed to the published illustrations.

Although most of the partition dividing the living room from an adjacent bedroom was removed,

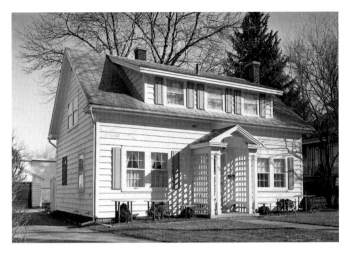

Fig. 341. 156 West Main Street, Fredonia, New York, 1923.

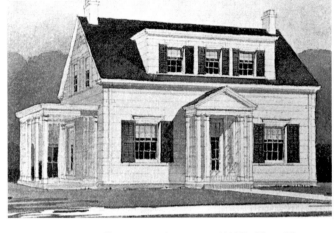

Fig. 342. Small Home Service Bureau *(1922), Plan 612.*

1930. Articles about ASHSB were published in *McCalls, Good Housekeeping, Colliers, House Beautiful,* and *Country Life,* among others."[5]

Although the Bureau may have assisted in educating the public in good house design, as the ASHSB saw it, the number of plans sold was actually not very large: About four hundred plans were made available (some were very popular while others had few if any takers), and it is estimated that over the twenty-three years of the Bureau's existence, about five thousand houses were built to its designs.[6]

The Bureau catalogs included a good deal more than just house plans. The volume *How to Plan, Finance, and Build Your Home,* published by the Mountain Division of the ASHSB in 1922, contained fifty-two designs, but also essays on many useful subjects: "Home Owner or Tenant—Which?"; "The Financing of Your Home"; "Building Materials—How to Use Them"; "Decorating and Furnishing the Small House"; "The Garden"; "Planning the Kitchen"; and "Electricity in the Home", to cite a few. The catalog also included twenty-nine pages of ads for building materials and supplies and a Classified Builders' Directory. Although the introduction to this catalog stated that the Bureau was not "connected with" the sale of supplies and materials—did not get a commission on them—such ads obviously helped pay for the well-produced and illustrated large-format catalogs. Other volumes were co-sponsored by various building materials companies, such as the Southern Pine Association, the Weyerhaeuser Forest Products, or the Morgan Woodwork Organization.

The styles of houses offered by the Bureau tended to be conservative, in response to public interests; Tu-

dor and Colonial were especially popular. Despite the fact that relatively few ASHSB houses seem to have been built, a reasonable number of constructed examples have been located;[7] we can examine in detail one erected in Fredonia, New York, in 1923.[8]

The Bessie Young House follows Bureau Plan Number 612, a "compact" yet "unusually attractive" Colonial design, quite faithfully. There are some minor exterior changes, however: The long roof dormer is provided with a steeper slope, to better shed the snow and rain; paired- rather than single-facade windows are used; and the porch pediment is altered to provide more headroom. The interior plan is followed closely, although with some minor changes as well: The staircase is on the left rather than the right of the hall. A comparison of interior dimensions confirms how faithfully the builder followed the blueprints: The bureau dining room is 11 feet, 6 inches square, while as built it is 11 feet, 10 inches, by 11 feet, 4 inches, and the living room is 11 feet, 6 inches, by 20 feet, as designed, versus 11 feet, 5 inches, by 21 feet, 2 inches, as built. The kitchen is 1 foot deeper than the Bureau plan.

These one-and-a-half-story gabled Colonial-style houses with roof dormers (either a long shed dormer or two or three individual ones in the roof slope, historically more accurate) making the second story almost fully usable became extremely popular during this period. Most plan and mail-order-house companies carried the model; especially in the 1930s when comparable houses restored at Colonial Williamsburg became well known, many advertised dwellings were quite close to real historic models.

A modest change in the roof shape of the ASHSB Plan Number 612, from gabled to gambrel, would not

only increase usable space and headroom in the second story, but would make the dwelling reflect a different well-known Colonial type, small houses with gambrel roofs. This house type was illustrated in the same 1922 catalog as Plan Number 517 and at a glance looks like a duplicate of Number 612 except for the gambrel roof (although the long shed dormer has two rather than three windows). Such gambrel-roofed houses with connected rather than individual dormers became immensely popular during these years: Sears offered thirteen or fourteen models of so-called Dutch Colonial houses between 1918 and 1937 (see Color Plate IX). Because of the ubiquity of this type and its use by almost all plan companies in the 1920s and 1930s, an examination of its origins and early manifestations is in order.

We have already examined Dutch houses with flared roofs over their porches, a distinctive house-type always associated with Dutch settlers in the Hudson valley, Long Island, and parts of New Jersey (see Fig. 278). Yet gambrel-roofed houses given the denomination "Dutch" are quite another matter. Actually, one-and-a-half-story gambrel-roofed houses were frequently built by *English* craftsmen in the eighteenth century along much of the eastern seaboard, and good examples can be found in Massachusetts, Connecticut, and Rhode Island, as well as in Maryland and Virginia—although gambrel-roofed houses were indeed built in Dutch areas of New York state, too.[9] Although the house type was recognized as not found in Holland—while common enough in England[10]—for better or for worse, this house type must be called "Dutch Colonial," as it has been for more than ninety years.

Gambrel-roofed dwellings from the colonial era were, as we have seen, a vivid source of inspiration for architects of the Shingle Style; William Ralph Emerson even designed his own house of 1886 in Milton, Massachusetts, as one long, although animated, gambrel-roofed composition. Either used as one compact form or with a cross-gambrel adding spatial variety and complexity, it became a common feature in Shingle Style designs of the 1880s. As we have seen, gambrel-roofed houses, often with cross-gables, were common in the work of Shoppell in the 1890s and in the early years of the twentieth century were popular with the Radford architects. The Sears Modern Home Number 123, offered between 1911 and 1915, which we examined as erected in Granville, Ohio, is a late manifestation of this tradition. (See Figs. 304 and 305.)

Our main concern here, however, is with compact one-and-a-half-story gambrel-roofed houses with the entrance on the long side and with roof dormers. This type also has its own sequence of discovery and development.

During the revival of interest in colonial architecture, especially from the 1880s on, genuine gambrel-roofed colonial dwellings were certainly well known; for example, the famous view of the Fairbanks House in Dedham, Massachusetts, with its prominent eighteenth-century gambrel-roofed wing, was reproduced in *The American Architect* on November 26, 1881. Even earlier, a vignette of a gambrel-roofed house in Newport, Rhode Island, with three shed-roofed dormers, appeared in an article on colonial architecture on August 13, 1881; another modest vernacular gambrel-roofed colonial house at Hingham, Massachusetts, with several gabled dormers, was illustrated on August 22, 1885.

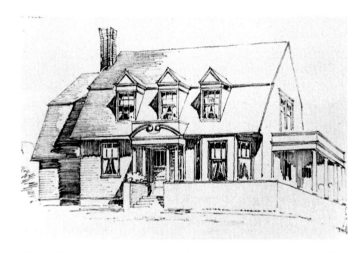

Fig. 343. House design by C. H. Blackall, AABN, *January 24, 1891.*

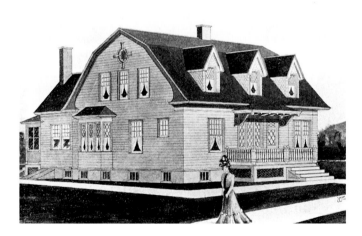

Fig. 344. Radford Ideal Homes *(1904 ed.), Design 81.*

This type of house was adapted to small dwellings soon after. Three good examples of this specialized form of Colonial Revival can also be cited from *The American Architect*. "A $2,000 Cottage" with paired shed dormers appeared on June 2, 1888, to be built in Melrose, Massachusetts; a more high-style version with three gabled dormers and a quasi-classical porch, one of three "small country houses near Boston" (in West Newton), was published on January 24, 1891; and a less pompous version of the type, but with shed dormers, by the Boston architect Arthur F. Gray, was illustrated in the September 17, 1896, Advertisers' Supplement. Not surprisingly, Radford picked up this house type quite early; Design Number 81 in *The Radford Ideal Homes* (page 38 in the 8th edition of 1904) may date from 1898, when that catalog first appeared.

The Dutch Colonial type with long shed dormer rather than several discrete dormers (with either gabled or shed roofs) does seem to have first been codified by the architect Aymar Embury II in his 1907 design for a house he entered in a Garden City competition.[11] It became a type he popularized; his article in the August 1908 issue of *International Studio*, "Modern Adaptations of the Dutch Colonial," and his subsequent book, *The Dutch Colonial House: Its Origin, Design, Modern Plan, and Construction* (1913), firmly established the type and its name. Soon versions of it could be found in mail-order-house company offerings. Aladdin's attractively designed "The Lancaster," "a Dutch Colonial type and one of the most truly artistic Aladdin homes," is depicted in its 1915 catalog. Perhaps reflecting its relative newness as a type, the copy notes that "The Lancaster [is] an original design from the Aladdin architects." It immediately became a popular type. "The Verona," a gambrel-roofed house of this type available from Sears between 1918 and 1926, was another attractive version, with a surprisingly sumptuous living room twenty-seven feet long, made all the more appealing in the 1918 catalog by the rich color plates used to illustrate it. (See Color Plate IX.)

Thus it is not surprising that the ASHSB featured Dutch Colonial houses for years. Fourteen were included in the 1929 compendium *Small Homes of Architectural Distinction: A Book of Suggested Plans Designed by The Architects' Small House Service Bureau, Inc.*, edited by Robert T. Jones, "technical director" of the Bureau. Design 5-A-71 is a good example; and in fact one can find constructed dwellings that might have been built following these ASHSB plans. Such Dutch Colonial designs were still popular in the 1930s.

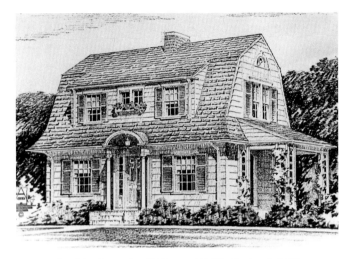

Fig. 345. Jones, Small Homes (1929), Design 5-A071.

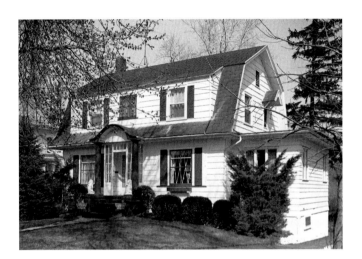

Fig. 346. 854 Central Avenue, Dunkirk, New York.

Standard Homes Company

A house plan company active throughout this period (based on the Union Catalog listing, from at least 1921 through 1952) and one that produced especially attractive catalogs was Standard Homes Company of Washington, D.C. Its 1925 catalog ("Book Number 7") is typical: *Better Homes at Lower Cost, 101 Modern Homes Standardized,* with color cover front and back, contained full-page displays for each dwelling, including a large photo, large clear floor plans (both stories), and a brief fatuous paragraph about the nobility of freedom and home ownership, the economy and beauty of the design, and so on. Book Number 7 also included rear additions (porches and entryways), five garages, and a sampling of outside doors. Later

catalogs had fewer designs, but were similar in large-scale format.[12]

The special advantages of these houses were the wide range of styles offered and the economy arising from the company's "standardized" system: "Every home has been designed so that standard stock-length materials may be used without waste, and practically all windows and doors are of standard designs usually carried in stock." Although there were always savings to be had on the carpenters' bill by being able to use "stock-length" materials that needed little or no cutting, the emphasis here on economy of lumber was undoubtedly in response to its high price—between 1910 and 1920, lumber had increased in cost by more than three times.[13]

Even the interior planning, the company claimed, had been worked out for greatest economy and efficiency: "It has required years to bring before the prospective home builder the hundreds of practical money-saving ideas to be found in this book. . . . Every window and door is located exactly as it should be to provide the right space for each piece of furniture, and every room has been provided with an abundance of light." The company recognized that customizing individual designs was a common practice and sanctioned it: "While each floor plan has been especially and carefully arranged for each exterior design, yet it is entirely practical to make changes to meet the requirements of each builder, and any reliable contractor can easily move partition walls, windows, or doors to suit the owner without affecting the exterior design to any great extent."

The cost of the blueprints is not given in the 1925 catalog (it was on a separate insert), but the 1930 catalog, *Better Homes at Lower Cost: A Collection of Modern Homes Standardized as to Dimension*, states that "[c]omplete blue prints [from four to six sheets] in duplicate, including specifications and Contractors' Agreement forms, will be furnished within 24 to 48 hours for $20 (three sets, $25), subject to two days' examination."

Prospective builders could use the plans with confidence and economy: "The blue prints for each home have been prepared with the greatest possible care and when followed by the contractor there is not only a saving in construction of at least five to ten percent, but the exterior of the completed house is exactly as illustrated."

Furthermore, owners had ostensible protection from pirating because both the 1925 and 1930 catalogs contained copyright warnings: "[A]ll house designs [including plans] shown herein are copyrighted,

and are to be constructed only when our trade-mark plans are used. . . . Imitators are warned against infringement." One wonders how effective such notices were, however, because minor changes would nullify copyright protection—and as we saw, one of the Standard Homes Company designs ("The Cardenas," on page 63 of the 1925 catalog) had already been published by von Holst in 1913 and used by Sears in its 1915 catalog!

Where Standard Homes Company got the bulk of its designs is not known, but some clues are provided by the catalogs themselves. In 1925, the company observed that the homes depicted "have been selected from several thousand submitted designs," implying that architects by competition, through advertisements, or on commission submitted designs for possible adoption. The company seems to have been linked with other such firms selling (and assembling) plans: The 1921 copy of *101 American Homes* ("Book Number 5") was actually published by the Home Builders Service Bureau of New York City, but had a "Standard Homes Co., Washington, D.C.," label pasted over it, suggesting cozy relations among these companies to encourage the use of lumber.[14]

In fact, we know that these catalogs were available—probably *only* available, because the Standard Homes Company address and location are omitted in the catalog—from lumber dealers. The copy of the 1925 "Book Number 7" consulted was neatly imprinted on the title page, as if by the publisher, "Harris, McHenry, & Baker Co., Lumber, Wall Boards, and Kindred Products . . . Elmira, N.Y." (on the front and back covers appears "The Home Builder's Lumber Co."); a Library of Congress copy of the same book seems to have come from a Detroit concern; and a copy of the 1926 "Book Number 9" is imprinted with "Adams Bros. Paynes Co. . . . Where Modern Building Materials Are Displayed in a Practical Way. Visit our Model Home," in Lynchburg, Virginia.[15] The 1925 Standard Homes Company catalog included most of the popular house types of the day: Twenty-one were gabled one-and-a-half-story bungalows, usually with Craftsman-style detailing; eighteen were Foursquares of various types; sixteen were Stickley Bungalows of many forms; thirteen were Dutch Colonial; ten were "English" types (some half-timbered, others with thatch-roof effects or Voyseyesque massing, etc.); a few were clipped-gable designs and colonial types of one-and-a-half or two stories. By examining a few examples of houses apparently built following Standard Homes' plans, we can both confirm the company's popularity and discover some little-known uses of its plans.

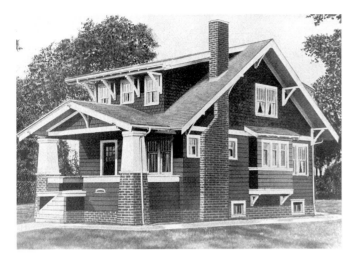

Fig. 347. Standard Homes Company, "The Lincoln" (1925 catalog).

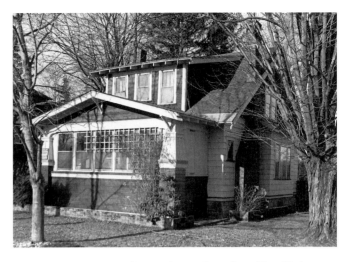

Fig. 348. 105 North Main Street, Cassadaga, New York.

By the 1920s, the Stickley Bungalow type had been taken up and vigorously developed by countless companies. One typical Standard Homes Company model was "The Lincoln," whose combination of clapboard, shingle, brick, painted trim, and "constructional" detailing in its exposed rafter ends and support brackets is a representative 1920s Stickley Bungalow. Its accompanying fatuous blurb is typical of the copy: "The strength and union of America has been developed and kept sacred by liberty and home-loving people. Freedom and democracy as enjoyed and expressed in the home are the principles which promote our progress as

a nation. Could every family enjoy in a home like The Lincoln the freedom to which all are justly entitled, strife would cease and crime would be unknown."

A house that appears to have been built following these plans, with a few changes inside and out, is in Cassadaga, New York. Although two feet wider, it is the same depth as the published design, and the plan is also extremely close, with partition shifting—as the company assured clients was perfectly acceptable—in the rear. It certainly confirms how easily sophisticated designs could find their way into even the tiniest rural hamlets; in 1925 Cassadaga's population was about 460.[16]

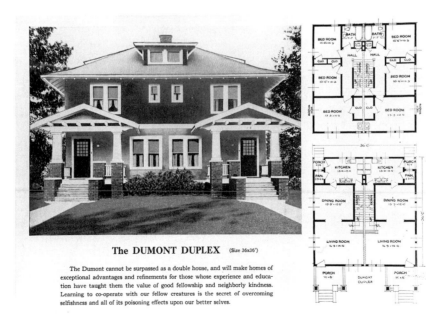

Fig. 349. Standard Homes Company, "The Dumont Duplex" (1925 catalog).

Fig. 350. 1081–83 North Main Street, Jamestown, New York.

Fig. 351. Standard Homes Company, "The Laverne" (1925 catalog).

Fig. 352. Donald M. Wilson House, Dunkirk, New York, c. 1920.

Standard Homes carried a number of duplex models, helping assure artistic designs even for "income" houses: Seven were two-family homes, and one a design for four. The "Dumont Duplex" is representative of the Foursquare type adapted with Craftsman detailing to two-family use; it was beautifully realized in Jamestown, New York, even to plantings in the location suggested by the catalog photograph.[17] This particular dwelling seems to have maintained, over the years, its original color scheme: the deep red shingles above yellow clapboards, white trim, black sash, red brick foundations and piers—and green roof—reveal how richly hued some of these houses could be. (See Color Plate IV.)

The one-and-a-half-story gabled bungalow, a type featured as we saw by Stickley as early as 1911 (see Fig. 272), was the most popular offering in the 1925 catalog. "The Luverne" is an attractive example in brick. As the comparison of the Standard Homes plate and the same view of the Donald M. Wilson House in Dunkirk, New York, shows, constructed examples often reveal minor exterior adjustments or improvements. Both houses are identical in size (24' 0" x 40' 0"), but the lot for the Wilson House was particularly narrow, and thus the bay windows on both sides were omitted. The front living-room window was enlarged as built by making the entrance porch a bit narrower; but in most ways the Standard Homes model appears to have been followed quite closely on the exterior.

Although this house appears to be the Standard Homes model, in fact the Wilson House was built to blueprints prepared by a local architect, Henry T. Higgins.[18] The floor plan is extremely close to the Standard Homes model but has been cleverly reworked by Higgins: The rather small living room is "expanded"

by opening it up to the dining room with a colonnade, and the "breakfast porch" provides access to the bathroom off the rear bedroom, for example. The similarity in general arrangement of the plans, the identical dimensions, and the closeness of the exteriors suggest convincingly that the Standard Homes design was the model—probably reworked from the plans illustrated in the book, for architect Higgins would hardly need copies of the blueprints to draw up his customized versions. Higgins provided his client with two large blueprint sheets: The first contained the plans (basement, first and second floors, and roof) and details; and the second illustrated the four elevations, transverse section, and additional details.[19]

It may come as a surprise to learn that the house was built about 1920 (the blueprints appear to be dated 1917), although the Standard Homes plans illustrated date from 1925. Because the catalog *Number 5* ap-

Fig. 379. *Creo-Dipt Company flyer (1927), plate 169.*

Fig. 381. Home Builders Catalog *(1927), 607, detail.*

Fig. 380. Aladdin (1922), 72.

greater protection from winter-cold and summer-heat—and they solve the painting problem for years to come." What is especially significant in this context is that the remodeled building looks a great deal like an Aladdin 1922 design ("The Westwood") and reminds us how closely linked were designs by professional architects and the popular models offered by companies such as Bennett Homes, Aladdin, and Sears—and how cautious one must be in matching constructed dwellings with particular plates.

The 1927 *Home Builders Catalog*, although featuring 604 house plans (and 57 garages), also included twenty pairs of photographs depicting the remodeling of older "out of date" buildings, very much like the Creo-Dipt flyers. These were included because the other half of the catalog, consisting of nearly five hundred pages, was devoted to builders' supplies and materials. The index has 442 headings, from Adjusters for Casement Windows, and Face Brick (twelve

companies represented), to Roofing of all types, and Zinc Coated Nails. Remodeling was clearly one of the many skills of the modern contractor. The sample comparison illustrated, which shows a rundown vernacular Gothic cottage transformed into a stylish "modern English Type of home of effective design," is typical.

Home Builders Catalog Company

The largest and most complete house plan book from this period was certainly the encyclopedic *Home Builders Catalog* "compiled, edited, and published annually" by the Home Builders Catalog Company of Chicago and New York. The 1927 (second) edition consulted consisted of a fully indexed section on building materials and products (33–525) representing 404 manufacturers or firms—a useful way of uniformly presenting such advertisements.[40] Next came the section "Small Home Architecture" (582–632) explaining architectural styles, the importance of plans and specifications, the need for high-quality materials, the nature of mortgages, how to select the home site, the methods of economizing when building, samples of old house remodeling, as well as illustrated discussions on interior decoration. The final portion of the huge catalog consisted of 604 house plans (including 12 summer cottages and 20 duplex dwellings) of frame, brick, or stucco construction and designs for 57 garages.[41]

The catalog was produced "by the same men who for 12 years have conducted the Architectural & Publicity Bureau—the Bureau whose plan service is used by eleven of the leading Retail Lumber Associations

of America,"[42] even though a good number of the houses depicted were of brick or stucco. The catalog had two main purposes: to advertise building products and to provide a plan service. The information on products was for contractors as well as the prospective home builder.

> Hundreds of leading manufacturers have adopted *Home Builders Catalog* as a means of presenting the merits of their products. . . . This great co-operative catalog takes the place of thousands of individual catalogs. . . .
> The Manufacturers' Section . . . is the most comprehensive exhibit of building materials and home equipment ever presented to the Building Contractor in a single volume. A careful study of this Section will not only give you many new and helpful ideas but will enable you to demonstrate to your customers the advantages of the materials or equipment you propose to incorporate in the homes you build for them. . . . As a means of raising the standard of customer appreciation of better homes you can have no more potent aid than *Home Builders Catalog.*[43]

For the prospective homeowner, however, the most impressive part of the catalog was undoubtedly the hundreds of house designs it presented—with ninety-six pages in color, "a new feature that will greatly aid one in visualizing the appearance of the completed home." Each design had been carefully selected:

> The present (1927) edition of *Home Builders Catalog* is practically a new book. Of the material used in the 1926 edition only a small part has been retained. Some of the houses illustrated in the 1926 edition have proved to be so popular that it was deemed wise to include these in the present edition, but all designs for which there was not a considerable demand have been omitted and replaced by new designs more in keeping with prevailing styles of architecture and interior arrangements. . . .
> The homes illustrated in this volume are the last word in up-to-date style and convenience, yet so perfectly are they designed that not an unnecessary dollar of

expense is incurred. The price range is from $3,500 to $12,500, covering the needs of the great middle class of home-builders. Ninety percent of all homes built in this country fall within these price limits.
> Careful attention has been paid to those details of design and construction that give distinction, charm, and convenience to the home—such things, for instance, as big, bright living rooms with open fireplaces; conveniently arranged kitchens with built-in features and breakfast nooks; bedrooms with disappearing beds and private bath; bright, cozy, sun parlors, and cool, shady porches.[44]

Although the plans appear quite typical of what was being offered by other companies at the same time and some of the designs had been carried over from the previous edition, other house designs were, the company claimed, the result of its own fieldwork.

> During several months last summer a representative of *Home Builders Catalog* visited the principal countries of Europe, collecting data on English Cottages, the half-timbered houses of France and Germany, and the Mediterranean types of dwellings typified by the stucco homes of Spain and Italy— a style of architecture now very popular in this country, particularly in California, Florida, and other Southern states. This edition of *Home Builders Catalog* is, therefore, particularly rich in designs based on Old World models, though in every case the interior arrangements have been modified to conform to the higher standards of comfort and convenience demanded in America.[45]

These "data" on European styles and house types were probably not views of traditional dwellings on which modern American adaptations could be based, but rather books of designs for small houses then being built in Europe—houses that had already adapted high-style motifs to small dwellings. R. Randal Phillips's book, *Small Family Houses* (2d ed., London, 1926), which illustrated designs and plans for houses in the $5,000 to $15,000 range, was probably the sort of "data" sought by the *Home Builders Catalog* representative.[46]

As the editors proudly noted, "[E]very illustration" in the catalog was "reproduced from a photograph. You see the completed house itself, surrounded

by trees and shrubbery," although close scrutiny reveals that most of the halftones have been reworked, with landscaping improved or added or architectural details clarified. The photographs were important too as proof that the design could really be built as depicted: "Every home shown in this volume has already been built—some of them many times. The plans have been put to the acid test of actual construction. Nothing has been left to chance. You can, therefore, use any of these plans with perfect confidence that the house built from them will be in every respect identical with the illustration."[47]

Any one of the 604 house, duplex, or summer camp designs depicted could be purchased for twenty dollars (garages were only five dollars). For this price, the purchaser received two sets of blueprints; a materials guide; two sets of specifications, and two building contracts:

> Each set of plans consists of three sheets, showing all floors plans, including basement, together with front, rear, and side elevations, all drawn to scale of 1/4" to the foot. Plans also include many details of construction, cross sections, and other drawings necessary to enable builder to erect house exactly as illustrated in *Home Builders Catalog*.
>
> The 16-page Material List Guide is divided into sections covering foundation material, lumber, mill work, roofing, flooring, hardware, paint, etc. Nothing is omitted. If the builder uses this list he will be sure that every essential item is included in his estimate. Saves hours of time and prevents costly omissions.
>
> The Specifications (two sets) have been prepared by experienced architects and builders. Everything is set down in black and white—nothing is left to the imagination. Exact specifications such as these prevent misunderstandings and insure the house being built of proper materials and in a thoroughly workmanlike manner.
>
> The two blank, legal contract forms, to be signed by building contractor and owner, put the agreement on a sound, legal basis and save lawyer's fee for drawing contract.[48]

Prospective home builders were assured that the floor plans with each illustration "are those that experience has shown to be best suited to that particular type of house." However, if minor changes were desired, "an additional closet, for instance, a downstairs toilet and lavatory, a sun parlor addition, or an attached garage," these could be made "at a very nominal cost" by the company. For those who could not find just the house they wanted in the catalog, the company's architectural department could "also prepare plans to order, based on your own rough pencil sketch. The charge for this service depends on the number of rooms, averaging about seven dollars per room, with a minimum charge of twenty-five dollars. Full particulars of this individual plan service will be furnished on request."[49]

The houses depicted in the catalog were, however, carefully thought out and skillfully designed, reflecting a wide range of popular styles. In the section "Small Home Architecture," six major types were discussed: Colonial, Dutch Colonial, Italian, Gothic or Half-Timber, Modern English (these being stucco finished), and Spanish Mission. "Today, there is not a style of home architecture but what has been adapted to the small home field," the company noted, but (reflecting a nice understanding of architectural propriety) this did not mean "that small replicas of large houses have been made. Rather, the architectural principles themselves have been altered and modified to suit the requirements of the small home with the result that the artistry and beauty of all styles can be had in any size house he may desire."[50] The editors confidently observed that "each design has something about it that distinguishes it from the ordinary stock-plan house," yet the designs were conservative enough to retain their resale value: "The possibility that you may one day wish to sell should always be borne in mind. Remembering this, . . . in selecting a design you will choose one that does not depart too radically from accepted standards, for houses that embody ideas the owner thinks highly original are sometimes considered freakish by other people and are not easy to sell."[51]

Although not mentioned in the list of six major styles featured in the *Home Builders Catalog*, the editors did include a variety of the house types that we have seen were popular in years before, such as Stickley Bungalows, one-and-a-half-story bungalows, and a few California-style bungalows, but most designs fell into the six major groups. Because we have already examined the character and origins of gabled colonial and Dutch Colonial houses, I focus here mainly on the English-style dwellings that abound in the catalog and that were actually constructed.

No architectural feature could suggest the quaint English cottage and the associations of cozy home life

Fig. 382. Home Builders Catalog *(1927), "The Coombs."*

Fig. 383. Charles R. Farnham House, Fredonia, New York, 1930–31.

as well as a thatched roof. Using an actual thatched roof in the United States was out of the question, but the effect of the smoothly sculpted contours and thick insulating mass of thatch could be approximated by a curved eaves treatment around which shingles were fitted. "The Coombs," from the *1927 Home Builders Catalog*, with its roof of variegated reddish-brown and tan, is an excellent example of the type. A constructed version can be found in Fredonia, New York, the Charles R. Farnham House, erected in 1930–31.[52]

The Farnham House follows the model in almost every detail including the yellow brick chimney; the original flower boxes even survived until about 1977. The dimensions of the house are exactly those given for the exterior, with variations of only an inch or two inside. As constructed, closets at the end of the living room were omitted, as was the exterior door near that

end. The second floor also followed the *Home Builders Catalog* plans precisely.

Such thatched-roof–type houses were well represented in studies of the day on small vernacular English cottages and farmhouses,[53] although perhaps equally persuasive (and better known to the general public) was Anne Hathaway's cottage and its romantic associations with William Shakespeare.

A second English-style house type that was extremely popular, both in the *Home Builders Catalog* and in the offerings of other companies, was that of the dwellings that reflected the lofty facade gable, simple geometry, and low-swooping eaves seen in turn-of-the-century houses by architects developing Arts and Crafts ideas such as C. F. A. Voysey, M. H. Baillie Scott, and even Edwin Lutyens.[54] Features such as prominent facade chimneys, projecting entrance porches, and

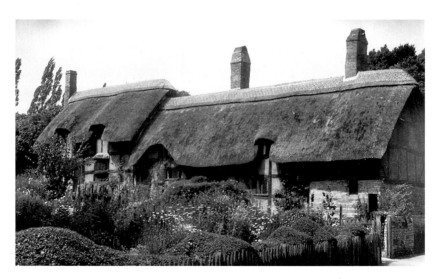

Fig. 384. Anne Hathaway's cottage, near Stratford-on-Avon, England,
late sixteenth century.

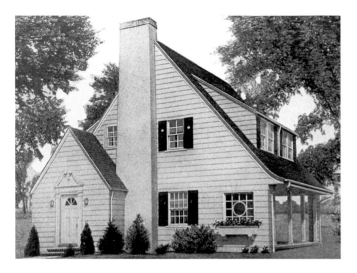

Fig. 385. Home Builders Catalog *(1927)*, *"The Chene."*

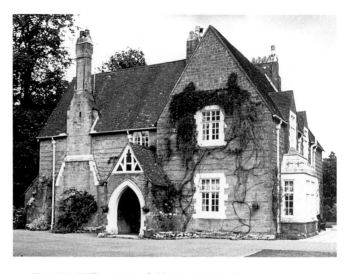

Fig. 388. William Butterfield *(attr.)*, W. Lavington parsonage, Sussex, England, c. 1850.

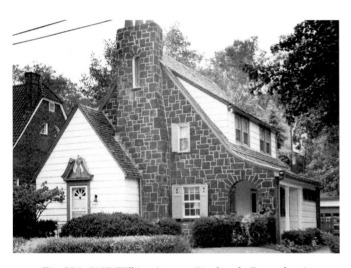

Fig. 386. 5487 Wilkins Avenue, Pittsburgh, Pennsylvania (Photo by Lu Donnelly).

Fig. 389. James Gamble Rogers, house at East Lyme, Connecticut (1913).

Fig. 387. 67½ Pierrepont Street, Potsdam, New York.

Fig. 390. Home Builders Catalog *(1927)*, *"The Crestline."*

Fig. 391. 4 Bard Road, Cassadaga, New York.

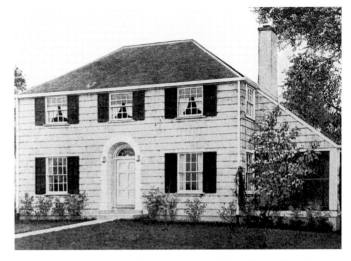

Fig. 392. Home Builders Catalog *(1927), "The Caldwell."*

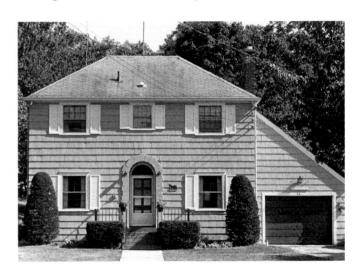

Fig. 393. 5919 East Main Street, Brocton, New York, 1928.

shed dormers in the long side roof slopes are also found in their work—and are brought together in a compact, impressive way in a dwelling such as the *Home Builders Catalog*'s "The Chenee." One can find examples of this most popular design throughout the northeast; the two illustrated are in Pittsburgh, Pennsylvania, and, in mirror image (and now re-sided), Potsdam, New York. The style appeared in other plan books of the day. Versions of the type (lacking the facade chimney) were offered by Standard Homes Company in 1930 and by Sears between 1928 and 1931.[55]

Although the simple forms and tall facade gable may remind us of Voysey and Baillie Scott or Lutyens, these motifs actually go back to the creative Vernacular Revival movement in England of the mid-nineteenth century. The parsonage at West Lavington, Sussex, of about 1850, thought to have been designed by William Butterfield, is an excellent example. The essential and distinctive features of "The Chenee," such as the dominating facade gable two-and-a-half stories tall, a prominent facade chimney, a small projecting gabled entrance porch, and even the dormers in the side roof slope, all appear here—reminding us of the durable links with English vernacular design and small country dwellings that houses such as "The Chenee" evoke.

The distinctive open side porch with upturned roof and shed dormers above was a motif developed in America, too. James Gamble Rogers's own house built at East Lyme, Connecticut, in 1913, may be the direct source for this distinctive grouping of features. *Home Builders Catalog*'s "modern English" house "The Crestline" is another good example of the type. As built in Cassadaga, New York, it was of frame construction, rather than with solid brick walls (the

Permastone siding dates from about 1960).[56] Not only was the exterior design closely followed, despite the translation, but distinctive features such as steel sash for the windows were also employed. Because of the change of exterior walling material, the Cassadaga house is one-and-a-half feet smaller in each dimension than "The Crestline"; but the interior plan is virtually identical. The only change was omitting a breakfast nook between the dining room and kitchen and incorporating the space into each room, so that they are both three feet longer than the catalog plans. This is just the sort of minor adaptation that one would expect as a contractor modified a mail-order design to a homeowner's needs.

A second version of this house type in the *Home Builders Catalog*, "The Crockett," had an almost iden-

tical exterior, but with a cladding of stucco, brick, and also half-timbering in the facade gable, emphasizing the English vernacular quality. Sears produced a brick version of this, "The Belmont," offered in 1932 and 1933, and also a shingle-clad one, "The Lynnhaven," sold between 1932 and 1937. Both are virtually the same in exterior design as "The Crestline," and, their plans are similar, too. Another popular model was "The Crestwood," in "the English Cottage style," with impressive central gabled feature, all clad in shingles. A built version survives in Dayton, Ohio.[57]

Although I have focused on English-style houses from the *1927 Home Builders Catalog,* as previously noted there was a full range of other types as well. Two can be illustrated to suggest this variety. The first is a formal hipped-roof colonial house, "The Caldwell," of traditional central hallway plan with a large living room occupying one entire side and two rooms (here a dining room and a kitchen) on the other—a plan two centuries old in America. The three-bay facade composition and high-style doorway with rusticated voussoirs around it make this one of the company's most formal designs.[58] As built in Brocton, New York, in 1928, the model was followed with great fidelity, with impressive results.[59]

At the other end of the scale are the catalog's twelve "summer camps and lodges" (921–24). "The Mankato" is typical of these lightly built vernacular cottages; one similar to this model was built on Eagle Crag Lake in the Adirondacks as a speculative venture by a contractor from Tupper Lake.[60] Clearly, a prospective home builder could find almost any style and plan of house, in a wide variety of materials, in this enormous catalog.

Finally, we should examine where the plans included in the *1927 Home Builders Catalog* came from and how widely (and in what manner) these were disseminated. Introductory material on page 2 gives clues to both.

> Of this 1927 edition of *Home Builders Catalog,* 25,000 copies were printed and distributed to leading building contractors who specialize in home construction. Copies are also on file in many public libraries. With this broad distribution it is hoped and believed that the helpful information contained in this book will be available to hundreds of thousands of home builders and will aid them, with the help of their building contractor, in securing more attractive, substantial, and conveniently arranged

homes than would otherwise have been possible. . . . Complete working blue print plans of any house illustrated can be obtained through the building contractor whose name appears on the front cover of this book.

It is clear that the main source for consulting the catalog was the home builder's local contractor—although the copy examined for this study was not imprinted with any firm's name.

The company's design source is also mentioned, on page 4: "In preparation of *Home Builders Catalog* we have not relied only upon our own large staff of building experts but have had the co-operation of the leading national associations affiliated with the building industry as well as the helpful assistance of hundreds of manufacturers of building materials."

A clue to one specific source for the plans (and also the method of distribution) is found in the fact that many of the designs and plans illustrated are the same as those published and copyrighted a year or

Fig. 394. Home Builders Catalog *(1927), "The Mankato."*

*Fig. 395. Villaneuve Camp, Eagle Crag Lake,
New York, 1937.*

two earlier by C. L. Bowes of Hinsdale, Illinois. His plans were issued in smaller catalogs provided to contractors and lumber dealers and imprinted with these firms' own names and addresses.

Charles Lane Bowes had been producing books of plans for a number of years. The Union List includes three works: *Modern American Homes* (Chicago, 1918) of 288 pages, *American Homes Beautiful* (Chicago, 1921) of 192 pages, and *Book of Home Designs* (Chicago, 1926), a two-volume quarto work, unpaged. A catalog he published in 1925, containing 144 house designs (some in renderings, others in photographs), similar in style and format to the *Home Builders Catalog,* is particularly revealing. Such catalogs were apparently customized for each firm they were sent to. The copy consulted was entitled by overprinting on the front cover *Weston's Book of Homes* and was offered by A. Weston Lumber Co. ("Lumber and Builders' Supplies—Mill work Built in Olean") of Olean, N.Y. The inserted introduction (i–ii), "Our Building and Plan Service," was also stamped "A. Weston Lumber Co."[61] All the house designs are either designated by a number followed by the letter A or have names beginning with A, with only one exception. Some are identical to plans shown in the *1927 Home Builders Catalog* under a different name: Thus "The Ankerton" (3) is the same as "The Chenee" in the *Home Builders Catalog;* and C. L. Bowes's "The Arlington" is the same as "The Crestline" of two years later. The Weston catalog also included various ads and educational essays for products and equipment, as well as a full-page ad for the 1926 edition of the *Home Builders Catalog,* demonstrating that Bowes was one of the main sources for these house designs.

Two other Bowes catalogs from this period can also be cited. *Our New Book of Practical Homes,* imprinted for the Wilson-Wetmore Lumber Company of Warren, Pennsylvania, and copyrighted in 1926, is similar to the 1925 edition. Of the 140 house designs, the 45 provided with names all begin with the letter A, but those given numbers all have the letter B at the end. Again, some duplicate designs are found in the *1927 Home Builders Catalog,* such as Bowes's "The Arnold" (47), identical to "The Caldwell." The rather casual interpretation of copyright protection among these companies that shared and adapted one another's plans is suggested by Design 14140-B, page 5, which is identical (except for being in frame with shingle cladding) to the English cottage design of 1919 by John Floyd Yewell, which was published by The American Face Brick Association in 1920, was included in *The Books of a Thousand Homes, I,* in 1923 and 1927,

and also was published, with minor changes, in the *1927 Home Builders Catalog.*

A third catalog by Bowes (in all three many of the photos have his monogram, CLB in a circle) is somewhat different. It emulates the horizontal layout of the Standard Homes Company catalogs, lacks advertisements, and does not carry an ad for the current *Home Builders Catalog. Our Book of Homes* was imprinted for the Martin Clifford Lumber Company ("See Us When You Build") of Lockport, New York. Although lacking pages 1–2, it dates from 1925, for all 114 house design numbers end with the letter A. One house, Number 12210-A, is also published in the 1925 Weston book—and both, interestingly enough, are the same photograph, with minor changes, as used in the 1925 Standard Homes Company catalog for its design, "The Kendall," but with different plan and dimensions.

Clearly, untold thousands of such catalogs, imprinted for local firms, helped spread far and wide these designs by C. L. Bowes and his staff; and it is not surprising that the *Home Builders Catalog* used his services for many of its own offerings.

As plan companies frequently noted (as was brought out in the nineteenth century as well), such blueprints by experienced architects, from which many houses had been built, avoided all possibility of error and excess charges. "When [the blueprints are] followed by the contractor . . . the exterior of the completed house is exactly as illustrated"; from the plans "correct cost estimates may be made"; and "with an accurate material list, no contractor can later bring in a bill for extras," to quote from typical Standard Homes Company blurbs. It was just such changes and "extras" that made Mr. Blandings' dream house such an exorbitantly expensive (although for us a wonderfully humorous) adventure.[62]

House-plan companies were thriving during these decades, but the "mail-order houses" by Aladdin and Sears continued to be built in considerable numbers. A look at Sears's offerings from its 1928 and 1929 catalogs reveals the company's continued success and the variety of new styles it offered.

Sears Houses in the 1920s and 1930s

The 1928 Sears *Honor Bilt Modern Homes* catalog illustrated seventy-four dwellings (three of which were duplex apartments), and it tells us a good deal about the company's methods of promotion and the services offered.[63] The introductory sections (1–20) provide a

clear picture of the approach twenty years after founding the mail-order homes division.

One of the catalog's most persuasive sales arguments (occupying all of page 2) was not architectural at all, but psychological: With charming pictures and evocative text, home ownership and happiness itself were seductively equated. "Own your own home. *Make your dreams come true!* Realize the independence, the happiness, the comfort, and the economy of living under your own roof. Get *YOUR* share of contentment for yourself and for your kiddies that comes only when you live in a home of your own."

The accompanying vignettes of happy, healthy children, the wife relaxing under a shade tree; the family working in its vegetable garden; and the fortunate couple (the kiddies safely asleep) gazing contentedly at the glowing fireplace; were potent arguments that owning a Sears house was a summum bonum of earthly existence (see Color Plate X).

Most of this introductory section dealt with Sears houses, sales methods, construction, design, and so on. Sears now had five "Modern Homes Exhibit Offices" where materials and constructed examples could be shown. These offices were in New York City, Newark, Philadelphia, Pittsburgh, and Washington, D.C. Sears also had seventeen sales offices throughout the northeastern states, in New York, New Jersey, Connecticut, Maryland, Pennsylvania, Ohio, and West Virginia. "Over 42,700 'Honor Bilt' Modern Homes [have been constructed] in the U. S. A.," Sears proclaimed, and included photographs of whole neighborhoods of Sears houses. Two pages of letters from satisfied customers, with illustrations of a wide range of house types mentioned, helped assure customers of the company's probity. The Ready-Cut method, compared to the numbered assembly of a skyscraper (as had Aladdin) in a two-page spread, explained the wisdom and modernity of the system. The impressive two-page photocomparison (on pp. 10–11) of a dwelling built (during July 1921) by the precut method and the "old fashioned" cut and fit method, helped demonstrate the savings of time and labor in the Ready-Cut system. (The same prices and photos were in the 1929 catalog; see Fig. 311.) The catalog also illustrated the high quality of materials and construction standards on the following two pages. Included are photographic views of the Sears warehouses, lumberyards, factories, and offices with busy workers and vast quantities of first-rate materials.

One of the persuasive selling points was the value of the free architectural plans and the savings these ensured. Sears home builders paid no "architects' fees,"

worked with proven plans "guaranteed free from architectural errors," were guaranteed to have enough materials with highly accurate cutting and fitting, and saved time and money in construction (see Color Plates XI and XII).

The "package" that one received was truly impressive, as the two-page spread shows. Naturally Sears supplied complete blueprint plans and all the materials; but also included were "complete erection plans" "showing all the framing material cut to exact measure, . . . marked with numbers that show where every piece belongs, and which correspond with the numbers marked on all framing material" as well as an itemized bill of materials, contractor's proposal form, "legally correct" construction contract, and also (vital for homeowners planning to build the house themselves) a "Special 'How to Build' book," which included "easy-to-follow instructions and 93 illustrations, covering every step in 'Honor Bilt' construction." One could also obtain free booklets on installing steam, hot water, or warm air heating systems, plumbing, and electrical wiring. Home financing is also mentioned. For the completed Sears house, "we furnish 3 coats of paint," proclaimed the catalog (20), illustrating samples of eight hues. Such colorful, appealing pages were surely effective inducements to purchasing Sears houses. (See Color Plate XIII.)

Finally, an impressive and legal-looking "Certificate of Guarantee" was provided, assuring "every Modern Home in our Catalog to be exactly as represented and to give perfect satisfaction"; Sears would indeed "furnish sufficient material to complete the house you purchase according to our plans and specifications" and also pledged safe delivery of all materials—and a money-back guarantee. "This guarantee is backed by the entire resources of our whole institution amounting to over one hundred million dollars and by the testimony of twelve million satisfied customers."

It is important to note that the two-page spread (see Color Plate XII) also included a view of the Sears "Council of Architects and Home Planners," five men and one woman gathered around a table (with a room full of industrious draftsmen behind them) discussing house plans—a vignette undoubtedly inspired by the Aladdin Company's Board of Seven. The catalog also provided a glimpse, following the house entries, of other offerings: frame garages, both Ready-Cut and of prefabricated Simplex panels; steel garages; plumbing and heating systems; electrical fixtures of various grades; door and window hardware; and asphalt roofing.

As the chart demonstrates, the range of house types Sears offered was considerable. Although Stickley

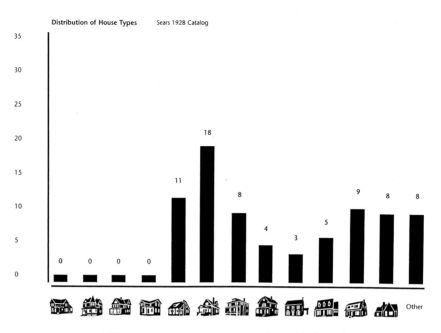

Fig. 396. Distribution of house types: Sears, 1928 catalog.

Bungalows, gabled one-and-a-half-story bungalows, and Dutch Colonial designs were the most popular, the Foursquare and English Cottage types were also provided in several models. As a comparison with earlier Sears catalogs shows, the Sears designers and architects regularly updated their offerings to remain competitive in the small-house market. They were not above cribbing designs from their rivals, either. For example, the catalog illustration for "The Van Page," a side hallway Dutch Colonial model offered between 1926 and 1928, is identical (with minor changes in detail and shrubbery) to the photograph reproduced of "The Howard" in the National Homebuilder's Society 1923 catalog, *The Homebuilder.*

The 1929 Sears catalog was similar to that of 1928, but had some new information. A sticker on the back cover announced that additional offices were now open (in Albany, Schenectady, Scranton, New Haven, and Boston). We learn that 45,900 Sears houses had now been constructed,[64] and the quality of the work

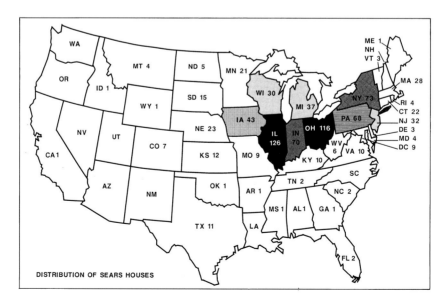

Fig. 397. Distribution of Sears houses based on citations in
Stevenson and Jandl, Houses by Mail.

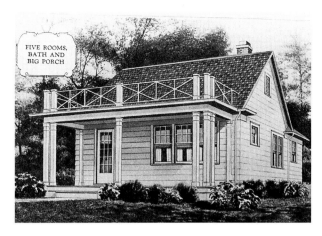

Fig. 398. Sears, "The Prescott" (1928 catalog)
(Courtesy Sears, Roebuck & Co.).

Fig. 399. Mount Vernon, Virginia (1920s postcard).

and ease of the Honor Bilt precut system was discussed in a two-page illustrated essay by Elmer M. Blume, a "well known contractor of Des Plains, Ill." The Sears mortgage plan (75 percent of the total costs, loaned at 6 percent for five to fifteen years) was fully explained; the modern machinery in Sears's factories was illustrated; and the architectural experts of Sears's Council were finally identified by name and photographic portrait. These included the Manager of Factories and Mills, the Mill work Supervisor, the Roofing Expert, the Construction Superintendent, as well as the Architect D. S. Betcone, the Chief Engineer H. F. Lotz, and the Interior Decorator Miss E. L. Mayer. Probably reflecting the assertive marketing of their wares by brick companies, Sears now offered a special house catalog 'Honor Bilt' Face Brick Homes.

Sears Houses were clearly popular throughout the United States. Just how wide this distribution was, and where the largest concentrations of Sears homes are to be found, can be gleaned by the selection of site locations provided in Stevenson and Jandl's compendium, Houses by Mail. Many of their entries cite locations (based on the data provided in the original catalogs) where the model has been constructed. A tabulation of their selections entered on a map shows that the greatest concentration was in Illinois and Ohio, with New York state and Indiana next in density, followed by Pennsylvania, and then Iowa, Michigan, New Jersey, and Wisconsin.[65] These figures are only representative, because Stevenson and Jandl did not include, for each model, all the locations provided in the original catalogs. For example, "The Rossville," offered between 1911 and 1918, they list as having been built in eleven states, from Nebraska to New Jersey, but in the 1915 catalog additional states not included in their listing are also cited (Montana, Missouri, Penn-

sylvania, Wisconsin, and Washington, D.C.).

The house designs published by Sears continued, for the most part, to be based on appropriate models—that is, inspired by the smaller, more vernacular versions of English or colonial antecedents, or bungalows originally designed as "small houses." In only a very few instances do we find dwellings that overstep architectural propriety and are diminutive versions of mansions. Sears's "The Prescott," offered in 1926 through 1929, is one example. Its visual allusion to that great talisman of historical piety, Mount Vernon, was surely intended to be apparent to all. Perhaps the architect responsible for the design also felt that this somehow assured its artistic quality; whatever the reasons, it is not typical of the small houses illustrated by Sears, or other companies either, during these decades.

A look at several of the Sears houses sold during this period shows how up-to-date the designs were and how faithfully the built models could follow published illustrations—but also displays some intriguing and revealing anomalies.

One of the most distinctive designs Sears offered in the 1920s was "The Americus," "a dignified, substantial house." It owes a good deal to the Foursquare and Craftsman traditions, as the hipped roof, boxy shape (despite its slightly irregular outline, the house is 26 feet square), brackets, and porch supports show. "Already Cut and Fitted," it was advertised between 1921 and 1929 and in 1928 cost $2,146. The example constructed in Lucketts, Virginia, follows the catalog illustration meticulously, even to the shape and spacing of eaves brackets, design of the porch supports, and distinctive cross-mullion treatment of the glazed front door.

Next door to "The Americus" in Lucketts is another Sears house, "The Dover," a dwelling that "heralds its English architecture, where this cottage type

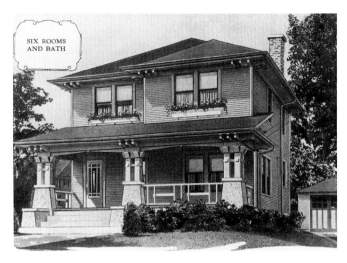

Fig. 400. Sears, "The Americus" (1928 catalog)
(Courtesy Sears, Roebuck & Co.).

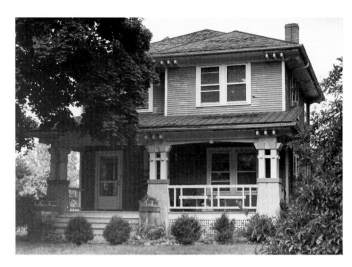

Fig. 401. House in Lucketts, Virginia.

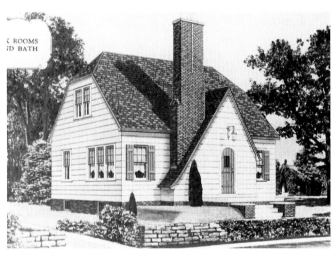

Fig. 402. Sears, "The Dover" (1928 catalog)
(Courtesy Sears, Roebuck & Co.).

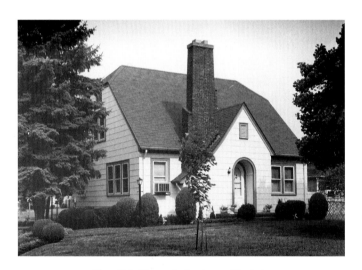

Fig. 403. House in Lucketts, Virginia.

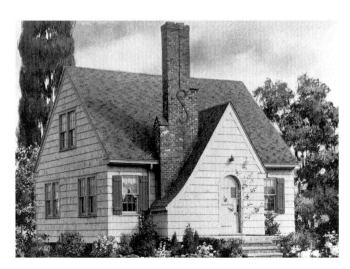

Fig. 404. Sears, "The Maplewood" (1932 catalog)
(Courtesy Sears, Roebuck & Co.).

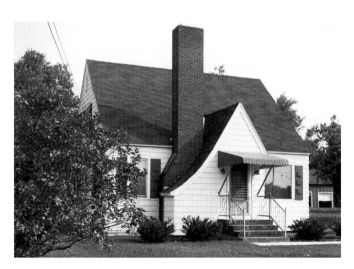

Fig. 405. 93 East Main Street, Canton, New York.

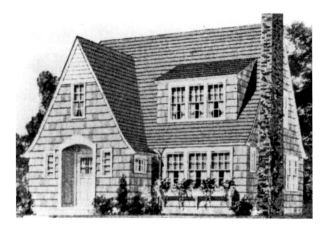

Fig. 406. Sears, "The Lynnhaven" (1933 catalog)
(Courtesy Sears, Roebuck & Co.).

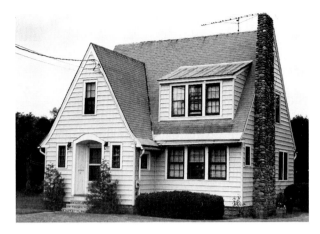

Fig. 407. House in Hamilton, New York.

has been designed," as the 1928 catalog copy observes. It was sold between 1928 and 1939. Because of the one-and-a-half-story design and clipped-gable roof, it appears to be smaller than "The Americus," although the plan is twenty-six by thirty-two feet, and the precut package cost $2,270. The house seems to follow the Sears design carefully, but there are some departures: The arched doorway is recessed; the eaves of the entrance porch do not swoop down on either left or right side quite as low as in the catalog illustration; and there are two windows rather than one to the right of the entry. These changes are probably due to modifications made when the house was constructed; but it is worth noting that the location of the entrance-porch eaves is the same as on another Sears house of similar English style, "The Maplewood" (offered in 1932 and 1933), perhaps the source of the changes.

Constructed examples of "The Maplewood," a slightly smaller version of this type (it measures 24 by 28 feet) are not hard to find. A good example is located in Canton, New York, where the porch eaves follow the Sears model exactly.

A final English-style house, "The Lynnhaven," offered by Sears between 1932 and 1937, is particularly instructive. The example built in Hamilton, New York, despite being re-sided, clearly follows the Sears model precisely, even to the form of window mullions and the paneled reveals of the entrance door and its curved upper casing. (Another Lynnhaven was built just south of Clarion, Pennsylvania.)

What is interesting to note is that this design is almost identical to "The Crestline," a brick English-style cottage from the *1927 Home Builders Catalog,* page 1107. Not only is the exterior design based closely on this model, even to the curved upper casing of the entrance, but the plans are almost identical; Sears

improved it somewhat by projecting the entrance porch farther, allowing for more space in the closet and W.C. that flank the doorway. Sears must have been impressed with "The Crestline," for the company also offered a face brick version, "The Belmont," in 1932–33, as a direct rival to the *Home Builders Catalog* dwelling.

While Sears included many English-style houses, it also featured popular Dutch Colonial models. "The Puritan," "the most modern type Dutch colonial architecture," was sold between 1922 and 1929. The precut package with sun porch cost $2,425 in 1928. A version of this was built in Newark, Ohio, in 1930.[66]

This comparison, however, reveals some of the anomalies previously found on occasion in such comparisons: The built version is not exactly like the Sears original. The exterior design is certainly extremely close, even to the form of window mullions, although the entrance porch has been enlarged and improved. A comparison of the plans reveals that although they are virtually identical (even to small details such as the location of the telephone niche recessed into the side of the closet at the bottom of the living-room stairs), the Newark version is two feet wider and four feet deeper than the Sears model. It is always possible that Webb & Webb, the local firm that built the house, used plans from some other company; Standard Homes published a similar Dutch Colonial house in 1930, "The Lenox," with an exterior as well as a plan similar to the Sears model. It is also possible that instead of ordering the precut material, Webb & Webb, which was a lumber company as well as a builder, copied and improved the Sears illustration—and used its own materials.

A look at a final Sears model, "The Crescent," a one-and-a-half-story gabled "bungalow" with colonial details and columned porch, brings this issue into

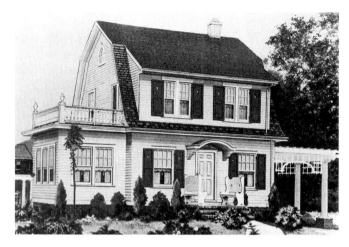

Fig. 408. Sears, "The Puritan" (1928 catalog)
(Courtesy Sears, Roebuck & Co.).

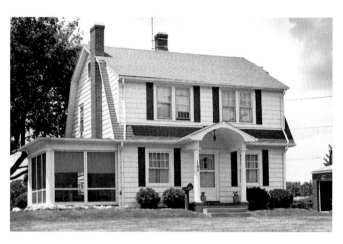

Fig. 409. 165 North Twenty-first Street, Newark, Ohio.

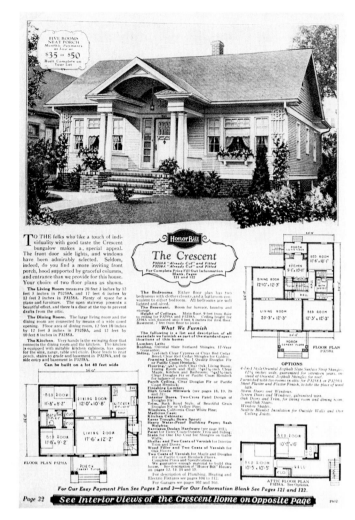

Fig. 410. Sears, (1929 catalog), 32 (Courtesy Sears, Roebuck & Co.).

focus. This precut house was offered by Sears between 1921 and 1933. It was available in two models: One measured thirty-four feet across and twenty-four feet deep and cost $1,783 in 1928; the second was also thirty-four feet wide, but twenty-six feet deep, with a rear wing projecting ten additional feet. This version cost $2,316. On the exterior, the overall design was essentially the same (with some differences in fenestration), except that the smaller version had a shallower porch with paired columns at each corner, and the larger one had a deeper porch and three columns at each side.

Two versions of Plan Number 1 can be found in New York state, one in Norwich, and another in Geneva; a third was built in Rogertown, Pennsylvania.[67] In all three cases, the constructed houses follow the Sears de-

signs faithfully, with the paired-column porch and the cellar and kitchen entrance at grade on the right side.

"The Crescent" seems to have caught the eye of other companies, too. *The Homebuilder* of 1923 offered plans for "The Lincoln," which on the exterior was nearly identical to "The Crescent" Plan Number 2 (the exterior illustrated by Sears in its catalogs). Aside from the rear wing or the kitchen projecting somewhat at the side, "The Lincoln" measured thirty-six feet across by twenty-six feet deep. Although like Sears, this model had a projecting rear wing as well as an identical porch, the plan was more traditional in having the dining room and living room across the front, with bedrooms and kitchen behind—Sears, in both models, had a bedroom adjacent to the living room at the front.

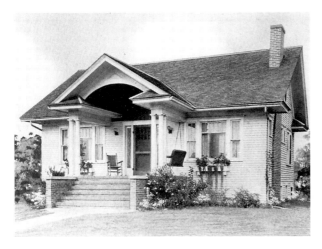

Fig. 411. The Homebuilder *(1923), "The Lincoln."*

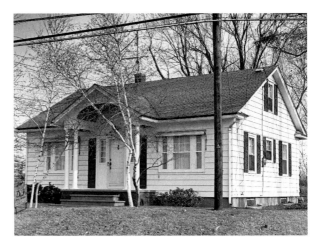

Fig. 414. 10970 Bennett Road, Town of Dunkirk, New York.

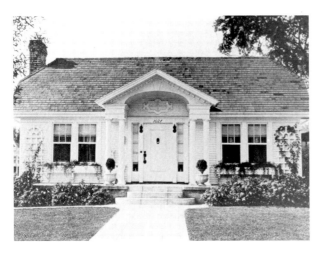

Fig. 412. Standard Homes Company, "The Cornell"
(1925 catalog).

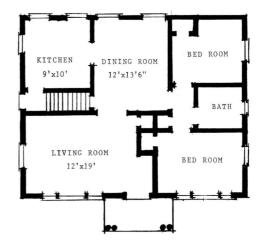

Fig. 415. 10970 Bennett Road,
Town of Dunkirk, New York.

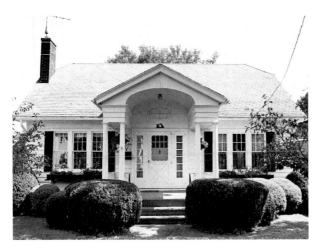

Fig. 413. 218 Jamestown Street, Gowanda, New York.

Standard Homes Company also developed a version of Sears's "The Crescent." Its 1925 offering, "The Cornell," was a little narrower (32 feet wide) but a good deal deeper (42 feet). The design avoided too close an infringement by providing a clipped-gable roof, paired- rather than triple-facade windows, and a slightly differently shaped porch pediment. This particular model exists in constructed versions, complete with decorative cutout in the elliptical pediment arch, in Gowanda, New York, although the use of triple rather than paired windows suggests that the local builder had looked at "The Crescent," too.

With these permutations in mind, we can examine a house near Dunkirk, New York, which at first certainly looks to be "The Crescent," Model Number 2: The arrangement of windows on the right side,

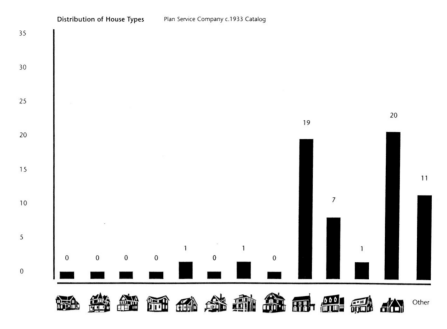

Fig. 416. Distribution of house types: Plan Service Company, c. 1933 catalog.

which light two bedrooms and a bath between, is the same.[68] There are several anomalies, however. For one, the form of the porch is closer to that of the Standard Homes Company model than to that of Sears's "The Crescent," even though the triple facade windows and the gabled roof with eaves returns are the same as "The Crescent." Yet the width of the facade (34' 0") is the same as Model Number 2, and (unlike "The Lincoln" or "The Cornell") the depth (26' 1") is the same as "The Crescent" without the rear wing.

A comparison of the plans shows that the Dunkirk house is in fact different from all four plans cited, although it is closest to "The Crescent" Number 2. If a builder ordered the Sears precut kit, such major differences would be impossible. It appears, then, that a local contractor, inspired by the Sears design (and perhaps using a stock porch similar to that specified in "The Cornell"), created his own version of "The Crescent" and his own plan to go with it.

Plan Service Company

That such purloining of designs published in catalogs and creating one's own plan to go with the designs was common practice for carpenters and builders is suggested by an example from a firm not heretofore discussed, the Plan Service Company of Saint Paul, Minnesota. The Union List contains only one entry

for this company's catalogs, *Ideal Homes* of 1923; but the copy of the catalog consulted for this study, *Ideal Homes, Two-Story Houses* (11th ed.) of about 1933, provided additional information about the offerings.[69]

On the title page, the Plan Service Company lists all its catalogs, and this provides a good overview of its intended audience. All booklets had the general title *Ideal Homes.* "Section One Book," subtitled *Medium-Priced Bungalows,* was thirty-two pages long, had twenty-eight house designs (and 37 plans), and by this date was in its twelfth edition. The price range was between $4,000 and $6,000. The "Section Two Book" of *Two-Story Houses* was twice as big, at sixty-four pages, with sixty house designs, in the $4,000 to $8,000 range. "Section Three Book," *Low-Cost Bungalows,* now in its thirteenth edition, contained twenty-nine house designs (but 42 plans) on thirty-two pages, in the $2,500 to $4,500 range. "Section Four Book" just appearing in its first edition was *Popular-Priced Bungalows,* containing twenty-eight house designs and thirty-two plans on thirty-two pages. These were in the $5,000 to $6,500 range. Finally, also in its first edition was the "Section Five Book," *De Luxe Bungalows,* with twenty-eight house designs on thirty-two pages, with no prices provided. The company must have been reasonably successful to have such a wide range of house plans for sale.

A glance at a tabulation of the offerings in the *Ideal Homes, Two-Story Houses* catalog shows that the largest category was colonial houses, with another

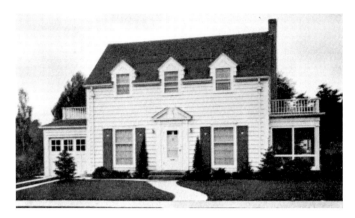

Fig. 417. Plan Service Company, Design 407 (1930s catalog), 32.

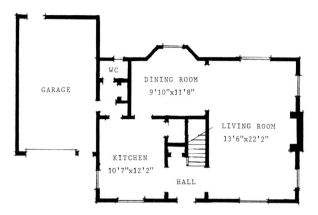

Fig. 419. Toomey House, Fredonia, New York, plan.

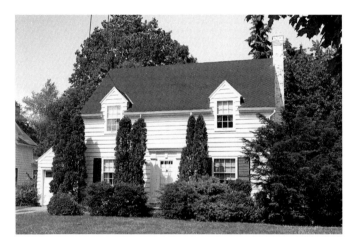

Fig. 418. Toomey House, Fredonia, New York, 1941–42.

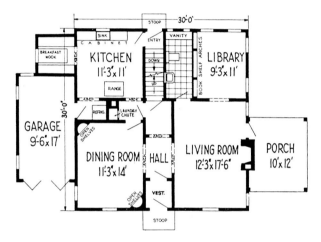

Fig. 420. Plan Service Company, Design 407, plan.

large group being English types. The bungalow and the Foursquare were represented by token single entries. One of the colonial designs, Number 407, built in Fredonia, New York, in 1941–42, reveals much about the popularity of these catalogs as sources for local builders.[70]

The Toomey House follows the *Ideal Homes* illustration with great care. Although there are two wall dormers rather than three and the front door employs a different stock colonial door casing, there can be no doubt that this is the illustration followed for this house. As the photograph shows, the plantings that survived until 1987 are fully mature versions of the shrubs indicated in the catalog color plate. Although the attached garage is provided with a gable roof rather than a flat one and the side porch (because of the narrow lot) was omitted, the faithfulness of the exterior to the Plan Service Company's Design Number 407 is remarkable.

The builders do not seem to have ordered the blueprints at all, however (which for this house cost

$16.25); the Toomey House is a different size (32' 4" wide by 23' 2" deep, versus 30' square for Design 407) and has an entirely different plan. Whereas the exteriors are virtually identical, the interior plans have almost nothing in common, except for the living room at the right of the entrance. With so many differences between the two, it is obvious that no builder would have bothered spending money on mail-order blueprints; he just studied the illustration in the Plan Service Company's catalog and produced his own variant to meet his clients' particular needs.

We can confirm this practice of builders and carpenters using such catalogs simply as helpful compendia of designs for adaptation from the recollections and statements of carpenters (and the owner of a building supply company) who worked during this era. Their recollections also give us valuable insights into actual working methods and procedures in smaller cities and towns during the 1920s through the 1940s.

Carpenters and Designs:
The Kofoeds of Silver Creek

I focus on the Kofoed family of Silver Creek, a village in western New York. Over three generations, three members of this family—between 1875 and 1963—were carpenters, and the recollections of Nelson Kofoed about his father and his great-uncle tell much about their activities and working methods as well as their use of published designs and contact with precut houses.[71]

August Kofoed came to Silver Creek from his native Denmark in 1875, at the age of twenty-one already a trained carpenter. He was soon joined by his brothers Christian (Chris) and Peter. The latter established a furniture factory (in which Chris and his wife worked), which prospered in Silver Creek for many years. Although located in a predominately farming county, Silver Creek owed its prosperity largely to several local industries that made grain processing and farm equipment. The most famous firm was Howes, Babcock, and Company (later the S. Howes Company) whose "Eureka" wheat-cleaning machine was sold worldwide by 1880.[72]

August Kofoed built a good many houses in Silver Creek, including, about 1914, four in a row on Christy Street (Numbers 7, 9, 11, and 13); Number 7, his own house, included a carpentry shop behind it. August appears to have been a busy and well-respected local carpenter. Between 1870 and 1900, the population of Silver Creek grew from 666 to 1,944—clearly a village with a good deal of residential and commercial construction going on.

Christian Kofoed had four children. One of them, Christian (Chris), became a tinsmith and worked at the S. Howes Company; another, Carl (born in 1896), became a carpenter. In 1910, at the age of fourteen, Carl left school at the end of the eighth grade and was apprenticed to his uncle, whom he apparently joined as a partner in 1914 when he was eighteen. That was also the year that "Uncle Gus" purchased a combination woodworking machine for his shop—a machine (still extant) that was a circular table saw, had cutters for moldings, and could also smooth boards. Another piece of equipment that may date from 1914 was a horizontal boring machine for doweling door and window frames and for general cabinetmaking.

After working with his uncle for ten years, Carl bought the business in 1924 and launched his own career, which was to last (although reduced in scope in his later years) until his death in 1963. A great

deal is known, however, about his business, working methods, and approach to design—surely typical of carpenters in small towns throughout the country—because one of Carl's two sons, Nelson (born 1917), also became a carpenter, worked for his father from 1934 through 1958, and clearly recalled the details of their joint career.

Actually, Nelson began helping his father soon after he bought the business, for as a lad of eight or nine, on Saturdays and during all of the summer, he cleaned up the shop, a building sixty feet square "full of all kinds of machinery," and generally made himself useful. At about the age of *ten*, he was driving the Model T pickup truck back and forth from the shop to jobs in the country to get things that were needed (he was stopped by the State Police only once). After completing high school in 1934, he joined his father full time.

Silver Creek continued to expand in these decades as well. The population had reached 2,512 by 1912 and by 1950 stood at 3,068. Not only did the numerous local manufacturing companies provide jobs, but so did a local canning company, established soon after 1900. Although the surrounding farms still raised large quantities of grains (oats, corn, and buckwheat), as well as fruits and vegetables, by 1918 grapes (introduced into Silver Creek in the 1890s) were the dominant crop for local farmers.[73] Thus prosperous Silver Creek and the surrounding areas were fertile ground for building.

The Kofoed carpentry shop ultimately became quite ample in size. Located behind Carl Kofoed's Silver Creek house, on a large lot, it eventually consisted of the main building sixty feet square with the woodworking machinery, a shed of about twenty by thirty feet, and a three-car garage of roughly the same size, these latter two being used largely for storage of material. The truck often had to sit outside.

Nelson learned his carpentry "on the job," by helping, observing, and doing. "My father was a funny guy. He never showed me much; I had to *watch* him; and if he didn't like what I did he'd say, 'No, tear it out and do it over again.'" He also learned a lot from his uncle Chris who, although a trained tinsmith, worked with his brother Carl a good deal beginning in 1924 as a carpenter as well.

The work that the Kofoeds did, from the 1920s onward, was varied. They constructed houses, worked on a few public buildings (such as the local Christian Science Church of 1934), designed and built a clinic for Dr. Barissi in the 1940s, and did a great deal of remodeling and additions, which was more than half

Fig. 421. Carl Kofoed (with granddaughter Judy) in front of his Christy Street shop (Courtesy Nelson Kofoed).

their work. These jobs were not just in Silver Creek, but in outlying municipalities as well, including Farnham, Hanover Center, and Derby.[74] One house, for the president of the Silver Creek bank, was a rustic country lodge in the woods, the logs for the dwelling being shipped in from Wisconsin.

The remodeling jobs included adding new rooms to houses, rebuilding roofs (for example, to include dormers),adding new bathrooms or kitchens, and occasionally just "doing the whole house over." One large remodeling project in Silver Creek was the local bank in 1930, following the designs of an architect.

That the Kofoeds did a great deal of remodeling, making "the whole house over," reminds us of how important in the total building picture was "revising" of earlier styles to bring them in line with current tastes and improving plans to meet new ideas of efficiency or changing modes of living. This sort of remodeling took a good deal of ingenuity and was featured frequently in nineteenth-century pattern books; by the 1870s, entire books on the subject were available, such as William M. Woollett's *Old Homes Made New* (1878) and George C. Mason's *The Old House Altered* (1878).[75] As we have seen, complete remodeling of houses was regularly featured in *The American Architect and Building News* in the 1870s and 1880s. The continued prominence of such renovation in the 1920s is signaled by the promotional literature of the Creo-Dipt Shingle Company flyers of 1925–28, the *Home Builders Catalog* (1927) section

on remodeling, and the Weatherbest Shingle Company's 1929 catalog, all mentioned previously.[76] If this sort of work was about half of the Kofoeds' projects, it provides a welcome cautionary reminder that houses are not always what they superficially seem to be.

The Kofoeds not only built houses as well as additions to houses, but they also made the necessary doors, windows, and interior cabinetry. "We did everything back in those days . . . you name it, we made it." When working on old houses, this even entailed carefully matching old trim of dormer and eaves that had rotted out. As Nelson explained, "My father said, 'We'll do anything but put spots on pigs, and we'll do that if we have to.'"

They did more than just the carpentry; "we'd do a little bit of wiring, a little bit of plumbing, all the roofs." Roofing was in fact one of their main sidelines: "We did more roofs than anything else," buying material by the truckload, so that they could offer almost any color. They almost always had plenty of work to do and never advertised.

The Kofoeds frequently hired others to help them; they often had three or four additional workers on their various jobs and occasionally twelve or fifteen extra men when they had three or four jobs going at once. Having a lot of work did not always mean making a lot of money. Nelson recalled a particularly busy period during the late 1920s: "Two years in a row [my father's business] got kind of big, and he had twenty-five men, and was running eight, ten jobs at a time—

putting on roofs, remodeling, and building some. So he had a lot of jobs going . . . and he lost money! So he quit, right then. 'No more of that,' he said, 'We'll do what we can do and that's that.' And so we did."

The Kofoeds were always working, and when they had several jobs going at once, they worked "overtime," too. "All the men worked from 8 to 5 [but] my dad and I always went back in the summer time at 6 o'clock, and worked till at least 10, sometimes later, and then back up in the morning. Saturday was always the short day; we always quit at 5 o'clock. And we didn't ever work on Sunday." Vacations were unheard of. Nelson worked full time for his father from 1934 until 1945, when he went into the Army for a year and a half. He was discharged in 1946. When he came home, he took a week's vacation. "That was the first time I'd ever had any time off. We used to work every holiday . . . [although] we had Christmas Day off; that's the only holiday we'd ever take."

Wages were modest. In 1934, Nelson was paid fifty cents an hour; when he was married in 1937, it was raised to sixty cents (and when he ceased carpentry in 1958 it was $2.50 an hour). Jobs that his father and he undertook were always lump-sum contracts. "It was always priced by the cost of material . . . , and you'd figure how many hours it would take, and that's the way it was done." But it was not always a profitable method, especially on remodeling: "Once in a while . . . you'd make a buck, and then again you'd lose your shirt."

For smaller jobs and remodeling, Carl Kofoed bought material from the local Madigan Lumber Company (which had a yard and mill in Dunkirk, New York, too); for larger jobs materials were purchased from lumberyards in Buffalo, thirty-five miles to the northeast. Montgomery and Malou of Buffalo, which ran a large mill, was their main supplier for lumber and other materials; hardware sometimes came from Weed & Co., also in Buffalo, and "McKinney's Hinges and Butts" were bought in bulk, in eight-by-twelve-by-eighteen-inch wooden boxes. When they had decided how much lumber was needed for a house, they would order it all from Buffalo—but no prefabricated parts; they built everything themselves. If the material was not satisfactory, they would send it back for replacement: "You'd order [the lumber] and if things came that you didn't like, [they] went back . . . and lumber in those days was a lot better than it is today."

Books of house designs were readily available from the lumber companies; Montgomery and Malou provided them, as did Matigan Lumber Company and many others. "All the big mills" supplied such books and booklets, "with pictures and floor plans in them." Another source for house designs was professional magazines. Carl Kofoed got *Practical Builder* every month, and he and his son consulted it a lot, as well as looking at other trade magazines (such as *Builders Age*). "They'd always have a lot of plans," as well as information on materials and other useful data.

The Kofoeds never ordered any of the offered plans. Sometimes the catalogs from lumber companies were taken to the prospective homeowners, "and they'd find something they liked. . . . They'd say what they wanted and we'd draw it up like that." Sometimes—possibly half the time—the owners provided their own sketches or plans that were then customized. "We'd change all our plans and everything, and build it the way the people wanted, or the way *we* wanted," observed Nelson. "My dad drew an awful lot of plans and everything. I never did much of that because I was out in the field all the time, and he was always working on that stuff." Often his father would study the designs in the magazines or catalogs to see if there were "any that somebody wanted." Then, he would draw up his own plans and elevations; he had taken a correspondence course in architectural design and drawing in the 1920s.[77]

This is not to say that publications were not referred to for their instructive contents. Chris Kofoed's *Tin, Sheet-Iron, and Copper-Plate Worker*, "New and Revised Edition" (Philadelphia, 1892?) was valued by all the Kofoeds; and *Architectural Graphic Standards for Architects, Engineers, Decorators, Builders, and Draftsmen* (New York, published in several editions beginning in 1932) was consulted "all the time" by Carl as well as Nelson. As the Appendix 6 listing, "Sampling of Technical Books for Contractors and Craftsmen, 1881–1946," shows, such volumes were widely published and undoubtedly used by craftsmen like the Kofoeds.

The various books and booklets of house plans were used only as a source for their own drawings. Carl would draw up on graph paper "the whole house" (not just floor plans), which usually included the four sides, the floor plans, and details, all at one-quarter inch or one-half inch to the foot, and some details were drawn full scale, as needed. "They were blueprints . . . only they weren't blue!" A listing of materials required was also prepared.

Plans and elevations for a Silver Creek building drawn up by Carl Kofoed in 1930 survive and give a good illustration of what must be typical "carpenter's

ber of companies, mainly the lumber wholesalers from Chicago, Buffalo, or elsewhere. In addition, advertising and insurance companies, such as Lumbermen's Mutual of Boston (which insured Dunkirk Lumber), provided colorful calendars with house designs depicted, from which one could order plans. Such books and calendar plans were not much in demand; Dunkirk Lumber dealt mainly with carpenters and contractors, not directly with prospective home builders, and there was actually little call for such catalogs. The company would get them, "keep them around" perhaps fifteen or twenty at a time, and pass them on to anyone who wanted them; some catalogs were returned, some were not.

According to Mr. Case's recollections of the 1940s (and what he knew of the business in the decade before), until well after World War II, local carpenters did not have much use for blueprints—whether mail order or locally produced. When someone wanted to build a house, a common practice seems to have been to discuss the requirements with the carpenter—number and purpose of rooms, overall size, and so on—and the carpenter drew the plan on a piece of paper and went by that (although any stylistic refinements for the exterior design would be arrived at either by reference to constructed models nearby or by illustrations they could consult).

As to the use of precut houses such as Sears or Aladdin, Mr. Case observed: "No, they weren't too popular; you didn't save too much unless you built it yourself." If one hired a carpenter, most of the savings in lumber costs would be spent on his services. Case could not think of any houses in the area built during the 1940s from precut materials.[87]

Although in the next chapter we return to the actual working practices and design sources for a group of carpenters and contractors in one village, from this sampling it is clear that despite the apparent popularity and documented examples of mail-order plans and precut houses, in the overall picture they appear to represent only a modest percentage of houses built. The influence of the designs *in* the catalogs, as I document more fully in the next chapter, appears to have been considerable, however.

As suggested by William Case, the savings of precut houses were greatest for those prospective homeowners who built their houses themselves. A final example of a constructed precut dwelling, for which full data (and all its blueprints) are available, illustrates this point and documents more fully how such precut houses were generally erected.

An Aladdin House of the 1940s

The Aladdin Company's Pilgrim model (see Color Plate XIV) is a one-story house (with attic that could be finished if desired) of the sort of "modernized colonial" that became more common, thanks to the modernist movement of the 1930s, by about 1940. This model was available by 1943 and probably earlier.[88] The example discussed here was erected near Troy, New York, in 1950–51 by Charles J. Czech for his wife and two young sons.[89]

Although Czech had no experience at all in carpentry, he was mechanically adept (he was able to fix cars and overhaul motors) and always "enjoyed working with tools."[90] A 1934 graduate from Cohoes, New York, High School, he took finance and accounting courses for a year at the Troy Business College and in June 1935 began working for Behr-Manning Company (now Norton Company) in Watervliet, which made coated abrasives of all kinds. He married in 1941, was in military service between 1943 and 1946, and thereafter lived in rented housing while he and his wife saved money and thought about a home of their own. At that time, he was secretary for the Chief Engineer at Behr-Manning.

Czech looked at newly constructed houses, but thought they were too expensive—and having been brought up (as had so many during the Depression) to pay cash and keep out of debt, he did not want to have a mortgage, either. He decided on building a precut house himself and in 1950 located a half-acre building lot at a good price half a mile outside the Troy city limits, in the Town of Brunswick, in the

Fig. 431. Czech House, Troy, New York, 1950–51.

"Spring Crest Development," a farm being divided into building lots. He selected a steeply sloped site as he wanted to have a garage in the basement.

Just why he chose an Aladdin house Czech does not now recall, but it was probably because his brother-in-law was at that time having a contractor erect an Aladdin home for him, although he planned to finish the interior himself. He also may have seen a published ad for the company. Be that as it may, Czech ordered the Aladdin catalog, and he and his wife Frances studied the designs, paying special attention to the floor plans and room sizes. While they liked the exterior design of "The Pilgrim," it was the plan, specifically of version Number 5, that sold them on that model. The house cost about $5,000.

The first thing Aladdin sent were the foundation plans, so that he could have the site excavated (including a shelf of rock that had to be blasted out), the concrete footings poured, and the concrete block cellar walls constructed. Czech built a fourteen-by-seventeen-foot shed nearby to store things like paint, nails, shingles, roofing felt, finished wood, and tools. He had one electric outlet, with its own meter, installed on the site.

Having no experience in carpentry, he decided to learn all he could about Aladdin homes and their construction. On inquiring, Aladdin sent him the address of another Pilgrim model being built in his area, in Schenectady, seventeen miles away. He visited it when it was framed in and the electrical work was being done. He was "very impressed with the materials and construction of the house"—and carefully noted down where the electric outlets were being placed.

Czech also visited *daily*, for several months, his brother-in-law's house, then under construction, to see what he would be facing. The contractor, going by the Aladdin blueprints, told him that they were very clear and easy to follow. Aladdin catalogs, as we have seen, fully explained the systematic way that the material was cut and shipped and assured prospective home builders that "all you have to do is nail the materials in place."

When the materials arrived in late summer by boxcar in South Troy (the load weighed 45,000 pounds), it included everything needed to build the house from the foundations up except for plumbing, plasterboard, electrical wiring, and fixtures. Czech was impressed by the high quality of the materials, and even best-quality paint (Pratt and Lambert) was included. He had specified some modifications to the basic design—such as stairs to the attic, attic windows, subfloor for the attic, two-by-eight-inch rather than

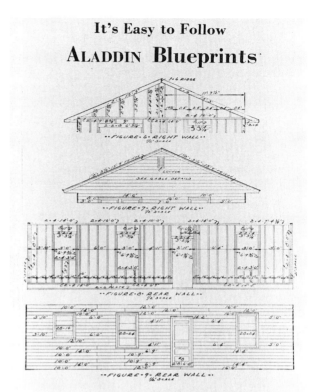

BUILD YOUR OWN ALADDIN HOME
Here we have shown in greatly reduced size, a few figures taken from a set of Aladdin Readi-cut House Plans. They show the size, length and position of every piece of material entering into the construction of the home. All materials including mitered materials are marked and cut to exact length, and all you have to do is nail the materials in place.

Fig. 432. Aladdin Company, 1952 catalog, 62, detail.

two-by-six-inch rafters to be placed sixteen inches on centers rather than twenty-four inches, cellar windows for the rear of the house, and two-by-ten-inch rather than two-by-eight-inch floor joists—and all these were duly included. With a borrowed truck, Czech and several friends unloaded everything in three evenings. Aladdin had even sent a sketch of how the materials were packed in the boxcar. Most of the material they took to the site, but the windows and oak flooring were stored in a friend's cellar. The framing lumber was put in the newly built cellar; the other material in the shed.

Constructing the house was reasonably straightforward; Aladdin had sent a complete set of blueprints.[91] These included eleven sheets (one of them, for the foundations, wall sections, etc., in duplicate), for the "Pilgrim Number 5"—although one is marked "Pilgrim No. 1 and Nos. 2 and 5"—and two sheets of standard trim and window and door details applicable, it would appear, to various Aladdin models of the same type. The plans are all dated either 1948 or 1950. Ev-

As such a "model" I have selected Fredonia, New York, for a number of reasons. First, I have lived in this village for many years and have studied its architecture and history: The village offers a corpus of buildings I am quite familiar with. Furthermore, during 1984 I conducted a house-by-house survey of all 2,239 of its dwellings to categorize them by style types, which makes an assessment of the use of published designs possible. Finally, Fredonia has had few losses of houses over the years, so that most of what was built is still extant. It also has (as of course do so many villages and small cities in America) a full range of houses from vernacular efforts of the early nineteenth century through the usual progression of architectural styles to—and past—the 1940s. As a reasonably prosperous village, modest as well as more sophisticated high-style dwellings can be found.

Although not large, Fredonia is nonetheless representative of hundreds and thousands of villages in the United States. For example, in 1898 Fredonia's population was 2,692; according to the U.S. Census for 1900, there were 1,297 other municipalities in the country of about that size. In 1910 (with Fredonia's population about 5,429), there were 1,665 other villages of comparable size; in 1923, with a population of 6,235, there were 1,970 others; and in 1940, the census reported 2,287 municipalities comparable to Fredonia.[1] Villages and cities larger than Fredonia undoubtedly also reflect the same trends in the use of designs from books, but I want to emphasize that there were a great many "Fredonias" in the United States in the period from about 1890 through 1940 and they would probably reveal just about the same information if they were similarly studied.

I have already cited more than a dozen examples of houses in Fredonia dated between c. 1837 and 1942, which reflected the use of pattern-book or catalog designs, and this finding confirms that for well over a century such illustrations were indeed in use here.

I explore Fredonia's architecture and use of design books in the following way. First, a brief sketch of the village as of the late nineteenth century enables us to see its economic basis and allows comparisons with other villages of the time. Then, a review of evidence from the local press showing interest in architecture, in illustrations of architectural designs, and even in pattern books, helps link local concerns with national trends. Any documented cases of the use of pattern-book and catalog designs—in addition to instances of houses that, by their matching exactly, are themselves proof of such use—confirm the importance of designs from books.

A careful analysis of the numbers of carpenters and builders resident in the village between about 1875 and 1940, in the context of the population growth and known local architects, helps visualize further sources of design—we saw repeatedly but especially in the careers of the Kofoeds that carpenters seem to have adapted published designs on a regular basis. Interviews with retired carpenters of Fredonia can confirm or modify what is known of their "standard" design practices in the early to mid-twentieth century.

Finally, a careful review of the house types built in Fredonia, focusing on the period 1890–1940 (when documentary evidence about carpenters, builders, and architects is available), allows us to get a firm idea of just how prevalent the use of pattern-book and catalog house designs—and the influence of such designs—seems to have been. Such a "catalog" of house types and comparable plates offers a useful compendium for those researching the sources of such house designs.

Architecture and Catalog Designs in the Local Press

Located near the shore of Lake Erie in western New York, Fredonia was first settled in 1803; it is connected to the lake four miles to the north by Canadaway Creek.[2] Soon grist mills and a tannery sprang up, a bridge spanned the creek, and the fertile land was developed for farms. By 1817, the village had its own post office, newspaper, and numerous trades established along the creek, including smithies, leather works, wagon builders, and a cabinetmaker. By the 1830s, a central common had been laid out, around which were a hotel, three churches, and the Fredonia Academy, with commercial buildings on the fourth side. By 1840, the population of Fredonia had reached about 1,000. In 1867, the local academy became a New York State Normal School. By 1873 (with a population of about 2,500), Fredonia boasted five churches, two newspaper offices, two banks, two hotels, and "several manufacturing establishments, principally wagons and carriages, sashes, doors and blinds, and pumps."[3] The seed industry, founded in 1834, was another significant local business. Almost everyone in the surrounding township (Town of Pomfret) was a farmer, with oats, corn, potatoes, and apples the main crops and with sheep and milk cows the principal livestock. In the 1873 directory, the village also boasted eight carpenters, five contractors or builders, and five

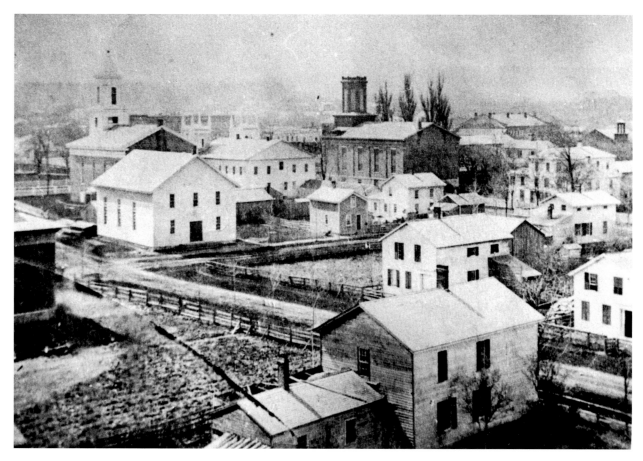

Fig. 439. View of Fredonia from the hill at Day Street and Central Avenue, probably late 1860s (Courtesy Historical Museum of the D. R. Barker Library, Fredonia, New York).

painters, although no architects are listed. The 1890s brought grape growing, which is still the dominant local crop.

The local newspapers tell us a good deal about contemporary interests in building and architecture, along with other valuable insights. For example, although local carpenters undoubtedly had their own manuals and pattern books among their "tools of the trade,"[4] carpenters' manuals and pattern books were also available from a local bookseller. An advertisement in the *Fredonia Censor* for June 8, 1836, alerted the public that "Shaw's and Benjamin's Architects, both latest editions, just received"[5] were for sale at the Fredonia Bookstore, run by Henry C. Frisbee. The volumes in question were probably Edward Shaw's *Civil Architecture, or, A Complete Theoretical and Practical System of Building . . . with Many Useful and Elegant Ornaments . . .* (4th ed., revised and enlarged; Boston, 1836); and Asher Benjamin's *The Practical House Carpenter: Being a Complete Development of the Grecian Orders of Architecture . . . to*

Which Are Added a Series of Designs for Porticos, Frontispieces, Doors . . . (4th ed.; Boston, 1835).

Some seven years later, in a *Censor* ad of October 23, 1843, Frisbee announced that "Downing's Landscape Gardening . . . also his Cottage Residences, two very desirable works, for every person of taste, and especially to those intending to build and improve their grounds" were now for sale at his bookstore.[6] These ads prove that nationally known manuals and pattern books were available in Fredonia soon after publication.

Building activity was considered news, and, especially from the 1860s on, items about public and private construction found their way into the *Censor.* For example, when Robert Wolfers, who had erected the first normal school building in 1867, built his own brick Gothic Revival home in 1868, construction progress was duly noted at least twice in the *Censor.*[7] On rare occasions at this time, architectural items of a technical nature were also included, such as an article on cottage building using lightweight balloon-

frame construction.[8] Brief notices of local "Building News" were a regular feature in the *Censor* for the rest of the nineteenth century.

Interest in architectural matters seems to have increased in the late 1880s and 1890s. For example, when the Buffalo architect Milton E. Beebe moved to Fredonia and purchased one of the impressive Greek Revival Risley mansions (and improved the house and grounds in 1889), his activities were described in a long article, as was the large commercial block in Buffalo designed by M. E. Beebe and Son a few years later.[9] The new and capacious village hall, designed by Enoch A. Curtis, was illustrated prominently on June 18, 1890; and the 1893 rebuilding of the old Park House Hotel as the new Columbia Hotel, a more fashionable Richardsonian edifice of brick, found ample coverage in the *Censor*, including two illustrations.[10] (A new hotel in nearby Dunkirk was described at length in the May 4, 1892, issue.) Enoch Curtis's new dining hall and gymnasium for the normal school were also depicted in 1898, when construction was underway.[11]

Not surprisingly for a largely agricultural area, building related to farm use was most often illustrated in the 1890s. Several articles appeared in 1896: a "Splendid Bank Barn," shown in perspective and two plans (reprinted from the *New York Tribune*); a "Cheap Poultry House," depicted in a perspective view and plan (from *Farm and Home*); a "Stone Dairy House" in a perspective drawing (from *Country Gentleman*); a hen house design, shown in perspective and section. In 1897 an illustrated article entitled "Building a Tub Silo" was reprinted from *Rural New Yorker*.[12]

These articles were of only local and regional interest, but one article in 1896, which depicted and described a modest Queen Anne–style house, is of special importance: The "model cottage," which could be built for $1,125 (or only $1,000 if the rear kitchen wing was omitted,), was a *Shoppell* design.[13] No information about his publications or instructions for ordering plans was provided, but the illustration has (buried in the grass), the legend "Co-operative Bldg. Plan Assn., Architects, NY," R. W. Shoppell's firm. This seems to be the only "mail-order" plan to appear in the *Censor* in the late nineteenth century.

Another local newspaper that also included architectural matters in its coverage—in fact had more items of broad interest and illustrations—was *The Grape Belt*, published first in Brocton and then in Dunkirk. Serving the agricultural and grape-growing community of northern Chautauqua County, from its earliest months (it was founded in 1893) the newspaper included numerous architectural items. For example,

in April and July 1893, two articles described and illustrated the Columbian Exposition of that year in Chicago.[14] In 1895, there appeared articles on the mansard roof (contrasted with current architectural styles) and one on artistic taste in the design of dwellings.[15]

Coverage of regional architecture, including newly erected houses and other buildings, was often quite lengthy. New artistic dwellings in Portland, Brocton, and Fredonia were illustrated and described,[16] as well as significant public buildings, such as the proposed cemetery gates lodges (by Enoch Curtis) in Fredonia and the new Dunkirk Academy building.[17] Articles depicting local architecture, both historic and modern, were also included, focusing on Westfield, Dunkirk, and Fredonia.[18]

The most interesting series, from the point of view of providing plans and illustrations for building designs (and a source for mail-order plans), was the sequence of fourteen articles in 1894–97 by George Palliser.[19] Eleven of these articles were about houses, in a wide variety of styles, from a somewhat old-fashioned Stick Style dwelling, to Queen Anne (usually on the restrained side), Tudor, Shingle Style, and an early version of the Foursquare. Two stables were shown; one was Queen Anne, and the other, with gambrel roofs, was called "Dutch Colonial." (One article was on a design for an impressive brick school building.)

The three designs from 1894 were all copyrighted by Palliser, Palliser & Co.; the four published in 1895 have no identification of designers at all; and those from 1896–97 bear the copyright of George Palliser alone, with his new address at 32 Park Place in New York City.

The purpose of these articles was, naturally, to introduce local readers to reasonably up-to-date "high-style" designs, mainly for domestic structures. In the descriptions of the houses, which ranged in price from $2,400 to $7,000, the value of professional plans was emphasized: "If a private house is built without the services of an architect, it is the general and candid acknowledgment afterward that a great mistake had been made and that many things could have been improved by the employment of a skilled man."[20] One column, two years later, included a full, cogent argument for the true economy and wisdom of employing an architect in designing a house and concluded: "By all means employ a good architect and build first on paper, and no regrets will be forthcoming when the house is finished."[21]

In all these articles (at least those with Palliser's name and address), it was implied that the experienced author was a good source to consult for domestic

building; and in two articles (for a house and for the school), Palliser was explicit in offering plans by mail: "Full working plans and specifications furnished for 2 per cent on cost named by applying to George Palliser, architect, 32 Park Place, New York."[22]

None of these designs appears to have been built in Fredonia, although several houses in the town are generally similar to the "$4,000 Cottage" and the "Suburban Home." Perhaps local builders, with access to designs in pattern books and periodicals, found these illustrations a bit old-fashioned. The first dwelling published in June 1894, for example, is actually a design from plate 9 of *Palliser's Model Homes* of 1878—and had, as we have seen, been one of the sources for the Aaron Putnam House in Fredonia, which Enoch Curtis had built that same year, 1878. George Palliser apparently did not realize how widespread and influential his book from sixteen years earlier had been.

Illustrated news accounts of local architecture of significance appeared regularly in the Fredonia *Censor* during the early twentieth century. Although national "architectural news" was occasionally featured (such as the Pan American Exposition in Buffalo in 1901 or the newly built Grand Central Station in New York City in 1903), most items were regional or local. For example, plans for a new Grange Hall in 1903, the impressive new County Court Building in Mayville (completed in 1909), and three large brick Colonial Revival structures at Chautauqua Institution (1916) were all illustrated and described.[23]

Most of the *Censor's* architectural illustrations in the first quarter of the century focused on new or proposed local building: the new State Normal School and the new Fire Hall (both in 1901), the proposed West Hill and Eagle Street Schools (1909), plans for remodeling and expanding the Barker Library (1910), the new Fredonia Grange building (1915), the new Junior High School (1920), and the new Methodist Church (1924).[24] Five of the new or proposed buildings (the Fire Hall, Grange, and local schools) were designed by the local architect Harry P. Beebe.

No new series of mail-order plan designs appears locally, however, until 1922, suggesting that there was little demand by the reading public for such columns. In the "Better Homes" section of the *Censor* for May 10, 1922, however, were three designs by Charles S. Sedgwick, each illustrated with a perspective view and one or two floor plans. His "Attractive Small Cottage" was an L-shaped one-and-a-half-story design of which many versions (some dating to the late nineteenth century) can be found in Fredonia—although none so small as this one. The second was a two-story clipped-gable dwelling of which numerous examples can be found locally, although not with the prominent roof dormers shown in Sedgwick's design. His "Brick and Stucco Cottage" was a form of Stickley Bungalow, but of a type not known in Fredonia. Thus although these designs might have been of general interest, none seems to have had any direct local progeny. The articles also omit any reference to Sedgwick's address or credentials.

In 1926, however, the *Censor* ran a series of three illustrated columns of design by William A. Radford,[25] with his "offer to the public," qualifications, and address prominent: "Mr. William A. Radford will answer questions and give advice FREE OF COST on all problems pertaining to the subject of building, for the readers of this paper. On account of his wide experience as editor, author, and manufacturer, he is, without doubt, the highest authority on the subject. Address all inquiries to William A. Radford, No. 1827 Prairie Avenue, Chicago, Ill. and only inclose two-cent stamp for reply."[26] Besides describing the house design, one column also made the case for ordering plans prepared by an "expert" and then making small changes required as needed: "There are almost as many different kinds of houses as there are different kinds of people. Everyone has his own idea of just how his house should look and how the rooms should be arranged. But when it comes to making the actual plans expert knowledge is required and a good way to handle this is to select a plan which most nearly fulfills your idea and then have whatever small alterations are needed to perfect it made by an expert."[27]

As we have seen (with the Kofoeds, for example), experienced carpenters were indeed the "experts" in such matters, using published plans as the basis for improved or customized house designs. Thus one wonders how many readers of the *Censor* would have written to Radford. Certainly the designs depicted were not really new. The first was a clipped-gable one-story "bungalow" of the type sold by Aladdin eight years before ("The Pasadena"). The second was similar, but with a classical pedimented entrance porch—very much like Standard Homes Company's Cornell of 1925 (and with a gabled, rather than clipped-gable roof, almost the same house design was sold by Sears as early as 1921 and by National Home Builders Institute in 1923). Thus houses similar to either of these Radford designs could already have been available locally in catalogs known to and used by local carpenters and even by architects. (The third design was a gabled bungalow of a type not known in Fredonia.)

The appearance of these columns—with designs by Palliser, Sedgwick, and Radford—in local newspapers confirms the general local interest in house designs, but it does not appear that columns in newspapers were a source for models for houses: None of the published designs seems to have been built locally. The fact that these columns appeared so rarely over this thirty-three-year period also implies that local newspapers were probably not sources for house designs.[28]

Nevertheless, it can be demonstrated that houses following plans from mail-order catalogs and precut houses by Sears, Aladdin, and Bennett Homes were indeed built locally. A number of points prove the case.

First, one can find actual mention of such houses in the local press. An item from the *Censor* in 1916 states: "Ray Gibbs is putting up an Aladdin House on what was part of the Paschke farm, West Main Street."[29] Second, there is a "local tradition" that at least one Fredonia house (33 Lambert Avenue) is a Sears house, which I was told by both the daughter of a local builder and by a long-time resident;[30] and indeed the house is a Sears model.

There is also ample evidence from built houses that match mail-order designs almost perfectly. In this study, I have previously discussed a number of Fredonia dwellings whose very existence is incontrovertible evidence that mail-order plans were followed. Companies (and catalog dates) represented include: Shoppell (1890), Radford (1898, 1903, and 1919), Sears (1908), Chicago House Wrecking (1909), Architects' Small House Service Bureau (1922), Home Builders Catalog (1927), and Standard Homes Company (1930). Furthermore, occasionally homeowners have the original plans marked with the name of the precut house company in question or plates from the original house plan catalog or magazine.[31] In one case, the blueprints for a Fredonia house survive, and although not marked with a company's name, are clearly from some mail-order concern.[32] In other instances where there is no current documentary proof, homeowners with good reason to know the facts state that their houses were indeed built from mail-order plans.[33]

Finally, there are quite a number of Fredonia houses that, although no catalog plate has been found to match exactly, do look very much like houses appearing in popular catalogs of the day—and at least some of these houses must have been built following plans from some yet to be identified company.

How common, then, in the overall picture, were houses built from mail-order plans or precut materials? The best way to assess this for Fredonia is to first study the context of building between about 1875 and 1940—to examine how many carpenters, craftsmen, and architects were working in the village during this period—and then to explore what interviews with retired Fredonia carpenters and similar witnesses can tell us about working methods of the early twentieth century. Finally, a close study of just what was built and the nature of the designs helps arrive at an assessment of what impact mail-order plans and houses might have had.

Carpenters, Craftsmen, and Architects in Fredonia to c. 1940

Local records tell a good deal about the state of early building in Fredonia even before the listings in gazetteers and directories beginning in the 1870s. Old photographs show that both log houses and then frame clapboarded houses of vernacular design were built during the first decade of settlement.[34] A photograph of the village taken about 1868 (see Fig. 439) depicts many of the boxy frame dwellings that were common in the early years (and in later years were often given more high-style trim and detailing or were extensively remodeled).

The Greek Revival was introduced by the 1830s; more than 250 dwellings in this style survive today. A carpenter who was responsible for the more elaborate ones (and probably many of the well-designed smaller ones, too) was John Jones, who had come to America from Wales in 1824, already an experienced carpenter. He settled in nearby Westfield in 1830 and by 1834 was working and designing in Fredonia. The brick Episcopal Church (1834–35), the Presbyterian Church of 1835–36, the Abel Hotel of 1837, and his own house of 1839–40 are all known to be by him. The Episcopal Church was in a rather thin Gothic Revival, but the others were in a very capable Greek Revival style. Other distinctive Greek Revival buildings followed in the 1840s; his last work was the Baptist Church of 1852–53, where he was killed when a scaffold collapsed.[35]

From the earliest years, Jones was clearly a talented carpenter who could also design, and his obituary states that he was the *architect* of the church—although the *Censor* notice of the accident implies that he was one of the workmen, too.

To carry out all this building, whether sturdy vernacular frame houses or more sophisticated Greek Revival ones both large and small, there were clearly a large number of capable workmen less professionally

CARPENTERS/ARCHITECTS/POPULATION

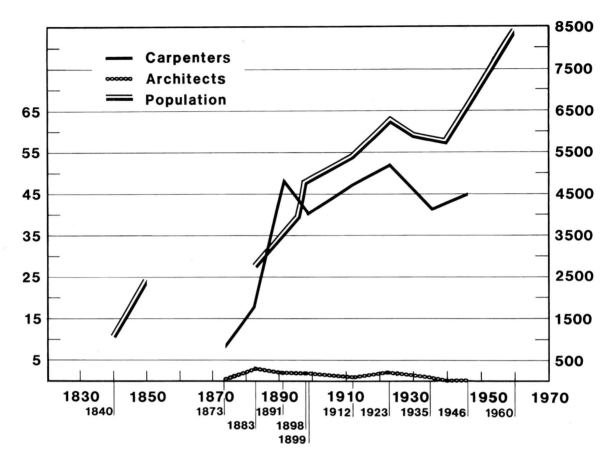

Fig. 440. Carpenters/architects/population: Fredonia.

trained than Jones. A glimpse into the life of one such man is provided by eight surviving letters from the 1830s written by Aaron L. Putnam or his wife to their family, still living in Massachusetts.[36]

Aaron L. Putnam, his wife Dolly, and small daughter Jane came to Fredonia in 1834, and their letters tell in detail of their life and activities. Putnam was a man of many talents, as successful settlers had to be in those days; he seems to have been a farmer and carpenter by trade. In April 1835, he wrote to his brother Nathan:

> I have not gone into any business yet and I think I shall not this spring as money is very scarce here and it is hard times for mechanicks that do mutch business. . . .
> I think I shall stay here in the village this summer and work at carpenter and joiner work if nothing hapens, about scythe, snath, sash, and pail business. I cannot tell

but I think the pail business would be the best but I think farming is as good business as any here, for the country is full of mechanicks and professional men.[37]

He looked around at farms with an eye to buying them, but wanted to see how the crops grew first. He also bought and sold land and seems to have had a real talent for making money on the transactions.

The letters show that he did a good deal of carpentry work, too. A January 1836 letter from his wife Dolly to her mother in Massachusetts comments: "Aaron has been to work on the meeting house [undoubtedly Jones's Presbyterian Church] most of the time. It is now finished and was dedicated last sabbath. . . . Aaron is [now] gone to work a finishing off a hatters shop."[38]

Putnam owned properties in the village with houses on them, which he rented out, and one of which he and his family occupied, although he planned to build himself another house if he did not sell off more

Fig. 480. 96 East Main Street, Fredonia.
Fig. 481. 35 Hamlet Street, Fredonia.

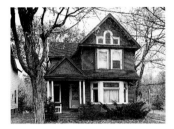
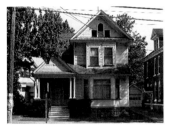

Fig. 482. 30 Forest Place, Fredonia.
Fig. 483. 93 East Main Street, Fredonia.

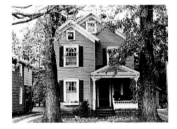
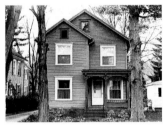

Fig. 484. 96 Center Street, Fredonia.
Fig. 485. 100 Center Street, Fredonia.

it, a process, as we saw, with a long history and documented in Fredonia, too.

Three pairs of Queen Anne houses, for which no exact model has surfaced, can represent this group of capacious two-story houses. Both 96 East Main Street (built by 1903) and 35 Hamlet Street (about 1912) are authoritative Queen Anne houses with corner towers, which Barber as well as *Scientific American* had popularized in the 1890s. *Carpentry and Building* published a similar design in 1897, Shoppell had a version in 1900, and Radford (1903) sold plans similar to this.[74] No published design has yet surfaced for 30 Forest Place and 93 East Main Street although they certainly look like the type. Others of more simplified outlines, such as 96 and 100 Center Street (both about 1903) could be economical versions of a pattern-book plate such as Design 10 from Radford's *Ideal Homes* (1898) or a local carpenter's own version of the type. Even though the exteriors are almost identical

(even to the symmetrical trees, one pair of Norway Maples, the other Sugar Maples), the plans are somewhat different.[75]

Smaller picturesque Queen Anne houses are also common. One type, of which there are fifteen versions, is represented by the cottage with chamfered-facade treatment, such as 25 Chestnut Street, built between 1907 and 1908.[76] This example matches closely Radford Design Number 20, from about 1898, which was still being carried in the 1904 edition of *Ideal Homes*. A similar but somewhat less richly detailed version was in the *Radford American Homes* (1903) as Design 143 (see Fig. 243). Both, as we recall, go back to Design 27 in *Palliser's New Cottage Homes* of 1887, and the style seems to have been so popular nationally that Sears carried it as Number 116 between 1908 and 1913. Caution is always necessary, however. Numerous houses in Fredonia are related to this type and can be matched with various Radford plates, such as 56 Lakeview Avenue and Radford's Design 123 from 1903. The Fredonia house, however, dates from about 1890, so that some other model—probably still a pattern-book design, however—was evidently the source or inspiration.

Whereas most Fredonia houses of this period have cousins of similar or related style elsewhere in the village, one Queen Anne house with a low silhouette and capacious roof is unique. The house at 32 White Street, built about 1913 or 1914, seems to be

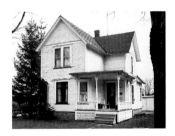

Fig. 486. 25 Chestnut Street, Fredonia.
Fig. 487. Radford (1904 ed.), 10.

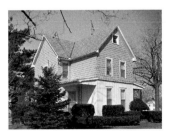
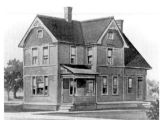

Fig. 488. 56 Lakeview Avenue, Fredonia.
Fig. 489. Radford (1903), 121.

Fig. 490. 32 White Street, Fredonia.
Fig. 491. Shoppell (1900), Design 2001.

Fig. 494. 121 East Main Street, Fredonia.
Fig. 495. Sears (1915), 39, Design 170.

Fig. 492. 123 East Main Street, Fredonia.
Fig. 493. Radford (1904 ed.), 11, Design 37.

Fig. 496. 126 Central Avenue, Fredonia.
Fig. 497. Aladdin (1918), 70.

modeled on a Shoppell design of 1900[77] or possibly on a later version by some other company; but there is none other just like it in the village. The plans are quite similar, but the Shoppell dwelling is wider than its Fredonia version.

A related design in a more humble style can be found at 123 East Main Street, dating from 1910. The house at 75 Hamlet Street, of 1907–8, is virtually identical to it.[78] In both cases, the design source seems to be a plate such as Radford's design 37. Even the plans are close, as are the exterior dimensions. It was a design picked up by Sears as well, offered (as Design 136) in 1911 and 1913. A similar design, without the subsumed porch, can be found at 121 East Main Street, built between 1910 and 1912, with a duplicate at 5 Cleveland Avenue (1910 or 1911); there is also a mirror-image pair at 109–11 Temple Street. The source for all of these is a plate like Sears's Design Number 170, which was sold between 1908 and 1917.

These examples of small Queen Anne houses of the early twentieth century can be closely or nearly matched with a variety of pattern-book plates. The impact of such published designs must have been profound, as a house at 126 Central Avenue demonstrates. It looks a good deal like Aladdin's "The Yale" of 1918, or even Bennett Homes' Niagara of 1927. Yet this is a case of local carpenters remodeling in the "catalog style," so to speak. This was originally the carriage house of the boxy Queen Anne at 130 Central Avenue, moved up the street and thoroughly modeled into a residence in 1924.[79]

Queen Anne Foursquare

One of the most popular house types in Fredonia during this period was the simplified gabled dwelling type I have earlier called the Queen Anne Foursquare. I illustrated the Harry Joy House at 339 Water Street of 1913–14 as closely based on Radford's 1903 Design 110 (see Figs. 238 and 240). There are nearly sixty versions of this in the village, some, like the one at 45 Risley Street (1909), with somewhat varied facade fenestration, but often with other details, such as the central chimney or stairway window between first and second floors, which suggest the Radford model as its source. Even variants of this Radford type, such as Design 526, with wraparound porch and additional entrance in the side wing, can find local variants, such as 116 Temple Street. All these Radford designs—and there were many in the catalogs—probably can be traced back to houses by Shoppell, such as

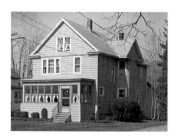
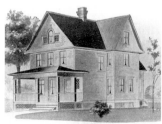

Fig. 498. 45 Risley Street, Fredonia.
Fig. 499. Radford (1903), 123.

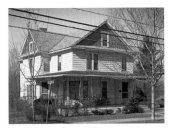
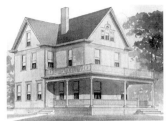

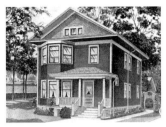

Fig. 500. 116 Temple Street, Fredonia.
Fig. 501. Radford (1903), 167, Design 526.

Fig. 505. 17 Houghton Street, Fredonia.
Fig. 506. Sears (1918), 71.

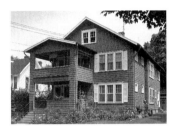
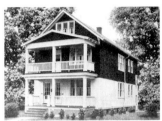

Fig. 502. Shoppell's Modern Houses
(1890), Design 635.

Fig. 507. 125–27 Temple Street, Fredonia.
Fig. 508. Home Builders Catalog (1927), 918.

his Design 635 from 1890,[80] or to intermediary designs by others.

This house type continued in popularity for decades. The dwelling at 15 Maple Avenue at first glance looks like a version of these Radford Queen Anne Foursquare designs. Originally built in 1896–97, it was thoroughly remodeled between 1922 and 1923 in light of "The Hopeland," a Sears model offered in 1921 and 1922. The current plan is very close to the Sears model, and many details (such as the small window lighting a closet on the second floor above the entrance hall) are exactly the same. Even though it is a remodeling, the dimensions are almost the same, too.[81] The Sears Hopeland reminds us that the plan companies frequently updated and revised early and even vernacular types to maintain their currency. Perhaps their general familiarity to the public was a selling point.

Even a boxy house that looks as though it might be just a vernacular dwelling given stylish bay win-

dows on two floors may instead have been inspired by some pattern-book plate, as with 17 Houghton Street of about 1918. "The Lorain," offered by Sears between 1911 and 1918, could have been the model for this treatment. Duplex dwellings of a few years later, given stylishness by shingle cladding in the Craftsman mode and convenient two-story porches, are also a type with sources in catalog plates in the 1920s. The duplex at 125–27 Temple Street, built between 1921 and 1923, has much in common with Sears's "The Windermere" (offered between 1925 and 1929) or the comparable duplex from *The Home Builders Catalog* of 1927.

Even for small versions of the Queen Anne Foursquare, with only a one-story bay at the side (rather than a full two-story gabled wing) such as at 9 Berry Street, built between 1907 and 1909, one can find Radford plates from a few years before (such as Design Number 561 of 1903), which could have inspired the design.

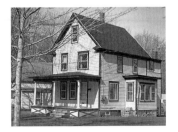

Fig. 503. 15 Maple Avenue, Fredonia, 1922–23?
Fig. 504. Sears (1921), 79.

Fig. 509. 9 Berry Street, Fredonia.
Fig. 510. Radford (1903), 211, Design 561.

The type was soon revised, however, in light of the Craftsman preference for natural surface textures, especially shingles. The house at 17 Washington Avenue, built sometime between 1925 and 1930, has a lot in common with "The Roanoke," purveyed by Sears between 1918 and 1922 (a version with simpler detailing was Number 222, sold in 1912–18). The arrangement of windows, small attic ventilator, and side entrance is very similar, even if the detailing of the Sears model is more elaborate; that "extra" embellishment is just the sort of thing a local builder, adapting an illustration for local use, could leave out or modify. The somewhat smaller house at 303 West Main Street (built sometime between 1926 and 1930) picks up the differentiated treatment of first and second stories popularized by Craftsman designs. Here the model might have been "The Morley," a Sears design issued in 1918 and close to Stickley's "Craftsman House" published in May 1909 (See Fig. 287)—reminding us of how earlier archetypes were popularized and widely disseminated through the adaptations of catalog companies. In the Fredonia house, the pattern of shingling above the clapboards, the double facade window, and the side entrance (the enclosure was a feature one could order separately) are extremely close to the Sears model of a decade before.

Fredonia houses of this simple gabled form with highly distinctive features, such as 105 Forest Place (built between 1925 and 1930) with its heavily gabled enclosed front porch, can also find possible models in mail-order catalogs. "The Bristol," a Standard Homes Company design shown here in the 1930 catalog illustration, is quite close in many ways. And another Fredonia dwelling, at 39 Cushing Street, seems to have had an eye on this distinctive treatment. Although the house dates from before 1917, it was remodeled in this style sometime after 1923. The form of the porch, with the four windows grouped together, the doorway recessed at one end, and a porch window beside it, is so close that this Standard Homes Company plate might well have been the model.

Gabled cottages (such as 40 Spring Street, of 1909), which, because of their diminutive size and very simple treatment seem more like vernacular dwellings with a later stylish porch, could also be inspired by catalog plates. Aladdin's Finley is taken from the 1918 catalog, but we recall that the company, founded in 1907, was doing a good business by 1910 and by 1911 had forty-seven houses in its catalog. Perhaps this model was one of Aladdin's earliest efforts.

Aladdin was not the only company to produce extremely simple gabled houses, however. The dwelling at 29 Terrace Street, an older house remodeled into its current form apparently in the 1910s or 1920s, has much the same lines, front door to one side, and paired second-story windows as Sears's Model 36, sold between 1908 and 1916. Thus even among the simplest gabled houses, catalog plates with the same design can

Fig. 511. 17 Washington Avenue, Fredonia.
Fig. 512. Sears (1918), 83.

Fig. 515. 105 Forest Place, Fredonia.
Fig. 516. Standard Homes Company (1930), 51.

Fig. 513. 303 West Main Street, Fredonia.
Fig. 514. Sears (1918), 16.

Fig. 517. 40 Spring Street, Fredonia.
Fig. 518. Aladdin (1918), 81.

Fig. 519. 29 Terrace Street, Fredonia.
Fig. 520. Sears (1913), 16.

usually be found, arguing strongly for the pervasive in-fluence of these plates in the early twentieth century.

Even plain house designs related to the vernacu-lar ell tradition but given stylish detailing (such as chamfered corners, bargeboards, or quaint dormers) have parallels in books. In Chapter 6, I illustrated 138 Lakeview Avenue, an ell house, which copied Design

Fig. 521. 37 Washington Avenue, Fredonia.
Fig. 522. Radford (1903), 109, Design 133.

Fig. 523. 84 Hamlet Street, Fredonia.
Fig. 524. Sears (1913), 71.

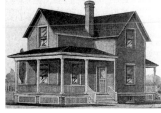

Fig. 525. 24 Norton Place, Fredonia.
Fig. 526. Sears (1913), Design 104.

21 from Radford's *Ideal Homes* (see Figs. 248–249). I also previously noted that Aladdin was selling a very simple vernacular ell-type house, "The Michigan," as late as 1918 (see Fig. 333). A good number of Fredonia dwellings follow the ell form, either simplified or with Queen Anne-style detailing. The house at 37 Wash-ington Avenue, built by 1894, probably goes back to a Shoppell design (such as 636 of 1890, previously seen used in Fredonia for 50 Curtis Place), but the type was perpetuated by Radford, too, as witnessed by its Design 133 of 1903. Although much simpler, 84 Ham-let Street, which is possibly a true vernacular ell-type house, could equally be based on a Sears model. The Fredonia dwelling dates from 1912; the Sears model Number 175 was offered from 1908 through 1913 and bears a good deal of resemblance. Even the simplest vernacular ell houses, of which there are many ver-sions, have parallels with later catalog plates, as the comparison of 24 Norton Place (built before 1902) and Sears Design Number 104, sold between 1908 and 1913, shows.

Stickley Bungalows

One of the most common house types in Fredonia es-pecially during the 1920s and 1930s was the bunga-low; at least eighty-five examples, in various styles, were built. A review of the many permutations of this popular dwelling type confirms that almost every varia-tion finds a parallel in catalog plates.

Stickley Bungalows were the most popular, and about fifty of this type were built. One form empha-sizes the "one-story" quality with a wide and rather low shed-roof dormer. The structure at 121 Seymour Street (Fig. 527), built between 1919 and 1921, finds its closest parallel in the Sears Glyndon, sold between 1911 and 1922. A second version of this type, with a somewhat bigger dormer, is found at 197 Water Street (Fig. 529); it was built between 1923 and 1925. A simi-lar catalog design is the Standard Homes Company Loraine, as seen in the 1925 catalog.

Even designs that look like unique variations, such as the bungalow at 57 Summer Street (Fig. 531), of 1927–28, with half of the porch enclosed as a sunroom lighted by three windows and the remaining porch spanned by a single lintel, can have plan book sources. The Stan-dard Homes Company's Kendall of 1925 was only one possible model, for the almost identical design (as Num-ber 12210-A) is in a C. L. Bowes catalog of 1925 im-printed with the name of a lumber company in Olean, New York. Although the Bowes design has different ma-terials on the outside (brick and shingling), the plan of

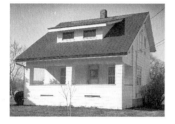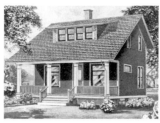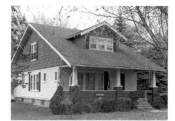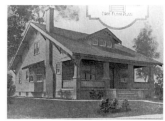

Fig. 527. 121 Seymour Street, Fredonia.
Fig. 528. Sears (1918), 60.

Fig. 535. 378 Chestnut Street, Fredonia.
Fig. 536. Radford (1919), 61.

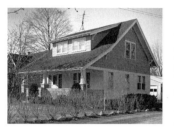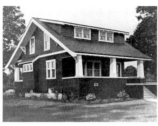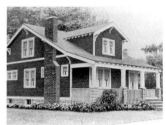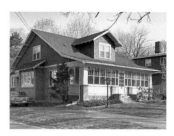

Fig. 529. 197 Water Street, Fredonia.
Fig. 530. Standard Homes Company (1925), 54.

Fig. 537. 29 Risley Street, Fredonia.
Fig. 538. Aladdin (1931), 31.

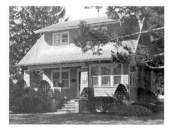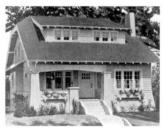

Fig. 531. 57 Summer Street, Fredonia.
Fig. 532. Standard Homes Company (1925), "The Kendall," 32.

the Fredonia house is actually more like this model than "The Kendall," and the exterior dimensions are closer as well (both are just 26 feet wide).[82]

All varieties of Stickley Bungalows were built, too, many of them types that are quite common in other villages throughout the northeast. One features an impressively capacious roof, which reaches down at the back almost as far as at the front, with a modest-sized gabled dormer, as found at 378 Chestnut Street, built sometime between 1930 and 1935. Radford offered a model of this type as early as 1919, its Design 10496P, and the same type was sold by Sears between 1925 and 1929 as "The Sheridan" (which also had numerical denominations). This type with a break in the front roof to signal the extent of the porch was also popular. In Fredonia, 29 Risley Street, of 1929–30, is a good example with excellent Craftsman brickwork (buff colored with reddish mortar); "The Bedford" by Sears (offered by name or number between 1926 and 1933) is a close match, even with brick on the first story; but other companies' models, such as the National Homebuilders Institute's Litchfield of 1923 or Aladdin's Portland of 1931, also popularized the type.

Modest-sized Stickley Bungalows with small gabled dormers were also erected; 155 Chautauqua Street with straight front-roof slope is one example, comparable to a Radford design (Number 6836P). Naturally, the roof break could have been a local option, as was whether to insert a bay window in the living room (or dining room) or whether to provide

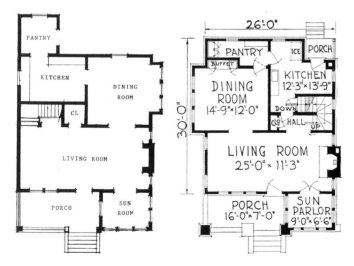

Fig. 533. 57 Summer Street, Fredonia.
Fig. 534. Bowes, Number 12210-A (1925).

Fig. 539. 155 Chautauqua Street, Fredonia.
Fig. 540. Radford (1919), 93.

Fig. 541. 164 Water Street, Fredonia.
Fig. 542. Radford (1919), 28.

Fig. 543. 19 Newton Street, Fredonia.
Fig. 544. Home Builders Catalog (1927), 792.

Fig. 545. 330 East Main Street, Fredonia.
Fig. 546. Radford (1919), 11.

the living room with a fireplace. Whatever the size, almost any Stickley Bungalow in Fredonia can be matched with a similar catalog plate.

Even special or rare features can usually be found in some catalog. The second-floor roof dormer is occasionally provided with a balustraded balcony, as at 164 Water Street, built between 1925 and 1930. This detail was used by Radford in its Design 6925P of 1919 and popularized by Sears (as in "The Westly," sold between 1919 and 1929). Stickley Bungalows of modest size with single-span porch lintels and very large dormers above them, as built between 1917 and 1919 at 19 Newton Street, have catalog parallels (for example "The Custard" in the 1927 *Home Builders Catalog*). Even an oddity such as the front porch completely closed in, as at 330 East Main Street, was a treatment found in catalog bungalows, such as the Sears Number 155 of 1913 or—even to the arched entrance—Radford's Design 6838P of 1919.

Occasionally, there are variants in Fredonia Stickley-type bungalows for which I have found no exact model, yet the feature is well known in catalog illustrations. One such element is the long front-roof slope turning up in a slight curve over the front porch, as found at 195 Water Street (see Color Plate V). Published illustrations with this feature include a Stickley design of February 1905 (reprinted in *Craftsman Homes* of 1909, 76—see Fig. 273); Plan 641 in Smith's *Books of a Thousand Homes*, I (1923, 1927); Sears's "The Lakecrest" of 1931–33 and "The Marion" of 1933–39; and a brick version published by the Common Brick Manufacturers' Association in its catalog *Your Next Home* (1925), 45. Clearly, details, motifs, and overall forms found in Fredonia bungalows strongly echo national models, even when exact models have not surfaced.

One distinctive dwelling at 26 Cleveland Avenue (Fig. 547) is of special interest. It combines a straightforward gabled vernacular house type with the broad front porch and prominent dormer of the Stickley Bungalow tradition; it was erected in 1919 or 1920 by the

carpenter Louis Salhoff who in January 1919 began tearing down the planing mill building on this site.[83] Whether he had a catalog house design in mind at the time or not, the type does appear (several years later, in 1927) in a Bennett Homes catalog as "The Raymond."

A local architect, Harry P. Beebe, also used the Stickley Bungalow type. His own house at 266 Central Avenue followed this style, but was a more sophisticated design than most. While the overall lines, complete with large dormer, follow the Stickley model, the front portion containing a long living room has both ends rounded off, and the porch extends only as far as the start of this curvature. There are other bungalows of identical or similar design, both in Fredonia and nearby.[84] We have seen that practicing architects did use pattern-book designs in creating their work, so that Beebe may owe this distinctive feature to a published design that he adopted.

Fig. 547. 26 Cleveland Avenue, Fredonia.
Fig. 548. Bennett Homes (1927), 43.

Gabled Bungalows

Among the "other types" of one-and-a-half-story bungalows in Fredonia, a popular model was the gabled house, often with a side dormer, with the narrow end to the street and usually graced with a porch. Sometimes the houses have Craftsman-type detailing, such as prominent eaves brackets or beam ends, contrasts in materials (especially shingles), and square bay windows. The house at 205 East Main Street of 1928 is a representative example. As early as 1903, Radford was publishing models (such as Design 140) quite similar to this; Chicago House Wrecking Co.'s Number 115 in its 1909 catalog is also of this type; and Stickley published a number of houses like this between 1901 and 1911. It was clearly a type popular in catalogs. Sears's "The Niota" (sold between 1911 and 1918) is a good example, complete with a variety of Craftsman details; the Aladdin Harrison (from the 1931 catalog) is a later version.

One such bungalow, completely clad in shingles, is at 39 Barker Street; it was built about 1915 or 1916. The closest catalog plate to this is the Bennett Homes Davenport; although the illustration comes from the 1927 catalog, the model may be much older, for Bennett Lumber Company was founded in 1905, and the 1927 catalog was its thirty-sixth issued. Another bungalow of this general type is at 24 Maple Avenue, built sometime between 1925 and 1930. Here the closest model I could locate is the Radford Design 6827P as shown in the 1919 catalog.

Sometimes there is no question that a Fredonia house follows a specific catalog model. The distinctive bungalow at 199 Water Street, of 1924 (see also Color Plate V), is obviously the Sears Kilbourne, sold between 1921 and 1929, and interestingly enough, itself based closely on Gustav Stickley's "Craftsman Cottage" published in March 1911 (see Fig. 272).

The simplest one-and-a-half-story gabled bungalows also find parallels or models in catalog designs. The house at 33 Seymour Street is a good example. Built sometime between 1930 and 1935, it is extremely close to the National Homebuilders Institute's Castleford of 1923, even to the paired dining-room window (although built without projecting bay) and the location of the chimney.

Even the smallest such dwellings, which rest almost on the threshold of the vernacular, such as 125 Forest Place of about 1925, are comparable to published models. Features like its projecting porch and

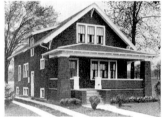
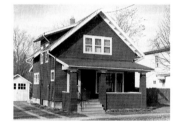

Fig. 549. 205 East Main Street, Fredonia.
Fig. 550. Radford (1903), 59, Design 140.

Fig. 553. 39 Barker Street, Fredonia.
Fig. 554. Bennett Homes (1927), 52.

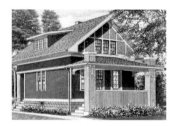
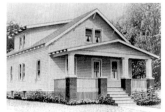

Fig. 551. Sears (1918), 96.
Fig. 552. Aladdin (1931), 18.

Fig. 555. 24 Maple Avenue, Fredonia.
Fig. 556. Radford (1919), 41.

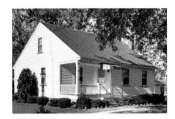
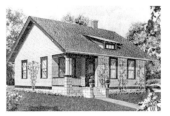

Fig. 557. 199 Water Street, Fredonia.
Fig. 558. Sears (1928), 81 (Courtesy Sears, Roebuck & Co.).

Fig. 565. 74 Gardner Street, Fredonia.
Fig. 566. Sears (1918), 44.

Fig. 559. 33 Seymour Street, Fredonia.
Fig. 560. The Homebuilder (1923), 112.

that time, he took to building houses (the family homestead was a few doors away).[85] This is just the sort of dwelling, whether a precut house or one based on the Aladdin design (for the plans are only similar), a non-professional carpenter could undertake successfully.

Even a very small house of this type, without any features to give it distinction, nevertheless can have parallels in catalogs, as a comparison of 172 Liberty Street and the Aladdin Princeton (1918) demonstrates.

Occasionally, simple dwellings have a feature that at once suggests "catalog design." The house at 74 Gardner Street, with its subsumed corner porch, is one such distinctive house (unique in Fredonia). Sure enough, Sears offered "The Arcadia" between 1917 and 1921 with just this feature, which must have been a popular motif, for Aladdin's Thelma (1918) and Radford's Design 10327P (1919) both had the same treatment; the Architects' Small House Service Bureau Plan Number 3A3 (1923) used this feature, too.[86]

paired facade windows had been offered in catalog houses, such as Aladdin's Merrill of 1918, for several years. Even the dimensions here are close; the Fredonia house is the same width as the Merrill and only a foot or so shorter. The man who built this house, Richard S. DeLong, was a railroad mail clerk who after his six continuous days "on the road" was off six days. During

Hipped-Roof Bungalows

Hipped-roof bungalows, usually only one usable story in height and thus "true" bungalows, are also found in Fredonia. The example at 140 Lambert Avenue (Fig. 567), built sometime between 1912 and 1915, has much simpler detailing than "The Hawthorne" by Sears (sold between 1913 and 1918), but the spatial composition is certainly the same, and some elements (form and location of the bay window, placement of the chimney, and configuration of the front porch) are close. At least one Fredonia bungalow of this size is of stone—57 Maple Avenue (Fig. 569), of 1931. Masonry examples of similar hipped-roof bungalows with no projecting wings (but with subsumed porch) were also available in catalogs, such as Radford's Design 10326P from 1919. Even tiny hipped-roof cottage-bungalows, with a projecting gabled porch, such as 176 Water Street (Fig. 571), built sometime between 1925 and 1930 and unique to the village, have a catalog parallel. The Bennett Homes Monroe (1927) seems the closest match.

Fig. 561. 125 Forest Place, Fredonia.
Fig. 562. Aladdin (1918), 53.

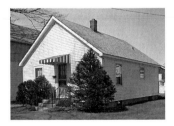
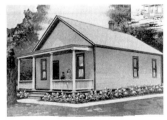

Fig. 563. 172 Liberty Street, Fredonia.
Fig. 564. Aladdin (1918), 64.

Fig. 567. 140 Lambert Avenue, Fredonia.
Fig. 568. Sears (1918), 73.

Fig. 573. Garage at 39 Barker Street, Fredonia.
Fig. 574. Bennett Homes (1927), 76, detail.

Fig. 569. 57 Maple Avenue, Fredonia.
Fig. 570. Radford (1919), 112.

Fig. 575. Garage at 165 Temple Street, Fredonia.
Fig. 576. Architectural Economy (1920), 101.

Fig. 571. 176 Water Street, Fredonia.
Fig. 572. Bennett Homes (1927), 61.

Garages

I should also mention in passing that many of these Fredonia houses have garages that appear to be catalog designs, reminding us of how truly pervasive these books were. The garage at 39 Barker Street (a house previously suggested to be a Bennett Homes design) is almost identical to the Bennett Homes Hudson model of 1927. Although the Fredonia example is a little smaller, the general design and the exact form of the double doors and their hardware follow the catalog plate. Catalog models seem to have been used for larger garages, too. The one behind 165 Temple Street (a house dating to 1927) is almost identical to a design published in the Lumber Dealers' Service Bureau catalog *Architectural Economy* of 1920.[87] These are just two of a good number of garages that appear to be catalog designs, although because the doors were usu-

ally altered later, it is sometimes difficult to match them convincingly with published illustrations.

The Stickley Bungalow and other bungalow types began to be built in Fredonia in the 1910s and continued into the 1930s; the same is the case for another of the most durable and popular house types of those decades, the Foursquare. The earliest in Fredonia appears to be 1910 (see Fig. 297); the type flourished for at least twenty years more. Out of eighty-three Foursquares in Fredonia, with a wide variety of detailing and materials, there are two large groups: Fifty-five with prominent roof dormer of one type or another and the others (usually smaller examples) without dormers. Whether large or small, richly detailed or with straightforward clapboarding, the local Foursquares reflect the wide design variety found in contemporary catalogs.

Foursquares

Radford was one of the earliest popularizers of the Foursquare; Design Number 6 in *Ideal Homes* (1898) is a mature example of the type. The company published many variants (see Fig. 270). One Fredonia house, at 28 Risley Street, of about 1919–21, because it lacks an attic dormer and has a three-bay width, might be based on another of Radford's early Foursquare designs, Number 566 from the 1903 catalog.

Most Foursquares this large have roof dormers, however. A good example is 115 Lakeview Avenue of

Fig. 577. 28 Risley Street, Fredonia.
Fig. 578. Radford (1903), 25.

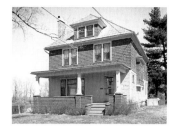
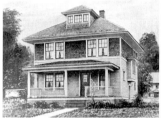

Fig. 581. 248 Water Street, Fredonia.
Fig. 582. Radford (1919), 39.

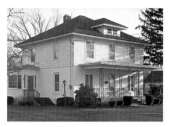
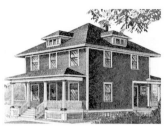

Fig. 579. 115 Lakeview Avenue, Fredonia.
Fig. 580. Sears (1915), 63.

Fig. 583. 165 Temple Street, Fredonia.
Fig. 584. Sears (1928), 94.

1916–17, which is in fact a Sears house. It exactly follows "The Hamilton" design, offered between 1908 and 1918. The Sears model is, of course, all frame construction, and the Fredonia dwelling has a first story of brick, but we recall that in 1915 (from which catalog the illustration is taken) one could still order the Sears plans separately from any material. This was apparently the case with this house, the local contractor effecting the change in construction. Despite this (and the reversed plan), the current exterior dimensions are identical to those of the Sears model, and the original plan was also the same.[88]

Another popular Foursquare treatment, in larger houses, was paired facade windows; such dwellings also sometimes had projecting bays for the stair landing halfway between floors. The house at 248 Water Street, built sometime between 1925 and 1930, is of this type, which had been published by Radford as early as Design 6869P of 1919. The contrast of materials, clapboards below and shingles above, was a popular treatment.

Occasionally in Fredonia, such bungalows were built of brick, such as 165 Temple Street of 1927. Although not as common as frame, one can indeed find models of brick in catalogs of the day, such as "The Rockford" offered by Sears between 1926 and 1929. This is not the actual model for 165 Temple Street although the plans are indeed quite similar (and both are face brick over frame construction), but it does

remind us that plan companies and even firms like Sears did provide designs in brick as well as frame.

Another masonry Foursquare in Fredonia is at 168 Water Street, built between 1917 and 1919. It is unique, being constructed with solid walls of random ashlar. Yet its distinctive shortened windows in the second story, lack of dormers, masonry construction, and porch with massive piers all match another Sears model, "The Canton" (sold between 1911 and 1918), a concrete block design.

One of Fredonia's earliest Foursquares reveals a bit more about carpenters and building in the village. Some time before 1910, the carpenter George A. Bouquin purchased 37 Hamlet Street, which included a lot to the east ample enough for two more houses. He built Number 39 about 1912–13, left the remaining parcel vacant (as it remains today), and moved into his new house.[89] The design he chose appears to

Fig. 585. 168 Water Street, Fredonia.
Fig. 586. Sears (1918), 86.

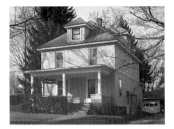
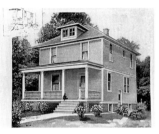

Fig. 587. 39 Hamlet Street, Fredonia.
Fig. 588. Aladdin (1918), 62.

Fig. 591. 60 Forest Place, Fredonia.
Fig. 592. Standard Homes Company (1925), 74.

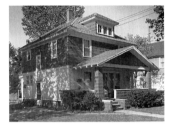
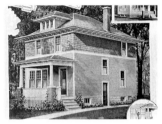

Fig. 589. 63 Cushing Street, Fredonia.
Fig. 590. Aladdin (1918), 22.

Fig. 593. 167 Central Avenue, Fredonia.
Fig. 594. Standard Homes Company (1925), 76.

be a close copy of the Aladdin Hudson model. Although my illustration is from the 1918 catalog, it could well have been in catalogs of c. 1912, as the Foursquare was by then an established type. Bouquin's house duplicates the catalog design almost exactly, including the overall simplicity of design, size of dormer, placement of side entrance, and even location of belt course. The plans are also extremely close; but whereas the Bouquin house is about the same width, it is five feet longer and has a large bay window for the dining room, not found in the Hudson. This sort of customizing by local carpenters, following catalog designs for inspiration, must have been common practice.

Sometimes Fredonia Foursquares that look like duplicates of catalog designs, such as 63 Cushing Street, turn out to be thorough remodelings. This house was originally constructed in 1909–10, but it was completely transformed by 1929. Thus it appears to be the Aladdin Standard, but it was in fact just updated to *look* like the popular catalog designs.

One variation of Foursquare frequently built locally was that with a gabled dormer and a gabled front porch. The house at 60 Forest Place, of 1925–26, is one such, and the closest model, even to its plan, appears to be the Standard Homes Company Herndon of 1925 (its Fernwood model of the same year is almost identical, although a bit smaller).

This company seems to have been a favorite in Fredonia. One Foursquare almost certainly built fol-

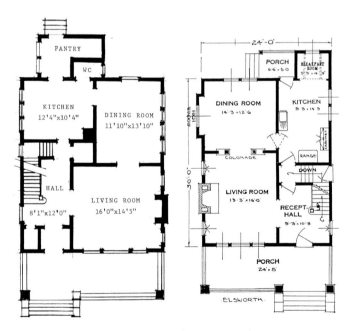

Fig. 595. 167 Central Avenue, Fredonia.
Fig. 596. Standard Homes Company (1925).

lowing Standard Homes mail-order plans is 167 Central Avenue, of 1924–25. Although "The Elseworth" is pictured in frame construction, we recall that this company pointed out that instructions came with the blueprints permitting construction in any material. The Fredonia example has face brick for the first floor and

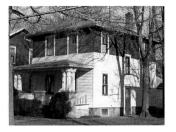
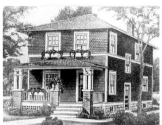

Fig. 597. 33 Lambert Avenue, Fredonia.
Fig. 598. Sears (1922), 44.

shingles on the second. The exterior dimensions of the house and catalog plans are identical, but a comparison shows that the local builder improved on his model in several ways. First, the plans were reversed, so that the living room would face southwest. The kitchen was shortened so that the stairs could be pushed back farther, allowing for a coat closet and entrance lobby (needed in a northern clime) to be built; the breakfast nook was omitted and replaced by a small pantry; the colonnade between living room and dining room was left out; and the dining room window, facing a pleasant open field, was enlarged. These changes, customizing the design for the owners, do not, however, disguise the fact that the local contractor arrived at the stylish result with the aid of Standard Home Company plans.[90]

The Foursquare at 33 Lambert Avenue, built in 1924 or 1925, is apparently the only house more-or-less generally known by older residents to have been a Sears precut dwelling. We have seen, of course, that other houses in the village are indeed Sears designs, but they may have been either non-precut models (which would have been no different to construct than houses with materials supplied by a local mill), or "bootleg" copies or variants of the plates. This one, however, was distinctive for having come as a "package."

It appears that this is "The Havens" model because of the Craftsman-style porch supports, overall alignment of window openings, and other details, which match the Sears plate. As with Bennett Homes, Sears apparently modified its models as it went along. According to Stevenson and Jandl, "The Havens" was available only in 1922; thereafter the same plan (lengthened two feet) and same exterior design became "The Cornell," sold between 1925 and 1938 "The Cornell" also had a small closet added at the base of the stairs. It is this plan that the Fredonia house follows. Because it was constructed and occupied by 1925, "The Havens" must have been increased in size and the plan augmented in the 1923 catalog (not extant): The distinctive porch supports, omitted in "The Cornell," were

used. Probably Sears found that the original Havens was a bit small and simply improved it. The Fredonia residents have found it to be a solidly built and comfortable dwelling.[91]

Fredonia Foursquares with distinctive features, which one might think local variants, often have catalog parallels nevertheless. Some Foursquares have tiny attic dormers, such as 131 Center Street, just as do Standard Homes Company's Lewiston of 1925 or Bennett Homes' Roanoak of 1927. A few have a two-story bay on the front, such as 37 Newton Street of 1910–13 (see Fig. 297), which, in Chapter 6, we saw was based on Chicago House Wrecking Co.'s Design 134 of 1909—although it was a type that Radford had published earlier in *Ideal Homes* (Number 100) and continued to illustrate for many years, such as Number 10071P in its 1919 catalog. A few Fredonia Foursquares have a peculiar wraparound projecting corner window on the second floor; but these features too can be found in catalog illustrations, such as the Sears Number 174 of 1911–13. Foursquares with a *gabled* roof were also occasionally built, and catalogs (such as Smith's volume of 1923/27, with Plan Number 561) have them as well. No local variation appears to be without some catalog parallels.

Other Foursquare houses in Fredonia, even if quite plain, can be matched with catalog plates, such as 35 Clinton Avenue, built sometime between 1925 and 1930, and "The Albion" by Sears, sold in 1925 and 1926. Even dwellings of distinctive composition, such as 16 Risley Street (between 1925 and 1930) with its central chimney, off-center entrance, and side porch (Fig. 601), is a type found in catalogs, such as Design 6-G-6 from Robert T. Jones's *Small Homes of Architectural Distinction* (1929). It may even be that the villa at 277 Central Avenue (Fig. 603), built in 1930, with its side porch with eared parapet, is inspired by a model such as Jones's Design 6-C-20.

Even a unique Fredonia house, such as 348 Temple Street, a sort of asymmetrical Foursquare built between 1923 and 1925, seems to owe a good deal to

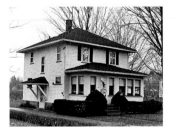

Fig. 599. 35 Clinton Street, Fredonia.
Fig. 600. Sears (1925), 75.

Fig. 601. 16 Risley Street, Fredonia.
Fig. 602. Jones, Small Houses (1929), 270.

Fig. 603. 277 Central Avenue, Fredonia.
Fig. 604. Jones (1929), 208.

Fig. 605. 348 Temple Street, Fredonia.
Fig. 606. Sears (1928), "The Americus"
(Courtesy Sears, Roebuck & Co.).

Fig. 607. 102 Liberty Street, Fredonia.
Fig. 608. Radford (1903), 163.

a catalog illustration. Its similarity of composition to Sears's "The Americus" (sold between 1921 and 1929) is undeniable. Occasionally, *two different* catalog models may be involved. We saw (in Chapter 6) that 102 Liberty Street (1912–13) had a plan almost iden-

tical to Sears's Number 52 (1908–13); but the exterior treatment of the roof—to distinguish it from its identical and more Foursquare-like neighbor—is similar to Radford's Design 516 of 1903. Foursquares in Fredonia and houses related to them in style certainly owed an enormous debt to designs in books.

Clipped-Gable Houses

Although not as popular as Foursquares, the clipped-gable house, in a variety of styles, can be found in twenty-three Fredonia examples. Ten of them are two-and-a-half-story dwellings, such as 38 Liberty Street of 1925, with the main entrance in the end facing the street. This example is stuccoed, but most have clapboards below and shingles above. Sears sold "The Flossmoor" between 1912 and 1922 (shown here as depicted in 1915), and a similar model, Number 177, between 1911 and 1917. The same wide proportions are found in "The Salem" (1925–26), which looked much like "The Flossmoor" except for having the main entrance at the side. Even Fredonia examples that are a bit taller and narrower find parallels in catalog plates, such as 94 Center Street (a late nineteenth-century house remodeled in the early twentieth), which reflects Design 833 from Henry Atterbury Smith's book of 1923/27.

One unique version of the type, somewhat remodeled around the ground level, is not just a local variant but is, indeed, a type also found in catalogs: Fifteen Berry Street, of 1924, has the orientation and large clipped-gable dormer of "The Conroe" in the *Home Builders Catalog* (1927). Sears too offered a house with this sort of dormer in the long side in "The Madelia" (1918–22).

Six Fredonia clipped-gable houses are of one-and-a-half-story height and oriented with their narrow ends out. The example at 171 Lambert Avenue, of 1929–30, is typical. Generally similar to the Bennett Homes Portland (1927), the plan nevertheless differs and was probably based on another company's version of this popular model. A few examples are even smaller and simpler, such as 28 Chestnut Street, and a catalog design is not hard to find—the Sears Sunlight (sold in 1925–29) is a close parallel.

Clipped-gable houses with the long side (and the entrance) facing the street were also popular; seven were built in Fredonia. The example at 111 Lakeview Avenue, of about 1936, is closest in dimensions, and also plan, to the Bennett Homes Winslow of 1927—but it is a type that Aladdin had popularized

Fig. 609. 38 Liberty Street, Fredonia.
Fig. 610. Sears (1915), 65.

Fig. 615. 171 Lambert Avenue, Fredonia, 1929–30.
Fig. 616. Bennett Homes (1927), 42.

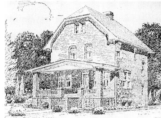

Fig. 611. 94 Center Street, Fredonia.
Fig. 612. Smith, Books of a Thousand Homes (1923/27), 1: 260.

Fig. 617. 28 Chestnut Street, Fredonia.
Fig. 618. Sears (1926), 107 (Courtesy Sears, Roebuck & Co.).

Fig. 613. 15 Berry Road, Fredonia.
Fig. 614. Home Builders Catalog (1927), 800.

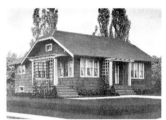

Fig. 619. 111 Lakeview Avenue, Fredonia.
Fig. 620. Bennett Homes (1927), 60.

by 1918 in "The Pasadena"; that Henry Atterbury Smith had illustrated (Design 868) in 1923/27; that Standard Homes had offered as "The Fairmont" in 1925; and that the Home Builders Catalog of 1927 had also included as "The Casey." There were obviously plenty of sources for the local builder, in this case Harry Salhoff, to draw on.[92]

Fredonia houses of this type, but with a more prominent projecting porch (sometimes with vestigial pergolas flanking it) are also notable, such as 207 East Main Street. They may even go back to the Stickley prototype, Craftsman Bungalow Number 201, published in February 1915.

Even the tiniest clipped-gable dwelling, such as 160 Water Street (Fig. 621), reflects catalog designs, such as the Sears Delevan of 1917–22 or Bennett Homes' Newton of 1927. This house was originally a

garage, remodeled into a dwelling by the carpenter Lawrence R. Beamish, who lived nearby.[93] The influence of catalog designs indeed seems ubiquitous.

The revival of colonial-style houses had a great impact on Fredonia, and about one hundred dwellings, large and small, were built in this mode. In Chapter 6, I discussed an early example at 193 Central Avenue, the William S. Sly House, built in 1907–8, which followed closely (with significant improvements in plan) Radford's Design 569 of 1903 (see Figs. 259 and 262). In the context of building in Fredonia, it is significant that Sly was a carpenter turned contractor, half-owner of Sly & Coddington, "Contractors and Builders." Thus it is not surprising that he built one of the early colonial-style houses in the village (although the architect Enoch Curtis had built creative Colonial Revival dwellings a decade earlier).

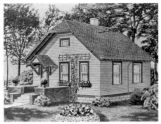
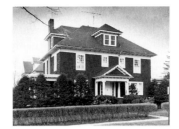
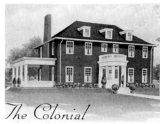

Fig. 621. 160 Water Street, Fredonia.
Fig. 622. Sears (1918), 42.

Fig. 623. 129 Central Avenue, Fredonia.
Fig. 624. Aladdin (1918), 72.

Colonial Styles

Another early colonial style house is at 129 Central Avenue; it is much like the Aladdin Colonial. In Chapter 6, I discussed a somewhat larger version of this dwelling, the Charles Romer House in Dunkirk (of about 1906), which had been erected well before the Aladdin design; it seemed to have been built following some earlier model—possibly the same model the Aladdin architects adapted. The Fredonia house, built in 1908, appears to be a slightly modified version of the Aladdin model itself, despite its early date (see Fig. 336). Was "The Colonial" one of Aladdin's earliest offerings? The exteriors are within six inches, in depth as well as length, of being the same size, and although the Fredonia dwelling has a slightly different plan, it is largely a matter of partition shifting. Both living rooms are essentially the same size (15' 0" by 29' 3" versus the Aladdin 15' by 30'), and interior views of both show that the general disposition is much the same. Whether the Fredonia house is based on the Aladdin Colonial or on the model Aladdin copied, it seems clear that 129 Central Avenue was much indebted to a published design from some source.[94]

Hipped-roof colonial style houses are not common in Fredonia, and they do not really form a "type." The William Sly House and 129 Central Avenue are quite different, as is the third example, 20 Central Avenue, which is the grandest of them all. At once we recognize that it is closely modeled on the Sears Magnolia, offered between 1918 and 1921; it was the highest-style dwelling Sears offered. What is remarkable is that 20 Central Avenue is a thorough remodeling, carried out in 1923 by Benjamin Luke, of a Queen Anne house of the 1890s—which itself had been a remodeling of a Federal-style house of 1829–30![95] The symmetrical wings, the balcony within the paired-column portico, even the pedimented dormer on axis above the portico roof are almost certainly based directly on "The Magnolia," emphasizing again what a fertile source of ideas catalog plates were.

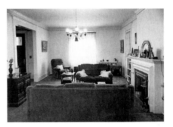
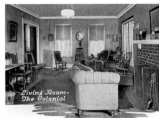

Fig. 625. 129 Central Avenue, Fredonia, interior.
Fig. 626. Aladdin, "The Colonial," interior.

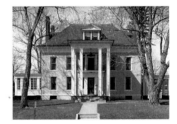
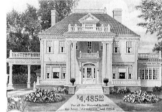

Fig. 627. 20 Central Avenue, Fredonia.
Fig. 628. Sears (1918), "The Magnolia."

From large dwellings to three-bay cottages, most of the types of colonial houses in Fredonia follow published models. An especially grand five-bay brick house at 272 Central Avenue, built in 1916–17, is a good deal earlier than the plate of similar design I came across (from Henry Atterbury Smith's book of 1923/27), but the comparison shows nonetheless that published designs of the type were available in the popular catalogs. It is always possible that as grand a house as 272 Central Avenue was designed by someone like Harry Beebe, who in fact lived next door and drew on plates in volumes such as *The Georgian Period*.

Given the popularity of colonial architecture as witnessed by the plethora of books published on the subject (my Appendix 7 shows that at least one new volume appears almost every year between 1890 and 1940), it is not surprising that Colonial is one of Fredonia's commonest house styles. Even an appar-

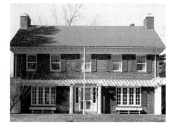
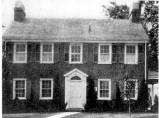

Fig. 629. 272 Central Avenue, Fredonia.
Fig. 630. Smith, (1923/27), 1: 23.

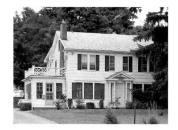
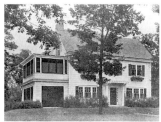

Fig. 633. 411 East Main Street, Fredonia.
Fig. 634. Radford (1919), 15.

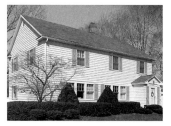
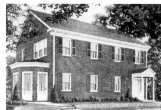

Fig. 631. 244 Central Avenue, Fredonia.
Fig. 632. Your Next Home (1925), 48.

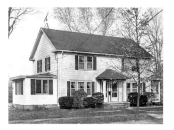

Fig. 635. 90–92 Hamlet Street, Fredonia.
Fig. 636. The Homebuilder (1923), 68.

Fig. 637. 167 Temple Street, Fredonia.
Fig. 638. Bennett Homes (1927), 10.

Fig. 639. 40 Maple Avenue, Fredonia.
Fig. 640. Standard Homes Company (1925), 83.

ently unique dwelling (owing to its length and asymmetrical entrance) such as 244 Central Avenue (built some time between 1935 and 1938) actually has an overall design and details (such as the eaves returns, entrance porch at one end, and louvered shutters) found in a published design, "The Assiniboia" from *Your Next Home* of 1925.

One of the most popular Colonial house types is the two-story gabled dwelling; there are twenty-six in Fredonia. Most have a central entrance, are three bays wide (although the window grouping varies), and lack roof dormers; many have a side porch. The house at 411 East Main Street, of 1923–24, is close to Radford's Design 10037P of 1919, especially in the arrangement of all those windows. Although a double house, 90–92 Hamlet Street, around 1923, finds a catalog parallel, even in its length and the porches at both ends, in "The Jeanette," from the National Homebuilders Institute's catalog *The Homebuilder* of 1923.

One form of this house type has a prominent porch with a small window above it on the second floor and often triple ground-floor windows, as at 167 Temple Street, of 1922–23. *The Home Builder* offered one just like this, but with roof dormers ("The Jackson") in 1923; Bennett Homes' Washington (as shown in its 1927 catalog) was also close; and Standard Homes Company's version, "The Haverhill," was very similar, too. More common was the type with second-story central window about the same size as the adjacent ones and with only paired windows on the first

floor. The house at 40 Maple Avenue, built sometime between 1925 and 1930 (as well as a near-duplicate at 205 Water Street of five years later) looks as if it could have been copied directly from Standard Homes Company's Fremont design of 1925.

Although one might think that the size of windows, and whether the living-room and dining-room

windows were single or in pairs would be completely up to local preference, one can still find most permutations in catalogs. Thus 26 Cottage Street, of about 1923–25, can be paired with several catalog plates, such as the Architects' Small House Service Bureau Plan Number 6A17 of 1923 (although it lacks a projecting porch), or—from catalog editions later than the house—Design 6-A-66 from Robert T. Jones's book of 1929 and Standard Homes Company's Esterbrook of 1930. "The Cowan," in the 1927 *Home Builders Catalog*, is also similar. Another Colonial house of this type at 288 East Main Street, built in 1932, I discussed at length in Chapter 7; it was based directly (through the intermediary architect G. Wesley Stickle) on the Esterbrook model. (See Figs. 356–357.)

In the late 1930s and into the 1940s, the colonial designs tended to have thinner detailing and, as built, often lacked side porches. Two examples of this type

Fig. 641. 26 Cottage Street, Fredonia.
Fig. 642. Jones (1929), 157.

Fig. 643. 124 Lambert Avenue, Fredonia.
Fig. 644. Standard Homes Company (1930), 11.

Fig. 645. 130 Lambert Avenue, Fredonia.
Fig. 646. Standard Homes Company (1925), 36.

Fig. 647. 27 Curtis Place, Fredonia.
Fig. 648. Home Builders Catalog *(1927), 1183.*

Fig. 649. 11 Risley Street, Fredonia.
Fig. 650. Bennett Homes (1927), 21.

can be illustrated: 124 Lambert Avenue of 1941–42 and 130 Lambert Avenue, built by Fred Ahrens in 1939. For both houses, one can readily find earlier catalog designs that have much in common or are perhaps even the actual model or for the Fredonia dwelling.

A few Fredonia houses of this type are of brick. The example at 27 Curtis Place, built by Fred Ahrens in 1929 (a similar one, from a dozen years later, is at 175 Lambert Avenue), might be based on a brick model such as "The Castlewood," as shown in the *Home Builders Catalog* of 1927.

Gable-roofed houses with entrance in the first bay were also built. That at 11 Risley Street, of about 1925, is in the same style as Plan Number 6A37 published by the Architects' Small House Service Bureau in its 1923 catalog; the parallel illustration here, however, is the almost identical Bennett Homes Plymouth model. A similar design, without the projecting porch, is "The Cambridge," from the 1927 *Home Builders Catalog*. A narrower version of this type, with a side door at grade and without an end porch, is at 35 Forbes Place (built sometime between 1930 and 1935). It too has catalog parallels, such as "The Cranbury," also from the 1927 *Home Builders Catalog*.

A different type of gabled Colonial house, one based on seventeenth- rather than eighteenth-century models, has become popular since the 1940s. The example at 49 Cottage Street, built in 1952–53 but based on blueprints ordered from a plan catalog of about

Fig. 651. 35 Forbes Place, Fredonia.
Fig. 652. Home Builders Catalog *(1927), 812.*

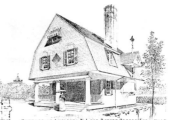

Fig. 655. 80 Liberty Street, Fredonia.
Fig. 656. AABN, *January 6, 1900.*

Fig. 653. 49 Cottage Street, Fredonia.
Fig. 654. Design from anonymous catalog, c. 1937
(Courtesy Lawrence A. and Theresa D. Williams).

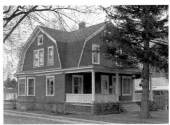
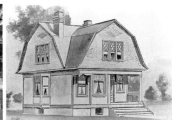

Fig. 657. 204 Chestnut Street, Fredonia.
Fig. 658. Radford *(1903), 119.*

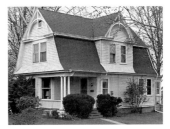
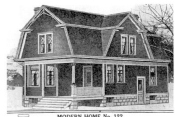

Fig. 659. 321 West Main Street, Fredonia.
Fig. 660. Sears *(1915), 71.*

1937, signals the advent of this new type, which was still popular in Fredonia in the 1960s and 1970s.[96]

A second style of house inspired by colonial precedent during this same period is the gambrel-roofed dwelling. Fourteen were built in Fredonia, five with the end toward the street, but the rest with the entrance in the long side.

The first type, such as 80 Liberty Street (built about 1911–12), is a form that goes back to Shingle Style adaptations of colonial precedent; while I did not come across a catalog design to match 80 Liberty Street, a published antecedent appeared in *The American Architect* in 1900, and popularized versions undoubtedly followed. Sears sold variations of this (but with a projecting, not subsumed, porch) as "The Lucerne" (between 1908 and 1918) and "The Bonita" (1912–18).

Models with cross gables are also found in Fredonia, such as 204 Chestnut Street, built in 1916, which is much like the type made popular by Radford (such as Design 121 of 1903). That the professional press in 1903 was also still publishing these "latter day" Shingle Style cross-gabled designs (a handsome dwelling by a Saint Louis architect was illustrated in *The American Architect* of October 10, 1903) suggests that Radford was reasonably up-to-date in its offerings. (Sears too sold this type, its Number 113, between 1911 and 1913.)

One distinctive gambrel-roofed house in Fredonia of this sort is 321 West Main Street. Although built about 1904–5 and thus earlier than the closest Sears version (Number 122, sold between 1911 and 1915), if Radford had comparable house designs by 1903, surely other firms did, too. This well-detailed Fredonia house could have been based on one such design.

The commonest type of gambrel-roofed dwelling in Fredonia followed the "Dutch" Colonial model and was built in both large and small versions. About the grandest in Fredonia is 444 Temple Street (Fig. 661), built between 1915 and 1917.[97] There are many versions of the type in catalogs; one from Bennett Homes, in a later catalog, shows the same triple-facade windows and open porch at one end. Another mail-order design with paired windows on the second floor (like the Fredonia example) is the Standard Homes Company Hamilton. The Architects' Small House Service Bureau Plan Number 6B11 (1923) is similar, as is the Plan Service Company's Number 36 (1930s). Smaller Dutch Colonial–style houses with double windows

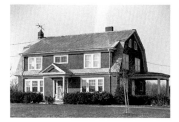 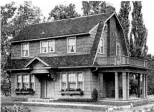

Fig. 661. 444 Temple Street, Fredonia.
Fig. 662. Bennett Homes (1927), 9.

Fig. 665. 205 Lambert Avenue, Fredonia.
Fig. 666. The Homebuilder (1923), "The Howard," 87.

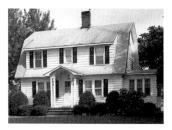

Fig. 663. 4891 West Main Road, Fredonia.
Fig. 664. Standard Homes Company (1925), 5.

 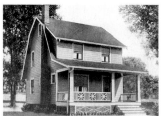

Fig. 667. 11 Summer Street, Fredonia.
Fig. 668. Home Builders Catalog (1927), 681.

on the first floor and single on the second, such as 4891 West Main Road or 25 Moore Avenue (built sometime between 1925 and 1930), have catalog parallels in Standard Homes Company's Northcliff of 1925. Aladdin's Pilgrim, of 1924, was similar, but lacked the front porch or hood.

One smaller Fredonia house, 205 Lambert Avenue (built sometime between 1941 and 1944), has the entrance at one end of the facade. An early catalog design of this type is "The Howard" from The Homebuilder (1923); its Clinton model is similar. The 1927 Home Builders Catalog also illustrated a version, "The Carmi"; its second-story windows, like 205 Lambert Avenue, are single, not paired. Sears too offered several variations of the type: "The Van Dorn" (sold between 1926 and 1933), the somewhat bigger Oak Park (1926–33), "The Amhurst" (1926–28), and also "The Van Page" (1926–28)—which interestingly enough uses the very same photograph that the Home Builders Institute published for "The Howard"! The plans of the two dwellings and their exterior dimensions are somewhat different, however.

One gambrel-roofed house in Fredonia combines Dutch Colonial lines with the Stickley Bungalow treatment for the front porch: 11 Summer Street, built between 1925 and 1930. This too is a catalog design, similar to "The Cozard" in the 1927 Home Builders Catalog. Although the Fredonia version is longer than "The Cozard," several houses following The Home Builders Catalog model quite closely are found in nearby Dunkirk.[98]

Only one Fredonia version has separate rather than linked dormers—134 East Main Street, built in 1926 by John Luke. "The Colony," a later version from the Home Builders Catalog, also shows this treatment. In Jones's 1929 catalog, another example of the type is included, Design 6-A-75. These shingled one-and-a-half-story gambrel-roofed dwellings with separate roof dormers emulate real colonial houses on the New England coast; the Gott House (1702) in Rockport, Massachusetts, is a good example.[99]

We have observed, since Downing's cottages of the 1840s onward, that those who drew up most pattern-book and catalog designs were fully conscious of architectural propriety: Virtually no design is a "minimansion." Small houses were composed in a manner quite different from large, expensive ones, and when historical models were used as a basis, designers selected examples that in their own time and place were more modest in cost and scale. Thus it is not surprising to find that, in Fredonia, most of the smaller colonial-style houses are based on colonial models far less grand than the full two-story houses with which I began this section. These one-and-a-half-story dwellings, usually three bays wide and with roof dormers, so common from the seventeen and eighteenth centuries in Virginia and elsewhere,[100] were easily adapted for modest middle-class homes. Forty-one houses in Fredonia follow this type.

The smallest subgroup is made up of one-and-a-half-story houses with wall dormers; there are seven of this type in Fredonia. We already saw an excellent example of this at 203 Temple Street, which was closely

Fig. 705. Ad in Roger Smithells, ed.,
Country Life Book of Small Houses
(1939), 90.

and 1949. This is further proof that local carpenters often studied the designs in plan and precut house catalogs and built their own "bootleg" copies, for this house was erected well after the model was discontinued and even eight years after Sears had gone out of the precut house business entirely![108]

English-style houses with prominent facade gables and steep roofs were the most popular of the type in Fredonia, and one of the most impressive is

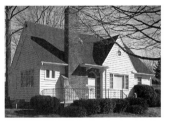

Fig. 706. 177 Lambert Avenue, Fredonia.
Fig. 707. Sears (1928), 86 (Courtesy Sears, Roebuck & Co.).

Fig. 708. 171 Temple Street, Fredonia.
Fig. 709. Home Builders Catalog (1927), "The Cotton," 947.

171 Temple Street of 1926–27. This is distinctive, too, in having been designed by the architectural firm of Beck and Tinkham of Jamestown, New York, a small but prosperous city twenty-nine miles to the south. The firm was well known for the quality of its design and construction.[109] The Fredonia house is set on a spacious lot 120 feet wide; behind the house was a lawn, formal garden (with sundial at the middle), and beyond a picket fence, an extensive orchard. Clearly the well-to-do owner, Jacob Bohn, wanted the best.[110]

Although the house was custom designed by Ellis Beck (who had graduated from Cornell University, was awarded Phi Beta Kappa membership, and won a Rhodes Scholarship), it was nonetheless quite close to the gabled English vernacular dwellings being popularized in catalogs at that very time. In Chapter 7, we explored one such house in Cassadaga, New York, built following plans from the 1927 *Home Builders Catalog* (see Figs. 390 and 391). Bohn's house too finds a close parallel in this catalog's Colton model. The houses are within nine inches of being the same depth, although the catalog design is three and a half feet longer. The plans, however are entirely different, the Fredonia dwelling having a more traditional layout of central hallway with living room to the right and dining room and kitchen to the left. (This was the plan, however, used in another *Home Builders* model, "The Crayton," similar to "The Colton" in exterior appearance.) Thus even though 171 Temple Street was designed by a professional architect, we see that catalog designs were popularizing this style at the very same time.

It was, we recall, a house type owing much to the creative work in England of C. F. A. Voysey and others in the 1890s; by 1901 a similar design was prominently published in *The American Architect*. The example illustrated (Fig. 710), for a stuccoed house in Kent, has both the general composition of interlocked steep gables (and high roof behind) of 171 Temple Street and the *Home Builders Catalog* designs, but also many of the details we have already observed in other English-style dwellings: the eyebrow window, for example, in 38 Leverett Street; the corner buttresses in 114 Lakeview Avenue; the diamond-pane casements in the same house, as well as the Sears Lewiston model (although not used in 177 Lambert Avenue); and even the archway next to the house, leading into the garden, a motif used by John Floyd Yewell in his American Face Brick Association Design Number 102 and carried out in 1191 Central Avenue, Dunkirk (see Fig. 368). That all these motifs as well as the general composition could find their origins in authentic English designs must have given the catalog versions added luster.

Fig. 710. House at Bromley, Kent, England, AABN, June 8, 1901.
Fig. 711. 200 Temple Street, Fredonia.

Fig. 714. 203 Water Street, Fredonia.
Fig. 715. Bennett Homes (1927), 8.

Fig. 712. Home Builders Catalog *(1927), 951.*
Fig. 713. William Drummond, Badenoch House,
River Forest, Illinois, 1925.

Fig. 716. 180 Temple Street, Fredonia.
Fig. 717. Home Builders Catalog *(1927), 696.*

Fig. 718. 55 Summer Street, Fredonia.
Fig. 719. Standard Homes Company (1930), 28.

In 1930 or 1931, at 200 Temple Street (half a block away from Bohn's house), another English-style dwelling of almost the same style was erected. The contractor was Fred Ahrens. It too was similar to a contemporary catalog design, "The Canover," from the 1927 *Home Builders Catalog.* The plan, however, was unlike the catalog design, following instead the model of 171 Temple Street (or the *Home Builders*' Crayton), although with the sun porch across the rear of the living room rather than to the side.[111] How professionally up-to-date such English designs were is confirmed by the closeness of both 171 and 200 Temple Street (and the related catalog plates) to a house in River Forest, Illinois, designed in 1925 by the architect William Drummond—a suave stucco version of the English type. Henry Atterbury Smith's catalog (1923/27) had a comparable model, Design Number 309-W ("one of America's most popular homes").

Smaller versions of such gabled English-style house were offered by precut house companies, too. Bennett Homes' Wilshire model (as shown in the 1927 catalog) is a good example; it was built in Fredonia at 203 Water Street sometime between 1928 and 1935 by Benjamin Luke. The congruence of exterior design and interior plan with "The Wilshire" confirms that Luke looked closely at the Bennett Homes model. Although the exterior dimensions of the house are essentially the same as "The Wilshire," he did modify the plan— enlarging the dining room a bit, extending the kitchen in an ell to the rear, and reorienting the stairs (the front vestibule was also enlarged to provide an entrance closet). On the exterior, the main change is the simplified roof dormer.[112]

The popular English-type model with the gable end toward the street (see Figs. 385–387) was built in Fredonia, too; 180 Temple Street, erected sometime between 1930 and 1935, is a good example. The closest catalog design is probably the 1927 *Home Builders Catalog*'s Camanche. A slightly different version, without facade chimney, was built at 55 Summer Street, also between 1930 and 1935; here the closest model I came across is the Standard Homes Company's Beaumont (although Sears had a similar design, "The Cedars," sold in 1928–30).

Two Fredonia houses have even broader facade gables. The dwelling at 251 Eagle Street, which seems to date to before 1905, was either rebuilt or replaced with a new dwelling by Harry Salhoff about 1955; the

Fig. 720. 251 Eagle Street, Fredonia.
Fig. 721. The Homebuilder *(1923)*, 57.

Fig. 724. 29 Curtis Place, Fredonia.
Fig. 725. Jones *(1929)*, 6.

Fig. 722. 147 Forest Place, Fredonia.
Fig. 723. Ideal Homes *(1930s)*, 54.

Fig. 726. 18 Maple Avenue, Fredonia.
Fig. 727. Jones *(1929)*, 106.

owner recalls looking at one of Salhoff's books of house designs for a model ("The Hillsboro" from *The Homebuilder* of 1923 or Number 418 from the Plan Service Company's *Ideal Homes* catalog of the 1930s are both of similar design).[113]

Another broad-gabled house, at 147 Forest Place, built between 1938 and 1940, also had much in common with the Plan Service Company's Design Number 418, but without the chimney. Such English-style houses were featured in the 1927 *Home Builder's Catalog* as well, such as its Culver model—which itself is a copy (changing only the shape of the dormer) of Plan 6B4 from the Architects' Small House Service Bureau catalog of 1923.

English-style houses with a single prominent gabled feature in the facade were also built in Fredonia, as at 29 Curtis Place of 1929. Details such as the stone label molding over the front door give it additional authenticity (the low wing to the left was added about 1974). A similar treatment can be found in Design 4-A-7 in Jones's 1929 catalog. A unique dwelling such as 18 Maple Avenue, built between 1935 and 1938, with its hooded entrance and clipped-gable roof, also suggests English influence. Comparable designs, as Jones's Number 5-E-1, even contain a door hood of a type quite common in England around 1700.[114] The Jones design seems to have been copied from "The Churdan" in the 1927 *Home Builders Catalog*, again reminding us of how common was cross-fertilization from one company to another.

After the 1950s, the use of mail-order plans not only continued to flourish, but such blueprints were employed for ever more grand and impressive dwellings. One final English model illustrates this, a Fredonia house from the late 1970s. It is interesting to note that the "Inviting English Tudor" design (Fig. 729) published in 1976 by Habitat, Incorporated, is a version of the "ideal" cozy English dwelling, for the same type (rustic stonework below the second-story half-timbering, prominent end chimney, gabled wall dormers, even attached garage) was codified by Fisher-Price in 1974 for one of its popular toys, an archetypal home.

International Modern

The smallest category of house style for this period is the one reflecting the International Modern movement of the 1930s. Only three dwellings in Fredonia follow this important national trend, which elicited more interest among architects than among ordinary people. All the Fredonia examples seem to have catalog links. The most sophisticated of these is 340 Central Avenue (Fig. 371), built about 1937 or 1938. Constructed of concrete block with more or less flush joints, a corner steel sash window, a flat hood over the door, and a flat roof (later changed to hipped because it leaked), this is a good local example of the international movement. A local architect or designer could have been aided in his composition by consulting plan-book models: The example published by the Architects'

Fig. 728. 24 Castile Drive, Fredonia.
Fig. 729. Home of Your Own *(1976), 77.*

Fig. 731. 340 Central Avenue, Fredonia.
Fig. 732. ASHSB, Twenty-two Low Cost Concrete Homes *(1935), 23.*

Fig. 730. Fisher-Price house, 1974.

Fig. 733. 199 Lambert Avenue, Fredonia.
Fig. 734. Ideal Homes *(1930s), 65.*

Small House Service Bureau a few years earlier in 1935 might even have been the specific inspiration for the Fredonia dwelling.

A second house, at 199 Lambert Avenue of about 1942, also reflects the International Style in its white concrete block finish, large steel sash windows, lack of traditional moldings or detailing, and its nearly flat roof. It is possible that a local builder got the idea for this house from the Plan Service Company's design Number 444 in its *Ideal Homes* and simply built the ground floor; this was, as we have seen, a catalog known to have been used in Fredonia. Another one-story house similar to this (but with overscaled rustic stonework around the front doorway) is found at 396 Chestnut Street.

As this review of Fredonia houses built in the period of about 1890–1940 shows, a great number were based directly on mail-order plans (or were precut dwellings), were closely based on designs in plan catalogs, or were constructed in a style close to what could be found in contemporary catalogs. Even a house de-

signed by an architect may reflect closely (and in Stickle's case, essentially pirates) some published model.

My sampling of houses linked with actual or comparable models reflects the kinds of published sources that seem to be behind the majority of Fredonia houses built during this period; and there were quite a number for which, although almost certainly "catalog designs," I found no similar models in the catalogs I happened to survey. If from the total of about 592 houses one leaves out, say, half the Queen Anne dwellings of all types—those being a gray area in my survey, possibly inspired by plan books, perhaps creations of local carpenters or architects—and even omits two-thirds of the vernacular ell types, there are still, for the period of c.1890–1940, about 450 houses (roughly 75 percent) that can be linked, directly or indirectly, with designs in books. Clearly, the impact of these catalogs on the styles built in this typical village was profound, far greater than the estimated number of precut houses or mail-order plans sold would ever suggest.

Conclusion

Considering how original and creative an architect Inigo Jones became, it seems remarkable that he turned to plates in books for assistance in designing some of his buildings; but as we saw, this was indeed the case. Perhaps it should be viewed in slightly different terms: Jones turned to his fellow architects—Palladio and especially Serlio—for some professional hints; and thanks to the printed book, these were easily conveyed. If a talented architect like Jones could find such treatises of interest and use, it is certainly not surprising for a master mason like William Arnold and skilled craftsmen in generations to follow also to find volumes illustrating the work of professional designers of real value.

This overview of the influence in America of such books, in their various permutations during two centuries, brings up a number of points about the nature of architectural design between 1738 and 1950.

One interesting feature is how modestly the whole process began in the eighteenth century. The actual instances of house designs based on plates in treatises were rare around mid-century: Drayton Hall and Mount Airy vividly stand out by their unique sophistication. They were, however, the tip of the wedge: Now high-style mansions could be based on designs prepared by the outstanding European architects (Palladio and Gibbs in these cases), and potential house owners did not have to depend on the skills and abilities of craftsmen whose knowledge of the advanced trends in architecture was usually limited.

Once such academic dwellings began to appear, a new standard of architectural sophistication was established. Although training in the new Renaissance style could be achieved by a thorough study of books so that one could design *in* the new mode, most eighteenth-century craftsmen and even architects took a more direct route: They consulted the books of designs prepared by the more skillful designers and copied or emulated the results. Even if the underlying principles were not well grasped, the finished design thus copied would seldom show it.

With Bulfinch's and McIntire's work in the early nineteenth century, both of whom drew on published plates, the widespread importance of such design books (such as those by Asher Benjamin) became firmly established for upper-middle-class dwellings, not just for the mansions of the rich. With the Greek Revival a generation later, the growing number of such books and the ubiquity of their use permitted even the most humble dwelling to have good classical detailing (as we saw on many examples), based on the work of skilled designers like Minard Lafever—whose debt to Stuart and Revett and even to Iktinos and Kallikrates is not hard to trace. As the examples of dwellings from the Greek Revival period showed, the importance of the local architects and craftsmen and carpenters in creating house types that met local needs was significant. Once established, these house types had a vigorous life of their own, even if they owed much to designs in books for their sophisticated detailing.

The concept that even the smallest dwelling for a thrifty laborer could be skillfully designed by a trained professional so that the plan was practical and efficient and the exterior was made artistic and pleasing was one of A. J. Downing's major contributions. As we saw, during the 1850s, the impact of the house types and stylis-

tic features in his books began to be widespread. As the number of design books published in America grew dramatically with every decade for the next hundred years, so did the *use* of such books. The influence of Downing's volumes of the 1840s and 1850s was considerable, and in almost any community a small number of houses based on his designs and details can be found. In less than a century, as the model of Fredonia showed, the number of middle-class houses either based directly on the plans (or prefabricated kits) available from books and catalogs or strongly influenced by the styles and types they set forth became very large indeed—perhaps three-fourths of the houses erected! This is a major transformation from two centuries before, when only the rare and palatial house was given professional sophistication by being based on a design in a book.

This great increase in the use of published images to improve the architectural sophistication of house designs, their plans, and their detailing was usually linked to architects or experienced craftsmen sharing their insights with others. As we saw, the authors of eighteenth- and early nineteenth-century design books were almost all architects who, even if they began as craftsmen, had achieved a level of design expertise that others were eager to emulate. Thus many of these books are in fact educational treatises, a point of view recognized by *The American Architect* editors, too. Even in the twentieth century when so many house-plan catalogs were produced, professionally licensed architects (like those who worked for Radford) were the authors of much of the work; and with the popularity of competitions in which architects and draftsmen across America entered designs for possible publication, the sharing of good ideas and models with craftsmen became extremely easy. These catalog designs seem almost indistinguishable from those published by the Architects' Small House Service Bureau, all created by professional architects and members of the American Institute of Architects, suggesting how quickly a reasonably high level was achieved. That these illustrations of small houses could be copied or simply emulated successfully by local carpenters also confirms the abiding design skill of many craftsmen themselves.

One important result of the expanding use of designs in books as models for houses was an increased homogeneity of domestic architecture in geographically diverse areas. As more and more people built houses based on plans from these books and catalogs and more and more carpenters and even architects turned to these volumes for models for emulation (or for making direct copies), house designs that had originated in Knoxville, Tennessee, Bay City, Michigan, or Chicago appeared throughout the United States.

Most of the larger catalogs, among the wide range of stylistic choices offered, also included "regional" types, such as stuccoed or Spanish-style houses, which might well have appealed more to prospective home builders in the southwest. Throughout the northeast, however, there was a good deal of uniformity in the house types selected, especially after the 1880s when these catalogs grew so much in popularity and numbers.

If the model of Fredonia is any guide, however, there was still a great variety of house styles and types and much individuality in each type available in the catalog models. Far from producing a bland sameness, these published designs greatly improved the overall sophistication and artistic quality of local houses. As the graph of Fredonia house types in the nineteenth century showed (see Fig. 442), there were a great many vernacular houses—roughly 40 percent of all houses built before about 1890. Most of these vernacular dwellings lacked any details (or even overall design) of any distinction; they are, in fact, by and large pretty dull stuff, without even the "tiniest allusive gesture" to high-style movements. The models published in books and catalogs thus permitted every carpenter to design in a mode with cultural, historical, and aesthetic references, which are indeed found in virtually every Fredonia dwelling from the 1890s onward. As the paucity of International Style houses confirms, this traditionalism was what almost everyone wanted.

One of the reasons for the great upsurge of domestic building beginning in the early twentieth century, which provided such a fertile market for the precut houses of Sears, Aladdin, Bennett Homes, and others and for the plans of Radford, Standard Homes, Stickley, and legions more, was the growing number of middle-class Americans who, thanks to a rising standard of living, wanted a home of their own rather than an apartment. The dramatic increase in the demand for single-family homes, either to rent or to own, was commented on by the editors of *The American Architect* in 1903; they attributed it to both a lack of house building in the past few years (owing to high costs of materials and labor) and to the growth of suburbs. Thanks to the electric streetcar, now it was "just as convenient and just as cheap for a man to live in his own house in the suburbs, where the heating, lighting, and other services are under his own control . . . as it is to share an apartment-house with half a dozen or more tenants."[1]

Without the vast number of plan books and illustrations in journals, which both educated the prospective owner and provided cut-rate designs for local carpenters to erect, the encouragement to build an attractive home of one's own would surely have been far less.

Virtually all the pattern-book and catalog house designs from the 1840s through the 1940s followed the principle of hierarchical propriety set out as an architectural ideal by Serlio in 1575, Pratt in the 1650s, and Downing in the 1850s: Houses of small size must be designed in an entirely different way from a mansion, with stylistic features appropriate to their size. The fact that the ultimate models for smaller houses designed in the nineteenth and twentieth centuries were often historic or vernacular dwellings of the same general size (and of modest social position) reminds us that although pattern-book and catalog houses were only small- or medium-sized dwellings, they usually still had eminently cogent and appropriate designs.

Every ambitious carpenter and would-be architect from the 1840s to the 1940s could hardly undertake a course of professional study to become a skilled designer of domestic architecture, but the next best thing was readily at hand: pattern books, catalogs, and journals that published the end result of such training. These plans and designs could be copied, adapted, and emulated—and as we have seen, indeed were, providing remarkably sophisticated (as well as historically allusive) dwellings for countless middle-class families across the face of America.

Appendixes

Appendix 1

Sampling of House-Plan Books, 1883–1951, by Company

Aladdin Company, Bay City, Michigan

Aladdin Houses "Built in a Day." Bay City, Mich.: North American Construction Company, 1915. Catalog Number 26. 128 pp. [Many black and white and color illus.]

Aladdin Homecraft Marketplace. Bay City, Mich.: North American Construction Company, 1916. 2d ed. 151 pp., many black and white and color illus.

Aladdin Homes: Built in a Day. Bay City, Mich.: Aladdin Company, 1919. Catalog Number 31. 116 pp. [Illus. with perspectives, plans, dimensions, with costs, specifications, description.]

Aladdin Plan of Industrial Housing. Bay City, Mich.: Aladdin Company, 1920.

Aladdin Readi-Cut Houses. Bay City, Mich.: Aladdin Company, 1921. 115 pp. [Many black and white and color illus.]

Aladdin Homes. Bay City, Mich.: Aladdin Company, 1922. 128 pp. [Illus. with color plates, plans, and photos; interiors.]

Aladdin Readi-Cut Homes. Bay City, Mich.: Aladdin Company [c. 1950]. 31 pp. [Many illus.]

American Builder Publishing Company, Chicago and New York

Modern Homes, Their Design and Construction. A Collection of Home Designs with Plans and Details Contributed by Various Architects and Builders. With Interior Views, Suggestions for Decorating and Furnishing, and Descriptions of Twelve Architectural Period Styles Suitable for Modern American Homes. Details of Building Construction with Notes on Materials and a Model House Specification. Chicago and New York: American Builder Publishing Company, 1931. 272 pp. [Hundreds of photographs and drawings. Architects credited.]

American Builder 1936 Homes. Chicago and New York: American Builder Publishing Company, 1936. 170 pp. [Large collection of drawings, photographs, plans, details, color plates, interiors and exteriors, with descriptive text. Includes articles on material usage.]

American Face Brick Association, Chicago

A Manual of Face Brick Construction. Chicago: American Face Brick Association, 1920. 115 pp. [Illus. from photos, color renderings, plans, and details. 38-page outline of the history and technique of brick making and bricklaying, followed by 30 designs for houses from 4 to 9 rooms and one design for a 4-flat building, all using face brick construction.]

The Home of Beauty. A Collection of Architectural Designs for Small Houses Submitted in Competition by Architects and Architectural Draftsmen. [Chicago]: American Face Brick Association, 1920. 70 pp., 50 designs.

Three and Four Room Face Brick Bungalow and Small House Plans. Chicago: American Face Brick Association, 1925. 24 pp. [Illus. with drawings of elevations, details, and plans; descriptive text.]

American Portable House Company, Seattle

[*Catalog*]. Seattle: American Portable House Company [c. 1905]. 32 pp. [Text, instructions, dimensions, testimonials; illustrated with photographs and plans. According to the catalog, the houses had been proven in Arctic winters, tropics of Hawaii, and South Africa.]

American Society for Better Housing, New York

Homes. New York: American Society for Better Housing, 1936. 110 pp. [Illus. with photographs, drawings, and plans. Descriptive text; includes chapters on landscape and decoration.]

Architects' Small House Service Bureau

How to Plan, Finance, and Build Your Home. Minneapolis, Minn.: Architects' Small House Service Bureau, published for the Southern Pine Association, 1921. 155 pp. [Illus. with numbered house designs showing perspectives and plans, with descriptions.]

Your Future Home. A Selected Collection of Plans for Small Houses from Three to Six Rooms, for Which Complete Working Drawings May Be Secured at Nominal Cost. Saint Paul, Minn.: Architects' Small House Service Bureau, Northwestern Division, and Weyerhaeuser Forest Products, 1923. 165 pp. [Illus. of plans and perspective drawings.]

Small Homes of Architectural Distinction. A Book of Suggested Plans Designed by the Architects' Small House Bureau Service, Inc. Robert T. Jones (ed. and "technical director"). New York: Harper and Brothers, 1929. 278

pp. [Illus. of photos and measured plans of more than 200 designs for houses of from 3 to 6 rooms.]

The Architectural Forum, New York

Seventy-two Designs for Fire Proof Homes, from a National Competition Among Architects, Draftsmen, and Architectural Students, Sponsored by the American Institute of Architects and Conducted by the Architectural Forum. Chicago: United States Gypsum Company, 1925. 112 pp. [Illus. with house designs, plans, diagrams.]

The Book of Small Houses. By the Editors of the Architectural Forum. New York: Simon and Schuster, 1936. [Many illus. and plans. This book went through four editions.]

Arkansas Soft Pine Bureau, Little Rock

Houses of Wood for Lovers of Homes. A Group of Original House Plans Submitted in the Annual Architectural Competition of 1927, Conducted by Pencil Points, N.Y., and Sponsored by the Arkansas Soft Pine Bureau of Little Rock. Little Rock, Ark.: Arkansas Soft Pine Bureau, 1927. 48 pp. [Illus. of plans and renderings of 25 houses, 15 text figs., and some other illus. from photos.]

Association of American Portland Cement

Competitive Designs for Concrete Houses of Moderate Cost. Philadelphia: Association of American Portland Cement, 1907. 54 pp. [Elevations, plans, drawings. Prices range from $2,000 to $4,500 each.]

Atlas Portland Cement Company, New York

Concrete Houses and Cottages. Volume I, Large Houses. New York: Atlas Portland Cement Company, 1909. 120 pp. [Each illus. by a photo and a plan; architects and locations noted.]

Houses of Stucco. Atlas White Portland Cement–Pure White and with All the Strength of Gray Portland Cement. New York: Atlas Portland Cement Company, 1926. 44 pp. [Illus. from plans and photos, incl. 4 color plates of stucco finishes. Many designs by the Architects' Small House Service Bureau.]

Bennett Homes, Tonawanda, New York

Bennett Homes Better Built Ready Cut Catalog Number 18. North Tonawanda, N.Y.: Ray H. Bennett Lumber Company, 1920. 72 pp. [Illus. with drawings and plans.]

Plan Book of Bennett Better-Built Ready-Cut Homes. By William F. Bennett. Tonawanda, N.Y.: Bennett Homes, 1937.

Louis Bossert & Sons, Brooklyn

Bossert Houses. Brooklyn, N.Y.: Louis Bossert & Sons, 1917. 64 pp.

Bossert Houses. Brooklyn: Louis Bossert, 1920. 74 pp. [Illus. with photos, drawings, and plans.]

C. L. Bowes, Hinsdale, Illinois

Our New Book of Practical Homes. Hinsdale, Ill.: C. L. Bowes, 1926. 184 pp. [Fully illus. in color and black and white. Designs and plans for 140 houses, informative essays, ads.]

Brooks-Skinner Company, Quincy, Massachusetts

Wood and Steel Buildings. Catalog Number 65. Quincy, Mass.: Brooks-Skinner Company [c. 1926]. 64 pp. [Illus. from photos and plans. Brooks-Skinner proclaims itself on the title page to be "the largest manufacturers of wood and steel portable and permanent garages, bungalows, cottages, school houses, hospitals, factories, storage buildings, machine shops, hangars, etc., in the Eastern States." This catalog has mainly garages.]

Brown-Blodgett, Saint Paul, Minnesota

The Book of 100 Homes. Containing the Designs and Floor Plans of More Than 100 Homes, Cottages, and Two-Story Homes. Saint Paul: Brown-Blodgett, 1946. 104 pp. [Illus. with photos and plans with descriptive text.]

Building Age and the Builders' Journal, New York

Beautiful Homes of Moderate Cost. A Selection of Modern, Artistic, Practical Designs by Well Known Architects, Together with Information on Planning, Financing, Construction, Decoration, and Furnishing. New York: Building Age and the Builders' Journal, 1923. 96 pp. [Illus. from photos, perspective drawings, and plans. Nearly all the designs are by R. C. Hunter & Bro. of New York, Philip Resnyk of New York, Schermerhorn & Phillips of Philadelphia, and Gordon Robb of Boston.]

Homes of Beauty and Convenience. Carefully Selected Designs Whose Beauty and Livableness Mark Them as Among the Best Work of Nationally Known Architects. Illustrated by Exterior and Interior Views, Floor Plans, and Details. New York: Building Age and the Builders' Journal, 1924. 96 pp. [Illus. with photos, plans, and elevations. Moderate to substantial houses, most already executed in the areas around New York, Philadelphia, and Boston by about 20 cited architects.]

Building Brick Association of America

A House of Brick of Moderate Cost. Boston: for Building Brick Association of America by Rogers and Manson, 1910. 95 pp. [Full-page plates of illus. from perspective line drawings, plans, details, and placements. A selection from more than 800 drawings submitted in a competition; many designs included are by architects from the northeast.]

A House of Brick for Ten Thousand Dollars. 2d ed. Boston: for Building Brick Association of America by Rogers and Manson, 1910. 64 pp. [Illus. from perspective line drawings, plans, details. Results of a competition held through the *Brickbuilder* in which 150 sets of drawings were submitted. Most of the selected designs by architects from the northeast, with a great number from New York City, Brooklyn, and Boston.]

One Hundred Bungalows. Boston: Rogers and Manson, 1912. 120 pp. [Illus. with full-page plates of perspective line drawings, plans, details, site planning. Selected from 666 drawings submitted by architects and draftsmen from all parts of the country in a competition conducted by the *Brickbuilder.*]

Building Plan Holding Corp., New York

Home Builder's Plan Book. A Collection of Architectural Designs for Small Houses Submitted in Competition by Architects and Architectural Draftsmen in Connection with the 1921 Own Your Home Expositions, New York and Chicago. New York: Building Plan Holding Corp.,

1921. 84 pp. [Plates of 50 house designs in plan, perspective elevation, site plan. Architectural competition conducted with the approval of the American Institute of Architects (AIA) for well-planned and economical four, five, and six room houses, to be built in frame, brick, or stucco; to be available in book form at the Expositions with working drawings and specifications available to owners, architects, or builders at a nominal price.]

Bungalowcraft, Los Angeles

New English Designs. Los Angeles: Bungalowcraft, 1927. 48 pp. [Illus. with photographs and drawings, with descriptive text.]

California Redwood Association, San Francisco

Redwood Home Plans: By California Architects. San Francisco: California Redwood Association, 1925. 48 pp. [Illus. with photos, drawings, plans, and color plates of wood finishes. A collection of 22 designs by a juried competition under the auspices of the San Francisco AIA Small All Wood House Competition.]

Plans for Redwood Week-end Homes. San Francisco: California Redwood Association, 1927. 20 pp. [17 designs in plan and elevation sketch. Designs by Clifford A. Truesdell Jr. and by architects for the Frank Meline Company, Los Angeles.]

Redwood Home Plans by California Architects [2d ed.]. San Francisco: California Redwood Association, 1928. 48 pp. [Thoroughly illus. from plans, perspective elevations, photographic illus., and color illus. of wood samples. Contains eleven of "the most pleasing and popular of the designs originally selected by the Jury of Award from entries of forty-eight certified California Architects in Small, All-Wood House Competition held under the auspices of the San Francisco Chapter, AIA." To these were added nine "new and original designs by other well known California Architects" and ten small home designs chosen from the Architects' Small House Service Bureau.]

Carr Ryder & Adams Company, Dubuque, Iowa

Homes of Comfort. Series 100. Bilt-Well Mill Work. Dubuque, Ia: Carr Ryder & Adams Company [c. 1911]. [Illus. from plans and perspective renderings.]

Century Architectural Company, Cleveland, Ohio

Modern Homes. A Collection of Practical Designs of Houses and Cottages. With Interior Views. Cleveland: Century Architectural Company, 1898. 46 pp. [Each with perspective drawing and floor plans; design number and costs; and descriptive captions.]

Chicago House Wrecking Co.

A Book of Plans. Number 61. Chicago: Chicago House Wrecking Co., 1912. 96 pp.

Common Brick Manufacturer's Association of America, Cleveland, Ohio

Farm Homes of Brick. Cleveland: Common Brick Manufacturer's Association [c.1915–20]. 23 pp. [Illus. from perspective renderings and measured plans. Ten designs by the Ohio State University Department of Agricultural Engineering for brick farmhouses.]

Brick for the Average Man's Home. Cleveland: Common Brick Manufacturer's Association of America, 1920. 72 pp. [Drawings, photos, with costs and descriptive text; 35 designs for "practical and artistic homes, including cottages, bungalows, houses, and two-apartment buildings, one and two-car garages"; every house designed to be built of common brick; working drawings and specifications available for each house and garage.]

Spanish Homes. Cleveland: Common Brick Manufacturer's Association of America [c. 1920.] 32 pp. [Many black and white house plans.]

The Home You Can Afford. Sixty-Two Brick Homes of Beauty and Economy. Cleveland: Common Brick Manufacturer's Association, 1924. 62 pp.

Your Next Home. Photographs and Plans of Fifty-Eight Beautiful Homes. Cleveland: Common Brick Manufacturer's Association, 1925. 64 pp. [Also includes photos of four garages.]

The William T. Comstock Company, New York

Bungalows, Camps, and Mountain Houses. (William Phillips Comstock.). New York: William T. Comstock Company, 1908.

Two Family and Twin Houses. Consisting of a Variety of Designs Contributed by Leading Architects in All Parts of the Country, Showing the Latest Ideas in Planning This Class of Dwellings in City, Village, and Suburbs, with Improvements in Sanitation, Heating, Lighting, Etc. New York: William T. Comstock, 1908. 127 pp. [Illus. with over 100 photos with corresponding plans. Full descriptive text; list of architects represented.]

Co-operative Building Plan Association, New York

How to Build, Furnish, and Decorate. Consisting of Elevations and Plans for Houses, Barns, and Every Description of Outbuilding, Accompanied with Clear and Concise Instructions; Also, a Complete Treatise on Home Furnishing and Decoration. Robert W. Shoppell (comp.). New York: The Co-operative Building Plan Association, 1883. 650 illus. and plans.

Complete Collection of Shoppell's Modern Houses. New York: Co-operative Building Plan Association, architects [1886–89]. 668 pp., fifteen hundred illus.

Artistic Modern Houses of Low Cost. Sixty Designs Illustrated & Described. Robert W. Shoppell. New York: Co-Operative Building Plan Association [1887?]. 31 pp. [Many illus.; building plans with dimensions, details of construction, and costs.]

Descriptive Price List of Shoppell's Modern House Design. New York: Co-Operative Building Plan Association, 1897. 155 pp. [Plans & drawings of houses, cottages, and stables. Plans are numbered from 1154 to 1502; houses cost from $1,000 to $2,000.]

How to Build, Furnish, and Decorate. . . . New York: Co-Operative Building Plan Association, 1897. 207 pp. [Plans and perspectives of 82 cottages, residences, stables, and churches.]

How to Build, Furnish, and Decorate. New York: Co-Operative Building Plan Association, 1899. [Three parts

bound in one volume. Parts one and two, 142 pp. & 106 pp., consist of a perspective drawing or photograph with plans, costs, and descriptions on each page. The designs are numbered consecutively from Number 1524 to 1767. Mainly residences, with a few clubhouses, hotels, etc. Part three deals with the furnishings and interiors, illus. with photos and drawings.]

Craftsman Publishing Company, New York

Craftsman Homes. By Gustav Stickley. New York: Craftsman Publishing Company, 1909. 205 pp. [Illus. from photos, plans, drawings.]

More Craftsman Homes. By Gustav Stickley. New York: Craftsman Publishing Company, 1912. 201 pp. [Illus. from photos, plans, drawings.]

Craftsman Houses. A Book for Home-makers. By Gustav Stickley. New York: Craftsman Publishing Company, 1913. 62 pp. [Illus. from photos, plans, and perspective drawings.]

Curtis Companies, Clinton, Iowa

Better Built Homes, Volume VI. Clinton, Ia.: Curtis Companies, 1921.

De Luxe Building Company, Los Angeles

The Draughtsman Bungalows. 3d ed. A Book on the Bungalow; Showing the Latest and Advanced Designs of This Particular Type of Architecture. . . . Los Angeles: De Luxe Building Company, 1913. 64 pp. [Illus. of photos, drawings, and plans of approx. 60 bungalows.]

Future Homes Company, Jacksonville, Florida

Your Future Home Guide. By Gilbert D. Spindel and Bernard W. Close. Jacksonville, Fla.: Future Homes Company, 1945. [50 popular priced house plans in color, with foldout frontispiece. Houses designed by B. W. Close, editor of the 1930 American Country Homes publications. Published for the Florida market.]

Garden City Company of California

Ideal Homes in Garden Communities. A Book of Stock Plans. New York: McBride, 1919. 78 pp. [Numerous perspectives and plans. Published by the Garden City Company of California.]

Garlinghouse Company, Topeka, Kansas

Garlinghouse Plan Book: Book of Model Homes, Topeka, Kans.: 1920. [Photos and plans of small houses and bungalows.]

Artistic Homes. Topeka, Kans.: L. F. Garlinghouse [c. 1935]. 48 pp. [Illus. with photos and plans.]

Colonial Homes. Topeka, Kans.: L. F. Garlinghouse [c. 1935]. 48 pp. [Illus. with photos and plans.]

Fireside Homes. Topeka, Kans.: L. F. Garlinghouse [c. 1935]. 48 pp. [Illus. with photos and plans.]

New Brick Homes. Topeka, Kans.: L. F. Garlinghouse [c. 1935]. 56 pp. [Illus. with photos and plans; text and costs.]

New American Homes. Topeka, Kans.: Garlinghouse Company, 1938. 96 pp. [Illus. with photos and blueprints, full and half-page, with dimensions, costs, and instructions.]

De Luxe Small Homes. Topeka, Kans.: Garlinghouse [c. 1939]. 72 pp. [Illus. with photos of 210 houses, with plans, which could be ordered by mail.]

Fireside Homes. Topeka, Kans.: L. F. Garlinghouse Company, n.d. [c. 1945]. 48 pp. [Illus. with photos and plans, with descriptive text.]

Gordon-Van Tine Company, Davenport, Iowa

Gordon-Van Tine's Ready-Cut Homes. Davenport, Ia.: Gordon-Van Tine Company, 1916. 102 pp. [Illus. of photos and plans. More than 100 house designs; homes range in cost from $284 to $1,736, with the majority falling between $800 and $1,200. A Ready-Cut Home could be ordered with the form included in the catalog.]

Book of Homes. Davenport, Ia.: Gordon Van Tine Company, 1932. 135 pp. [Text, photos, drawings, and plans of cottages and small family homes.]

Harris Brothers Company, Chicago

A Plan Book of Harris Homes. Chicago: Harris Brothers Company, 1916. 98 pp., 100 designs.

A Plan Book of Harris Homes. Chicago: Harris Brothers Company, 1920. 110 pp. [Drawings of houses and plans, with a thorough text; small houses and bungalows; instructions, costs, etc.]

T. W. Harvey Lumber Company, Chicago

Architectural Designs Issued by the T. W. Harvey Lumber Company. Chicago: T. W. Harvey Lumber Company, 1889.

E. F. Hodgson Company, Boston

Hodgson Houses and Outdoor Equipment for Your Country Home. Boston and New York: E. F. Hodgson Company, 1931. 32 pp. [Illus. of photos and plans. Eight plans for houses, but also designs for garages, playhouses, garden ornaments, birdhouses, etc.]

Hodgson Houses, Camps, and Equipment. Boston, Mass.: E. F. Hodgson Company, 1936. 64 pp. [Illus. with black and white photos.]

Home Builders Catalog Company, Chicago

Home Builders Catalog. A Reference Work for Building Contractors and Home Owners. 3d ed. Chicago and New York: Home Builders Catalog Company, 1928. 1,258 pp., hundreds of illus. and plans. [Half of this catalog consists of illus. of all types of small houses, with plans. Blueprints are priced at $20. Also a compendium of suppliers, their products, and their available literature.]

Home Builders Catalog. 4th ed. A Reference Work for Building Contractors, Building Supply Dealers, Architects, and Homeowners. Compiled, edited, and published annually by National Buildings Publications. Chicago, 1929. 850 pp. [Illus. with over 400 pages of plans and photos of smaller houses and also garages.]

National Builders Catalogue, 1931. Formerly Home Builders Catalog. A Reference Work for Contractors, Builders. New York: National Buildings Publications, 1931. 368 pp. [Illus. and plans of small homes and garages.]

Home Owners Service Institute, New York

The Book of a Thousand Homes. By Henry Attenbury Smith. New York: Home Owners Service Institute, 1923. 334 pp. [Many photographic plates and plans. Also issued in 1925.]

Hydraulic-Press Brick Company, Saint Louis, Missouri

Genuine Economy in Home Building. Saint Louis, Mo.:

Hydraulic-Press Brick Company, 1913. 62 pp. [Illus. of color photos of houses, both large and small—gives architect and type of brick pattern and brick product used.]

The Hy-Tex House of Moderate Cost. Saint Louis, Mo.: Hydraulic-Press Brick Company [1914]. 100 pp. [Illus. with full-page plates from plans, perspective drawings, details, and site plans. Selected designs from a nationwide competition for a detached house, faced with Hy-tex brick, to be completed at a cost not to exceed $7,500. A number include decorative brick designs (herringbone, lattice, etc.).]

Industrial Publishing Company, Chicago

Small Practical Homes. Chicago: Industrial Publishing Company, 1946. [Illus. with 100 plans and photos; houses selected from *Building Supply News* and *Practical Builder.*]

International Mill and Timber Company, Bay City, Michigan

The Sterling System of Home Building. Bay City, Mich.: International Mill and Timber Company, 1919. 74 pp. [Illus. with photos, color plates, each building with a plan and corresponding text; mail order and construction costs. Homes, Garages, Summer Cottages, Accessories.]

Sterling Homes. Bay City, Mich.: International Mill and Timber Company [c. 1943]. 40 pp. [Illus. with color and black and white photos. Depicts 30 house designs, with plans; three garages, details, and two interiors.]

M. L. Keith, Minneapolis, Minnesota

Keith's Book of Plans. Volume 7. 100 Designs in Cement, Brick, and English Half-Timber. Minneapolis, Minn.: By the Author [c. 1909]. 144 pp. [Illus. with hundreds of photos, renderings, plans, with instructions and details.]

Keith's Plan Book: Inexpensive Homes. Minneapolis, Minn.: Keith Corporation, 1928.

Ladies' Home Journal

Model Houses for Little Money. By William L. Price with an Additional Chapter on Doors and Windows, by Frank S. Guild. Ladies' Home Journal Household Library. Philadelphia: Curtis, and New York: Doubleday and McClure [1898]. 193 pp. [Illus. with photos, plans, and drawings. Full building plans for the designs by this Philadelphia-based architect were available from the Journal's Art Bureau.]

Lehigh Portland Cement Company, Allentown, Pennsylvania

Build Your Castle of Dreams. Allentown, Pa.: Lehigh Portland Cement Company [c. 1925]. 32 pp. [Photos, plans, text. Cement stucco-covered homes.]

Twenty-Eight Better Homes. Allentown, Pa.: Lehigh Portland Cement Company [c. 1926]. 32 pp. [Plans, technical drawings, informative text; the result of a competition judged by David Adler, Harrie T. Lindeberg, Aymar Embury et al.]

Lewis Manufacturing Company, Bay City, Michigan

Lewis-Built Homes. Book "A-6" of One Hundred Homes. Bay City, Mich.: Lewis Manufacturing. Company [1916?]. 112 pp. [Photo illus. and plans for 100 house designs.]

Liberty Ready-Cut Homes. Bay City, Mich.: Lewis Manufacturing Company [1940]. 48 pp. [Fully illus. from plans and color perspective renderings; price list inserted.]

Libby-Owens-Ford Glass Company

Solar Houses. An Architectural Lift in Living. Libby-Owens-Ford Glass [c. 1940]. 23 pp. [Illus. with photos and drawings; instructions.]

Los Angeles Investment Company

Inexpensive Bungalows. Typical California Homes Costing from $1,000 to $2,250. Designed and Built by the Los Angeles Investment Company, 333-335-337 South Hill Street, Los Angeles, California. Eighth Bungalow Book Edition. Los Angeles: Los Angeles Investment Company, 1912. 96 pp. [Fully illus. from plans and photos. Nearly 100 variants of the modest California bungalow.]

Gustav Lowenthal Company, Middletown

Our New Book of Summer Houses. Middletown: Gustav Lowenthal Company, 1930. 32 pp. [Illus. with photos, drawings, and plans.]

Lumber Dealers' Service Bureau, Chicago

Architectural Economy: 1920, 1921. Chicago: Lumber Dealers' Service Bureau, 1920. 105 pp. [Illus. with exterior color photos, plans, and black and white interior photos and descriptions. Bungalow or modified prairie-style houses; also contains a section on pergolas and garages.]

Mershon & Morley Company, Saginaw, Michigan

Section-Built Dwellings and Garages. Book of Designs, Number 11. Saginaw, Mich.: Mershon & Morley Company [c. 1922]. 46 pp. [Illus. with photos and plans. Depicts 12 cottages and two garages; also illustrates construction details and methods.]

Metal Shelter Company, New York

Beachwood Bungalows. All-Steel–Fireproof–Artistic–Economical. New York: Metal Shelter Company, 1915. 12 pp. [Illus., plans, and prices.]

Morgan Woodwork Organization, Cleveland, Ohio

Building with Assurance. Cleveland, Ohio: Morgan Woodwork Organization, 1920. 408 pp. [Illus. with drawings, plans, some color plates, with price suppl.]

Building with Assurance. 2d ed. New York: Morgan Woodwork Organization, 1923. 439 pp. [With many black and white and color illus. Depicts in color 56 houses and plans and eight "ideal" interiors, also in color; most of the catalog being interior work: doors, windows, colonnades, moldings, trims, etc.]

National Fire Proofing Company, Pittsburgh, Pennsylvania

Fireproof Construction for Houses and Other Buildings of Moderate Cost. 6th ed. Pittsburgh, Pa.: National Fire Proofing Company, 1912. 64 pp. [Illus. from photos, plans, and details of construction. A series of already executed homes, many of substantial size, by a range of architects including Price & McLanahan, Mellor & Meigs, Walter F. Price, George Oakley Totten Jr., and Grosvenor Atterbury.]

Fireproof Houses of Natco Hollow Tile and How to Build Them. Pittsburgh, Pa.: National Fire Proofing Company, 1912. 64 pp. [Illus. with plans, drawings, details of

construction, technical and promotional text, photos. Locations and architects noted, some architects nationally known.]

The Natco House for Six Thousand Dollars. Attractive, Economical, Durable, Fireproof. Boston: Rogers & Manson, 1912. 72 pp. [Illus. with full-page plates including plans, perspective drawings, details, and site plans. Selected designs from prize-winning competition for a $6,000 house to be built of Natco Hollow Tile. The designs selected represent a wide range both geographically and stylistically. The second part of the catalog illustrates a series of houses built of Natco Hollow Tile and designed by well-known architects including Aymar Embury II, Delano & Aldrich, and Walter Burley Griffin.]

The Natco Bungalow for Four Thousand Dollars. Attractive, Economical, Durable, Fireproof. Boston: for National Fire Proofing Company, Pittsburgh, Pa., by Rogers & Manson, 1913. 80 pp. [Illus. from composite plates of perspective line drawings, plans, details, site plans, some photos. Designs submitted from all over the country, with the architect named in every instance.]

Fireproof Houses of Moderate Cost. Natco Hollow Tile. "Chicago Edition." National Fireproofing Company, 1914. 20 pp., 24 designs.

The Natco Double House–Semi-Detached. Attractive, Economical, Durable, Fireproof. Boston: for National Fire Proofing Company, by Rogers & Manson, 1914. 80 pp. [Illus. with full-page plates from plans, perspective drawings, details, site plans, and a few photos. Competitive designs for double houses—cubical contents not to exceed 45,000 cubic feet—to be built of Natco XXX Hollow Tile (a hard-burned clay block) at a cost not to exceed $9,000. Included at the end is a series of double houses that had been built of Natco Hollow Tile and designed by well-known architects including examples of Grosvenor Atterbury and J. T. Tubby Jr.'s designs for Forest Hills Gardens, L.I.].

The Natco Tex-Tile One-Family House. A Selection of Designs Submitted in Competition by Architects. . . . Together with Articles Treating of Design, Plan, and Construction of Dependable Houses of Moderate Cost. Pittsburgh, Pa.: National Fire Proofing Company, 1917. 72 pp. [Illus. from perspective line drawings, plans, details, and a few photos. Designs for one-family houses of not more than 20,000 cubic feet, on a residential street—frontage of 30 feet, depth of 100 feet—the cost not to exceed $4,000. The designs selected are primarily from the northeast, but with several each from Minnesota, Michigan, and California, and one from Melbourne, Australia.]

National Homebuilders Institute

The Homebuilder. [Chicago?]: National Homebuilders Society, 1923. 188 pp. [Illus. from photos, plans, drawings, and renderings. Full sets of plans and specifications available; *The Homebuilder* also provides much useful information about financing, site selection, materials, etc.]

National Lumber Manufacturers Association, Washington, D.C.

For Home Lovers. Washington, D.C.: National Lumber Manufacturers Association, 1929. 32 plates. [Many plates in color; drawings and measured plans, with elevations; some details, and commentary. Architects noted.]

National Plan Service, Chicago

Plans for Sixty-Two Homes. [Chicago]: National Plan Service [c. 1920]. 53 pp. [Plans and perspective line drawings for 62 house designs, mostly modest in size—2 to 3 bedrooms.]

A Home of Your Own. . . . Chicago: National Plan Service, 1931. 86 pp. [With illus. and plans.]

Homes for Better Living. National Plan Service, 1941. 64 pp. [Photos and plans, with commentary. Mostly Colonial Revival styles.]

Homes of Moderate Cost. [National Plan Service, 1941]. Imprinted: Conrad Brothers Lumber Company, Barnegat, N.J. 40 pp., illus.

Homes of the Southland. [National Plan Service, 1947]. Imprinted: Carr Brothers, Inc., Johnson City. 33 pp. [Illus. with photos and drawings, some in color; plans and descriptive text, vignettes.]

Modern Ranch Homes Designed for Town or Country Living. [National Plan Service, 1951]. Imprinted: Hannah & Lay Dock, Traverse City. 37 pp. [With illus. in color, and plans; descriptive text.]

National Small Homes Demonstration, Incorporated, Washington, D.C.

"Best Way to Achieve Low-Cost Housing Is to Build Low-Cost Homes. . . ." Washington, D.C.: National Small Homes Demonstration, Inc., 1939. 32 pp. [Illus. with photos and drawings; informative articles. Includes designs used as display for 1939 New York World's Fair.]

Page & Hill Company, Minneapolis, Minnesota

Cabins of Real Logs. Minneapolis, Minn.: Page & Hill Company, 1934. 6 pp. [Illus. with photos and captions of interiors and exteriors. Promotional pamphlet for mail order plans.]

Portland Cement Association, Chicago

Plans for Concrete Houses. 3d ed. n.p.: Portland Cement Association, 1925. 79 pp. [Illus. of photos, plans, and diagrams. Forty designs in plan and rendering and seventeen designs in plan and photo, selected as representative of the architectural profession from Boston to Los Angeles, with a short section of garage design and a longer section on stucco-finished and construction details.]

Plans for Concrete Houses. A Guide for the Home Builder. [Chicago]: Portland Cement Association, n.d. 64 pp. [Illus. from photos, perspective renderings, plans. Designs by architects throughout the United States.]

Beautiful Homes of Concrete Masonry. Chicago: Portland Cement Association [1929]. 31 pp. [Illus. from photos and plans, interiors, exteriors, and with descriptive text. Executed houses, many of substantial proportions, in various parts of the United States. The architect is named in every case, and in most instances the client is also given.]

Why People Like Concrete Homes. Chicago: Portland Cement Association, n.d. [c. 1939]. 30 pp. [Descriptive text

illus. with photos and plans. National examples and architects noted.]

Concrete Improvements Around the Home. Chicago: Portland Cement Association [c. 1940]. 39 pp. [Illus. with detailed drawings, plans, and photos. Features outdoor improvements.]

Designed for Concrete. Chicago: Portland Cement Association, 1936. 48 pp. [Illus. with floor plans, drawings. 55 selected designs from the 1936 competition for the design of fire-safe concrete homes.]

The Radford Architectural Company, Chicago

The Radford American Homes: 100 House Plans. Riverside, Ill.: Radford Architectural Company, 1903. 255 pp. [Many illus. and plans. Includes a 14-page description of plan service, 18 pp. of tables and guidelines for craftsman, and ads for other Radford publications.]

Radford's Artistic Homes. 250 Designs. Chicago: Radford Architectural Company, 1908. 261 pp. [Illus. with perspectives and plans.]

Radford's Artistic Bungalows. Unique Collection of 208 Designs. Best Modern Ideas in Bungalow Architecture. Chicago and New York: Radford Architectural Company, 1908. 219 pp. [Designs in plans and renderings.]

Radford's Combined House and Barn Plan Book. Chicago: Radford Architectural Company, 1908. 288 pp. [Illus. with perspectives and plans.]

Cement Houses and How to Build Them. Chicago: Radford Architectural Company, 1909. 167 pp. [Including 87 house designs and plans.]

Cement Houses and How To Build Them . . . Perspective Views and Floor Plans of Concrete Block and Cement Plaster Houses. Chicago: Radford Architectural Company, 1909. 75 pp. [Also contains 77 pages of ads.]

Radford's Portfolio of Plans. A Standard Collection of New and Original Designs. . . . Chicago: Radford Architectural Company, 1909. 316 pp., with over 300 plans. [This is a compilation of various Radford books.]

Radford's Stores and Flat Buildings. Illustrating the Latest and Most Approved Ideas in Small Bank Buildings, Store Buildings, Double or Twin Houses, Two, Four, Six, and Nine Flat Buildings. Chicago: Radford Architectural Company, 1909. 102 pp. [Illus. with plans and drawings for 57 designs.]

Cement and How to Use It. Chicago: Radford Architectural Company, 1910. 113 pp.

Radford's Garages and How to Build Them. Chicago: Radford Architectural Company, 1910. 108 pp. [55 plans; designs for private and public garages.]

Radford's Portfolio of Details of Building Construction. Chicago: Radford Architectural Company, 1911. 200 pp. [Including 185 pp. of detail drawings.]

Radford's Brick Houses and How to Build Them. Chicago: Radford Architectural Company, 1912. 218 pp. [With 300 designs and details of construction.]

The Radford Ideal Home. 100 house plans. Chicago: Radford Architectural Company, 1912. 108 pp.

Stores and Flat Buildings. Chicago: Radford Architectural. Company, 1913. 82 pp., depicting 72 designs.

Building Guide for Those About to Build. Chicago: (Wm. Radford) Whipple-Winckel Company, 1915. 160 pp. [Many illus., ample text; includes house plans, interior finish, sleeping porches, sun parlors, garages, stores, etc.]

The Radford Ideal Homes. Chicago: Radford Architectural Company, 1919. 110 pp., 100 house plan designs.

Red Cedar Shingle Manufacturers Association, Seattle, Washington

Red Cedar Shingle Homes. Seattle, Wash.: Red Cedar Shingle Manufacturers Association, 1912. 17 pp., illus.

Sears, Roebuck & Co., Chicago

Practical House Builder. By H. E. Burnham. Chicago: Sears, Roebuck & Co., 1902. 24 pp. [Perspectives, elevations, floor plans, specifications, etc., of houses, flats, stables, churches.]

Honor Built Modern Homes. Chicago: Sears, Roebuck & Co., 1918. 144 pp. [With many color and black and white house designs and interiors.]

Economical Standard Built Homes. Chicago: Sears, Roebuck & Co. [c. 1925]. 17 pp., illus.

Garages. Philadelphia: Sears, Roebuck & Co., 1929. 9 pp. [Illus.; dimensions, costs, etc.]

Homes of Today. Chicago: Sears, Roebuck & Co., 1931. 84 pp. [Illus. with drawings, plans. Promotional and informative text.]

Log Cabins. New York: Sears, Roebuck & Co. [c. 1935]. 10 pp. [Illus. with drawings and plans.]

Small House Plan Service, Hempstead, Long Island, New York

Beautiful Long Island Homes. Hempstead, N.Y.: Small House Plan Service [c. 1925.] Portfolio of 21 plates. [Each illustrates a perspective drawing with measured plans.]

Southern Pine Association, New Orleans, Louisiana

Homes for Workmen. A Presentation of Leading Examples of Industrial Community Development. New Orleans, La.: Southern Pine Association [1919]. 250 pp.

Standard Homes Company, Washington, D.C.

Better Homes at Lower Cost. Book Number 7. Washington, D.C.: Standard Homes Company, 1925. 108 pp. [Depicts 101 designs and house plans and 5 garages.]

Homes of Today. Washington, D.C.: Standard Homes Company, 1929. 80 pp. [With photos and plans, descriptive text.]

Standard Paint Company, New York

Building Your Own Garage. New York: Standard Paint Company [c. 1910]. 13 pp. [Illus. with drawings and plans.]

E. W. Stillwell and Company, Los Angeles

All American Homes. Los Angeles: E. W. Stillwell and Company, 1927.

Sunset Magazine, San Francisco

Cabin Plan Book. By Ralph P. Dillon. San Francisco: Sunset Magazine, 1938. 63 pp. [With house plans, details, and illus.]

A. Tuxbury Company, Charlestown

Quickbuilt Bungalows. Artistic Bungalows. Built for Comfort, Durability, Beauty, Convenience, and Economy.

Charlestown: A. Tuxbury Company Bungalow Department, 1920. 56 pp. [Illus. with photos and mostly color perspectives in landscapes; with plans and descriptions.]

United Sash and Door Company, Wichita, Kansas

Modern Homes: Proven Practical Plans. ("Book Two: Modern Homes"). Wichita, Kans.: United Sash and Door Company [c. 1925]. 86 pp. [Illustrating 30 houses with exterior photos, plans, many with interior views; some garages.]

United States Gypsum Company

Seventy-Two Designs for Fireproof Homes from a National Competition Among Architects, Draftsmen, and Architectural Students. Approved by the American Institute of Architects and Conducted by the Architectural Forum. n.p.: United States Gypsum Company, 1925. 112 pp. [Illus. from photos, plans, drawings, and diagrams. The designs are grouped under Colonial, Spanish, Italian, French, English, and Modern American styles, including 28 prize designs selected by a jury that included Dwight James Baum.]

West Coast Lumber Bureau, Seattle, Washington

Prize Homes of West Coast Woods. Chosen by a Jury of America's Foremost Architects. Seattle, Wash.: West Coast Lumber Bureau, 1928. 31 pp. [Illus. with drawings of houses with details and descriptive text, with prices. Architects credited.]

Weyerhaeuser Forest Products, Saint Paul, Minnesota

Good Houses. Typical Historic Architectural Styles for Modern Wood-Built Homes. By Russell F. Whitehead. Illustrations by Birch Burdette Long. Saint Paul, Minn.: Weyerhaeuser Forest Products, 1922. 63 pp. [Illus. of perspective drawings, photos, and plans. About 20 designs in plan and perspective rendering, each representative of a different "Domestic Architectural Style" or a variant of that style. In many cases, the actual house or type of house inspiring the design is illustrated (e.g., the Talmadge House at Litchfield, Connecticut, juxtaposed with the "Litchfield"

type of New England Colonial Style, and a Frank Lloyd Wright house in Riverside, Illinois, juxtaposed with the design for the American "Prairie" Style).]

A Dozen Modern Small Houses Selected from 150 Designs Submitted to a Jury of Architects in a National Six-Room House Competition Sponsored by Weyerhaeuser Forest Products. Saint Paul, Minn.: Weyerhaeuser Forest Products [1926]. 56 pp. unbound portfolio. [Plans, elevations, perspectives, site planning, etc., for 12 prize-winning house designs. Complete plans and working drawings for each of the 12 house designs in the portfolio could be secured at $15.00 a set. The jury was composed of Frank Couteau Brown of Boston, Laurence Hall Fowler of Baltimore, Leon Gillette of New York, and Carl A. Ziegler of Philadelphia, and the architects whose designs were selected included Platt & Cook, Chisling & Fordyce, and Raymond J. Percival.]

Weyerhauser 4-Square Book of Homes. Saint Paul, Minn.: Weyerhauser Sales Company, 1940. 79 pp. [Drawings and plans, with informative detailed text. Homes designed by noted architects.]

David Williams Company, New York

Low-Cost Houses with Constructive Details. Carpentry and Building Series, Number 2. New York: David Williams Company, 1907.

Woman's Weekly, Chicago

The Home, 1924. Supplement Given Only with One Full Year's Subscription to Woman's Weekly. Chicago: Woman's Weekly, 1924. 112 pp. [Illus. from photos, plans, and drawings. Sections on specific rooms of the house, some illustrated with color plates, and a series of small houses illustrated in plan and photo.]

Wyckoff Lumber and Manufacturing Company, Ithaca, New York

Cornell Portable Houses. Ithaca, N.Y.: Wyckoff Lumber and Manufacturing Company, 1906. 48 pp. [With black and white illus.]

Appendix 2

Sampling of House-Plan Books, 1884–1948: Individuals, Unique Issues

Architectural Forum

Small House Reference Number. Vol. XLIV, Number 3 (March 1926). New York: Rogers & Manson Company, 1926. 226 pp. [Many illus. from photos, plans, drawings. Includes articles by Frank J. Forster (on Norman-English influence in country houses, using his own designs as illus.), Julius Gregory (on English cottage architecture transplanted to Riverdale, Spuyten Duyvil, Bronxville, etc.), Aymar Embury II (on the Colonial), D. West Barber (on bungalows in the colonial style), Leigh French (on Ernest Flagg and others), William Lawrence Bottomley (on Italian and Spanish houses as a basis for design), and Rexford Newcomb (on bungalows in the Spanish and Italian style).]

Axelrod, Jay

Artistic and Practical Homes for the Average Man. Jay Axelrod, Architect. Saint Paul, Minn.: By the Author, 1922. 46 pp. [Illus. with drawings and color plates, with plans. Including bungalows, houses, and two- and four-apartment buildings. Working drawings and specifications for each, with price information.]

Brinckloe, William Draper

The Small Home: How to Plan and Build It. With Sixty Practical Plans for Low Cost Bungalows, Cottages, Farmhouses. New York: McBride, 1924. 223 pp. [Illus. with plans and drawings.]

Brown, Henry Collins

Book of Home Building and Decoration. Garden City, N.Y.: Doubleday, Page, 1912. 200 pp. [Iillus. throughout the text and on plates (many in color). The text, prepared in cooperation with and under the direction of leading manufacturers, illustrates methods of construction, interior decoration, hardware, lighting fixtures, plumbing, etc. There is a 28-page advertisement section at the end.]

Brunner, A. W. (ed.).

Cottages, or Hints on Economical Building. Containing Twenty-four Plates of Medium and Low Cost Houses, Contributed by Different New York Architects. Together with . . . Practical Suggestions for Cottage Building. New York: William T. Comstock, 1884. 77 pp. and 23 plates of designs in plan, elevations, and perspective. ["To which is added a chapter on the water supply, drainage, sewerage, heating and ventilation, and other sanitary questions relating to country houses, by Wm. Paul Gerhard." The architects are Wm. A. Bates, Chas. I. Berg, Jas. D. Hunter Jr., Messrs. Rossiter & Wright, Thos. Tryon, Wm. B. Tuthill, Frank F. Ward, Fred B. White, and the author.]

Chivers, Herbert C.

Artistic Homes. Saint Louis, Mo.: Herbert C. Chivers, 1903. 1025 pp. [The book consists mainly of illustrations and plans.]

Comstock, William Phillips (comp.).

The Housing Book. Containing Photographic Reproductions, with Floor Plans of Workingmen's Homes, One and Two Family Houses of Frame, Brick, Stucco, and Concrete Construction; Also Four, Six, and Nine Family Apartments. Showing Single Houses, Groups, and Developments That Have Been Built in Various Parts of the United States. Compiled by William Phillips Comstock . . . from the Designs of Many Prominent Architects. New York: Comstock [1919]. 132 pp., plus 150 illustrations and plans.

Dustman, U. M.

Dustman's Book of Plans. And Building Construction for General Contractors and Home Builders. Freeport, Ill.: Charles Thompson Company, 1910. 239 pp. [Illus. with hundreds of photos and plans. The specifications for the buildings can be ordered from the publisher. The book is mainly houses, but with a section on barns, garages, and farm buildings. A comprehensive book with many pages of details and instructions for all the aspects of building. Costs included.]

Embury, Aymar

One Hundred Country Houses: Modern American Examples. New York: Century Company, 1909. 264 pp. [Illus. with photos. Many different styles, arranged according to type, with locations and notable architects cited.]

Ford, Ivon R.

Portable Cottages, Poultry Houses, Garages, Tourist Cabins . . . Built at Factory. New York: McDonough, 1945. 4 pp., plus 1 p. price insert. [Black and white photos.]

Forster, Frank Joseph

Country Houses. The Work of Frank J. Forster. New York: William Helburn, 1931. 7 pp., plus 183 full-page plates. [Illus. with photos, drawings, and plans.]

Gibson, Louis H.

Convenient Houses with Fifty Plans for the Housekeeper. New York: Thomas Y. Crowell and Company, 1889. 321 pp. [Thoroughly illus. from plans, elevations, and diagrams, with 6 full-page plates. Contains sections on the architect and housewife; a journey through the house; fifty convenient house plans; practical house building for the owner; business points in building; how to pay for a home. The plans are all by Gibson, an Indianapolis architect, and emphasize the utilitarian and practical aspects of design.]

Glaser, Samuel

Designs for 60 Small Homes from $2,000 to $10,000, Showing How to Buy, Build, and Finance a Small Home. New York: Coward-McCann, 1939. 72 pp. [Many illus., plans, and detailed drawings.]

Gowing, Frederick M.

Building Plans for Colonial Dwellings, Bungalows, Cottages, and Other Medium-Cost Homes. Boston: Frederick H. Gowing, 1925. 224 pp. of plans and photo illus., with price list tipped in at rear. [Over 200 designs by Frederick H. Gowing, architect, for a wide range of sizes and types of single- and multifamily houses, for which complete sets of plans and specifications were available. Nearly all the designs are illustrated from photos rather than renderings.]

Group, Harold E. (ed.).

House-of-the-Month Book of Small Houses. Garden City, N.Y.: Garden City Publishing Company, 1946. 138 pp. [Illus. with house designs and floor plans.]

Hodgson, Fred T.

Common-Sense Hand-Railing and Stair-Building. . . . Illustrated with Over 250 Drawings and Diagrams, and Containing a Glossary of Terms Used in Stair Building and Hand-Railing; and in Addition, 25 Moderate-Priced House Designs, Showing the Perspective View and Floor Plans. By Fred T. Hodgson. Chicago: Frederick J. Drake [1903].

Hodgson, Fred T.

Hodgson's Low-Cost American Homes. Perspective Views and Floor Plans of One Hundred Low- and Medium-Priced Houses. Fred T. Hodgson(ed.). Chicago: Frederick J. Drake and Company, 1904. 124 pp. [Plans and perspective views. "Full and complete working plans and specifications of any of these houses will be mailed at the low prices named, on the same day as the order is received." The plans and specifications costs ranged from $5.00 (the majority) to $8.00. The costs of construction estimates (based on costs in the Chicago area at the time) ranged from $400 to $4,400.]

Hodgson, Fred T.

Practical Bungalows and Cottages for Town and Country. Perspective Views and Floor Plans of One Hundred Twenty Five Low- and Medium-Priced Houses and Bungalows. Fred T. Hodgson (arranger and editor). Chicago: Frederick J. Drake and Company, 1906. 270 pp., 125 designs in perspective and plan. [The preface gives an account of the development of the California bungalow, and the first 12 designs are designated as bungalows. The remainder are mainly 2-story.]

Hodgson, Fred T.

Practical Bungalows and Cottages for Town and Country. Perspective Views and Floor Plans for 200 Low- and Medium-Priced Houses and Bungalows. Arranged and edited by F. T. Hodgson. Assisted by E. N. Braucher. Chicago: Frederick J. Drake, 1912. 495 pp. [Many illus. and plans. Later enlarged eds. appeared in 1915 and 1916.]

Hunter, R. C.

Ten Little Cottages: Complete Working Drawings Available. Designed by R. C. Hunter, Architect, New York. 1938. 10 plates of perspectives with plans and descriptions. [Included is a home on exhibit at the 1938 Model Homes National Exhibition.]

Keefe, Charles S.

The American House. Being a Collection of Illustrations and Plans of the Best Country and Suburban Houses Built in the United States During the Last Few Years. New York: U.P.C. Book Company, 1922. 24 pp., 219 plates. (Later ed., 1924.) [Works by Baum, Bottomley, Delano & Aldrich, Myron Hunt, Mellor, Meigs, & Howe, Pope, and others.]

Palliser, George

Modern Buildings. Containing One Hundred Practical House Plans, Also Plans for Private Stables, Carriage Houses, and Ideas for Schools, Churches, and Public Buildings. New York: Ogilvie, 1901. 122 pp. [Illus. by drawings and plans.]

Patterson, Augusta Owen

American Homes of Today. Their Architectural Style, Their Environment and Characteristics. New York: Macmillan, 1924. 393 pp. [Illus. with nearly 100 photos. Interiors and exteriors; residences by prominent designers and architects of the day.]

Power, Ethel B.

The Smaller American House. Fifty-five Houses of the Less Expensive Type Selected from the Recent Work of Architects from All Parts of the Country. Boston: Little, Brown, and Company, 1927. 12 pp., plus 100 full-page plates containing illus. from plans and photos. [Houses by more than 40 architects or partnerships are included, among them work by Dwight James Baum; Frank Forster; Philip Goodwin; Aymar Embury II; and Mellor, Meigs, & Howe. The locations and owners are also given.]

U. S. Department of the Interior, Division of Subsistence Homesteads

Homestead Houses. A Portfolio of Plans and Perspectives Issued by the Division of Subsistence Homesteads of the United States Department of the Interior. Washington, D.C.: [U.S. Dept. of the Interior], 1934. 30 full-page drawings with floor plans.

Winslow, Carleton Monroe, and Edward Fisher Brown, (eds.).

Small House Designs Collected by Community Arts Associations of Santa Barbara, California. 2d ed. Santa Barbara, Calif.: Community Arts Association, 1924. 153 pp. [Fully illus. from full-page plates of illus. for plans, drawings, details, and site plans. Designs from a prize-winning competition for a dwelling house, suitable for California, of not over five rooms and to cost not more than $5,000.]

Miscellaneous

Ideal Homes in Garden Communities. A Book of Stock Plans. Designed by Various Architects. New York: McBride, 1919. 78 pp. [Illus. with drawings and plans. Various price ranges; descriptive text.]

Modern Homes. Meriden, Conn.: Lyon & Billard Company [c. 1930]. 87 pp. [Illus. with photos, color plates, plans. Cottages and small family homes; with commentary.]

Plan Book of Modern Homes. 40 Complete Plans [for a $6,000 House] Submitted in a National Competition.

Columbus, Ohio: Real Estate and Building Show, 1910. 40 pp. of plates showing plans, perspective drawings, details, site plans, and 10 pp. of contemporary adverts. [Selection of designs from a prize-winning competition for the Real Estate and Building Show held in Columbus, Ohio, January 21–30, 1918. The contemporary advertisements, however, all pertain to Madison, Wisconsin, real estate interests where this particular copy was distributed.]

Stone Harbor Bungalow & Cottage Booklet. Philadelphia: South Jersey Realty Company [c. 1915]. 16 pp. [Illus. with photos, plans, and drawings; exteriors and interiors. Ocean-front and beach-side homes.]

Sunset Cabin Plan Book. San Francisco: Lane Publishing Company, 1948. [Many illus. and plans.]

Two-Family Houses of Concrete Masonry. Prize Winning and Other Designs Submitted in the Architectural Competition Conducted by the T-Square Club of Philadelphia. New York: Portland Cement Company, 1929. 23 pp. [Descriptive text, with drawings, details, and plans.]

Appendix 3

Sampling of Books on Small Houses, 1896–1946, Not Specifically Mail-Order Plan Books

1896 *House and Home: A Practical Book*. New York: Scribner's, 1896. 2 vols. 400 & 397 pp., with hundreds of drawings and engravings and several color plates. [Every aspect of home keeping and housekeeping with several chapters on building and landscaping.]

1897 Moore, Francis. *How to Build a Home*. The House Practical, Being Suggestions as to Safety from Fire, Safety to Health, Comfort, Convenience, Durability, and Economy. New York: Doubleday, 1897. 158 pp., illus.

1898 Coleman, Oliver. *Successful Houses*. New York: Fox Duffield, 1898. 165 pp., illus. (Later ed. 1906.)

1900 *Suburban Houses Built by Wendell & Smith*. Overbrook, Pa.: [Wendell & Smith] [c. 1900]. 142 pp. of photographic plates and advertisements. [Title page drawing by Horace Trumbauer. Homes in the Overbrook, Pelham, Wayne, and Saint Davids areas.]

1902 *The Book of a Hundred Houses*. A Collection of Pictures, Plans, and Suggestions for Householders. New York: Duffield, 1902. 403 pp., illus. (Later ed. 1906.)

1904 Keeler, Charles. *The Simple Home*. San Francisco: Paul Elder and Company, 1904. 55 pp. plus 9 photographic plates. [Keeler's tribute to his friend Bernard R. Maybeck and his domestic architecture. For Maybeck, "[T]he strength of society [is] based upon the home".]

1905 Hooper, Charles Edward. *The Country House*. A Practical Manual of the Planning and Construction of the American Country Home and Its Surroundings. Illustrated by E. E. Soderholtz and others. Garden City, N.Y.: Doubleday, Page, 1905. 330 pp., with full-page plates, plans, and text-illus. (Later eds. 1906, 1909, 1911, 1913.)

1909 Desmond, H. W., and H. W. Frohne. *Building a Home*. A Book of Fundamental Advice for the Layman About to Build. New York: Baker & Taylor Company, 1909. 222 pp., with 89 photographic plates.

1909 Embury, Aymar II. *One Hundred Country Houses: Modern American Examples*. New York: Century, 1909, 264 pp., illus. [Eleven different styles pictured with residences and their architects identified. From Southern Colonial through Modern English, Japanese, and Art Nouveau. With chapters on the house and garden and the plan of the house.]

1910 Saylor, Henry H. *Distinctive Homes of Moderate Cost*. Being a Collection of Country and Suburban Homes in Good Taste, with Some Value in Suggestion for the Home-builder. New York: McBride, Winston, 1910. 173 pp., many illus.

Saylor, Henry H. *Bungalows*. Their Design, Construction, and Furnishing, with Suggestions Also for Camps, Summer Homes, and Cottages of Similar Character. Philadelphia: John C. Winston Company, 1911. 188 pp., many illus. from photos and plans. [Over 75 examples of early bungalow designs, many from New York (particularly Long Island) and California.]

1912 Saylor, Henry H. (ed.). *Inexpensive Homes of Individuality*. Being a Collection of Photographs and Floor Plans Illustrating Certain of America's Best Country and Suburban Homes of Moderate Size. Introduction by Frank Miles Day. New and enlarged ed. New York: McBride, Nast, and Company, 1912. 80 pp., illus. from photos and plans; (later ed. 1915). [Includes a discussion of costs by Aymar Embury II. Designs illustrated are drawn primarily from New York, New Jersey, Pennsylvania, and southern New England and include work by Lawrence Visscher Boyd, Aymar Embury II, Oswald C. Hering, and Mellor & Meigs.]

1913 Saylor, Henry H. *Bungalows*. Their Design, Construction, and Furnishing; with Suggestions Also for Camps, Summer Houses, and Cottages of Similar Character. New York: McBride, Nast, 1913. 209 pp., illus. with photos and plans. [Nearly 100 bungalows described.]

1914 *The Book of Little Houses*. New York: Macmillan, 1914. 107 pp., 11 plates and other illus.

1916 Price, Charles Matlack. *The Practical Book of Architecture*. Philadelphia and London: Lippincott, 1916. 348 pp., 255 plates including colored frontispiece. (later ed. 1932).

1916 Wright, Richardson (ed.). *Low Cost Suburban Homes*. A Book of Suggestions for the Man with the Moderate Purse. New York: Robert M. McBride, 1916. 120 pp. Many plates and plans. (later ed. 1920).

1917 Embury, Aymar II. *The Livable House*. Its Plan and Design . . . Being Volume I of the Livable House Series.

New York: Moffat, Yard, and Company, 1917. 198 pp., black and white photos.

1919 Wright, Richardson (ed.). *House & Garden's Book of Houses*. Containing over Three Hundred Illustrations of Large and Small Houses and Plans, Service Quarters and Garages, and Such Necessary Architectural Details as Doorways, Fireplaces, Windows, Floors, Walls, Ceilings, Closets, Stairs, Chimneys, etc. New York: C. Nast & Company, 1919. 94 pp., many illus. (later ed. 1920).

1922 Hering, Oswald C. *Concrete and Stucco Houses*. The Use of Plastic Materials in the Building of Country and Suburban Houses in a Manner to Insure the Qualities of Fitness, Durability, and Beauty. (The Country House Library.) Rev. ed. New York: McBride, 1922. 105 pp., with numerous full-page plates and several plans and detailed drawings in text.

1922 Weyerhaeuser Forest Products. *The High Cost of Cheap Construction*. A Book for Home-Builders on the Importance of Right Construction in House Building. Saint Paul, Minn.: Weyerhaeuser Forest Products, 1922. 67 pp., with many illus. from drawings and diagrams.

1923 Walsh, H. Vandervoort. *The Construction of the Small House*. A Simple and Useful Source of Information on the Methods of Building Small American Homes, For Anyone Planning to Build. New York: Scribner's, 1923. 269 pp., illus. with drawings by the author.

1924 Cary, Harold. *Build a Home—Save a Third*. The Story of a Collier's House. From Plans by Ernest Flagg, Architect. Sketches by Warren S. Matthews. New York: Reynolds Publishing Company, 1924. 117 pp., with 15 text sketches, 20 photographic plates, and 1 folding blueprint. [As billed on the dust jacket: "Mr. Cary, the author, with no previous building experience, set out to build a home by means of a system developed by the distinguished American architect, Ernest Flagg, designer of the Singer Building, New York City. At the request of Collier's, The National Weekly, Mr. Cary kept a diary of his experiences, all of which are recorded in this volume, with additional chapters, photos, diagrams, blueprint, and specifications. He was successful in actually saving one-third of his building costs." Develops the principles put forth by Flagg in *Small Houses: Their Economic Design and Construction*, of 1922.]

1924 Hering, Oswald. *Economy in Home Building*. With Consideration of the Part Played by the Architect. Foreword by Royal Cortissoz. New York: Robert McBride, 1924. 210 pp., illus. with 210 photos and plans.

1924 Patterson, Augusta Owen. *American Homes of Today, Their Architectural Style, Their Environment, Their Characteristics*. New York: Macmillan, 1924. 393 pp., many illus.

1926 *House Beautiful Building Manual 1926*. A Comprehensive and Practical Method of Procedure, Materials, and Methods of Construction for All Who Contemplate Building or Remodeling a Home. Thorough Revision of 1925 Edition with Important Additions. Boston: Atlantic Monthly Company, 1926. 204 pp., many illus. from photos, plans, and diagrams, including plates of blueprints. [Intended as a source of useful information for home builders and as a supplement to rather than replacement of the architect, this provides a range of material on general considerations, exterior and interior construction, mechanical equipment, and an appendix (including a chapter "Some Common Mistakes"). Dwight James Baum, John Mead Howells, John Russell Pope, and H. T. Lindeberg are among the 60 architects or firms whose work is represented in this volume.]

1926 Bottomley, M. E. *The Design of Small Properties*. A Book for the Home-Owner in City and Country. New York: Macmillan, 1926. 233 pp., 63 illus.

1926 Brinckloe, William Draper. *The Small Home*. How to Plan and Build It, with Sixty Practical Plans for Low-Cost Bungalows, Cottages, Farmhouses, Apartments, Garages, and Barns. New York: Robert M. McBride, 1926. (Rev. ed.; first published in 1924.) 223 pp., elevations and plans for 60 structures. [Brinckloe had conducted "Home-planning Contests" for *The Ladies' Home Journal*, *The Farm Journal*, *People's Popular Monthly*, etc., and he here provides 60 plans drawn to suit those thousands of American housewives. He provides much useful information for first-time homebuilders.]

1929 Edgell, George H. *The American Architecture of Today*. New York: Scribner, 1929. 401 pp., 374 illus.

1929 White, Charles E., Jr. *The Bungalow Book*. New York: Macmillan , 1929. 221 pp., with line drawings, plans, and photos. (Rev. ed. version of 1923 ed.)

1932 Newcomb, Rexford, and William A. Foster. *Home Architecture*. A Textbook for Schools and Colleges. A Manual for the Homebuilder and Home Owner. New York: John Wiley and Sons, 1932. 336 pp., with 238 illus. from photos, plans, drawings, and diagrams.

1933 Newcomb, Rexford. *The Colonial and Federal House*: How to Build an Authentic Colonial House. With 100 plates of Colonial Houses, Antique and Modern. Philadelphia: Lippincott, 1933. 174 pp.

1935 Coffin, Lewis A. (ed.). *American Country Houses of Today, 1935*. Including a section on The Better Homes in America Small House Competitions by James Ford. New York: Architectural Book Company [1935]. 152 pp., many illus. [The last volume in a series, depicting the smallest houses.]

1939 Waugh, Alice. *Planning the Little House*. New York: McGraw-Hill, 1939. 267 pp., illus. with 144 photos and drawings. [Interior and exterior points of view; solving the problems of "good taste." The author was an instructor of applied art at Iowa State College.]

1939 White, Charles D. *Camps and Cottages*. How to Build Them Yourself. New York: Thomas Y. Crowell, 1939. 235 pp. with 45 line drawings, plans, and diagrams in text.

1940 Wills, Royal Barry. *Houses for Good Living*. New York: Architectural Book Publishing Company, 1940. 104 pp., many illus. from photos and plans. [The majority of the designs are traditional but adapted to modern needs and demands.]

1941 Wills, Royal Barry. *Better Houses for Budgeteers.* New York: Architectural Books Publishing Company, 1941. 102 pp., many illus. from measured plans and renderings. [Includes a section on the "minimum plan" house and how it can "grow up;" dollar saving tips; and plans for three different economic ranges (incomes of $1,500–2,500, $2,500–3,700, and $3,700 and above).]

1943 Meinecke, Conrad E. *Your Cabin in the Woods.* A Compilation of Cabin Plans and Philosophy for Discovering Life in the Great Out Doors. Buffalo: Darnock Cabin Craft Guild, 1943. 136 pp., many text-illus. (Revised ed. 1945.)

1945 Nelson, George, and Henry Wright. *Tomorrow's House.* How to Plan Your Post-War Home Now. New York: Simon and Schuster, 1945. 218 pp., 232 illus. plus a few detailed drawings and plans. [Some of the architects included are: Richard Neutra, Manuel Pereira, Lloyd Wright, George Howe, Paul Laszlo, Marcel Breuer, Walter Gropius, Carl Koch, Hugh Stubbins, Kenneth Kassler, Philip Goodwin, William Lescaze, Antonin Raymond, Edward Stone, and Frank Lloyd Wright.]

1945 Wills, Royal Barry. *Houses for Homemakers.* New York: Franklin Watts, 1945. 94 pp., many illus. from renderings, plans, and working details.

1946 Dean, John P., and Simon Breines. *The Book of Houses.* New York: Crown, 1946. 150 photos, 100 plans, many drawings.

Appendix 4

Sampling of "Small House" Books, England, 1891–1939

1891 Briggs, R. A. *Bungalows and Country Residences.* A Series of Designs and Examples of Recently Executed Works. London: Batsford, 1891. Folio, 11 pp. plus 29 litho. plates. [Briggs became known as "Bungalow" Briggs from his series of books with that title, of which this is the first edition. His definition of a bungalow was "a homely, cozy little place, with verandahs and balconies and . . . a feeling of rusticity and ease." His 20 designs here included range widely in style, from Tudor to Grecian to Queen Anne. Briggs was quite successful, both as an architect (many of his designs presented here were actually executed) and in his publications. There were a number of later editions in quarto format, each with additional plates.]

1895 Goldsmith, Henry. *Economical Houses.* Manchester: George Faulkner and Sons, 1895. 3 pp. text, 46 pp. illus. of photos, plans, line drawings; 19 pp. advertisements. [Goldsmith was a Manchester-based architect whose clients included a good number of the comfortably off middle class in Lancashire, Cheshire, and other neighboring counties. The 50-odd designs for detached or semidetached houses included here (in plans and views) had already been built. Many of the designs are in some form of Victorian half-timber.]

1898 Poore, George Vivian. *The Dwelling House.* Second impression. London: Longmans, Green, 1898. 178 pp. with 36 text illus. [Particularly concerned with proper planning, ventilation, circulation, disposal of house refuse, and other matters pertaining to sanitation and healthful living conditions.]

1898 Richardson, C. J. *The Englishman's House.* A Practical Guide for Selecting or Building a House. A new edition. London: Chatto and Windus, 1898. Chromolitho. frontispiece plus vi plus 504 pp. with 534 fine woodengr. illus. [Originally published under the title *Picturesque Designs for Mansions, Villas, Lodges, &c* (London, 1870), this book appeared as early as 1871 in this smaller edition. It contains 40 designs by Richardson for cottages, lodges, villas, etc., with many cross-sections and details as well as plans and elevations.]

c. 1900 Clare, George E., and Walter G. Cross. *Ideal Homes for the People.* "Being a statement of the difficulties met with in building for the working classes in rural districts and particulars of a new, substantial, and cheap form of construction, which will be found to constitute a remedy." 2d ed., revised and enlarged. Chelmsford: J. H. Clark and Company, n.d. (1900–1905). 44 pp. plus 33 plates with plans and perspective elevations. "With thirty-three plates showing some recently executed examples of cottages, farm buildings, gentlemen's bungalows, and small country houses, etc., etc." [On the cover identified as "inexpensive, sanitary, artistic. Important to land owners, farmers, speculators, & all employers of labour." The authors claim these houses could be built for an average of one-third less cost than normal building construction by using Clare's Patent Concrete and Fireproof Timber Construction.]

1901 Parker, Barry, and Raymond Unwin. *The Art of Building a Home.* A Collection of Lectures and Illustrations. 2d ed. London: Longman, 1901. 133 pp., 68 full-page plates and plans.

1905 Bidlake, W. H., Halsey Ricardo, and John Cash. *The Modern Home: A Book of British Architecture for Moderate Incomes.* A Companion Volume to "The British Home of To-day." Edited by Walter Shaw Sparrow. New York: Armstrong [1905]. 176 pp., well illus. [Includes works by Newton, Lutyens, Voysey, Baillie Scott, Shaw, Lorimer, and Mitchell.]

1906 *Cottage Exhibition, Cleveleys, Lancashire.* July to September 1906. Complete catalogue with plans, drawings, and illustrated articles. Cleveleys (near Blackpool): Cottage Exhibition Committee, 1906. 120 pp. fully illus. from plans and drawings, with folding plan tipped in at rear. [The cottages at the Cleveleys exhibition were built under the Building Bye-Laws commonly adopted in urban districts and did not impose a cost limit, although economy was certainly a consideration.]

Elder-Duncan, J. H. *Country Cottages and Week-End Homes.* With Numerous Illustrations and Plans of Cottages by Well-known Architects. London: Cassell and Company, 1906. 224 pp., many illus. from photos, plans, and drawings. [Includes the work of Ernest Gimson, Ernest Newton, Parker and Unwin, C. H. B. Quennell, Baillie Scott, and C. F. A. Voysey, and others.]

1906 [Taylor, Samuel]. *Inexpensive Rural Cottages and Buildings for Small Holdings.* London: Land Agents' Record, 1906. 112 pp., with 17 full-page plates of plans, elevations, diagrams (including photographic frontisp.).

[The author's main concern here is to provide practicable buildings, "unpretentious in appearance, inexpensive to erect and maintain, and adapted to meet the requirements of a large proportion of the country."]

1907 Sparrow, W. Shaw (ed.). *Flats, Urban Houses, and Cottage Homes*. A Companion Volume to "The British Home of To-Day." Text by Frank T. Verity, Edwin T. Hall, Gerald C. Horsley, and W. Shaw Sparrow. London: Hodder and Stoughton [1907]. 168 pp. with numerous illus. from photos, plans, and drawings (18 in color). [Although primarily concerned with English examples (including the work of C. R. Ashbee, M. H. Baillie Scott, Edwin Lutyens, and R. Norman Shaw), examples from Paris and Vienna are also included.]

1907 Sparrow, Walter Shaw (ed.). *The Modern Home*. A Book of British Domestic Architecture for Moderate Incomes. A Companion Volume to "The British Home of To-Day." The text by W. H. Bidlake, M. S. Halsey Ricardo, and John Cash. London: Hodder and Stoughton [1907]. 176 pp., many illus. from drawings, plans, and photos, and 32 color plates. [Sections on "The Home from Outside," "The Interior and Its Furniture," and "Some Decorative Essentials," illustrating work by many of the leading architects and decorative artists of the time, including houses by Lutyens, Newton, Lorimer, and Voysey and furniture by Sidney H. Barnsley, and Ernest W. Gimson, and others.]

1908 London Daily Mail. *Ideal Homes*. The Prize Designs and Many Others Submitted in the Architects' Competition Held Under the Direction of the London "Daily Mail." London: British Architect [1908]. 71 pp. fully illus. with 65 full-page plates of designs in plans, elevations, perspective renderings, some site plans, roof or other details. [Edwin L. Lutyens was the "assessor" for this competition; the designs included works by W. Rupert Davison, G. W. Webb, Charles Voysey, and Williams-Ellis & Scott.]

1908 Nettlefold, J. S. *Practical Housing*. Letchworth: Garden City Press, 1908. 200 pp. with 5 text illus. and 34 illus. from photos and plans. [Nettlefold was the chairman of the Birmingham Corporation Housing Committee and a leading figure in the Garden City movement. He was particularly concerned with improving conditions existing in urban housing and provided "before and after" examples for both inner-city and garden city designs.]

1909 Sparrow, Walter Shaw. *Our Homes and How to Make the Best of Them*. London: Hodder and Stoughton, 1909. 280 pp., with many photographic plates, some in color.

1909 Sutcliffe, G. Lister (ed.). *The Principles and Practice of Modern House Construction*. New edition, thoroughly revised and considerably extended. 2 vols. London: Gresham Publishing Company, 1909. xvi plus 502 pp., xvi plus 536 pp. with 737 text figs. and 40 plates (including frontispiece). ["Including plan and design, construction, water-supply and fittings, sanitary fittings & plumbing, drainage & sewage-disposal, warming, ventilation, lighting, stables & cow-houses, sanitary law, etc."]

1910 Fletcher, Banister. *The English Home*. New York: Scribner's, 1910. 392 pp., 336 engravings and photographic plates.

1912 Adams, Maurice B. *Modern Cottage Architecture*. Illustrated from Works of Well-known Architects. 2d ed., revised and enlarged. London: B. T. Batsford, 1912. xii plus 81 pp. with 58 text figs. (mostly plans) plus 133 full-page plates of photo illus. [Includes works by Lutyens, R. S. Lorimer, Ernest Newton, Aston Webb, and many others, with a fair number of designs by the author himself.]

1913 Weaver, Lawrence. *The "Country Life" Book of Cottages Costing from £150 to £600*. London: Country Life, 1913. 231 pp., 291 illus.

1919 Weaver, Lawrence. *Small Country Houses of To-day*. Second Series. ("Country Life" Library of Architecture.) London: Country Life; New York: Charles Scribner's Sons, 1919. 222 pp., 299 illus. and plans, frontispiece.

1919 Weaver, Lawrence. *The "Country Life" Book of Cottages*. 2d ed., revised and enlarged. London: Offices of Country Life, 1919. xiv plus 266 pp. with 302 illus. from photos and plans. [Weaver's first book on cottages appeared in 1913, when he perceived a need for examples of built cottages with actual costs, photos, and plans rather than "cunningly drawn perspective plans" and no real consideration of costs. In this new edition, with many chapters wholly rewritten and with new illustrations, the author puts less emphasis on the details of building costs because "no one can prophesy what will be their ultimate level when the grave shortage and consequent high cost of certain materials have given place to normal cost."]

c. 1920 National Building Guild. *Labour-Saving Houses*. A Book of Type Plans. Manchester et al.: National Building Guild [c. 1920]. 48 pp. with 22 "types" in plan and elevation or photo illus. [At the time of this publication, the National Building Guild, "an entirely new type of industrial organization," had been in existence for several years. Among other things, the Guild would only undertake a building contract in cooperation with a qualified architect. This, then, is not a catalog of plans but of types (the examples include designs by noted architects such as Hennell & James and Philip Hepworth), which would help the customer either himself to select an architect or to invite the Guild to do so for him.]

1920 Phillips, R. Randal. *The Book of Bungalows*. London: Country Life, 1920. 160 pp. with 116 illus. from photos, plans, elevations. [Phillips is concerned with both the advantages and limitations of the bungalow and presents a series of English examples (many of which were actually built at the time of publication), which are suited to the climate and conditions and from which the prospective (and primarily middle-class) homebuilders might benefit. With a list of architects and a list of materials with suppliers' addresses.]

1922 Phillips, R. Randal. *The Book of Bungalows*. 2d ed. London: Offices of "Country Life," 1922. 176 pp. with 136 illus. from photos, plans, and elevations.

c. 1923 Newbold, Harry Bryant. *House and Cottage Construction*. With special chapters by Guy Cadogan Rothery, Paul Willoughby, E. W. King, E. J. Strange, A. C. Martin. 4 vols. London: Caxton Publishing Company [c.1923]. 3 frontispieces are colored, abundance of full-page plates, text-illus., plans, and detailed drawings. [Volume IV has subtitle: "dealing with setting up in business, builder and architect, estimating, tendering, forms of contracts, notes on specifications, the steel square: its mechanism and uses, shoring and underpinning, insurance, etc., by Samuel Smethurst, Horace W. Langdon, Herbert Jeans, G. Cadogan Rothery, Harold Ryder, W. H. Coggan, and H. G. Holt.]

1924 Phillips, R. Randal. *Small Family Houses*. London: Country Life; New York: Charles Scribner's Sons [1924]. Many illus. and plans.

1924 *The Smaller House*. Being Selected Examples of the Latest Practice in Modern English Domestic Architecture. London: Architectural Press, 1924. 191 pp., illus. with many plans and photos. [Survey of early 20-century English house architecture, with examples of works of Parker, Lutyens, Williams-Ellis, de Soissons, Goodhart-Rendel, etc.]

1925 James, C. H., and F. R. Yerbury (eds.). *Modern English Houses and Interiors*. London: Ernest Benn, 1925. 99 full-page plates of illus. from photos and plans. [Includes the work of 31 architects or firms (including Louis de Soissons, Oliver Hill, P. D. Hepworth, Hennell & James, and H. M. Fletcher, many of whom show "a strong leaning to the Georgian tradition."]

1925 Phillips, R. Randal. *Small Country Houses of Today, Volume Three*. (The Small Country House Series.) London: Country Life; New York: Charles Scribner's Sons, 1925. 206 pp., 277 illus. and plans.

1926 Iodines, Basil. *Colour and Interior Decoration*. London: Country Life, 1926. 81 pp., 48 plates, including 8 in color.

1926 Phillips, R. Randal. *Small Family Houses*. 2d ed. London: Country Life, 1926. 159 pp. with 145 illus. from photos and plans. [A series of designs for houses (many examples actually built) that fall within the cost range of £1,000 to £3,000. A few three-bedroom plans are included, but most provide four or five bedrooms on the upper story.]

1927 *Daily Mail Ideal Houses Book*. Reproductions of the Best Designs . . . in the "Daily Mail" Ideal Houses Competition for Architects, 1927, . . . with Designs of Houses and a Bungalow Exhibited at the Ideal House Exhibition at Olympia. London: Associated Newspapers, 1927. 66 pp. of designs in plan, elevation, perspective. [The judges for this competition were E. Guy Dawber, Louis de Soissons, and C. W. Miskin; the first-prize winners for the two classes were Gordon Allen and Theophile Schaerer. Includes also 80 pp. of contemporary advertisements.]

1928 Keeley, Cecil J. H. *A Book of Bungalows and Modern Homes*. A Series of Typical Designs and Plans. London: B. T. Batsford [1928]. 80 pp. fully illus. from plans and perspective elevations. [House designs by the au-

thor, ranging from modest 3-bedroom bungalows to quite large 2-story, 7-bedroom homes. Estimates for construction in a variety of materials are given.]

c. 1930 Philpott, Hugh B. *Modern Houses and Bungalows*. Plans, Sketches, and Photographs of Houses by Many Architects with Notes and an Introduction. London: "Illustrated Carpenter and Builder" [c. 1930]. 104 pp. with many illus. from photos, plans, and drawings. [Among the architects are C. F. A. Voysey, Gordon Allen, Raymond J. Ward, G. Alan Fortescue, C. A. Crickmer, and A. M. Foxley, and Barry Parker. Several of the 100 designs were planned to qualify for government subsidy, which was discontinued after 1933.]

1930 Sutcliffe, F. and H., Inc. *Sutcliffes' Portable Buildings*. 1930 Issue. Yorkshire: Hebden Bridge, 1930. 116 pp., fully illus. plus 6 folding plates (5 in color). [Price list not included. Offers a wide array of buildings including bungalows, garages, summerhouses, garden houses and sheds, stables and loose boxes, kennels, bathing huts, and a variety of fences, gates, and garden furniture. Many of the buildings offered were of "ornamental, planed, tongued and grooved weather boards."]

1931 Phillips, R. Randal. *The House Improved*. London: Country Life, 1931. 143 pp., 136 illus. and plans.

1936 Phillips, R. Randal. *Houses for Moderate Means*. London: Country Life, 1936. 112 pp., many illus. from plans and photos. [later eds. 1946, 1947, 1949.]

1936 Smithells, Roger (ed.). *Modern Small Country Houses*. London: Country Life, 1936. 192 pp., many illus. from photos and plans. [Includes several late works by Baillie Scott and Beresford and a variety of houses designed by Howe and Lescaze, Leslie Graham Thomson, William Walter Wood, F. R. S. York, Mendelsohn and Chermayeff, Oliver Hill, and P. D. Hepworth.]

1937 Briggs, Martin S. *How to Plan Your House*. London: English Universities Press, 1937. 210 pp., illus., plus 16 plates ["Model specification approved by the National House Builders' Registration Council," pp. 185–205.]

1939 Abercrombie, Patrick (ed.). *The Book of the Modern House*. A Panoramic Survey of Contemporary House Design. London: Houghton and Stoughton [1939]. 378 pp. with 244 illus. from photos and plans plus 6 full-page color plates. [Survey of domestic architecture in Britain, including individual chapters on the country house (Guy Dawber), country cottage (Archie Gordon), townhouse (Clifford Holliday), suburban house (H. C. Bradshaw), ready-built house (Stanley C. Ramsey), working man's home (L. H. Keay), coastal homes (Clough Williams-Ellis), the house in its suburban and country setting (G. A. Jellicoe), the contemporary house (Oliver Hill), comparison studies of the house in Sweden (Karl A. Wessblad) and America (John Gloag), and comments on interiors and furnishings.]

For additional titles, see Priscilla Wrightson, ed., *The Small English House: A Catalogue of Books* (London: B. Weinreb Architectural Books, 1977), esp. 95–124.

Appendix 5

Sampling of Catalogs and Manuals on Interior and Exterior Details, 1877–1947, by Company or Publisher

Acme Cement Plaster Company, Chicago

The Perfection of All Plastering Material. Chicago: Acme Cement Plaster Company, 1893. 33 pp. [With photos of noted buildings where in use and testimonials.]

Arkansas Soft Pine Bureau, Little Rock

Satin-like Interior Trim Soft Workable Lumber. Little Rock: Arkansas Soft Pine Bureau, 1925. 48 pp., illus. [Wood moldings, designs, prices, and information for proper use.]

Beautiful Woodwork-How to Have It. Little Rock: Arkansas Soft Pine Bureau, 1926. 21 pp. [Illus. with photos of room treatments; descriptive text.]

J. W. Baily & Son, Boston

Catalogue for Carpenters and Builders, 1879. J. W. Baily & Son, Wholesale and Retail Dealers in Building Trimmings; 14 Charlestown Street; Boston, Mass. Maplewood, Mass.: William G. Perry, 1879. 40 pp., illus. [Engravings depict balusters, posts, newels, etc.]

Beaver Products Company, Buffalo

Beaver Wall Boar: The Beaver Plan Book. Buffalo: Beaver Products Company, 1925. 32 pp., many illus. [Includes photos, drawings and details; dimensions, and descriptive text for application; various finishes.]

Roofs for the Home. Buffalo: Beaver Products Company, 1926. 16 pp. [Illus. in color, showing roof shingling patterns and styles; instructions, and information.]

Becker, Smith& Page, Philadelphia

Becker, Smith, & Page Catalog. Philadelphia, 1912. 25 plates, several in color. [Plates show rooms finished with wallpaper and furniture, in several styles; each plate is titled appropriate to the style of decor.]

Berger Manufacturing Company, Canton, Ohio

Berger Manufacturing Company [*Catalog*]. Manufacturers of Berger's Patent Eaves Trough, Hangers, Corrugated and Plain Conductor Pipe, Ridge Capping, Cornices, Window Caps, etc. Steel Roofing, Corrugated Iron, Steel, Brick . . . Embossed Steel Ceilings . . . Tin Plate. Canton, Ohio: 1904. 181 pp., many illus. throughout.

Built-In Furniture Company, Berkeley, California

Architects Handbook: Peerless Built-In Furniture. Berkeley, Calf.: Built-In Fixture Company, 1925. 30 pp. [Plans and details for various installations.]

The Celotex Corporation, Chicago

Celotex Technical Notes. Applications of Celotex. Standard Building Board. For Sheathing; Under Plaster; Insulating Roofs as Interior and Exterior Finish. Chicago: Celotex Company, 1926. Small portfolio of 15 pp.

Less Noise, Better Hearing. An Outline of the Essentials of Architectural Acoustics for the Practicing Architect and Engineer. Chicago: Celotex Corp., 1941. 92 pp. [Illus. with numerous photographic plates and drawings.]

Chicago House-Wrecking Co., Chicago

Chicago House-Wrecking Co. Catalogue 110. Chicago, 1900. 177 pp. [Includes boilers, steam pumps, engines, fire apparatus, safes, gas fixtures, bath tubs, locks, tools, etc.]

Chicago Millwork Supply Company, Chicago

Guaranteed Millwork and Building Material. Chicago: Chicago Millwork Supply Company, 1912. 177 pp., illus. [Some plates are in color; hundreds of building products for sale, with prices.]

Clifford & Lawton, New York

American Interior Decoration. New York: Clifford & Lawton [c. 1905]. 55 plates. [Interior furnishing schemes in many styles. The publisher notes the four English, three German, and one French interiors exhibited at the Saint Louis Exposition (1904) "that are sure to have a marked and immediate influence on American Interior decoration and that we present in this portfolio for that purpose." Also a Japanese plate. Several designs for hotels.]

Collier-Barnett Company, Toledo, Ohio

"Bilt-Well Millwork for the Interior and Exterior of Every Home of Comfort." Toledo, Ohio: Collier-Barnett Company, n.d. 403 pp., numerous plates, some in color. [Casements and windows, incl. leaded, ceiling and paneling, cupboards, sideboards, kitchen cabinets, linen cases, breakfast nooks, stairs, newel posts, porches, art glass windows, etc.]

Co-operative Building Plan Association, New York

How to Build, Furnish, and Decorate. Consisting of Elevations and Plans for Houses, Barns, and Every Description of Out-building, Accompanied with Clear and Concise Instructions; Also, a Complete Treatise on House Furnishing and Decoration. New York: Co-operative

1730–1830. With Accounts of Houses, Places, and People. Photography by Margaret De M. Brown. New York: Payson, 1931. 205 full-page plates.

1931 Wallace, Philip B. *Colonial Houses, Philadelphia, Pre-Revolutionary Period.* New York: Architectural Book Publishing Company, 1931. 6 pp., plus 248 pp. of illus. [Measured drawings are by M. Luther Miller.]

1931 Waterman, Thomas Tileston, and John A. Barrows. *Domestic Colonial Architecture of Tidewater Virginia.* New York: Charles Scribner's Sons, 1931. 191 pp. [Illus. with 71 photos and 49 drawings.]

1932 Bennett, George Fletcher. *Early Architecture of Delaware.* Introduction and Text by Joseph L. Copland. Wilmington: Historical Press, 1932. 213 pp. [Hundreds of illus., plans, and sections.]

1932 Briggs, Martin S. *The Homes of the Pilgrim Fathers in England and America, 1620–1685.* [Oxford]: Oxford University Press, 1932. 211 pp., 96 illus.

1932 Carmichael, Virginia. *Porches and Portals of Old Fredericksburg, Virginia.* Richmond: Old Dominion Press, 1932. 46 pp., 17 full-page plates.

1932 *Chain of Colonial Houses.* Philadelphia: Association Committee of Women of Pennsylvania Museum of Art, 1932. 24 pp. of photographs, with descriptive text. [The colonial mansions in Fairmount Park, Philadelphia.]

1932 *Old Houses in the South County of Rhode Island.* Compiled by the National Society of the Colonial Dames in the State of Rhode Island and Providence Plantations. Boston, Providence: Printed by D. B. Updike at the Merrymount Press, 1932. 94 illus.

1932 Torbert, Alice. *Doorways and Dormers of Old Georgetown.* A Historic Tour. Georgetown: By the Author, 1932. 31 pp., illus. with drawings.

1933 Architects' Emergency Committee. *Great Georgian Houses of America.* New York: Kalkoff Press, 1933. 264 pp. (244 illus., including photos, plans, measured drawings, site plans.)

1933 Newcomb, Rexford. *The Colonial and Federal House.* How to Build an Authentic Colonial House. Philadelphia and London:. Lippincott, 1933. 174 pp. with 101 full-page plates from photos, plans, and drawings.

1934 Forman, Henry Chandlee. *Early Manor and Plantation Houses of Maryland.* Easton, Md.: Privately Printed, 1934. 271 pp., illus. with photos, sketches, and plans. ["An architectural and historical compendium, 1634–1800."]

1934 Lockwood, Alice G. B. *Gardens of Colony and State.* Gardens and Gardeners of the American Colonies and of the Republic Before 1840. New York: Scribner's, 1931–34. 444 pp. 2 vols., folio, many illus.

1935 Gallagher, H. M. Pierce. *Robert Mills, Architect of the Washington Monument, 1791–1855.* New York: Columbia University Press, 1935. 233 pp., many illus.

1935 National League of American Pen Women. Birmingham Branch. *Historic Homes of Alabama and Their Traditions.* [Birmingham]: Birmingham (Alabama) Publishing Company, 1935. 314 pp. [Many illustrations and map.]

1935 Orcutt, Philip Dana. *The Moffatt-Ladd House: Its Garden and Its Period, 1763.* Portsmouth, N.H.: Society of Colonial Dames of America, 1935. 48 pp., illus.

1936 Bailey, Rosalie Fellows. *Pre-Revolutionary Dutch Houses and Families in Northern New Jersey and Southern New York.* With an Introduction by Franklin D. Roosevelt. Photography by Margaret de M. Brown. Under the Auspices of the Holland Society of New York. New York: William Morrow and Company, 1936. 612 pp. with 171 full-page half-tone plates.

1936 Moore, Mrs. John. *History of Homes and Gardens of Tennessee.* Nashville: By the Garden Club of Nashville, 1936. Folio. 503 pp., illus. with hundreds of photos.

1936 Stotz, Charles M. *The Early Architecture of Western Pennsylvania.* New York: William Helburn for the Buhl Foundation, 1936. Folio, 290 pp. with hundreds of illus. from photos and measured drawings and 1 folding map. ["A record of building before 1860 based upon the Western Pennsylvania Architectural Survey; a project of the Pittsburgh chapter of the American Institute of Architects."]

1936 Tallmadge, Thomas E. *The Story of Architecture in America.* New York: W. W. Norton, 1936. 332 pp., 82 illus.

1937 Architects' Emergency Committee. *Great Georgian Houses of America,* Vol. II. New York: Scribner Press, 1937. 256 pp., 293 illus., including photos, plans, measured drawings, site plans.

1937 Frary, I. T. *Early American Doorways.* Richmond: Garrett and Massie, 1937. 193 pp., illus. with photos.

1937 Howells, John Mead. *The Architectural Heritage of the Piscataqua.* Houses and Gardens of the Portsmouth District of Maine and New Hampshire. New York: Architectural Book Publishing Company, 1937. Includes 301 illus. from photos and measured drawings.

1938 Eberlein, Harold Donaldson, and Cortland Van Dyke Hubbard. *Colonial Interiors.* Federal and Greek Revival. 3d ser. New York: Helburn, 1938. 153 full-page plates.

1939 Chamberlain, Samuel. *New England Doorways.* New York: Hastings House, 1939. 101 pp. with several hundred photographic illus.

1939 Eberlein, Harold Donaldson, and Cortland Van Dyke Hubbard. *Portrait of a Colonial City: Philadelphia, 1670–1838.* Philadelphia: Lippincott, [1939]. 580 pp. with many illus.

1939 Thomas, Elizabeth Patterson. *Old Kentucky Homes and Gardens.* Louisville, Ky.: Standard Printing Company, 1939. 180 pp., many illus.

1940 Congdon, Herbert Wheaton. *Old Vermont Houses: The Architecture of a Resourceful People.* Brattleboro: Stephen Daye Press, 1940. 190 pp. with 124 fine photographic illus.

1940 Newcomb, Rexford. *Old Kentucky Architecture: Colonial, Federal, Greek Revival, and Other Types Erected Prior to the War Between the States.* New York: Helburn, 1940. xx pp. intro., list of plates, 131 plates with over 225 photographs and measured drawings.

1940 Osburn, Burl Neff, and Bernice B. Osburn. *Measured Drawings of Early American Furniture.* Milwaukee:

Bruce Publishing Company [1940]. Many illus., including full-page measured drawings.

1941 Barrington, Lewis. *Historic Restorations of the Daughters of the American Revolution.* New York: R. W. Smith, 1941. 320 pp., illus.

1941 Johnston, Frances Benjamin. *The Early Architecture of North Carolina: A Pictorial Study with an Architectural History by Thomas Tileston Waterman.* Foreword by L. B. Holland. Chapel Hill: University of North Carolina Press, 1941. 290 pp. [Illus. with photographs by the author; historic and descriptive text, with captions.]

1941 Scott, Mary Wingfield. *Houses of Old Richmond.* Richmond: Valentine Museum, 1941. 332 pp., many illus.

1942 Eberlein, Harold Donaldson, and C. Van Dyke Hubbard. *Historic Houses of the Hudson Valley.* Sponsored by the Hudson Valley Conservation Society. New York: Architectural Book Publishing Company [1942]. 207 pp., 200 illus.

1945 Dilliard, Maud Esther. *Old Dutch Houses of Brooklyn.* New York: Richard R. Smith, 1945. 118 pp.; black and white photos, drawings.

1945 Ravenel, Beatrice Saint Julien. *Architects of Charleston.* Photographs by Carl Julien. Charleston: Carolina Art Association [1945]. 329 pp. with 107 photographic illus.

Appendix 8

A Note on Methodology

For anyone attempting to track down the possible pattern-book and catalog models for reasonably large groups of houses, the following notes on how I went about locating comparable plates for the many houses illustrated in this study will be of interest.

Before beginning my search, I familiarized myself with the general appearance of catalog houses (dating from the period c. 1840-1940) by looking through all books and catalogs of this period in my collection. With the general types in mind, I searched my own photographs (both black and white and color slides) of houses, which I had amassed in my work over the previous twenty years, recording the image number or setting aside the relevant slide (for a copy negative) for each. For my local corpus of houses, I had sixteen rolls of film shot during my house-by-house survey of the village, when I had photographed any dwelling that looked remotely as if it could have come from a book or catalog.

I then made contact prints of all the "best" examples and arranged the resulting 683 images by style and subtype in a notebook so that they could easily be reviewed. It was then simple to go through the books and catalogs I selected (ones that spanned the period in question, with appropriate overlaps) plate by plate and to turn to the page of proof photos that more or less matched the published design. Any similar, close, or exact matches to actual houses were noted with a three-part code: the level of congruency depicted, the volume in question, and its page number. (Although I also took notes along the way, these turned out to be of little use because of the way that I ultimately used the data.) In my Select Bibliography, I have listed virtually all the manuals, pattern books, and catalogs I used in this study. Those between 1842 and 1952, which I selected to go through plate by plate, are indicated by a number in brackets following the entry: This indicates the number of designs for *houses* that particular book contains, which were compared to the photographic notebook.

This project was ongoing; as new catalogs came to hand, they were surveyed in turn. Almost at once, close matches and some "identical" models were found, and the second phase of the survey could begin.

Both for proper study purposes and for possible future use, I made two xerographic copies of each catalog plate that seemed to match a particular house and prepared a three-by-five-inch card for each dwelling with its address,

level of comparison, plate in question, and xerographic copy of the proof print. Other information was added to the card as it came to hand, such as the owner's name and the negative numbers for site photos as well as copy negatives of the catalog plates. Usually, I also marked the house, if it was local, on a map with directions of sunlight at particular times of day noted with arrows so that I could efficiently rephotograph the house in the best light, from the same angle (and position) as the catalog plate. Lenses ranging from fifty to twenty-eight millimeters were used to make the match as exact as possible. These photos were usually taken in springtime when the light was at a good angle and foliage problems could be avoided if necessary.

Two xerographic copies of the plate were needed because after the photo was taken, the time was usually opportune—especially if the homeowner had observed my presence—to introduce myself to the owner, explain my project, give him or her a copy of the plate, and thereby elicit information about the house and its date. With the homeowner's name now entered on the card, I was then able to call later if I needed to survey the interior as well—or to get more information.

As I soon found out, houses with exteriors almost identical to a given plate could have interiors with somewhat different plans—and occasionally entirely different plans—from those published. To assess this situation thoroughly, I selected ninety-three houses (which I thought was a large enough sampling to make my conclusions meaningful) that I had targeted, both locally and throughout the northeast, for making measured plans. These often revealed a great deal about changes and dimensions invisible to cursory examination.

Once I had photographed a number of houses that matched their respective catalog plates, I then made copy negatives of these plates. These I printed for best contrast, and with that print in hand I could make a good comparison print (often by simply projecting the negative of the house onto the photo of the plate, slipped temporarily into the easel), which matched the plate in contrast.[1] This pro-

1. A good deal of "darkroom manipulation" is often needed, in addition to selecting the correct contrast grade, to make the best picture and/or comparison; as Jack E. Boucher once said, "Remember: 25 percent of any photograph is in the darkroom!" See Daniel D. Reiff, "An Amateur's Guide to Architectural Photography," *Historic Preservation* 27, 1 (1975), 20–23.

cedure, while at times laborious and tedious, nevertheless assures that the cropping was correct and the comparisons most effective. This nearly unending exercise, during the period I worked on this project, made study of the house and its plate far easier and more accurate.

The dwellings selected for my notebook were restricted by what I had seen and photographed, and the comparison plates were limited to what books I had selected or could obtain. The comparison, page by page, of 4,153 plates was indeed a "brute force" endeavor; but with each potential "match" visual judgment was almost always needed—as when the house photo and plate were from different angles or there were minor differences (the forms of windows and trim, extra porches, etc., which did not truly change the character of the basic design), which at first glance made the two less close than they truly are. To accurately assess the houses, such careful if time-consuming comparisons cannot be avoided.

Other comparisons between houses and book plates surfaced (in my travels) once I was familiar with a large corpus of published models, especially those that seemed to be the most popular. Even without the plate at hand, photographing the suspected catalog house from several points of view usually produced close matches to the remembered plate. A fair number of houses illustrated in this study were in fact discovered in this serendipitous manner.

An alternative method (which I did not use) of locating catalog houses is to follow up the testimonial letters in catalogs. The encomiums from satisfied customers published by Aladdin cited only the states the writers were from, but Sears was more specific. With each design, Sears usually listed several locations by city and state where that model was erected; and testimonial letters not only gave the city and state, but also the customer's name. Using local directories for that date, one could easily find the specific address for the dwelling erected. In the Bennett Homes catalogs, the letters are signed only by initials, but the city and state, and occasionally even the street address, are provided. This certainly appears to be a direct way of locating such houses.[2]

2. See also Daniel D. Reiff, "Identifying Mail-Order & Catalog Houses, *Old-House Journal* 23, 5 (1995), 30-37.

Notes

Preface

1. See full citation in the Bibliography.
2. Ibid.
3. Ibid.
4. The survey of 1973–74, of which I was project director and editor, was published the following year: Marlene Lindquist and Therold Lindquist, *Architecture in Westfield, An Historical Survey* ([Fredonia, N.Y.:] Lakeshore Association for the Arts, Inc. [1975]). The book also contains my essay (4–9), "The Design of Architecture," which briefly traces and illustrates methods of architectural design, including the uses of treatises, builders' manuals, pattern books, original architectural designs, and mail-order catalogs.

The three 1975 summer surveys covered architecture in Dunkirk, N.Y., Chautauqua Institution, and non–Greek Revival buildings throughout Chautauqua County; the two 1976 surveys studied Greek Revival architecture throughout the county and the city of Jamestown. I was the project director and editor of all five surveys, sponsored by the Lakeshore Association for the Arts, Inc. Only the first has been published: J. A. Chewning, *Dunkirk, New York: Its Architecture and Urban Development* (Dunkirk: Access to the Arts, 1992).

5. The specific books and catalogs surveyed are listed in the Bibliography.

Introduction

1. New York: Oxford University Press. The book contains 788 pages and about 950 illustrations.
2. Englewood Cliffs, N.J.: Prentice-Hall. The book contains 288 pages and about 365 illustrations.
3. New York: Charles Scribner's Sons, 1922. Kimball's parallels include designs drawn from Palladio (figs. 72–73), Abraham Swan (figs. 90–91 and 92–93), William Kent (figs. 94–95), Batty Langley (figs. 104–5), and William Pain (figs. 218–19).
4. Clay Lancaster, "Builders' Guides and Plan Books and American Architecture from the Revolution to the Civil War," *Magazine of Art* 41, 1 (1948), 16–22.
5. Abbott L. Cummings, "An Investigation of the Sources, Stylistic Evolution, and Influences of Asher Benjamin's Builders' Guides" (Ph.D. dissertation, Ohio State University, 1951).
6. Kimball was not alone in recognizing the importance of printed illustrations in the development of American architecture. Talbot Hamlin's *Greek Revival Architecture in America* (New York: Oxford University Press, 1944) considers their significance at length and illustrates a number of features drawn from plates in books by Benjamin and Lafever (see Hamlin, plates XCI–XCIV).
7. First published in the *Journal of the Society of Architectural Historians* (*JSAH*) (October 1961), the revised and expanded listing was issued in book form by Hennessey & Ingalls, Inc., in 1973.

8. First published in 1946, a revised edition was issued by the University of Minnesota Press in 1962.
9. Eileen Harris, assisted by Nicholas Savage, *British Architectural Books and Writers 1556–1785* (Cambridge: Cambridge University Press, 1991); and John Archer, *The Literature of British Domestic Architecture, 1715–1842* (Cambridge, Mass.: MIT Press, 1985).
10. See *1908 Catalogue*, 594–97. Related material in this catalog is on 574–81 (machines for making concrete blocks and other architectural features), and 589–91 and 604–13 (building supplies, interior mill work, plumbing, and heating).
11. See Daniel D. Reiff, *Architecture in Fredonia, 1811–1972* (Fredonia, N.Y.: Michael C. Rockefeller Arts Center Gallery, 1972), 92–93.

This work was revised and enlarged later as *Architecture in Fredonia, New York, 1811–1997* (Fredonia, N.Y.: White Pine Press, 1997). A few references are to illustrations or data found only in this edition; because it has an index, other material can be located here easily as well.

12. Ibid. The blueprints lacked any architect's or building company's name, and instead of cardinal directions, facades were labeled "left," "right," and so on.
13. Two other factors led me to believe that mail-order plans might be a significant but overlooked source of house designs. In 1969, Charles H. Atherton (Secretary of the U.S. Commission of Fine Arts and also an architect) lent me a copy of Floyd A. Dernier's book of house designs *Distinctive Homes (22nd Edition)*, published sometime in the 1920s by the Lumbermen's Service Association of Los Angeles. Although Dernier was listed as "compiler and copyrighter," there was no entry at all for him in *Union Catalog Pre 1956 Imprints*, suggesting that these frequently issued booklets were distributed and "used up," rather than saved and cataloged. One of Dernier's designs was extremely close to the 1930 Fredonia house mentioned above, suggesting the national scope of such catalogs (see *Architecture in Fredonia*, figs. 184 and 186). Furthermore, about 1971, I purchased a twelve-page color wall calendar of 1922 issued by the P. Smith Sons Lumber Company of Newark, Ohio, illustrated with views of houses and farm buildings—whose plans evidently could be ordered (ibid., fig. 168). It thus appeared to me that such plans were at one time common, but because the catalogs, calendars, or flyers were ephemera, they had dropped from sight.
14. Reiff, *Architecture in Fredonia*, 86–87. See also 11.
15. Patricia Poore, "Pattern Book Architecture: Is Yours a Mail-Order House?" *The Old-House Journal* (*OHJ*) 8, 12 (1980), 183, 190–93.
16. *Landscape* 25, 3 (1981), 1–9.
17. *Winterthur Portfolio* (*WP*) 16, 4 (1981), 309–34.
18. Marylu Terral Jeans, "Restoring a Mail-Order Landmark," *Americana*, 9 (May/June, 1981), 40–47.
19. Kay Halpin, "Sears, Roebuck's Best-Kept Secret," *Historic Preservation* 33, 5 (1981), 24–29.
20. Also of considerable interest was reprinting a catalog of interior details (doors, trim, "colonnades," mantels, etc.) that were

also available by mail: *Gordon-Van Tine Co. Architectural Details 1915* (Watkins Glen, N.Y.: American Life Foundation, 1985).

21. The Jones volume was given a new title: *Authentic Small Houses of the Twenties . . .* when reprinted. Dover also recognized the importance of mail-order architectural detail catalogs and issued a reprint of E. L. Roberts and William L. Sharp's catalog No. 500 of 1903 as *Roberts' Illustrated Mill work Catalog* in 1988.

22. Katherine Cole Stevenson and H. Ward Jandl, *Houses by Mail: A Guide to Houses from Sear, Roebuck & Co.* (Washington, D.C.: Preservation Press, 1986). This book is not a reprint of any specific Sears catalog, but rather an illustrated compilation of virtually all 454 designs sold between 1908 and 1940. See my review in *JSAH* 47, 2 (1988), 212–13. Alan Gowans's study was *The Comfortable House: North American Suburban Architecture 1890–1930* (Cambridge, Mass.: MIT Press, 1986).

23. Robert Schweitzer and Michael W. R. Davis, *America's Favorite Homes: Mail-Order Catalogues as a Guide to Popular Early-20th-Century Houses* (Detroit: Wayne State University Press, 1990).

24. Evie T. Joselow, *The Ideal Catalogue House: Mail-Order Architecture and Consumer Culture, 1914–1930* (Ann Arbor, Mich.: UMI Dissertation Services, 1998). Written as a doctoral dissertation for the City University of New York, this includes new information on companies I have studied here (Sears, Aladdin, Harris Brothers, and Bennett Lumber Company) and companies mentioned only in passing (Montgomery Ward, Sterling Homes, Lewis Manufacturing Company, Gordon-Van Tine, and E. F. Hodgson Company). Her section on industrial housing developments by some of these companies—including Aladdin—is especially interesting.

25. Especially in the 1970s, original copies of house-plan books and catalogs were difficult to find; they began to be offered in antiquarian booksellers' lists in the 1980s. A convenient source for citations of some of the more ephemeral items is E. Richard McKinstry, *Trade Catalogues at Winterthur: A Guide to the Literature of Merchandising, 1750 to 1980* (New York: Garland, 1984), which puts the house-plan books in the context of catalogs for other architectural items, such as mantels, moldings, and interior and exterior details. Eleven house-plan books (nos. 118, 119, 121, 123, 131, 137, 138, 153, 171, 175, and 181) are listed in the citations of 103 "Architectural Building Plans and Materials" items, 19–37. The architectural plan books—one of which specifically notes that "working plans and elevations" could be purchased from the publisher—date between 1864 and 1900.

Some additional plan books (also in the context of building-component catalogs) can be found in Lawrence B. Romaine, *A Guide to American Trade Catalogs, 1744–1900* (New York: R. R. Bowker, 1960), 25–38. A number from before 1895 are also listed in Hitchcock, *Architectural Books.*

To augment these research tools, I have added in Appendixes 1 and 2 two annotated compilations or "Samplings" of house-plan books from the nineteenth and twentieth centuries, which include 197 entries (and also an annotated sampling of 116 building components and materials catalogs). See also my Bibliography.

Many architectural "trade catalogs" are available on microfiche. Clearwater Publishing Company issued *Trade Catalogues from Avery* (1988), which reproduces about 2,300 catalogs pertaining "primarily to architecture and the building arts" held by the Avery Architectural and Fine Arts Library at Columbia University. It also published *Trade Catalogues at Winterthur* (1984).

Naturally the Library of Congress has copies of many such catalogs of well-known companies (such as Standard Homes, Aladdin, and Sears). The Avery Architectural and Fine Arts Library, Colum-

bia University, however, is now probably the best library source for architectural trade catalogs.

26. This exhibition, held between October 30, 1988, and April 30, 1989, at the Cornelius Low House/the Middlesex County Museum, Piscataway, New Jersey, was curated by Robert P. Guter and Janet W. Foster, with photography by Jim DelGiudice. Complete with architectural models and historic artifacts, it occupied eight rooms of the museum. Fortunately the excellent exhibit was subsequently transformed into a book (see Bibliography) published in 1992. My thanks to Kyle Nardelli, curator, for her assistance during my visit of April 1989.

The Guter and Foster book documents a number of houses based on volumes that I also cover; but good examples from books I have omitted (specifically William Ranlett's *The Architect*, 1854, and John Riddell's *Architectural Designs*, 1861) are also illustrated. So as not to overlap the pairs included in Guter and Foster's work—to expand the number of comparative examples available to researchers—I have largely avoided using illustrations of pattern-book houses from New Jersey in this study.

27. *WP* 15, 3 (1980), 285.

1: Architectural Books in England, c. 1550–1750

1. See Frank E. Brown, "Vitruvius," in Adolf K. Placzek, ed., *Macmillan Encyclopedia of Architects* (New York: Free Press, 1982), 4: 334–41, and also Dora Wiebenson's essay on his writings, ibid., 341–42. For a listing of editions and translations of Vitruvius with commentary on each, see the entries in Dora Wiebenson, ed., *Architectural Theory and Practice from Alberti to Leduc*, 2d rev. ed. (Chicago: University of Chicago Press, 1983). This volume, which provides full bibliographic entries for European architectural treatises, lists works by 167 authors. It is the source used in this chapter for information on non-English architectural volumes.

2. When translated into Italian and published by Cosimo Bartoli (Florence, 1550), more than sixty woodcut illustrations were added. The most recent modern translation, Leon Battista Alberti, *On the Art of Building in Ten Books*, trans. Joseph Rykwert, Neil Leach, and Robert Tavernor (Cambridge, Mass.: MIT Press, 1988), includes the Bartoli illustrations.

The Introduction (n.p.) in Wiebenson, ed., *Architectural Theory*, contains an excellent summary and analysis of the development of the architectural book in these early years.

3. For the general context of medieval building design, see Spiro Kostof, "The Architect in the Middle Ages, East and West," in Spiro Kostof, ed., *The Architect: Chapters in the History of the Profession* (New York: Oxford University Press, 1977), 59–95.

4. Theodore Bowie, ed., *The Sketchbook of Villard de Honnecourt* (Bloomington: Indiana University Press, 1959). For information on his life and his book, see François Bucher, "Villard de Honnecourt," in Placzek, ed., 4: 322–24.

5. Bucher, 322–23. In his notebook, the Laon drawings are plates 39 and 40. Villard also at one point observed (in the caption to a drawing of a window at Rheims Cathedral): "I had been invited to go to Hungary when I drew this, which is why I liked it all the more" (Bowie, 102). That he had work at other sites in mind when he made his drawings is signaled by his comment on a drawing of the exterior elevation of the Rheims apse chapels: "If those at Cambrai are done properly they will look like this" (Bowie, 94).

6. Bowie, 94–105 (plates 42–47).

7. This discussion on the introduction of classical elements and design into England in the sixteenth century is based mainly

on John Summerson, *Architecture in Britain, 1530–1830*, 5th ed. (Harmondsworth, Middlesex: Penguin Books, 1970), 29–79. See also Malcolm Airs, *The Making of the English Country House, 1500–1640* (London: Architectural Press, 1976), 1–45; Frank Jenkins, *Architect and Patron: A Survey of Professional Relations and Practice in England from the Sixteenth Century to the Present* (London: Oxford University Press, 1961), 1–57; and John Harris, *The Design of the English Country House, 1620–1920* (London: Trefoil Books, 1985), 9–14.

8. Summerson, fig. 6.

9. Ibid., fig. 11.

10. Bibliographic information on the following architectural volumes is drawn mainly from Wiebenson, ed., *Architectural Theory*, and also (if it is an English imprint) from Eileen Harris, *British Architectural Books and Writers, 1556–1785* (Cambridge: Cambridge University Press, 1990). This volume also contains extensive biographical essays on each of the authors.

For the context of early architectural books, see chap. 7, "English Literature on Architecture," in Rudolf Wittkower, *Palladio and Palladianism* (New York: George Braziller, 1974), esp. 95–102.

11. Summerson, 42–43.

12. E. Harris, 418, 421.

13. Summerson, 24.

14. Ibid., 59.

15. The very first of the illustrated books on the orders, for craftsmen and clients, seems to have been Diego de Sagredo's *Medidas del Romano* (Toledo, 1526). It was based on Vitruvius's Books III and IV but included many ancillary decorative details as well. A French translation appeared in Paris about 1537 and another in 1542; it was reprinted five times in Spanish. As Wiebenson explains (*Architectural Theory*, introduction, section III A), "Serlio's even more popular Book IV . . . may have been written simultaneously, although it was published just over ten years after Sagredo's Spanish first edition appeared. Both of these books, but especially Serlio's, were extremely popular."

16. Ibid., 48 and fig. 23.

17. Ibid., 56. See also E. Harris, 120–22.

18. Certainly his book is a source for many of the classical motifs from this era that can be traced. As Summerson says (56), "Serlio was unquestionably the most widely recognized authority."

19. Summerson, 48.

20. For the drawing, see Summerson, fig. 29. The globes are found in Serlio I, Book IV, fols. 42, 51, 54, 58, and 61.

21. On the Wollaton Hall plan, see Summerson, 67–68; for the chimneypieces, see Mark Girouard, *Robert Smythson and the Architecture of the Elizabethan Era* (New York: A. S. Barnes and Co., [1967]), plates 40–41.

22. Summerson, 75.

23. Girouard, plates 80–81.

24. Condover Hall is discussed by Summerson, 76–77; for Burghley House tower, see his fig. 40. For a detail of the Condover Hall doorway, see William H. Pierson Jr., *American Buildings and Their Architects: The Colonial and Neoclassical Styles* (Garden City, N.Y.: Doubleday, 1970), fig. 21.

25. Pierson (39) states that it is "not a pure Renaissance motif" but one "adulterated by misuse in a hybrid English style."

26. Besides many doorways generally similar to this, Serlio includes two that specifically depict arched openings flanked by Doric columns supporting an entablature and pediment: Book III, fol. 25v (fig. B), and Book IV, fol. 22. Serlio does depict several Roman triumphal arches in Book III, but not the arch at Rimini; nor is it illustrated by Palladio. This may be because it is a com-

memorative city gate rather than a full-fledged freestanding triumphal arch.

27. It is illustrated in John B. Ward-Perkins, *Roman Architecture* (New York: Harry N. Abrams, 1977), plate 242.

28. Montacute House, in the context of the introduction of classical motifs during this period, is discussed in Daniel D. Reiff, *Small Georgian Houses in England and Virginia: Origins and Development Through the 1750s* (Newark : University of Delaware Press, 1986), 24–26; for a bibliography on the house, see 60 n. 13.

29. For the English use of Dutch gables in the seventeenth (and eighteenth) century, see Reiff, *Georgian Houses*, 40–42.

30. The plates in Serlio's Book IV are as follows: Tuscan columns, fols. 3 and 5; Doric pedestals, fol. 3; capitals with rosettes, fol. 17v; arched doorway above steps, fol. 55; shell-topped niches, fol. 50; Doric entablature, fol. 19; Ionic entablature, fol. 36; beveled panels, fol. 15; segmental pediments over windows, fol. 28; and balustrades, fol. 52. The rusticated arched doorway may come from Book II, fol. 18.

The row of pyramidal bosses that enrich the Ionic entablature finds no exact source in Serlio. It is possibly based on portions of fol. 15 of Book IV; or perhaps it is drawn from Wendel Dietterlin's *Architectura* (Nuremberg, 1598), plates 9–11. Another possible source might be the unique Palazzo dei Diamanti in Ferrara (1493–1516; completed 1567), which is covered entirely with such little pyramids—*except* in the entablatures. (For an illustration of the Palazzo, see Placzek, ed., 3: 517.)

It will be noted that the *chimneys* on Montacute are also made in a classical form—Serlio's Tuscan columns. That this is a foreign practice is borne out by Sir Henry Wotton's observation a generation later in *The Elements of Architecture* (London, 1624) of the Italians' "manner of disguising the shafts of Chimneys in various fashions, whereof the noblest is the Pyramidall" (108).

31. The circles are seen in Book IV, fol. 55, and other plates.

32. For the obelisks, see fol. 55.

33. The "Nine Worthies" were Hector, Alexander the Great, Julius Caesar (three Gentiles); Joshua, David, and Judas Maccabaeus (three Jews); and King Arthur, Charlemagne, and Godfrey of Bouillon (three Christians). For the Roman-type soldier in Shute, see the plate "Dorica" facing fol. vi.

34. Summerson, 68.

35. Ibid., 56.

36. Ibid., 71.

37. Ibid., 86.

38. Ibid., 56.

39. The additive nature of classical detailing on traditional building types as we have seen throughout the century is not the only indication of this process. Summerson, *Architecture in Britain*, cites the building accounts of Hengrave Hall, Suffolk (begun in 1525), which, with the piecemeal division of building responsibility, documented the fact that, as he puts it, "a great house was 'assembled' rather than 'designed'" (39).

40. *The Elements of Architecture, Collected by Henry Wotton Knight, from the best Authors and Examples* (London: John Bill, 1624) was reprinted in facsimile by the University Press of Virginia in 1968. The introduction by Frederick Hard includes biographical data, as well as the sections "The Background of Elizabethan Interest in Architecture" (lv–lxv) and "The Vitruvian and Palladian Tradition in England" (lxv–lxxxiii). See also E. Harris (499–503) for an analysis of the book and its influence.

41. Wotton explains (74) that he has left specific designs to the architect: "It might heere perchance bee expected, that I should at least describe (which others have done in draughts and designes)

divers Formes of Plants and Partitions, and varieties of Inventions; But speculative Writers (as I am) are not bound, to comprise all particular Cases, within the Latitude of the Subject, which they handle; General Lights, and Directions, and pointings at some faults, is sufficient. The rest must be committed to the sagacitie of the Architect, who will bee often put to divers ingenious shifts."

42. The following discussion of Jones is drawn largely from Summerson, *Architecture in Britain*, 111–202 ("Inigo Jones and His Times [1610–60]"); John Summerson, *Inigo Jones* (Baltimore, : Penguin Books, 1966); John Harris, Stephen Orgel, and Roy Strong, *The King's Arcadia: Inigo Jones and the Stuart Court* (London: Arts Council of Britain, 1973); Wittkower, *Palladio and Palladianism*, 50–64 ("Inigo Jones, Architect and Man of Letters"); and John Harris, "Inigo Jones," in Placzek, ed., 2: 504–13.

43. The New Exchange design and the proposal for Saint Paul's tower are illustrated in Summerson, *Inigo Jones,* figs. 4 and 5, and in Harris et al., *King's Arcadia,* figs. 28 and 30. Serlio was one of the books documented as owned by Jones and in fact, was "one of the most fully annotated books" in his library (Harris et al., *King's Arcadia,* 64).

Although it is generally thought that Jones bought his copy of Palladio in Venice in 1601, the annotations in it all date after 1613, so that he may have purchased it only on his second trip. Ibid., 64–65.

44. For the Hatfield House gallery in context, see Summerson, *Architecture in Britain*, fig. 54; for a detail of it, see Harris et al., *King's Arcadia,* fig. 31. John Harris, "Inigo Jones," 505, considers the classical gallery in Robert Lyming's design to have been a "revision" by Jones.

45. For illustrations of these, see Girouard, *Smythson,* plates 141–43 and 145–54.

46. Jones's ability to see architectural design as a totality was closely bound up with his fluid "Italianate" drawing style. As Summerson (*Architecture in Britain*) observes: "It is not simply the ability to draw which is significant, but the state of mind, the sense of control of which that ability is the outward sign" (112). For illustrations of his drawings, see Harris et al., *King's Arcadia.*

47. Jones was granted the "reversion" of the position of surveyor in April 1613; he took office in 1615 when the incumbent died. The title "surveyor" needs some clarification. As we have seen, during the sixteenth and into the seventeenth century, building design was created from many sources: ideas shared among the owner or patron and the craftsmen and augmented by the emulation of pre-existing models and the craftsmen's experience and inventiveness, sometimes with the prompting of printed illustrations. Often the ideas might be coordinated by the master-craftsman (be it the carpenter or mason) who supervised the other artisans. The idea of the *architect,* a person who created the overall design, sometimes down to the smallest detail, and supervised its execution by the craftsmen, was essentially unknown then, even though in the Middle Ages a master craftsman might rise in status to act *as* an architect. The *surveyor* (often of origin a craftsman) grew in importance after the 1540s and the dissolution of the monasteries. These former church properties and those of the king (who was now the largest holder of land and buildings in the realm) needed to be measured, surveyed, and recorded and the buildings on them repaired or added to. Thus an experienced surveyor was well qualified to propose and draw up plans for new buildings and even to make "uprights" (elevation drawings). The splendid drawings by John Thorpe reproduced in John Summerson, ed., *The Book of Architecture of John Thorpe in Sir John Soane's Museum* (Glasgow: Printed for the Walpole Society, 1966) show how capable one could be. As Summerson notes, "[H]is career had less to do with build-

ing than with the measurement of land and the cataloging of tenancies. He was . . . one of the most eminent land surveyors of the reign of James I" (12). For an excellent discussion of the surveyor, see Jenkins, *Architect and Patron,* 31–39.

Although the term *architect* was revived by John Shute and Henry Wotton from the example of Vitruvius (who discussed the wide-ranging expertise required of an architect), Inigo Jones was in fact the first man in England to truly fit the description. See also John Wilton-Ely, "The Rise of the Professional Architect in England," in Kostof, ed., *The Architect,* 180–208.

48. For this comparison, see Reiff, *Georgian Houses,* figs. 19–20.

49. Jones had a good number of architectural treatises in addition to Palladio; Scamozzi is one of the documented volumes. See Wittkower, 62.

50. For the first two drawings, see Reiff, *Georgian Houses,* figs. 21 and 24; for the completed building, Summerson, *Architecture in Britain,* fig. 79.

51. Palladio, Book II, plate 14, and Scamozzi, Book II, 126 (repeated in Book III, 260); for illustrations of these, see Reiff, *Georgian Houses,* figs. 26–27.

52. Harris, "Inigo Jones," 506.

53. See Wittkower, 52–53 and figs. 86–88.

54. For a discussion of Jones's library and a listing of the books, see Harris et al., *King's Arcadia,* 64–65 and 217–18.

55. Summerson, *Architecture in Britain,* 90. For the Jones balcony and doorway and Smythson's drawing of it, see Harris et al., *King's Arcadia,* figs. 190 and 191; for the gateway, figs. 185 and 186.

56. The inscription reads: "Mr Surveyors desygne."

57. For the Serlio design, Book VII, 191, see Reiff, *Georgian Houses,* fig. 126.

58. The drawing is inscribed: "uprighte for my Lo Maltravors / his house at Lothbury 1638".

59. Serlio had moved to France to work for François I in 1541; Book VII was prepared in France and may reflect northern practices. Jacopo Strada purchased the manuscript from Serlio in 1552/3, and it was published in Italian and Latin in Frankfurt in 1575.

60. Four other houses of this type are depicted in Reiff, *Georgian Houses,* and range in date from 1616 to 1676; see figs. 191, 311, 312, and 318.

61. In Reiff, *Georgian Houses,* see "The Small House: Professional Designs, 1620–1750," 99–122, and "The Small Brick House and the Vernacular Tradition," 123–88.

62. For a glimpse of Jones as a connoisseur of paintings, see "Inigo Jones—Puritanissimo Fiero," in Wittkower, *Palladio and Palladianism,* 66–70.

63. Wotton, 11–12. At this point in his treatise, Wotton is making the distinction between the architect and a superintendent of works: "I must heere remember that to choose and sort the materials, for every part of the Fabrique, is a Dutie more proper to a second Superintendent, over all the Under Artisans called (as I take it) by our Author [Vitruvius] *Officinator* lib. 6. cap. 11. and in that Place expressly distinguished, from the Architect, whose glory . . ." (11).

64. The main source of information on Pratt is R. T. Gunther, ed., *The Architecture of Sir Roger Pratt . . .* (Oxford: Printed for the Author, 1928); biographical information is primarily on 1–17.

65. Pratt's comments (in Gunther, ed., 23–24) on the nature of the architect are worth quoting at length: "No man deserves the name of an Architect, who has not been very well versed both in those old [houses] of Rome, as likewise the more modern of Italy and France etc. because that with us, having nothing remarkable but the banquetting house at Whitehall and the portico at St. Paul's,

it is no ways probable that any one should be sufficiently furnished with the variety of invention, and of excellent ideas, which upon several occasions it will be necessary for him to have. . . . True it is that a man may receive some helps upon a most diligent study from those excellent, and most exact designs of Palladio, Freart, Scamozzi, and some few others, yet never having seen anything in its full proportions, it is not to be thought that he can conceive of them as he ought."

66. For a discussion of Coleshill in the context of the influences on its design, see Reiff, *Georgian Houses*, 50–56. For a bibliography with full illustrations of Coleshill—valuable because it was demolished in 1953 after burning the year before—see ibid., 63 n. 79.

67. Pratt's criteria for country houses for gentlemen are in Gunther, ed., 29–30; for noblemen, 30–31; and for "Princes, Kings, etc.," 32–33.

68. Gunther, ed., 30.

69. Ibid., 80.

70. In referring to the designs in Book II of *Palazzi . . . di Genova Raccolti e Designati da Pietro Paolo Rvbens* (Antwerp, 1652), Pratt comments (Gunther, ed., 37): "There are about 6 of them, which besides the greate door of the Entrance, the cinctures [belt courses] of buildings, and the balustred stools of the windoes etc., the Arch: freeze, Cornish and Piedistal at the toppe, seem to be void of all other Ornaments of the walleing, except what the just symmatrie of the parts doe naturally give them." It could almost be a description of Coleshill.

71. The first book of Rubens's volume is *Palazzi Antichi di Genova;* it contains seventy-two plates. The second book, with sixty-seven plates, is entitled *Palazzi Moderni di Genova.* Pratt critiques these designs in his notebooks (Gunther, ed., 37–40).

72. See Reiff, *Georgian Houses*, 34–38.

73. Pratt mentions books in his possession in his notebook (Rubens's book, for example), but there are also lists of books purchased or books Gunther found in the Pratt library; see 6–7 and 302–4.

74. The Serlio design with roof chimneys was reproduced in Oliver Hill and John Cornforth, *English Country Houses: Caroline, 1625–1685* (London: Country Life, 1966), fig. 125.

75. James Lees-Milne, *English Country Houses: Baroque, 1685–1715* (London: Country Life, 1970), 212.

76. For these two houses, see Reiff, *Georgian Houses*, 54–58.

77. Lees-Milne, 215.

78. See Reiff, *Georgian Houses*, 64–67.

79. In houses for noblemen, "we likewise sometimes find a frontispiece [pediment] in the midst with a noble shield with festoons to it" (Gunther, ed., 31). In his notebooks, Pratt uses *frontispiece* to mean pediment, as is clear from the following: He refers to Saint Paul's in London and observes that the classical portico, added by Jones, is very fine, "but without a frontispiece is very unusual" (294). Elsewhere he uses the word *pediment* to mean base or pedestal. For an illustration of this portico sans pediment, see Harris et al., *King's Arcadia,* 140.

80. Wotton mentioned quoins with approval (29): "Lastly, that the Angles bee firmly bound, which are the Nerves of the whole Edifice, and therefore are commonly fortified by the Italians, even in their Bricke buildings, on each side of the corners, with well squared stone, yeelding both strength and grace."

81. Gunther, ed., 295–96.

82. Pediments, mainly capping a classical portico, are after all one of the dominating features of Roman temples. Palladio adopted them for domestic use, and they are found on most of his villas, almost always above a columned portico.

83. See Book II, plates 32 and 41. Pediments without columns or pilasters below them are more common for subsidiary wings to villas, as in plates 31, 32, 45, 51, and 58.

84. Many of the grandest palaces and country seats of the sixteenth and seventeenth centuries were of brick, such as Hampton Court Palace (begun 1515) or Hatfield House (1607–11). For a discussion of brick building in England up to the 1630s, see Reiff, *Georgian Houses*, 38–44.

85. Pratt produced *two* houses of this type at this time; the second was Horseheath, Cambridgeshire. It was designed in 1662 for Lord Allington and built in 1663–65. Somewhat larger (it had a bay system of 4/3/4 versus that of 3/3/3 at Kingston Lacey), it was faced entirely in stone (brick was used for the core, however). See ibid., 66–67.

86. For Melton Constable, see ibid., fig. 99. For a tabulation of the Kingston Lacey--type buildings, see 320–22.

87. Ibid., 83.

88. For plate 51, see ibid., fig. 115.

89. Andor Gomme, "Smith and Rossi," *Architectural History* 35 (1992): 183–91. This includes eighteen illustrations of architectural details by Smith and related Rossi plate (see figs. 1, 3, 4, 5, 7, and 9–21). The gentleman-architect Thomas Archer also used Rossi for distinctive detailing (see figs. 1, 2, and 8–10). For Smith, see also Placzek (ed.), 4: 87–88.

90. Gomme, 183, citing a study by Alistair Rowan.

91. Wanstead was reproduced in *Vitruvius Britannicus* I, plates 22–25. For three houses "which were conscious and studied derivatives," see Summerson, *Architecture in Britain,* 322–25; see also Paul Breman and Denise Addis, *Guide to Vitruvius Britannicus: Annotated and Analytic Index to the Plates* (New York: Benjamin Blom, 1972), 24.

92. For this development, see Reiff, *Georgian Houses*, 123–66.

93. For Delbridge House, see ibid., 152–55 and 179–81. The door casing now on the house is a modern replacement of the deteriorated original; for a photograph of the original, see ibid., fig. 244. The semicircular bays at each end of Delbridge House were added in the nineteenth century.

94. The best coverage of this topic is "English Literature on Architecture," in Wittkower, *Palladio and Palladianism,* 94–112, and the introductory chapters in E. Harris, *British Architectural Books,* 23–68. See also "Pattern Books and the Small Hipped-Roof Brick House," in Reiff, *Georgian Houses*, 173–81; and John Harris, "The Pattern Book Phenomenon," in Mario di Valmarana, ed., *Palladian Studies in America, I: Building by the Book 2* (Charlottesville: University Press of Virginia, 1986), 101–15.

95. See Reiff, *Georgian Houses*, fig. 281.

96. E. Harris, 33. For example, see the two door cases published by Batty Langley as plate 31 in his *The City and Country Builder's and Workman's Treasury of Design* (1740), which are copied directly from Gibbs's plates 102 and 195 (Reiff, *Georgian Houses*, figs. 296, 297, and 298). Other examples of Langley's pirating from Gibbs in this book include another pair of door cases (with prominent keystones) in his plate 30, taken from Gibbs's plate 104, nos. 1 and 3; and a fireplace design (plate 83) from Gibbs's plate 91, no. 3. In fairness to Langley, it should be noted, however, that he "improved" the borrowed designs by adding dimensions and guides to correct proportioning; at the bottom of each plate, he notes: "The Measures Invented, Proportioned, and affixed by Batty Langley 1739."

97. Wittkower, 95.

98. These numbers are derived by E. Harris's "Chronological Index of Titles and Editions," 513–32.

99. For examples, see Dan Cruickshank and Peter Wyld, *London: The Art of Georgian Building* (London: Architectural Press, 1975), Part II; plates 15, 19, and 89 show doorway designs by Gibbs, and plates 16, 20, 90, and 91 depict London doorways based on them; plate 61 shows a design in Abraham Swan's *A Collection of Designs in Architecture* (1757) and plate 62 the doorway based on it.

100. For illustrations of these, see Reiff, *Georgian Houses*, figs. 296–98.

101. In all fairness, it should be mentioned that Langley does state on the title page of *Ancient Masonry, Both in the Theory and Practice* that he includes the "orders of the most eminent masters of all nations" and then enumerates twenty-one of them (including Alberti and Palladio, as well as Jones and Wren). As John Harris notes (in Placzek, ed., 2: 608), "nearly all its five hundred or more plates were plundered from the works of others." *Zusammengestohlen* perhaps describes it best.

102. Cruickshank and Wyld, 212, fig. 65 for Pain's plate, and 120, fig. 63 for a London doorway, dated 1753, of the same style.

103. Ibid., 121.

104. Ibid., 84.

2 Architectural Books in Eighteenth- and Early Nineteenth-Century America

1. For illustrations of two such farmhouses from about 1650, see Reiff, *Georgian Houses*, figs. 191 and 311.

2. For illustrations of this type of house from the 1690s through the 1740s, see ibid., figs. 203–79.

3. For studies of American architecture, which include illustrations of most of the buildings to be discussed in this chapter, see Fiske Kimball, *Domestic Architecture of the American Colonies and of the Early Republic* (New York: Charles Scribner's Sons, 1922); Hugh Morrison, *Early American Architecture from the First Colonial Settlements to the National Period* (New York: Oxford University Press, 1952); and Part I of Marcus Whiffen and Frederick Koeper, *American Architecture, 1607–1976* (Cambridge, Mass.: MIT Press, 1981). Specifically for the seventeenth century in Massachusetts, see Abbott Lowell Cummings, *The Framed Houses of Massachusetts Bay, 1625–1725* (Cambridge, Mass.: Harvard University Press, 1979); in Virginia, see Reiff, *Georgian Houses*, 189–220.

4. See Abbott Lowell Cummings, "The Beginnings of Provincial Renaissance Architecture in Boston, 1690–1725," *JSAH* 42, 1 (1983), 43–53.

5. See Reiff, *Georgian Houses*, 222–23.

6. Ibid., 224–26; and 209–12, 231–32.

7. For the Jaquelin-Ambler House (little known because it has been in ruins since the 1890s), see Reiff, *Georgian Houses*, 234–36.

8. Ibid., 235–37.

9. Although at first glance the fine brick door casings found on many public buildings (and two dwellings) in Virginia in the 1740s and 50s may appear to suggest pattern-book prototypes, a closer examination reveals that they are very simple in their design and detailing and are well within the capabilities of Virginia bricklayers of the time (see ibid., figs. 388, 390, 391, and 409; the door casing at Ware Church, fig. 389, is of uncertain date). It is in comparison to these that the elaborately carved and accurately detailed brick door cases at Christ Church (1722–31) and at Rosewell (c. 1726–37) stand out so clearly (see ibid., figs. 489–90). In both these cases, the buildings employ fluted keystones that are identical to comparable work in London and were certainly imported (see ibid., figs. 494–95). Rosewell was the largest and most advanced brick dwelling in Virginia at the time; it was unique in being of London townhouse design, and it seems likely that a London bricklayer was brought over to supervise the massive undertaking and to execute the more complicated detailing in brick—like the door casings.

10. For Drayton Hall, see Morrison, 401–4; and John Cornforth, "The Future of Drayton Hall," *Country Life*, August 1, 1974, 290–93; see also Jane Brown Gillette, "American Classic," *Historic Preservation* 43, 2 (1991), 2, 21–29, 71–72.

The comparable facade illustration in Leoni's version of Palladio is reproduced in Morrison, fig. 309.

11. "Over many decades, scholars of Virginia architecture have looked for pattern-book designs that would be models for the facades and plans of tidewater houses of the first half of the eighteenth century: neither [Thomas T.] Waterman nor [Marcus] Whiffen nor [Paul] Buchanan found any, and the author's own study of thirty-five of the major pattern books published in 1755 or before arrived at the same conclusion. While there may be an occasional feature that might have been a source for an exterior detail, no overall plans or elevations are at all close." Reiff, *Georgian Houses*, 279.

12. For the east elevation of Drayton Hall, showing the three window enframements and the door casing, see Morrison, fig. 336.

13. For illustrations of the Rosewell and Westover door casings and the comparative material, see Reiff, *Georgian Houses*, figs. 494–95 and figs. 465–68. For the Westover fireplaces, see Thomas T. Waterman, *The Mansions of Virginia 1706–1776* (1945; reprint ed., New York: Bonanza Books, n.d.), 160–61. It may also be that the marble fireplace in the first floor main parlor is also imported, for it is very close to a design shown in Gibbs (1728) and at this early date would also have to be brought from England; see Waterman, 156–57.

14. See Arthur L. Finney, "The Royall House in Medford: A Re-Evaluation of the structural and Documentary Evidence," in Abbott Lowell Cummings, ed., *Architecture in Colonial Massachusetts* (Charlottesville: University Press of Virginia, 1979), figs. 6–7.

15. Morrison, 403. For the Kent design, see Kimball, fig. 95; for the fireplace, see Gillette, 21.

16. Helen Park, *A List of Architectural Books Available in America Before the Revolution*, rev. ed. (Los Angeles: Hennessey & Ingalls, 1973); Janice G. Schimmelman, *Architectural Treatises and Building Handbooks Available in American Libraries and Bookstores Through 1800* (Worcester, Mass.: American Antiquarian Society, 1986).

17. For the library facade, see Carl Bridenbaugh, *Peter Harrison, First American Architect* (Chapel Hill: University of North Carolina Press, 1949), fig. 15 (or Morrison, figs. 373 and 375); for the Hoppus design, see Bridenbaugh, fig. 16 (or Morrison, fig. 374). Hoppus borrowed this design from Isaac Ware's *Designs of Inigo Jones and Others* (1735) plate 43 (Bridenbaugh, fig. 17), although Hoppus omitted the dome on a drum capping the Kent design. The plan for this building (a garden pavilion) is also given in plate 43 and was the basis for Harrison's plan of the library.

18. For the windows, see Bridenbaugh, fig. 19; for Kent's design, fig. 20.

19. For the chapel, see Bridenbaugh, fig. 23; for the Gibbs design, fig. 24. It also appears that Thomas McBean drew on this same plate 24 in Gibbs for his side elevation of Saint Paul's in New York City (1764–66); and the rustication used on the church is certainly Gibbsian as well.

20. For a listing of Harrison's architectural books, see ibid., 168–70.

21. For the ceiling in the library, see Waterman, 323 (top) and Kimball, fig. 104; for the Langley plate, Waterman, 322 (top right), and Kimball, fig. 105. For the ceiling in the drawing room, see Waterman, 322 (bottom); and for the Langley plate, 322 (top left).

22. For the Gunston Hall porch, see Rosamond Randall Beirne and John Henry Scarff, *William Buckland, 1734–1774: Architect of Virginia and Maryland* (Baltimore: Maryland Historical Society, 1958), 49 (top); for the Langley plate, see 49 (bottom). An alternative Langley plate that could also be the source is depicted in Calder Loth and Julius Trousdale Sadler Jr., *The Only Proper Style: Gothic Architecture in America* (Boston: New York Graphic Society, 1975), 13.

23. For the Mount Vernon doorway, see Waterman, 276; for Langley's plate, 277 (top).

The copy of Langley's *Treasury of Designs* that I consulted (Colonial Williamsburg) appears to be an edition not mentioned in Harris; it is dated 1741, with most of the plates inscribed 1739—undoubtedly the same as for the original 1740 edition—but a few dated 1741, indicating some revision.

24. For the Vassall-Longfellow House doorway, see Bainbridge Bunting and Robert H. Nylander, *Survey of Architectural History in Cambridge, Report Four: Old Cambridge* (Cambridge, Mass.: MIT Press, 1973), fig. 113; for the Langley plate, fig. 112.

25. For the dining-room mantel, see Morrison, fig. 303; for the Swan plate, fig. 304. (These are also depicted in Waterman, 288.)

26. For the mantel in the west parlor, see Waterman, 289 (right); for the plate in Swan, 289 (left).

27. For the west parlor door casing, see Waterman, 284 (bottom); he does not illustrate the Langley plate.

28. The Mount Airy/Gibbs comparison is also reproduced in Waterman (255) and Morrison, figs. 294–95. The plan, which was advanced for its day, is also very close to a design in Gibbs; see Pierson, figs. 73–74.

29. "A letter of 1754 . . . suggests that John Tayloe II was more than likely the designer of his new house," William M. S. Rasmussen, "Palladio in Tidewater Virginia: Mount Airy and Blandfield," in Mario di Valmarana, *Palladian Studies in America, I: Building by the Book*, 1(Charlottesville: University Press of Virginia, 1984), 77. Mount Airy has previously, on no real evidence, been attributed to John Ariss (as in Waterman, 245–47).

30. Charles E. Peterson, "Philadelphia Carpentry According to Palladio," in Mario di Valmarana, ed., *Palladian Studies in America, I: Building by the Book*, 3 (Charlottesville: University Press of Virginia, 1990), 21–22.

31. Catherine W. Bishir, Charlotte V. Brown, Carl R. Lounsbury, and Ernest H. Wood III, *Architects and Builders in North Carolina: A History of the Practice of Building* (Chapel Hill: University of North Carolina Press, 1990), 92.

32. For the Touro Synagogue porch, see Bridenbaugh, fig. 28; the Gibbs plate, fig. 29. For the interior details and the related plates in Ware, Kent, and Langley, see figs. 30, 33–35.

33. For the market, see Bridenbaugh, fig. 36; for the Campbell plate, fig. 37.

34. See Bridenbaugh, figs. 40–41.

35. For the summerhouse, see ibid., fig. 21; for the Gibbs plate, fig. 22.

36. For the facade of Brandon, see Waterman, 366 (top); for the Morris plate, 366 (bottom). See also Calder Loth, "Palladio in Southside Virginia: Brandon and Battersea," in di Valmarana, ed., *Building by the Book, 1*, 25–46.

37. For the Brewton House, see Pierson, fig. 82.

38. For Shirley Plantation, see Waterman, 347 (bottom). The Leoni plate is in both Morrison (fig. 309) and Waterman (347 top).

39. See Kimball, 277, and Morrison, 423–25. An excellent summary of Hawks's work on the building is in Bishir et al., *Architects and Builders*, 122–25.

40. The preliminary drawing is reproduced in Margherita Azzi Visentini, "Palladio in America, 1760–1820," in Irma B. Jaffe, ed., *The Italian Presence in American Art, 1760–1860* (New York: Fordham University Press, 1989), 241.

41. Bishir et al., *Architects and Builders*, 122.

42. For the Gibbs attributions, see di Valmarana, ed., *Building by the Book, 1*, 89. For a facade view of Blandfield after restoration (replacement of the nineteenth-century sash and porches), see Charles E. Brownell et al., *The Making of Virginia Architecture* (Charlottesville: University of Virginia Press, 1992), fig. 1.41.

43. This comparison is reproduced in Kimball, figs. 94–95.

44. James Leo Garvin, *Academic Architecture and the Building Trades in the Piscataqua Region of New Hampshire and Maine, 1715–1815* (Ph. D. dissertation, Boston University Graduate School, 1983; Ann Arbor, Mich.: UMI Dissertation Information Service, 1989), 134 and 136. The Hoppus plate is illustrated in fig. 36. Garvin also notes that "Hoppus's volume was rendered still better known through the fact that it was sometimes bound together with William Salmon's relatively popular *The Builder's Guide and Gentleman and Trader's Assistant* at about the mid-century" (ibid., 136); and furthermore, "whichever book was used, the volume clearly remained in the area and continued to be used by local carvers" (ibid., 139).

45. Ibid., 208. The mantel and the Kent plate are figs. 63 and 64. For similar "selective copying" in Portsmouth from the 1780s, see 271–74.

46. For this comparison, ibid., figs. 90 and 91 (it is also reproduced in Pierson, figs. 89–90). Swan recognized that woodcarvers might need to alter the sizes and proportions of the fireplace designs he provided. Thus after illustrating three with a full overmantel panel, his next plate (51) depicts one with panel reduced and joined directly above the shelf; and he explains above the design: "This plate shews how any of the fore going chimneys may be shortened if required."

47. For the facade drawing, see Kimball, fig. 72, or Waterman, 391 (top).

48. Books in Buckland's "Inventory of Estate" made in 1774 are listed in Beirne and Scarff, 149–50.

Interestingly enough, this treatment of attached one-story wings with polygonal facades seems to have been picked up and published in America, too: Asher Benjamin's *The Country Builder's Assistant* (1805 edition) depicts on plates 31–32 a five-bay two-story house connected to wings with just such facades; because the Boston edition of 1798 (which I have not consulted) had the same number of text pages and plates as the 1805 edition, the polygonal wings appear to have got "into print" in America in less than twenty-five years.

49. Although the central-pedimented pavilion with pilasters is mentioned by Pratt (Gunther, 31), the earliest built example in England was Hugh May's Eltham Lodge, Kent (designed 1663, built 1664–65), itself based closely on a building of 1636 in The Hague (see Reiff, *Georgian Houses*, figs. 72–76). Although a few other buildings with this sort of pilaster treatment were erected in the 1660s and 1670s, it was not a type that caught on; the motif did not reappear again until 1694. The dwelling of this "Eltham Lodge type" that did have a later influence was Stoke Edith, Herefordshire,

c. 1697–99 (ibid., 71). Its reproduction in volume I of Campbell's *Vitruvius Britannicus* (1715), plate 46, introduced this type into the architectural literature. Gibbs has a couple facades with pedimented pavilions with pilasters (plates 51 and 54), and several without, that is, of the Kingston Lacey tradition (especially plates 63, 64, 65, and 66).

50. The idea of enriching the window above the entrance door with a specially elaborate enframement is an old one found in England on high-style country houses (Uppark, c. 1690, for example) and smaller dwellings emulating them in the second half of the seventeenth century; it is finally adapted to small mansions depicted in builders' manuals. For some examples of these from houses of the seventeenth century, see Reiff, *Georgian Houses*, figs. 150–51 and 153–56.

51. For the Buckland doorway, see Beirne and Scarff, 121 (top); for the Swan door casing, 121 (bottom).

52. For the Buckland window, see Barbara Allston Brand, "William Buckland, Architect in Annapolis," in di Valmarana, ed., *Building by the Book, 2*, fig. 3.10; for the Gibbs plate, fig. 3.11. This essay includes numerous other citations of plates in books thought to be models for many of Buckland's details.

Obviously Buckland's bull's-eye surround is not an exact copy of the Gibbs plate. One feature left out is the face at the very bottom, which Buckland replaces with a bit of foliage. For such a detail he might have been looking at plate 57 in Swan's *British Architect*, where the first cartouche in the second row has a detail at the bottom of this type.

53. The side window is shown obliquely in Morrison, fig. 331; for the east end of Saint Martin's (plate 4), see Beirne and Scarff, 120 (bottom).

54. Ibid., 127 and 129.

55. Beirne and Scarff, 149–52.

56. Bunting and Nylander, figs. 114–15.

57. See Waterman, 305.

58. See Pierson, figs. 97 and 98 for the meetinghouse and the Gibbs plate, and figs. 99 and 100 for the porch detail and the Gibbs model.

59. See Morrison, figs. 299–300, for this comparison and the placement of the window on the building.

60. For the Mount Vernon library mantel, see Waterman, 287 (bottom); for the Langley plate, 283 (left).

61. From a letter dated October 10, 1797, quoted in Fiske Kimball and Wells Bennett, "William Thornton and the Design of the United States Capitol," *Art Studies* 1 (1923), 77.

62. See Elinor Stearns and David N. Yerkes, *William Thornton, A Renaissance Man in the Federal City* (Washington, D.C.: American Institute of Architects Foundation, 1976), 20–21, for an old view of the building in its context and also the Swan plate.

This building was sold in 1884 and demolished in 1887. In 1952, with the successor building on the site demolished in its turn, the current structure was designed as the home of the American Philosophical Society. The architect, Sydney E. Martin, made the front portion of the society's new building essentially a duplicate of the old Library Company, basing his design on old prints and photographs. See James F. O'Gorman, Jeffrey A. Cohen, George E. Thomas, and G. Holmes Perkins, eds., *Drawing Toward Building: Philadelphia Architectural Graphics, 1732–1986* (Philadelphia: Pennsylvania Academy of Fine Arts, 1986), 218–19. A clear nineteenth-century photograph of the building before demolition is reproduced in Kimball and Bennett, fig. 62.

63. Richard J. Betts, "The Woodlands," *WP* 14, 3 (1979), 213–34.

64. For the comparison, see Pierson, *The Colonial and Neoclassical Styles*, figs. 156–57.

65. Betts, 225–26. About the Pierson comparison, Betts observes: "Pierson's elevation of High Down (fig. 157) is incomplete and slightly in error, so the resemblance between Woodlands and High Down is much less close than he would imply" (ibid., 226 n. 36). It is interesting to note that the Woodlands facade is compositionally close to a design in Palladio, II, plate 31.

66. See Harold Kirker, *The Architecture of Charles Bulfinch* (Cambridge, Mass.: Harvard University Press, 1969), 41–42 and figs. 14–15.

67. See Egon Verheyen, "'The Splendor of its Empire': Reconsidering Jefferson's Role in the Planning of Washington," 183–206, in Erich Hubala and Gunter Schweikhart, eds., *Festschrift Herbert Siebenhüner* (Würzburg: Kommissionsverlag Ferdinand Schöningh, 1978). The discussion of the President's House drawing is 190–92.

68. In Kimball, Jefferson's design is fig. 131 and the Leoni plate (Book II, plate 15) fig. 132.

69. Campbell readily acknowledged the source of the design: "I shall not pretend to say, that I have made any Improvements in this plan from that of *Palladio*, for *Signor Almerico*;" *Vitruvius Britannicus*, III: 9. The dates of construction are provided in Paul Breman and Denise Addis, *Guide to Vitruvius Britannicus: Annotated and Analytic Index to the Plates* (New York: Benjamin Blom, 1972), 18.

70. The Villa Rotonda was also adapted to domestic use (but following the original treatment of arched openings for the portico flanks) in Foots Cray Place, Kent, of c. 1754. It is reproduced in John Woolfe and James Gandon, *Vitruvius Britannicus*, IV (1767), plate 8. The date is provided by Breman and Addis, 102.

71. See Verheyen, "Splendor of its Empire"; William Ryan and Desmond Guinness, *The White House, An Architectural History* (New York: McGraw-Hill, 1980), esp. 55–84; Egon Verheyen, "James Hoban's Design for the White House in the Context of the Planning of the Federal City," *Architectura* 2 (1981), 66–82; and William Seale, *The President's House: A History*, 2 vols., (Washington, D.C.: White House Historical Association, 1986), esp. I: 22–81.

Seale also provides new research on Hoban's life and training; see I: 39–42.

72. This was reconstructed by Verheyen in 1979 (see "Hoban's Design," fig. 5) and also independently by Ryan and Guinness (their fig. 43).

73. The 1779 engraving is reproduced in Ryan and Guinness, fig. 54; a measured drawing of Leinster House as it really appears is fig. 55.

74. Gibbs, plate 54 (see also plates 42 and 52). A similar design can be found in John Crunden, *Convenient and Ornamental Architecture, Consisting of Original Designs, for Plans, Elevations, and Sections* (London, 1767), plate 67.

75. For the full text, see Seale, I: 26–27.

76. Ibid., 47–48; and also Verheyen, "Hoban's Design," 74 n. 29, which gives the full text of the letter.

77. Verheyen, "Splendor of its Empire," 189–90 and 197 n. 41.

78. From a letter of July 12, 1792, quoted in Kimball and Bennett, 78.

79. From an "autobiographic fragment" dated October 12, 1802, quoted by Kimball and Bennett, 77.

80. For the "Tortola Plan," see ibid., fig. 63 (also reproduced, with its floor plan, in Stearns and Yerkes, 23). For the Campbell plates, see Summerson, *Architecture in Britain*, figs. 258–60.

81. These are cited in a letter to George Washington dated November 2, 1795, and one to the Commissioners, dated January 9, 1798; see Kimball and Bennett, 79.

82. These are all illustrated in Waterman, 388–90; for the Morris elevation for the original design, see 378 (top).

83. Quoted in Frederick D. Nichols and James A. Bear Jr., *Monticello* (Monticello: Thomas Jefferson Memorial Foundation, 1967), 22–23.

84. Ibid., 23.

85. Ibid., plates 12 and 15, 13 and 18, and 14 and 23.

86. A building in Robert Morris's *Select Architecture* (plate 43) has been proposed as a model for this facade (see Alan Gowans, *Images of American Living* [Philadelphia: Lippincott, 1964], 48). But the Morris design lacks many of the features contained in Gibbs's plate (such as the octagonal drum with occuli, the octagonally shaped dome, and the Roman Doric order with full entablature), which are incorporated in the final design of Monticello.

87. Nichols and Bear, 9.

88. William B. O'Neal, "Pattern Books in American Architecture, 1730–1930," in di Valmarana, ed., *Building by the Book, 1*, 52.

Jefferson's use of books in his design of the University of Virginia building is also worth mentioning; see Azzi Visentini, 240–43.

89. See Matthew Baigell, "James Hoban and the First Bank of the United States," *JSAH* 28, 2 (1969), 135–36. Both buildings are illustrated.

90. See Kirker, figs. 43–44.

91. Ibid., figs. 50–51.

92. Ibid., fig. 101, depicts Stoughton Hall; for Hollis, see Morrison, fig. 390.

93. See Kirker, figs. 70–71 and 74.

94. *The Works . . . of Robert and James Adam* began to be published, in sections, in 1773; the complete volume I appeared as a unit in 1778, and volume II in 1779. Each volume contained five parts, each part (containing eight plates) devoted to a particular building. The Williams-Wynn house is part 2 in Volume II; see E. Harris, 83–88, 94.

For a listing of twenty-seven titles known to have been in Bulfinch's library, see Kirker, 388. For the Boston bookseller of the Adam books, see Schimmelman, 321.

95. Garvin, *Academic Architecture*, 343; the house and the pattern-book plates are illustrated in figs. 108–10.

96. See Paul F. Norton, "Samuel McIntire," in Placzek, ed., III: 137.

97. The title continues in part: "Illustrated with new and useful designs for frontispieces, chimney pieces, . . . cornices, and mouldings for the inside of rooms;" it is indeed a small book, measuring less than seven and one-half inches tall. See Schimmelman, 408–9, and E. Harris, 341–42.

98. The title of Pain's book reads in part: *The Practical House Carpenter; Or, The Youth's Instructor: Containing a Great Variety of Mouldings at Large for Practice, with Their Proper Embellishments, Two Designs for Gentlemen's Houses, with Their Plans, Elevations, and Sections; Likewise, A Great Variety of Stair-Case Work . . .* Second ed.; London: 1788. According to E. Harris (344–45), this was a most popular work, issued in nine editions through 1823 (a tenth, with a different title, appeared in 1860–61); no copy of the first edition has been found. The American edition of 1796 was based on the fifth London edition, with additional material (including "Prices for Carpenters Works in the Town of Boston").

Pain's plate 100 is displayed by the Peabody Essex Museum at the Gardner-Pingree House as a source for its facade design.

At the time of his death in 1811, McIntire owned seven architectural books (O'Neal, 52).

99. The copy of this volume that I consulted was the 1805 edition on microfilm; but the two editions both have thirty-six pages of text and thirty-seven plates, and Hitchcock notes that the 1798 edition has "plans and elevations of [3] houses," as does the 1805 edition; thus I assume the contents are the same.

Plate 30 is reproduced as fig. 2 in Neville Thompson, "Tools of Persuasion: The American Architectural Book of the Nineteenth Century," in Gerald W. R. Ward, ed., *The American Illustrated Book in the Nineteenth Century* (Charlottesville: University Press of Virginia, 1987), 137–69.

Although the facade photo of the Gardner House does not show it, the hipped roof is actually about the same height and profile as that shown in the Benjamin plate, not the Pain engraving; this is clear from an elevation *drawing* of the Gardner House: See Robert G. Miner, ed., *Architectural Treasures of Early America: Colonial Architecture in Massachusetts* (New York: Arno Press, 1977), 104.

The Gardner House is also much closer in size to the Benjamin illustration: As built, McIntire's dwelling is 52' 5" wide, and the Benjamin model is 54'; Pain's house is only 41' across.

100. Plate 26 (same in all editions), Design B, depicting drilled detailing for an eaves cornice, found on the cornice of the Bank of Marietta, Ohio, of 1831, illustrated in I. T. Frary, *Early Homes of Ohio* (Richmond, Va.: Garrett & Massie, 1936), plate 84.

101. Illustrated in Bishir et al., *Architects and Builders*, 63; the Biddle plate is reproduced on 62.

102. Quoted in Jan Cohn, *The Palace or the Poorhouse: The American House as a Cultural Symbol* (East Lansing: Michigan State University Press, 1979), 35–36.

103. Reiff, *Washington Architecture*, 74.

104. The earliest design in a builders' manual to look like the Virginia hipped-roof houses that flourished from c. 1715 onward (cousins of the English houses of the 1680s through the 1730s and beyond) appears to be a five-bay house in Halfpenny's *Modern Builder's Assistant* (1742), plate 40, number 17 (see Reiff, *Georgian Houses*, fig. 295) although all the detailing (window sills, keystones, cornices, and steps) was to be of Portland stone, certainly a high-style treatment. Another five-bay design very close to these models (but with a London-style eaves parapet) is in Swan's *Collection of Designs* (1757), II, plate 11 (ibid., fig. 476); a third, the plainest of them all (with no indication of embellishments in stone at all, not even a door casing) is a five-bay dwelling in John Aheron's *A General Treatise on Architecture* (Dublin, 1754), Book V, plate 5 (ibid., fig. 477), with a very similar three-bay design, but with stone quoins, on plate 2 (ibid., fig. 478). Thus the brick hipped-roof type, so common in the home counties in England and in Virginia, appeared only after built examples had thrived for many years and had begun to be modified by new high-style motifs and supplanted by more advanced forms (like miniature Kingston Lacey types).

It should be noted that the three-, five- and seven-bay houses of this hipped-roof type (although usually embellished with stone quoins), which were included in William Adams's *Vitruvius Scoticus* (see ibid., figs. 461, 462, 474, and 475), are *not* a possible influence. As E. Harris explains fully (*British Architectural Books*, 94–104), this folio did not appear in parts, between 1720 and 1740, as previously assumed; the plates (engraved c. 1728–40 and 1758?–64) were finally published only in 1811.

105. Actually, the comparison may not be quite as close as it first appears. The high basement level in the Law House is probably the result of the grade changes throughout Washington in the 1870s; the lowest level of windows was probably concealed in an areaway, and the main doorway was reached by only a few steps. (For examples of dramatic grade changes in Georgetown, see Reiff, *Washington Architecture*, 54 and fig. 49, where the basement level was exposed a full story in height; and 142 and fig. 239, a dwelling now entered at the second-floor level, with the first floor largely below the street level.)

106. The Gate House at Kimbolton Castle, c. 1765, and 20 Portman Square of 1775–77 are depicted in Geoffrey Beard, *The Work of Robert Adam* (New York: Arco, 1978), plates 98 and 133.

107. Such arches can be found in Bulfinch's Barrell House, Somerville, Massachusetts (1792–93); in the Hartford State House (1793–96); and in Franklin Place; see Kirker, figs. 16–17, 22 and 24, and 39.

108. McComb's and Latrobe's buildings are depicted in Kimball, figs. 163 and 167.

109. Reiff, *Washington Architecture*, 52. In the 1971 edition, the illustrations for figs. 43–44 have been transposed; in the 1977 edition, they are correct. Such arches were also used on houses in Washington; see fig. 121.

110. Two studies and the final plan are reproduced in Stearns and Yerkes, 31–33.

111. Thornton's studies and current plans are all illustrated in Armistead Peter III, *Tudor Place, Designed by Dr. William Thornton* (Georgetown: [privately printed], 1970); one early plan and two elevation studies are also reproduced in Stearns and Yerkes, 42–53. See also Architects' Emergency Committee, *Great Georgian Houses of America*, I (New York: Kalkhoff Press, 1933), for the current plan.

112. The "up-to-dateness" was even emphasized in Richardson's title for both volumes, which continues: "Consisting of Plans and Elevations of Modern Buildings, Public and Private."

113. In volume I, plates 1, 57, and 60; in volume II, plates 15, 36, and 61.

114. I, plates 1, 6, 8, and 20; II, plates 23, 31, 36, 45, 61, and 66.

115. I, plates 2, 10, and 21; II, plate 37.

116. For example, I, plates 25–26, 52–53, and 65–66; II, plates 19–20, 21–22, 47–48, and 49–50.

117. I, plates 21, 28, and 72–73; II, plates 19–20, 21–22, 47–48, and 49–50.

118. I, plates 26, 28, 37, and 59; II, plates 21–22.

119. The country seat of William Henry Pigou, in Sussex (completed in 1798), depicted in volume I, plates 25–26, is identified as being "built entirely with brick, and stuccoed" (8).

120. Of course, Latrobe could also have had drawings of the cathedral or could have remembered the composition from some visit to it; but recourse to an engraving for a Gothic design, especially in the early nineteenth century when Gothic architecture was just starting to grow in popularity in this country, seems more likely. For Saint Paul's, see Talbot Hamlin, *Benjamin Henry Latrobe* (New York: Oxford University Press, 1955), plate 26.

121. Anyone who has read through an eighteenth-century English builders' manual cannot but be profoundly impressed by how very capable a carpenter must have been to use such books. Not only did he need to be literate and technically adept, but he had to understand complex geometry, calculations, proportion, and measure and have artistic abilities. It is not surprising that craftsmen with these attributes were able to become architectural designers. For an insightful discussion of this issue of professional capability, see Dell Upton, *Holy Things and Profane: Anglican Parish Churches in Colonial Virginia* (Cambridge, Mass.: MIT Press, 1986), 26–29; see also Reiff, *Georgian Houses*, 283–84, and Bishir et al., *Architects and Builders*, 102–8.

122. Floor plans for two Newport houses, one of 1735 and another of 1739, are reproduced by Kimball, figs. 32 and 45.

123. Jeffrey A. Cohen, "Early American Architectural Drawings and Philadelphia, 1730–1860," in James F. O'Gorman et al., *Drawing Toward Building: Philadelphia Architectural Graphics, 1732–1986* 15. For an excellent and extended discussion of the design process (especially of craftsmen) during the eighteenth century in North Carolina—methods surely not too different from

other parts of the country at the time—see Bishir et al., *Architects and Builders*, 60–81.

Except for elaborate work (such as that by McIntire or Buckland), many contracts for interior details and paneling simply specified that the craftsman was to carry out the work "in a good, genteel, fashionable manner," as specified in a 1794 contract for a house in Litchfield, Connecticut. See *The American Architect and Building News (AABN)*, October 11, 1902, 15–16.

124. Roger W. Moss Jr., "The Origins of the Carpenters' Company of Philadelphia," in Charles E. Peterson, ed., *Building Early America: Contributions Toward the History of a Great Industry* (Radnor, Pa.: Chilton Book, 1976), 48.

125. Ibid., 49.

126. Charles E. Peterson, "Philadelphia Carpentry According to Palladio," in di Valmarana, ed., *Building by the Book, 3*, 2.

127. Moss, 49.

128. Ibid.

129. Peterson, "Philadelphia Carpentry," 4.

130. Contrary to popular belief, Pierre Charles L'Enfant was not trained as an engineer in France; his only academic training was in art. As Caemmerer discovered (see H. Paul Caemmerer, *The Life of Pierre Charles L'Enfant* [Washington, D.C.: National Republic, 1950], 9), L'Enfant had been a student at the Académie Royale de Peinture et de Sculpture under his own father, who was a painter. Furthermore, L'Enfant had not been in the French military service before coming to America as a volunteer: "[A] brevet [in the French army] was given him in 1777 to protect him in case he should be taken prisoner by the British on his way to America" (ibid.). The erroneous idea that L'Enfant was an engineer undoubtedly came about because once in America this enthusiastic and artistic volunteer was given a captaincy in the Corps of Engineers, probably a logical and useful place for a trained artist. See Daniel D. Reiff, "Pierre Charles L'Enfant," in Placzek, ed., II: 660–61.

131. E. Harris, 328.

3 Builders' Manuals and Pattern Books, 1820s–1850s

1. The first volume of *The Antiquities of Athens Measured and Delineated by James Stuart . . . and Nicholas Revett, Painters and Architects*, was published in London in 1762. Although covering "lesser" buildings and structures in Athens, it did include all three orders in meticulous measured reconstruction drawings (twenty-six of the full-page plates were devoted to sculptures). The second volume appeared in 1787 and was devoted to the famous buildings on (or near) the Acropolis (again with twenty-six of the plates exclusively illustrating sculpture). The third volume was issued in 1794. It contained a wider variety of buildings and sites, including the temple of Theseus and the arch of Hadrian in Athens, the temple at Corinth, and buildings on Delos (with twenty-six of the plates again of sculpture).

2. The columns, made of wood, were unfluted but painted in imitation of veined marble. The central portion was erected between one-story wings that had been built at either side between 1802 and 1804; see Reiff, *Washington Architecture*, 73–75.

3. Richard C. Cote, "Rethinking the Early Greek Revival: The Success of Influences and the Failure of a Builder," *Old-Time New England* 64, 3–4 (1974), 68.

4. Numerous palatial Greek Revival mansions along the same lines as the Bowers House followed, all with a pedimented portico

of six Ionic columns and symmetrical flanking wings. They include Rose Hill, Geneva, New York, of 1838 (see Talbot Hamlin, *Greek Revival Architecture in America* [New York: Oxford University Press, 1944], plate 86 top); the Richard De Zeng House, Skaneateles, New York, of 1839 (see Harley J. McKee, ed., *Architecture Worth Saving in Onondaga County* [Syracuse: Syracuse University School of Architecture, 1964], 50–55); and Madewood Plantation, Louisiana, of 1846 (see Arthur Scully Jr., *James Dakin, Architect* [Baton Rouge: Louisiana State University Press, 1973], 119).

Perhaps the Rehlen House (1848), Castleton, Vermont, erected by the master builder Thomas Reynolds Dake, should be included, too, even though its impressive Ionic portico contains only *five* columns (Sanders H. Milens and Paul A. Bruhn, *A Celebration of Vermont's Historic Architecture* [Windsor: Preservation Trust of Vermont, 1983], 46–47). Although the Elias Brown House (1835) at Old Mystic, Connecticut, has an Ionic portico of only four columns, it is an especially grand mansion, complete with a cupola in the manner of Rose Hill. See Pierson, *The Colonial and Neo-Classical Styles*, fig. 321.

This form of Greek Revival dwelling based on the Bowers House type—or its progeny—with a central pedimented unit of four columns with flanking side wings became widely popular; good examples can be found from Massachusetts to Wisconsin. A sampling is cited in the notes below.

5. See Hamlin, 315–29 passim, for the reasons for its popularity. See also James Marston Fitch, *American Building: The Historical Forces That Shaped It*, 2d ed. (New York: Houghton Mifflin, 1966), 77–93.

6. Hamlin, 70.

7. Cote, 63–64.

8. Quoted from the manuscript volume (n.p.) "Records of the 1st. Presbyterian Church, in Newburyport, 1795 [-1861]," in the archives of the church. I am indebted to Frank Landford for permitting me to consult this volume.

9. Hamlin illustrates Greek Revival buildings in twenty-nine states, from Maine and Massachusetts to Oregon and California, as well as the District of Columbia. Roger G. Kennedy's *Greek Revival America* (New York: Stewart Tabori & Chang, 1989), Appendix C, 398–422, lists significant Greek Revival buildings in thirty-seven states (including Hawaii and the District of Columbia).

The number of classical city and town names is from the map in Fitch, 84. A glance at a map reveals as well how popular Greek names were. In New York state, for example, there are Attica, Corfu, Corinth, Greece, Ilion, Ionia, Ithaca, Macedon, Marathon, Mycenae, and Troy. Proper names also appear: Alexander, Hector, Homer, even Niobe; and perhaps most revealing of all, Byron.

10. I. T. Frary, *Early Homes of Ohio* (Richmond, Va.: Garrett & Massie, 1936); Hamlin is cited above.

11. The smaller house, "Design for a Country Villa," is the frontispiece; it is identified as designed by James Gallier. The larger building, "A Country Residence," (plate 75) was both designed and drawn by Lafever.

12. For example, Asher Benjamin published a total of seven builders' guides (some more popular than others), of which there were forty-seven editions between 1797 and 1856; see Jack Quinan, "Asher Benjamin and American Architecture," *JSAH* 38, 3 (1979), 244.

13. In Hitchcock's listing, no copies of the fifth edition of *The Modern Builder's Guide* or the second edition of *The Beauties of Modern Architecture* had yet been located; but my tabulation assumes they were indeed issued. Benjamin's *American Builder's Companion* has been omitted, however; only the sixth (1827) edition included Greek orders.

14. The sampling here reviewed is generally from well-known published sources; a thorough search of the literature would undoubtedly turn up a great many more, as would study of photographs in the files of organizations, local or statewide, which have conducted house-by-house surveys of regional architecture.

15. Vernacular variations of the Benjamin motif appear on a house in Sinclairville and another just east of Ellington, in Chautauqua County (author's photographs). The motif was also used (more correctly) on doorways of the Gurney House (c. 1844) in Collins, Erie County; see Austin M. Fox, ed., *Erie County's Architectural Legacy* (Buffalo: Erie County Preservation Board, 1983), 14.

16. Frary, plates 88 and 87; the Lafever plate is reproduced as plate 86. See also plate 177 for a vernacular adaptation of this motif. A similar "free" version of the motif is found on interior door casings of the Avery House, Granville, Ohio, of 1842; see plate 173.

17. For the Nantucket doorway, see Hamlin, plate 40, top; for those in East Lexington, see Elizabeth W. Reinhart and Anne A. Grady, "Asher Benjamin in East Lexington, Massachusetts," *Old-Time New England* 67, 3–4 (1977), 30–31.

18. For the house, see Frary, plate 75; for the Benjamin plate, see plate 77.

19. Bishir et al., *Architects and Builders*, 138.

20. Illustrated in ibid., 140.

21. See Mary Wallace Crocker, "Asher Benjamin: The Influence of His Handbooks on Mississippi Buildings," *JSAH* 38, 3 (1979), 266–70.

22. The epilogue in Abbott Lowell Cummings's "An Investigation of the Sources, Stylistic Evolution, and Influence of Asher Benjamin's Builder's Guides" (Ph. D. dissertation, Ohio State University, 1951) considers the impact of Benjamin's books. It was very strong in the northeastern states (where he gives special emphasis to Ohio), but was also felt in the midwest and the south. For the Oregon comparison, see Robert K. Sutton, *Americans Interpret the Parthenon: The Progression of Greek Revival Architecture from the East Coast to Oregon, 1800–1860* (Niwot, Colo.: University Press of Colorado, 1992), figs. 2.33 and 2.34.

23. Close examination of the photograph reveals that strips of wood surrounding the central boss have fallen away; originally the corner block would indeed have looked just about like the Benjamin plate. The house was demolished in the 1980s.

24. Richard N. Campen, *Architecture of the Western Reserve, 1800–1900* (Cleveland: Press of Case Western Reserve University, 1971), 211, for the plate, and 117 for the doorway.

25. For the porch, see Frary, plate 11; for the Lafever design, see plate 76.

26. An almost identical doorway, complete with dentil band and carved panel above the cornice, is found on a house in Panama; see Jewel Helen Conover, *Nineteenth-Century Houses in Western New York* (Albany: State University of New York Press, 1966), plate 84. The only difference is that the side pilasters are fluted and thus lack palmettes.

Asher Benjamin also published, in *The Builder's Guide* (1839), plate 27, a doorway almost identical to Lafever's plate 80, although slightly richer (the orders have necking bands like the Erechtheion) and more correct (the architrave contains the canonical three courses of moldings rather than being plain, as in Lafever); Benjamin does not have the top horizontal panel above the cornice, either.

27. For the house in Mystic, Connecticut, see Kennedy, 40.

28. Benjamin also used these "top and bottom" palmettes in his design for a cast-iron railing above a sumptuous four-column porch, depicted in plate 32 in *The Practice of Architecture*.

In addition to his doorway in plate 80, Lafever also used the anthemion motif at the top of the pilasters of his fireplace design, plate 87 of the *Modern Builder's Guide*. In Lafever's *Beauties of Modern Architecture* (1835), palmettes adorn the top and bottom of a window shutter and reveal: The Benjamin palmette doorway is reproduced in Reinhardt and Grady, fig. 5, and Crocker, fig. 3.

29. Discussion based on author's photos. The main doorway (but not its palmettes) can be seen in H. Edmond Wirtz, *Treasures of American Architecture in Geneva, New York* (Geneva: Geneva Historical Society, 1987), 40.

30. These New York citations are all from the author's photos, but additional examples can also be cited in published sources. See Conover, plate 80, for a house in Clymer with twelve pilasters visible, each with a palmette at the top (the front door, however, does not employ them). See also Conover, plate 82, for a house of 1842 in Panama with the motif in its facade pilasters (and possibly the front door as well).

31. On a house in Orwell, Vermont, remodeled in Greek Revival style in 1843, the palmettes are found in facade pilasters (Kennedy, 35). For Ohio dwellings, see Frary, plates 79, 80, and 81; and Campen, 101, for a house of c. 1840. For a house of 1852 in Riceville, Pennsylvania, with the motif in both doorway and facade pilasters, see Charles Morse Stotz, *The Early Architecture of Western Pennsylvania* (New York: William Helburn, 1936), 140; my thanks to David L. Rowe for this citation. For the Wisconsin house (where the palmette is used on interior pilasters), see Richard W. E. Perrin, *Wisconsin Architecture* (Washington, D.C.: U.S. Department of the Interior, 1965), 69, which reproduces HABS drawings of a house in Racine of c. 1853.

32. The doorway is illustrated in Reiff, *Architecture in Fredonia*, fig. 47.

33. See Frary, plate 45; a detail of the doorway is in Wayne Andrews, *Architecture in Chicago & Mid-America: A Photographic History* (New York: Atheneum, 1968), 14.

34. For the 1842 Forbes-Cushing House, see Reiff, *Architecture in Fredonia*, 32–33. The doorway is now hidden by a porch added in the 1930s; the old photograph is courtesy of Mrs. Albert Morrison.

35. Interestingly enough, the Forbes-Cushing House and 100 Eagle Street are dwellings of very different styles, despite having similar doorways.

Other versions of this doorway occur throughout Chautauqua County, for example, on houses in Ashville (author's photo); in Frewsburg (Conover, plate 106); and in Fentonville (ibid., plate 108).

36. See Clay Lancaster, "Builders' Guide and Plan Books and American Architecture from the Revolution to the Civil War," *Magazine of Art* 41, 1 (1948), fig. 6.

37. The house is depicted in Frary, plate 46, and a detail of the grille is shown on plate 166.

38. In his introduction to the DaCapo reprint edition of this book, Denys Peter Myers lists ten houses and two churches that employed specific plates in their design (viii n. 1).

39. For the Kentucky house, see Rexford Newcomb, *Old Kentucky Architecture* (New York: William Helburn, 1940), plate 92; for the other two, see Kennedy, 303 and 313.

40. For the doorway and the columns, see Campen, 33. Both the Lafever plates are followed by an additional detail plate (plates 26 and 32, respectively) to aid in their execution.

41. See [Antoinette F. Downing and David Chase], "The Milford Papers," *Victorian Society in America Newsletter* 5, 7 (1973), 1–4. The article also includes illustrations of the exterior and interior features based on Lafever plates.

42. For the Bocage Plantation comparison, see William Nathaniel Banks, "The River Road Plantations of Louisiana," *The Magazine Antiques* 111, 6 (1977), 1179; for the house in Georgetown, Kentucky, see Hamlin, plate 93 (top left).

43. Leavenworth House (now demolished) is shown in Hamlin, plate 75, and in Architects' Emergency Committee, *Great Georgian Houses of America* II (New York: Scribner Press, 1937), 165–70.

44. This analysis based on author's photos. Two of the windows are depicted in Paul Malo, *Landmarks of Rochester and Monroe County* (Syracuse: Syracuse University Press, 1974), plate 79.

45. For overall views of the house, see Conover, 21 and 131; and Kennedy, 243.

46. Or has the architrave simply been misplaced? Perhaps the woodwork above the columns was somehow assembled incorrectly; if the flat band under the cornice moldings was moved below the carved panel, the more-or-less correct form of an entablature would then be achieved.

47. See Catherine W. Bishir, "Jacob W. Holt, An American Builder," *WP* 16, 1 (1981), esp. 7–8 and figs. 6–11. As Bishir notes, "[H]e relied on these [builders'] volumes to keep his work current and appealing to the tastes of his wealthy patrons"(7).

48. Hamlin, 267.

49. Pierson, *Colonial and Neo-Classical Styles*, fig. 332. This particular house type (four-columned pedimented Doric with colonnaded symmetrical side wings) can also be found in Chautauqua County; see Conover, 68 (for a house of c. 1837) and 124 (for one of 1833). By the 1840s, the type was being built in Michigan, too; an Ionic example from c. 1845 in Green Oak Township, Michigan, is illustrated in Kathryn Bishop Eckert, *Buildings of Michigan* (New York: Oxford University Press, 1993), 159.

50. The cornerstone reads: "E. S. Barger Architect, Westfield, N.Y. 1830." The name "Barger" does not appear in the 1830 U.S. Census for Westfield; nor does the name appear on the 1837 "Assessment Roll, of the Real and Personal Estates, in the Town of Westfield." Elias S. Barger does appear in the 1850 Census (recorded in Westfield on August 13), where his age is given as thirty-seven (and his occupation as "Joiner"); in the 1860 Census (recorded July 6) his age is given as forty-six (and his occupation now as "Architect"). Thus his birthday fell sometime between those dates. If he began the Austin Smith House before July 6, 1830, he would have been only sixteen!

By 1860, his "value of real estate" was $7,000 and his "personal estate" $1,500, a substantial amount. For comparison, another Westfield carpenter, Isaac Shaw (aged sixty-two in 1860) had property worth $2,000 and "personal estate" of $200. Barger had a wife and three children (teenagers by 1860), a sure spur to economic endeavor.

It is possible, in view of Barger's youthfulness in 1830, that his father (assuming he was also a carpenter or even a bricklayer) assisted him with the Smith House; but a preliminary examination of relevant early records has not shown Barger living in Westfield in the 1830s. Austin Smith, however, is recorded: in 1830 with his wife and two children; and in the 1837 Assessment Roll, where his one-and-one-quarter-acre property is valued at $1,150 and his country wood lot of six and three-quarter acres at $240.

According to the 1850 (and 1860) census, Barger was born in New York state; unless he had apprenticed in New England or visited there, the house type must have been familiar in New York state before 1830.

My thanks to Douglas H. Shepard for providing me with copies of the 1850 and 1860 census reports.

51. For the house at 15423 Old Wattsburg Road, Union City, my thanks to Susan Beates Hansen of the Erie County [Pennsylvania] Historical Society for a copy of the Pennsylvania Historic Resource Survey Form for the house; the Ohio dwelling is illustrated in Frary, plate 68; and the Milwaukee house (now demolished), is illustrated in Perrin, 57.

52. Survey conducted by the author in 1985. Of the 257 Greek Revival houses of all types, 123—very nearly half—were of this type, although some omitted the side wing.

53. "Windshield survey" of Chautauqua County paved roads, excluding the thirteen major villages and two cities, conducted by the author in 1981. There were approximately 480 Greek Revival houses, of which about two-thirds were of this type.

54. See C. Stevens Laise, "A. J. Davis and American Classicism," *Antiques* (December 1989), 1328, plate VII.

These simplified door casings, with side pilasters and entablature, eventually find their way into carpenters' manuals; one is illustrated by Benjamin in his *Builder's Guide* (1839), plate 25, although enriched a bit with four wreaths in the frieze.

55. Examples can be found in Campen, Hamlin and various of the countywide surveys cited above. Some of the types, which appear in widely separated areas, include (in descending order of elaboration and expense): two-story houses with four-column porticoes but lacking pediments or lacking wings; two-story houses with full pediment but with pilasters rather than columns across the facade; the same type but with pilasters only at the corners or without any pilasters; one-and-a-half-story houses with corner pilasters and richer trim—and "below" the standard type illustrated, smaller versions with only one window in the gabled area.

56. "Architecture at the Present Time as Compared with That of Fifty Years Ago," a paper read by W. W. Boyington at the twenty-first annual convention of the American Institute of Architects, reprinted in *AABN*, October 29, 1887, 205.

57. The house is published in *The Architectural Heritage of Genesee County, New York* ([Batavia, N.Y.]: Landmark Society of Genesee County [1988]), 16; another view shows an end wing with the portico.

My thanks to Don E. Burkel, president of the Landmark Society of Genesee County, for providing a print of the John King photo.

A second house based closely on the Lafever model (although with flanking one-story wings designed with *open* porches with square piers) is the Sydney T. Smith House (1840) formerly in Grass Lake, Michigan, built by a settler from New York state. It is illustrated in Eckert, *Buildings of Michigan*, 15.

58. This book was reprinted in 1980 by DaCapo Press; the new edition has a six-page introduction by Jane B. Davies.

59. For an overview of the life and work of Downing, see George B. Tatum, "A. J. Downing," in Placzek, ed., I: 593–96. The book by George B. Tatum and Elisabeth Blair MacDougall, eds., *Prophet with Honor: The Career of Andrew Jackson Downing, 1815–1852* (Washington, D.C.: Dumbarton Oaks Research Library and Collection, 1989), contains nine essays on many facets of Downing's life and career. See also David Schuyler, *Apostle of Taste: Andrew Jackson Downing, 1815–1853* (Baltimore: Johns Hopkins University Press, 1996).

60. In this discussion, I have used the American Life Foundation reprint of 1967 of the fourth edition (1852, reprinted 1853) of this book. The first edition contained Designs I–X, but because there were two Design VIIs, eleven houses were depicted (one of them, Design V, was shown twice—once in a stone version, then "as constructed in wood"). The fourth edition added five house designs (one house and its plans illustrated as figures only, not as a full

plate) and "A Carriage House and Stable in the Rustic Pointed Style," as its final model (Design VIII).

The Dover reprint (1981) of the expanded 1873 edition has all the foregoing material (and figs. 83 and 84 with accompanying text, omitted in the American Life Foundation reprint) and the additional "New Designs for Cottages and Cottage Villas" (Designs XVI–XXVII).

61. At the end of his chapter "Rural Architecture," Downing listed a number of the English sources he had consulted: Loudon, *Encyclopaedia of Cottage, Farm, and Villa Architecture*; Robinson, *Rural Architecture and Designs for Ornamental Villas*; Lugar, *Villa Architecture*; Goodwin, *Rural Architecture*; and Hunt, *Picturesque Domestic Architecture*, and *Examples of Tudor Architecture*.

62. *Cottage Residences*, 5–6 (same in either edition).

63. Ibid., 4.

64. Except where he states explicitly the name of the architects who provided the designs (which naturally recommended them to prospective clients), the illustrations in this and subsequent books were essentially his own designs. Even if inspired by models in English books, Downing adapted each one to his own aesthetic point of view and to American requirements and materials. On occasion, his friend A. J. Davis drew up his sketch for the wood engraver, but in most cases Davis made few if any improvements to Downing's design.

However, Downing was not averse to copying an English model if it pleased him: his own house in Newburgh, New York, was based on plates in English books. See figs. 1 and 3–5 in Arthur Channing Downs Jr., "Downing's Newburgh Villa," *Bulletin of The Association for Preservation Technology* 4, 3–4 (1972), 1–113.

65. *Cottage Residences*, 44.

66. In 1844, the Chicago builder John M. Van Osdel, who was adept at drawing, was induced by his fellow builders to set up an architectural office:

> Just what impelled the builders of the city to combine and solicit Van Osdel to open an architect's office cannot be definitely determined now. There is no record of a code or written agreement.... What Van Osdel says in his *Recollections* is that the builders pledged themselves that they would neither make plans of their own nor construct any building of any importance without architectural plans. Until they made this proposal, Van Osdel says, no one had ever used an architect, and it was difficult to convince proprietors of the necessity for such a branch of the builders' business.
>
> ([Henry Ericsson], *Sixty Years a Builder: The Autobiography of Henry Ericsson* [Chicago: A. Kroch and Son, 1942], 137)

Ericsson subsequently observes (150) that because most builders generally did their own drawings, "until after the great fire of 1871, fully nine-tenths of all buildings in Chicago were constructed without architects."

Comments by the architect W. W. Boyington about Chicago building practices in the early 1850s are also revealing:

> When I came to Chicago [in 1853] I found the architects then in practice were recent master builders or contractors. ... At that time the structures were but simple buildings, but the builders soon found that it would be better for them to have plans made rather than to spend their time in making plans, so they clubbed together, and induced one of them most apt in drawing plans to give up his contracting and to

devote his whole time to architecture, and guaranteed him a compensation of $2 per day, which should be paid to him if he did not get business enough to aggregate that amount. (*AABN*, October 29, 1887, 205)

67. *Cottage Residences*, 16. Earlier on the page, he discusses it more fully: "A Greek temple or an old cathedral speaks to the soul of all men as audibly as could a Demosthenes. Even a Swiss chalet, with its drooping, shadowy eaves, or an old English cottage, with its quaint peaked gables, each embodies a sentiment in its peculiar form which takes hold of the mind, and convinces us that, in some way or other, it has a living power. To reproduce the beautiful in this manner, and to infuse a spirit and a grace in forms otherwise only admirable for their usefulness, is the *ideal* of architecture as an art of taste."

68. Ibid., 20.

69. Ibid., 23.

70. Ibid., 11.

71. Ibid., 12.

72. "The Picturesque," in Downing's own words, "is seen in ideas of beauty manifested with something of rudeness, violence, or difficulty. The effect of the whole is spirited and pleasing, but parts are not balanced, proportions are not perfect, and details are rude." *The Architecture of Country Houses; Including Designs for Cottages, Farm Houses, and Villas . . .* (New York, 1850), 28.

For a fuller discussion of this movement, see Summerson, *Architecture in Britain*, 473–95; and Christopher Hussey, *The Picturesque: Studies in a Point of View* (New York: G. Putnam's Sons, 1927). See also chapter 2, "Romantic Naturalism: The Picturesque" in James Early, *Romanticism and American Architecture* (New York: A. S. Barnes, 1965), 51–83. Later in the nineteenth century, it was given new impetus (and influence in the United States) in the writings of John Ruskin.

73. *Cottage Residences*, 13.

74. Ibid., 12–13.

75. This is explored in Carroll L. V. Meeks, "Picturesque Eclecticism," *Art Bulletin* 32, 3 (1950), 226–35. It is "applied" in his *Railroad Station, An Architectural History* (New Haven: Yale University Press, 1956).

76. William H. Pierson Jr., *American Buildings and Their Architects: Technology and the Picturesque; The Corporate and the Early Gothic Styles* (Garden City, N.Y.: Doubleday, 1978), fig. 254. Robinson's design in turn undoubtedly was influenced by such picturesque cottages as those by John Nash at Blaise Hamlet, near Bristol, of 1811.

77. Located at 68 Elm Street. Although the Davis house was published in 1838, the design goes back to an 1836 watercolor drawing that is almost identical, except that the facade flanking windows are considerably larger (and are surrounded by a vine-festooned rustic trellis of bark-clad logs and posts, similar to the porch).

It is possible, of course, that the model was not the plate in Davis's *Rural Residences*, but rather the miniature vignette of "The Gardener's House, Blithewood," reproduced on page 361 of the 1849 fourth edition of Downing's *Treatise on . . . Landscape Gardening*, at the end of Section IX (and found at this location in subsequent editions as well). In this view, the trellis porch is replaced with a more canonical Gothic porch, and the windows are of a more traditional size.

78. See Downing, *Cottage Residences*, Design VI* and his *Country Houses*, Designs VI, XVI, and XXVIII.

79. Downing's original drawing for Design II is reproduced in Tatum and MacDougall, eds., *Prophet with Honor*, 10, and in Pierson, *Technology and the Picturesque*, fig. 268. See also Schuyler, 67–70.

The very year that *Cottage Residences* was published, Downing was able to write to a friend in Philadelphia: "Some of my 'castles in the air' I have the satisfaction in knowing will soon be brought into palpable form by amateurs in different parts of the country. No 2 is an especial favorite" (letter of October 21, 1842, quoted in Tatum and MacDougall, eds., *Prophet With Honor*, 22–23). The fact that it was also taken over by *The American Agriculturist* of New York and used in its masthead illustration beginning with the April 1843 issue surely spread its fame even wider. See Schuyler, 73 and fig. 32.

80. See Pierson, ibid., 402–6 and fig. 267, where it is illustrated in an angle view. A similar view, from the other side, is in Andrews, *Architecture in New York*, 27.

81. *Cottage Residences*, 43.

82. An old view of the Sedgwick House, showing it with original porch cresting, is in McKee, ed., *Onondaga County*, 11, with descriptive text, 12 and 14. A later photo without cresting is in Andrews, *Architecture in New York*, 29. It was demolished in 1962.

83. Information on the Upham-Wright House, 342 Granville Street, Newark, is from an interview with Mary Sherwood Wright Jones (granddaughter of Virgil H. Wright) and her daughter Fanny Jones Kennedy, December 26, 1977.

The facade photo (see Color Plate I) illustrated was taken in 1967; by 1974 a permanent awning had been installed over the central lancet window.

84. According to Mrs. Jones, George Upham had been the "black sheep" of the family and had been sent out to Ohio. It is also said that this house was "just like" the Upham home in Claremont. Virgil Wright, who like his father was a tanner by trade, moved to Newark from the small village of Granville (where Denison College had been established by the Baptists in 1831) because, according to his granddaughter, "he got tired of [only] reading the Bible and hanging out the laundry." He established the Newark bank because he had lost $250 that had been deposited in Newark's Smith Bank when the owner absconded with the funds.

85. The front right parlor measures 16' 11" by 17' 7" wall to wall, almost the same as Downing's dimensions of 17' by 20'. Downing's hallway is marked as 7' wide; the Upham-Wright House hallway measures 7' 4" wide. The room behind this, now the library, was formerly a bedroom, just as on the Downing plan.

86. My thanks to George B. Tatum for this information and a xerographic copy of a photo taken of the house by Richard Betts (correspondence of April 1990).

87. See Bryant F. Tolles Jr. with Carolyn K. Tolles, *Architecture in Salem, An Illustrated Guide* (Salem, Mass.: Essex Institute, 1983), 237–38.

88. See Pierson, *Technology and the Picturesque*, 409–10 and fig. 271. The old photo was in the house on the author's visit, August 24, 1972; the description is based on a copy photo taken at that time.

89. See Elizabeth Mills Brown, *New Haven, A Guide to Architecture and Urban Design* (New Haven: Yale University Press, 1976), 98.

90. The old photo has been published in Chester Williams and Parker F. Scripture, eds., *Photographs of Rome, New York, 1880–1930* (Rome, N.Y.: Authors, 1975), 35. The house has now been remodeled into a Christian Science Church: The side portions of the veranda have been removed and the upper and lower story windows linked as one. See Virginia B. Kelly, Merrilyn R. O'Connell, Stephen S. Olney, and Johanna R. Reig, *Wood and Stone: Landmarks of the Upper Mohawk Region* (Utica, N.Y.: Central New York Community Arts Council, 1972), 48.

My thanks to Chester Williams for providing me with an original print of the vintage photograph (correspondence of November 1978).

91. See Pierson, *Technology and the Picturesque*, 427–29. Davis's original drawing is reproduced in fig. 289, a current view of the house in fig. 290. The Frederic Remington House in New Rochelle, New York, is also of this type.

The popularity of Downing's Design II has revived in the present day; mail-order blueprints of a slightly modernized version (the facade windows are wider) are now available. See *OHJ* 21, 1 (1993), 66.

92. Kelly et al., 29.

93. Pierson, *Technology and the Picturesque*, fig. 279; in the text, however (418), he dates the house "in the early 1840's." For two houses of this type but constructed more simply than the model, see Arthur Channing Downs, *Downing and the American House* (Newtown Square, Pa.: The Downing & Vaux Society, 1988), figs. 1 and 2.

94. Patricia McGraw Pancoast and Josephine H. Detmer, *Portland* (Portland, Me.: Greater Portland Landmarks, 1972), fig. 40.

95. My thanks to George B. Tatum for bringing this house to my attention and for providing me with a color slide of it (December 1982).

96. Tatum and MacDougall, eds., *Prophet with Honor*, 22.

97. Editor Louise Antoine Godey, writing in 1849, stated: "Everywhere have we received credit for our efforts to improve the cottage architecture of our country, and we have the proud satisfaction of knowing that hundreds of cottages have been built from plans that we have published. In one place not far from us, it has been suggested to call the place Godeyville, so numerous have been the cottages put up there from our plans." Quoted in George L. Hersey, "Godey's Choice," *JSAH* 18, 3 (1959), 104.

98. In *Country Houses* (257), Downing defines a cottage as "a dwelling so small that the household duties may all be performed by the family, or with the assistance of not more than one or two domestics;" while a villa (in the United States) is a "country-house of a person of competence or wealth sufficient to build and maintain it with some taste and elegance," and "requiring the care of at least three or more servants."

99. Pierson, *Technology and the Picturesque*, figs. 273 and 274, and pages 411–12.

100. Located at 31 Union Street; although published and illustrated in Marlene Lindquist and Therold Lindquist, *Architecture in Westfield, An Historical Survey* (Fredonia, N.Y.: Lakeshore Association for the Arts [1975]), n.p., it was not recognized at that time that the house duplicated a specific Downing design.

The date of c. 1863 was determined by the current owner's finding local newspapers of 1862 or 1863 date in the attic when insulating the house in the early 1970s. Two layers of newspaper have also been found in the walls (presumably between the stud sheeting and the exterior vertical boards) during repair work. My thanks to Robert C. Schofield for this and other information and for permission to study and measure his house (June 16, 1989).

For another dwelling (in Colt's Neck, New Jersey, erected in 1857) based on Downing's Design VII, see Robert P. Guter and Janet W. Foster, *Building by the Book: Pattern Book Architecture in New Jersey* (New Brunswick: Rutgers University Press, 1992), fig. 83.

101. The illustration, by R. J. Stevenson and R. A. Walker, a detail from a University of Auckland School of Architecture measured drawing, dates from 1966. Highwic is currently managed by the New Zealand Historic Places Trust as a house museum. My thanks to the senior curator David Reynolds for this information (February 1996).

102. The design is explained by Wheeler in material quoted by Downing, 298–304.

103. The 1850s date is proposed in Mary Raddant Tomlan, *A Walking Tour in Canandaigua* (Watkins Glen, N.Y.: American Life Foundation & Study Institute, 1977), 8 and 25. From the position

of the front doors and the location of the chimneys, they seem to have mirror image plans.

104. Clearly the classical porch and dormer on 40 Gibson Street are twentieth-century modifications, but the latticework between the cobblestone porch piers is certainly Gothic Revival scrollwork.

105. The western New York house is located in French Creek and is illustrated in Conover, 122. For the example in Midway, Utah, see John Maass, *The Victorian Home in America* (New York: Hawthorn Books, 1972), 49.

106. See Nancy E. Strathearn, "The Willows," *Nineteenth Century* 10, 2 (1990), 8–11. It is now a fully restored house museum on a two hundred-acre "living history" farm, open to the public.

107. Lancaster, "Plan Books," 20 and fig. 9.

108. Fredrika Bremer, *The Homes of the New World* (New York, 1853), I: 46, quoted by George B. Tatum in his introduction to the DaCapo reprint of *The Architecture of Country Houses*, vi.

109. These are discussed and illustrated in Downs, *Downing and the American House*, 8–10.

110. According to the late David G. Smith, who had conducted research into Chautauqua County architecture, "Oliver P. Smith practiced in the Ashville and Panama region and is probably the architect of many of the fine Greek Revival houses in that area which are not documented" (quoted on an introductory page of the American Life Foundation and Study Institute 1978 reprint of *The Domestic Architect*).

O. P. Smith's preface is dated September 1852, and the copyright is also 1852; but the publishing date on the title page is 1854.

111. Schuyler, 181.

112. Illustrated in Conover, 80–81. It is possible, of course, that these two houses were designed and built by Smith himself, even though they do not follow the published designs exactly.

113. Downing's Design XI from *Cottage Residences* (or some close adaptation of it) seems to have been the model for an 1869 dwelling erected as far away as Oysterville, Washington; see Sally B. Woodbridge and Roger Montgomery, *A Guide to Architecture in Washington State* (Seattle: University of Washington Press, 1980), 64.

It is interesting to note that the appeal of Downing's designs has revived in the later twentieth century; a Gothic cottage based on his plates was constructed in Alabama in 1977. See Walter B. Clement, "A Treatise on Building a New-Old Downing Cottage Adapted to the Late-20th Century . . . ," *OHJ* 17, 3 (1989), 48–52 and front cover.

114. Woodward also included, as Design 4 (fig. 14) his version of the L-shaped Gothic cottage of Downing and Smith; his has a bay window at the end of the side wing.

115. Although Downing was not cited as the source for this design of "a very cheap cottage," Baker's plans and elevations (figs. 73 and 75) from Orson Squire Fowler's *A Home for All* were properly credited. Baker's book, like Smith's, was a transitional work, for it combined house designs and descriptive text with technical portions on stair building (190–98) and included "Methods of Joining Timbers" (199–200).

Charles B. Wood III has traced this design for a "Working Man's Model Cottage" (which had in fact first appeared in Downing's *Horticulturist* in 1846) in several other publications, too (see 188–89 in his essay "The New 'Pattern Books' and the Role of the Agricultural Press," in Tatum and MacDougall, eds., 165–89).

116. In Harold N. Cooledge Jr.'s introduction to the reprint edition of these volumes (*Sloan's Victorian Buildings* [New York: Dover, 1980]), he asserts that "no other work of its kind had so long-lasting an influence upon the development of American vernacular architecture." For a discussion of the development and publishing of these volumes, see also Harold N. Cooledge Jr.,

Samuel Sloan, Architect of Philadelphia, 1815–1884 (Philadelphia: University of Pennsylvania Press, 1986), 35–38.

117. *Cottage Residences*, 10. Sloan noted that attempts "to produce in wood bold and striking effects that properly belong to stone or other material may, for a time, please an uneducated eye, but cannot fail ultimately, to be condemned as they deserve"; *Model Architect*, II: 64. Sloan also recognized, however, that timber was available in "abundance" and that "in many sections of our country, wood is the only available material for building purposes" (ibid.). In the construction cost estimate (65), timber was about 10 percent less than stone.

118. Ibid., 64.

119. Located at 323 Summit Street. The builder was Wallace Carpenter, who, according to research by Horace King, erected the house for his new bride. Carpenter built several extant dwellings in Granville, including a Greek Revival house with Italianate detailing; in 1888 he was hired to lengthen the village's Greek Revival Opera House (now demolished). My thanks to Robert N. Drake for this information (correspondence of May 1992).

120. *Cottage Residences*, 42.

121. Ibid., 24.

122. A. J. Downing, *Rural Essays* (New York, 1853), 171. The book is a collection of his editorials in the *Horticulturist*, this essay appearing in the March 1850 issue and reprinted here as chapter XI.

123. *Cottage Residences*, 21.

124. Ibid., 24.

125. Ibid.

126. See, for example, Domenichino's fresco *Punishment of Midas* of 1616–18, now in the National Gallery, London.

127. For the origins of the Italianate style, see C. L. V. Meeks, "Henry Austin and the Italian Villa," *Art Bulletin* 30, 2 (1948), 145–51; see also Charles E. Brownell, "The Italianate Villa and the Search for an American Style, 1840–1860," in Jaffe, ed., *Italian Presence*, 208–30. Cronkhill is illustrated in Meeks, "Henry Austin," figs. 1–2.

128. Meeks, "Henry Austin," 148.

129. Ibid., 149. It is interesting to note that these design books were used in England, too; houses based on Goodwin plates have been identified. See Angus Taylor, "Francis Goodwin's 'Domestic Architecture' and Two Cockermouth Villas," *Architectural History* 28 (1985), 125–30, with illustrations 131–35.

130. Meeks, "Henry Austin," 149.

131. For Riverside, see Constance M. Greiff, *John Notman, Architect, 1810–1865* (Philadelphia: Athenaeum of Philadelphia, 1979), 63–68, illustrated, 64. Notman's long description, quoted in Greiff, was on 314–16 in this edition of Downing's *Treatise*.

132. For Downing's original drawing of this design, see Schuyler, fig. 22; for his comments about it in a letter to A. J. Davis, see 63.

133. The house was built by a Utica lawyer; see Kelly et al., 44; it is illustrated on 45.

134. Barbara Clayton and Kathleen Whitley, *Guide to Flemington, New Jersey* (Stanton, N.J.: Clayton & Whitley, 1987), 38–39. Formerly located at 55 East Main Street, the house was demolished sometime between 1967 (author's photos) and the early 1980s. For an illustration, see John Maass, *The Gingerbread Age* (New York: Holt, Rinehart & Winston, 1957), 104.

135. The house, locally called "The Anchorage," was built by Douglas Putnam. The source of the date and other information (on the author's slides of December 1972) is not known.

136. This villa is located on the Chautauqua-Stedman Road, four miles south of Mayville. The date refers to the time that an early owner of the property took out a mortgage and seems about right for the area; my thanks to the current owners George and Sandy Green for this information (December 1991). The illustration in Conover, 112, shows it with the original rear porch.

Other villas of the same type are illustrated in Conover: one in Gerry, built about 1870, 54; one in South Stockton (with a mansard roof on the tower, suggesting a date of the 1870s), 83; and a third in Westfield, built in 1874, 106. All of these are very similar to the Green house, including the bay windows on both wings. A fourth example, in Busti (the John R. Robertson House), with bay only on the lateral wing, is illustrated in the 1867 Chautauqua County atlas.

137. For the Schneider House, see Reiff, *Washington Architecture*, 127–28, and fig. 191; for Stafford Place, see Maass, *Victorian Home*, 66.

138. Brownell, 211.

139. Ibid., 214–15, and fig. 131.

140. Austin's original drawing is depicted in Meeks, "Henry Austin," fig. 9; for the house as built (with later remodeling), see Brown, 124.

141. Bishir, "Jacob W. Holt," fig. 36.

142. See figs. 11–12 in Edward F. Zimmer, "Luther Briggs and the Picturesque Pattern Books," *Old-Time New England* 47, 3–4 (1977), 36–55. His creative use of Downing is also illustrated.

143. A few years later, Calvert Vaux explained in his *Villas and Cottages* (1857), 184, the need for both perspective views and elevation drawings: "If a study for a house is proposed to be so drawn out that it may be used by builders for working purposes, it is absolutely necessary that plans, elevations, and sections should be furnished, because no measurements can be taken from a perspective drawing, however neatly it may be done; but if the study is submitted with a view to show what sort of artistic effect may be produced, in execution, from a certain arrangement of ground plan, nothing but a perspective view will convey an accurate idea to the mind."

144. *AABN*, August 2, 1884, 49.

145. Cooledge, *Samuel Sloan*, 36.

146. Reiff, *Washington Architecture*, 129–30. A detail of the Boschke Map, published in 1861, depicting the layout of the Barber estate, is fig. 194. The attribution to Calvert Vaux is given in Mary Mitchell, *Divided Town* (Barre, Mass.: Barre, 1968), 65–66, but no source is provided. Downing had been invited to Washington in October 1850 to design the Mall, the grounds of the Smithsonian Institution, and those of the President's House. While in the capital, he and Vaux designed two (and possibly three; see Mitchell, 4) villas in Georgetown for the Dodge family. Downing's work of course ceased at his death on July 28, 1852 (at the age of 36); see Reiff, *Washington Architecture*, 114–22.

My thanks to Robert Rhynsburger of the U.S. Naval Observatory (which purchased the site in 1881) for this photo of the Barber villa.

147. This discussion of the Kent Mansion is based on my twelve-page "Report on Scottish Rite Temple Also Known as the Kent Mansion," prepared December 1988; on a seven-page mimeographed chronology and history, "The A. A. S. R. Building"; and other material provided by Thomas H. Neathery, secretary of the Temple. The vintage photos were printed from old negatives in the temple archives.

148. This house, now called Parrot Hall of the New York State Agricultural Experiment Station, is located at 643 West North Street; an angle view is published in H. Edmond Wirtz (photography by George J. Hucker, Research by Eleanore R. Clise, coordinated by H. Merrill Roenke Jr.), *Treasures of American Architecture in*

Geneva, New York (Geneva: Geneva Historical Society, 1987), 56. The print of 1856, with the legend "residence of Nehemiah Denton," is reproduced on the plaque now in front of the building; it also notes that the house was "built by Louisa A. Denton" in 1856, implying that her husband had died in that year. The old photo, also reproduced on the plaque, is dated 1885. The dimensions are from my own measurements (May 6, 1989).

149. Lindquist, *Westfield*, n.p. The house was located at 189 East Main Street; it was demolished in 1998 (despite a vigorous preservation campaign) so that the hospital that owned it could be expanded.

150. Bryant F. Tolles Jr. with Carolyn K. Tolles, *New Hampshire Architecture, An Illustrated Guide* (Hanover: University Press of New England, 1979), 79.

151. For illustrations and a discussion of these houses, see Reiff, *Washington Architecture*, 122–25. For a detailed investigation of the Robert P. Dodge House, see [Ellen J. Schwartz and Daniel D. Reiff], *Georgetown Architecture* ("Selections from the Historic American Buildings Survey," No. 10) Washington, D.C.: Commission of Fine Arts and HABS, 1970, 18–36.

152. The illustrations in *Villas and Cottages* were accidentally transposed; the upper engraving depicts the Francis Dodge House and the lower one that for Robert Dodge, not vice versa.

153. See Walter Creese, "Fowler and the Domestic Octagon," *Art Bulletin* 28 (June 1946), 89–102, which includes twelve plans and eleven illustrations. In *The Octagon House, A Home for All*, the 1973 Dover reprint of Fowler's 1853 edition, the introduction by Madeleine B. Stern, v–xii, is also informative. This reprint includes illustrations of nineteen constructed houses, primarily in New York state.

154. In Carl F. Schmidt, *The Octagon Fad* (Scottsville, N.Y.: Author, 1958), 62, the location is given as East Williamsburg, New York. In Fowler's 1853 treatise, the house is discussed and illustrated on 108–15; both floor plans are included as well. The house was "designed by Messrs. Morgan and Brothers, architects, Williamsburg, New York, for Mr. William Howland (our engraver), and has been much admired by builders for its neatness, simplicity, convenient arrangement, and cheapness" (108). It was thus an early example of the influence of Fowler's 1848 treatise.

155. In *The Octagon Fad*, Schmidt includes about 391 entries ("about" because I have interpreted his "several" to mean four) for the United States; this includes houses and buildings of all types octagonal as well as round and polygonal. Of the listed houses, churches, schools, barns, and other buildings (bandstands, carriage houses, dovecotes, bathhouses, offices, etc.), 252 are octagon houses. In Carl F. Schmidt and Philip Parr, *More About Octagons* (1978), the authors include about 335 new entries for the United States of which 165 are octagon houses. Only a very small number of these dwellings were built before 1848. Both volumes include numerous photos and plans of buildings listed and have introductory essays on Fowler and his times.

See also James A. Newton, "Crows' Nests or Eagles' Aeries? The Octagon Houses of E. A. Brackett and H. P. Wakefield," *Old-Time New England* 67, 3–4 (1977), 57–72, for creative variations on Fowler's ideas and plans.

156. *Model Architect*, I: 34.

157. Cooledge, *Samuel Sloan*, 38. For a North Carolina church with a facade copied faithfully from Sloan's Design XIX (vol. I), see Bishir, "Jacob W. Holt," fig. 38.

158. Such ads were not unknown before, however. Batty Langley, in a notice at the end of his *Ancient Masonry* (1736) "first advertised his services for building"; Placzek, ed., II: 608.

159. Although Cleaveland & Backus Brothers appear to have inaugurated this mail-order plan service for readers of pattern books, it was an idea whose time had come. Although published in 1856, their *Village and Farm Cottages* bears a copyright date of 1855. This is the same year that another plan service is recorded: The September 1855 issue of *Godey's Lady's Book* published "designs provided by the Haddonfield Ready Villa Association, which furnished ready-made plans and specifications at nominal cost"; see Hersey, 105.

160. Placzek, ed., IV: 222.

161. Placzek, ed., under the relevant entries.

162. Quoted in R. W. Liscombe, "A 'New Era in My Life': Ithiel Town Abroad," *JSAH* 50, 1 (1991), 6 n. 8.

163. [Ericsson], *Sixty Years a Builder*, 131.

164. James C. Massey, "Carpenters' School, 1833–42," *JSAH* 14, 2 (1955), 29–30.

165. Quoted by Richard Cote, 64, in his essay "Builders and Building Practices in Nineteenth Century America," in *Who Was the Architect of the Taft Museum? A Symposium* (Cincinnati, Ohio: Taft Museum [1987]), 62–74.

166. Jeffrey A. Cohen, "Building a Discipline: Early Institutional Settings for Architectural Education in Philadelphia, 1804–1890," *JSAH* 53, 2 (1994), 139–83.

167. Placzek, ed., I: 505.

168. Bishir et al., *Architects and Builders*, 138.

169. In comparing measured elevation drawings of both houses (as figs. 42 and 47 in Marcus Whiffen's *The Public Buildings of Williamsburg* [Williamsburg, Va.: Colonial Williamsburg, 1958]), they appear identical, but they are not actually the same size: The Brafferton plan measures 52' 6" by 34' 0" while the President's House is 56' 3" by 37' 9".

170. See Upton, *Holy Things and Profane*: The church planned for Wicomico Parish in 1753 "was designed as an explicit copy of Christ church," Lancaster County, Virginia (15); in the 1660s it had also been "the traditional practice of modeling a new building on a standing one" (31). For the Hooker and Bulfinch churches, see Mary Raddant Tomlan, ed., *A Neat Plain Modern Stile: Philip Hooker and His Contemporaries, 1796–1836* (Amherst.: University of Massachusetts Press, 1993), figs. 20–22.

171. Douglas G. Bucher, "Philip Hooker: Upstate Federal Period Architect," Preservation League of New York State *Newsletter* 10, 1 (1984), 4.

172. Peterson, "Philadelphia Carpentry," 12, quoting a letter by Latrobe of January 12, 1812.

173. Catherine W. Bishir and Marshall Bullock, "Mr. Jones Goes to Richmond: A Note on the Influence of Alexander Parris' Wickham House," *JSAH* 43 1 (1984), 74.

174. Quoted in S. Frederick Starr, *Southern Comfort: The Garden District of New Orleans, 1800–1900* (Cambridge, Mass.: MIT Press, 1989), 68. My thanks to Elizabeth Scarborough for bringing this item to my attention.

Literature of the day also confirms the popularity of constructed dwellings as models. In *The Pioneers* (1823), James Fenimore Cooper describes a grandiose classical-style house that becomes "a local model for emulation"; see Cohen, 37.

175. Greiff, 40.

176. Ibid.

177. [Ericsson], *Sixty Years a Builder*, 137. It also appears that Chicago's Tremont House had been modeled on its Boston namesake (ibid.).

178. Bishir et al., *Architects and Builders*, 144. The article appeared in the Raleigh *Southern Weekly Post* (November 3, 1855) and the *Carolina Cultivator* (December 1855)—both quoting an article by a *Connecticut* author! Ibid., 458.

179. My thanks to Susan Beates Hansen of the Erie County Historical Society (correspondence of January 1989) for providing me with the data needed for this examination: a transcript of the "Articles of Agreement" between Battles and Slater; copies of modern measured drawings and a plan of the house as it stands today; the *1987 Annual Report* of the Society; and xerographic copies of illustrations of both houses. My copy photo of the Battles farmhouse is from a stereograph of c. 1883; that of the Koch House (also called Cleveland House) is from an illustration in *The City of Erie, Pennsylvania, with Illustrations of Its Public Buildings, Churches, Schools, Summer Resorts, and Some of Its Residences, Business Blocks, Manufactories, and Citizens* (Erie, Pa., Herald Printing and Publishing, 1888).

180. Blackford was a carpenter living in Millcreek Township, Erie County, Pennsylvania, in 1850 who moved to Fairview Township by 1860, according to the Censuses. In the *Financial Assessment of Erie County and General Business Directory*, 1859–60, he is listed as having $54 worth of taxables compared with Rush Battles' $210 and Erastus Slater's $350." My thanks to Susan Beates Hansen for this information (correspondence of January 1992).

181. For these houses, see Alice Doan Hodgson, "History in Towns: Orford, New Hampshire," *Antiques* 112, 4 (1977), 712–25; plates V–VI and VII–IX.

182. Ibid., 719.

183. Campen, 62–63.

184. Daniel D. Reiff, *Architecture in Fredonia, New York, 1811–1997: From Log Cabin to I. M. Pei* (Fredonia, N.Y.: White Pine Press, 1997), 46–47.

185. Hamlin, plate 75, lower left; the duplicate is around the corner at 150 Main Street (author's photo). The house shown in Hamlin also has a molding with dentil band below it at the base of the frieze, but its twin has a molding only.

186. Such existing houses also made a builder's job easier, for dimensions and calculations of materials could be made from the standing dwelling, if access were permitted.

We should also remember how insistent Roger Pratt was that prospective owners have a three-dimensional model constructed of their proposed dwelling: "Whereas all the other drafts aforesaid do only superficially and disjointedly represent unto us the several parts of a building, a model does it jointly, and according to all its dimensions. So that in one rightly framed all things both external and internal with all their divisions, connexions, vanes, ornaments, etc. are there to be seen as exactly, and in their due proportions, as they can afterwards be in the work of which this is composed to be the Essay" (Gunther, 22–23). Pratt also observed (22) that "the Italians, the best architects of all others, . . . will hardly ever undertake to build anything considerable, or of expense, without" a model. He also describes how to make such models (23).

187. Quoted (4) in Tony Opalka, "Orr & Cunningham: Gothic Revival Builders in Albany," Preservation League of New York State *Newsletter* 15, 4 (1989), 4–5.

188. Clayton and Whitley, 115.

189. Roth et al., 20. One house is in Alabama Center; the other (now demolished) was in Wheatville.

190. Helen Schwartz, *The New Jersey House* (New Brunswick: Rutgers University Press, 1983), 91. Another square Italian villa pair, identical in all details except for one having three bays and the other four, can be found in Jefferson, Ohio; see Campen, 14.

191. Three essays that provide additional insights on material covered in this chapter (and to a degree, the previous one) can be cited: Neville Thompson's "Tools of Persuasion: The American Architectural Book of the Nineteenth Century," in Gerald W. R. Ward, ed., *The American Illustrated Book in the Nineteenth Century* (Charlottesville: University Press of Virginia, 1987), contains an excellent analysis of the purposes and character of selected carpenters' manuals and pattern books; Charles B. Wood III's "The Architectural Book in Nineteenth Century America," in di Valmarana, ed., *Building by the Book, 3*, 89–120, focuses on the changing nature, and effect, of illustration techniques (and also bindings); and Dell Upton's "Pattern Books and Professionalism: Aspects of the Transformation of Domestic Architecture in America, 1800–1860," in *WP* 19, 2/3 (1984), 107–50, is especially useful in his analysis of developing concepts of architectural professionalism.

4 Books and Building, 1863–1897

1. For information on Holly, see Michael Tomlan, "The Domestic Architectural Style Books of Henry Hudson Holly," a ten-page illustrated introduction to *Country Seats & Modern Dwellings*, the American Life Foundation 1977 reprint of Holly's two pattern books of 1868 and 1878.

His contact with English architecture had a lasting impact. His *Modern Dwellings in Town and Country* (1878) appears to have drawn prominently on ideas and designs already published in England. A letter critical of this "copying or very apparently adapting" of designs from "'Talbert's Examples,' the London *Building News*, and Cox & Sons' Catalogues," was printed in *AABN*, June 15, 1878, 212.

2. For a discussion of the mansarded style, see Rosalie Thorne McKenna, "James Renwick Jr. and the Second Empire Style in The United States," *Magazine of Art* 44, 3 (1951), 97–101. Often called the "Second Empire Style," the "French" or "mansard" mode actually antedates the Second Empire (1852–70) of Napoleon III, during which time it was indeed widely used. The 1837--49 extensions of the Hôtel de Ville in Paris carried out by Godde and Lesueur were an early prominent use of this traditional French roof form; and according to Hitchcock, "by the late forties the use of such mansards was fairly common in France" (Henry-Russell Hitchcock, *Architecture: Nineteenth and Twentieth Centuries*, 4th ed. [Harmondsworth, Middlesex: Penguin Books, 1977], 193). Notable private and public buildings were erected in this new style in England in 1849–51, and "as early as 1848" it was introduced into America; Hitchcock, ibid.

The New York hospital is reproduced in McKenna, fig. 8; for the Corcoran Art Gallery, see Reiff, *Washington Architecture*, 105–10.

3. The earliest mature example of an American dwelling in the "Stick Style" (a term coined in 1953 by Vincent Scully, not a contemporary usage) is Hunt's Griswold House in Newport, of c. 1861–63. For the origins of this style, see Sarah Bradford Landau, "Richard Morris Hunt, the Continental Picturesque, and the 'Stick Style,'" *JSAH* 42, 3 (1983), 272–89. See also Vincent J. Scully Jr., *The Shingle Style and the Stick Style*, rev. ed. (New Haven: Yale University Press, 1971).

4. Balloon framing, invented by George Washington Snow and used in his 1832 Chicago warehouse, has been studied at length; see especially Paul E. Sprague, "The Origin of Balloon Framing," *JSAH* 40, 4 (1981), 311–19, and Paul E. Sprague, "Chicago Balloon Frame: The Evolution During the Nineteenth Century of George W. Snow's System for Erecting Light Frame Buildings from Dimension Lumber and Machine-Made Nails," in H. Ward Jandl, ed., *The Technology of Historic American Buildings* (Washington, D.C.: Foundation for Preservation Technology, 1983), 35–61.

The astonishingly rapid construction made possible by the balloon frame was recognized by contemporaries, as this observation

by Henry Ericsson (*Sixty Years*, 136) attests: "When Builder A. S. Sherman became mayor in 1844, Chicago had a population of 8,000; when Dr. Boone became mayor in 1855, the city had grown to 84,000—nearly elevenfold in eleven years! How could housing be provided for so great a growth? The invention of the balloon frame alone made housing for such a multitude possible—a miracle hardly less dramatic than the feeding of the multitude with the loaves and fishes."

5. *Woodward's Country Homes*, 152.

The earliest pattern-book illustrations of balloon-frame construction appear to be in William E. Bell's *Carpentry Made Easy; or, the Science and Art of Framing . . .* (Philadelphia, 1858). This covers all forms of timber framing, but the balloon frame is briefly discussed and illustrated (part II, plates 4–6): "As Balloon Frames are the simplest of all, they are the first to claim our attention" (n.p.). This book seems not to have been reprinted, but is available on microfilm.

6. *Woodward's Country Homes*, 164.

7. In Woodward's description for his Design 8, he observes: "This design for a timber cottage is simple and at the same time picturesque. . . . It will be seen that some of the principal timbers of the frame are intended to show on the outside, and that there is a design contrast between the horizontal siding . . . and the vertical and batten covering" (50). Clearly the old timber-frame method, not the balloon frame, was here being employed. For a side-by-side illustration of timber framing versus balloon-frame construction in two Greek Revival houses, see Reiff, *Architecture in Fredonia, New York*, figs. 271 and 272.

8. *Woodward's Architecture and Rural Art*, I: 13.

9. Ibid., 104, in a two-page section "Computing Cost."

10. *Woodward's Architecture and Rural Art*, I: 51.

11. An interesting illustrated discussion of the careers of both men and the publishing successes of their books is found in Diana S. Waite's nineteen-page introduction to the American Life Foundation reprint edition (entitled *Victorian Architectural Details*) of the fourth edition of *Architecture* and the first edition of *Cummings' Architectural Details*. The original 1978 reprint does not include Waite's introduction; this appears only in the subsequent 1980 printing. According to Hitchcock, all the editions of *Architecture* between 1865 and 1872 that he lists have the same number of pages and plates. For the complete listing of the editions and reprints of *Architecture*, see Waite, n. 1.

12. Waite ["Introduction"], n.p.

13. In their introduction to the third edition of 1867 of *Architecture*, the authors observed that the book had "met with a reception and sale which far exceeded our expectations, and has found its way into the hands of architects, carpenters and builders in every portion of the United States, from Maine to California, and the demand for the same still continues unabated" (ibid.).

14. Ibid.

15. Ibid., citing in note 9 Allan Nevins and Henry Steele Commager, *A Short History of the United States*, 6th ed. (New York, 1976), 282, as the source.

16. In Paul Goeldner's eight-page "New Introduction & Commentary" to the 1976 American Life Foundation reprint of *Bicknell's Village Builder* and *Supplement*, biographical information on fifteen of these architects or firms is provided.

17. This house, at the corner of Knower Avenue and Bridge Street, is now the Mary Beatrice Cushing Memorial Library. Exterior measurements were taken on July 19, 1992.

It is thought that the house was built by Jacob Miers (born in Schoharie in 1835), who was a partner in Miers and Borst, "Mer-

chant Tailors & Dry Goods Dealers" (as listed in the 1872 county directory). No firm date of construction has yet come to light. My thanks to Emily Rauch, curator of the Schoharie County Historical Society, for these data (correspondence of September 1992). The house is reproduced in Edmund V. Gillon Jr. and Clay Lancaster, *Victorian Houses, A Treasury of Lesser-Known Examples* (New York: Dover, 1973), plate 73, although it is not identified as a Bicknell design. A similar house (plate 74) in New Berlin, New York, may be a freer adaptation of this Design 1. For a house in Somerville, New Jersey, that appears to be an exact copy of this plate, see Guter and Foster, fig. 111.

18. The plate is reproduced in color as the frontispiece to the American Life Foundation 1976 reprint.

19. Furthermore, plate 46, "Designs for a One-Story French Cottage, with Tower," has been torn out of my copy, probably by the owner for use in building the depicted design. The copy is blind-stamped on the fly leaf "Alfred Ernest Bower / Faulkner / Mass."

20. The title of the 1878 edition (corrected in later editions in light of the review) continued: "including Specifications, Bills of Materials, etc." The *AABN* review (July 6, 1878, 5) observed:

> [The book] does not fulfil the promise of its ample title, either in respect to the number of the designs, of which there are by no means one hundred, or as regards bills of materials, of which there are but two and these useless, or as regards specifications, of which there are none at all. But it is not easy for the general or the professional reader to understand why the market, already overburdened apparently with such works, should be charged with this new fardel. It is a disjointed and illiterate collection of wood-cuts mostly blurred by long usage, borrowed from a dozen authors. . . . The many minds herein represented as working upon the American theme of house building have fairly kept to the dead level.

21. Full-page ad in the advertising section at the back of *Palliser's Model Homes* (Bridgeport, Conn.: Palliser, Palliser & Co., 1878).

22. Such books, probably because of their ample text with descriptive and intellectual content, were also looked on kindly by the professional press. For example, H. Hudson Holly's *Modern Dwellings in Town and Country* (1878) was favorably reviewed in *The American Architect* (June 8, 1878, 198–99): "[T]he plans are nearly all ingenious—some of them exceptionally so—and their idiosyncrasies are on the right side; . . . large habitable halls . . . almost always cleverly contrived; . . . roofs . . . always well composed and interesting as part of the design;" and so on. It was later recommended on occasion to subscribers requesting the names of good books on domestic design, along with Vaux's *Villas and Cottages* (1857, but with later editions through 1874). See *AABN*, April 8, 1882, 226, and May 13, 1882, 166.

23. A. J. Downing, *Cottage Residences*, new ed. (New York: John Wiley & Son, 1873), 251.

24. Ibid., 252. "Unless his house is a fac-simile of his neighbor's, so that the builder has only to copy what he has already done, the alterations and additions the owner is obliged to make before he gets the edifice completed cost him double the architect's charge for the design" (254).

25. Ibid., 253.

26. Ibid., 253–54.

27. Ibid., 256.

28. Ibid., 259.

29. The house is located at 24 North Main Street. My thanks to Mr. and Mrs. Terry Tomsic for permission to photograph and measure their house and to copy the exterior photo reproduced here (visit of July 1981). This photo, taken in the late 1970s, and one taken about 1910 are reproduced in Howard D. Williams and Robert H. Kuiper, *Hamilton, Yesterday and Today* (Hamilton, N.Y.: Privately printed, 1985), 80.

30. The Lewis House, at 211 Chestnut Street, is a good example of how deceptive comparisons of this sort can be without the dwelling's being firmly dated. Despite the similarities of the exterior of the Lewis House and Hussey's plate 3, it was in fact built before any of his publications—perhaps based on a model Italianate cottage on which Hussey himself drew. The *Fredonia Censor* of January 5, 1870, notes that Mr. Lewis had just built "a fine brick house near the Bobbin factory on Chestnut Street"; later directory listings and the recollections of the widow of Lewis's son (who lived farther along the street) confirm the location, address, and date of the house. My thanks to Douglas H. Shepard for this information.

31. *AABN*, September 1, 1877, 280 ("American Vernacular Architecture").

32. This and most subsequent biographical information is drawn from Michael A. Tomlan's six-page introduction (n.p.) to the American Life Foundation 1978 reprint of *Palliser's Model Homes* (1876). See also Jeff Wilkinson, "Who They Were: Geo. Palliser," *OHJ* 18, 6 (1990), 18 and 20; and Gary E. French, "Palliser Pedigree," *OHJ* 19, 4 (1991), 8 and 10.

33. Preface, [4] to the 1878 fully revised version of *Palliser's Model Homes*. He also observes that "these [copies] have . . . been sent into every State and Territory in the Union, and many to the provinces."

34. *Model Homes* (1876), 6–7.

35. Tomlan reproduces a one-page sheet of drawings of the Centennial Villa, which had been reproduced in Scofield's *Atlas of the City of Bridgeport, Connecticut* (New York, 1876); this is probably a copy of Palliser's lithographed plans and elevations mentioned.

36. *Model Homes* (1876), 1.

37. Ibid., 5.

38. Ibid., 6.

39. "To parties who are about to erect cheap houses and do not think it necessary to get a full set of plans, specifications, etc., I make the following proposition: Write full particulars, as per directions given on page 6, and enclose to my address, with a sum not less than $2.50 per $1,000 of the estimated cost of the building, and on receipt of which your case shall receive prompt and careful attention, and I will make floor plans in the ordinary manner to a scale of one-eighth of an inch to the foot, arranging the rooms in the best form for appearance, convenience, and economy, and forward the same for your examination; and if any alterations or additions are required, return them at once, and I will make the same to your satisfaction; and for outside finish you can decide from my lithographed or other plans; and I would here say that I do not advise any one to conduct their building in this way, but I make this proposition to meet the wants of those who wish to do so, and my aim is to give satisfaction to all" (ibid., 3).

40. Ibid.

41. "My extensive practice in the designing and planning of all kinds of buildings, public and private, and the great number and variety of designs which can be seen at my offices, from which buildings have been erected, a great many of them under my direct supervision, ought to be a sufficient guarantee that those employing me will have their buildings designed in the best possible man-

ner and to their satisfaction, and any one who intends to build will find it good economy to communicate with me at once" (ibid., 2).

42. "I have been employed by quite a number who heretofore have done their own designing, etc., and they have invariably admitted their error in not having an Architect to do it, and that in the future they would not fail to employ one" (ibid., 3).

43. The adjacent house, 15 Cleveland Avenue, is a near duplicate of Number 11, except for lacking gable enrichment and in having a front veranda—both features of Design 23. Perhaps the local builder ordered both Designs 23 and 23 1/2 and combined their features in these houses.

44. Tomlan, *Model Homes* (1876) ["Introduction"], n.p.

45. *Model Homes* (1878) [4].

46. For the development of the Queen Anne style, see Scully, *Shingle Style*, 1–55; and Sadayoshi Omoto, "The Queen Anne Style and Architectural Criticism," *JSAH* 23, 1 (1964), 29–37.

Hitchcock (*Architecture*, 296) points out the direct international impact of Shaw's designs: "After their showing each year at the Royal Academy Exhibition Shaw's brilliant pen-and-ink perspectives of . . . houses were published photo-lithographically in the professional press. . . . Not surprisingly, these were the most influential of Shaw's works abroad . . . in the late seventies and early eighties."

47. "We shall be pleased to furnish Plans, Detail Drawings, and Specifications for any Design in this book, with any alterations that may be required, on receipt of full particulars. Without working drawings it is impossible for any one to carry out the spirit of a Design as intended by the Designer."

48. *Model Homes* (1878), 13.

49. Ibid., 14.

50. Ibid., 83.

51. Two main sources for biographical information on Curtis are George D. Merrill, ed., *History of Chautauqua County, New York* (Boston: W. A. Fergusson & Co., 1894), 503–5; and "Death of Capt. E. A. Curtis," *Fredonia Censor*, October 9, 1907, 1.

In Curtis's obituary, in the context of the late 1850s, we read: "Having a desire to perfect himself as an architect he bent himself to the task with the aid of . . . books obtainable on the subject." This is also confirmed by the entry on Curtis in B. F. Dilley, ed., *Biographical and Portrait Cyclopedia of Chautauqua County* (Philadelphia: John M. Gresham and Co., 1891), 133. The author observes that Curtis followed "the trade of carpenter and joiner . . . until the breaking out of the late civil war," and that after the War he settled in Fredonia, "where he *resumed* his studies in architecture" (italics added). A few of his plans or specifications have survived. The plans for a Gothic Revival house of 1875 in Sheridan, New York, are signed "E. A. Curtis Architect."

A three-page listing of many of his works, with citations, was prepared by Ann Fahnestock, Barker Historical Museum, Fredonia, in June 1986. This listing includes forty-six buildings designed, erected, or remodeled; a waterworks system; and "many school buildings" in New York state. Newspaper citations range from 1860 through 1906. Other buildings, mainly in Pennsylvania, have come to light since 1986.

52. Putnam certainly did not "need" a house this big: He and his wife had no children, although they had become foster parents of a little girl in 1875. Putnam's unmarried sister had died in 1876, but his elderly father may have lived with him. For a detailed account of Aaron O. Putnam and his house, which includes illustrations of six professional photographs of the interior taken about 1880, see Daniel D. Reiff, "The Aaron O. Putnam House: A Victorian Showplace in Fredonia, New York," Society of Architectural Historians Western New York Chapter *Little Journal* 6, 1 (1982), 21–29.

53. *Fredonia Censor*, June 12, 1878, 3. After discussing, under "Building News," a brick house in course of construction, it noted: "Aaron O. Putnam has the cellar dug on his Temple street lot and will have a fine house there in short order. E. A. Curtis is the architect; Porter Brothers build both houses. Putnam's will be a frame house but very nicely finished." The dwelling, complete with porte-cochere, was depicted in a perspective view in the New York *Daily Graphic* of September 24, 1879, along with other noted local buildings.

54. For example, the eaves brackets are similar to some shown in Cummings (1873) on plate 3, numbers 3, 5, and 6; perhaps even closer is a bracket shown in Bicknell (1873) on plate 5, fig. 8. Bicknell's "piazzas" are also in much the same style as the Putnam House veranda; see his plates 23 and 24.

By this date, factories making architectural features such as brackets and ornamental details were well enough established that the eaves brackets could come from some outside source; or perhaps they were a style that Porter Brothers favored or could produce on its own woodworking machines.

55. *Atwood's Modern American Homesteads*, published by A. J. Bicknell & Co., was somewhat different from many of the books we have been examining. It included "designs and studies for actual houses built in various places" and was intended to be a sort of "idea book." As Atwood states in his preface, because "works of this kind are chiefly valuable for the suggestions they offer in comparison of one plan with another, we have ventured to omit full specifications, but, instead, have furnished brief descriptions to most of the designs." Houses were illustrated by lithographed perspective views and also elevation drawings. As these latter were all of "uniform scale," the "pursuit of comparison and choice is a less wearying occupation than it usually is," Atwood observed. Curtis borrowed his porte-cochere from "E. W. Dean's Country House," which was illustrated on plates 25–28. The facade elevation drawing of the house reveals a full-width veranda and paired windows, similar to the A. O. Putnam House. Although Atwood's book was published in only one edition, the perspective view of the rear of Dean's house was copied in woodcut for Bicknell & Comstock's *Specimen Book* of 1880, 55.

For the account of Enoch Curtis and his book of house designs, my thanks to Ann Fahnestock; it is not recorded, however, on the taped interview she conducted with his son Lyvenus Ellis [II] on December 15, 1982 (Barker Historical Museum, Fredonia, New York). The same story was told to me by Mr. Ellis's daughter, Mrs. William A. Rowley (conversation of June 13, 1984). The family still preserves the Curtis drawings. They consist of four sheets, each measuring about 15 by 21 inches, marked "Residence of C. D. Ellis. Laona. Scale 1/4" = one foot." The sheets consist of a first-floor plan; second-floor plan; front elevation, foundation and wall section; and side elevation. They are in black ink with red ink for dimensions, yellow wash for solid walls; darker yellow for "door opening" lines; dark blue-green for indicating ceiling medallions; and pink for brickwork. They are neither signed nor dated. The house type was one he repeated several times locally, but its published archetype has not yet, alas, been found. My thanks to William A. Rowley for permission to study and photograph the plans (June 1990).

56. The house, still extant at 10 Follen Street, Cambridge, was designed for T. B. Mackay and was built in 1875. For a current view, see Bunting and Nylander, *Old Cambridge* (1973), fig. 211.

57. The design was actually for the remodeling and updating of an older side-hallway-type house. The work was by the architect Richard Briggs of Bridgeport, Connecticut.

58. The cornice was for "Store No. 31 Green St., NY—Iron Facade"; the architect was G. W. Romeyn of New York City.

59. *AABN*, November 17, 1877, 371 ("Self-Made Architects").

60. See, for example: *AABN*, May 13, 1882, 226 ("Books on Modern Architecture"); June 2, 1883, 262 ("Book for Beginners"); February 14, 1885, 82 ("A List of [thirty-five] Books"); February 12, 1887, 81 ("The Best Twenty Books for An Architect's Library"); and January 7, 1888, 11 ("Books [on construction and interior decoration]").

61. The Palmettos was built in 1877 for the Hammond family (of Hammond organ fame) of Cincinnati as a winter residence and is constructed of heart cypress and heart pine. The house was purchased in 1888 by J. Monroe Taylor of New York state (whose business was fire extinguishers), and the Taylor family owned it for ninety years. My thanks to Susan Muije for this information, photos of the house and grounds, and the color negative from which the photo reproduced was made (correspondence of January 1987).

62. The illustration reproduced is from a plate in Woollett's book, which was reprinted in Bicknell & Comstock's *Specimen Book* of 1880, on page 19.

63. See *Historic Preservation* 48, 3 (1997), 5.

64. No documented proof that Curtis was the architect has yet appeared, but it is very similar in style to another Victorian Gothic house he designed in the late 1870s in Fredonia; he is the documented architect for a nearby dwelling in Laona for one of Horace White's former partners; the manner of composing based on numerous design sources is the same as in the Putnam House; and Curtis was the only architect practicing in the immediate region at the time.

Horace White died in January 1879 at the age of fifty. His biography in the 1881 county atlas, with his portrait, vignette of his house, and a larger view of his tannery work (facing 58), lauds his business success and untiring energy. He bought out his last partner in 1875, suggesting that the house was designed in a period of financial prosperity about 1877–78.

65. Hussey's plate in turn is quite similar to Design 16 in Vaux's *Villas and Cottages* of 1857 (but with several later editions, the last in 1874), reminding us of how seemingly ubiquitous was the practice of drawing ideas from published designs.

66. Comstock became sole publisher in 1881 and continued the business through at least 1890.

67. The Pallisers also published a work of this type in 1881, their *Palliser's Useful Details: A New and Practical Work on Every Description of Modern Architectural Detail*, consisting of forty plates. It received mixed praise (as one would expect) when reviewed in *The American Architect* (July 23, 1881, 37–38): the editors observed that it contained "a multitude of details, well arranged and properly co-ordinated, of such constructive features as must be wrought into the small houses, stables, shops, etc., in whose construction nine-tenths of the mechanics and a large proportion of the architects of the country find their occupation. . . . There is much shown in these sheets that is good and worthy of imitation, while there is more that, judged as design, is commonplace, and not a little that is vulgar and reprehensible."

68. In response to a letter from a subscriber in Missouri asking for titles of books on modern architecture, the editors of *The American Architect* recommended several, including Comstock's *Modern Architectural Designs and Details* (May 13, 1882, 226). A few years later in a list of "the best books on architecture and building" requested by an Illinois subscriber, they cited Comstock's *American Cottages* of 1883 as the sole entry under "Dwellings" (February 14, 1885, 82).

69. Quoted from the last page of *New Cottage Homes*, n.p.

The Pallisers also asserted, in an ad included in this book (but not reproduced in the American Life Foundation reprint of c. 1975), that "over 75,000 copies of the plans" of the dwelling depicted had al-

ready been sold! See James L. Garvin, "Mail-Order House Plans and American Victorian Architecture," *WP* 16, 4 (1981), 321 and fig. 18.

70. *AABN*, January 15, 1881, 30 ("Palliser's Specifications"). Later that year when an architect in Tennessee inquired about how to learn to write builders' specifications, they recommended this volume to him (December 3, 1881, 271).

71. *AABN*, April 16, 1881, 189 ("Palliser's Form of Contract"). Five years later, their forms, and also W. T. Comstock's, were recommended to a Missouri architect (January 12, 1886, 289). See also November 30, 1889, 260.

72. This discussion of Shoppell and his Association is based largely on Susan G. Pearl, *Victorian Pattern Book Houses in Prince George's County, Maryland* (Upper Marlboro: Prince George's County Planning Board, 1988), which is devoted almost entirely to Shoppell; and also on Garvin, "Mail-Order House Plans," esp. 314–26.

73. Garvin, "Mail-Order House Plans," 314.

74. Pearl, 53.

75. *Shoppell's Modern* Houses, I: 1 (January 1886), "Miscellaneous Notes," quoted in Pearl, 4.

76. A sample "Complete Bill of Materials" for Design 936 is reproduced in Pearl, 7–10.

77. The portfolio and handbook are discussed in Garvin, "Mail-Order House Plans," 317 and 321; a full-page ad for them, with most of the explanatory text readable, is reproduced in Pearl, 12. The portfolio and handbook were "prepared and published by the Co-operative Building Plan Association, Architects . . . under the supervision of R. W. Shoppell and Stanley S. Covert."

78. Quoted in Pearl, 11.

79. R. W. Shoppell et al., *Turn-of-the-Century Houses, Cottages, and Villas* (New York: Dover., 1983), 119.

80. *AABN*, July 6, 1878, 5 ("American Vernacular Architecture, IV"); October 4, 1879, 105–6 ("Architectural Piracy"); March 10, 1883, 119 ("Copyrighting Designs"); and October 8, 1887, 175 ("No Redress for Stealing Executed Designs").

81. *AABN*, March 17, 1988, 132 ("A Question of Commission").

82. All "Fifty Favorites," and accompanying text, are reproduced in Pearl, 67–79.

83. Pearl, figs. 6–22, designs published between 1887–91. Garvin also illustrates six pairs, but at least four of them depict houses erected before the date of the plate illustrated; these may have been the first dwellings built following the plans prepared by Shoppell and his colleagues.

84. The house is at 50 Curtis Place. The date, courtesy of Douglas H. Shepard, is based on local directories and the records of the Fredonia Street Commissioner. The house was built for E. P. Wilson.

85. Shoppell et al., *Turn-of-the-Century Houses*, 38.

86. The house is located at 533 Swan Street. According to research by Douglas H. Shepard (October 1992), the lot was sold by a local brewer, Andrew Dotterweich (whose brewery was located two blocks behind this property), to James Chapman ("clerk") on July 16, 1897, for $1,000. By September of that year, Chapman is listed at this address in the local directory.

It is said, however, that soon after the house was built the owner moved away, and it was sold to the Dotterweich family. Edward R. Dotterweich (1900–1995) inherited the house when his grandmother died about 1968. My thanks to Karm Tuttle for this information; to Mr. Dotterweich for permission to inspect and measure his house; and to Mike Campese for assistance with the survey (December 6, 1989, and January 9, 1990). The artificial siding was added to the house in about 1986, and the porch columns were altered (from paired supports to single) at the same time.

87. Shoppell et al., *Turn-of-the-Century Houses*, 97.

88. Reproduced in Pearl, figs. 11–12. Both these Shoppell designs, but especially. 563, were probably inspired by the dwelling published in *The American Architect* on July 31, 1886, in its $5,000 house competition. Shoppell's 563 was to cost $4,585.

This sort of design, with a prominent full-height facade tower, can be found in the work of other architects of the day, too. A rendering of a gabled house by Lamb and Rich with an off-center tower very much like Shoppell's design (open at the top) can be found in *The American Architect* of July 9, 1887. A second published design of August 31, 1889, depicts a gambrel-roofed house by E. H. Hammond with tall central-facade tower quite similar to, if more lofty than, Shoppell's, confirming that his designs were actually reasonably up-to-date.

89. The dimensions of the published design are 34' 6" wide by 55' 0" deep (including veranda); as built it measures 37' 1" by 41' 5".

90. Pauline Fancher, *Chautauqua: Its Architecture and its People* (Miami, Fla.: Banyan Books, 1978), 28–29.

91. Most of the following information on Barber is from Michael A. Tomlan's "Toward the Growth of an Artistic Taste," 4–32, in the 1982 American Life Foundation reprint edition of Barber's *The Cottage Souvenir No. 2*. Tomlan's essay has twenty-seven illustrations and twenty plates depicting constructed Barber buildings. See also Patricia Poore, "Pattern Book Architecture: Is Yours a Mail-Order House?" *OHJ* 8, 2 (1980), 183, 190–93.

92. Tomlan, "Artistic Taste," 12.

93. Barber, *Souvenir No. 2*, 11.

94. Ibid., 9.

95. Tomlan, "Artistic Taste," 10.

96. Marylu Terral Jeans, "Restoring a Mail-Order Landmark," *Americana* 9, 2 (1981), 47, citing research by Richard Lucier, observes that he had "located 175 Barber houses across the country"; now Mr. Lucier notes that "the locations of Barber houses known to me have grown into the hundreds" throughout the United States. For example, in the small town of Calvert, Texas, "there are several Barber houses . . . and dozens more in other nearby towns." My thanks to Mr. Lucier for this information (correspondence of April 1992). For an illustration of a Barber dwelling in Mississippi and its model, see "Readers' Gallery," *Americana* 10, 1, (1982).

97. Richard Butcher and his wife Susan came to the United States from England as newlyweds in the fall of 1865 and settled near Fredonia. According to his obituary (*Fredonia Censor*, May 24, 1916), "[F]or many years, Mr. Butcher engaged in farming and in grape growing, and by hard work, thrift, and integrity was successful. He became . . . one of the most substantial and successful growers west of the village." An undated *Censor* account of January 1915 mentions that he was also "vice president of the National Bank of Fredonia and a Trustee of the Village."

It is said that Butcher built the house (now 4728 West Main Road, Fredonia) as a surprise for his wife, but that she did not much like it; about 1911 they moved into the village, and in 1912 it was sold to Charles Aldrich, whose descendants still own the house (now considerably remodeled on the exterior).

My thanks to Marjorie K. Hastings, a daughter-in-law of Charles Aldrich, for the above information (July 24, 1985) and to her grandson Kirk Hutchinson for the floor plan (redrawn by Richard L. Peebles Jr.) and the old photos of the house (December 1981). My thanks to both for permission to take current measurements (April 13, 1992).

98. Omitting (or shifting) fireplaces was even expected. As Barber notes (9): "Quite a number of fireplaces are shown in each floor plan in this work—only to give their location in case they are

wanted—but to be omitted and their places supplied with sliding or other doorways, when they are not required."

99. The house, located at 115 East Main Street, was published in Lindquist, *Westfield*, n.p., but was not then known to be a Barber design.

According to William S. Edwards, the owner of the house between 1959 and 1985, there was another dwelling almost identical in style in nearby Brocton, New York, which was demolished about 1961 for the current American Legion building. According to Edwards, who visited with her in the 1960s, Clara Miller (daughter of the builder Henry Wratten) recalls her father erecting the house and remembers that an existing frame dwelling on the lot was moved off to accommodate it; the Storm House barn/carriage house had been built for this older home. The only apparent alteration to the exterior of the house today is the replacement of an openwork frieze between the porch posts with solid boarding and the loss of the balustrade on the roof in front of the corner tower.

When Edwards purchased the house in 1959, the adjacent supermarket had also submitted an offer (slightly lower, it transpired) intending to demolish it for a parking lot. My thanks to William S. Edwards for permission to photograph and measure his house and for this and other information (July 23, 1985).

100. A colored postcard of the house, c. 1900 (courtesy William S. Edwards), which shows Captain Storm at attention on his front steps, reveals that the wood trim was painted tan, with brown for corner boards and some detailing; the latticework was apparently ocher; and the relief in the porch gable (and the long panels below the circular window) were cream colored. The roof (which in 1985 was still the original metal shingles) was painted bluish-gray. With the bright red of the pressed brick, the house was as colorful as it was picturesque.

The foundations, as Barber specified, are solid stone. Walls are standard stud construction, with boarding both inside and out; on the inside, lath is nailed on, with plaster applied to this; on the outside, one thickness of brick is attached. The total wall thickness is 13".

An example of Barber's Design 33, which is in frame construction and seems to follow the original drawings faithfully, was built in Bellville, Kansas, in 1894. See *OHJ* 22, 5 (1994), 71. Barber's Design 33 can also be found in Reed City, Michigan; it is illustrated in Eckert, *Buildings of Michigan*, 378.

101. For the Illinois house, see Gwendolyn Wright, *Building the Dream: A Social History of Housing in America* (Cambridge, Mass.: MIT Press, 1981), 103 (although not identified as a Barber house); for the one in Wisconsin, see Poore, "Pattern Book Architecture," 192; and that in Texas, ibid., 193, and Tomlan, "Artistic Taste," plate 12.

102. The Roueche House is located at 762 Park Avenue. My thanks to Mr. and Mrs. Edward Sternby for this information (February 1992). I am also indebted to Jean B. Harper for bringing this house to my attention.

103. Jeans, "Mail-Order Landmark," 40.

104. Both Tomlan quotes are from "Artistic Taste," 11.

105. My thanks to Richard Lucier for these quotations and references (correspondence of April 1992).

It is interesting to note that Barber designs are still available in mail-order blueprints: for "A Barber Cottage" based on his Design 41 of 1891 see *OHJ* 20, 1 (1992), 54. See also Lynn Elliott, "Reproduction Houses," ibid., 21, 5 (1993), 37–43 and the front cover, which include two other Barber designs.

106. See Charles E. Peterson, "Early American Prefabrication," *Gazette des Beaux-Arts* ser. 6, 33 (1948), 37–46; Margaretta Jean Darnall, "Innovations in American Prefabricated Housing, 1860–1890," *JSAH* 31, 1 (1972), 51–55; and also Charles E. Peterson,

"California Prefabs, 1850," *JSAH* 11, 3 (1952), 27, and Charles E. Peterson, "Prefabs in the California Gold Rush, 1849," *JSAH* 24, 4 (1965), 318–24. Despite its title, Alfred Bruce and Harold Sandbank, *A History of Prefabrication* (New York: John B. Pierce Foundation, 1943), has virtually nothing to say about prefabricated dwellings before the 1930s.

In the 1850s, prefabricated houses were built in abundance in the middle west as well as in California. In 1855, *The New York Tribune* noted that "the western prairies are dotted over with houses which have *been shipped there all made*, and the various pieces numbered." Michael J. Doucet and John C. Weaver, "Material Culture and the North American House: The Era of the Common Man, 1870–1920," *Journal of American History* 72, 3 (1985), 573.

Three catalogs for "portable houses" are listed in Lawrence B. Romaine, *A Guide to American Trade Catalogs, 1744–1900* (New York:. Bowker, 1960), 25, 29, and 35. They are the 1862 catalog "Portable Sectional Houses," by D. N. Skillings and D. B. Flint (New York and Boston); the c. 1887 Grand Rapids Portable House Company catalog featuring cottages, cabins, bathhouses, and hunters' cabins; and the American Patent Portable House Manufacturing Company (of Corona, Long Island) catalog of c. 1890. The sectional houses of Skillings and Flint are discussed and illustrated in Darnall, 51–52.

One must also keep in mind the important developments in prefabricated building in the United States carried out in *iron*, especially the work of James Bogardus, who erected a complete iron facade as early as 1848 and buildings completely of iron units bolted together soon thereafter. See Antoinette J. Lee, "Cast Iron in American Architecture: A Synoptic View," in Jandl, ed., 97–116; and Carl W. Condit, *American Building Art: The Nineteenth Century* (New York: Oxford University Press, 1960), 25–74.

Despite the claims of Bogardus, the first prefabricated iron building in America actually seems to date from some years earlier. An item in *The New York Times* of July 29 1853, discovered by Jeanne H. Watson, states that "the first building erected entirely of cast iron in this country" was planned, and construction supervised, by James Rodgers of New York City in 1841. It was set up briefly, then taken apart, and shipped to Cuba. See "The *Very* First Cast-Iron Building, 1841," *The Magazine Antiques* 113 (February 1978), 448.

See also Gilbert Herbert, *Pioneers of Prefabrication: The British Contribution in the Nineteenth Century* (Baltimore: Johns Hopkins University Press, 1978).

107. See *AABN*, May 6, 1882, 215 ("Portable Houses"), and September 9, 1882, 117 ("Who are the Makers of Portable Houses?"); see also May 17, 1890, 107 ("Portable Chapels").

108. By 1936, E. F. Hodgson was even producing prefabricated houses, in addition to cottages, playhouses, and farm buildings. By that date, there were numerous others in the field, too: For example, the Houston [Texas] Ready-Cut House Co., organized in 1917, produced sectional houses for the oil industry; the Southern Mill & Manufacturing Co. of Tulsa, Oklahoma, began selling its "Sturdybuilt" sectional houses in 1919; and the T. C. King Co. of Anniston, Alabama, "began production of portable, demountable buildings in 1935." See Bruce and Sandbank, 54, 55, 63, 65, and 66.

109. Darnall, 52. This sort of prefabricated house owes a great deal to the enormous upsurge in machine-worked wood and lumber by 1860. Statistics cited in Bishir et al., *Architects and Builders*, 218–19, make this clear. According to the 1860 census, companies that manufactured sash, blinds, doors, and moldings were doing a booming business; "Pennsylvania had 108 factories, and New York's 212 factories turned out over $1,500,000 worth of sash and blind materials" (ibid., 219). Even Ohio had 91 factories, producing almost a million dollars worth of such components.

Timber-framed houses in the colonial era were also occasionally prepared and shipped to distant sites. A documented case of this from the late eighteenth or early nineteenth centuries is cited in *The American Architect* of February 21, 1903, 64 (under "The Old City-Hall, Hartford").

110. Bishir et al., *Architects and Builders*, 230.

The wonders possible with the new machines of the 1870s were noted in contemporary trade periodicals of the day. The *American Builder* in 1874 observed that the "past few years have been wonderfully prolific in the production of labor-saving machinery"; and in 1887 the journal pointed out that in many houses "the parts are brought together all prepared and fitted, and it is short and easy work to put them together." Doucet and Weaver, 572. See also their Table 2, "Hand and Machine Labor Costs in the Woodworking Industry, 1858 and 1896 Compared," 571.

111. The cottage (actually a good-sized two-story house), completed by the summer of 1875, derives special fame for having been owned by Miller's son-in-law, Thomas A. Edison, who installed electricity at an early date. The house (remodeled inside in 1922 when a wing was added to the right side) was entered on the National Register as a National Historic Landmark in 1966. For a good vintage photo of the Miller Cottage, see Fancher, *Chautauqua: Its Architecture and its People*, 35. See also Richard N. Campen, *Chautauqua Impressions: Architecture and Ambiance* (Chagrin Falls, Ohio: West Summit Press, 1984), 25–26 and figs. 23, 24, and 26.

For Lewis Miller (1829–99), see *The National Cyclopaedia of American Biography* (New York: James T. White, 1944), 31, 136–37.

112. The Otis House mantel is reproduced in Kimball, *Domestic Architecture*, fig. 210. Richard Nylander and Abbott Lowell Cummings (conversation with the latter, May 29, 1985) think that the Otis House mantel, signed with a name not known to have been one of the Boston plaster or compo workers, and the mantel in the Newton House, were both imported from England.

113. The mantel in the George Reed II House, New Castle, Delaware, is illustrated in Robert G. Miner, ed., *Architectural Treasures of Early America: Colonial Homes in the Southern States* (New York: Arno Press, 1977), 66, and is discussed in Michael Olmert, "Delaware's Colonial Hideaway," *Historic Preservation* 37, 3 (1985), 62–63. The *Triumph of Mars* motif is also found on the frieze capping a mantel mirror in 69 Castle Street, Canterbury, Kent, a house of 1551 and 1664, which was remodeled and redecorated in the late eighteenth century (author's photos, September 1984). Similar *Triumph of Mars* mirrors can be found in the United States, too.

114. Bishir et al., *Architects and Builders*, 77. See also 127 for reference to compo details for a North Carolina fireplace (of 1817) imported from New York City.

115. See also Herbert Mitchell and Frank G. Matero, *The Architectural Trade Catalog in America 1850–1950: Selections from the Avery Collection* (New York: Columbia University, 1985), a forty-two-page catalog that includes 100 annotated entries (copy courtesy Frank G. Matero). The introduction cites locations of the major collections of trade catalogs in the United States.

I have also included in Appendix 5, a "Sampling of Catalogs and Manuals on Interior and Exterior Details, 1877–1947," of over 100 catalogs or flyers, the majority briefly annotated, from eighty-six different firms.

See also Gordon Bock, "Mail-Order Interiors," *OHJ* 16, 6 (1989), 38–39, and Herbert Gottfried, "Building the Picture: Trading on the Imagery of Production and Design," *WP* 27, 4 (1992), 235–53.

116. *AABN*, September 21, 1878, 101, reviewing S. B. Reed's *House-Plans for Everybody, for Village and Country Residences* (1878), which, it should be noted, was quite popular, having five editions through 1884.

117. *AABN*, March 20, 1886, 143 ("Catalogues Wanted").

118. This discussion is based on the reprint edition, which reproduces twenty-two of these color plates, some of the descriptions and specifications for each, and a selection of some of the journal articles; see Eugene Mitchell, comp., *American Victoriana: Floor Plans and Renderings from the Gilded Age* (San Francisco: Chronicle Books, 1979).

119. The Michaels House (also called Forestview because a forest was originally located across the street) is located at 17 Nelson Avenue; it was published in Diantha Dow Schull, *Landmarks of Otsego County* (Syracuse: Syracuse University Press, 1980), 33, where the *Scientific American* source of its design is identified.

The carpenter for the house was Charles L. Root, and the mason was Charles J. Tuttle, according to Harold H. Hollis et al., *A History of Cooperstown* (1976), 124–25. For this and other information on the house and for permission to measure and photograph it, my thanks to Mr. and Mrs. Leonard A. Sauer (June 26, 1988).

120. The Kingsbury House, located at 55 Elm Street, is published in Lindquist, *Westfield*, n.p., although the design source is not identified. Harry E. Wratten "worked on" the house, according to his daughter.

My thanks to Beckman Realty for permission to inspect and measure the house (June 16, 1987).

121. For example, on the published plan, the front parlor is 12' by 14' 6" while the Westfield house measures 11' 7" by 14' 5 1/2"; the library on the plan is 12' by 15' and as built 11' 10" by 15' 0"; and the kitchen is 12' by 14' versus 12' 1" by 14' 1" as built.

122. The house is located at 499 Fairmount Avenue. My thanks to Randall J. Elliott for information on the house and the floor plan on which this examination is based (December 1986).

123. Twenty-one of these designs have been reprinted in Donald J. Berg, ed., *Modern American Dwellings, 1897* (Rockville Centre, N.Y.: Antiquity Reprints, 1984). "Design 9" is reproduced on 41–43. The architects represented came from a variety of states: New Jersey, Ohio, Massachusetts, Connecticut, Rhode Island, Tennessee, Illinois, Michigan, Nebraska, and Colorado.

124. My thanks to Robert and Joanne Schweik for permission to inspect and measure their house (April 29, 1985). The date, based on assessment records and village directories, was provided by Douglas H. Shepard.

125. Berg, ed., 1.

5 The Impact of Architectural Journals

1. *AABN*, November 28, 1885, 255–57. The preceding article, "Advice to Students," on 255, lists in essay form a great number of books as well. For other citations of suggested books in the *AABN*, see above Chapter 4, note 60.

2. *AABN*, July 30, 1887, 50–52.

3. Charles B. Wood III, "The New 'Pattern Books' and the Role of the Agricultural Press," in Tatum and MacDougall, eds., 167, 169, and 178 and figs. 3–6.

4. Tatum and MacDougall, eds., 36 and figs. 13–14.

5. See plates facing 35, 265, and 271, and 250–51, from essays published in 1846 and 1848.

6. George L. Hersey, "Godey's Choice," *JSAH* 18, 3 (1959), 104.

7. *AABN*, June 8, 1878, 199.

8. Margaret Culbertson, comp., *American House Designs: An Index to Popular and Trade Periodicals, 1850–1915* (Westport,

Conn.: Greenwood Press, 1994). The author provides an annotated bibliography of the indexed periodicals, a listing of designs appearing in each title, an index of architects cited, and indexes where the designs were built (if given in the original issues).

9. The following discussion of journals is based primarily on: "American Architectural Journals," *AABN*, May 9, 1885, 219–20; [Michael A. Tomlan, Judith Holliday, and Julee Johnson], *Nineteenth Century American Periodicals Devoted to Architecture and the Building Arts: A Microfilming Project* (Ithaca, N.Y.: Cornell University Fine Arts Library, [1992?]), a sixteen-page illustrated and annotated brochure; Mary Woods, "The First American Architectural Journals: The Profession's Voice," *JSAH* 48 (June 1989), 117–38; and Mary N. Woods, "History in the Early American Architectural Journals," in Elisabeth Blair MacDougall, ed., *The Architectural Historian in America* (Washington, D.C.: Center for Advanced Study in the Visual Arts, 1990), 77–89.

10. Woods, "History," 78.

11. The journal "was found in fragmentary form in a second-hand bookstore," but enough was preserved to provide information as to who produced it: "The first copy was edited by 'an association of practical architects,' the second by 'Ritch & Grey, Architects,' the third by John W. Ritch, who continued to edit the work until the twentieth number appeared, after which we assume that the work must have been done by Amzi Hill, as his name replaces Ritch's in an advertisement." The journal cost three dollars per year, and was published monthly. *AABN*, March 20, 1897, 90. Hitchcock, however, considered this simply a pattern book that appeared in monthly parts between at least June 1847 and May 1849; see items 1013–19 in Hitchcock, *Architectural Books*, 84–85.

John Haviland had prepared a prospectus in 1830 or 1831 for an architectural journal, but nothing came of it.

12. This is considered "the first architectural journal published in the United States" by modern scholars; see Woods, "First Journals," 117.

13. In Sloan's obituary, it was noted that "he deserves the credit of being one of the first persons in the country to perceive the deficiency in technical literature which he afterwards endeavored to supply in his *Architectural Review and Builders' Journal*." *AABN*, August 2, 1884, 49. See also Cooledge, 87–94.

14. Woods, "First Journals," 132.

15. Tomlan et al., 10.

16. Doucet and Weaver, 575.

17. *AABN*, May 9, 1885, 219; the list consisted of "still surviving journals" as of that date.

18. Ibid., 220.

19. *AABN*, March 24, 1888, 133.

20. *AABN*, November 29, 1890, 138.

21. Ibid., 139. A few years later, there were "between fifty and eighty journals and "building papers" being published—far too many for the market, according to the editors. *AABN*, December 2, 1893, 105.

22. Tomlan et al., 6.

23. *AABN*, January 7, 1888, 11.

24. *AABN*, April 2, 1898, 7. That the correspondent described the product at length indicates that he had read the article, not just looked at illustrations (if any).

25. Tomlan et al., 16.

26. The 1898 *Year Book of the School of Architecture* for the University of Pennsylvania was seventy-nine pages long with drawings, plans, and a descriptive text. Cornell's first "architectural annual" (1898–99) was seventy-six pages in length. After the demise of the *Technology Architectural Review* in 1890, MIT students published an "architectural annual" too; the 1901 issue con-

tained seventy-five pages and even had trade advertisements like a journal.

27. My thanks to the library at West Point Military Academy for lending its microfilm copy of the *AABN;* and to Librarians Donald Cloudsley and Mary Jane Smith of the Buffalo and Erie County Public Library for facilitating my xerographic and copy-photo work with their original issues of the journal during 1991–93.

28. *AABN* issues of July 26--October 4, 1884.

29. Articles or series that I have cited by title and date can be looked up in the index provided for each volume of the *AABN*.

The series "Water Closets" ran between December 16, 1882, and October 20, 1883. See also "Ventilation of Sewers and Drains," August 31, 1878, 76–77.

30. Sometimes very detailed accounts were published, such as "The Siphonage and Evaporation of Traps: Report to the Boston City Board of Health," June 7, 1884, 267–71.

31. *AABN*, August 13, 1881, 79; November 5, 1881, 221–23; December 3, 1881, 270–71; and January 7, 1882, 10.

32. *AABN*, August 7, 1886, 67.

33. "U.S. Timber Examinations and Tests," *AABN*, February 18, 1893, 110–11.

34. *AABN*, February 4, 1888; June 7 and June 28, 1890; and September 19, 1891.

35. *AABN*, June 4, 1892 (Advertising Section).

36. *AABN*, September 16, 23, and 30, 1882, and December 7, 1889. The material is best described in "A Test of Straw Lumber," August 4, 1883, 56–57.

37. *AABN*, January 4, 1896, 1.

38. Concrete was also discussed, in conjunction with iron, October 4, 1884, 163–66, and in slabs (with and without iron reinforcing rods) February 3, 1900, 37.

39. *AABN*, September 15, 1900, 81.

40. For example, *AABN*, March 17, 1888, 130–31.

41. Doucet and Weaver, 577, table 4.

42. *AABN*, June 10, 1899, 81.

43. An *AABN* article of August 14, 1897, 53–54, observed that *licenses* were now needed to cut timber from public lands.

44. *AABN*, May 20, 1899, 57–58, and June 3, 1899, 78–79.

45. *AABN*, September 30, 1876, 314. This is part of a series "Architectural Students" which began on September 23, 1876.

46. Joan Draper, "The École des Beaux-Arts and the Architectural Profession in the United States: The Case of John Galen Howard," in Spiro Kostof, ed., *The Architect: Chapters in the History of the Profession* (New York: Oxford University Press, 1977): 209–10.

47. *AABN*, September 30, 1876, 314–15.

48. *AABN*, May 4, 1878, 154.

49. See, for example, *AABN* responses to letters June 23, 1883, 298; October 4, 1884, 166; January 15, 1887, 35; and December 17, 1887, 295.

50. *AABN*, June 2, 1883, 262; June 23, 1883, 298; October 4, 1884, 166; August 16, 1890, 107; and March 5, 1892, 160.

51. *AABN*, November 17, 1877, 371, and especially the vivid account by an anonymous contributor (who had been on his own since the age of nine) on August 31, 1878, 79.

52. See James F. O'Gorman, "Documentation: An 1886 Inventory of H. H. Richardson's Library, and Other Gleanings from Probate," *JSAH* 41 (May 1982), 150–55.

53. The library (and also his studio) is discussed in *AABN*, December 27, 1884, 304.

54. *AABN* Advertising Section, May 5, 1894, xi.

55. At the end of the school's publication *The Building Trades Pocketbook: A Handy Manual of Reference on Building Construc-*

tion (Scranton, Pa.: Colliery Engineer Co., 1899), ix--xvi, are informative testimonials from twenty-four former students, many of whom rose from the ranks of craftsmen to become architects.

56. *AABN,* July 4, 1891, 1–2.

57. Draper, 209–10. In response to letters on December 13, 1884, 286, as well as on June 28, 1890, 202, *The American Architect* editors recommended each time Columbia, MIT, Cornell, and Illinois as "the principal schools of architecture in this country."

58. *AABN,* Advertising Section, May 25, 1895, v.

59. Ibid., February 18, 1899, i.

60. *AABN,* September 17, 1881, 129; February 12, 1887, 84; August 4, 1888, 47–49; January 5, 1889, 11; November 6, 1897, 45; and December 17, 1898, 93.

61. *AABN,* August 6, 1881, 61–62; December 1, 1888, 251–52; December 8, 1888, 272; December 29, 1888, 303; and August 6, 1898, 44–45.

62. *AABN,* October 6, 1888, 155–57; April 4, 1896, 1; May 30, 1896, 88; April 22, 1892, 25–26; and June 23, 1900, 91.

63. *AABN,* June 2, 1899, 73; July 8, 1899, 9; January 20, 1900, 17; and September 22, 1900, a plate showing Harvard's new Architecture Building by McKim, Mead, and White.

64. *AABN,* November 21, 1891, 113–15; September 1, 1888, 95–97; March 31, 1894, 152–53; September 14, 1889, 117; August 26, 1899, 65; and August 16, 1890, 105.

65. *AABN,* March 19, 1881, 136–39 (an essay by George Edmund Street); November 28, 1885, 255–57; October 1, 1887, 109; November 19, 1887, 245–46; May 24, 1890, 117–18; and October 24, 1891, 57–59.

66. *AABN,* May 19, 1888, 238; May 24, 1890, 110; February 13, 1897, 50; February 27, 1897, 72 (a letter by John Galen Howard); April 15, 1899, 22; and November 25, 1899, 61–68; and October 6, 1900, 3–4.

67. *AABN,* May 4, 1889, 211–13; March 22, 1890, 181–82; and July 10, 1897, 17–19.

68. *AABN,* May 10, 1890, 86–88.

69. *AABN,* April 17, 1880, 180–81 (England and Germany); November 18, 1882, 246; and July 5, 1884, 5–6 (England, France, Austria, Germany).

70. *AABN,* December 26, 1896, 107–10.

71. *AABN,* July 17, 1886, 35; and January 15, 1887, 35.

72. The "Summer School" series, by E. B. Homer, was fully illustrated with photos and plans and ran from July 31, 1897, through September 17, 1898; "Hints" was by J. W. Case.

73. *AABN,* February 26, 1881, 104; June 25, 1881, 307–8; and June 20, 1885, 296–98.

74. See Daniel D. Reiff, "Viollet-le-Duc and American 19th Century Architecture," *Journal of Architectural Education* 42 (Fall 1988), 32–47.

75. See also *AABN,* January 22, 1876, 26–27; "Domestic Architecture" (by Josiah Conder) April 2, 1887, 160–61; and (in the Imperial Edition only) a "Helio-chrome" entitled "Entrance to Temple, Nikko, Japan," July 20, 1889.

76. See *AABN,* September 10, 1898, "Mitla and Other Ancient Cities of Mexico," 85–86; the article contained illustrations, and the two-page plate "Ruins at Mitla, Mexico" appeared in the same issue.

77. The Letter, "Professional Charges A. I. A." (*AABN,* December 27, 1884, 308), confirmed the rate of 5 percent "upon the cost of the work" for "full professional services (including supervision)" and also included a breakdown of fees for various stages of the drawings prepared in case of "abandonment of work."

78. See, for example, *AABN,* February 23, 1895, 87; September 28, 1895, 139; December 14, 1895, 128; July 17, 1897, 28; August 28, 1897, 76; September 3, 1898, 64; January 7, 1899, 7; and February 18, 1899, 55.

79. For example, see *AABN,* September 11, 1880, 121.

80. For example, *AABN,* April 5, 1890, 16; June 19, 1897, 91; and September 18, 1897, 95–96.

81. *AABN,* June 5, 1886, 265–66; January 1, 1898, 3–4; January 21, 1899, 20–21; and February 4, 1899, 34.

82. See *AABN,* January 15, 1881, 30; April 16, 1881, 189; December 3, 1881, 271; January 12, 1886, 287; November 30, 1889, 260; and October 10, 1896, 14–15.

83. *AABN,* October 29, 1898, 34; and July 15, 1899, 18.

84. *AABN,* August 5, 1899, 41–42.

85. For example, see *AABN,* June 15, 1878, 206–8; October 19, 1878, 135; December 7, 1878, 191–92; July 5, 1897, 7; June 4, 1881, 267; December 27, 1884, 308; November 5, 1887, 223; November 12, 1887, 234 (a letter from McKim, Mead, and White); April 6, 1889, 168; July 19, 1890, 44–45; October 1, 1892, 10–12; January 23, 1897, 27; and August 26, 1899, 70–71.

86. *The American Architect* editors were not unequivocal champions of the issue: "[S]ave in exceptional cases, we believe . . . the [importance] of the ownership of drawings . . . is generally overestimated by the profession." *AABN,* July 3, 1886, 83.

87. See *AABN,* July 20, 1878, 21–22 (an article reprinted from *The Architect*); March 10, 1883, 119; July 23, 1898, 25; and November 29, 1890, 137–38 (from *The Building News*). Copyright is also occasionally referred to in some of the citations in note 82 above.

88. For this case, see *AABN,* December 6, 1879, 178–79 and 183–84.

89. Most of the cases discussed in the *AABN* are in response to letters about specific instances of drawings being reused; see July 24, 1880, 45–46; October 27, 1888, 199; August 31, 1889, 103; April 19, 1890, 48; October 18, 1890, 29; March 28, 1891, 207; July 11, 1891, 30; August 1, 1891, 76; October 22, 1892, 64; October 29, 1892, 76: December 19, 1896, 94; and July 23, 1898, 25. See also December 20, 1902, 96. The letters come from many parts of the country, including Massachusetts, New York, New Jersey, Rhode Island, Iowa, Michigan, Indiana, and Utah.

90. *AABN,* July 24, 1880, 46. Complaints by architects of builders copying constructed features—or whole buildings—also occasionally appeared in the journal; see October 4, 1879, 105–6; October 25, 1879, 129; October 8, 1887, 175; and July 30, 1892, 61–62.

91. *AABN,* April 26, 1884, 203. See also March 15, 1884, 129; January 9, 1886, 23; May 5, 1894, 55; and February 16, 1895, 69.

92. *Harper's Monthly* (March 1857), 451–63; and (July 1875), 161–80.

93. *AABN,* May 17, 1879, 153.

94. *AABN,* October 22, 1881, 192–94; August 15, 1896, 53; January 19, 1895, 29–30; and November 30, 1889, 260.

95. *AABN,* October 10, 1891, 30–31; July 9, 1892, 30–31; and June 22, 1895, 122–23.

96. See *AABN,* June 26, 1886, 301, and June 27, 1896, 121. In the final preservation campaign, even C. R. Ashbee sent a letter of support (May 2, 1896, 45–46). A history of the building was included June 29, 1895, 127–29.

97. *AABN,* August 20, 1898, 57.

98. *AABN,* August 6, 1898, 49.

99. *AABN,* December 24, 1898, Advertising Section, xi.

100. Review of March 9, 1899, quoted in *AABN,* June 3, 1899, Advertisers' Trade Supplement, 3.

101. *AABN,* July 1, 1899, Advertisers' Trade Supplement, 2. The volumes had broad cultural appeal as well: "It is to the general

reader quite as much as to the professional student that these . . . drawings and photographic reproductions offer pleasure and instruction" (ibid., Advertising Section, x, quoting the *Springfield Republican*). Ads for the volumes in the July 22, 1899, issue quoted laudatory comments from *The New York Times* and the *Providence Journal*.

102. *AABN*, January 28, 1899, 25.

103. *AABN*, August 25, 1900, Advertising Section, xi. The "final volume" (part X) of *The Georgian Period* was published in August 1902. See *AABN*, November 20, 1901, 65, and October 4, 1902, 1. A listing of the previously published parts and press encomiums for most of them is on page ii of the August 23, 1902, Advertising Section.

104. See also *AABN*, August 14, 1886, 89; February 12, 1887, 81; and November 25, 1893, 100–103.

105. *AABN*, April 4, 1891, 1. For a sampling of requests for book information during the year before, see April 19, 1890, 48; May 3, 1890, 74; August 2, 1890, 75; and February 21, 1891, 127–28.

106. *AABN*, March 17, 1888, Advertising Section, xvii.

107. *AABN*, July 24, 1886, 37. See also December 4, 1886, 261; and January 8, 1887, 13. The journal was especially valued by students, it would seem; see June 17, 1891, 47.

When *The American Architect* moved to a different building in Boston in 1903, it held a "removal sale" of back issues, which the editors were confident would be of great interest to "draughtsmen and younger architects" who sought illustrations (and articles) "of interest and value." *AABN*, October 31, 1903, 33.

108. *AABN*, January 11, 1890, 18.

109. *AABN*, December 26, 1896, 105.

110. *AABN*, April 3, 1897, 8. Even H. H. Richardson saved illustrations from journals; item 214 of the probate book list is "*Building News*, Plates from and other sources." See O'Gorman, "Documentation," 152.

111. *AABN*, November 28, 1891, 140.

112. *AABN*, December 12, 1891, 171–72; and January 23, 1892, 63.

113. *AABN*, June 8, 1878, 199; and November 24, 1894, Advertising Section, xvi.

114. *AABN*, September 5, 1891, 141; and September 26, 1891, 204. For comments on the large collection of architectural photographs in the Boston Public Library, see September 23, 1899, 98.

115. *AABN*, April 26, 1884, 203.

116. Ibid., and January 9, 1886, 23. In the *AABN*, July 21, 1900, 17–18, the editors observe that "illustrations . . . afford instruction, foster emulation, and give encouragement to professional readers; and, secondly, they serve to inform the public as to the artistic capacities of the architects whose designs are published." See also "The Influence of Architectural Journals on the Reputation of Architects," *AABN*, January 11, 1890, 17–18.

117. *AABN*. January 9, 1886. 23; and April 26, 1884, 203–4.

118. See *AABN*, March 15, 1884, 129; and May 5, 1894, 55.

119. *AABN*, June 14, 1886, 299–300.

120. *AABN*, September 27, 1884, 153.

121. *AABN*, December 19, 1896, Advertising Section, xviii.

122. For examples of small houses that were occasionally reproduced, see *AABN*, January 1, 1876; November 24 and December 29, 1877; February 16, September 14, and November 30, 1878; March 8, 1879; January 30, July 3, and December 4, 1880; August 6, 1881; and February 11, August 5, and November 4, 1882.

123. *AABN*, September 1, 1877, 280.

124. *AABN*, June 8, 1878, 198–99; July 6, 1878, 5; and September 21, 1878, 101.

125. *AABN*, April 8, 1882, 166; and May 13, 1882, 226.

126., July 23, 1881, 37–38; and February 14, 1885, 82.

127. *AABN*, January 27, 1883, 42–43.

128. "The Wholesale Architect as an Educator," by C. H. Blackall, *AABN*, November 3, 1894, 44–45. The journal's editors expressed their own opinions clearly two years later (in an essay "Ready-Made Plans for the German Market"): "We cannot say that we have a very high opinion of the collections of ready-made plans which are so extensively sold in this country, as compared with the work of a thoroughly accomplished architect"; *AABN*, September 12, 1896, 82.

129. *AABN*, November 18, 1882, 243.

130. *AABN*, January 20, 1883, 25; the letter from Canada was published January 6, 1883, 10.

131. The jury reports appeared March 17, 126; March 24, 139; April 21, 185–86; May 5, 211–12; and May 19, 233.

132. *AABN*, December 23, 1882, 307–8; February 3, 1883, 59–60; and June 3, 1883, 262.

133. The jury report on the Danfors design appeared May 17, 1883, 126; he had been identified and the prize announced March 3, 1883, 104. One reader wrote to complain that his estimate was too low, however, February 3, 1883, 59–60.

134. *AABN*, June 2, 1883, 262.

135. *AABN*, June 15, 1878, 212. Our critic "W. S. C." thought that the book would be improved by having "these lines of Montaigne on the title-page . . . : 'I have gathered a posie of other men's flowers, and nothing but the thread that binds them is my own.'"

In *The American Architect*'s review of the book (June 8, 1878, 198–99), Holly's acknowledgment of drawings "borrowed from the *Building News*, from Dresser, Talbert, and others" was cited, but the reviewer thought that his sources should have been given with the titles of each plate, not just in the body of the text, because architects studying the illustrations (only) would otherwise overlook them.

136. H. Hudson Holly, born in 1834 in New York, had studied architecture with Gervase Wheeler in 1854–56 and then went to England "to complete his studies"; his practice was "confined chiefly to dwelling-houses . . . in all parts of the country." This information is from a brief biographical passage in the article "A Group of American Architects" (*AABN*, February 16, 1884, 75–76), which identifies twenty-eight members of the American Institute of Architects whose group photograph—unique among all the illustrations of the journal—was published in the journal with an identifying key. Others in the photo include such illustrious architects as William Le Baron Jenney, Thomas U. Walter, and Napoleon LeBrun. Holly died in 1892 (see *AABN*, August 17, 1892, 174).

137. *AABN*, June 23, 1883, 291. The jury consisted of H. W. Hartwell (chairman), Robert S. Peabody, and F. W. Chandler.

138. *AABN*, August 4, 1883, 54.

139. *AABN*, November 3, 1883, 214.

140. *AABN*, January 9, 1886, 23. The editors suggested the possibility of "re-publication in book-form" of the entries, but nothing came of the idea.

141. *AABN*, March 13, 1886, 121.

Although small house designs do continue to appear on occasion in the journal's plates during the next half-dozen years, by 1894 (when Waddy B. Wood's "Suburban Cottage of Modest Cost" was published in the March 24 issue) such houses were a rarity. The only subsequent reference before 1900 to small-house competitions seems to be "An Interesting Competition for Artisans' Homes," *AABN*, May 21, 1898, 57.

142. Doucet and Weaver, 581–82.

143. See Leland M. Roth, "Getting the Houses to the People: Edward Bok, *The Ladies' Home Journal*, and the Ideal House," in

Thomas Carter and Bernard L. Herman, eds., *Perspectives in Vernacular Architecture, IV* (Columbia: University of Missouri Press, 1991), 187–96 and 236–38.

See also Sharon Ferraro, "Ladies' Home Journal Houses, 1895-1919," *OHJ* 26, 2 (1998), 52--57; several designs with their built versions are depicted.

The journal does not appear to have been as punctilious in giving architects credit for their designs as was the professional press, however. See "A Correction Denied," *AABN*, August 2, 1902, 40.

144. The whole page, with text and illustrations, is reproduced in Roth, 190. In the advertisements on this same page, there is one for a book of house plans ("all grades, cheap, medium, and elaborate") published by the architect Frank P. Allen of Grand Rapids, Michigan. The book of 100 plans cost one dollar.

145. Roth, 191.

6 Catalog and Mail-Order House Companies and Designs, 1900–1920

1. Catalogs cited in the Appendixes were derived primarily from the listings of antiquarian book dealers, so that their descriptions and collations are probably reliable. Others are items lent by friends and colleagues or copies in my own collection, which I did not survey plate by plate and are thus not listed in the bibliography of pattern books and catalogs studied.

2. This quotation and data about Radford's early business are from John J. Mojonnier Jr., "Introduction," n.p., in *Old House Measured and Scaled Detail Drawings for Builders and Carpenters*, the 1983 Dover reprint of *Radford's Portfolio of Details of Building Construction* of 1911. (See also Neal Vogel, "Who They Were: William Radford," *OHJ* 21, 5 (1993), 24 and 26.)

However, the Radford Architectural Company did not cease business on William Radford's retirement. The Library of Congress National Union Catalog lists the company's *Artistic Homes* with a publication date of 1928.

3. *The Radford Ideal Homes* apparently first appeared in 1898, for a copy of the October 15, 1898, newsletter called *The Red Radford Review* (edited by William Radford and Benjamin Cobb) advertised *Ideal Homes*. See *OHJ*, 22, 1 (1994), 10 and 12.

The 1904 and 1907 editions, the issues I consulted for this study, are hardcover books with a two-color embossed front cover (the enframement in Art Nouveau style), which each sold for one dollar. Following page 109 are eleven unnumbered pages of index, information on plans and specifications, lumber bills, guarantees, and ads for other Radford publications. The 1904 copy has a drilled or punched hole in the upper left corner as if it had been kept on display in a contractor or lumber dealer's office.

4. This and all other quotations about Radford's company and plan business (except as noted otherwise) are taken from the introductory material (3–16) of *The Radford American Homes* (1903), which essentially duplicates all the material in the earlier *Ideal Homes*.

5. *Practical Carpentry* was "edited under the supervision of William A. Radford," but the copy consulted was a "Special Exclusive Edition printed by The Radford Architectural Company expressly for Sears Roebuck and Company, Chicago, Illinois." Furthermore, although the house designs are clearly Radford products and the explanatory text is the same as in Radford's catalogs, the "blue printed working plans and typewritten specifications" were to be ordered from Sears!

6. The regular edition, which cost one dollar when ordered directly from Radford, was hardbound "in English cloth" with a decorative pictorial cover and "gilt top."

7. Quoted from Mojonnier, n.p.

8. The Jackson House is located at 19 South Mercer Avenue, Sharpsville, about twelve miles northeast of Youngstown, Ohio, and a couple miles northeast of Sharon, Pennsylvania. This discussion is based on the original blueprints and specifications; an old photograph of the house taken soon after it was completed; a newspaper article including many data on Jackson, "Historical Society gets B & O Locomotive Model," *The Herald* (Sharon, Pennsylvania), November 14, 1981, 2; and an on-site visit on May 1, 1988. The date of construction is derived from the house deed. I am indebted to the current owners, Frank E. and Connie Robinson, for sharing this and other material with me and for permission to measure and photograph their house. See also Judi Swogger, "Home Is a Mail-Order Gem for Sharpsville Couple," *The Herald*, May 12, 1988, 9.

All my interior measurements were taken wall-to-wall and exclude baseboards or trim.

9. According to the Robinsons, who purchased the house from a daughter of John W. Jackson in 1981, these pages are said to have been removed so that no one would be able to know just how much Jackson paid to have the house built. Because the house has a full basement with stone walls and brick partitions within rather than just brick pier foundations and was finished in an artistic manner (the downstairs trim is all oak, and the upstairs doors and moldings are expertly grained to imitate woods such as maple, oak, and mahogany), it certainly cost far more than Radford's estimate.

10. That mantels in houses of this period could be seen as "additions" to the interior—and even be "demountable"—is confirmed by a legal item cited by *The American Architect* (May 6, 1899, 42), in which no less than the Supreme Court determined that mantels could be considered "furnishings" rather than "fixtures": "'[A]dvancing mechanical science and taste have evolved an altogether differently constructed mantel . . . sold separately, and made adaptive to any kind of house. They are, in fact, as much a separate article of merchandise as a bedstead or a table.'"

11. Reproduced in R. W. Shoppell et al., *Turn-of-the Century Houses, Cottages, and Villas* (New York: Dover, 1983), 48. The same design was republished as Design 1988 in the October 1900 issue of *Modern Houses;* see ibid., 83.

12. The Day House is located at 122 Central Avenue. My thanks to Robert and Minnie Town for permission to inspect and measure their house (April 30, 1985). The date of construction, based on 1905 news accounts in the *Fredonia Censor*, the 1906 Directory, and the assessment rolls, is courtesy of Douglas H. Shepard. My thanks also to Del Findley and Jackie Swansinger, current owners, for permission to take additional measurements (March 29, 1992). It was they who discovered, after removing the wallpaper, the traces of the parlor door, originally leading out onto the wraparound porch, and the broad (but rather short) window at the rear of the sitting room, looking out onto the back porch.

13. Model 119 is illustrated and the dates it was sold are recorded in Katherine Cole Stevenson and H. Ward Jandl, *Houses by Mail: A Guide to Houses from Sear, Roebuck & Co.* (Washington, D.C.: Preservation Press, 1986), 323. In the 1915 Sears catalog, it states that the Sears version could be built for about $3,345; the Radford estimate of 1903 for a house a couple feet narrower, although otherwise almost identical, was $2,250 to $2,500.

14. The house is located at 438 Washington Avenue. From local directories between 1898 and 1912 and an examination of the

1904 and 1910 Sanborn atlases (courtesy Douglas H. Shepard), it appears that Toomey purchased an existing frame house on the site soon after 1903, had it demolished, and constructed his new dwelling on the same site before 1907. In 1912, he is listed as co-owner of Toomey, Fitzer, Hollander Livery.

My thanks to Sue Sheedy for permission to inspect, measure, and photograph her house (June 5 and 11, 1987). On the plan, the width of the living room includes the bay, but in the parlor and the dining room the dimensions are to the wall surfaces only.

15. Morgan Woodwork Organization, *Building with Assurance,* 2d ed. (Chicago, Detroit, Cleveland: Morgan Sash & Door Co., 1923), 127. Although most of the catalog (84–430) is concerned with all manner of components and details for the house inside and out, there is also a section of fifty-six house designs and plans (24–79).

By 1905, however, there were a good number of woodworking companies that could supply such interior details; I have mentioned the E. L. Roberts 1903 catalog earlier, and the contemporary E. J. Davis Manufacturing Co., also in Chicago, is cited in my Appendix 5 listing interior and exterior details. In addition to this listing, see also Romaine.

16. The 1915 building materials catalog of this well-known Davenport, Iowa, firm was reprinted as *Gordon-Van Tine Co. Architectural Details, 1915,* by the American Life Foundation in 1985. Mantel 654 is depicted on 92.

17. See *Turn-of-the Century Houses,* 37; related designs are on 6 and 8.

18. "Residence of Dr. G. C. Clarke," on Jefferson Avenue, Niagara Falls, New York, by Block, Barnes, and Orchard, Architects, of the same city.

19. The house is located at 339 Water Street. The current owner, Harry Joy, remembers as a boy of eight or nine years seeing the house built for his mother and father, John and Rose Joy—which would put the construction date as 1913 or 1914. According to Douglas H. Shepard, local directories and the local Town Assessor's Tax Map confirm a date of 1913–14.

My thanks to Harry and Nettie Joy for giving me permission to inspect and measure their house and providing background information (April 27, 1985).

20. This lower-story chamfered bay can also be found in a more complex Queen Anne cottage in *Palliser's Model Homes* (1878), plate VIII, and in subsidiary wings of other designs in that volume. The treatment was also used in a number of Barber designs, such as Numbers 14, 15, and 34 in *Cottage Souvenir No. 2* (1891).

21. n Stevenson and Jandl, see 229 for Number 24, offered between 1908 and 1917; 196 for Number 116, between 1908 and 1913; and 197 for "The Avoca," of 1908–19.

22. Located at 124 West Main Street. The exact dating of this house is something of a conundrum. It is essentially identical in design to 232 West Main Street, which Douglas H. Shepard has established was built between 1905 and 1906, but the records for 124 West Main are not conclusive. In Dr. Shepard's report to me (April 1, 1992) on this house, he found that

it belonged to Charles E. Straight at least from 1889 through 1915. In the 1903 assessment roll the value was $420 and again in 1904. In 1905 it jumped to $750 and in 1906 to $1,000. The problem is that I cannot find any mention in the newspapers of his remodelling or rebuilding, nor can I find any petition to the Board of Trustees for permission to do either in 1903–1905. Something fairly dramatic happened on the property between 1904 and 1905/6, but

that's as much as I can say right now. The 1904 assessment was made around June or later in that year. That means the change in valuation happened after June 1904. In his annual report for the preceding year, given in May 1905, the secretary for the Village Fire Department listed the fires in the previous year and 124 is not included. So the change was probably not caused by the old place burning down.

I am indebted to Timothy and Susan Slate for permission to inspect and measure their house (April 26, 1985).

23. Located at 138 Lakeview Avenue. My thanks to Joseph Lodico for permission to inspect and measure his house (May 1, 1985, and July 21, 1986). According to Douglas H. Shepard, the house was built by Bernard Lewis by 1904 and owned by William H. Lewis in 1909 and by Cosimo Lodico in 1910, as recorded in local directories and assessment rolls.

24. In *Country Houses,* after discussing a shingled "Swiss Cottage" design by an Albany architect, Downing observed (128): "This mode of covering wooden houses with shingles is a very durable mode, and, when the shingles are cut in ornamental patterns, it has a more tasteful and picturesque effect than common weatherboarding. It is quite as durable a material for exteriors as wood in any form, and we can point to examples of shingle-covered Dutch farm-houses in our vicinity, more than a hundred years old, and still in good preservation."

25. For the development and character of this style, see Scully, *The Shingle Style and the Stick Style,* and also Robert A. M. Stern, gen. ed., *The Architecture of the American Summer: The Flowering of the Shingle Style* (New York: Rizzoli, 1989).

26. See Cynthia Zaitzevsky, *The Architecture of William Ralph Emerson, 1833–1917* (Cambridge, Mass: Fogg Art Museum, Harvard University, 1969), figs. 13–14.

27. See, for example, plates in the issues of November 4, 1882, April 24, 1886, and December 10, 1887.

28. See 68 and 75, in Pearl, *Pattern Book Houses.*

29. See *Turn-of-the-Century Houses,* 63 and 103.

30. It is located at 9 Catlin Avenue.

31. For these examples, see Stevenson and Jandl, 315; Gustav Stickley, ed., *Craftsman Bungalows* (New York: Dover, 1988), 127; and Henry Atterbury Smith, ed., *The Books of a Thousand Homes,* vol. I, 3rd ed. (New York: Home Owners Institute, 1927), 51.

32. See *Turn-of-the-Century Houses,* 105 and 109.

33. Two thorough accounts of the Colonial Revival are William B. Rhoads, *The Colonial Revival,* 2 vols. (New York: Garland, 1977), and Alan Axelrod, ed., *The Colonial Revival in America* (New York: W. W. Norton, 1985); see also Bridget A. May, "Progressivism and the Colonial Revival: The Modern Colonial House, 1900–1920," *WP* 26, 2/3 (1991), 108–22, and William B. Rhoads, "The Colonial Revival and American Nationalism," *JSAH* 35, 4 (1976), 239–54.

For an insight into broader interests in "things colonial" during the early years of the twentieth century, see Joyce P. Barendsen, "Wallace Nutting, an American Tastemaker: The Pictures and Beyond," *WP* 18, 2/3 (1983), 187–212.

34. Located at 196 East Main Street. According to the deed for the house, Jerome Farrar bought the property in May 1904; by family tradition the house was built that same year at a cost of $4,500. Mr. Farrar died in 1941, and the current owners purchased it from his daughter in 1964. My thanks to Cosmo and Margaret Trippy for this and other information and for permission to inspect, measure, and photograph their house (June 16, 1987).

According to Lindquist, *Westfield,* the house was erected by E. J. Bailey, a local builder "who had constructed a similar residence

for himself in the town of Brocton" nearby. In my introduction to this volume, n.p., I pointed out that this was a Radford design.

35. Located at 193 Central Avenue. The date was determined by Douglas H. Shepard, based on local directories, assessment rolls, and a notice in the Fredonia *Censor* of June 10, 1908, that the house was recently completed. My thanks to Julius and Laura Paul for permission to inspect and measure their house (March 24, 1992).

36. See Reiff, *Georgian Houses*, 234–75.

37. See, for example, the John Jones House of 1839–40, in Reiff, *Architecture in Fredonia, New York*, fig. 68; another (illustrated on the front cover) is the Elijah Risley House of c. 1843.

38. See Thomas W. Hanchett, "The Four Square House Type in the United States," in Camille Wells, ed., *Perspectives in Vernacular Architecture, I* (Columbia: University of Missouri Press, 1987), 51–53. The plate reproduced on 52 shows four floor plans of the house and the rear elevation (and a cornice detail) as printed in the April 1895 issue of *Carpentry and Building*. This same dwelling (perhaps after completion because a photograph of it is included) with the identical plans and rear elevation, as well as the facade, side elevation, and numerous details, is reproduced as "Design Number 20" in Berg, ed., *Modern American Dwellings*, 86–91.

39. See William Allin Storrer, *The Architecture of Frank Lloyd Wright, A Complete Catalog*, 2d ed. (Cambridge, Mass.: MIT Press, 1978), entry 29.

That by the late 1890s the Foursquare was a firmly established national style is signaled by the fact that two attractive models with clapboard and shingle cladding published in *The American Architect* (May 3, 1899, advertising supplement, iv) were built in Pasadena, California, by the architects Blick and Moore. In the 1990s, blueprints for Foursquares can once again be ordered by mail; see *OHJ* 21, 5 (1993) 68, for a dwelling extremely close to Radford's Design 126 of 1903.

Plans for slightly larger Foursquares were offered by *OHJ* in its issues of July–August 1994 (69) and September–October 1996 (76).

40. Located at 425 College Street. My thanks to Jules and Rochelle Steinberg for permission to inspect and measure their house (June 25, 1987). The plan is close to the Radford model in general layout of rooms, but the house is of slightly different proportions: two feet wider and two feet shallower than Schroeder's Foursquare.

41. For a full account of Stickley's life and work, see Mary Ann Smith, *Gustav Stickley, The Craftsman* (Syracuse: Syracuse University Press, 1983); the book pays special attention to his architecture. For succinct accounts, see Mary Ann Smith, "Gustav Stickley: Master Craftsman Designer," Preservation League of New York State *Newsletter* 10, 6 (1984), 4–5; and Jeff Wilkinson, "Gustav Stickley," *OHJ* 19, 4 (1991), 22 and 24.

42. "In place of the romantic Victorian justification of art and beauty as complex and inspirational was a new theory of aesthetics that stressed practicality and simplicity, efficiency and craftsmanship . . . The new middle-class family ideal, as espoused in popular magazines and advice books, placed a premium on naturalness and conviviality, openness and informality" (Clifford Edward Clark Jr., *The American Family Home, 1800–1960* [Chapel Hill: University of North Carolina Press, 1986], 132. These developments are treated at length pages 131–70). For related English background, see Peter Davey, *Architecture of the Arts and Crafts Movement* (New York: Rizzoli International, 1980).

This reform effort in the United States was not limited to the Arts and Crafts movement or to Stickley's house designs and furniture; see also May.

43. *Craftsman Homes* (New York: Craftsman, 1909), 1.

A few years later, he explained that *The Craftsman* magazine was published "as an exponent of the ideals of craftsmanship in

this country. . . . [T]oday it is recognized as the creator of a movement in America toward the development of a style of architecture which shall be the true expression of the character and needs of the American people" (57, in "The Purpose of the Craftsman Magazine," in his *Craftsman Furniture* catalog [April 1912], 57–58, reprinted in Gustav Stickley, *The 1912 and 1915 Gustav Stickley Craftsman Furniture Catalogs* [New York: Dover, 1991]).

44. The movement has been studied extensively; the most useful works are: Clay Lancaster, *The American Bungalow, 1880–1930* (New York: Abbeville Press, 1985), a greatly expanded and augmented version of his original article, "The American Bungalow," *Art Bulletin* 40 (September 1958), 239–53; Robert Winter, *The California Bungalow* (Los Angeles: Hennessey & Ingalls, 1980); Robert Winter, "The Common American Bungalow," in Charles W. Moore et al., eds., *Home Sweet Home: American Domestic Vernacular Architecture* (New York: Rizzoli, 1983), 98–101; and Alan Gowans, *The Comfortable House: North American Suburban Architecture 1890–1930* (Cambridge, Mass.: MIT Press, 1986), 74–83. See also Clark, 171–92. Tony Wrenn's essay, "Bungalows: A Reintroduction," v–xxvi, in the American Institute of Architects reprint edition of William Phillips Comstock and Clarence Eaton Schermerhorn, *Bungalows, Camps, and Mountain Houses* (New York: W. T. Comstock, 1915), contains a survey of books and magazines on bungalows published between 1908 and 1935.

See also Frances Downing, "The Common Bungalow Planning Tradition," Society of Architectural Historians Western New York Chapter *Little Journal* 6, 1 (1982), 1–20; and Cheryl Robertson, "Male and Female Agendas for Domestic Reform: The Middle-Class Bungalow in Gendered Perspective," *WP* 26, 2/3 (1991), 123–41.

For a thorough overall study of the bungalow from its origins and varieties in India to its adaptation in England and elsewhere, see Anthony D. King, *The Bungalow: The Production of a Global Culture* (London: Routledge & Kegan Paul, 1984); for the United States, see ibid., chapter 4, "North America 1880–1980," 127–55.

Two recent studies on bungalows, focusing especially on those in California, are Paul Duchscherer, *The Bungalow: America's Arts and Crafts Home* (New York: Penguin Studio, 1995), and Robert Winter, *American Bungalow Style* (New York: Simon & Schuster, 1996). Both have excellent color plates; Duchscherer's review of the origins and development of the bungalow style (1–15) is noteworthy.

45. The bungalows by Preston and Brunner are illustrated in Lancaster, *American Bungalow*, figs. 44 and 46. The Shoppell cottage is reproduced in Shoppell, *Turn-of-the-Century Houses*, 35.

46. See Lancaster, *American Bungalow*, figs. 79–81. For a well-illustrated discussion of the life and work of Charles Sumner Greene and Henry Mather Greene, see Randell L. Makinson, "Greene and Greene," in Esther McCoy, ed., *Five California Architects* (New York: Reinhold, 1960), 102–47.

47. Diane Maddex, ed., *Master Builders: A Guide to Famous American Architects* (Washington, D.C.: Preservation Press, 1985), 124, which also reproduces a photograph of the Willett House.

48. Placzek, ed., II: 240.

49. See *Craftsman Homes*, 104, 106, and 108. Stickley may have also had firsthand exposure to the work of Greene and Greene, for he "took his family on a trip to California in 1904 . . . [and] [i]t seems likely that he met Charles Sumner Greene . . . and Henry Mather Greene . . . during this trip or at least saw their Bandini house (1903) in Pasadena and their Hollister house (1904) in Hollywood" (Smith, *Gustav Stickley*, 83).

50. Stickley, *Craftsman Homes*, 77.

The summer "living porch" had also been advocated by Downing over half a century before: "In all countries like ours, where

there are hot summers, a verandah, piazza, or colonnade is a necessary and delightful appendage to a dwelling-house, and in fact during a considerable part of the year frequently becomes the lounging apartment of the family." Andrew Jackson Downing, *Cottage Residences*, 4th ed. (New York: 1852), 13.

For an illustration of this type of Stickley Bungalow erected soon after the design was published, see the example of 1907 in Daniel D. Reiff, "Smaller Camps of the Adirondacks," *Nineteenth Century* 12, 2 (1993), fig. 5.

51. Some of these dwellings (and their architects) from *The American Architect* include plates published July 3, 1880 (Cummings and Sears); January 7, 1882 (Lamb and Rich); January 20, 1883 (Sanford Phipps); September 12, 1885 (John Calvin Stevens); January 30, 1886 (John Calvin Stevens); April 30, 1887 (F. W. Stickney); October 8, 1887 (H. Neill Wilson); November 3, 1888 (L. S. Buffington); March 23, 1889 (Thomas Nolan); and September 5, 1891 (A. E. Hitchcock). This distinctive architectural composition was thus part of a long tradition, with illustrations readily accessible to Stickley.

The house by Stephen C. Earle was built in North Conway, New Hampshire, for Dr. James Schouler, a Boston "historian and legal authority" (an 1859 Harvard graduate) as a summer residence for himself and his wife. He later became a benefactor to the village, aiding in the creation of North Conway's park and library. The house, for many years run as a bed-and-breakfast inn, still survives (at 3486 Main Street) on a two-acre lot. Although now painted white, the exterior is in near-original condition. My thanks to Kathleen Sullivan Head of Badger Realty for information on the house (January 1997). The "Swiss" roof line and the rustic porch posts were eminently appropriate for its mountainous setting (Mount Washington is visible from the dwelling).

52. For Hudson valley examples, see the Hoogeboom House, Claverack, New York, c. 1760, and the Southard House, town of Fishkill, New York, c. 1766, reproduced in Helen Wilkinson Reynolds, *Dutch Houses in the Hudson Valley Before 1776* (New York: Payson and Clarke, 1929), 142 and 427. For the "Dutch Manor, Long Island, New York," see *AABN*, June 8, 1895, 97, fig. 29.

53. Others especially close to this formula include the model cottage by Sanford Phipps (January 20, 1883); a house in Cincinnati by F. W. Stickney (April 30, 1887); a house in Pittsfield, Massachusetts, which was to have its first floor of rough boulders taken from old stone "fences" of the neighborhood and the second floor clad in cedar shingles, designed by H. Neill Wilson (October 8, 1887); and a house in Rochester, New York—although with a tiny subsidiary dormer next to the main roof -slope dormer—by Thomas Nolan (March 23, 1889).

54. A Radford bungalow from this book is illustrated in Gowans, *Comfortable House*, fig. 4.6. The plan, however, is un-bungalow-like, with stairs in a central hallway and rooms on either side in eighteenth-century Georgian fashion.

55. Lancaster illustrates and discusses briefly four such bungalows (figs. 139, 157, 160, and 192), ranging in date from 1914 through 1931; but condemns this type (196, 198) because of its later "mass-produced" versions. King illustrates two Stickley Bungalow houses, one from 1908 in Australia (plate 135) and another in the United States from c. 1925 (plate 92). Neither author makes any comment as to the origin of this ubiquitous type.

The Stickley Bungalow was a popular and widespread type between about 1905 and 1930, but its popularity thereafter sharply declined, in part because of a revived interest in colonial-based styles.In recent years, however, Stickley Bungalows are once again in favor: The "house of the year" for the magazine *Country Living* (February 1996; cover and 68–77 and 126) is a perfect Stickley

Bungalow—here called a "Craftsman-style cottage"—erected in Poulsbo, Washington. Plans for the house could be ordered from an Ohio concern for $185 a set (137). My thanks to Janet M. Reiff for this article.

56. See *More Craftsman Homes*, 79–80 and 42–43, for Designs 112 and 67. Number 201 is reprinted in Gustav Stickley, ed., *Craftsman Bungalows, 59 Homes from "The Craftsman"* (New York: Dover, 1988), 125–26 and 128–29.

57. Smith, *Gustav Stickley*, 57.

58. Ibid., 66. See also 77–107, which discuss the Home Builders' Club and houses built following Stickley's plans. Illustrations of typical blueprints supplied are figs. 42–44.

59. My thanks to Jean B. Harper for lending me her original copy of *Craftsman Homes*. The notice is not reproduced in either of the Dover reprints of Stickley's books.

In Stickley's 1912 *Craftsman Furniture* catalog, all of page 56 was devoted to explaining the advantages of Craftsman homes and how one could obtain free copies of the plans. Stickley included illustrations (with plans and an interior view) of four "characteristic Craftsman homes" as well, 52–55.

60. Smith, *Gustav Stickley*, 76, 118, and 122.

61. Ibid., 77.

62. See ibid., 87–131, for a discussion and illustrations of these.

63. Ula Ilnytzsky, "Craftsman House No. 104: Old-House Living in a Stickley Original," *OHJ* 16, 6 (1988), 42–47. Design 104 was also published in *More Craftsman Homes*, 97-98.

64. Information on the company is based on material in two of their catalogs: *Chicago House Wrecking Co. Catalog No. 160, 1909–10* (copyrighted in 1909) and Chicago House Wrecking Co., *A Book of Plans No. 63* (1913). (See Fig. 291.) Pages 4–5 of the General Catalog reprints two long articles about the company, the first by William E. Curtis, "journalist of Chicago," which had been in the *Record-Herald;* and a second essay by R. A. Foley, "journalist of Philadelphia." The cover of the 1909 catalog reproduces a bird's-eye view drawing of the company's extensive buildings and property; the lumberyard with huge stacks of material is prominent at the far right.

65. Inserted into the *Book of Plans* consulted for this study was a three-page "dittoed" letter outlining the architectural services; the letterhead listed the "executive officers" as follows: A. Harris, President; F. Harris, Treasurer; S. H. Harris, Secretary; and D. C. Harris, Vice President. This letterhead also has an engraved vignette of the company's forty acres of buildings, sheds, and lumberyards; compared with the 1909 view, there is at least one major new building.

66. The General Catalog, 7, provides the following data: "We are situated on 35th Street three miles from the center of the city and about 35 minutes ride by street car. Our plant is located midway between Halsted St. and Ashland Ave. . . . We extend from 35th Street to 37th Street on the south and from Iron Street to Laflin Street on the west."

67. The blueprint drawing for the facade of the W. F. Brinton House is preserved and is obviously not a "stock" plan: The owner's name and house location are written on the drawing in the same hand as all the other text, and no "Model Number" is indicated. It is, however, given "Order No. 101634." A slightly enlarged near duplicate of the house, but in mirror image, was erected soon after elsewhere in the same town for the sister-in-law of Brinton. This dwelling, the P. M. Powelson House, survives in good condition, and a vintage photo of it shows that it did follow the Brinton House in all but small details. The ground-floor plans were essentially the same, but the second floors were different. My thanks to Linda L. Bean for this information (correspondence of December 16, 1993).

For reproductions of both houses—the Brinton House now greatly remodeled—see *OHJ* (January--February 1993), 82 (although both images were reversed in printing).

68. Robert Schweitzer and Michael W. R. Davis, *America's Favorite Homes* (Detroit: Wayne State University Press, 1990), 74.

69. Located at 37 Newton Street. According to Douglas H. Shepard, based on local directories and assessment records, the house was built in 1910 and improved in some manner in 1911–13. The 1910 date is confirmed by Ann Green, who married Lewis Green, one of Henry's sons, in 1934; one of Lewis's sisters was born in the house in 1910. The rear kitchen window, now blocked up, was formerly in the same location as specified on the Chicago House Wrecking Co.'s plans. My thanks to Ann Green for this information and for permission to inspect and measure her house (April 25, 1985, and April 14, 1992).

70. The best account of the Sears "Modern Homes" business is the "Introduction" in Katherine Cole Stevenson and H. Ward Jandl, *Houses by Mail: A Guide to Houses from Sear, Roebuck & Co.* (Washington, D.C.: Preservation Press, 1986), 18–43. Articles that also discuss Sears's "houses by mail" include Kay Halpin, "Sears, Roebuck's Best-Kept Secret," *Historic Preservation* 33, 5 (1981), 24–29; Tim Snyder, "The Sears Pre-Cut: A Mail-Order House for Everyone," *Fine Homebuilding* 28 (August--September 1985), 42–45 (courtesy Stephen E. Rees); and David M. Schwartz, "When Home Sweet Home Was Just a Mailbox Away," *Smithsonian* 16, 8 (1985), 90–96, 98, 100–101. All these articles are well illustrated with built examples of Sears houses. See also Alan Murray, "Mail-Order Homes Sears Sold in 1909–1937 Are Suddenly Chic," *The Wall Street Journal*, February 11, 1985, 1 and 18; and Bruce and Sandbank, chapter 5 passim.

Marina King's book, *Sears Mail-Order House Survey in Prince George's County, Maryland* (Upper Marlboro, Md.: Maryland-National Capital Park and Planning Commission, 1988), is especially interesting for documenting eighty-two Sears houses, many of them illustrated along with the original design. See also "Recollections," 8–17, in Stevenson and Jandl, which documents specific Sears houses, too. Other such cases are found in letters submitted by readers of articles on Sears houses; see, for example, *Historic Preservation* 34, 6 (1981), 4 and 6; and *OHJ* 18, 5 (1990), 6.

As a sampling of the interest Sears houses evoke in local newspapers, see the following: "Mail-Ordered: Old Sears Houses Enjoying New Popularity," *Pittsburgh Press,* April 7, 1985, sec. E, 1; Nathan Cobb, "Sears Modern Home No. 3088," *Boston Globe*, March 7, 1986, 25 and 30; "Some Fine Homes Are from Sears Catalogs," *Syracuse Herald American*, September 24, 1989, Sec. I, 1 and 7; Irene Liguori, "Mail-Order Homes Came in Barrels and Bundles," *Buffalo News*, June 17, 1990, sec. A, 1 and 14, and Julie Vargo, "Made to Order," *Dallas Morning News*, April 9, 1993, sec. G, 1 and 6. My thanks to Mr. and Mrs. James Richards, Marian Anderson, Charmaine Alessi, Harlan Holladay, Joan Glenzer, and Ellen Lupean for providing me with these articles.

For an interesting sidelight on the renewed interest in Sears houses and their "typically American" character, see Julian Cavalier, "An American Classic: The Sears Home," *Railroad Model Craftsman* 53, 7 (1984), 88–95 and 146 (and front cover); and 53, 8 (1985), 95–98. My thanks to Roger Schulenberg for these references.

71. This discussion is based largely on material in the *Sears, Roebuck & Co. 1908 Catalogue Number 117*, 594–97.

The 1897 Sears *Consumers Guide—Catalogue No. 104* has been reprinted as Fred L. Israel, ed., *1897 Sears Roebuck Catalog* (New York: Chelsea House, 1968). In the 786-page volume, "Builder's Hardware and Material" is pages 86–96, and paint, varnish, and stain is pages 21–22.

72. Although I was unable to consult the 1908 *Modern Homes* catalog, the same terms seem to have been in effect for the 1915 catalog. Like the Chicago House Wrecking Co.'s offer, one could either order the Sears plans for one dollar (as explained on 6) or, if one intended to build that year, send a dollar and receive a certificate for one dollar in return. This could be applied toward any "order for mill work, such as doors, windows, molding, etc. whether the order is small or large. In this way you get these plans, specifications, and bill of materials without charge." My thanks to Richard Cheek for lending me this catalog; although lacking front and back covers, Mr. Cheek's records indicate that it was issued in 1915.

No date for it is given, but a Sears catalog from about 1912–14 (looking very much like the 1915 catalog in contents and layout) has recently been reprinted: *Homes in a Box—Modern Homes from Sears Roebuck* (Atglen, Pa.: Schiffer, 1998). My thanks to Evie T. Joselow for this information.

73. Doucet and Weaver, 572.

74. That Sears had a sharp eye on the Chicago House Wrecking Co. and its catalogs is suggested by the fact that the Sears Modern Home 167 in the 1909 catalog (Stevenson and Jandl, 9) is a virtual duplicate of the House Wrecking Co.'s Design 6 (1909 general catalog, 66–67; the design had already been offered for "six or eight months"), but with the corner tower provided a different-shaped roof by Sears and the bay window shifted from the living room back to the dining room. The plans are also virtually the same. Interestingly enough, when the Sears model was constructed in Maryland (see Stevenson and Jandl, 8), the bay window was put in the living room, where the House Wrecking Co. had originally placed it. We also recall that the House Wrecking Co. complained in its 1913 catalog about other firms who had copied "our most successful designs." Sears offered its version through 1922.

For illustrations of two constructed examples of the Chicago House Wrecking Co.'s Design 6 (which the company considered "the most popular design ever placed on the market," having been built "from one end of the United States to the other"), see *OHJ* 21, 5 (1993), 105. Another survives in Westfield, New York.

75. By 1908, concrete blocks were available in a large number of designs, and the machinery to make them had been improved steadily. The Sears 1908 general catalog notes (597) that "with our machines you can make all the concrete blocks, columns, porch rails, etc. for this house or any other style of concrete block buildings. Our machines are perfect and our low prices will surprise you." The machines were illustrated, priced, and described on pages 574 to 581; the *Gun Digest* reprint of this catalog, which omits some pages throughout, includes 574–76 and 581, which is nonetheless a thorough examination and depiction of the equipment and designs. As one would expect, concrete block machines and equipment were also featured and fully illustrated (152–58) in the Sears 1910 *Our Special Catalog for Home Builders* (reprinted by Dover in 1990).

The Chicago House Wrecking Co.'s general catalog of 1909 also had several pages on concrete block machines and equipment (91–94). See also Pamela H. Simpson, "Cheap, Quick, and Easy: The Early History of Rockfaced Concrete Block Building," in Thomas Carter and Bernard L. Herman, eds., *Perspectives in Vernacular Architecture, III* (Columbia: University of Missouri Press, 1989), 108–18.

76. My thanks to Jennie Lascola for permission to examine and measure her house (Number 102) and to David Holland for providing access to it (June 5, 1987). Examination of the attic rafters shows that the facade gable was original construction, not a later alteration.

77. Located at 124 South Pearl Street. The deed indicates that it was built in 1911 or 1912. My thanks to Orville and Audrey Orr for permission to examine and measure their house (June 24, 1987). At that time, the house was being restored; according to Mr. Orr, the original exterior paint colors were light gray with white trim.

78. Two such houses are found on North Granger Street, and a third on North Pearl.

79. The house is located at 7644 East Lake Road, Westfield, and is now owned by John and Amy Gregory, who purchased it in 1972. At that time, the farm, after having had several lots sold off, was 156.9 acres. The date of c. 1914 was provided by a daughter of Bert and Emma Taylor, Mrs. Minnie Franz, who recalled both the house being constructed and that it was from Sears. I am indebted to Mrs. Franz (1889–1988) for information on the house and the Taylor family and for sharing with me old photos of the farm. My thanks as well to Mrs. Gregory for additional information and permission to measure her house (July 25, 1985). The cellar door seems to show two of its original colors: ocher and dark brown.

Some time before 1972, the house was sheathed in aluminum siding and the front porch was made smaller; the second-story corner windows have now also been reduced considerably in size. The old Queen Anne Taylor residence burned about 1966, and the vernacular Greek Revival dwelling is also no longer extant. My thanks to Mrs. Gregory for additional information provided on April 10, 1992.

80. By 1911, the Sears house catalogs were being issued in both spring and fall editions (Stevenson and Jandl, 25). The 1918 catalog I consulted for this section was apparently a fall edition; the price of "The Magnolia" in the 1918 catalog illustrated by Stevenson and Jandl is $5,140, but in my copy it had been increased by $345, suggesting inflation—or a more exact understanding of the cost of materials compared with previously ordered examples.

Information on materials and methods of construction, complete with illustrations and diagrams, appears on 8–13. An illustrated sampling of their mill work, interior fittings, lighting, plumbing, furnaces, and so on, is on 118–23, 126–27, and 132–39; barns are featured on 124–25; "Ready Made Buildings Furnished in Sections, Strong, Durable, and Attractive, Anyone Can Bolt Them Together," 128–31; and views of their architectural offices, "correspondence division," mill yards, warehouses, and factories, 4–5 and 142–44.

81. Even as late as the Sears 1939 *Book of Modern Homes,* carpenters on the site are shown (51) using hand saws.

82. The largest selection of illustrations of constructed Sears houses, here paired with the relevant plates, is in Marina King's study: Thirty-seven houses are depicted. Stevenson and Jandl illustrate fifteen, and the Schwartz and Halpin articles together illustrate seven more; see also *OHJ* 18, 5 (1990), 6.

The Sears 1918 catalog illustrates fifteen houses built from Sears's materials and plans (in states as far apart as Illinois, New York, Kansas, Missouri, Indiana, Colorado, Iowa, New Jersey, Massachusetts, Ohio, and Virginia) on 140–41 and the inside back cover.

83. For the Perez Morton House, see Kirker, *Bulfinch,* figs. 61 and 63; for an illustration of the DeWolf House, see Robert G. Miner, ed., *Architectural Treasures of Early America: Early Homes of Rhode Island* (New York: Arno Press., 1977), 78.

84. Reproduced in Tomlan, "Artistic Taste," fig. 24. This Barber design, which was still offered in the 1905 edition of *Modern Dwellings,* seems to have been the source for the palatial McFaddin-Ward House (built by W. C. Averill in 1905–6), in Beaumont, Texas. My thanks to Tim Matthewson for this information and an illustration of the house (correspondence of January 1985). Another copy of this Barber design can be found in Taylor, Texas; see Virginia and Lee McAlester, *A Field Guide to American Houses* (New York: Alfred A. Knopf, 1984), 248, fig. 4.

85. See *AABN,* September 12, 1896 (a house in Illinois); October 10, 1896 (one in Massachusetts); and February 13, 1897 (also Massachusetts). See too the house (in Cleveland, Ohio), published January 27, 1900, which although of brick construction and with a pediment over the porch, is otherwise extremely close to the overall design of the Sears Magnolia.

86. The house was built by Auguste L. Langellier and is said to have been patterned after one in Jacksonville, Florida. The house is larger with a more complex interior plan than the Sears version (the living room is 17' by 22' versus 15' 6" by 20' 3" for "The Magnolia"), and the interior detailing is much richer. My thanks to Mrs. Charles Beebe for this information, a sketch plan, and the photograph of the house (correspondence of April 1988).

87. The Canton, Ohio, example is illustrated in Schwartz (94) and also Snyder (44) and Halpin (27). The South Bend, Indiana, version is depicted in Stevenson and Jandl, 13. It now lacks corner pilasters and window trim, apparently owing to later re-siding.

88. My thanks to David L. Larson for permission to inspect and measure his house (June 3, 1987).

89. The Aladdin Company has been documented quite thoroughly; see Robert Schweitzer and Michael W. R. Davis, *America's Favorite Homes* (Detroit: Wayne State University Press, 1990), esp. 81–92 and 99–102. See also Robert Schweitzer and Michael W. R. Davis, "Aladdin's Magic Catalog," *Michigan History* 68, 1 (1984), 24–31 and inside front cover; my thanks to Gary Pierce for providing me with this issue. This discussion of the early years of the Aladdin Company is based on these two sources, as well as an examination of the 1915 *Aladdin Houses "Built in a Day,"* catalog (Number 26, 2d ed.), lent by Jean B. Harper; the 1918 *Aladdin Homes Built in a Day,* catalog (Number 31, 4th ed.); and the 1919 *Aladdin Homes "Built in a Day,"* catalog (Number 32), courtesy of Donald Hoffmann. In all three, the date is that of the copyright. The *Aladdin Homes* catalog Number 31 reprinted in 1985 by the American Life Foundation but dated 1919 is identical to the Number 31 examined above, except for minor copy change on page 11 (the map that divided the United States into three regional ordering areas is not in the reprint). See also Bruce and Sandbank, chapter 5 passim.

Aladdin's motto "Sold By The Golden Rule" needs no explanation, but the phrase "Built in a Day" used from about 1910 on certainly does. Clearly Aladdin houses, unlike the portable houses in premade panels, could *not* be erected in a ten-hour working day—as the Sears "Three Room Portable Summer Cottage" was demonstrated to have been. The most rapid construction of a normal Aladdin house recorded in the catalogs consulted was that of "The Kentucky," a five- or six-room bungalow (depending on plan) erected at the 1914 Michigan Agricultural Exposition "in just twelve days by one carpenter and three helpers" (*Aladdin Houses,* 1915, 64–65), for which the company received a gold medal. The Aladdin name comes, of course, from the Arabian Nights story in which Aladdin's genie magically builds him a palace in a single night. "Built in a day" may suggest the rapidity with which the houses could be built, but it is nonetheless an uncharacteristically misleading phrase, used by the company for many years. (Although houses could, as a stunt, be built in one day—see Doucet and Weaver, 567—it was certainly uncommon.) When the phrase was given up is uncertain, but it does not appear in Catalog Number 33 (2d ed.) of 1922 or in a sixteen-page color catalog of 1923.

90. Schweitzer and Davis, *Favorite Homes,* 83. Despite its being the first advertisement, the company was offering "free catalog number 5."

91. "Of course, all excavation and masonry work must be done on the ground. No money would be saved by including stone or brick or concrete, for every section of the country produces this material and prices vary but little. We furnish you with the foundation plan and will give you figures on the amount of material required for whatever kind of foundation material you decide to use—concrete, stone, or brick. Fireplaces or chimneys may be built inside or outside as desired" (*Modern Houses* [1915], 8).

92. "The Detroit" appears in the 1915 catalog (Number 26), 37; in 1918 (Number 31), 91–92, in a color foldout; in 1919 (Number 32), 78–79, an identical foldout; in 1922 (Number 33), 76–77, a two-page spread; and in 1931, where the name is changed to "The Carlton," 33. Here the design is changed a bit: The porch supports are now single, not paired, piers.

The house in Granville is located at 232 North Granger Street. According to the current owners, the changes to the front room were carried out in the 1940s; a kitchen wing was added across the back by subsequent owners in the 1950s. My thanks to James and Paula Barnett for permission to inspect, measure, and photograph their house (May 26, 1985, and June 28, 1987).

The embossed and enameled fob of the key chain features the Aladdin seal with the mottoes "Aladdin Readi-Cut Houses" and "Sold by the Golden Rule"; the serial number 6131; and the legend "Return keys to the Aladdin Company, Bay City, Mich." On the rear are two encomiums: "Aladdin Houses, Readi-Cut, Highest Award, Michigan State Fair, 1914," and "Highest Award: Panama Pacific Exposition, 1915." The fob was made by a company in Newark, New Jersey. The fob and keys are illustrated in Daniel D. Reiff, "Identifying Mail-Order & Catalog Houses," *OHJ* 23, 5 (1995), 35.

93. Actually, Keaton conflates somewhat the "portable" and the "precut" house in his twenty-minute comedy. The dwelling is delivered to the site in *boxes* (unlike real precut houses), and it is the numbers on two of these boxes that are changed by the miscreant former suitor. Although the house is not made of panels but is of traditional construction, the boxes are labeled "Home Portable House Co." In fact, the term "portable" is essential to some of the film's most hilarious moments, for not only does the house twirl about on its foundations in a mini-hurricane, but when the couple discovers that they have erected their home on the wrong lot, they jack it up, put it on barrels, and pull it with their car toward the correct lot, across some railroad tracks. Naturally it becomes stuck on the tracks, and there it ultimately meets its dramatic fate.

My thanks to Spiro Kostof for bringing this film to my attention (conversation of April 21, 1985), to James Shokoff for providing me with its author and title, and to the Darwin R. Barker Library, Fredonia, New York, and the Chautauqua County Library System for obtaining a copy of the film for me.

For a photo of the misshapen house, see *The New York Times Magazine*, March 7, 1999, 19.

94. See the letters to the editor columns in *OHJ* issues of September–October 1989 (4), May–June 1989 (16), and March–April 1991 (14). See also James C. Massey and Shirley Maxwell, "Pre-Cut House," *OHJ* 18, 6 (1990), 36–41, which shows two constructed Aladdin homes in Bay City, 39, and a third (with its catalog illustration), 40, at an undisclosed location.

95. This was reproduced in Bicknell & Comstock's *Specimen Book of One Hundred Architectural Designs* (1880), 59, but without the original plate citation.

96. Aladdin 1915 catalog, 60. "The Colonial" is also included in the 1918, 1919, and 1922 catalogs, and undoubtedly many others—although it is not in the 1931 catalog. It was known at least by 1913 because a constructed example of that date, carefully following the model (the plan seems to have been reversed, however, and French doors open onto the top of the entry porch) was built in Franklin, Tennessee. See *OHJ* 19, 2 (1991), 14. (The 1917 *Aladdin Homes* "catalog number 29" was reprinted by Dover in 1995.)

97. The Wadsworth House (c. 1784), Danvers, Massachusetts, is a five-bay house of similar design with three dormers in the roof slope; a shingled house very like "The Colonial" is found on Main Street, Nantucket; and a semicircular porch almost identical to the Aladdin example can be seen on the Governor S. E. Smith House (c. 1792) in Wiscasset, Maine. For illustrations of these three, see Robert G. Miner, ed., *Colonial Architecture in Massachusetts* (New York: Arno Press, 1977), 99 and 39; and Robert G. Miner, ed., *Colonial Architecture in New England* (New York: Arno Press, 1977), 159.

98. Pages 35–36 in Cram's essay, "The Promise of American House Building," in Richardson Wright, ed., *Low Cost Suburban Houses: A Book of Suggestions for the Man with the Moderate Purse* (New York: Robert M. McBride, 1920), 31–41. The book was copyrighted in 1916. A good example of an early Colonial Revival hipped-roof house (with three dormers in the roof slope and a semicircular columned entrance porch) is the design for a dwelling in Woburn, Massachusetts, by the Boston architect S. J. Brown, *AABN*, June 26, 1897.

99. The Romer House (painted bright yellow about 1985) is located at 638 Central Avenue, Dunkirk. My thanks to David Civilette, its owner, as well as to the occupants Sherry Derr and Randall Brown—for it is now divided into two apartments—for permission to inspect and measure the house (June 3, 1987, April 20 and 26, 1990). The date of first occupancy and the Sanborn Atlas information are courtesy Douglas H. Shepard.

The Dunkirk architect Nelson J. Palmer, whose family purchased the house in 1936, remembers that in his youth the original blueprints were still in the house. He recalls, from family tradition, that the date of construction was about 1906–10 and thinks that it was certainly designed by an architect, probably from Buffalo, forty-five miles to the northeast (interview of March 13, 1990).

The additional ten feet in width, when compared with the Aladdin dimensions, was added uniformly: The living room is two feet wider, the hallway four feet (so that a closet with its own window, next to the entrance lobby, could be inserted); and the dining room is also four feet wider. Although the staircase was pushed back to provide a more spacious entrance hall (eliminating a small chamber behind the stairs on the Aladdin plan), the disposition of rooms is otherwise close to the Aladdin version—although the 1915 plan was slightly changed by shifting a pantry in 1918 and subsequent editions.

100. The Taylor House is at 123 Temple Street. My thanks to Willard and Adelaide Marsh Gaeddert for permission to inspect and measure their house (June 12, 1989). The original owner and construction date, based on local directories and assessment rolls, is courtesy Douglas H. Shepard.

101. The Olsen & Urbain "attractive bungalow," also finished in stucco and brick, is illustrated (72) as "Plan Number 322." Quite a number of organizations had "co-operated in supplying plans" for the book, including the American Face Brick Association, the Portland Cement Association, the Common Brick Manufacturers Association of the United States, the Curtis Companies, the Hollow Building Tile Manufacturers Association, the National Lumber Manufacturers Association, the Associated Metal Lath Manufacturers, the Long Bell Lumber Company, and the Lehigh Portland Cement Company.

102. The Architects' Small House Service Bureau's Design 6-A-55, a six-room dwelling "in the English cottage style," is reproduced on 144; although stucco finished, it is of wood-frame construction. For the fee of $36.50 (based on number of rooms), one received "three complete sets of detailed blue prints, three sets of specifications, three quantity surveys, and two forms of contract agreements" (272). One also purchased (273) "the privilege of consulting by mail with the technical service departments of our Regional Bureaus; the privilege, at a fair hourly rate, of having revisions and alterations made in the working drawings by Bureau architects; personal advice, also by Bureau architects and at a fair hourly rate; and finally, assistance in obtaining an architect to supervise the construction of the building." As one might suspect from this, the ASHSB was an organization that "originated in and is approved by the American Institute of Architects"; it was also "endorsed by the United States Department of Commerce" (vii).

103. Doucet and Weaver, 564; for additional data on Hodgson, see 574, 579, and 582. For a description and laudatory review of a volume by Fred T. Hodgson ("a writer of practical manuals for mechanics, which have had an extensive and well-deserved circulation") in *The American Architect*, see October 11, 1902, 15.

Technical books for craftsmen (such as Hodgson wrote) were an important resource; see Appendix 6, "Sampling of Technical Books for Contractors and Craftsmen, 1881–1946."

104. Gordon-Van Tine Co., Lewis Manufacturing Company, as well as Sterling Homes, and Montgomery Ward, all purveyors of precut homes, are discussed in Schweitzer and Davis, *Favorite Homes*. For a recent article on the Lewis Manufacturing Company, see Sally Linvill Bund and Robert Schweitzer, "The House That Lewis Built," *Michigan History Magazine* (March/April 1995), 18–25. My thanks to Evie T. Joselow for a copy of this article.

Another manufacturer of precut homes from this period, although not listed in the Appendixes, was Pacific Systems of Los Angeles, California, founded in 1908. See Bruce and Sandbank, 57.

7 Catalog and Mail-Order House Companies and Designs, 1920–1940

1. See Thomas Harvey, "Mail-Order Architecture in the Twenties," *Landscape* 25, 3 (1981), 1–9, which deals almost exclusively with the ASHSB; Lisa Schrenk, "The Small House Bureau," *Architecture Minnesota* (May-June 1988), 50–55 (copy courtesy the author); and Lisa D. Schrenk, "The Work of the Architects' Small House Service Bureau," the introduction (iv–xxiv) to the 1992 American Institute of Architects reprint of the Bureau's *Your Future Home, A Selected Collection of Plans for Small Houses* . . . (1923).

2. Quoted in Schrenk, "Small House Bureau," 51.

3. *How to Plan, Finance, and Build Your Home* (Denver: Architects' Small House Service Bureau, Mountain Division, 1922), 5–6.

4. A full-page reproduction of a sample article is reproduced in Harvey, 4; the main feature is "Good Taste vs. Poor Taste in Home Building." Interestingly enough, the example of "poor taste and waste" is the somewhat Craftsman-like two-story dwelling reproduced in the Lumber Dealers' Service Bureau 1920 book of plans, *Architectural Economy*, design 4002, 65 (see Color Plate VIII). The ASHSB revision for "good taste and savings" is more in the colonial style. Harvey reproduces part of another such column (8); neither is dated.

5. Schrenk, "Small House Bureau," 55.

6. Ibid., 50.

7. "Close to 100 ASHSB houses have been identified in Minneapolis and St. Paul" (Schrenk, "Small House Bureau," 54); five (two with their comparative plates) are illustrated by Schrenk, six others by Harvey. Four more, and a streetscape view depicting six adjacent ASHSB houses, are depicted in Schrenk, "Work."

8. Located at 156 West Main Street. My thanks to Holly and James F. De Golyer Jr. for permission to inspect and measure their house (May 9, 1985). Since that date, there has been some minor exterior remodeling, and the house has been re-sided. The construction date, based on local directories and assessment rolls, is courtesy Douglas H. Shepard.

9. See Robert G. Miner, ed., *Early Homes of Massachusetts* (New York: Arno Press, 1977), 104, for a house in Rockport, Massachusetts, with three gabled dormers; Robert G. Miner, ed., *Early Homes of New England* (New York: Arno Press, 1977), 26, for a house in Ridgefield, Connecticut, with three shed dormers; Miner, ed., *Rhode Island*, 154–55, for two houses in Warren, Rhode Island, with shed and gabled dormers; Christopher Weeks, *Where Land and Water Intertwine: An Architectural History of Talbot County, Maryland* (Baltimore: Johns Hopkins University Press, 1984), 22 and 156, for houses with both types of dormers; and Calder Loth, ed., *The Virginia Landmarks Register*, 3d ed. (Charlottesville: University Press of Virginia, 1986), 29, 131, 276, and 466, for comparable Virginia dwellings. For illustrations of two one-and-a-half-story gambrel-roofed Dutch houses (both with shed roof dormers) in New York state, see Reynolds, *Dutch Houses*, plates 45 and 46.

10. Writing in 1908, the architect Aymar Embury II observed that the gambrel "Dutch roof" had "no precedent in Holland, and so he believed [it] had been the invention of the Dutch colonists who had been unable to secure rafters long enough to build simple gable roofs" (Rhoads, *The Colonial Revival*, I: 119). The gambrel roof is one of eight common vernacular roof types found in England, however: see R. W. Brunskill, *Illustrated Handbook of Vernacular Architecture* (New York: University Books, 1971), 198. For an illustration of a frame gambrel-roof house in Essex, England, see Marcus Whiffen, *The Eighteenth-Century Houses of Williamsburg* (New York: Holt, Rinehart and Winston, 1960), fig. 10.

11. Rhoads, *The Colonial Revival*, I: 118; the house is illustrated in II, fig. 99.

12. This discussion is based on an examination of two catalogs, that of 1925 ("Book No. 7") and of 1930 ("Book No. 17"); and the Union List of Standard Homes Company publications. This includes the following catalogs, all entitled *Better Homes at Lower Cost* unless other noted: 1921 (*101 American Homes*), Book Number 5, 108 pp.; 1925, Book Number 7, 107 pp.; 1926, Book Number 8, and the same year, Book Number 9, both 107 pp.; 1927, Book Number 10, 107 pp.; 1928, Number 11, 64 pp.; 1928, Number 12, 80 pp.; 1930, Number 17, 64 pp.; 1948, no number, 30 pp.; and 1952, no number, 31 pp. The Union List also cites the following: 1929, *Homes of Today*, 79 pp.; 1948, *Homes of Today and Tomorrow*, 31 pp., *Homes You Can Build Yourself*, 15 pp., and *Homes for Your Street and Mine*, 31 pp.; and 1950, *Standard Construction Details for Home Builders, with Estimating Charts and Tables*, 126 pp. In the 1930 catalog, the company's address was the "Colorado Building."

According to Jack Brewer of the Historical Society of Washington, D.C. (correspondence of June 1992), the Standard Homes Company is listed in local directories from 1922 through 1967, with A. G. Johnson as manager throughout that time. "In the early years, the office was located in The Colorado Building at 1341 G Street N.W.; from 1954 to 1967, it was at 2524 L Street N.W."

13. Doucet and Weaver, 577, table 4.

14. The same volume, according to the Union List, was also issued in 1921 as *Plan Book of Modern American Homes*, Book Number 5, with a Washington, D.C., imprint.

That these plan companies sometimes shared (or pirated) one another's material is borne out by a variant of a Stickley Bungalow, "The Kendall," in the Standard Homes Company's Book Number 7 (1925), 32. The identical photograph, somewhat reworked (the foundations and porch supports are rendered in brick, for example), is used for a somewhat smaller house with a different plan in a catalog published in 1925 by the C. L. Bowes Company of Hinsdale, Illinois, and provided to lumber dealers with their own imprint; "The Kendall" here becomes Design 12210-A. The street number visible next to the front door is the same in both photos.

15. The Union List includes as the place of publication for the 1925 Book Number 7 "[Detroit]," which in light of Standard Homes Company's omitting its address in the copy of this issue I consulted, suggests that it was imprinted with a Detroit building supply company's address.

My thanks to Richard Guy Wilson for supplying me with a xerographic copy of the Book Number 9 title page (September 1992). The firm was a large one: Its "office and yard" were on Park Avenue at Kemper Street, and its "paint store and display rooms" were at 714 Main Street. By this date, the catalogs sold for one dollar.

That such catalogs were given away or sold cheaply by such building supply companies (no price is given in Book Number 7, but Book Number 17 is marked "Price 50 cts.") is not at all new: I noted earlier that the copy of *The Radford American Homes* (1903) studied was stamped with the name of a firm in Ogdensburg, New York.

16. The bungalow is located at 105 North Main Street. My thanks to Cecelia Perry for permitting me to inspect and measure the house (June 18, 1987). According to Mrs. Perry, the house was built about 1924; the fact that the design appears in the 1925 catalog does not preclude it from having been in earlier catalogs, too. A virtually identical design, with a slightly different plan, is published in the *Home Builders Catalog*, 2d ed. (Chicago, 1927), 1133.

According to the 1980 Census tabulations of the population for Chautauqua County between 1920 and 1980, Cassadaga's population in 1920 was 435 and by 1930 had increased to 480 (table courtesy Marion Wisniewski).

17. Jamestown is especially rich in houses that appear to be "catalog" designs.

18. The house is located at 95 West Fourth Street. In the 1917 directory, Wilson is listed as a tinsmith; in 1923 he had moved into his new house and moved his business to a location on Main Street, near numerous Dunkirk factories.

Henry T. Higgins seems to have been a local man who year by year improved his station in life. In 1907, he is listed as a "clerk," boarding at 77 West Fifth Street. In 1912, now married, he is a "superintendent" and owns 73 West Fifth. By 1917, he is listed as "architect," with his office (at 71 West Fifth) next door to his house. In the 1923 directory, he is identified as a "registered architect" and even has an ad for his services; in 1930, he is still practicing, but now has his office in his home.

19. My thanks to Mr. and Mrs. John A. Wiles for permission to inspect and measure their house and to photograph the blueprints (May 28, 1987). Both sheets, drawn at 1/4" = 1 foot, are marked "6-2-17," which is presumably the date. The details on Sheet 1 include "Methods to Employ When Using Fisklock" brickwork; detail of the colonnade (removed before 1984) between living room and dining room; an alternative bathroom plan (the form

that was in fact built); and the doors between living room and hall. Details on Sheet 2 included "Bracket Detail, Scale 3/4" = 1'," and full-size sections of interior moldings. Like mail-order plans, the elevations are marked "Right Side" and "Left Side," not North-South.

20. Studies on the Colonial Revival by Rhoads, Axelrod, and May have already been cited; see also David Gebhard, "The American Colonial Revival in the 1930s," *WP* 22, 2/3 (1987), 109–48, and David Gebhard, "Royal Barry Wills and the American Colonial Revival," *WP* 27, 1 (1992), 45–74, which is concerned mainly with his work in the 1930s.

The importance of the Neo-Colonial style for its cultural, social, and patriotic value, quite aside from its aesthetic and historic appeal, is discussed at length in Rhoads, *Colonial Revival*, I: 408–527. For a parallel contemporary view (by a political scientist) of the importance of national and patriotic symbols, see Henry Reiff, "'We Live by Symbols'," *Social Studies* 31, 3 (1940), 99–103.

The fact that dwellings of the two-story gabled type were being constructed by professional architects during these same years confirms how up-to-date these catalogs were. A house almost identical to "The Esterbrook" (three bays wide with a small columned entry porch and a one-story side porch) was built in 1911 by the architect Charles S. Keefe as his own home in Kingston, New York; see William B. Rhoads, "Charles S. Keefe: Colonial Revivalist," Preservation League of New York State *Newsletter* 11, 5 (1985), 4–5. Five-bay versions (as sold by Sears by 1928) can also be found in the oeuvre of noted architects of the day; Royal Barry Wills built one in 1936 (see Gebhard, "Wills," fig. 7).

21. See Miner, ed., *Colonial Architecture in Massachusetts*, 148; Miner, ed., *Early Homes of New England*, 27; and Whiffen, *Houses of Williamsburg*, figs. 49 and 105. For three-bay examples, see Miner, ed., *Early Homes of New England*, 87, and Whiffen, *Houses of Williamsburg*, fig. 118.

22. For side porches, see Miner, ed., *Early Homes of Rhode Island*, 208, and Miner, ed., *Early Homes of New England*, 150; for the arched entrance pediment, Miner, ed., *Colonial Architecture of New England*, 18; and for the square piers, Miner, ed., *Early Homes of New England*, 150.

23. For information on Nicholas G. Heary (1895–1965), my thanks to his son Robert R. Heary (conversation of May 27, 1992); for information on Nicholas L. Smith (died 1953), my thanks to his son Donald Smith (conversation of May 27, 1992). Although Heary was born in Sheridan, New York, he grew up in Dunkirk, married a Dunkirk girl, and lived there in rented accommodations until moving to Fredonia.

At some time in the 1930s, Heary, Smith, and two other men established the Farm King Canning Company as a rival to Red Wing. It unfortunately soon went bankrupt, and Smith lost about $10,000. Thereafter relations among the four men were strained.

Smith preferred building houses to the lumber business and erected quite a number, as well as at least three small Catholic churches in the area. After World War II, he built ranch houses whose plans, according to his son, were only in his head—so that work could not continue unless he was on the job or gave specific instructions!

24. A good deal about Stickle can be gleaned from Erie, Pennsylvania, directories:

> G. Wesley Stickle is listed for the first time in Erie directories in 1917 boarding at 801 French Street and working at 1004 Palace Building, both in downtown Erie. In 1919 Margaret appears as his wife and they are living at 738 East 11th Street. There is no business address. Stickle's office is listed at 704 Ariel Building in 1921 and his home address

has changed to 959 West 7th Street. Stickle's office address changes again in 1922 to 200 Commerce Building.

The following year, 1923, Stickle is joined by a partner, Fred A. Fuller, at the same office address as Stickle occupied in 1922. Stickle and his wife now live at 649 Downing Court. The Fuller and Stickle partnership lasted until 1928. Stickle then moves his office down the hall to 227-228 Commerce Building in 1929 and remains there until 1941. In 1942 Stickle's office changes location for the final time to the Stickle Apartments at 118 East 9th Street. The office remains on East 9th until 1945 which is the final listing for G. Wesley Stickle in city directories.

Stickle's wife Margaret ceases to appear in directories after 1938. Between 1923 and 1937 G. Wesley and Margaret move about once every two years to places all around the downtown and far south side of the city of Erie (near the present Glenwood Hills). Their final home is on Pasadena Drive (RD #1) Erie. Stickle remains at this home address through the final listing for him in 1945. A check for an obituary in this year turned up nothing seeming to indicate he simply moved outside the city limits, where we cannot determine.

My thanks to Pamela Green of the Erie County Historical Society for providing me with this information (correspondence of February 1992).

Another way that Nicholas Heary could have become acquainted with Stickle is through his church. As a young man, Heary belonged to Dunkirk's Sacred Heart Church (the parish for German Catholics) but was married on June 30, 1927, to Hildegard Reding at Saint Mary's Church, the largely Irish parish; thereafter he was a member of that church (my thanks to Alice D. Connell, a cousin of Robert R. Heary, for this information; conversation of June 9, 1992). As a plaque in Saint Mary's Hall (now Saint Elizabeth Ann Seton Hall), built in 1931–32, notes that the architect was G. W. Stickle, Heary could have met the Erie architect in this connection.

25. The Heary House is located at 288 East Main Street. My thanks to Walter and Darlene Doyle for permission to inspect and measure their house and to study and photograph their blueprints and papers (July-August 1986).

The plans and elevations are in two groups. The first group, on half-size sheets, consists of three blueprints and a second-floor plan on tracing paper; these appear to be the preliminary studies. The second group consists of ten full-size blueprint sheets and one half-size, showing plans and elevations in various stages of development and details. These sheets are incomplete, with many having portions cut out; there are ample pencil notations, especially on the final versions. Some are marked at the top "Proposed Residence For / Mr. N. Heary, Fredonia, N.Y. / G. W. Stickle, Architect / Erie, PA." A preserved wrapper shows that this business was in part at least carried out by mail (with Heary's address as "c/o Redwing Factory"). Although the plans are not dated, a booklet, "Specification of 'Standard' Plumbing Fixtures" prepared by the Standard Sanitary Manufacturing Company of Syracuse, is dated January 9, 1933, suggesting that the plans were completed by then. The booklet, with illustrations cut from a company catalog with typed information below, describes two types of toilets, two kitchen sinks, a bathroom sink, and alternative drain and faucet details. Because it is addressed to Mr. Heary, it confirms Donald Smith's assertion that Heary probably subcontracted—or at least was directly involved in the planning of the house—himself.

26. Another group, not included in the Appendixes, was the National Brick Manufacturers Association, founded as early as

1886; see Doucet and Weaver, 578. The Common Brick Manufacturers Association of Cleveland even founded a monthly magazine, *Building Economy*, in 1925, "to challenge the critics of brick homes"; (ibid., 570).

27. Publishing plans for which different exterior designs could be used were not uncommon. Von Holst's plate 46, "Studies of Different Exterior Treatments of the Same Plan," depicts five very different styles all using the same plan; and the 1915 Sears catalog illustrates four plans (12, 48, 77, and 99) for which two—and in one case, three—different exterior treatments were available. In one pair, Modern Home 264P207 and 112, the exteriors were radically different in style.

28. One documented instance of this appears in the work of the Buffalo, New York, architect Olaf William Shelgren (1891–1972). Born in Johnsonburg, Pennsylvania, and early recognized as a gifted draftsman, at age seventeen he entered a year's apprenticeship with an architect in Warren, Pennsylvania. Moving to Buffalo, he worked "on and off" for the architect Robert North until the World War and did freelance work for the landscape architecture firm of Townsend and Fleming. After the War, he worked full time for North and became his partner.

Shelgren provided a number of house designs for catalog companies, in response to competition notices in professional and trade journals. One that received third prize in a White Pine competition was singled out as the only submission that could really be built for the cost limit imposed! In Mr. Shelgren's library were "several books" with designs that he had prepared published in them; and one home builder in the middle west even sent him a photo of his house, erected following the Shelgren plans.

My thanks to his son Olaf William Shelgren Jr. for this information (conversation of March 7, 1990). One of Shelgren's plans appears in Smith's *Books of a Thousand Homes, I*: 94 (Plan 504).

29. Located at 1191 Central Avenue. My thanks to T. Dean and Marie Shaw for permission to inspect and measure their house (June 8, 1987). A brick garage in similar style was added behind the house a few years later.

30. Located at 5026 Route 5. Wanakah is about ten miles southwest of Buffalo, New York.

31. The architects listed were De Jarnette and Carver, Des Moines, Iowa; John Kalsch, Cleveland, Ohio; M. B. Kane, Edwardsville, Illinois; Arthur Kelly, Los Angeles, California; Olsen & Urbain, Chicago, Illinois; Spencer and Powers, Chicago, Illinois; John F. Suppes, Akron, Ohio; and Trowbridge and Ackerman, New York, New York.

32. Smith, 229, 247, and 250.

33. This discussion is based mainly on a study of the 1927 catalog *Bennett Better Built Homes* (copy courtesy Herbert J. Graves). The Union List cites a 1925 copy (88 pp.) and a 1937 offering, *Dura-Bilt Homes of Charm*.

34. "The Stanley," a gabled four-room cottage with front porch, cost less ($886) but lacked a bathroom.

35. Daniel Finkbeiner, quoted by Nelson J. Palmer (conversation of June 3, 1992), who worked with Mr. Finkbeiner in the office of the Buffalo architects Highland and Highland as draftsmen in the late 1950s.

36. Located at 5042 Route 20, 2.1 miles south of the village limits of Fredonia. The deed to the house indicates that it was built between 1925 and early 1928 by Floyd J. Taylor. My thanks to Steven J. and Anne LaVoice for this information and permission to inspect and measure their house (June 20, 1987).

Although the dimensions are close to those of the Bennett Homes Dover, the interior plan is somewhat different. "The Dover" sold for $1822 (or $1886 with asphalt shingled roof); Sears offered an almost identical model, "The Winona," between 1916 and 1939.

37. For eight "field tested" methods of determining whether a house is a "mail-order" dwelling, see Daniel D. Reiff, "Identifying Mail-Order & Catalog Houses," *OHJ* 13, 5 (1995), 30–37.

38. Located at 83 Main Street. My thanks to Joanne De Pasquale for permission to inspect and measure the house (April 24, 1990).

39. This discussion is based on a group of thirteen Creo-Dipt flyers in my collection; they bear copyright dates of 1925, 1926, and 1927 or 1928 and have "plate numbers" ranging from 127–128A to 199–200. One illustrates two methods of applying the shingles rather than building comparisons.

The Creo-Dipt Company was of course not alone in urging homeowners to update their old houses to contemporary styles by using shingles in their remodeling. The Weatherbest Stained Shingle Company, Incorporated, general offices in North Tonawanda, New York (with plants there and in Saint Paul, Minnesota), published a series of eighteen comparative before-and-after views in its twenty-four-page catalog, *Making Old Houses into Charming Homes*, of 1929. It too included designs (such as Colonial and English) that emulated modern small-house types and had a section on methods of applying shingles.

40. The problem of how to alert architects and builders to new materials and products was decades old. In the 1890s, architects were inundated with trade circulars (on which they had to spend "an appreciable part of each day in opening and tossing into the wastebasket"). See *AABN*, May 23, 1891, 109, and January 23, 1893, 49–50. Yet at the same time, architects recognized that "a vast amount of useful information can be gathered from the catalogues of manufacturers" (*AABN*, May 4, 1901, Advertisers Trade Supplement, 1). Systematic organization appears to have been the best solution.

The *Home Builders Catalog* was thus a sort of rival (although short lived) of the "Sweet's Catalogs." To systematize the flood of "several thousand catalogues per annum" that "every firm in the building material world" sent to "every architect whose name and address could be discovered by any means," the editors of *The Architectural Record* compiled and edited an annual "Book of Catalogues" beginning in 1906, bringing together "all available trade literature," including ads similar to those in the *Home Builders Catalog*. See item 100 in Mitchell and Matero, *The Architectural Trade Catalog in America*, which is *"Sweet's" Indexed Catalogue of Building Construction for the Year 1907–08* (New York: Architectural Record, 1907).

A good indication of just how many catalogs, flyers, and leaflets published by building materials companies were available in the 1920s—and have survived even to this day—is the listing of 141 "Trade Catalogues" offered by Book Mark (Philadelphia antiquarian booksellers) in its 1991 Catalog 12: Although ranging from c. 1859 to c. 1959, fully *108* of the items date from the 1920s.

41. The book's full title tells more about its purpose: "A Reference Work for Building Contractors and Home Owners Containing Authentic Information on Building Materials and Home Equipment and Hundreds of Original Illustrations and Plans of All Types of Small Homes." Although both New York and Chicago are printed on the cover and title page, the only address given for the company throughout the catalog is 1315 Congress Street, Chicago.

It is clear this catalog was revised from an earlier work, for some page numbers are left out, and some leaves added. Pages 25–32 and 526–581, at the beginning and end of the manufacturers' section, are omitted; eight additional pages of plates are inserted (between 44 and 45, 48 and 49, and 60 and 61). There is also a typeface change between the page numbers in this section and the plans. Thus although the book ostensibly has 1,256 pages, there are actually somewhat fewer.

Except for eleven of the summer camps (and the fifty-seven garages), all the houses depicted have names beginning with the letter C.

42. *1927 Home Builders Catalog,* 633.

43. Ibid., 3.

44. Ibid., 586.

45. Ibid., 586–87.

46. European books on small houses must have been a welcome source of inspiration for American designers during this period; a sampling of a few relevant volumes from England between 1891 and 1939 is included in Appendix 4. This is certainly a potentially fruitful area for examination.

47. *1927 Home Builders Catalog,* 587.

48. Ibid., 588.

49. Ibid.

50. Ibid., 582.

51. Ibid., 4 and 587. The editors, in fact, prided themselves on their conservative and traditional approach (582): "If harmony of effect, as well as economy of building, are to be obtained, certain fundamental principles must be known and followed. It is well to remember that no style of architecture is the arbitrary creation of any few people. Rather, its perfection is the result of generations of slow and painful labor. It would be folly not to take advantage of this experience."

52. Located at 38 Leverett Street. As built, the interior height of the first floor is 8' 1" rather than 8' 6" as specified in the catalog—although what was on the blueprints is not known. The date of the house and the original owner's name, based on local directories and assessment rolls, are courtesy of Douglas H. Shepard. The addition across the rear of the house was built in 1985. My thanks to David A. and Lynn Giambrone for permission to inspect and measure their house (May 23, 1990).

The 1930–31 directory lists Farnham (who then lived half a block away at 90 Center Street) as a clerk in the Main Street store of Ray Beck, who sold "cigar & tobacco & elec[trical?] supplies." In the 1935 directory, Farnham, listed again as "clerk," had moved to his house at 38 Leverett Street.

53. In Louis Conrad Rosenberg's *Cottages, Farmhouses, and Other Minor Buildings in England of the 16th, 17th, and 18th Centuries* (New York: Architectural Book Publishing, 1923), thatched-roof cottages and houses are frequently depicted (see for example plates 37, 38, 47, 48, and frontispiece), with some (plate 46, bottom) about as small as the *Home Builders Catalog* model.

54. For illustrations of houses by these three architects, in which one can see the features enumerated, see Peter Davey, *Architecture of the Arts and Crafts Movement* [in England] (New York: Rizzoli International, 1980), figs. 75, 77, 181, and 191.

55. Standard Homes Company's "The Beaumont" and Sears's "The Cedars" had almost identical exterior designs and interior plans, with rooms about the same size, too.

The *1927 Home Builders Catalog*'s "The Camanche" looks almost identical to "The Chenee"; it is the same width (including the porch), but it is seven feet deeper; it lacks the small window above the gabled entrance and next to the chimney; the windows in the shed dormer are uniformly spaced, not paired; and the front door lacks the distinctive swan's neck pediment.

56. Located at 4 Bard Road. My thanks to David and Darlene Goede for permission to inspect and measure their house (June 14, 1987).

57. See *OHJ*, 32, 1 (1994), 8, 10.

58. The plan is the same as The Brafferton, Williamsburg, Virginia, built in 1723; see Reiff, *Georgian Houses*, fig. 361. The arched

doorway with a surround of chamfered blocks is uncommon in America, but frequently found in England on high-style buildings. As we have seen, it was popularized by Serlio in his Book II, fol. 18 (1st ed. 1545), and can be found on Montacute House, Somerset (1599–1601); Jones's design for Killigrew House, London (1620s); and the remodeled form of the Mompesson House stable wing, Salisbury (c. 1740, see Reiff, *Georgian Houses*, fig. 151). Thus "The Caldwell" may actually be inspired by English as well as American small-house models.

59. Located at 5919 East Main Street. According to the owner Richard W. Cuningham (conversation of August 12, 1986), the house was built in 1928 by a local lumber company, which also erected the adjacent Dutch Colonial–style dwelling. About 1985, the Cunningham house was clad in vinyl siding.

60. According to John L. Debes and Helen Crook, eds., *Mount Arab Preserve Directory of Camps* (Piercefield, N.Y.: Mount Arab Preserve Association, 1985), entry EC 38, this camp was built by Lionel Villaneuve in 1937 and is said to be a *Sears* model; while Stevenson and Jandl, *Houses by Mail*, 343–45, do list thirty Sears cottages, only four are illustrated.

61. Despite the catalog's ostensibly being "published" by the A. Weston Lumber Company, the designs were copyrighted by C. L. Bowes and included the following warning: "[E]very part of this book, including illustrations, text matter, and floor plans, is protected by this copyright. Unless permission is obtained, the use of these illustrations, floor plans, and type matter is expressly forbidden." Such a notice was probably aimed at discouraging contractors from just copying the plans and illustrations and not ordering the blueprints—although it probably had no real effect.

The introduction to this catalog notes that modifications of the blueprints were also available: "The Plans have been prepared by the best architectural talent and combine practicability, distinctiveness of designs, and economical construction cost. The blue prints and materials for these homes are furnished by our Company. . . . Frequently one has some certain arrangements, or a special feature they desire to have incorporated into the general plans. And, quite possibly, an entirely different arrangement may be desired. In either event, these changes will require but a few days and will be made by capable architects at a small cost."

A C. L. Bowes catalog has—unbeknownst to the publisher—been reprinted. *Classic Houses of the Twenties*, issued by Dover in 1992, is a reprint of *Loizeaux's Plan Book No. 7* (a lumber and builders supply company in New Jersey). It is a fully customized C. L. Bowes catalog with the Loizeaux name on the cover and four pages about the company and plants inside. All 134 house designs (given various names and numbers) appear to be identical to comparable plates in the *Home Builders Catalog* of 1927, and the "house styles" essay and most of the model "interiors" views use the same photos, and even the text, as the 1927 *Catalog*.

62. See Eric Hodgins, *Mr. Blandings Builds His Dream House* (New York: Simon & Schuster, 1946), chapter 14, esp. 204–11 and 229–31, where the $1,247 extra charge for "changes in a closet" are explored. The book is "based loosely on the author's own homebuilding experiences."

63. My thanks to Richard Cheek for lending me this catalog; although lacking front and back covers, Mr. Cheek's records indicate that it was issued in 1928.

64. Just how many houses were sold by Sears is not always easy to determine. Two different figures are provided by the 1929 catalog. On page 24, an ad for the *Face Brick Homes* catalog states that the Sears Modern Homes Division had furnished "over 45,900 homes to American home builders." In a two-page letter to Miss

E. F. Jamerson of Brant, New York, dated October 17, 1929, and found in the copy of the 1929 catalog consulted, however, we are informed that "practically every illustration" in the catalog is reproduced from an actual photograph "sent to us by some of our 44,200 satisfied customers." Perhaps the personalized form letter had not been revised recently, or perhaps Sears was indeed precise in its calculations—for some of its customers, such as Standard Oil Company, American Magnesia Company, and "a construction company at Akron, Ohio," bought 100 or more houses each (Standard Oil bought 192). Photos of some of these developments are found on pp. 4–5 of the 1928 catalog.

65. My thanks to Charmaine Alessi for her assistance in preparing the tabulations for this map.

66. Located at 165 North Twenty-first Street. According to the owner, the house was built in 1930. The steel beam in the cellar, which supports the median walls, is marked "Webb & Webb, Newark, Ohio." My thanks to R. James Brucker for permission to inspect and measure his house (June 27, 1987).

67. The Norwich example is illustrated in Stevenson and Jandl, 16; the Geneva version is located on Hamilton Street near the intersection of Routes 5 and 20 (author's photos). Rogertown, Pennsylvania, is a hamlet just outside Warren, Pennsylvania (author's photos).

68. Located at 10970 Bennett Road, Town of Dunkirk; according to D and F Real Estate, which permitted me to inspect the house (November 1984), it was built in 1945. The interior room dimensions were taken from their real estate form, not from my own measurements.

69. There is no indication in this catalog of its date; the bookseller from whom it was purchased listed it as "ca. 1930." Because of the number of attached garages (forty-three, many of them double) and the frequent mention of air conditioning as an option, it seems to be some years later than that; and if the first edition was 1923 and it was revised yearly, then the eleventh could well be about 1933 or later. The fact that the title page is in sans-serif type also suggests mid-30s.

The 1923 and this edition are of the same size (15 $\frac{1}{2}$ by 23 $\frac{1}{2}$ inches). This congruency of dimensions and the fact that the catalogs were published in "sections" suggest that on occasion the Plan Service Company issued its catalogs brought together in one or more volumes. Of the sixty house illustrations in *Two-Story Houses*, thirty are in color, with one repeated on the title page.

If the Plan Service Company is the same firm as the "National Plan Service," it must have been a supplier of plans directly to lumber companies in its early years. An item from an antiquarian bookseller's list is a "folio" of fifty-three pages, "containing plans and perspective line drawings for 62 houses," but with no date, no place of origin for the Service, and no title for the designs. It was, however, imprinted with the name of the C. Chase Lumber Company of Springfield, Massachusetts. The date of "c. 1920?" was proposed. Houses depicted were of two- to three-bedroom size, in "Colonial" or "English" styles, with some in "Dutch," "French," or "Mediterranean."

70. Located at 203 Temple Street. According to the village Assessment Roll (courtesy Douglas H. Shepard), the house was "incomplete" and owned by Edna R. Toomey in 1941; in 1942 it is listed as owned by A. D. Toomey. My thanks to David Narraway, owner, and Mark and Kathy Dolce, occupants, for permission to inspect and measure the house (April 24, 1985, and January 19, 1987).

Of the ninety-three houses surveyed in detail for this study, this one is unique in that information was volunteered about its resident ghost. The door of a second-floor room (where a valuable clock collection had previously been kept), now an infant's bed-

room, occasionally locked itself. This was common enough that a key was kept on a ledge in the hall to unlock it. The musical mobile in this bedroom now and then (when the child was not present) started by itself. And at 2 A.M., the front door (kept locked at night because the house is on a major street) occasionally unlocked and popped open. There was never anyone at the door, which was clearly visible from the upstairs main bedroom. The residents did not feel these events at all threatening, only baffling.

For similar old-house ghosts, see *OHJ* 16, 5 (1988), 18–27.

71. Information on the Kofoeds and their work in Silver Creek is based on a thirty-five-minute taped interview with Nelson Kofoed (1917–93), of Orchard Park, New York, August 20, 1986; notes from conversations the same day in his woodworking shop; data provided by Mrs. Kofoed from family records; and subsequent conversations of September 9 and October 7, 1992. Nelson Kofoed reviewed and corrected the manuscript and added additional information in March 1993.

Carl Kofoed's house and shop (which he purchased from August Kofoed in 1924) were located on a large lot at 7 Christy Street. Nelson purchased the house next door in 1943.

72. This and subsequent historical data on Silver Creek are derived from the following sources: Hamilton A. Child, *Gazetteer and Business Directory of Chautauqua County, New York, for 1873–74* (Syracuse, 1873), 125–26; F. W. Beers, *Illustrated Historical Atlas of the County of Chautauqua New-York from Actual Surveys and Records* (New York, 1881), 18–19 and plates 72–73; and *American Agriculturist Farm Directory . . . of Chautauqua County New York* (New York, 1918).

See also Helen G. McMahon, *Chautauqua County, A History* (Buffalo, N.Y.: Henry Stewart, 1958), 313–15; and Marion Thomas, *Once Upon a Time* (Silver Creek, N.Y.: Fortnightly Club, 1976), 26–34.

According to a page from an unidentified Silver Creek directory or gazetteer of about 1882 (courtesy Dorothy Kofoed, April 1993), "Kofoed Bros." sold all manner of furniture: "honest goods at low prices." The manufacture of furniture seems to have increased over the years, and a 1914 photograph of "employees of the Peter Kofoed Furniture Manufacturing Company" (published in the Dunkirk *Evening Observer*, January 29, 1970, 16, courtesy Mrs. Kofoed) identifies most of his twenty-five employees.

73. Silver Creek is located on the southern lake plain of Lake Erie; to this day the entire band of farmland across the northwest corner of Chautauqua County is (because of its moderated temperature) fertile grape country.

74. According to Nelson Kofoed, "We did a lot of work down there for all the rich people in Derby"; but he does not know how many houses overall he and his father actually built or remodeled during their career. According to Sam Crino (an acquaintance of Nelson) who grew up in Silver Creek and remembers the building activity of the 1930s and 1940s, the Kofoeds built "a significant number of the better quality homes" in Silver Creek and environs (conversation of December 1, 1992).

Other craftsmen who worked with the Kofoeds on their many projects included George Ortalano, excavation; Vince Kahabka, masonry; Louis Guarcello, plumbing and heating; Johnson & Beebe, electric; Ralph Erdle, brickwork; Henry Esperson, painting; and Walter Beck, papering and painting (Nelson Kofoed notes, March 1993).

75. Illustrations of stylistic transformations of old houses to make them more up-to-date are found in Vaux (1857), Holly (1863), Woodward (volumes of 1865, 1867, and 1868), and Palliser (1876). The books by Woollett and Mason were both deemed significant enough to be reviewed by the *AABN* (May 18 and December 28, 1878).

76. See also Amelia Leavitt Hill, *Redeeming Old Houses* (New York: Henry Holt & Co., 1923), which includes good before and after comparisons, too.

77. Builders drawing up their own plans seem to have been quite common during the nineteenth century, too. Henry Ericsson, speaking of his work in 1886, mentions in passing that "I built for Lazarus Silverman . . . a four-story building for which I made the plans myself." *Sixty Years a Builder*, 87. A decade later, in their obituary notice for Henry M. Harmon, a builder and later a contractor in Boston, the editors of *The American Architect* noted that he and his brother had "an extensive business as superintendents of construction, and for many years the rich real-estate owners of the city put their building-work in the hands of the Harmons, who, in some cases, furnished plans for them" (*AABN*, May 4, 1895, 45).

78. My thanks to Sam Crino, one of Benny Crino's four sons, for information about his father (conversation of September 4, 1992).

79. Lothar Haselberger, "The Construction Plans for the Temple of Apollo at Didyma," *Scientific American* 253 (December 1985), 126–28, 128A–28B, 129–32.

80. Ibid., 128.

81. Ibid., 32.

82. Ibid.

83. From an interview with Aaron Wilson (born 1904) by Garry Moore and Wayne Campbell, October 9, 1981; my thanks to Garry Moore for lending me a copy of this tape.

84. Information on Thomas H. Renne and Brown & Gugino is primarily from conversations with Vincent C. Gugino (May 22, 1985, October 3, 1989, and December 7, 1992) and from local directories between 1902 and 1946–47. Tom Renne, as did his father, lived at 52 Orchard Street, near the Brown & Gugino mill and yard.

85. For information on Dunkirk Lumber and Coal Company, my thanks to William C. Case (taped interview of July 13, 1985; a twenty-seven-page typed transcript is in the collection of the Historical Museum of the Darwin R. Barker Library, Fredonia, New York). Additional data from company record books were provided by Evelyn "Betty" Putnam Case (December 1, 1992) and from local directories of the 1930s and 1940s. The company's "lumber yard and planing mill" were located at 526 Roberts Road, Dunkirk.

86. In directories of the 1930s, Clayton Putnam is listed as "President-Manager" and Allen Putnam as "Treasurer" of the company. In 1946–47, William Case is listed, in two locations, as "Yardman" and as "Foreman."

87. From a conversation with William Case, October 10, 1989.

88. The Pilgrim model is depicted in sample Aladdin Company catalog plates illustrated by Bruce and Sandbank (61); that issue of *Architectural Forum* appeared in April 1943.

89. Most of the following information is from a detailed interview with Charles J. Czech (April 20, 1987); an examination of fifteen sheets of original blueprints, and eleven construction photos taken by Czech between June 29 and October 1, 1950; and the Aladdin construction manual. Although Czech no longer has the original Aladdin catalog he received in 1950, he owns one from 1952 ("Catalog Nr 57"), which also illustrates the same Pilgrim model and plan Number 5. I am much indebted to Charles J. Czech for sharing all this material with me and for facilitating my thorough inspection of his home. The address is now 1049 Spring Avenue Extension, Troy.

This Aladdin model was a popular one; an example from the western end of New York state is found in Dunkirk, at 3788 Lake Shore Drive East.

90. The fact that Czech's father, Joseph (who was a supervisor at the Field and Hatch Knitting Company in Cohoes), had built a garage without any carpentry experience probably suggested to him that anyone with mechanical aptitude and common sense could put up an Aladdin house.

91. These blueprints, which measure 22 by 36 1/2" each, are actually "reverse prints," blue lines on cream-colored background. In the lower left is a box with "Drawn by," "Traced by," "Checked by," and "Date"; the spaces, when filled in, have initials, and the date is either 1948 or 1950. Most are also marked "Sheet __ of 11" as appropriate and the model name. One sheet, however, labeled "16" rafter plan 1948" is marked "Sheet 10 of 12," indicating that the models were indeed revised and updated over the years by the company.

92. *Instructions for the Erection of Your Aladdin Home Summer Cottage or Garage,* compiled by The Aladdin Company, Home Offices and Mills, Bay City, Michigan," copyrighted 1950. The twenty-four-page manual has twenty-one figures (either photos or line drawings) and six additional line drawings of roof-shingling methods.

93. How errors were corrected tells a good deal about the probity of the Aladdin Company. Czech was short one or two gallons of paint, for which the company sent a coupon for local use; for a piece of the ridge pole omitted, he purchased it locally and sent in the bill; when one window did not fit right, the company paid him to refit it; but the best indication of the company's fairmindedness was the Mystery of the Noisy Closet.

After having constructed it, Czech heard a scratching noise coming from an interior closet. On tearing out the wallboard, he discovered that one of the two by fours contained wood borers rustling around (which, according to the New York State Department of Agriculture, were not termites, but would turn into moths). Aladdin told him to have the closet repaired and send the company the bill—which he did.

94. In 1961, Czech finished the attic and installed a half-bath; aluminum siding was added to the house about 1981; and the canopy over the front steps was put up about a year later. The electrical system has also been updated, but otherwise the house remains just as originally built.

95. Thirty years later, one could still purchase houses in kit form to construct oneself; see Peter V. Fossel, "Houses You Can Build Yourself," *Country Journal* 7, 2 (1980), 68–81.

96. Bruce and Sandbank, 57.

97. Drawn from U.S. Bureau of the Census, *Historical Statistics of the United States, Colonial Times to 1970* (Washington, D.C.: Government Printing Office, 1975), II: 639–40, "New Housing Units Started . . . 1889–1970."

8 Pattern-Book and Catalog Houses in Context

1. The population of Fredonia during these years is taken from local directories for 1898, 1912, 1923, and 1940; the national data are from the chart "Population in Urban and Rural Territory, by Size of Place: 1790–1970," U.S. Bureau of the Census, *Historical Statistics of the United States, Colonial Times to 1970* (Washington, D.C.: Government Printing Office, 1975), I: 11.

2. Reiff, *Architecture in Fredonia,* 14–15. The first booklets of essays by the county historian Elizabeth L. Crocker, *Yesterdays . . .in and Around Pomfret, New York* (Fredonia, 1960–64), are especially useful sources for information on the history of Fredonia.

3. Hamilton Child, comp., *Gazetteer and Business Directory of Chautauqua County, N.Y., for 1873–74* (Syracuse, N.Y.: Hamilton Child, 1873), 143. The wagon and the pump manufactories together employed about 145 people.

4. The carpenters' manual by William Pain, *The Carpenter's and Joiner's Repository; or, a New System of Lines and Proportions for Doors, Windows, Chimnies, Cornices, and Mouldings, for Finishing Rooms, &c. &c.* (London, 1792), is now in the collection of the Historical Museum of the Darwin R. Barker Library, Fredonia; it is signed by its owner, Thomas Jones, "Joiner," and inscribed "1794." It seems to have been used by Jones for many years, for an account slip dated October 1820 is still in the book, and on it are listed both his eldest son (Thomas Jones Jr.) and a younger son John Jones—who settled in Westfield, New York, in 1829 and was working in Fredonia as a skilled carpenter by 1835, designing and building in that year the Greek Revival Presbyterian Church. It is unlikely that John Jones, who remained in Fredonia until his death in 1852, used the Pain book much himself, for the plates are of details in Federal, not Greek Revival, style, but the book was apparently retained by him, along with (one presumes) more modern carpenters' manuals, and ultimately found its way into the museum.

5. The ad was addressed "To Joiners" and appeared in several subsequent issues; but Benjamin was also included in the general listing of "New Books" at Frisbee's store published January 18, 1837. My thanks to Douglas H. Shepard for this citation.

6. Downing's *A Treatise on the Theory and Practice of Landscape Gardening* first appeared in 1841, and *Cottage Residences* appeared in 1842. My thanks to Douglas H. Shepard for the *Censor* reference.

7. See *Censor* items of November 25 and December 23, 1868 (courtesy Douglas H. Shepard). I have previously noted that when the cellar was excavated in 1878 for Aaron Putnam's house (designed by Enoch A. Curtis) the fact was recorded along with other "Building News" by the *Censor.*

8. The article, "How to Build Cheap and Comfortable Dwellings," reprinted from *Rural American,* appeared in the March 13, 1867, *Censor* (courtesy Douglas H. Shepard). The anonymous author points out that most people "who have but little money" and thus do not hire an architect "must plan their own houses, [and] perhaps build them" as well. He discusses the advantages and economy of balloon-frame construction (although the name is not used), rather than the use of heavy timbers—and asserts that *one by fours* instead of the more common two by fours are just as sturdy for a "cottage with five or six rooms."

9. *Censor,* December 4, 1889, and April 24, 1895. Most of these late nineteenth-century architectural references are drawn from the twelve-page paper by Karen Karalus, "The Fredonia *Censor* and Late Nineteenth Century Architecture" (December 4, 1985), covering issues through 1897.

10. *Censor,* April 6, 1892, January 4 and December 13, 1893, and June 27, 1894.

11. *Censor,* September 7, 1898. This *Censor* reference (and most subsequent ones through 1925) is from a twelve-page paper by Michele B. Furdell, "Architectural Illustrations of Local Significance [1898–1925]" (December 15, 1986).

12. *Censor,* January 15, January 29, April 8, June 10, 1896, and May 15, 1897.

13. *Censor,* August 19, 1896. The illustration is copyrighted 1896 and appears to be current work. The "model cottage" is a simplified version of Design 636 in Shoppell's *Modern Houses* (January–March 1890); the first- and second-floor plans are al-

most identical to it. (The 1896 cottage is also very close to Design 844.)

14. These and subsequent citations from the *Grape Belt* are drawn from the fourteen-page paper by Joanne Goetz, "A Review of Architecture Published in the *Grape Belt* January 6, 1893–April 28, 1900" (April 28, 1981).

15. *Grape Belt,* March 23 and April 23, 1895.

16. Ibid., December 15, 1893, December 22, 1894, and June 15, 1895.

17. Ibid., October 13, 1894, and November 21, 1896.

18. Ibid., June 29, 1895, and June 10 and August 29, 1899.

19. Ibid., June 24, 1894, "Model Farm Residence"; June 29, 1894, "A Handsome Cottage"; July 20, 1894, "Jacobite Period Design"; March 23, 1895, "Convenient and Handsome"; March 30, 1895, "A Compact Dwelling"; April 27, 1895, "$6,000 Farm House"; April 30, 1895, "Design for a Suburban House"; February 22, 1896, "Design for a $4,000 Cottage"; February 25, 1896, "Design for a Public School"; January 16, 1897, "Artistic Stable Design"; January 23, 1897, "Stone and Shingle (Cosy Colonial Residence)"; February 6, 1897, "Fit for a King (a Beautiful Colonial Home)"; February 23, 1897, "Dutch Colonial Style (Private Stable)"; and February 2, 1897, "$7,000 Colonial Home." The first two "colonial" house designs are more Queen Anne than academic colonial; and the last one is Shingle Style.

My thanks to Mary Jane Covley-Walker and the Dunkirk Free Library for lending me their microfilm copy of the *Grape Belt* (June 1993).

This sort of newspaper column by George Palliser, featuring a design and two plans with descriptive text, seems to have been common at this time; one entitled "A Unique Design" (a two-and-a-half-story shingled house for only $2,200) was published in the *Buffalo Sunday Morning Times* April 7, 1895, 11 (copy courtesy Francis R. Kowsky).

20. *Grape Belt,* July 20, 1894.

21. Ibid., February 22, 1896.

22. Ibid.

23. *Censor,* November 11, 1903; August 18, 1909; and June 14, 1916.

24. Ibid., September 11 and 18, 1901; April 14, 1909; June 8, 1910; May 19, 1915; May 12, 1920; and May 28, 1924.

25. *Censor,* February 3, February 24 and March 10, 1926. The series actually began on January 20, but the illustration and plan were from the third installment, and only the text was from the first—it was repeated (with correct illustrations) on February 3. The three were entitled "Popular Bungalow Provides Plan That Can Be Altered to Suit Taste," "Homelike Comfort, Inside and Out, Makes This an Attractive Home," and "Good Plan for Home That Permits of Expansion When Room Is Needed." Following each description of the house and plan, Radford appended a few short articles on other domestic building matters: "Breakfast Nook Ideal Addition to the Home," "French Doors," "Steel Girders Replace Old Wooden Joists," "Clean Floors Well Before Refinishing," "Home Not Done When Walls and Roof Are On," "Fireplaces," and "Molding in Bedrooms." My thanks to Douglas H. Shepard for these citations.

26. This is repeated verbatim at the beginning of each article.

27. *Censor,* February 3, 1926, 16.

28. Of course, local residents or carpenters could have written to Radford for catalogs of other house designs more to their liking than those appearing in the *Censor.*

29. *Censor,* November 1, 1916. My thanks to Douglas H. Shepard for the citation. The house appears to be 247 West Main Street, although now somewhat remodeled.

30. Interview with Elizabeth Luke (daughter of the carpenter and contractor Benjamin Luke), June 1, 1985; and interview with

John G. Fitzgerald (whose father was a paving contractor and builder), January 9, 1991.

31. The original blueprints for 65 Cottage Street, marked "Bennett Homes–Dura-Bilt," and the model "Karen 'A'" survive; the owners of 49 Cottage Street have preserved the original catalog plate, c. 1937, depicting their house design and the materials list, although neither gives the company name; and the owners of 185 Chestnut Street still have pages from the magazine *Small Homes Guide* (published in Chicago by W. Waddy Wood in 1947) from which their house plans were ordered.

32. The plans and elevations for 135 Central Avenue, which must date from about 1929, look like mail-order blueprints, but have no company or architect name. The elevations, rather than indicated by cardinal directions, are "left," "right," and so on. See Reiff, *Architecture in Fredonia,* 92.

33. For example, 134 East Main Street, constructed in 1926 for George Luke by John F. Luke (in both the 1912 and 1923 directories listed as "contractor"), was built from "plans . . . from some outside source" according to John Luke's daughter-in-law, who, in 1971, was living in the house. (See ibid., 92–93.) (John Luke also built the adjacent house, 136, in 1929.)

34. See Reiff, *Architecture in Fredonia,* 20–21.

35. Information on Jones is drawn from a *Censor* notice of September 14, 1852, and his obituary of December 14, 1852 (copies courtesy Ann Fahnestock). See also Reiff, *Architecture in Fredonia, New York,* 22–23, 40–43, and 46–51.

36. The group of eight letters, written between April 5, 1835, and February 13, 1839, are in the collection of the Barker Museum. My thanks to Ann Fahnestock for bringing them to my attention.

37. Putnam's plans of possibly starting a "scythe, snath [the handle of a scythe], sash, and pail business" indicate that he was also a skilled woodworker, not just a carpenter. This is confirmed by his wife's comment to their son Aaron O. Putnam (born 1836) in a letter of March 9, 1853 (also in the Barker Museum): "Your father has traded of his turning lathe for half dozen of Cane seat chairs."

38. In his letter of September 21 [1835], Putnam noted that he was still working on the "meetinghouse" and that "I have now ten shillings per day and board myself."

39. Tabulations based on listings in Childs's *Gazetteer and Business Directory* (1873) and the Fredonia directories (various publishers) of 1883, 1891, 1899, 1912, 1923, 1935, and 1946.

40. Tabulations based on listings in twenty-five local directories between 1883 and 1949, inclusive (collection of the Dunkirk Historical Museum).

During the 1880s, Enoch Curtis had assistants who are listed (as architects) in the directories: in 1883, John D. Abraham; and in 1887 and 1889, William H. Archer.

41. Information on Benjamin H. Luke (1877–1956) is based on a search of eighteen local directories between 1898 and 1946 (collection of the Dunkirk Historical Museum); interviews with his daughter Elizabeth Luke (born 1912) June 1 and 8, 1985; and a few business papers and account sheets still in her possession.

42. It seems to have been a small business, conducted from a shop near Charles Luke's residence at 14 Rail Road (now Cleveland) Avenue.

43. Although listed as a "building contractor" in 1930, he was a "carpenter" in 1935 and in 1938 was listed as a carpenter with the Niagara, Lockport, and Ontario Power Company. In 1940, he was an independent carpenter again and thereafter returned to "building contractor" with the 1944–45 directory.

44. From at least 1909 onward, Benjamin Luke lived at 45 Barker Street (which his daughter, a retired schoolteacher, owned

until about 1991). They also owned a house around the corner at 30 Forest Place. The "yard and mill" were located at the corner of White Street and Free Street (now Lambert Avenue).

45. Luke could, however, read blueprints well. At the beginning of World War II when a steel plant in nearby Dunkirk needed someone who could read blueprints, Luke was hired for that purpose.

46. Formerly the Opera House (the rear portion of the Fredonia Village Hall, built to designs of Enoch Curtis in 1891), it was thoroughly remodeled for motion picture use at a cost of about $25,000 during the summer and early fall of 1926. "Benjamin H. Luke has been the general contractor" (Dunkirk *Evening Observer*, October 23, 1926 [courtesy Douglas H. Shepard]).

47. Information on Fred C. Ahrens (1875–1965) is drawn from a review of local directories between 1917 and 1946; an interview with his daughter Esther Ahrens (born 1901) June 7, 1985; interviews with Homer Sackett (born 1913) August 27, 1985, and June 17 and August 25, 1986; and an interview with Dr. Frank Hall (1917–89) and Betty Hall May 28, 1985.

48. According to Mr. Sackett, Joseph Dietzen was Fred Ahrens's nephew; but fourteen was, after all, the age when youths were then permitted to quit school (after graduating from eighth grade) and go to work—and many of course did. My own father, Harry Reiff, was taken out of school by his parents in 1913, just *before* his fourteenth birthday, because they had found a good job for him as an office boy.

Joe Dietzen continued to lodge with the Ahrenses for some time; in the 1923 directory he is listed as boarding with them at their Fredonia house, although by 1935, married, he has his own home. He worked for Fred Ahrens his entire career.

49. Ahrens and Salhoff's mill and yard was at 63–69 Water Street. Ahrens lived nearby at 85 Liberty Street (until he retired and built a one-story brick house for himself and his daughter at 217 Lambert Avenue).

50. The carpenter Robert Dankert (interview of August 25, 1986), whose grandfather had been a skilled carpenter (and whose father, a farmer, also did some carpentry), started to work for Harry Salhoff in 1938 and learned carpentry on the job (he had originally wanted to work for Fred Ahrens, but he was not hiring). "Ahrens laid everything out for his carpenters and worked *with* them; [Harry] Salhoff did not; he was just a manager." But "he knew his carpentry" and inspected each job every day—and one never knew when he would show up. Salhoff provided all the plans: Many were blueprints (either mail order or from a local architect); others were drawn up by himself; and some plans were taken from *calendars*—only an outside view and a plan! "It was pretty rough, but it was no problem to build a house from it." Salhoff would draw out detail work and cabinetry on the wall itself. A full bill of materials was prepared for everything, and the mill man cut most of the wood to the right sizes—thus, in a way, making each house almost a "precut" house.

51. Fredonia Builders Supply Company was located at 156 Newton Street. The office, at the front of the yard, was built to resemble a gambrel-roofed house, complete with chimney at one end, so that if it ever had to be remodeled into a dwelling it would be an easier task. According to Mr. Sackett, it was a "big mill." The shop was full of equipment, including (by 1940) "a thirty-six-inch planer, big drum sander, double-headed shaper, big bandsaw, table saw, big twelve-inch jointer," and, soon after, "a sixteen-inch Wilson radial saw."

52. Mr. Sackett's father was a farmer, but also "could build anything," including Erie Canal barges and canning factories. Homer Sackett, one of twelve boys and two girls, "was always working with tools" as a youth and went into cabinetwork through apprenticeship in a Brocton, New York, furniture factory, in 1932.

Although he first worked for Ahrens as a carpenter, beginning in 1940, he was soon put in charge of the mill work, but he continued to do some carpentry if needed.

According to Mr. Sackett (conversation of June 21, 1993), the only things that were always cut exactly to size at the mill were the roof rafters; other lumber was cut to fit at the site.

53. Esther Ahrens was familiar with her father's work because she sometimes helped in the office; in the 1938 and 1944–45 directories she is even listed as "secretary-treasurer" of the company.

Fred Ahrens built very solidly. According to Sackett, houses were framed with angled braces at each corner for additional rigidity; and the exterior sheeting, usually one-by-six-inch boards (after World War II, plywood began to appear), was often put on at an angle for additional stiffening.

54. Regarding Mr. Ahrens's retirement house at 217 Lambert Avenue (a one-story brick dwelling) to which he moved in 1955, Sackett recalls: "One day he come in and he sat down and drew this out, and had it all detailed."

55. One set of such plans (courtesy Sackett) for a one-and-a-half-story three-bay colonial-style house with attached garage consists of three large sheets depicting at 1/4" scale all four elevations; floor plans (with electrical and plumbing details) of the basement and first floor; framing diagrams for all four elevations, and floor and ceiling framing at 1/8" scale; and at 3/4" scale roof, wall, and foundation sections, and two other details. The sheets bear no company name or date or title, although the plan is marked "No. 4808" and is signed, illegibly, by the designer.

56. Although Fred Ahrens could read blueprints well, according to Sackett not all carpenters could, although they all knew the standard construction methods. Only one man on the job (which would usually have three carpenters and sometimes Ahrens himself) needed to be able to read the blueprints anyway. Ahrens gave verbal instructions and laid out things on the floor with a snap line for them. Sometimes for individual carpenters he made a sketch of the part they were working on, based on the blueprints.

57. Information on Clifford A. Smith is from local directories; an interview with Mrs. Clifford Smith (1894–1990) June 11, 1987 (with thanks to Mrs. Charles Fryer); and a conversation with Mary Bonhoff (one of the Smith daughters), June 18, 1990.

58. The Smiths lived at 95 Hamlet Street, a house that Clifford Smith built himself sometime between 1915 and 1917.

59. Located at 46 Risley Street. In 1929, Clifford Smith also built the impressive Stickley Bungalow-style dwelling nearby at 29 Risley, according to Sidney Frost, nephew of the original owners (conversation of June 10, 1987). Soon after I surveyed this house, some remodeling of a rear glazed porch uncovered, behind the walling, the penciled notation: "C. A. Smith / Jos. Shuler / June 28, 1929."

60. As the carpenter Louis Salhoff said (according to Robert Dankert), "Anyone can make a mistake, but a mechanic [skilled carpenter] can get himself out of it."

61. Interview with retired carpenter Ernest C. Bull (born 1913), March 6, 1990. Although his father was a farmer, his great-great-grandfather had been a carpenter.

The prefabricated houses ("National Homes") came in large panels, manufactured in Horseheads, New York, and were put up by Kimball Construction Company of Dunkirk. At least fifty such houses were built in Dunkirk; others found their way to Fredonia, Brocton, Cassadaga, Silver Creek, and Lily Dale. Mr. Bull preferred, however, "working from scratch."

62. Other carpenters who worked in Fredonia in the 1950s confirm that although some houses were made from blueprints (often mail order), others were designed by the carpenters themselves in the current style, and that prefabs were built too.

Milton H. Lupean (interview of March 14, 1990), born in 1917, had taken industrial arts courses in high school, but decided to build his own home only in 1950 while working at a nearby steel plant. He ordered the blueprints (which included a complete materials list) from a design on a calendar put out by the Garlinghouse Plan Service of Topeka, Kansas. He taught himself carpentry by studying Gilbert Townsend's *Carpentry: A Practical Treatise on Simple Building Construction, Including Framing, Roof Construction, General Carpentry Work, Exterior and Interior Finish of Buildings, Building Forms, and Working Drawings* (Chicago: American Technical Society, 1948)—copyrighted in 1918 and 1935, but reprinted in 1948. In 1952, when workers at the steel plant were on strike, he began his house and completed it in 1954.

Thereafter, Mr. Lupean built a lot of houses in the Fredonia area, working for the major local contractors and on his own. Sometimes they worked from blueprints; often from just a picture of the exterior and a plan—because all the construction and finish detailing were in their heads. He also worked for a small local firm, Pomfret Sales Company (founded by Everett Potter), which made houses in prefabricated sections. Such employment allowed people to work indoors at the factory during the winter.

63. Nikolaus Pevsner, *An Outline of European Architecture*, 7th ed. (Baltimore: Penguin Books, 1963), 93.

64. For a note on how the survey was conducted and the method of matching houses with possible pattern-book sources, see "A Note on Methodology" in Appendix 8.

Most of the dates for Fredonia houses cited in this section are courtesy Douglas H. Shepard.

65. Two impressive Federal-style dwellings not included in the survey are a large two-story stone house dated 1829 and an adjacent brick house (both with stepped-end gables); see Reiff, *Architecture in Fredonia*, 22–23. Both were demolished in 1977. For illustrations and discussion of two others, see also Reiff, *Architecture in Fredonia, New York*, 36–37.

66. One local carpenter's creative adaptation of Greek detailing was found at 120 Eagle Street, where the four Ionic columns on the one-story facade porch were given *convex* flutes, even though the door enframement contains skillfully executed Benjamin-style palmette pilasters, and other details—mutules complete with guttae—are accurate transcriptions of Greek models. The porch columns were replaced by modern columns in the early 1980s. See Reiff, *Architecture in Fredonia*, fig. 52.

67. The weathering line on the brickwork may or may not reflect an original porch, for the house was remodeled about 1885 and given a Queen Anne style-porch and porte cochere. See ibid., fig. 71.

68. The original design was by Downing and Vaux. At the time the house was erected, Vaux suggested adding a ventilating turret in the front roof; but "this prominent feature" was not carried out when the house was built and I have removed it—for it is an adventitious feature—from the Vaux plate.

69. Ibid., 44–45. The original porch (fig. 78) was only three bays wide, like the Bicknell plate.

70. At least three Second Empire houses were demolished before the 1984 survey. See ibid., figs. 106 and 240, for two of them; a third, demolished in the late 1960s, was at about 20 East Main Street.

71. Ibid., 64–65. The house with small front and side porches and attic dormer is shown in the New York *Daily Graphic* for September 24, 1879 (copy courtesy Barker Museum), two pages are devoted to Fredonia and its architecture.

72. See *Shoppell's Modern Houses*, January–March 1890, Design 1971, reprinted in Shoppell, *Turn-of-the-Century Houses* (1983), 66; the house in *Carpentry and Building* is reprinted in Berg, ed., *Modern American Dwellings 1897* (1984), 2–6.

My thanks to Edward and Barbara Dailey for permission to inspect and measure their house (March 20, 1985).

73. My thanks to Robert and Jane Kerrick for permission to inspect and measure their house (May 2, 1985). The porch roof was rebuilt in April 1985, and the entrance pediment was removed.

74. See Berg, ed., *Modern American Dwellings, 1897* (1984), 10–13; *Shoppell's Modern Houses*, October 1900, Design 1998, reprinted in Shoppell, *Turn-of-the-Century Houses* (1983), 93; and Radford (1903), Design 109, 125.

75. New siding was added to 100 Center Street about 1986, at which time both attic windows were eliminated and the porch rebuilt in modern style.

76. This house was thoroughly remodeled and re-sided around 1980 and no longer retains its Queen Anne porch or detailing.

77. Design 2001, published in *Shoppell's Modern Houses* of October 1900, is reprinted in Shoppell, *Turn-of-the-Century Houses* (1983), 96. My thanks to Daryl P. and Sharon E. Brautigam for permission to inspect and measure their house (June 1, 1990).

78. My thanks to Charles F. and Florence M. Greene for permission to inspect and measure their house at 75 Hamlet Street, May 9, 1985.

79. The house at 130 Central Avenue was purchased about 1900 by William and Mary Clark; but after their four children grew up and moved away, they decided to sell the now too-large dwelling. The carriage house was moved up (on rollers, attached to a truck) beside it and remodeled as a residence for Mrs. Clark, possibly by Fred Ahrens. For information on these houses, my thanks to Florence McClelland, whose grandmother was Mary Clark (conversation of November 9, 1989), and George Weaver, who as a child witnessed the move (conversation of November 4, 1989). The exact date of remodeling is courtesy Douglas H. Shepard.

80. Originally published in *Shoppell's Modern Houses*, January–March 1890, and reprinted in Shoppell, *Turn-of-the-Century Houses* (1983), 37.

81. My thanks to Beth W. McKenna for permission to inspect and measure her house (March 3, 1990).

82. My thanks to Lucy Costanza for permission to inspect and measure her house (March 21, 1985).

83. A notice in the Fredonia *Censor* of January 22, 1919 (courtesy Douglas H. Shepard) notes that Louis Salhoff was demolishing these buildings and planned to build four "modern houses" on the site. Numbers 24 and 26 are identical except for the form of the front porch. All four seem to have been completed by 1920.

84. See Reiff, *Architecture in Fredonia*, 84–85. The duplicate at 138 East Main Street is fig. 167. It is possible that the several other local examples of bungalows with rounded-end bays are by local carpenters emulating Mr. Beebe's success.

85. My thanks to Sandra DeLong for information about her house and permission to inspect and measure it (May 9, 1985).

86. Although the Sears version appeared only through 1921, the design was apparently picked up by some other company, for this Fredonia house was in fact built by George McAllister about *1940*. According to Wilma McAllister, her husband built it himself and, having trouble with the roof, had to get outside help (my thanks to Douglas H. Shepard for this information).

George McAllister was clearly mechanically adept; he was a foreman and worked on the Lewis Straightener at the Allegheny Ludlum Steel Coporation in Dunkirk at this time. The plans were ordered from a catalog; the material, however, was local, most from a packing house being torn down several blocks away, and the remainder from Harry Salhoff's lumberyard. Mr. McAllister later built himself a barn behind his house, the lower story of which was reinforced concrete, and after leaving the steel company about

1949 went into house building and repair. (This information courtesy Mrs. McAllister and her son Alec McAllister, June 29, 1993.)

87. The copy of *Architectural Economy* I consulted is owned by a Fredonia resident (it had been used by her mother as a scrapbook for pasting in newspaper clippings of interest) suggesting that it was from a local firm.

Whoever built the garage may not have ordered the plan at all, because the roof as built is a good deal higher than the catalog design, and other details, such as the spacing of the doors, are slightly different, too.

88. The recessed side porch was enclosed in 1947, the front porch (which originally did have round columns) was remodeled in 1954, and extensive interior remodeling, including shifting partitions and altering the stairs, took place in 1958. My thanks to Walter J. and Maxine Koba for permission to inspect and measure their house (March 26, 1985).

89. Information on the construction of the house is from local assessment records as well as directories (courtesy Douglas H. Shepard). My thanks to Dennis and Joy Harper for permission to inspect and measure their house (June 16, 1989).

90. The date, based on local records, is confirmed by one of the sash windows, which bears the identification "Chamberlin Pat. February 10, 1925." My thanks to Ronald and Debra Ambrosetti for permission to inspect and measure their house (January 7, 1987).

91. My thanks to Mr. and Mrs. Robert Vickery Jr. for permission to inspect and measure their house (May 9, 1985).

92. My thanks to Mr. and Mrs. Joseph Grisanti for permission to inspect and measure their house (March 26, 1985). It has been remodeled somewhat inside; the picture windows in the facade were installed (also by Harry Salhoff) in 1950.

93. Lawrence Beamish, who in the 1946 directory is listed as employed by Fred Ahrens's Fredonia Builders Supply Company, lived around the corner—for 160 Water Street is actually on a short unnamed street, perpendicular to Water Street—at 164 in an attractive Stickley Bungalow. My thanks to Beatrice Beamish (conversation of March 21, 1985) for this information.

94. My thanks to Mr. and Mrs. Carlos Pato for permission to inspect and measure their house (June 1, 1987).

95. Information on 20 Central Avenue is courtesy William Larson; for illustrations of its two earlier incarnations, see Reiff, *Architecture in Fredonia*, figs. 234–35.

96. About 1936 or 1937, John and Caroline Dubnicki of Dunkirk bought a catalog of house plans (with "The Keene" model in it) in preparation for building a house, but they subsequently bought one instead. In the late 1940s, their daughter Theresa became engaged to Lawrence A. Williams of Fredonia, and in 1952 they sent away for copies of "The Keene" blueprints (two sets of floor plans, elevation views, and so on, and a list of materials; only the last item is now extant). The company that supplied them is, alas, not mentioned on the materials list.

In August of 1952, the year before they were married, Williams began building this house, using the mail-order plans. It was completed in the spring of 1953. The contractor was Fred Ahrens, and the carpenters who worked on it were Gerald Bouquin, Joseph Dietzen, Homer Sackett, and Calvin Thompson. Mrs. Williams prepared a typed list of eight changes in the plans (for example, no fireplace, different front window, and wood shakes instead of stone veneer on the facade), and Ahrens suggested a few more (such as a regular, not "disappearing," staircase to the attic and a floor for the attic). Williams subcontracted plumbing, heating, wiring, painting, and landscaping himself. The Williamses still retain many papers dealing with the work on the house, including the four-page "Articles of Agreement" with Fred Ahrens and the page from the original catalog illustrating "The Keene" and its plans.

My thanks to Mr. and Mrs. Williams for this information and for permission to inspect their house (June 12, 1985).

97. My thanks to Charles M. Notaro for permission to inspect and measure his house (June 9, 1987).

This dwelling formerly stood at 345 Temple Street having been built by Homer Holcomb (a professor at the State Normal School), who had five or six children and thus needed a large house. It was moved to its current site in the late 1960s when the college expanded on this site. (Information courtesy Sylvia Croninger, June 9, 1987, whose father, Henry Miller, had bought the house about 1942.)

98. In nearby Dunkirk, several houses, following more closely the catalog plate, were built, as at 824, 826, and 828 Central Avenue, 260, 270, and 272 Lincoln Avenue, 18 East Green Street, and 11 and 29 West Green Street. It can also be found in Newark, Ohio, at 75, 103, and 114 North Twenty-first Street and (a block away) at 162 Linden Avenue.

99. For the Gott House, see Reiff, *Architecture in Fredonia, New York*, fig. 224.

100. See Reiff, *Georgian Houses*, 202–9, for three-, four-, and five-bay versions of the type from the seventeenth and eighteenth centuries in Virginia.

101. For the Elsing Green outbuilding, see Reiff, *Architecture in Fredonia, New York*, fig. 222, or Reiff, *Georgian Houses*, fig. 333.

102. The house was built in 1954–55; the materials came by truck directly from the North Tonawanda millyards. Local carpenters Bernett & Son constructed it, but the owner did much of the interior work and subcontracted electric, plumbing, and final plastering. A Bennett Homes garage was added in 1961. My thanks to Henry and Adele Graminski for information about their house and permission to inspect it (June 15, 1987). All the original blueprints are extant.

103. Other houses that appear to be this same model are located at 6 Holmes Place, Fredonia, and at 9 and 35 Lafayette Avenue and 1019 Central Avenue in Dunkirk. According to Graminski, Bennett Homes had a sales representative, Anthony Manuel, in Dunkirk, who showed them his own house and encouraged them to visit the North Tonawanda office and mill, which they did.

104. *Ridge Homes Magazine: Choosing, Planning, and Building the Home That's Right for Your Family* (published by Ridge Homes, "a Division of Evans Products Company," 1972), 3. Copy of the eighty-four-page magazine courtesy Sallie L. Black.

105. The house was erected between July 10 and November 1, 1979. My thanks to Fortney for information on their project (July 7, 1993).

106. See Reiff, *Georgian Houses*, 125, and 183, n. 10.

107. The exterior was originally stucco finished, as depicted in an old tinted photo extant in the house; the siding was added some time before 1967. My thanks to Joseph C. and Diana Millonzi for permission to examine and measure their house (June 4, 1990).

108. Aladdin Company produced a model, "The Shelburne," almost identical to this except (as depicted in the 1952 catalog, 57) for omitting the gabled projection at the end. "The Shelburne" also lacked the tiny double window to the side of the chimney as shown in the Sears model and the Fredonia dwelling, and used a regular size instead.

109. For information on the firm of Beck and Tinkham and on Ellis Beck (who was the designer and wrote the specifications), my thanks to his daughter Mrs. Thomas J. Benedett (letter of December 8, 1990). See also *The Recent Work of Ellis W. Beck and Norman Tinkham, Architects* (Jamestown, N.Y., 1930), which depicts some of their work done between 1919 and 1929. Twenty-two houses and thirteen public buildings are illustrated.

110. For information on Jacob Bohn and his house, my thanks to his grandson the architect Nelson J. Palmer (conversation of March 13, 1990). Bohn's main job was his meat market, but he retired from this at age thirty-five and thereafter spent his time managing his properties (which included two farms). "The source of his income is not clear to this day," according to Nelson Palmer. The house was designed by Beck, but Bohn and the firm had a falling out ("over the fee, of course," according to Palmer), and the work was carried to completion by a Fredonia contractor.

My thanks to John and Barbara Krout for permission to inspect and measure their house (June 14, 1989).

111. My thanks to Suzanne K. Welch for permission to inspect and measure her house (February 17, 1990).

112. According to the title search, Benjamin and Grace Luke purchased the property in 1928 (deed recorded in 1935, perhaps after the house was completed?) and sold it in 1947. That Luke used his own materials rather than those from Bennett Homes is suggested not just by the plan alterations, but also by his reuse of three cast-iron columns (for beam supports in the basement), which appear to have originally supported the front of the balcony in the village hall Opera House, which he had remodeled in 1926.

Sears sold a similar model, "The Brookwood," in 1932–33, which might have had an influence on Luke's alterations, for it has a flat-headed dormer and an entrance lobby closet—although the plan is different from "The Wilshire."

My thanks to Richard and Susan Butts for permission to inspect and measure their house (June 11, 1987).

113. The ten-foot addition to the left of the facade was built in the 1960s. My thanks to Alfred J. Gervase for permission to inspect and measure his house (May 1, 1985).

114. See Reiff, *Georgian Houses*, figs. 203, 220, 225, and 231.

Conclusion

1. "A General Famine in Single Dwelling-houses," *AABN*, October 3, 1903, 1.

For readers who have perused or even scanned my 1,029 footnotes, I would like to point out that their number is not only an indication of my commitment to thorough documentation, but may be a hereditary tendency: My father's major book (Henry Reiff, *The United States and the Treaty Law of the Sea* [Minneapolis: University of Minnesota Press, 1959]) contained 1,219 footnotes.

Select Bibliography

Treatises, Builders Manuals, Pattern Books, Catalogs, 1600–1952 (in chronological order)

Seventeenth Century

1600 Serlio, Sebastiano. *Il Settimo Libro di Sebastiano Serlio, Bolognese. Nel quale si tratta, e mettono in disegno molto nobili edificij, tanto publici, come priuate; e varij accidenti, che possono occorrere nello edificare, come si narra nella seguente pagina.* Venice, 1600.

1611 Serlio, Sebastiano. *The Five Books of Architecture*, 1611. Reprint. New York: Dover, 1982.

1615 Scamozzi, Vincenzo. *Dell'Idea Della Architettura universale.* Venice: Presso L'Autore, 1615. The engraved title page is *L'idea della architettura universale.*

1624 Wotton, Sir Henry. *The Elements of Architecture.* 1624. Reprint. Charlottesville: University Press of Virginia, 1968.

1650s Gunther, R. T., ed. *The Architecture of Sir Roger Pratt: Charles II's Commissioner for the Rebuilding of London After the Great Fire: Now Printed for the First Time from His Note-Books.* 1928. Reprint. New York: Benjamin Blom, 1972.

Eighteenth Century

1715 Campbell, Colen. *Vitruvius Britannicus, or The British Architecture, Containing the Plans, Elevations, and Sections of the Regular Buildings, both Publick and Private, in Great Britain*, Vol. I. 1715. Reprint. New York: Benjamin Blom, 1967.

1717 Campbell, Colen. *Vitruvius Britannicus, or The British Architecture, Containing the Plans, Elevations, and Sections of the Regular Buildings, both Publick and Private, in Great Britain*, Vol. II. 1717. Reprint. New York: Benjamin Blom, 1967.

1725 Campbell, Colen. *The Third Volume of Vitruvius Britannicus, or, The British Architecture. Containing the Geometrical Plans of the Most Considerable Gardens and Plantations; Also the Plans, Elevations, and Sections of the most Regular Buildings, not Published in the First and Second Volumes.* 1725. Reprint. New York: Benjamin Blom, 1967.

1728 Gibbs, James. *A Book of Architecture, Containing Designs of Buildings and Ornaments.* 1728. Reprint. New York: Benjamin Blom, 1968.

1738 Palladio, Andrea. *The Four Books of Architecture.* 1738. Reprint. New York: Dover, 1965.

1739 Badeslade, J., and J. Rocque. *Vitruvius Brittanicus [sic], Volume the Fourth: Being a Collection of Plans, Elevations, and Perspective Views, of the Royal Palaces, Noblemen, and Gentlemens Seats in Great Britain.* 1739. Reprint. New York: Benjamin Blom, 1967.

1741 Langley, Batty. *The City and Country Builder's and Workman's Treasury of Designs, or the Art of Drawing and Working the Ornamental Parts of Architecture: Illustrated by Upwards of Four Hundred Grand Designs . . . , for the Immediate Use of Workmen, Never Published Before, in Any Language.* London, 1741.

1748 Salmon, William. *Palladio Londinensis: or, the London Art of Building.* 3d ed. London: S. Brit, 1748.

1757 Morris, Robert. *Select Architecture: Being Regular Designs of Plans and Elevations Well Suited to Both Town and Country.* 2d ed. 1757. Reprint. New York: Da Capo Press, 1973.

1757 Swan, Abraham. *A Collection of Designs in Architecture . . . Containing New Plans and Elevations of Houses for General Use: With a Great Variety of Sections of Rooms. . . .* 2 vols. London: Privately printed, 1757.

1762 Stuart, James, and Nicholas Revett. *The Antiquities of Athens.* 3 vols. 1762, 1787, and 1794. Reprint. New York: Benjamin Blom, 1968.

1767 Woolfe [John], and [James] Gandon. *Vitruvius Britannicus, or The British Architecture; Containing Plans, Elevations, and Sections, of the Regular Buildings—Both Public and Private, in Great Britain*, Vol. IV. London, 1767. Reprint. New York: Benjamin Blom, 1967.

1771 Woolfe [John], and [James] Gandon. *Vitruvius Britannicus, or The British Architecture; Containing Plans, Elevations, and Sections, of the Regular Buildings—Both Public and Private, in Great Britain*, Vol. V. 1771. Reprint. New York: Benjamin Blom, 1967.

Nineteenth Century

1802 Richardson, George. *The New Vitruvius Britannicus; Consisting of Plans and Elevations of Modern Buildings, Public and Private, Erected in Great Britain by the Most Celebrated Architects* [Vol. I]. 1802. Reprint. New York: Benjamin Blom, 1970.

1808 Richardson, George. *The New Vitruvius Britannicus; Consisting of Plans and Elevations of Modern Buildings, Public and Private, Erected in Great Britain by the Most Celebrated Architects* [Vol. II]. 1808. Reprint. New York: Benjamin Blom, 1970.

1827 Benjamin, Asher. *The American Builder's Companion.* 6th ed. 1827. Reprint. New York: Dover, 1969.

1830 Benjamin, Asher. *The Architect, or Practical House Carpenter.* 1830. Reprint. New York: Dover, 1988.

1833 Lafever, Minard. *The Modern Builder's Guide.* 1833. Reprint. New York: Dover, 1969.

1835 Lafever, Minard. *The Beauties of Modern Architecture.* 1835. Reprint. New York: Da Capo Press, 1968.

1838 Davis, Alexander Jackson. *Rural Residences, Etc. Consisting of Designs, Original and Selected, for Cottages, Farm-houses, Villas, and Village Churches: with Brief Explanations, Estimates, and a Specification of Materials, Construction, Etc.* 1837 [1838]. Reprint. New York: Da Capo Press, 1980.

1842 Downing, Andrew Jackson. *Cottage Residences; or, A Series of Designs for Rural Cottages and Cottage-Villas, and Their Gardens and Grounds, Adapted to North America.* [4th ed.]. [1852]. Reprint. Watkins Glen, N.Y.: American Life Foundation, 1967. [14]

1850 Downing, Andrew Jackson. *The Architect of Country Houses; Including Designs for Cottages, Farm Houses, and Villas.* 1850. Reprint. New York: Da Capo Press, 1968. [34]

1852 Sloan, Samuel. *The Model Architect: A Series of Original Designs for Cottages, Villas, Suburban Residences, Etc. Accompanied by Explanations, Specifications, Estimates, and Details. Prepared Expressly for the Use of Projecters and Artisans Throughout the United States. . . .* 2 vols. [1852–53]. Reprinted as: *Sloan's Victorian Buildings.* New York: Dover, 1980. [48]

1853 Fowler, Orson Squire. *A Home for All, or the Gravel Wall and Octagon Mode of Building. . . .* 1853. Reprinted as: *The Octagon House: A Home for All.* New York: Dover, 1973.

1854 Smith, Oliver P. *The Domestic Architect: Containing a Series of Original Designs for Rural and Ornamental Cottages, with Full and Complete Explanations and Directions to the Builder.* 1854. Reprint. Watkins Glen, N.Y.: American Life Foundation, 1978. [10]

1856 Cleaveland, Henry W., William Backus, and Samuel D. Backus. *Village and Farm Cottages: The Requirements of American Village Homes Considered and Suggested; with Designs for Such Houses of Moderate Cost.* 1856. Reprint. Watkins Glen, N.Y.: American Life Foundation, 1976. [24]

1857 Vaux, Calvert. *Villas and Cottages.* 1857. Reprint. New York: Da Capo Press, 1968. [40]

1863 Holly, Henry Hudson. *Holly's Country Seats: Containing Lithographic Designs for Cottages, Villas, Mansions, Etc., with Their Accompanying Outbuildings. . . .* 1863. Reprinted as: *Country Seats and Modern Dwellings: Two Victorian Domestic Architectural Stylebooks by Henry Hudson Holly.* Watkins Glen, N.Y.: Library of Victorian Culture, 1977. [25]

1865 Woodward, Geo. E. *Woodward's Country Homes, a New, Practical, and Original Work on Rural Architecture.* 1865. Reprint. Watkins Glen, N.Y.: American Life Foundation, n.d. [16]

1867 Woodward, Geo. E. *Woodward's Architecture and Rural Art, Number I–1867.* 1867. Reprinted as: *Woodward's Victorian Architecture and Rural Art.* Watkins Glen, N.Y.: American Life Foundation, 1978. [23]

1868 Cummings, [M. F.], and [C. C.] Miller, eds. *Architecture: Designs for Street Fronts, Suburban Homes, and Cottages, Including Details, for Both Exterior and Interior, of the Above Classes of Buildings.* 4th ed. 1868. Reprinted as: *Victorian Architectural Details: Two Pattern Books by Marcus Fayette Cummings and Charles Crosby Miller.* (2d printing) Watkins Glen, N.Y.: American Life Foundation, 1980. [21]

1868 Woodward, Geo. E. *Woodward's Architecture and Rural Art, Number II–1868.* 1868. Reprinted as: *Woodward's Victorian Architecture and Rural Art.* Watkins Glen, N.Y.: American Life Foundation, 1978. [16]

1869 Woodward, George E., and Edward G. Thompson. *Woodward's National Architect; Containing 1,000 Original Designs, Plans, and Details, to Working Scale, for the Practical Construction of Dwelling Houses for the Country, Suburb, and Village, with Full and Complete Sets of Specifications and an Estimate of the Cost of Each Design.* 1869. Reprint. New York: Da Capo Press, 1975. [16]

1871 *Supplement to Bicknell's Village Builder, Containing Eighteen Modern Designs for Country and Suburban Houses of Moderate Cost, with Elevations, Plans, Sections.* 1871. Reprinted in: *Bicknell's Village Builder: A Victorian Architectural Guidebook.* Watkins Glen, N.Y.: American Life Foundation, 1976.

1872 *Bicknell's Village Builder: Elevations and Plans for Cottages, Villas, Suburban Residences, Farm Houses, Stables and Carriage Houses, Store Fronts, School-Houses, Churches, Court-Houses, and a Model Jail; also Exterior and Interior Details for Public and Private Buildings, with Approved Forms of Contracts and Specifications.* Rev. ed. 1872. Reprinted in: *Bicknell's Village Builder: A Victorian Architectural Guidebook.* Watkins Glen, N.Y.: American Life Foundation, 1976.

1873 Bicknell, A. J. *Detail, Cottage, and Constructive Architecture, Containing 75 Large Lithographic Plates.* New York: A. J. Bicknell & Co., 1873. [26]

1873 Cummings, M. F. *Cummings' Architectural Details, Containing 387 Designs and 967 Illustrations of the Various Parts Needed in the Construction of Buildings, Public and Private, Both for the City and Country: Also Plans and Elevations of Houses, Stores, Cottages, and Other Buildings.* 1873. Reprinted as: *Victorian Architectural Details: Two Pattern Books by Marcus Fayette Cummings and Charles Crosby Miller.* (2d printing) Watkins Glen, N.Y.: American Life Foundation, 1980. [9]

1873 Downing, Andrew Jackson. *Cottage Residences.* ("new edition," ed. by Geo. E. Harvey, with additional material by Henry Winthrop Sargent and Charles Downing.) 1873. Reprinted as: *Victorian Cottage Residences.* New York: Dover, 1981. [11 additional]

1875 Hussey, E. C. *Home Building: A Reliable Book of Facts, Relative to Building, Living, Materials, Costs, at About 400 Places from New York to San Francisco, Containing 42 Plates and 45 Original Designs for Buildings. . . .* 1875. Reprinted as: *Victorian Home Building: A Transcontinental View.* Watkins Glen, N.Y.: American Life Foundation, 1976. [38]

1876 Atwood, Daniel T. *Atwood's Modern American Homesteads Illustrated by Forty-six Plates.* New York: A. J. Bicknell & Co., 1876.

1876 Palliser, George. *Palliser's Model Homes for the People. . . .* 1876. Reprint. Watkins Glen, N.Y.: American Life Foundation, 1978. [14]

1878 Bicknell, A. J. *Bicknell's Village Builder and Supplement.* 5th ed. 1878. Reprint. *Bicknell's Victorian Buildings: Floor Plans and Elevations for 45 Houses and Other Structures.* New York: Dover, 1979.

1878 Holly, H. Hudson. *Modern Dwellings in Town and Country Adapted to American Wants and Climate. . . .* 1878. Reprinted as: *Country Seats & Modern Dwellings: Two Victorian Domestic Architectural Stylebooks by Henry Hudson Holly.* Watkins Glen, N.Y.: Library of Victorian Culture, 1977. [22]

1878 [Palliser, Palliser & Co.]. *Palliser's Model Homes: Showing a Variety of Designs for Model Dwellings. . . .* [1878]. Reprint. Watkins Glen, N.Y.: American Life Foundation, [1970]. [18]

1880 [Bicknell & Comstock]. *Specimen Book of One Hundred Architectural Designs, Showing Plans, Elevations, and Views. . . .* 1880. Reprint. Watkins Glen, N.Y.: American Life Foundation [n.d.]. [42]

1880–1905 Mitchell, Eugene, comp. Waldhorn, Judith Lynch, ed. *American Victoriana: Floor Plans and Renderings from the Gilded Age: From the Scientific American Architects and Builders Editions, 1880 Through 1905.* San Francisco: Chronicle Books, 1979. [28]

1881 *Modern Architectural Designs and Details. . . .* New York: William T. Comstock, 1881. [33]

1883 Comstock, William T. *American Cottages: Consisting of Forty-four Large Quarto Plates, Containing Original Designs of Medium and Low Cost Cottages, Seaside and Country Houses. . . .* 1883. Reprinted as: *Country Houses and Seaside Cottages of the Victorian Era.* New York: Dover, 1989.

1887 [Palliser & Palliser]. *Palliser's New Cottage Homes and Details, Containing Nearly Two Hundred and Fifty New and Original Designs in All the Modern Popular Styles. . . .* [1887]. Reprint. Watkins Glen, N.Y.: American Life Foundation, n.d. [184]

1890 & 1900 Shoppell, R. W., et al. *Turn-of-the-Century Cottages and Villas: Floor Plans and Line Illustrations of 118 Homes from Shoppell's Catalogs.* [c. 1890 & 1900]. New York: Dover, 1983. [118]

1891 Barber, Geo. F. *The Cottage Souvenir No. 2, Containing One Hundred and Twenty Original Designs in Cottage and Detail Architecture.* 1891. Reprint. Watkins Glen, N.Y.: American Life Foundation, 1982. [58]

1897 Berg, Donald J., ed. *Modern American Dwellings, 1897.* Rockville Centre, N.Y.: Antiquity Reprints, 1984. [21]

Twentieth Century

1903 *The Radford American Homes: 100 House Plans.* Riverside, Ill.: Radford Architectural Company, 1903. [100]

1903 Roberts, E. L., and William L. Sharp. *Number 500 General Catalog of E. L. Roberts & Co. Wholesale Manufacturers of Doors, Glazed Sash, Blinds, Mouldings, Fine Stairwork, Art and Window Glass, Mantels, Grilles, Parquetry Floors, and Everything in the Line of Millwork in Any Wood.* 1903. Reprinted as: *Roberts' Illustrated Millwork Catalog: A Sourcebook of Turn-of-the-Century Architectural Woodwork.* New York: Dover, 1988.

1903–1916 Stickley, Gustav, ed. *Craftsman Bungalows: 59 Homes from "The Craftsman."* [1903–16]. New York: Dover, 1988. [36]

1904 *The Radford Ideal Homes: 100 House Plans.* "Eighth Ed., 1904." Chicago and Riverside, Ill.: Radford Architectural Company [1904]. [100]

1908 Sears, Roebuck & Co. *1908 Catalogue No. 117.* Reprint. Chicago: Gun Digest Company, 1969.

1908–1940 Stevenson, Katherine Cole, and H. Ward Jandl. *Houses by Mail: A Guide to Houses from Sears, Roebuck & Co.* Washington, D.C.: Preservation Press, 1986. [404]

1909 *Catalog No. 160, 1909–1910.* Chicago: Chicago House Wrecking Co., 1909. [20]

1909 Stickley, Gustav. *Craftsman Homes.* 2d ed. 1909. Reprint. New York: Dover, 1979. [37]

1910 Sears, Roebuck & Co. *Our Special Catalog for Home Builders.* 1910. Reprinted as: *Sears, Roebuck Home Builder's Catalog: The Complete Illustrated 1910 Edition.* New York: Dover, 1990.

1911 Hodgson, Fred T. *Builders' Reliable Estimator and Contractors' Guide. . . .* [Chicago]: Frederick J. Drake for Sears, Roebuck & Co., 1911. [31]

1911 [Radford, William A.]. *Radford's Portfolio of Details of Building Construction.* 1911. Reprinted as: *Old House Measured and Scaled Detail Drawings for Builders and Carpenters.* New York: Dover, 1983.

1912 Radford, William A., comp. *Radford's Brick Houses and How to Build Them.* Chicago and New York: Radford Architectural Company, 1912. [87]

1912 Stickley, Gustav. *More Craftsman Homes.* 1912. Reprint. New York: Dover, 1982. [78]

1913 *A Book of Plans, No. 63, 1913.* Chicago: Chicago House Wrecking Co., 1913. [70]

1913 von Holst, H[erman] V[alentin]. *Modern American Homes.* 1913. Reprinted as: *Country and Suburban Homes of the Prairie School Period.* New York: Dover, 1982.

1915 *Aladdin Houses "Built in a Day." Catalog No. 26.* 2d ed. Bay City, Mich.: North American Construction Company, 1915.

1915 *Book of Modern Homes.* Chicago, Ill.: Sears, Roebuck & Co. [1915].

1915 Comstock, William Phillips, comp. *Bungalows, Camps, and Mountain Houses, Containing a Large Variety of Designs by Many Architects Showing Homes in All Parts of the Country. . . .* 2d ed. 1915. Reprint. Washington, D.C.: AIA Press, 1990.

1915 *Gordon-Van Tine Co. Architectural Details, 1915.* Reprint. [1915]. Watkins Glen, N.Y.: American Life Foundation, 1985.

1918 *Aladdin Homes, Built in a Day, Catalog No. 31.* 4th ed. Bay City, Mich.: Aladdin Company [1918]. [57]

1918 *Honor Bilt Modern Homes.* Chicago: Sears, Roebuck & Co., 1918.

1919 *Aladdin Homes, Built in a Day Catalog No. 31, 1919.* 1919. Reprinted as: *Aladdin Homes, 1918–19.* Watkins Glen, N.Y.: American Life Foundation, 1985.

1919 Radford, William A., ed. *Radford's Homes for Everyone.* Chicago: Radford Architectural Company, 1919. [134]

1920 *Architectural Economy.* n.p.: Lumber Dealers' Service Bureau [1920].

1920s Dernier, Floyd A. compiler, copyrighter. *Distinctive Homes.* 22d ed. Los Angeles: Lumbermen's Service Association, n.d.

c. 1920 *Section-Built Dwellings and Garages: Book of Designs, No. 11.* Saginaw, Mich.: Mershon and Morley Company, n.d. [11]

1921 *Togan Cottages: Away from City Cares.* Grand Rapids, Mich.: Togan-Stiles, 1921.

1922 *Aladdin Homes "Sold by the Golden Rule" Catalog No. 33, Second Edition.* Bay City, Mich.: Aladdin Company, 1922. [73]

1922 *How to Plan, Finance, and Build Your Home.* Denver, Colo.: Architects' Small House Service Bureau, Mountain Division, 1922. [52]

1922 *Six-Room Face Brick Bungalows and Small House Plans.* 2d ed. Chicago: American Face Brick Association, 1922.

1923 Architects' Small House Service Bureau. *Your Future Home: A Selected Collection of Plans for Small Houses from Three to Six Rooms for Which Complete Working Drawings May Be Secured at Nominal Cost.* 1923. Reprint. Washington, D.C.: American Institute of Architects Press, 1992.

1923 *Building with Assurance.* 2d ed. Cleveland/New York/Atlanta: Morgan Woodwork Organization, 1923.

1923 *Five-Room Face Brick Bungalows and Small House Plans.* 2d ed. Chicago: American Face Brick Association, 1923.

1923 *The Homebuilder.* [Chicago?]: National Homebuilders Institute, 1923. [104]

1923 *Seven- and Eight-Room Face Brick Bungalow and Small House Plans.* 2d ed. Chicago: American Face Brick Association, 1923.

1923 *Three- and Four-Room Face Brick Bungalow and Small House Plans.* 2d ed. Chicago: American Face Brick Association, 1923.

1924 *Aladdin Homes "Sold by the Golden Rule."* No. 35. Bay City, Mich.: Aladdin Company [1924]. [10]

1924 *Price Supplement to "Building with Assurance" (Second Edition) for August, September, October, November 1924, Number 12.* New York and Atlanta: Morgan Sash and Door Company, 1924.

c. 1925 [C. L. Bowes]. *Our Book of Homes.* Lockport, N.Y.: Martin Clifford Lumber Company [c. 1925].

1925 [C. L. Bowes]. *Weston's Book of Homes.* Olean, N.Y.: A. Weston Lumber Company [1925].

1925 Standard Homes Company. *Better Homes at Lower Cost: 101 Modern Homes Standardized.* Book No. 7. Elmira, N.Y.: Harris, McHenry, and Baker Company, 1925. [101]

1925 *Your Next Home: Photographs and Plans of Fifty-eight Beautiful Homes.* Cleveland, Ohio: Common Brick Manufacturers' Association of America, 1925. [58]

1926 [C. L. Bowes]. *Our New Book of Practical Homes.* Warren, Pa.: Wilson-Wetmore Lumber Company [1926].

1926 Sears, Roebuck & Co. *Honor Bilt Modern Homes.* 1926. Reprinted as: *Sears, Roebuck Catalog of Houses, 1926, an Unabridged Reprint.* New York: Dover, 1991.

1927 *Aladdin Readi Cut Homes "Sold by the Golden Rule."* Number 38. Bay City, Mich.: Aladdin Company, 1927.

1927 *Bennett Homes Better Built.* North Tonawanda, N.Y.: Ray H. Bennett Lumber Company, 1927. [70]

1927 *1927 Home Builders Catalog. Second Edition: A Reference Work for Building Contractors and Home Owners. . . .* Chicago and New York: Home Builders Catalog Company, 1927. [604]

1927 Smith, Henry Atterbury, comp. *The Books of a Thousand Homes: Volume I, Containing 500 Plans of Moderate Cost 3 to 8 Room Houses: Working Drawings and Specifications Available.* New York: Home Owners Institute, 1927. [505]

1928 *Honor Bilt Modern Homes*. Philadelphia: Sears, Roebuck & Co. [1928].

1929 *Honor Bilt Modern Homes*. Chicago: Sears, Roebuck & Co., 1929.

1929 Jones, Robert T., ed. *Small Homes of Architectural Distinction: A Book of Suggested Plans Designed by the Architects' Small House Service Bureau, Inc.* 1929. Reprinted as: *Authentic Small Houses of the Twenties: Illustrations and Floor Plans of 254 Characteristic Homes*. 1929. New York: Dover, 1987. [254]

1929 *Making Old Houses into Charming Homes*. North Tonawanda, N.Y.: Weatherbest Stained Shingle Company, 1929.

1930 *Better Homes at Lower Cost: A Collection of Modern Homes Standardized as to Dimensions*. Washington, D.C.: Standard Homes Company, 1930. [62]

1930s *Ideal Homes (11th ed.): Two-Story Houses*. Saint Paul, Minn.: Plan Service Company, n.d. [60]

1931 *Aladdin Homes*. Bay City, Mich.: Aladdin Company, 1931. [47]

1936 [Duncan, Kenneth F.]. *Homes: Handbook of American Society for Better Housing, Inc.* 1st ed. New York: American Society for Better Housing, 1936.

1939 *The Book of Modern Homes*. Chicago: Sears, Roebuck & Co., 1939.

c. 1939 *Home Owners' Catalog: A Guide to the Selection of Building Materials, Equipment, and Furnishings*. New York: F. W. Dodge Corporation, n.d.

1943 *Sterling Homes*. Bay City, Mich.: International Mill and Timber Company, 1943.

1946 Dean, John P., and Simon Breines. *The Book of Houses*. New York: Crown, 1946.

1947 *Homebuilders' Book of Low-Cost Homes, Third Edition . . . Two-Story Houses, One-Story Houses, and Bungalows*. Saint Paul, Minn.: Brown-Blodgett, 1947. [36]

1947 *Summer Living; Featuring Cottages, Log Cabins, Piers, Boat Houses, Tourist Cabins*. n.p.: National Plan Service., 1947.

1952 *Aladdin Readi-Cut Homes (Not Pre-fabricated)*. Bay City, Mich.: Aladdin Company, 1952. [43]

About numbers in brackets following some entries, see "A Note on Methodology" in the Appendix.

Books, Articles, Essays

OHJ = The Old-House Journal
JSAH = Journal of the Society of Architectural Historians
WP = Winterthur Portfolio

The American Architect and Building News. Boston and New York, Vols. 1–90 (1876–1906).

Axelrod, Alan, ed. *The Colonial Revival in America*. New York: Norton, 1985.

Azzi Visentini, Margherita. "Palladio in America, 1760–1820." In *The Italian Presence in American Art, 1760–1860*, edited by Irma B. Jaffe, 231–49. New York: Fordham University Press, 1989.

Bishir, Catherine W. "Jacob W. Holt: An American Builder." *WP* 16 (Spring 1981), 1–31.

Bishir, Catherine W., et al. *Architects and Builders in North Carolina: A History of the Practice of Building*. Chapel Hill: University of North Carolina Press, 1990.

Bohrer, Frederick, Robert Reisenfeld, Kathleen Welch, and Edward N. Kaufman, eds. *The Printed House* (Exhibit Catalog). Chicago: University of Chicago Library, 1985.

Bowie, Theodore, ed. *The Sketchbook of Villard de Honnecourt*. Bloomington: Indiana University Press, 1959.

Brownell, Charles E. "The Italianate Villa and the Search for an American Style, 1840–1860." In *The Italian Presence in American Art, 1760–1860*, edited by Irma B. Jaffe, 208–30. New York: Fordham University Press, 1989.

Bruce, Alfred, and Harold Sandbank. *A History of Prefabrication*. 1944. Reprint. New York: Arno Press, 1972.

Carter, Thomas, and Bernard L. Herman, eds. *Perspectives in Vernacular Architecture, IV*. Columbia: University of Missouri Press, 1991.

Clark, Clifford Edward, Jr. *The American Family Home, 1800–1960*. Chapel Hill: University of North Carolina Press, 1986.

Cohen, Jeffrey A. "Building a Discipline: Early Institutional Settings for Architectural Education in Philadelphia, 1804–1890." *JSAH* 53, 2 (1994), 139–83.

———. "Early American Architectural Drawings and Philadelphia, 1730–1860." In *Drawing Toward Building: Philadelphia Architectural Graphics, 1732–1986*, edited by James F. O'Gorman, Jeffrey A. Cohen, George E. Thomas, and G. Holmes Perkins, 15–32. Philadelphia: University of Pennsylvania Press, 1986.

Cohn, Jan. *The Palace or the Poorhouse: The American House as a Cultural Symbol*. East Lansing: Michigan State University Press, 1979.

Cooledge, Harold N., Jr. *Samuel Sloan, Architect of Philadelphia, 1815–1884*. Philadelphia: University of Pennsylvania Press, 1986.

Creese, Walter. "Fowler and the Domestic Octagon." *Art Bulletin* 28 (June 1946), 89–102.

Crocker, Mary Wallace. "Asher Benjamin: The Influence of his Handbooks on Mississippi Buildings." *JSAH* 38 (October 1979), 266–70.

Culbertson, Margaret, comp. *American House Designs: An Index to Popular and Trade Periodicals, 1850–1915*. Westport, Conn.: Greenwood Press, 1994.

Darnell, Margaretta Jean. "Innovations in American Prefabricated Housing: 1860–1890." *JSAH* 31 (March 1972), 51–55.

di Valmarana, Mario, ed. *Palladian Studies in America, I: Building by the Book, 1*. Charlottesville: University Press of Virginia, 1984.

———. *Palladian Studies in America, I: Building by the Book, 2.* Charlottesville: University Press of Virginia, 1986.

———. *Palladian Studies in America, I: Building by the Book, 3.* Charlottesville: University Press of Virginia, 1990.

Doucet, Michael J., and John C. Weaver. "Material Culture and the North American House: The Era of the Common Man, 1870–1920." *Journal of American History* 72 (December 1985), 560–87.

Downs, Arthur Channing. *Downing and the American House.* Newtown Square, Pa.: Downing and Vaux Society, 1988.

Ericsson, Henry. *Sixty Years a Builder: The Autobiography of Henry Ericsson.* 1942. Reprint. New York: Arno Press, 1972.

Frary, J. T. *Early Homes of Ohio.* 1936. New York: Dover, 1970.

French, Gary E. "Palliser Pedigree." *OHJ* 19 (July-August 1991), 8, 10.

Garvin, James L. "Mail-Order House Plans and American Victorian Architecture." *WP* 16 (Winter 1981), 309–34.

Gebhard, David. "The American Colonial Revival in the 1930s." *WP* 22 (Summer-Autumn 1987), 109–48.

———. "Royal Barry Wills and the American Colonial Revival." *WP* 27 (Spring 1992), 45–74.

Gowans, Alan. *The Comfortable House: North American Suburban Architecture, 1890–1930.* Cambridge, Mass.: MIT Press, 1986.

Guter, Robert P., and Janet W. Foster. *Building by the Book: Pattern-Book Architecture in New Jersey.* New Brunswick: Rutgers University Press, 1992.

Halpin, Kay. "Sears, Roebuck's Best-kept Secret." *Historic Preservation* 33 (September-October 1981), 24–29.

Hamlin, Talbot. *Greek Revival Architecture in America.* New York: Oxford University Press, 1944.

Hanchett, Thomas W. "The Four Square House Type in the United States." In *Perspectives in Vernacular Architecture, I,* edited by Camille Wells, 51–53. Annapolis, Md.: Vernacular Architecture Forum, 1982.

Harris, Eileen, assisted by Nicholas Savage. *British Architectural Books and Writers, 1556–1785.* Cambridge: Cambridge University Press, 1990.

Harris, John. "The Pattern Book Phenomenon." In *Palladian Studies in America, I: Building by the Book, 2,* edited by Mario di Valmarana, 101–15. Charlottesville: University Press of Virginia, 1986.

Harvey, Thomas. "Mail-Order Architecture in the Twenties." *Landscape* 25, 3 (1981), 1–9.

Herbert, Gilbert. *Pioneers of Prefabrication: The British Contribution in the 19th Century.* Baltimore: Johns Hopkins University Press, 1978.

Hersey, George L. "Godey's Choice." *JSAH* 18 (October 1959), 104–11.

Heselberger, Lothar. "The Construction Plans for the Temple of Apollo at Didyma." *Scientific American* 253 (December 1985), 126–28, 128A, 128B, 129–32.

Hitchcock, Henry-Russell. *American Architectural Books: A List of Books, Portfolios, and Pamphlets on Architecture and Related Subjects Published in America Before 1895.* Minneapolis: University of Minnesota Press, 1962.

Hodgins, Eric. *Mr. Blandings Builds His Dream House.* Illustrated by William Steig. New York: Simon and Schuster, 1946.

Jaffe, Irma B., ed. *The Italian Presence in American Art, 1760–1860.* New York: Fordham University Press, 1989.

Jandl, H. Ward, ed. *The Technology of Historical American Buildings: Studies of the Materials, Craft Processes, and the Mechanization of Building Construction.* Washington, D.C.: Foundation for Preservation Technology, 1983.

Jeans, Marylu Terral. "Restoring a Mail-Order Landmark." *Americana* 9 (May-June 1981), 40–47.

King, Anthony D. *The Bungalow: The Production of a Global Culture.* London: Routledge and Kegan Paul, 1984.

King, Marina. *Sears Mail-Order House Survey in Prince George's County, Maryland.* Upper Marlbobo, Md.: Maryland-National Capital Park and Planning Commission, 1988.

Kostof, Spiro, ed. *The Architect: Chapters in the History of the Profession.* New York: Oxford University Press, 1977.

Lancaster, Clay. "The American Bungalow." *Art Bulletin* 40 (September 1958), 239–53.

———. *The American Bungalow: 1880–1930.* New York: Abbeville Press, 1985.

———. "Builders' Guides and Plan Books and American Architecture from the Revolution to the Civil War." *Magazine of Art* 41 (January 1948), 16–22.

Landau, Sarah Bradford. "Richard Morris Hunt, the Continental Picturesque, and the 'Stick Style.'" *JSAH* 42 (October 1983), 272–89.

MacDougall, Elisabeth Blair, ed. *The Architectural Historian in America.* Washington, D.C.: National Gallery of Art, 1990.

Massey, James C., and Shirley Maxwell. "Planbook Houses: Architecture by Mail." *OHJ* 17 (November-December 1989), 40–45.

———. "Pre-Cut Houses—'Catalog Homes.'" *OHJ* 18 (November-December 1990), 36–41.

May, Bridget A. "Progressivism and the Colonial Revival: The Modern Colonial House, 1900–1920." *WP* 26 (Summer-Autumn 1991), 107–22.

McCoy, Esther. *Five California Architects.* New York: Reinhold, 1960.

Meeks, Carroll L. V. "Henry Austin and the Italian Villa." *Art Bulletin* 30 (June 1948), 145–49.

———. "Picturesque Eclecticism." *Art Bulletin* 32 (September 1950), 226–35.

Miner, Robert G., ed. *Architectural Treasures of Early America.* 8 vols. New York: Early American Society/ Arno Press, 1977.

Mitchell, Herbert, and Frank G. Matero. *The Architectural Trade Catalog in America, 1850–1950: Selections from the Avery Collection.* New York: Columbia University Press, 1985.

Mojonnier, John J., Jr. "Introduction." In *Old House Measured and Scaled Detail Drawings,* by William A. Radford, i-iv. New York: Dover, 1983.

Moore, Charles W., et al., eds. *Home Sweet Home: American Domestic Vernacular Architecture.* New York: Rizzoli, 1983.

Morgan, Keith N., and Richard Cheek. "History in the Service of Design: American Architect-Historians, 1870–1940." In *The Architectural Historian in America,* edited by Elisabeth Blair MacDougall, 61–75. Washington, D.C.: National Gallery of Art, 1990.

Murray, Alan. "Mail-Order Homes Sears Sold in 1909–37 Are Suddenly Chic." *The Wall Street Journal,* February 11, 1985, pp. 1, 18.

Nevins, Deborah, and Robert A. M. Stern. *The Architect's Eye: American Architectural Drawings from 1799–1978.* New York: Pantheon Books, 1979.

O'Gorman, James F. "Documentation: An 1886 Inventory of H. H. Richardson's Library, and Other Gleanings from Probate." *JSAH* 41 (May 1982), 150–55.

O'Gorman, James F., Jeffrey A. Cohen, George E. Thomas, and G. Holmes Perkins, eds. *Drawing Toward Building: Philadelphia Architectural Graphics, 1732–1986.* Philadelphia: University of Pennsylvania Press, 1986.

O'Neal, William B. "Pattern Books in American Architecture, 1730–1930." In *Palladian Studies in America, I: Building by the Book, 1,* edited by Mario di Valmarana, 47–73. Charlottesville: University Press of Virginia, 1984.

Opalka, Tony. "Orr and Cunningham: Gothic Revival Builders in Albany." Preservation League of New York State *Newsletter* 15 (Winter 1989), 4–5.

Park, Helen. *A List of Architectural Books Available in America Before the Revolution.* Los Angeles: Hennessey and Ingalls, 1973.

Pearl, Susan G. *Victorian Pattern Book Houses in Prince George's County, Maryland.* Upper Marlboro, Md.: Maryland-National Capital Park and Planning Commission, 1988.

Peterson, Charles E., ed. *Building Early America: Contributions Towards the History of a Great Industry.* Radnor, Pa.: Chilton Book, 1975.

———. "California Prefabs, 1850." *JSAH* 11 (1952), 27.

———. "Early American Prefabrication." *Gazette des Beaux-Arts* ser. 6, 31 (1948), 37–46.

———. "Philadelphia Carpentry According to Palladio." In *Palladian Studies in America, I: Building by the Book, 3,* edited by Mario di Valmarana, 1–52. Charlottesville: University Press of Virginia, 1990.

———. "Prefabs in the California Gold Rush, 1849." *JSAH* 24 (December 1965), 318–24.

Poore, Patricia. "The American Foursquare." *OHJ* 15 (November-December 1987), 28–31.

———. "Pattern Book Architecture: Is Yours a Mail-Order House?" *OHJ* 8 (December 1980), 183, 190–93.

Quinan, Jack. "Asher Benjamin and American Architecture." *JSAH* 38 (October 1979), 244–56.

Reiff, Daniel D. *Architecture in Fredonia, 1811–1972: Sources, Context, Development.* Fredonia, N.Y.: Michael C. Rockefeller Arts Center Gallery, 1972.

———. *Architecture in Fredonia, New York, 1811–1997: From Log Cabin to I. M. Pei.* Fredonia, N.Y.: White Pine Press, 1997.

———. "Identifying Mail-Order & Catalog Houses," *OHJ* 23, 5 (1995), 30-37.

———. *Small Georgian Houses: England and Virginia: Origins and Development Through the 1750s.* Newark, Del.: University of Delaware Press, 1986.

———. *Washington Architecture, 1791-1861: Problems in Development.* Washington, D.C.: U.S. Commission of Fine Arts, 1971.

Reinhardt, Elizabeth W., and Anne A. Grady. "Asher Benjamin in East Lexington, Massachusetts." *Old-Time New England* 67 (Winter-Spring 1977), 23–35.

Rhoads, William B. "Charles S. Keefe: Colonial Revivalist." Preservation League of New York State *Newsletter* 11 (September-October 1985), 4–5.

———. *The Colonial Revival.* 2 vols. New York: Garland, 1977.

———. "The Discovery of America's Architectural Past, 1874–1914." In *The Architectural Historian in America,* edited by Elisabeth Blair MacDougall, 23–39. Washington, D.C.: National Gallery of Art, 1990.

Romaine, Lawrence B. *A Guide to American Trade Catalogs, 1744–1900.* 1960. Reprint. New York: Dover, 1990.

Roth, Leland M. "Getting the Houses to the People: Edward Bok, *The Ladies' Home Journal,* and the Ideal House." In *Perspectives in Vernacular Architecture, IV,* edited by Thomas Carter and Bernard L. Herman, 187–96, 236–38. Columbia: University of Missouri Press, 1991.

Ryan, William, and Desmond Guiness. *The White House: An Architectural History.* New York: McGraw-Hill, 1980.

Schimmelman, Janice G. *Architectural Treatises and Building Handbooks Available in American Libraries and Bookstores Through 1800.* Charlottesville: University Press of Virginia, 1986.

Schmidt, Carl F. *The Octagon Fad.* Scottsville, N.Y.: Author, 1958.

Schmidt, Carl F., and Philip Parr. *More About Octagons.* Scottsville, N.Y.: Author [1978].

Schrenk, Lisa D. "The Small House Bureau: Committed to 'the right of every American child to grow up in a real American home.'" *Architecture Minnesota* (May-June 1988), 50–55.

———. "The Work of the Architects' Small House Service Bureau." In *Your Future Home by the Architects' Small House Service Bureau,* iv-xxiv. Reprint. Washington, D.C.: AIA Press, 1992.

Schwartz, David M. "When Home Sweet Home Was Just a Mailbox Away." *Smithsonian* 16 (November 1985), 90–96, 98, 100–101.

Schweitzer, Robert, and Michael W. R. Davis. "Aladdin's Magic Catalog." *Michigan History* 68 (January-February 1984), 24–33, and inside front cover.

———. *America's Favorite Homes: Mail-Order Catalogues as a Guide to Popular Early 20th-Century Houses.* Detroit: Wayne State University Press, 1990.

Seale, William. *The President's House: A History.* 2 vols. Washington, D.C.: White House Historical Association; New York: Harry N. Abrams, 1986.

Smith, Mary Ann. "Gustav Stickley: Master Craftsman Designer." Preservation League of New York State *Newsletter* 10 (November-December 1984), 4–5.

———. *Gustav Stickley: The Craftsman.* Syracuse: Syracuse University Press, 1983.

Snyder, Tim. "The Sears Pre-Cut: A Mail-Order House for Everyone." *Fine Homebuilding* 28 (August-September 1985), 42–45.

Sprague, Paul E. "Chicago Balloon Frame: The Evolution During the 19th Century of George W. Snow's System for Erecting Light Frame Buildings from Dimension Lumber and Machine-Made Nails." In *The Technology of Historical American Buildings: Studies of the Materials, Craft Processes, and the Mechanization of Building Construction,* edited by H. Ward Jandl, 35–61. Washington, D.C.: Federation for Preservation Technology, 1983.

———. "The Origin of Balloon Framing." *JSAH* 40 (December 1981), 311–19.

Stearns, Elinor, and David N. Yerkes. *William Thornton: A Renaissance Man in the Federal City.* Washington, D.C.: American Institute of Architects Foundation, 1976.

Stevenson, Katherine Cole, and H. Ward Jandl. "Introduction." In *Houses by Mail: A Guide to Houses from Sears, Roebuck and Company,* edited by Katherine Cole, and H. Ward Jandl, 18–43. Washington, D.C.: Preservation Press, 1986.

Strathearn, Nancy E. "The Willows." *Nineteenth Century* 10 (Fall 1990), 8–11.

Summerson, John. *Architecture in Britain, 1530–1830.* 5th ed. Harmondsworth, Middlesex, England: Penguin Books, 1970.

Tatum, George B., and Elisabeth Blair MacDougall, eds. *Prophet with Honor: The Career of Andrew Jackson Downing, 1815–1852.* Washington, D.C.: Dumbarton Oaks Research Library and Collection, 1989.

Thompson, Neville. "Tools of Persuasion: The American Architectural Book of the 19th Century." In *The American Illustrated Book,* edited by Gerald W. R. Ward, 137–69. Charlottesville: University Press of Virginia, 1987.

Tomlan, Michael A. "Toward the Growth of an Artistic Taste." In *The Cottage Souvenir No. 2,* by George F. Barber, 4–32. Reprint. Watkins Glen, N.Y.: American Life Foundation, 1982.

[Tomlan, Michael A., Judith Holliday, and Julee Johnson]. *19th Century American Periodicals Devoted to Architecture and the Building Arts: A Microfilming Project.* Ithaca: Cornell University Fine Arts Library [1992].

Upton, Dell. "Pattern Books and Professionalism: Aspects of the Transformation of Domestic Architecture in America, 1800–1860." *WP* 19 (Summer-Autumn 1984), 107–50.

Verheyen, Egon. "James Hoban's Design for the White House in the Context of the Planning of the Federal City." *Architecture* 2 (1981), 66–82.

Waite, Diana S. ["Introduction"]. In *Victorian Architectural Details,* by M. F. Cummings and C. C. Miller, v-xxiii. Watkins Glen, N.Y.: American Life Foundation, 1980.

Ward, Gerald W. R., ed. *The American Illustrated Book in the Nineteenth Century.* Charlottesville: University Press of Virginia, 1987.

Wells, Camille, ed. *Perspectives in Vernacular Architecture, I.* Annapolis, Md.: Vernacular Architecture Forum, 1982.

———. *Perspectives in Vernacular Architecture, II.* Columbia: University of Missouri Press, 1986.

Wiebenson, Dora, ed. *Architectural Theory and Practice from Alberti to Ledoux.* Chicago: University of Chicago Press, 1982.

Wilkinson, Jeff. "Who They Were: George Palliser." *OHJ* 18 (November-December 1990), 18, 20.

Winter, Robert. *The California Bungalow.* Los Angeles: Hennessey and Ingalls, 1980.

———. "The Common American Bungalow." In *Home Sweet Home: American Domestic Vernacular Architecture,* edited by Charles W. Moore et al., 98–101. New York: Rizzoli, 1983.

Wittkower, Rudolf. *Palladio and Palladianism.* New York: George Braziller, 1974.

Wood, Charles B., III. "The New 'Pattern Books' and the Role of the Agricultural Press." In *Prophet with Honor: The Career of Andrew Jackson Downing, 1815–1852,* edited by George B. Tatum and Elisabeth Blair MacDougall, 165–89. Washington, D.C.: Dumbarton Oaks Research Library and Collection, 1989.

Woods, Mary N. "The First American Architectural Journals: The Profession's Voice." *JSAH* 48 (June 1984), 117–38.

———. "History in the Early American Architectural Journals." In *The Architectural Historian in America,* edited by Elisabeth Blair MacDougall, 77–89. Washington, D.C.: National Gallery of Art, 1990.

Wrenn, Tony P. "Bungalows: A Reintroduction." In *Bungalows, Camps, and Mountain Houses,* by William Phillips Comstock, iv-xxvi. Reprint: Washington, D.C.: American Institute of Architects Press, 1990.

Wright, Gwendolyn. *Building the Dream: A Social History of Housing in America.* Cambridge, Mass.: MIT Press, 1981.

Zimmer, Edward F. "Luther Briggs and the Picturesque Pattern Books." *Old-Time New England* 67 (Winter-Spring 1977), 36–56.

Interviews

(C = Copy of tape in the Historical Museum of the D. R. Barker Library, Fredonia, New York. T = Typed transcript on file as well.)

Esther Ahrens (daughter of Fred Ahrens, carpenter and builder), June 7, 1985 (C, T).

Ernest C. Bull (retired carpenter), March 6, 1990.

Donald R. Burgess (Fredonia resident, born 1902), August 4, 1984 (C, T).

William Case (retired owner of lumber company), July 13, 1985 (C, T).

Charles J. Czech (homeowner), April 20, 1987.

Robert Dankert (retired carpenter), August 25, 1986.

Frank and Betty Hall (homeowners), May 23, 1985 (C).

Nelson Kofoed (retired carpenter), August 20, 1986 (C).

Elizabeth Luke (daughter of Benjamin H. Luke, carpenter and builder), June 1, 1985 (C, T).

Milton H. Lupean (retired carpenter), March 14, 1990.

Nelson J. Palmer (architect), March 13, 1990.

Homer Sackett (retired carpenter), August 27, 1985 (C, T).

Olaf William Shelgren Jr. (architect), March 7, 1990.

General Index

Geographical Index

Location of buildings in the United States whose exteriors, in whole or in part (or whose interior details), are based on published designs:

DATE DUE